MW00770174

The Roanoke Valley in the 1940s

NELSON HARRIS

To Frank —
Hope you enjoy!
Nelson Harris
5·21·24

THE
History
PRESS

Published by The History Press
Charleston, SC
www.historypress.com

The Roanoke Valley in the 1940s
Copyright © 2020 by Nelson Harris
All rights reserved

First published 2020

Manufactured in the United States

ISBN: 978-1-46714-523-7

Library of Congress Control Number: 2019951903

Notice: The information in this book is true and complete to the best of our knowledge. It is offered without guarantee on the part of the author or The History Press. The author and The History Press disclaim all liability in connection with the use of this book.

Dedication
To my Dad

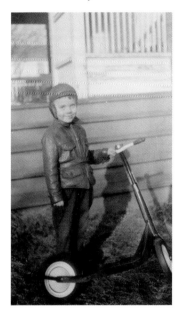

Charlie Harris on Westover Avenue, SW, in 1942. *Nelson Harris.*

Contents

Acknowledgments

This work is based on my reading every edition of the *Roanoke Times* from January 1, 1940, to January 1, 1950. Therefore, my primary recognition must be to that newspaper and the historical record it provided.

With every book I write, I am reminded of the outstanding community of librarians, archivists, volunteers, organizations, and individuals who commit themselves personally and professionally to preserving and documenting our region's history. Without them, this book would not have been possible. Thus, it is an honor for me to give them recognition here, though I wish I could do more to thank them for their work, cooperation, encouragement, and collaboration.

First and foremost, I am grateful to Sheila Umberger, director of Roanoke Public Libraries, to whom I pitched the idea of this book some six years ago. Her enthusiasm led the board of directors of the Roanoke Public Library Foundation to fund this project. I am deeply grateful to members of the library staff who gave me tremendous support, specifically Nathan Flinchum, Edwina Parks, Macklyn Mosley, and Megan Mizak. Dyron Knick was my Virginia Room liaison throughout the entire project and provided invaluable assistance.

A number of organizations, their staff, and volunteers assisted with the wonderful photographs that enhance this book immeasurably. They were as follows: Fran Ferguson, Alex Burke, and the Library Committee of the Salem Museum and Historical Society; Lynsey Allie and the Historical Society of Western Virginia; Mike McEvoy and Sarah Baumgardner of the Western Virginia Water Authority; Melinda Mayo of the City of Roanoke; Caitlyn Cline of the Roanoke Police Department; Lt. Travis Collins of Roanoke Fire-EMS; Beth Harris, archivist at Hollins University; Bev Fitzpatrick Jr. and Deena Sasser of the Virginia Museum of Transportation; Charles Price and the Harrison Museum of African American Culture; Judy Cunningham and the Vinton Historical Society; Brett Robbins and the Salem VA Medical Center; the Norfolk & Western Historical Society; Virginia Tech Libraries; Belinda Harris and Carilion Clinic; Huntington Court United Methodist Church; Kevin Meadows and Grandin Court Baptist Church; Dave Skole and Christ Evangelical Lutheran Church; Harry S. Truman Presidential Library; Mike Stevens and the City of Salem; and the Norfolk-Southern Foundation.

I am grateful to the members of the general public for contributing personal photographs for the book. They were Steve Nelson, Ed Bennett, Bob Kinsey, Ralph Berrier Jr., Edwina Parks, Betty Jean Wolfe, Roy Minnix, Mattie Forbes, John Ewald, Frank Ewald, Marshall Harris, Bob Stauffer, Mitch Drumm, Tommy Firebaugh, Raymond Hall, Judy Cunningham, and Benton Hopper.

George Kegley, Roanoke's premier local historian, read the manuscript in advance and provided much-needed grammatical suggestions and general advice. His friendship of many years is a treasure.

Finally, I am indebted to the wonderful editors at History Press who shepherded this work through the publishing process, among them Kate Jenkins.

Introduction

This book is the culmination of six years of research largely based on my reading every edition of the *Roanoke Times* from January 1, 1940, through January 1, 1950. At times, broader context was needed, so I consulted the database of historic African American newspapers via the Roanoke Main Library's Virginia Room website. I am grateful to a host of individuals and organizations for their partnership with me in this project, and I have credited them in the acknowledgments.

The decade of the 1940s was a dynamic period in the life and history of the Roanoke Valley. The ongoing development of the Roanoke Valley included Victory Stadium, the Roanoke Star, a remodeling of the Hotel Roanoke, the J-Class steam locomotives emerging from the Roanoke Shops, the expansion of the airport into Woodrum Field, the postwar boon in downtown retail and business activity, new headquarters buildings for Appalachian Electric Power Company and Shenandoah Life, the arrival of drive-in movie theatres, the end of streetcars, new radio stations, and significant public works projects.

There were individuals who opened service stations, beauty salons, restaurants, shops, and groceries. Large or small, I have tried to give each attention in this work.

This was also a time of complete segregation, minstrel shows, and blatant discrimination. Black high school athletes from Carver and Addison Schools were not named to All City-County sports teams, and blacks were seated at the backs of buses. Blacks and whites did not comingle on dance floors, and corporate and municipal employee picnics were held at separate venues—one picnic for blacks and the other for whites. There were separate schools, libraries, public toilets, canneries, and playgrounds. I have chosen not to minimize this, as one cannot appreciate the burgeoning local civil rights movement during this period without this larger context of the times.

Readers should be aware of some of the nuances within the book. This work covers the Roanoke Valley, meaning the city of Roanoke, Roanoke County, Salem, and Vinton. Developments in surrounding areas have been included to the extent they impacted the Roanoke region. During the mid-1940s and largely due to annexation, the City of Roanoke renumbered thousands of street addresses. Thus, a business may have been located at 104 Main Street in 1942 but at 1004 Main Street in 1947. In the city, some street names changed, especially in the Raleigh Court and Williamson Road sections. Other name changes occurred. The Roanoke Auditorium became the American Legion Auditorium, and Roanoke Municipal Airport became Woodrum Field. They are but two examples.

Two appendices are provided to bring more complete context to the decade. Appendix A contains the names of those from the Roanoke Valley who lost their lives in active

military service during World War II. When families provided information about their loved ones' deaths to the newspaper, I included such in the main text. Appendix B is a chronology of the burgeoning civil rights movement in the valley. While each bullet point is covered in the main text, the appendix allows for the events to be better connected into a more cohesive rendering of the movement.

No work is perfect, and the sources used are not perfect. Thus, I am certain there are misspellings and mistakes, hopefully minor. Corrections are welcome.

As with all of my prior local history books, I learned much about my home region and am better for it. I hope this book will have the same effect upon all who read it.

Nelson Harris
Roanoke, Virginia
August 2019

1940

As the Roanoke Valley rang in a new decade, world war dominated the headlines. But New Year's Eve had been marked by dancing at the Elk's Lodge and bumper-to-bumper traffic along Williamson Road as revelers moved from one night spot to another. Mr. and Mrs. Carey Bruce of Penmar Avenue, SE, missed having the first baby of the new year by twelve minutes when their daughter was born shortly before midnight. Instead, the honor of first baby went to Joseph Mays Jr., who came into the world at 8:01 a.m., being born at Burrell Memorial Hospital to Joseph and Lornia Mays. The Standard Oil Company was providing to each child born in and near Roanoke on January 1 a bank account with five dollars. (A total of five local births were reported on New Year's Day.) Private residences were the scenes of "watch parties," and St. John's Episcopal was showcasing their newly dedicated memorial windows depicting the Annunciation and the Nativity. The windows were in memory of the late Mrs. Sarah Bernard Berkeley, wife of the rector.

At Coyner's Springs Roanoke City opened a new tuberculosis sanatorium under the supervision of J. H. Falwell, director of public welfare, with the admission of the first five patients on January 1. Miss Dorothy Johnson and Mrs. Mildred Smith were the nurses, and the medical director was Dr. Dexter Davis. Two patients had been transferred to Coyner's Springs from Mercy House in Roanoke County. The sanatorium had been erected in 1939 at a cost of $110,000 in an effort to house a maximum of seventy patients with an anticipated annual operating budget of $38,000.

The Roanoke German Club held a New Year's Day ball at the Hotel Roanoke with a North Pole theme replete with white balloons completely covering the ballroom ceiling and alpine scenes lining the walls.

Dr. C. B. Ransone, Roanoke health commissioner, reported that approximately 2,500 occupied residences in Roanoke were without water or sanitation and that a house-by-house survey was needed to adequately assess certain living conditions in order to make available sanitary facilities in all homes in the city.

The January meeting of the Roanoke Norfolk & Western (N&W) Railway Better Service Club was held at Jefferson High School on the fifth. The speaker was C. G. Lindsey, and the entertainment was a performance by "The Dixie Minstrels."

The first week of January brought bitter cold temperatures such that several photographs appeared in the local newspapers of youth ice skating on Lakewood Pond in the Raleigh Court section of the city.

The Roanoke District of Boy Scouts, encompassing only Roanoke city and Roanoke County, was formally established on January 9. Prior to this arrangement, the Boy Scout district had included Craig and Botetourt Counties. According to the district officers, the

Roanoke Valley had forty-five Scout units with 1,077 boys participating. Other civic organizations held reorganization meetings as well. Harold Pearn was reelected president of the Roanoke Appalachian Trail Club, with fifty-two members. C. C. Cochran, a machinist with the Virginia Bridge plant, was elected president of the Roanoke Central Labor Council.

The Roanoke Life Saving and First Aid Crew elected Julian Wise as their captain and Samuel Oakey as president. Wise reported at their meeting that in 1939 the crew had responded to 143 calls and claimed credit for saving eighteen lives.

Local volunteers with the Roanoke chapter of the Red Cross made eighty-five sweaters for European war refugees between November 1, 1939, and the first week of January 1940. Red Cross volunteers also collected girls' dresses, hospital garments, and surgical dressings, with most items being sent to Poland and Finland.

City officials showcased improvements to the Roanoke Auditorium for the basketball season. The improvements included retractable glass backboards, an electronic scoreboard, a new floor and ceiling, and a freshly painted stage. The first game of the new season, held January 5, was between Virginia Tech and the House of David. (Tech won, 31–24.)

The Salem Kiwanis Club stated that one of their club's main objectives was the establishment of a state park in Roanoke County with an artificial lake, and they hoped other area civic organizations would join them in the lobbying of state officials.

The Smead and Webber Drugstore on Main Street in Salem caught fire on January 4, being the largest store fire in many years in the community. The dumping of ashes in the basement was deemed to be the cause of the fire, which heavily damaged the store's stock.

The Roanoke Chamber of Commerce estimated Roanoke city's population to be 78,000 for purposes of its promotional materials. Ben Moomaw, secretary, estimated the metropolitan area population to be around 118,000.

Elmore Heins, manager of the American Theatre, announced that *Gone with the Wind* would open on February 8, satisfying numerous callers. The movie would show continuously beginning every morning at eleven o'clock until midnight. Tickets for the three hour, forty-five-minute movie would be $0.75, or an evening price of $1.10 with all seats reserved.

Thornton-Creasy Pharmacists acquired the Jefferson Pharmacy, Inc.

Antrim Motors on Sixth Street, SW, advertised their new line of Dodge luxury sedans and coupes with a beginning sticker price of $815.

On January 9, WDBJ broadcast to the nation from its Roanoke radio studio the music of the Bog Trotters, a group of musicians from Galax who performed mountain ballads as part of the Columbia Broadcasting System's (CBS) Tuesday School of the Air series, devoted to American folk music.

During the second week of January, the American and Roanoke Theatres offered newsreel footage of the New Year's Day bowl games (Cotton, Rose, Sugar, and Orange) for patrons.

On the afternoon of January 7, the congregation of Oakland Baptist Church dedicated its new $25,000 auditorium building. The church was located at the corner of Roundhill Avenue and Oakland Boulevard.

Jackie Coogan starred at the Academy of Music in a production titled *What A Life*.

The "Five Smart Boys" of Roanoke College's 1930s-era basketball team (two-time state champions) played an exhibition game against the Maroons' current team before a

crowd of over one thousand spectators who had braved below-zero temperatures and a five-inch snowfall. The "Smart Boys" won, 40–29.

The Roanoke Chamber of Commerce at their regular meeting on January 11 considered a report from their airport committee that the municipal airport should be expanded to include possible air mail service and to work with other Virginia localities to make this a reality.

On January 12, William Wise Boxley died at his home, 324 Washington Avenue, SW, of a heart attack. He was seventy-eight. Boxley had been in the construction business in Roanoke for three decades and was drafted to serve on the first Roanoke City Council under the city manager form of governance. His fellow councilmen later drafted him as mayor, against his wishes. A member of First Baptist Church, Boxley was involved in numerous religious and civic causes in the city and region. A native of Louisa County, Virginia, he was first employed as a railroad construction worker in North Carolina, ultimately rising to have his own construction firm. His firm completed a portion of the aqueduct in New York City as well as work on the Brooklyn subway. He moved to Roanoke in 1906, having contracts with the N&W Railway, Virginian Railway, and the C&O Railway. In 1922, Boxley completed construction on the Boxley office building on South Jefferson Street. In his will, Boxley made significant bequests to First Baptist Church, Virginia Military Institute, and Washington and Lee University.

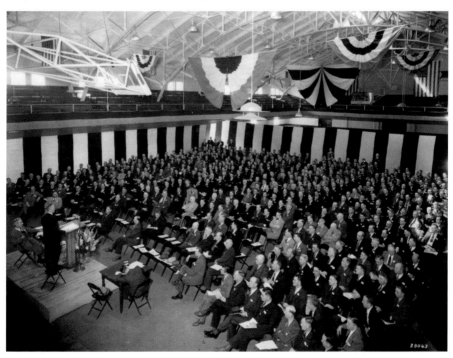

The N&W System Better Service Club Conference convened in the Hotel Roanoke (old ballroom) in 1940. *Digital Collection, Special Collections, VPI&SU Libraries.*

On January 12, the directors of Burrell Memorial Hospital held their annual meeting. It was reported that fireproofing the building was needed for the fifty-year-old structure, and that in 1939, 657 patients were admitted, up from 559 the previous year. Among the admissions for 1939 were seventy-one deliveries. Total income for the hospital was $23,920, about half of which came from patient fees. Rev. A. L. James was elected to serve as president and chairman of the board and J. Henry Claytor as vice president. Accomplishments for the previous year included the establishment of a pediatric clinic and nutrition clinic and the acquisition of new equipment. The hospital also played a critical role in the establishment of the Hospital Service Association of Roanoke, Inc., in 1939.

Dr. Charles Smith, president of Roanoke College, announced that $25,000 was in hand for the construction of a new chemistry building on the campus and that an additional $25,000 would be needed to fully fund the project. The structure would be placed on Colorado Street on the west side of the campus. Frye and Stone architectural firm in Roanoke was designing the two-story brick building.

Miss Sarah Hawkins, a native of Vinton, developed an improved incubator for premature babies in her role as superintendent of the Physicians Memorial Hospital in La Plata, Maryland. The incubator was credited with saving two lives at the hospital, and Miss Hawkins was invited to appear on CBS's *We, the People* national broadcast.

At the Roanoke City Council meeting on January 15, the council took up the issue of the increasing costs of caring for the city's indigent residents. The debate was viewed as a prelude to establishing a city-owned hospital to be located at property adjoining Coyner's Springs. The council formed a committee to investigate the matter, understanding that healthcare costs would continue to rise. The city budget included $7,500 for such care, but physicians with the Roanoke Hospital Association advised that the more realistic cost estimate should be between $12,000 and $15,000.

The Rev. Ramon Redford of Belmont Christian Church was elected president of the Roanoke Ministers' Conference, succeeding the Rev. Jesse Davis of Virginia Heights Baptist Church.

The Roanoke County Board of Supervisors sought more legislative powers to fight annexation at their first meeting of the year, in which Luther Bell was elected chairman.

The Roanoke Kiwanis Club celebrated its twentieth anniversary on January 17. The Roanoke Kiwanis Club was founded on November 26, 1919, receiving its charter on January 28, 1920, with 118 members. Early initiatives of the club included improving roads in Roanoke, especially the Roanoke-Rocky Mount Road. Another accomplishment was the Kiwanis Kampers program, as the club had sent in the previous two years 280 boys to Camp Johnson. Dr. John Boyd, oldest past president of the club, was the speaker for the occasion that was held at the Patrick Henry Hotel.

Out of the N&W Roanoke Shops on January 19 emerged a new Y-6 freight locomotive, the last on an order of ten such locomotives for 1939. An order for an additional ten was made for 1940.

Seventy workers employed by the Works Project Administration appeared at the city's Relief Center building in mid-January asking for help. Snow and ice had interrupted their work on the Blue Ridge Parkway, and the workers were pleading for coal, food, and medical care. J. H. Falwell, city welfare director, explained that the city's relief funds were available to those considered unemployed, and the WPA workers were deemed employed and

thus ineligible for assistance. The WPA workers had been out of work since December 21 due to weather conditions. (Some ninety workers were able to resume their jobs on January 22.)

Dr. Henry Lee, great nephew of Confederate general Robert E. Lee, spoke at the meeting of the Salem Kiwanis Club, providing insights into the thinking and habits of his famed uncle.

Paul Blackwell, chief engineer for the Virginia Bridge Company announced that he would retire February 1 after thirty-five years of service. C. W. Ogden, assistant chief engineer, was announced as his successor.

The Roanoke Boxing Club put on its first show of the year at the City Market Auditorium on January 19. Roanoke's Johnny Hodges was scheduled to fight New York state's Joe Duffy in a lightweight bout, but Duffy failed to appear. Other matches included Don "Dynamite" Webber versus Albert Smith, Leroy Coleman versus Jesse Baker, and William Dudley versus James Price. The night began with a "battle royal" that featured five fighters in the ring at once with the last two standing to meet in a three-bout round later. The region had already produced one semiprofessional boxer, Ed Barnett of Salem, who had recently moved to Florida to compete. Joe Terry was president of the boxing association. Over one thousand spectators attended the event.

Fire destroyed the home of C. C. Thomas on Washington Street in Vinton, a structure believed to have been erected in 1840 as part of the Preston family estate. It was one of the oldest residences in the town.

The Roanoke Chamber of Commerce celebrated its fiftieth anniversary on January 20. Its central mission was "advertise and publicize Roanoke in every possible way." Begun in 1890 as the Board of Trade Manufacturing and Investment Company, the board existed primarily to assist in relocating businesses in Roanoke. The Board of Trade became the Association of Commerce in 1919 and then the Chamber of Commerce in 1923. As part of its anniversary celebration, Morris Harrison was recognized as the city's oldest merchant, having been in his original business continually for the past half century. Harrison, a jeweler, opened his store on August 8, 1888, when he repaired watches in the window of a drugstore on Salem Avenue before opening his own store in space leased from Dr. W. E. Kirk on Salem Avenue. During that time Harrison resided at the Felix Hotel, located on the present-day site of the old N&W office building (now known as 8 Jefferson Place). In 1914, Harrison moved his jewelry store to 23 W. Campbell Avenue and in 1926 to 307 South Jefferson Street. The chamber's secretary, Ben Moomaw, was the tenth secretary the chamber had since its inception, and he had been serving in that capacity since 1923.

The chamber's golden anniversary was celebrated with a dinner meeting at the Hotel Roanoke. Dr. James S. Thomas, president of Clarkson College of Technology, Potsdam, New York, and president of the Chrysler Engineering Institute, Detroit, Michigan, was the guest speaker. At the dinner, forty businesses that had operated in the city fifty years or longer were recognized.

One hundred twenty adults and 112 Roanoke children had tuberculosis in 1939, resulting in twenty-five deaths, as reported by Miss Florence Deyerle, the tuberculosis control nurse for the city.

The *Roanoke Times and World News* radio station, WDBJ, announced the addition of Irving Waugh to its broadcast staff. Waugh replaced Roger van Roth, who had left for a job with the National Broadcasting Company (NBC) in Washington, DC.

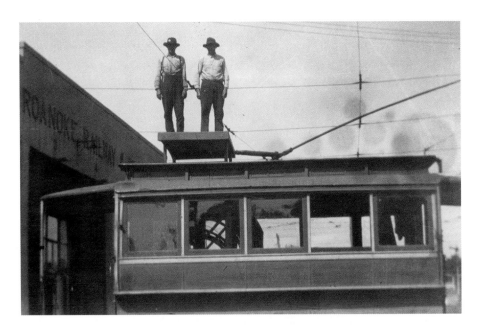

Two men stand on top of a streetcar at a terminal, January 1940. *Virginia Room, Roanoke Public Libraries.*

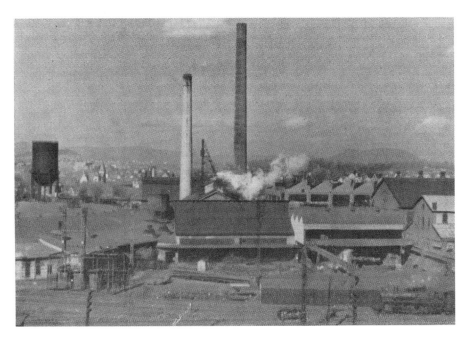

A portion of the N&W Railway East End Shops, January 1940. *Norfolk-Southern Foundation.*

Dr. Coleman Ransone, Roanoke city commissioner of health, launched a drive to educate the public about venereal diseases, estimating some 13,250 cases of syphilis in Roanoke. Ransone promoted the observance of National Social Hygiene Day on February 1. One week later, the Virginia General Assembly overwhelmingly approved a measure that would require premarital testing for syphilis.

The Virginia Synod of the Lutheran Church held their annual meeting at St. Mark's Church. Dr. Charles Smith, president of Roanoke College, addressed the group. He cited a general pessimism toward Protestantism as a call to find new ways to address problems in an era of scientific solutions.

J. Shirley Riley, forty-six, vice president and treasurer of the Roanoke Coca-Cola Bottling Works, died suddenly on January 29. Riley had been a resident of Roanoke since 1906 and associated with the bottling plant for all of his adult life. In Roanoke, he had been an enthusiastic supporter of local aviation and was president of the State Finance Corporation. Funeral services were conducted two days later from Second Presbyterian Church.

The Franklin Road-Northeast bus line began on January 28, replacing the streetcar. The city had purchased five new buses, each costing $9,000, for the new service.

The 1940 edition of *The Negro Motorist Green Book* had the following listings for Roanoke: Dumas Hotel on Henry Street; Reynolds Tourist Home at 34 Wells Avenue, NW; Tom's Place Tavern; and the Maple Leaf Garage on High Street at Henry Street, NW.

The *Roanoke Times* reported that during the summer, its WDBJ radio station would move from 930 to 960 on local radio dials due to the strong broadcasts from Cuba and Mexico creating interference. Other local stations were doing the same.

The Salvation Army shared plans to move to a new site in the 900 block of Salem Avenue, SW, when it vacated its present site at the corner of Salem Avenue and Second Street, SW.

The Roanoke Tuberculosis Association announced that it raised $5,147 from its 1939 Christmas seal sale. The local association was formed in 1930 and reelected Arthur B. Richardson to serve a tenth consecutive term as the local president.

The Virginia Theatre held its first amateur talent show on February 1. Emmett Nabors was the manager.

Three candidates declared for the Democratic nominations for the 1940 Roanoke City Council election, the deadline being February 2. They were incumbent mayor Walter W. Wood, W. B. Carter, and Benton Dillard. Two seats were up for election. Councilman James Bear decided not to stand for reelection. A councilman's annual salary was $1,000.

Judge Thurston Keister was appointed to a second eight-year term on the bench of the 20th Judicial District Court, encompassing the counties of Roanoke, Montgomery, and Floyd and the cities of Roanoke and Radford. Joseph Chitwood submitted his resignation as district attorney for Western Virginia due to ill health. He had been appointed to the office on January 16, 1934.

The William A. Hunton Branch, YMCA, hosted Congressman Arthur W. Mitchell as guest speaker at its annual public service banquet at the Roanoke Auditorium on February 4. Mitchell was the only black member of the United States Congress at the time. Dr. E. D. Downing was chairman of the branch. Some two thousand persons attended the event.

Pianist Eugene List played to a large crowd at the Academy of Music as part of its 1939–40 series.

A Virginian Railway passenger train wrecked near Shelby in Montgomery County as a result of a rock slide. Fortunately, there were no injuries to passengers or crew, and engineer L. P. Cormany of Roanoke was credited with greatly diminishing the seriousness of the accident.

Frank Noftsinger of Roanoke won one of three awards given in the fourth annual Virginia Photographic Salon, and his image, "Texture Study," became a part of the permanent collection of the Virginia Museum of Fine Arts.

A *Gone with the Wind* Ball was held at the Hotel Roanoke in anticipation of the film's opening on February 8 at the American Theatre. Mary Robinson and Roger Patterson were selected as best portraying Scarlett O'Hara and Rhett Butler. On opening night, 3,500 patrons packed the American Theatre for various showings of the film.

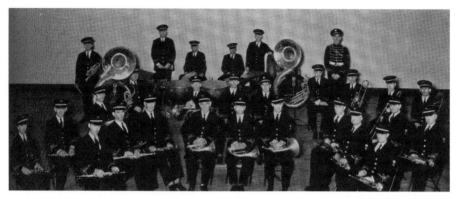

The Norfolk & Western Railway Band, February 1940. *Norfolk-Southern Foundation.*

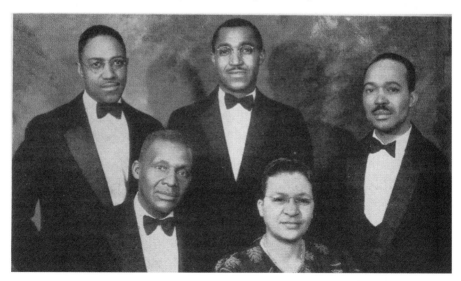

The Robertson Singers of Roanoke; *seated*, Mr. and Mrs. J. H. Robertson; *back row l–r*, J. W. Harris, Charles Wiley, V. Geurrant; 1940. *Norfolk-Southern Foundation.*

Irving Saks, president of Smartwear-Irving Saks, was chosen president of the Retail Merchants Association in Roanoke for 1940 at their annual banquet meeting at the Hotel Patrick Henry.

Leaders of the Garden City and Riverdale neighborhoods appeared before the Roanoke County School Board to lobby for the creation of a new school in their section, asserting that their present facility was no longer adequate.

Russ Peters of Roanoke attended the Cleveland Indians' spring training camp in Fort Meyers, Florida, in a bid to become a shortstop. In the summer of 1939, Peters played for the Atlanta Crackers and batted .316.

The trolley wires for the Northeast-Franklin Road streetcar line were removed during the second week of February. The tracks were removed two months later, as buses began serving the route in January.

The Salem Public Library reported that its collection had grown from 35 to 2,384 volumes in just three years. The library opened on February 15, 1937, under the sponsorship of the Salem Woman's Club. The number of patrons was at 2,460. There was also a branch library for Salem's black citizens, consisting of 456 books. The libraries were under the supervision of Mrs. C. B. Phinney.

On February 10 some thirty coal cars of the Virginian Railway derailed near Lafayette in Montgomery County, some careening into the Roanoke River. It was one of the costliest wrecks in the railway's history. The cause was speculated to be a defective freight car.

Local attorney and former member of the Roanoke City Council Col. James D. Johnston passed away at his home on Mountain Avenue on February 12. Johnston served on the council from 1901 to 1904. He was an ardent Democrat and a past president of Roanoke's Anti-Saloon League during the Prohibition era. He was also a charter member of Trinity Methodist Church. On the same day, another former member of the Roanoke City Council also passed away, Charles D. Keffer. Keffer was a native of Buchanan and came to Roanoke in 1888, later establishing a contracting and glass firm known as C. D. Keffer and Son. He was a fifty-three-year member of the Knights of Pythias. Funeral services were conducted from his home on Highland Avenue.

Salem City Council expressed its support for a new primary school to replace the Academy Street School. Mayor C. R. Brown commented that the Academy Street School was "nothing in the world but an antiquated building and we deserve something better." Their opinion was to be shared with the Salem School Board.

Perry Crumley, a 190-pound fullback for Roanoke College, announced he had a contract with the New York Giants. Crumley said a scout for the Giants noticed him play when Roanoke took on Georgetown University. Crumley had played for Roanoke College for three seasons.

A meeting of the City-County Race Relations Committee was held, and plans were developed for promoting Race Relations Sunday the second Sunday of February in 1941. The committee was well pleased with a conference they had sponsored the previous week at Calvary Baptist Church in which some six hundred persons attended and listened to a University of Richmond history professor speak on the topic of race relations relative to healthy communities.

The new Wasena Bridge, opened in 1939, had a final cost of $343,922 according to the city auditor's report. The city's share was $194,657, and the remainder was paid for by

the Public Works Administration. The bridge was constructed by the Wisconsin Bridge and Iron Company.

Ebony Escapades of 1940 was presented by theater students at Jefferson High School. The minstrel show drew a standing-room-only crowd such that the school announced another performance would be scheduled three nights later. The two-hour program featured dancing, jokes, and songs, including a performance by the school choir.

The first Y-6 locomotive to be built by the Roanoke Shops in 1940 steamed out of Roanoke on February 17, making a four-and-a-half-hour trip to Bluefield, West Virginia. The Y-6 was the first of ten ordered to be built during the year. The mallet freight locomotive's crew included S. E. Taylor, engineer; J. H. Whitlock, fireman; O. L. Amos, first brakeman; A. R. Wilkerson, second brakeman; and A. B. Mills, conductor. Accompanying the crew was a reporter for the *Roanoke Times*, Melville Carico.

Mayor C. C. Crockett of Vinton found himself embroiled in controversy when he received a speeding ticket. The practice was for such charges to be heard by the mayor, but the vice mayor was asked to preside in the case for obvious reasons. At the Vinton Town Council meeting, the mayor debated with the town manager about the "speed trap," suggesting that police officers not charge anyone with speeding who was driving less than forty miles per hour. The mayor was driving thirty-three miles per hour when he received his ticket. The mayor further charged that the town manager had given special instructions to a new night officer as a response to the council not giving him a raise. The town manager, H. W. Coleman, emphatically denied the mayor's allegation, making for good political theater at the council's February meeting. Two weeks later, Mayor Crockett was officially fined five dollars for driving thirty-three miles per hour in a fifteen-mile-per-hour zone. Vice Mayor Roy Spradlin presided over the hearing before a packed city hall.

Joseph Chitwood, US district attorney for the Western District of Virginia, died at his home on Walnut Hill on February 21. He was sixty-three. Chitwood had resigned his attorney post the previous month due to ill health. Services were conducted from First Baptist Church, with two US senators and two members of Congress serving as honorary pallbearers. Chitwood had served one term in the Virginia House of Delegates.

Representatives from parent-teacher associations from all Roanoke County public schools convened on February 21 and formed the Roanoke County Council of Parents and Teachers. The meeting was held in the Thurman and Boone assembly room, and the group elected Mrs. Frank Peters of Williamson Road as its first president.

On February 22, Edgar Funkhouser, past president of the Roanoke Gas and Water Company, died in Key West, Florida. He was spending the winter in Florida due to illness. His funeral service was conducted from his home, "Cherry Hill," in South Roanoke.

Roanoke's ten-pin bowlers captured first place in the N&W 14th Annual Ten Pin Tournament that was held in Cincinnati. The Roanoke team members were R. M. Ashworth, C. B. Carper, E. D. Cronise, C. G. Hammond, M. F. Ruddo, and J. H. Hahn.

Eight public schools in Roanoke were deemed to have such poor lighting for cloudy days that the city council appropriated funds for more wiring and lights in them. The schools were Highland Park, Virginia Heights, Monroe, Virginia Heights (old building), Norwich, Jamison, Harrison, and Gainsboro. It was estimated that nearly 3,900 pupils were in rooms either with inadequate lights or no lights. The school board had been lobbying for funds for lights over the past five fiscal years. Teachers at the eight schools complained that on cloudy days, they could not conduct lessons involving reading or use of the chalkboards because students could not see the materials.

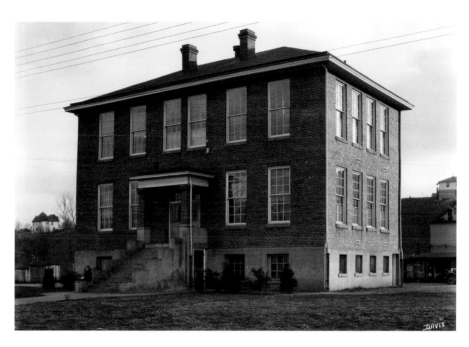

This is Norwich School in the 1940s. *Virginia Room, Roanoke Public Libraries.*

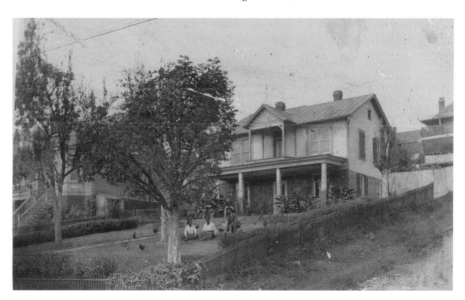

Home of William and Daisy Schley, 203 Gilmer Ave., NW c. 1940. *Edwina Parks.*

Roanoke city councilman Leo Henebry quoted fire chief W. M. Mullins statistics that during the previous decade, Roanoke city fire stations responded to 255 calls outside the city limits with no reimbursement from Roanoke County. Thus, he noted that city taxpayers footed the entire bill for county residents to have fire protection, and that the cost in 1939 came to $23,500. Henebry noted that this was not unusual for cities to respond to fires in neighboring counties but that almost all other cities were reimbursed for the service when rendered.

Frank Tavenner of Woodstock, Virginia, was appointed by Judge John Paul of Harrisonburg to become acting district attorney for the Western District of Virginia, a vacancy created by the death of Joseph Chitwood. Tavenner had been Chitwood's assistant.

The Old Dominion Civic Band was formed to provide a civic band for Roanoke. The director was Ollie W. Dillworth, director of the N&W Railway Band. The initial group consisted of thirty-five musicians whose purpose was to provide concerts and song festivals in the city's parks. Dilworth had written a song about the founding days of Roanoke entitled "March of the Magic City" and suggested it would be introduced to the public by the band and an accompanying chorus at one of their concerts.

National Business College's Golden Eagles basketball team defeated the Pulaski Indians 38–36 before some 1,600 spectators at the Roanoke Auditorium to win the AAU Western district title. The Eagles, state AAU Champions the past two years, would move on to play for the state championship. Two days later their championship hopes were made more difficult when their star center, Rex Mitchell, was ruled ineligible to play. Mitchell had been gone from Roanoke for twenty-two days trying out for a pro basketball farm team, the Toledo Mudhens, and his absence became a source of controversy. On March 1, the Golden Eagles upset the Apprentice School of Newport News 49–35 to win the first game of the state AAU Championship series before a packed house at Roanoke Auditorium. (NBC was awarded the state title when Apprentice refused to play further games in Roanoke for the series, arguing that one game must be played at Newport News.) In other sports news, Roanoke College announced an eight-game football season for 1940.

Maj. F. W. Thomas of the National Guard made a plea before the Roanoke City Council that an armory be built for the training of local guard units. The council agreed to make a study of the proposal and formed a committee for that purpose. Committee members named were Mayor Walter Wood, Vice Mayor Leo Henebry, and City Manager W. P. Hunter. The local guard unit had been using the Roanoke Auditorium for training purposes, but Major Thomas asserted that the facility was not adequate for the needs of guard training. Further, Major Thomas shared with the council that the city might lose its guard units if a facility were not provided in the near future.

Salem residents celebrated the one hundredth birthday of Mrs. Willie Ann Shipman of their town on February 27. Mrs. Shipman had come to Salem in the 1870s with her husband, A. M. Shipman. She was a tutor in Latin for students at Roanoke College and was an active member of Salem Presbyterian Church. The day prior, she had been formally recognized and honored by the Salem Town Council.

Lions Minstrels of 1940, a production under the auspices of the Salem Lions Club and the Salem Junior Woman's Club, began a two-night run on February 29 in the Andrew Lewis High School auditorium. The event was a fundraiser for sight conservation for indigent children.

The Roanoke Gilbert and Sullivan Light Opera Company presented *The Gondoliers* with Mary Louise Thomas, soprano, and Charles Cocke, both of Roanoke, in the leading roles at Hollins College's Little Theatre.

The *Roanoke Times*' All City-County Basketball Team for 1939–40 was announced and consisted of the following players: D. J. Showalter, guard, Andrew Lewis; Watt Ellett, forward, Jefferson; Aubrey McGeorge, center, William Byrd; Jesse Boston, guard, Jefferson; and Robert Doss, forward, William Fleming.

Harry Yates, Roanoke city municipal auditor, reported that per capita expenditures by the city in 1939 amounted to $31.27 per person, a decrease from the prior year. The city ended the year with a surplus of $74,138. Total expenditures for the city government in 1939 were just over $2.4 million.

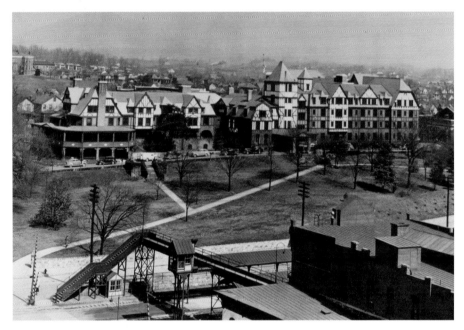

Hotel Roanoke, 1940. *Virginia Room, Roanoke Public Libraries.*

Sherwood Burial Park unveiled plans in early March for construction of a mausoleum. The $200,000 structure would house administrative offices, a chapel, and a crematory. The building would be made of granite, and in the structure proper would be eighty-four niches in the columbarium. The contractor for "Sherwood Abbey" would be U. J. Smith and Son of Cleveland, Ohio.

Melville Carico of the *Roanoke Times* provided a wonderful profile of the N&W Railway Dining Car services and personnel. In 1939, the crew served a total of 133,000 meals. The dining car department and commissary was near the Randolph Street Bridge at East End Shops, and the staff consisted of twelve crews, each crew having twelve stewards, twelve chefs, and thirty-two waiters. (There were ten dining cars.) Main menu items included roast beef, lamb chops, fried chicken, steak, and the always-popular seafood that the N&W purchased fresh in Norfolk. The oldest steward in service was H. R. Tillery,

who began employment with the N&W in 1906. The longest-serving waiter was Roscoe Banks, having begun his job in 1911. He had served many distinguished passengers, including Theodore Roosevelt, William Howard Taft, Woodrow Wilson, and First Lady Eleanor Roosevelt. The longest-serving chef was James Early. He began as a chef with the N&W in 1907 at the Jamestown Exposition, then moved to be the chef at the railway's restaurant in the Roanoke passenger station. When that restaurant closed in 1931, he moved to the dining car. Early said it took him some time to get his "train legs," whereby he could make food without spilling it. J. W. Menefee was superintendent of the dining car department.

A special committee, chaired by James Turner, recommended to the Roanoke City Council that a local housing authority be appointed to survey conditions in regard to the need for a federally funded building program. Turner reported that housing conditions, especially among minorities, were bad and that little improvement had been made in the past decade. City Manager W. P. Hunter suggested that a canvass be made for such an initiative after the federal census was completed.

The former high constable for Roanoke, George Beckner, made an appeal through his attorney to the Roanoke City Council that his position be reinstated, as the council had merged it with the position of city sergeant. Beckner had been accused and convicted of embezzlement of public funds, but his conviction had been overturned by the Virginia Supreme Court. City attorney C. E. Hunter advised the council not to recreate the office, and the council concurred.

Mayor Crockett of Vinton continued his campaign against the town manager, a crusade fueled by his being charged with speeding and later fined for the same. Crockett had written a letter to the town manager, H. W. Coleman, asking him to resign, but fellow members of the town council did not agree with the request. Crockett read his letter into the record at the town council meeting, and no action was taken.

The Roanoke Weaving plant at Vinton announced a planned expansion in order that an additional 150 to 200 looms might be added. The contract for the expansion was awarded to B. F. Parrott & Co. of Roanoke. The Vinton plant had been built in 1936. The Roanoke Weaving Company was a division of Burlington Mills, Greensboro, North Carolina.

The Roanoke Community Concert Association conducted its annual membership drive by sharing that it had secured noted Metropolitan Opera baritone Lawrence Tibbett for a concert as part of its 1940–41 Season. The association was established in 1931 as a nonprofit organization for the purpose of presenting musical performances and groups and was assisted in its endeavors by the Columbia Broadcasting System. Most of the association's events were held at the Academy of Music. Some six hundred memberships were purchased.

J. M. Ruffin, local manager for the Chesapeake and Potomac Telephone Company, offered plans to extend service to the Williamson Road area through the installation of underground and aerial cables. The service would cost the phone company $27,000 and would take six months to complete.

Dr. J. E. Flannagan was appointed as medical director for the Roanoke city Tuberculosis Sanatorium, beginning his service April 1. Flannagan came to the position from Southwestern State Hospital in Marion, Virginia.

Local organizers of the Finnish Relief Fund held a benefit double-header basketball game to raise money for relief in Finland, a country that had been invaded by Russia and suffered significantly. The double-header was held on March 11 in the Roanoke Auditorium. Some 1,200 spectators watched as Jefferson High School defeated Roanoke College's freshmen team, 31–28, and the state champion Golden Eagles of National Business College defeated the "Smart Boys" of Roanoke College 35–33. The event raised over $700. (Russia and Finland signed a peace treaty the next day, but former President Herbert Hoover took American funds, including those raised by the basketball game in Roanoke, to Finland a week later.)

For the 1939–40 high school basketball season, William Fleming High School finished in first place among area high schools with a record of 15–7. Jesse Boston of Jefferson High School scored the most points during the season: 193 in twenty-two games.

The Roanoke City Council offered to lease the Academy of Music for ten occasions during the year at a cost of $150 per event. This was an effort to assist the academy financially. The management of the cademy had asked for relief from paying taxes, but the council thought renting the facility was a better approach.

The store windows of forty merchants in downtown Roanoke were illuminated simultaneously at 8:00 p.m. on March 12 for the second annual spring style show. Shoppers were encouraged to vote for their favorite window display at voting booths situated at Campbell Avenue and First Street, Campbell and Jefferson Street, and Jefferson and Church Avenue. Two cash awards of $40 were given to N. W. Pugh Company, first place for both display and illumination, and to S. H. Heironimus Company, second place. The award monies were donated by Appalachian Power Company, and it was reported that several thousand Roanokers packed downtown streets for the event. Nat Spigel was chairman of the event committee.

The local chapter of the American Association of University Women sponsored their annual art exhibit, held at the Elks Lodge on Jefferson Street. In an address to open the exhibit, Professor Robert Shaffer of Hollins College urged the city to establish a permanent art gallery to serve as an "active laboratory for artists rather than a funeral parlor for works of art."

Hazel Hutcherson, sixteen, of Virginia Heights was wounded in Raleigh Court Park outside Woodrow Wilson Junior High School when another student, age thirteen, discharged a .22 rifle. According to police, the student had taken the rifle to the school that morning, and he and friends were firing it in the park that afternoon for target practice. Hutcherson was taken to Lewis-Gale Hospital, where she recovered after several days.

Lazarus, Inc., announced its move to a new location at 310 S. Jefferson Street, the former location occupied by Tudor Tavern. With extensive renovations, the store planned to offer expanded clothing options.

In mid-March, the Roanoke Theatre offered a live stage performance of *Vanities of 1940*, billed as a "continental heat wave of girls in scanties!" The show consisted of "25 youthful talented entertainers." Just a week before, the theater had brought in "an all colored revue" titled *Darktown Scandals* that starred, according to their advertisement "12 high stepping, high brown babies." Its feature films were occasionally billed as "adults only."

The United Press news service returned to the *Roanoke Times* in March after an absence of several years. The newspaper shared with readers that they would have the benefit

of "a broader news coverage during a period when most of the world is in a state of up-heaval." The Roanoke newspaper also used the Associated Press.

The Federal Bureau of Investigation began cooperating with Roanoke County authorities in the search for "Madame Valeria," a fortune teller who disappeared on March 8 with $6,000 belonging to Mr. and Mrs. J. T. Kessler of the Williamson Road section. Given that the suspect was believed to have fled the state, federal authorities intervened.

The cornerstone for Salem's G. W. Carver School, Roanoke County's consolidated school for black students, was laid during a ceremony on Sunday, March 17. Alice Webster, ninety-two, a former slave and lifelong resident of the county, set the stone. An address was given by the Rev. C. J. Smith of Salem's First Baptist Church.

Carver School under construction in Salem, 1940. *City of Salem.*

Burrell Memorial Hospital celebrated its twenty-fifth anniversary on March 18, having opened its doors on that day in 1915. Dr. L. D. Downing of the hospital presided over a special luncheon honoring the occasion.

In Vinton, Mayor Crockett continued his quest to have the town manager fired. At a meeting of the council on March 18, the mayor formally requested the resignation of H. W. Coleman. The motion was voted down by the other two council members, J. H. Moseley and Roy Spradlin. The mayor spoke for an hour and five minutes before a packed town hall.

The Roanoke County Board of Supervisors voted against further use of convict labor for highway and road improvements, and thus the discontinuance of convict camps in the county. The reason for the 2–1 decision was that supervisors heard from citizens that there was not support for the use of convicts on road projects. Interestingly, the decision was reversed two weeks later when an absent supervisor at the first meeting voted against the motion at the second meeting, making it a 2–2 tie. In tie votes by the supervisors, the

tie was broken by a trial judge, and in this case the deciding vote was cast by Trial Justice R. T. Hubard. Judge Hubard cited as his reason that some $20,000 of road improvements would go undone if convict labor were abolished.

National Business College's Golden Eagles state championship AAU Basketball team was quickly bounced from the national AAU Tournament in Denver, Colorado, when they lost their opening game 68–48.

Melvin Jones of Chicago, founder of Lions International, spoke to two hundred members of Lions Clubs of the Second Lions Zone at Hotel Roanoke. Jones had been secretary general of Lions International since its founding in 1917.

Four prisoners escaped the Salem jail on the night of March 20 by prying loose the bars in a window and dropping about twenty feet to the ground. Their escape was not noticed until 9:30 p.m. that evening when the jailer, R. T. Biggs, went to lock the prisoners in their cell block for the night. Two of the escapees were apprehended within twenty-four hours. The other two were federal inmates, and the search for them brought the involvement of the FBI. A third, Coburn Perdue, was apprehended by federal authorities several days later in Charleston, West Virginia, and the fourth, Charlie Sprye, remained at large.

Magic City Motor Corporation opened a "modern" used car lot illuminated by floodlights for night sales at 348 Campbell Avenue, SW. The lot could hold about a hundred cars and would be open until 10:00 p.m. Their Easter special during the grand opening was a 1937 Lincoln Zephyr for $499.

A banner headline in the *Roanoke Times* on March 22 informed readers of a devastating fire the previous night in Ferrum. Eleven structures were lost—an entire block in the business section of the small town—when an oil stove exploded in a room above the Ferrum Cafe. Total damages were estimated to be $250,000.

John H. Moseley announced that two terms on the Vinton Town Council were enough and that he would not seek reelection. He had served from 1930 to 1934, and then served another term, as mayor, beginning in 1936. It was noted that he was the first person to serve as mayor when Vinton converted to the town manager form of government in 1936.

Salem's annual community Easter egg hunt was held at Lake Springs Park with some eight hundred to one thousand eggs being hidden, including two golden eggs for special prizes. Students at Jefferson High School assembled in the school auditorium to hear an Easter message delivered by the Rev. Dr. Daniel H. Clare, who spoke on the relationship between a belief in immortality and the development of good character.

The Roanoke Corps of the Salvation Army celebrated the diamond anniversary of the movement in late March. The Salvation Army had an early presence in Roanoke beginning in 1885 with meetings held at an old skating rink located on the southwest corner of Church Avenue and Jefferson Street. The work did not initially take hold but was reestablished in 1900 and had operated in Roanoke continuously since that time.

At the urging of the chamber of commerce, the Roanoke City Council adopted a resolution of the McCarran Bill in the US Senate, a bill that would provide funds for the construction and expansion of airports around the country. In other action, Mayor Walter Wood presented a medal to Sanders Allison for saving the life of a twelve-year-old boy, Ernest Murphy, whose boat had capsized in the Roanoke River on April 10, 1939.

Roanoke Country Club golf pro Hugh Gordon suggested that the Professional Golf Association be approached about the club hosting a PGA tournament at the club next

spring given that such tournaments were held in Pinehurst, Greensboro, and Asheville. Gordon suggested a purse of $3,000 be offered. This was met with some skepticism by the club's leadership, but Gordon was granted permission to discuss the idea with PGA officials.

Roanoke building officials stated that the Center Hill section in southwest was the fastest-growing residential area in the city due to the large number of building permits for homes in that area. At this same time, John Parrott was offering choice building sites, 60 by 150 feet, in "Prospect Hills" for $1,500. Sigmon Brothers were developing "Green Hills," and the firm of Wendell-Lemon was promoting choice building locations in the Airlee Court Annex.

Roanoke city Democrats held a citywide primary on April 2 to nominate its candidates for two seats on city council. Mayor Walter Wood led the ballot with 1,678 votes followed by W. B. Carter at 1,486. Finishing third and not being nominated was Benton Dillard with 1,184 votes. Voter turnout was 6 percent.

Tuberculin tests were administered to 243 Roanoke school students, all first or seventh graders. The tests were part of an early-detection campaign by the Roanoke Tuberculosis Association and observance of National Negro Health Week.

Mayor Crockett of Vinton had his conviction of speeding dismissed on order of Commonwealth Attorney Eugene Chelf because of that office's contention that there was insufficient evidence presented at the mayor's court for conviction on the charge. The mayor had appealed his conviction to the Roanoke County Circuit Court, and a jury had been seated to hear the case, but with the action of the commonwealth attorney, the protracted legal battle between the mayor and his town's police came to an end.

The Salem-Roanoke Friends minor D-league baseball team announced an initial roster of twenty-two players. As a team in the Virginia League, the roster included twenty rookies under Manager Eli Harris. A preseason exhibition schedule was announced that had Salem playing teams in and from Danville, Elmira (New York), Bluefield (West Virginia), and Wilmington (North Carolina) between April 13 and 28. Harris would ultimately have a roster of thirty-four players for the start of the season.

Major League Baseball came to Roanoke's Maher Field on April 8 when the Cincinnati Reds were scheduled to play the Boston Red Sox in an exhibition game. General admission was seventy-five cents, and the game was sponsored by the Roanoke Lions Club. Unfortunately, heavy rains that day rained out the 3:00 p.m. game. Mayor Walter Wood and the Lions Club both hoped that a game could be scheduled for next spring. In 1939, their exhibition game drew nine thousand spectators to Maher Field.

Vinton residents were shocked by the shooting death of fourteen-year-old John Chambers by his companion, sixteen-year-old Oscar "Teddy" Buzik. The incident occurred at Lee and Second Streets around 8:20 p.m. when both boys had come from a nearby store. Witnesses, including other boys, said there was no malicious intent. In apparently playing with a handgun, Buzick discharged the weapon inches from Chambers's head, killing him instantly. Buzik was placed in the custody of the State Board of Public Welfare.

Hundreds of Roanokers turned out to watch a parade on April 5 of National Guard and Marine units from Roanoke and Vinton along Campbell Avenue in honor of Army

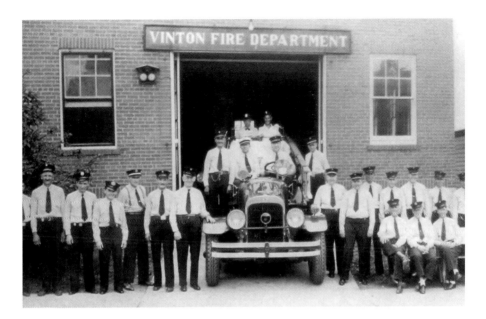

Vinton Fire Department, 1940. *Vinton Historical Society.*

Day, a national observance of the anniversary of America's entrance into the First World War. The parade began at the Roanoke Auditorium and circled through downtown via Church and Campbell Avenues, ending where it began.

WDBJ Radio Station began a new broadcasting schedule on April 15 by going on the air beginning at 6:30 a.m. Ray Jordan, station manager, had been using a seventeen-hour-per-day broadcast schedule since 1935 but decided an extra half hour earlier would be beneficial for early risers. The extra half hour was inaugurated with a performance by Roy Hall and his Blue Ridge Entertainers playing and singing "hillbilly" and "old time" songs. The group was from Greensboro, North Carolina.

T. B. Forbes of Roanoke celebrated his eighty-sixth birthday on April 10. His longevity was notable because he was one of the oldest citizens of the city who still remembered when Roanoke was "Big Lick." In an interview he reminisced about the city's early days when he arrived as a sheet metal worker for the railroad. According to Forbes, the first two brick buildings on Salem Avenue were the Markley Grocery and the Baker dry goods store. He also bought the first lot in what was called the Lewis addition (the lower southwest section of the city) and erected his home there in seven days. Forbes missed an opportunity, however, when he passed on a block of land bounded by Campbell Avenue, Tazewell Avenue, and Jefferson Street for $500. He drilled the town's first military company (Company F) of the National Guard, and he helped organize the first volunteer fire company. In regard to the fire company, Forbes said they kept a hook-and-ladder truck in a tobacco warehouse near what was the Greyhound Bus terminal.

William Bowles, prominent broker in the Roanoke Valley, died suddenly at his home in Salem at the age of forty-three on April 7.

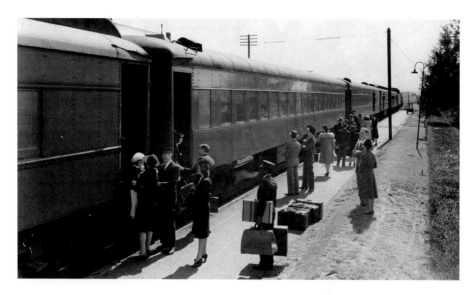

Passengers are boarding N&W Train No. 4 at Salem, April 10, 1940.
Digital Collection, Special Collections, VPI&SU Libraries.

Twenty-three Roanoke boys were offered screen tests at the Hotel Roanoke to play the part of Jody in the movie *The Yearling*, starring Spencer Tracy. This round of screen tests was one of six being held across the country by MGM Studios, and twenty-three were selected from hundreds who came for such an opportunity the previous evening at the City Market Auditorium. The screen tests were being conducted by A. L. Burks, a former Roanoker, who stated that three of the boys were "excellent."

The Vinton Town Council went on record approving a proposal by the Roanoke Railway and Electric Streetcar Company to abandon its Vinton-Melrose streetcar line and substitute bus service by December 31. The company had been operating a streetcar line to Vinton since 1892. The Roanoke City Council had previously endorsed abandonment of the line for bus service.

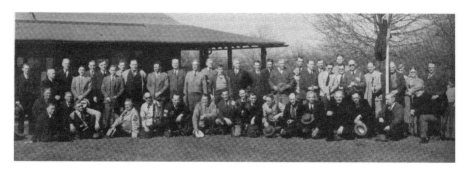

Members of the Roanoke Gun Club on opening day, April 16, 1940.
J. J. Barry was president. *Norfolk-Southern Foundation.*

Salem native Maj. Gen. David C. Shanks passed away in Walter Reed Hospital, Washington, DC, on April 10. Shanks was born in Salem on April 6, 1861, and attended Roanoke College, though he graduated from West Point. He was promoted to the rank of brigadier general on May 15, 1917, and then major general on August 5 of that year. He served with distinction in the Philippines, as a provincial governor, and during the World War. His widow was the former Nan Chapman, also of Salem. He was interred at Arlington Cemetery.

Roanoke College professor Julius F. Prufer, in a speech to the Cooperative Education Association meeting in Waynesboro, endorsed Virginia's sterilization law for what he termed as the "sub-standard and sub-marginal" of society. Among a number of proposals he either endorsed or presented, Prufer said the cost of children from poor and others who are "burdens to the taxpaying community" should be prevented through sterilizations. He endorsed "legislation requiring that, if children born to a family after the family has been on relief for 12 months or more, that they be taken at once off relief permanently or submit to sterilization." He endorsed "further application of the very excellent sterilization law which Virginia has had for the last two decades." The law that Prufer referenced was one that sterilized those considered "mentally deficient" by the state.

O. G. Lewis was the lone candidate to file for Salem City Council election. Lewis, an incumbent, was one of three members of the council, the other two terms not ending until 1942. He had been a member of the council since 1928. For the Roanoke City Council only one other candidate filed by deadline to challenge the Democratic nominees, and that was S. R. Hensley, an independent.

A local chapter of the Navy Mothers Club was organized in Roanoke on April 12. The chapter elected its first president, Mrs. Crystal A. Carter. The meeting was attended by thirty women who had sons in active service in the navy.

Martha Washington Candies, Inc., announced that it would open an ice cream parlor about May 1 on Church Avenue just east of Jefferson Street that would be connected to its existing candy store and restaurant. The ice cream would contain 18 percent butter fat content compared to the 12 percent in most commercial creams.

Murray A. Foster was elected president of the Roanoke Bar Association.

Councilman W. M. Powell raised the issue of poor housing conditions in black neighborhoods, citing the collapse of one residence off its foundation two weeks prior. He urged city involvement in the housing issue, echoing a similar sentiment shared some weeks ago by those who suggested the formation of a housing authority.

The Southeast Civic League in a meeting at Belmont Baptist Church voted to endorse the idea that Fallon Park be used by the city as a site for a future stadium.

Kroger Grocery and Baking Company opened their twelfth store in the Roanoke area on April 18. The new "super self-service store" was at the corner of Jamison Avenue and Ninth Street, SE. The building contractor was Clem Johnston. The store manager was A. E. Claytor. For its grand opening, Kroger advertising offered a ten-pound bag of sugar for fifty cents, a dozen oranges for twenty-nine cents, beef at thirteen and a half cents per pound, and a free vacuum-packed bag of Kroger's Country Club Coffee, among many other specials. Also in Southeast, "Waddie" C. Atkins opened his Shell Service Station at 1300 Ninth Street, offering free drinks (7 Up, Sun Spot, or Delaware Punch) to all customers on opening day.

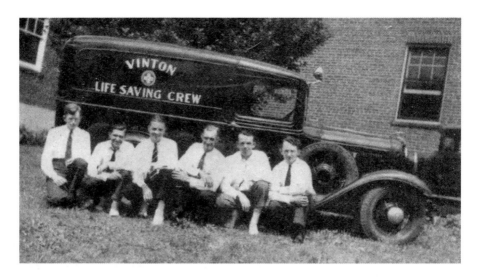

Vinton Life Saving Crew, 1940; l–r, Maroni Green, Mitch Powell, Terry Griffith, Guy Gearheart, Harry Goggin, Guy Markham. Vinton Historical Society.

Lou Alice Hills of William Fleming High School was crowned "Miss Roanoke County" in a pageant at Vinton. Eighty-six contestants participated. Miss Hill consequently participated in the Dogwood Festival in Bristol in May.

An underfunded school budget resulted in the resignation from the Roanoke County School Board of Moss Plunkett. The board and the county supervisors had been in discussions for many weeks over the budget, with the supervisors refusing to raise the school tax levy sufficient to pay for teacher raises and capital improvements. Plunkett had served on the board for almost eight years. The county supervisors' chairman, Luther Bell, had accused the school board of "spending money like drunken sailors." E. W. Carroll, dairy superintendent for the Catawba sanitarium, was appointed a few weeks later to complete Plunkett's term on the board.

Roanoke mayor Walter Wood publicly stated in late April his desire for the city to study a broad program of annexation, reflecting the sentiments of his council colleagues. The areas mentioned by the mayor included Forest Park, Williamson Road, Vinton, and two other sections south of the city. He estimated the city's population would increase to between ninety and one hundred thousand if the annexations could occur.

In early May the city-county marbles tournament was held. The first tournament held in Roanoke was in 1930. Winners in the previous decade were Howard Stultz (1930), Harry Simmons (1931), Cecil Dickerson (1932), Skippy Baker (1933), Paul Brammer (1934), Raymond Amos (1935), Garnett Thrasher (1936), Robert Rigby (1937), Dean Johnson (1938), and Jimmy Henderson (1939). All boys went on to compete in the national marbles tournament in Wildwood, New Jersey.

Members of Our Lady of Nazareth Catholic Church celebrated the recognition of their pastor, the Very Reverend James Gilsenan, to the office of "monsignor" by an act of Pope Pius XII. Father Gilsenan, a native of Ireland, had served his Roanoke parish since 1914, being the church's first pastor.

Twenty of the city's leading clothing merchants, tailors, and store clerks met and selected the top ten best-dressed men in Roanoke. Those chosen were Garland Miller, Z. V. Chenault, J. Curtis Merkel, Paul Reynolds, Gordon Johnson, W. S. Clement, Frank Angell, Dr. E. B. Neal, Robert Neighbors, and Fred Stultz.

The last living Confederate veteran in Craig County, Clifton Walker Elmore, died on April 22 at his home in New Castle. He was ninety-six. Wounded at the Battle of the Wilderness, Elmore reportedly stated the year previous that his biggest regret of the war was when he shot a Union cavalry officer leading a charge at the Battle of New Market. He was also the former postmaster at New Castle.

The Roanoke City Council decided to cut down a tree in the middle of the 400 block of Carolina Avenue in South Roanoke that was considered a nuisance and hazard. Days later, residents of Carolina Avenue and garden club members rallied in support of the large oak in the middle of the street, and the city manager agreed to a stay of execution for the tree so that the council might reconsider the matter. Some South Roanoke residents claimed that the tree had sheltered Col. George Washington when he camped on his way back from the Carolinas. Within a week, the city council had received numerous petitions, including those presented by delegations of women from the city's various garden clubs. The council asked the city manager to consider the feasibility of "bulging" the street on either side of the oak in order to better accommodate vehicles.

The Roanoke Symphony Orchestra, under the direction of Henry Fuchs, presented its first concert of the year on May 5 at the Academy of Music. The orchestra, composed of volunteers, had been reorganized by the Thursday Morning Music Club and presented a series of concerts for the 1938–39 season, after several years of inactivity. The orchestra held rehearsals in the Melody Haven music store.

Ben Moomaw, head of the Roanoke Chamber of Commerce, went to Washington, DC, with others from the city to meet with officials of the Civil Aeronautics Administration about Roanoke's airport and the need for federally funded improvements. The Roanoke Municipal Airport was such that it did not qualify to receive mail or passenger service. The field was unlighted, and the runways did not meet standard requirements as to length. The north-south runway was 2,550 feet, and the east-west runway was 3,000 feet. Federal standards required runways be 3,500 feet.

Hill Street Baptist Church observed its fiftieth anniversary the week of April 28. Preaching the Golden Jubilee sermon was the Rev. W. H. Powell of the Shiloh Baptist Church in Philadelphia, Pennsylvania.

Roanoke police and Alcohol Beverage Control agents made several raids of downtown establishments on Saturday, April 27, arresting proprietors and others for operating gambling establishments. Some forty-seven arrests were made for having gaming tables and illegal whiskey at the Uncas Club, the Roanoke Athletic and Pastime Club, the Paradise Club, the Recreation Club, and the Alpha Club. The night raid involved thirty police officers and three ABC agents. Roanoke County officers raided the Roanoke Country Club and seized six slot machines the same night.

Sunday, April 28, was Field Day at the Roanoke Municipal Airport, and some two thousand persons attended to take rides and watch planes. Manager R. J. Dunahoe said it was the biggest day in the airport's eleven-year history. Seven planes carried passengers for rides over the valley, and fifteen out-of-town planes registered for overnight stops during the day's festivities.

Roanoke mayor Walter Wood appointed L. D. James, city clerk, and Harry Yates, city auditor, to explore the question of annexing territory into the city and to bring a report to the city council in the near future. The request for a study was prompted by residential developments on the outskirts of the city wanting to connect to city water and sewer lines.

Fire destroyed a historic home on Bent Mountain the night of April 27. Known as the Mays home, the present occupant was Mrs. Stella Grubb, though the home had originally belonged to Mr. Jackson Mays and was said to have one of the best views of the Roanoke Valley.

Armistead Neal Pitzer, president of the Pitzer Transfer Corporation, died on May 1 at age seventy-two at his home, 1015 First Street, SW. Pitzer began his career as a driver of a grocery wagon and entered the transfer business in 1893 with a one-horse-drawn wagon operating from his residence. Three years later, his brother, Walter, joined him in the business, and they relocated the transfer company to Franklin Road and Second Street, SW. On the same day, a leading citizen of Salem, Orren Lewis Stearnes, passed away. Stearnes, a former member of the House of Delegates, died at his home at 135 High Street. He was seventy-seven. He came to the Roanoke area to serve as superintendent of the new Alleghany Institute, moving to Salem in 1890. He organized the Salem Development Company, the Salem Land Company, and the Creston Land Company. Stearnes spearheaded the effort to have Virginia Baptists locate an orphanage in Salem in 1891. He served in the Virginia General Assembly in 1914 and 1915.

Manager Eli Harris of the Salem-Roanoke Friends baseball team prepared his team for the opening game of the 1940 season, May 2, against Lynchburg. The starters for the Friends were Vince (Red) Palumbo, pitcher; Mike Berlich, catcher; Fred Selma, shortstop; Joe Krupa, first; Garr Ganoe, second; Ray Dvorak, third; Angelo Dulca, Dick Conley, and Dan Gardella, outfielders; and Al Henecheck and Bob Peckare, relief pitchers. Arch Davies and Joe Ella rounded out the roster. (Lynchburg won, 4–3, before two thousand spectators at Lynchburg's new City Stadium.) Salem was part of the Virginia League that consisted of four teams. Besides Salem, there were the Lynchburg Senators (formerly Grays), Staunton Presidents, and Harrisonburg Turks.

The Socialist Party held its first ever rally in Roanoke as the organization celebrated May Day in Elmwood Park on May 5. Lawrence S. Wilkes of Roanoke planned the gathering as demonstration against the totalitarian regimes in Germany, Italy, and Russia.

N&W Railway Class A locomotive 1206 left Roanoke to be displayed in New York, having been displayed at the World's Fair the previous year. Crews had cleaned the locomotive in preparation for its trip north to the 1940 World's Fair. The giant mallet locomotive was towed along the Shenandoah Valley route and then placed on a barge and floated from Greenville, New Jersey, to Flushing, New York, where the fair was located. The locomotive was part of a large rail exhibit of other American railway locomotives.

The Roanoke City Council in its regular session on May 6 voted to spare the Carolina Avenue oak in South Roanoke from the axe. The city manager indicated he would place large reflectors on the oak tree and prohibit parking within twenty-five feet of the tree. The manager recommended against bulging the street around the oak. The council approved the manager's recommendations, believing the oak tree would not live but a few more years anyway.

Hollins College students celebrate Tinker Day, 1940. *Hollins University Archives.*

May Court for May Day at Hollins College, 1940. Bessie
Nest was queen. *Hollins University Archives.*

Some five thousand persons attended a county music festival at William Byrd High School on May 6. The festival consisted of performances of area high school bands and choruses and ended with a Maypole dance by elementary school students.

Members of the Roanoke police traffic department sported new uniforms for the summer, consisting of white caps, gray shirts, and blue trousers. Motor officers wore the white caps for the first time as it was a recent innovation of the department.

An athletic stadium, a National Guard armory, and the annexation question filled the docket of the Roanoke City Council on May 15. Mayor Walter Wood proposed that an armory and stadium study group be composed, and the council appointed the following: W. P. Hunter, city manager; C. E. Hunter, city attorney; a representative of the American Legion, a representative of the chamber of commerce, and representatives of the National Guard (all to be named later).

Irving Saks and Joseph Spigel announced that the Retail Merchants Association and the Merchants Protective Association would merge. Edward C. Moomaw, secretary of the MPA, would become secretary of the new organization. The merged group, called the Retail Merchants Association, officially began a few weeks later on Monday, July 1, in leased space in the Rosenberg Building in downtown Roanoke.

Reid and Cutshall furniture announced a remodeling and expansion sale in light of their previous building being razed. The city building inspector had forced the store to remove the front and rear walls of their Salem Avenue structure if it was to be remodeled. Consequently, the furniture company decided upon a new building with a crossover from their Salem Avenue building to a main building on Campbell Avenue. Completion was to be in September.

Twenty-five men from the Catawba Civilian Conservation Corps camp were called to help foresters and firefighters battle a forest fire that covered a section of mountain between Cloverdale and Bonsack.

A charter for a second radio station in Roanoke was granted to the Roanoke Broadcasting Corporation, Paul Buford president. The only other station in operation was WDBJ, owned by the *Roanoke Times*. That station was the pioneer station in Roanoke, and a second station, WRBX, had ceased operating. The new station would be owned by the Shenandoah Life Insurance Company, as well as Edward A. Allen and Phillip Allen of Lynchburg, and Roanoke's J. P. Fishburn. The next step for the company was to obtain a license from the FCC.

Famed black soprano Dorothy Maynor entertained some two thousand patrons in a concert on May 15 at the Roanoke Auditorium. According to the *Roanoke Times*, "Miss Maynor has a great voice. Here is the dignity, the simplicity, the humility of a true artist. Her power is all that could be asked, and her interpretative ability is nothing short of marvelous." The night previous at the Roanoke Auditorium, some 2,200 had paid to watch Cowboy Whitey Grover wrestle Ginger, a 350-pound bear. The bear won and received a bottle of soda pop. Other wrestling matches followed, excluding Ginger, all under the artful promotion of Roanoke's Bill Lewis.

The Kroger Grocery opened its newest store at 306–307 Nelson Street on the Roanoke market on May 16.

Olympian Jesse Owens came to Salem on May 15 and gave a demonstration of his athletic talents following an exhibition game between the National Negro League's Ethiopian Clowns and Toledo Crawfords (the Clowns won 12–1). As part of the program, Owens ran low hurdles against Andrew Lewis' John McCluer and Rufus Bowman on the flat. McCluer barely edged out Owens. Before 711 spectators at Salem's municipal field, Owens ran the hundred-yard dash and made several broad jumps. Earlier in the day, Owens signed autographs for students at G. W. Carver School.

W. M. Packer of Detroit, Michigan, vice president of the Packard Motor Company, flew to Roanoke to present Dr. R. A. Bagley of Salem a new car. Bagley had won first prize in a national snapshot contest conducted by the car company. The car, a Packard 120 Convertible Coupe, was from the Rutrough-Gilbert Motors on Luck Avenue, Roanoke.

The Virginia Republican Party held their annual convention at the Hotel Roanoke in mid-May, drawing numerous nationally known politicians clamoring for the defeat of President Roosevelt and some soliciting support for various candidates seeking the GOP nomination for president. (The national convention for Republicans was a month later in

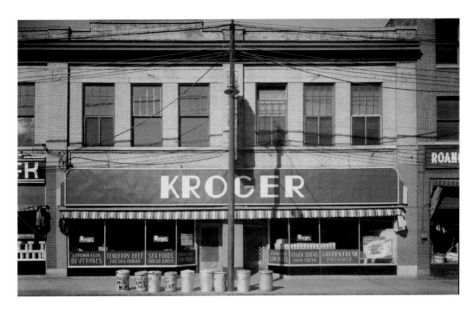

Kroger Grocery at 307 Market Street opened in 1940. Photo is from 1949. *Virginia Room, Roanoke Public Libraries.*

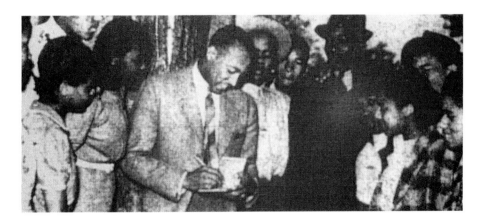

Olympian Jesse Owens signs autographs at Carver School in Salem in May 1940. *Salem Historical Society.*

Philadelphia.) T. X. Parsons of Roanoke was elected permanent chairman of the Virginia GOP convention.

The Roanoke Optimist Club formed a "Forward Roanoke Committee" to promote certain improvements in Roanoke, namely a slum clearance program, development of the airport, and construction of a municipal stadium. The chairman of the committee was A. S. Craft. Other members were H. L. Rosenbaum, W. J. McCorkindale Jr., John M. Oakey, and T. F. Boyle Jr. The Optimist Club would be joined in their effort a week later by the

Young Business Men's Club, the Roanoke Kiwanis Club, and the Roanoke Lions Club. The clubs launched what all four called their "Build A Stadium Drive."

Leading Hollywood personalities flew into Roanoke on May 22, lodging overnight, en route to the west coast. Among the group, most being pilots, were Roger Pryor, a popular band leader; actress Nancy Carroll; and actor Jackie Coogan. Joining them were T. W. Warner Jr., president of Falcon Aircraft, and several aviators associated with his company. The eleven-member group was flying in nine planes and conducted a brief press conference at the Ponce de Leon Hotel, where they were staying, announcing that they were flying across the country to demonstrate that the average person can become a pilot and that one can fly coast to coast on thirty-five dollars' worth of gasoline.

The Rev. Hajime Inadomi of Japan addressed the Roanoke Rotary Club at the Hotel Roanoke on May 23. His story was noteworthy in that he graduated from Roanoke College largely due to the generosity of J. M. Cronise of Roanoke. Cronise had funded Inadomi's education such that he was able to complete his studies at the college. Inadomi returned to his native Japan where, in 1935, he started that country's first Rotary Club in the city of Kamamoto.

Olympian Jesse Owens returned to Salem on May 24 to demonstrate again his athletic abilities. As with his prior appearance, Owens was touring with baseball teams of the Negro League. Owens was slated to race against a horse at Salem's municipal field, but rain prevented the event.

A playground in Langhorne Place, Salem, was opened on May 27, sponsored by Salem's WPA recreation program. The new playground included a tennis court, sand box, swings, wading pool, basketball goal, and baseball diamond.

Work at Salem Municipal Field, April 4, 1940. *Salem Historical Society.*

Road project in or near Salem in May 1940. *Salem Historical Society.*

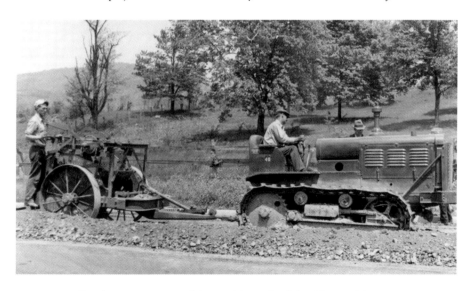

Road project in or near Salem in May 1940. *Salem Historical Society.*

Prominent Roanoke attorney Manley M. Caldwell died on May 25 at his home on Virginia Avenue in Virginia Heights at age seventy-nine. Caldwell came to Roanoke in 1906 and was the senior member of the Caldwell, Chaney and Lloyd law firm.

Jimmy Henderson, fourteen, won the 1940 city-county marbles tournament held in Elmwood Park. He had won the previous year as well, making him the first person to successfully defend his title in the eleven-year history of the tournament. Henderson was a student at Jackson Junior High School and a resident of Sixth Street, SE.

The *Roanoke Times* announced its first-ever All City-County baseball team. The team members were Harold Shelor, catcher, Andrew Lewis; John Cassell, first base, Jefferson; Pete Fuqua, second base, Byrd; Preston Reynolds, shortstop, Lewis; Robert Journell, left field, Lewis; Charlie Wade, center field, Jefferson; Billy Flint, right field, Jefferson; Dick DeShazo, utility, Jefferson; John Gleason, pitcher, Lewis; Earl Price, pitcher, Jefferson; and Billy Mason, pitcher, Byrd. It was noted that William Fleming High School did not field a team for the 1940 season.

A crowd of twelve thousand spectators watched Lucky Teter and his Hell Drivers perform at Maher Field. Teter was nationally known for daredevil auto stunts. At Maher Field, he drove an auto sixty miles per hour and flew a hundred feet across a transport truck.

O. W. Hiler, owner of the "Trout farm," offered that property to Roanoke City for purposes of constructing an armory and stadium. The Trout farm was located between Roanoke and Salem, south of the Lynchburg-Salem Road (Lee Highway) and north of the Veterans Administration Hospital. The Trout farm property had an interesting history. It had been used as an airfield in Roanoke's early aviation days, and the tract had been proposed as an ideal place for a baseball diamond by an official with the Virginia Baseball League. Hiler considered the site ideal for a stadium in that it had good road access, was on the city bus line, and was offering a sales price at half the land's value. His offer was referred to the armory-stadium study committee that had recently been named by the city council.

The John M. Oakey Funeral Service announced the purchase of a new ambulance powered by a Packard super eight motor. The newest services placed in the car included a revolving red light mounted with the siren on top of the cab, a ventilating system, a cot with pneumatic tires, an emergency cot, two removable Pullman chairs, first-aid and linen cabinets, and a hot-water heater.

The William Watts Chapter of the United Daughters of the Confederacy erected a granite monument honoring thirty Confederate veterans buried at City Cemetery as part of its Memorial Day observance. The UDC chapter had previously located monuments at Evergreen Cemetery, where sixty veterans were interred, and Fairview Cemetery, where three hundred veterans were buried. Throughout the city, the graves of all veterans of all wars were decorated by the Committee on Patriotic Affairs. Flowers for the graves were provided by city schoolchildren who brought flowers either to their school or local fire-house, and citizens assisted the committee by marking all veterans' graves with small flags.

Jack Coulter, a student at Jefferson High School, and Claude Moorman, head football coach for Jefferson, appealed to the school board for the development of football at the junior high schools. The two were accompanied by other students and coaches. The city parks and recreation had previously agreed to drop its sandlot program if the school system developed a junior high school league.

Reese's Shell Service Station opened on May 30 on Main Street, Salem, at Lake Spring. The proprietor, C. L. Reese Jr. offered a free bath towel and free drinks to his

opening weekend customers. A week later, W. A. Deyer opened his service station at 306 E. Campbell Avenue.

Diplomas were presented to nine graduates at Bent Mountain High School in commencement exercises that included an address by the president of Roanoke College. At William Byrd High School, 90 graduates received diplomas. The commencement speaker was Ben Chapman, a member of the Virginia House of Delegates. William Fleming High School graduated 65 (the largest class in its history), and commencement speeches by nine of the graduates were delivered. Professor George Leery of Roanoke College called for a "life of service" in the commencement ceremony at Andrew Lewis where 190 received diplomas. Lucy Addison High School had a graduating class of 123, and the ceremony was held in the Roanoke auditorium. Jefferson had a graduating class of 500, and the graduates heard from their superintendent, D. E. McQuilkin, on the topic of being a good neighbor to Latin America and the contributions Latin Americans have made to American culture. The ceremony was held in the Roanoke Auditorium. Rev. George Burke addressed the 33 graduates of St. Andrew's High School, warning them about "agnosticism, infidelity, and atheism to be found in the worldly life."

In early June, two army battalions, consisting of 750 men, forty officers, and 192 motorized units, all part of the Seventh Field Artillery Regiment, camped in Wasena Park for the weekend as they traveled from Alabama to New England.

The erection of a modern, air-conditioned theater in Vinton was announced on June 4 by Roth Enterprises, which operated several movie theaters in the Shenandoah Valley region. It was reported that the building would front Lee Street and be next to the Mountain Trust Bank.

Two members of the Roanoke School Board asked that restrictions be reinstated on the hiring of married teachers. Leading the effort was the board chairman, Harvey Gray. Mrs. Hiram Dance, the only female member of the board, vocally opposed the chairman's idea. The superintendent, D. E. McQuilkin, also opposed the restrictions. Chairman Gray eventually relented and pursued his policy no further.

Vinton mayor Crockett announced on June 4 that he would not be a candidate for reelection in the June 11 election. He had served six years on the council, and two of those as mayor.

The Roanoke City Council appointed a special committee to investigate conditions at the Coyner's Springs tuberculosis sanatorium after receiving various complaints. On the committee was the state health commissioner, Dr. I. C. Riggin.

Powell Chapman, editor of the *Roanoke Times*, organized a chapter of the Executives Club in early June for the purpose of allowing leading citizens to hear speakers of national and international importance. The chapter was affiliated with the Associated Executive Clubs of New York.

David J. Phipps, seventy-eight, died on June 6 at his home on Wasena Avenue. Phipps was a builder and was responsible for constructing notable structures in Roanoke, including the First National Exchange Bank, the American Theatre, and the First Presbyterian Church in South Roanoke.

The Roanoke County Chapter of the Red Cross sent a check for $10,000 to the American Red Cross for war relief in Europe. This was the first quote assigned to the chapter and came after several weeks of soliciting the community for donations. The

campaign's goal was $20,000, so the chapter continued its efforts to raise the full amount. F. M. Rivinius was the chapter's campaign chairman. Roanoke's Jewish community launched a campaign at Beth Israel Synagogue to raise $23,000 in relief funds for the United Jewish Appeal for Refugees and Overseas Needs. N. W. Schlossberg chaired the campaign.

A crowd of three thousand watched auto racing at Maher Field on Sunday afternoon, June 10. The inaugural race, sponsored by the American Legion, was won by Bert Helmuller of Matthews, North Carolina, who drove a car powered by a Curtiss airplane motor.

On June 11, local elections were held. In Roanoke, Walter Wood and W. B. Carter were elected to city council. Both Democrats, Wood received 1,241 votes, Carter 1,237, and an independent challenger, S. R. Hensley, 295. In Vinton, W. R. McGee led the ballot with 266 votes, followed by Joe Pedigo with 200, both being elected to the town council. Two others, Nelson Thurman and C. D. Linkous, received 184 and 26 votes respectively. In Salem, O. G. Lewis was reelected with no opposition.

A Salem landmark, a stately mansion known as the "Marston Place" near Lake Spring, was razed. The home was built in 1890 by Joe Chapman and sold in 1892 to George Logan. Emma Jolif bought the home in 1907. The building was willed to her grandson, who sold the property, and it had been vacant for some time and heavily vandalized. The property was salvaged by Furman Whitescarver and Frank Jones prior to demolition.

Roanoke police conducted raids on three clubs—the Uncas, Alleghany, and Colonial—on June 15 and made eighteen arrests on charges mostly dealing with illegal gambling and whiskey. The police were aided in the raid by law enforcement from Lynchburg. The raids were the result of an eight-week investigation of various establishments. An interesting comment was offered by Robert Smith, commonwealth attorney, a few days after the raids when he appeared before the Roanoke City Council. Smith asserted there had been a leak about the raids that diminished the ability of police to make further arrests. Smith stated that he believed the leaks had come from "certain politicians," a comment directed at the council. The city manager had asked the council to appropriate $2,000 for the raid, indicating that the council was aware of the raid plans in advance.

The Roanoke County Board of Supervisors unanimously enacted ordinances in mid-June that would prohibit the sale of beer and wine on Sundays and force dance halls to close at midnight on Saturdays. The action came as the result of a petition with four thousand signatures from county residents primarily living in the Williamson Road area. The petition drive had been organized by Baptist pastors. The board was told a few days later by the county attorney that it lacked the authority to mandate such regulations and was advised to make a formal appeal to the state ABC Board to instate such regulations within the county, as they had done in other counties.

J. W. Gwaltney, the last surviving Confederate veteran living in Roanoke city, celebrated his ninety-fifth birthday on June 18 at his home at 502 Virginia Avenue (now Memorial Avenue). Gwaltney had enlisted at the age of seventeen in the Confederate army in Knoxville, Tennessee, in June 1863 and served through the end of the war. He came to Roanoke when it was a way station on the line of the Virginia and Tennessee Railroad on June 15, 1865. His Sunday School class from Greene Memorial Methodist Church held a party at his home in his honor.

A committee investigating conditions at the tuberculosis sanatorium at Coyners' Springs delivered a scathing report to Roanoke officials on June 19. Among the recommendations were that the head nurse be dismissed and the medical director be placed on probation. Further, the committee suggested that the medical director be placed under the direct supervision of the city manager, that the kitchen operation be better supervised, and that unruly patients be dismissed. The Roanoke City Council referred action on the report to the city manager.

The newly formed Roanoke Executives Club announced their first speaker, Upton Close, for their first meeting on July 7. Close was a staff member of *Time* magazine and a regular contributor on international affairs for the *Saturday Evening Post.* The club had set a membership limit of one hundred.

At Roanoke College, Dr. Charles Smith was honored for his twentieth anniversary as president of the college. Prior to Roanoke College, he had served two Lutheran pastorates, the first in Lancaster, Pennsylvania, and the second in New York City.

Some seventy-five Roanokers employed by the WPA for work on the Blue Ridge Parkway were laid off due to budget cuts for the parkway project, effective July 1.

The employees of S. H. Heironimus Company presented a bronze plaque to be placed near the elevator in the store in downtown Roanoke. The plaque commemorated the fiftieth anniversary of the store and its three presidents and their terms of service: S. H. Heironimus, 1890–1912; R. Lee Lynn, 1912–1936; and Robert L. Lynn Jr., 1936–present.

The Roanoke School Board announced that it was considering converting the old federal post office building at First Street and Church Avenue, SW, into a vocational school to complement training classes at Jefferson High School. The board agreed to approach local and state officials about funding for such an endeavor.

The local chapter of the American Red Cross announced on June 27 that they had raised a second amount in excess of $10,000, meaning they had achieved their $20,000 fundraising goal for humanitarian war relief in Europe.

Roanoke marbles champion Jimmy Henderson finished in the fifth spot in the national marbles championship in Wildwood, New Jersey. He won eighteen and lost twenty-seven matches.

G. H. Spruhan, recreational director for Salem, announced the opening of a new playground in the town. A baseball diamond and other amenities would be constructed on the Robertson property on the north end of Broad Street beginning July 1.

The first meeting of the Roanoke Executives Club was held on July 1 with 210 persons in attendance. Noted author and historian Upton Close addressed the group at the Hotel Roanoke, and his comments stirred controversy. Speaking on the war in Europe, Close claimed that Adolf Hitler was effeminate and had a "crush" on Italy's Mussolini, that Japan was following Germany's lead in industrial domination, and that Russia was weak and incapable of posing a threat to Germany. Further, the author argued that the fate of the British Empire was in the hands of the German dictator. German conquests in Europe were aided by corrupt French politicians and British blunders, and that pacifism marked American foreign policy due to the unhealthy influence of women upon international affairs following World War I. Finally, Close predicted that the European conflict would end soon. The next day at the Roanoke Lions Club meeting, Close's speech became the

source of much debate among the membership such that the chairman of the club had to abruptly adjourn the Lions' meeting. One member declared that the Executives Club and organizations like it were nothing more than an excuse to promote anti-American propaganda. This drew a sharp rebuke from Mayor Walter Wood and others who attended the Close speech.

T. X. Parsons returned from Philadelphia, where he led a delegation of area Republicans to their party's national convention that resulted in the nomination of Wendell Wilkie for president.

Roanoke's city manager was encouraged to pursue WPA funds for airport development and expansion. Expanded runways, land acquisition, improved grading of existing runways, a parking area, and road realignments around the airport were needed to bring the airport up to CAA standards.

With the selection of Henry Stimson as secretary of war by President Roosevelt, the *Roanoke Times* did a profile on Walter Pedigo, a resident of the Virginia Heights section of Roanoke city. Pedigo served as the private secretary to Stimson when the latter served as secretary of war in the Taft Administration. In fact, Pedigo served as private secretary to five secretaries of war (Wright, Dickinson, Stimson, Garrison, and Baker) between 1908 and 1918.

The wooden, covered bridge at Hale's Ford was torn down with the completion of a steel bridge built by convicts. The humpback structure was in Franklin County, near Moneta, and was one of the last remaining such bridges in the region.

Lerner Shop, located at 305 S. Jefferson Street, announced that it would move locations in the fall. It planned to occupy the former Airheart-Kirk Clothing Company building, 25 W. Campbell Avenue, and the former Burns building site at 25 W. Salem Avenue. The Burns building had been razed, and Airheart-Kirk Clothing had moved to the former Roanoke Jewelry Company store at 107 W. Campbell Avenue. The jewelry store had relocated to the Ponce de Leon Hotel. In other business news, F. Roy Hunt was announced as the new manager and partner in the Fox-Hunt-Loyd men's clothing store, located at the corner of Henry Street and Kirk Avenue.

Buddy Woods returned to his home in Roanoke in early July from New York, where he starred in musical theatre. Woods, a graduate of Addison High School, was under contract with a publishing house to write short stories for children.

The congregation of Red Hill Baptist Church laid the cornerstone for their new sanctuary building on July 6. The new building was to replace the original wood-frame church. J. L. Hartman was the contractor. The new facility cost $12,000. The congregation was organized in 1910 and was reorganized in the 1920s.

The Roanoke Chamber of Commerce endorsed a proposal that the area have a non-college civilian pilots' training program. The chamber agreed to serve as the program's sponsor and solicit approval of such from the CAA.

It was announced that Route 221 would be completed in late summer and that a celebration would occur in Hillsville on August 3 with Virginia Governor Price as the speaker. The honor of introducing the governor on the occasion was granted to Col. J. Sinclair Brown of Roanoke County, who was credited with pioneering the development of the highway that went from Roanoke County to Carroll County.

A grand jury of the Hustings Court convened in closed session on July 12 to hear testimony and evidence about the recent raids on gambling houses in Roanoke. Judge J.

Lindsay Almond stated to the jurors that a leak had occurred within the police department such that the raids were compromised. Several police officials were called to testify. Shortly after the raids, Commonwealth's Attorney Robert Smith told city leaders that there had been a leak, somewhat suggesting at the time that it may have come from political leaders. However, Smith had come to believe that the leak was from within the police ranks, and Judge Almond pointed out that many in the city were curious as to why outside detectives, notably from Lynchburg, were called in to assist with the raids. Almond further stated that gambling interests in the city had grown remarkably over the past few years.

R. C. Johnson, identification expert within the Roanoke police department, was responsible for maintaining the local "ism" file. The file, began seven years ago, was started as a means to identify and monitor members of local organizations that engaged in subversive activities. The "ism" file was a national FBI initiative whereby local authorities would report to the FBI names and activities of suspects for a national database. In turn, the FBI would submit information to local authorities for their benefit. Johnson said he had a number of local informants, and he monitored activities such as persons taking excessive photographs of the operations and tracks of the N&W Railway, those involved in Socialist Party and Communist Party activities, and any deemed to be advocating un-American positions. Johnson stated that fifth columnists may come to Roanoke, but they would not find the local police "asleep."

The Virginia-Dixie Motorcycle Club sponsored motorcycle races at Maher Field on July 16. The winner of the feature, twenty-loop race was Al Crisler of Charlotte, North Carolina. The event attracted twenty-eight riders from several states and drew a crowd of 2,500.

The Roanoke County Board of Supervisors adopted two ordinances regulating the county's dance halls and taverns. One ordinance regulated the hours of operation such that dance halls must close at midnight and could not have any hours of operation on Sundays. A second ordinance barred persons under the age of sixteen from entering a dance hall unless accompanied by a parent or older sibling. Due to the large crowd that attended the session on this matter, the board relocated its meeting to a circuit court room.

Lloyd Hicks, fifteen, of Kimball Avenue, NE, was awarded a scout certificate in heroism in rescuing Bobby Frank Hargraves, fourteen, from drowning last May 7. The two boys were part of a large group of boys swimming at a quarry hole. The award was made by the national court of honor of the Boy Scouts of America in New York City. Hicks was presented his certificate at the Negro District Boy Scout Camp, Roanoke area council.

City Manager W. P. Hunter recommended that a committee be appointed to work with the Roanoke Railway and Electric Company to replace all streetcars with city buses. Only two streetcar lines remained (others had been abandoned or were set for the same), namely the Virginia Heights-South Roanoke line and the West End line via Patterson Avenue-Ninth Street.

Blacks in Roanoke were provided their first regulation football field and baseball diamond through work funded via the WPA. The athletic fields were completed in Washington Park on July 15. A few days later, two prominent black tennis stars played exhibition matches in Springwood Park for the dedication of that park's new tennis courts. Jimmy McDaniels, national singles champion, and Richard Cohen, who paired with McDaniels for the national doubles title, played. Two other notable black tennis players were also on hand for play: Harmon Fitch, who was ranked number two nationally, and

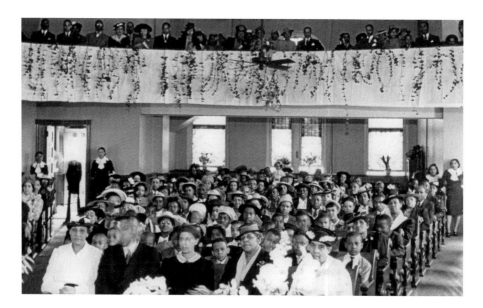

Mt. Zion AME Church in Gainsboro, 1940. *Betty Jean Wolfe.*

Roanoke's own Dr. E. D. Downing, a former coholder of the negro national doubles title. That same week WPA-funded work began at Lakewood Park in the Raleigh Court section, specifically to erect a dam and spillway for the pond and to construct tennis courts.

In mid-July the Roanoke chapter of the Red Cross announced the opening of a volunteer first-aid station at the y-intersection of Routes 11 and 117 near the Davidson Tourist Camp. This was the fifth such station to be opened by the chapter and staffed by volunteers for the benefit of highway travelers. Others included stations at Riverjack on Lee Highway and the Glenvar service station on the same road.

Roanoke police continued their raids of social and recreation clubs for gambling and liquor violations. On July 16, the Alleghany Club, First Street, SW, and the Pastime Club, East Church Avenue, were raided, resulting in several charges and the seizure of illegal whiskey, drinking glasses, decks of cards, and large amounts of cash.

The Roanoke Boat Club had its initial meeting on July 17 with sixty charter members present. The meeting was held at Bernard's boat shop on Commerce Street in Roanoke and had as its mission the promotion of boating and other recreation at Carvin's Cove. George Davis was elected president.

City physician Charles Irvin declared that 75 percent of the prisoners in the Roanoke city jail were physically unfit for manual labor, mostly due to venereal diseases, hernias, and heart conditions. The city used inmate labor to work farms at the city's poor house and on the property at the municipal airport, as well as for road and highway maintenance.

Miss Pearl Hinesley, the Roanoke city librarian, appealed to city officials that the library be moved to the old post office downtown as the Elmwood home was not fireproof. She stated that such a move would result in a large number of bequests to the library. It was estimated that the cost of converting the old post office into a library would be about $35,000. The old postal building was owned by the school board at the time and was being considered for use as a vocational school.

The Elmwood Home, shown here in the late 1940s, housed the Roanoke Main Library during the 1940s. *Virginia Room, Roanoke Public Libraries.*

Dr. Charles Lutz of Roanoke College addressed the Roanoke Lions Club and explained the civilian pilots' program housed at the college. Flight training occurred at the municipal airport for the twenty students. Lutz advocated improvements to the airport such as runway extensions and illumination for night flying.

Nationally known baseball clown Al Schacht made an appearance in Salem at the Salem-Roanoke Friends game on July 18. Schacht raced through the stands making fun of the baseball players, throwing boxes of popcorn and peanuts to children, tossing cigars to men, taking some infield batting practice, and initiating an argument with the home plate umpire. Schacht, well known in professional baseball as the game's "clown prince," reportedly had traveled twenty-seven thousand miles that season, entertaining at games in the US and Canada.

The N&W Railway constructed a 224-car capacity freight car paint yard on property that was the site of the old Crozier Furnace, just east of the Roanoke Shops. The cost for the new facility was estimated to be $125,000. The seventeen-acre site was purchased from the Virginia Iron, Coal and Coke Company and was on Ninth Street, SE.

The Hollins College alumnae association opened the Tinker Tea House just off Route 11 on the campus of the college. It was a tourist home during the summer and then hosted guests visiting students during the school year.

Robin Hood Park on Williamson Road advertised their new outdoor bowling alleys in late July. "Bowl for health and fun out where it's cool." In addition to the six bowling alleys, the park also offered archery and a rifle range, with hours of operation being 11:00 a.m. until midnight.

The Colonial-American Bank celebrated its thirtieth anniversary on July 21. The bank began on that day in 1910 as the Colonial Bank and Trust Company located at 116 W. Campbell Avenue. Thomas Cooper served as the bank's first president. In 1920, the new bank merged with the Liberty National Bank (also formed in 1910 with Robert Garrett as president). Several years later in 1929, Colonial merged with the American National Bank, whose first president was M. W. Turner. This new bank was called Colonial-American National Bank and was located at the southeast corner of Jefferson and Campbell. During its three decades, the bank had been served by five presidents: Cooper, E. W. Mollohan, R. H. Angell, Edward W. Tinsley, and George N. Dickinson. The bank's building was constructed in 1927 on a site previously occupied by the Terry Building.

Roanoke mayor Sydney Small returned with two other local delegates, George Via and Joseph Herbert, from the Democratic convention held in Chicago. The convention had nominated President Franklin Roosevelt for a third term. The Roanoke delegates were not pleased, however. Small declared he would not vote for Roosevelt and planned to sit out the 1940 presidential election. Small was disgruntled by Roosevelt's selection of Henry Wallace as his running mate, whom Small declared to be a Republican, and that Small had supported Jesse Jones as the vice presidential candidate. It should be noted that the Virginia delegation gave more votes to Roosevelt's opponents than to the sitting president, a tally consistent with many other Southern state delegations. Mrs. J. L. Almond Jr. of Roanoke also went as an at-large delegate.

Dr. Harry Martin received patent number 246887 for his new lens-grinding machine. The machine allowed him to impart a cylindrical as well as spherical curve to his eyeglass lenses. This was one of several patents the inventive optometrist had acquired.

The nationally known Wings over Jordan choir gave a concert at the Roanoke Auditorium to an audience of 1,500 persons. The black gospel choir was from Cleveland, Ohio, and their concerts were aired nationally by CBS over radio on Sunday mornings. The choir's appearance in Roanoke was sponsored by WDBJ and the First Baptist Church, Gainsboro.

On July 24, the Roanoke City Council decided to revive its study for a better municipal airport at the urging of the chamber of commerce. At stake were federal monies, under the McCarran Bill, that could pay completely for improvements at municipal airports like the one in Roanoke. The council also declared that it was not in a position to convert the old post office into a library, as the property was owned by the school board and the suggestion had met with intense opposition from local business leaders who believed the property had commercial potential.

At a meeting in Havana, Cuba, Lions International elected Dr. E. G. Gill of Roanoke as their third vice president. Gill was a past president of the Roanoke Lions Club and a former member of the Lions International board of directors.

The FCC in Washington granted a construction permit to the Roanoke Broadcasting Corporation for a new radio station. RBC announced hopes to have the station on air by October 1. The station would be the second one broadcasting in Roanoke along with WDBJ. An earlier station, WRBX, discontinued operations a few years ago. The new station would be known as WSLS, for "Shenandoah Life Station," and located on the top floor of the Shenandoah Life building with a 175-foot tower on the building's roof. The station would be part of a three-station chain operated by Edward and Phillip

Allen (brothers) in Lynchburg. WDBJ was owned and operated by the Times-World Corporation of Roanoke.

Dr. George Braxton Taylor ended his thirty-seven-year pastorate of the Enon, Troutville, and Cove Alum Baptist Churches. A chaplain at Hollins College, Taylor began his ministry in the Roanoke Valley in 1903. Taylor was widely known for his multivolume *Virginia Baptist Ministers* book series that contained the biographies of Virginia's most prominent Baptist clergy. He had been on the faculty and a chaplain at Hollins from 1903 to 1933.

Some Roanokers barely escaped serious injury if not death in an airplane accident on July 27. Irving Sharp, a radio personality with WDBJ; Marvin Turner, assistant airport manager; and Arthur Clay Jr., a local pilot, were on the ground near a plane piloted by "Boots" Frantz when a sudden gust of wind during a rain storm at the Roanoke Municipal Airport lifted Frantz's plane from the ground and slammed it first against a hangar and then to the ground. Frantz was unharmed, somehow remaining inside the plane during its unscheduled flight, while Sharp was knocked unconscious near the hangar. All three men were taken to Lewis-Gale Hospital with minor injuries. Most lucky was Sharp, who missed being crushed by the plane's descent to the ground by a few feet. Frantz had just rolled his ship from the hangar in preparation for a flight to Richmond when the winds picked up. Sharp, Turner, Clay, and others were assisting Frantz in positioning his plane back to the hangar when a single gust lifted the plane, carrying Sharp, Turner, and Clay into the air, clinging to the wings. The broadcaster dropped and landed on the concrete apron such that he was rendered unconscious. Clay and Turner landed on their feet. The ship then struck hangar No. 1 and dropped twenty feet, barely missing the helpless Sharp. Frantz told reporters he believed the plane lifted to thirty feet and considered himself lucky that the aircraft did not flip or catch fire as the fuel tanks were ripped from its wings and pieces of the propeller sheared off.

Zane Williams defeated ten-time winner of the city-county tennis tournament Charley Turner in three straight sets to win the 1940 men's singles championship. Some six hundred spectators watched the match played in Wasena Park. The doubles tournament was won by Lester Lee and Curtis Merkel, who beat Charley Turner and his twin brother, Rawley. The junior singles title went to George Conway with his win over Barton Morris Jr. The women's single title match was won by Betsy Jennings against Sugar Baker. The fourteenth annual tournament attracted players from a wide region.

Roanoke's application for a franchise in the Dixie Pro Football League was granted at a meeting of the league's board in Richmond on July 28. With Roanoke's entry, the league had six teams. Other cities with teams were Richmond, Washington, Portsmouth, Norfolk, and Newport News. J. L. Godwin of Roanoke was instrumental in representing Roanoke's interests in the matter.

The state highway department reported that the Blue Ridge Parkway was completed from Adney's Gap, near the Bent Mountain post office, to the North Carolina state line.

Local health departments declared their readiness for the new "marriage law" that went into effect on August 1. The law required that those getting married be administered blood tests by local health departments or physicians to determine if an applicant has syphilis or any other venereal disease. Should a test show an applicant had the disease, then their partner must be informed. The only documentation an application must present to a clerk issuing a license was that the test had been administered, and not its results.

Some anecdotal history about the home "Buena Vista" in Jackson Park was relayed as it hosted a garden show there in early August. It was sold for the first time in 1779, being one of the oldest homes in pioneer Virginia. It was acquired by the Tayloe family in 1833 for one dollar. By virtue of a marriage, it came into the possession of the Rogers family and was known by many in Roanoke as the "old Rogers place." According to local historians, the materials for the home—wood panels, mantels, and some stones—came from England. The materials were shipped up the Roanoke River to Danville and then transported overland to its present location. An additional story relates that during the Civil War, Union forces under the command of General Hunter were ordered to burn the home. When they stopped to ask for directions, a local woman pointed the way but added that she was aware that many Confederates under General Jubal Early were dining at the home. The Union forces quickly left the area, and no Confederates were anywhere close.

Eli Harris, manager of the Salem-Roanoke Friends baseball team, announced his resignation "for the good of all involved" in early August. The Friends had been in the cellar all season in the Virginia League, and Harris accepted the blame. Harris returned to his home in Beckley, West Virginia, where he owned and operated a bowling alley. His successor was Arnold "Andy" Anderson from Lawrenceville, of the Southside semipro league.

Roanoke's best skeet team won the Clark Challenge trophy at a tournament in Hot Springs. Team members consisted of N. C. Britt, W. B. Strickler, Harry Hewitt, J. C. Minter, and O. H. Ramsey.

Roanoke mayor Walter Wood named a four-person committee to advocate for improvements to the Roanoke Municipal Airport. The committee included the mayor, City Attorney C. E. Hunter, chamber of commerce president E. R. Johnson, and N. W. Kelley, chairman of the chamber's airport committee. The four were tasked with lobbying federal officials for WPA funds for the development and expansion of the airport.

Nearly 150 clergy and laymen from various denominations gathered at First Baptist Church to learn of obscene materials confiscated by Roanoke police in recent raids. The meeting, organized by the commonwealth's attorney, was to encourage the clergymen to denounce such materials and help protect the city's youth against its distribution.

The early August issue of *Life* magazine featured Verne Johnson of Roanoke demonstrating in photographs how one could put a vest on after a coat. The trick, according to Johnson, took forty seconds.

The Highlands Service Station opened at the corner of Ferdinand and Elm Avenues, SW, on August 3. It sold Amoco gasoline and products.

Some three thousand persons attended the ribbon-cutting ceremony six miles east of Hillsville that marked the formal opening of Route 221. Virginia Governor Price handed off the ribbon cutting to Miss Elizabeth Apperson.

Sixth District Republicans nominated Fred W. McWayne of Lynchburg to oppose incumbent congressman Clifton Woodrum in the November election. The nominating convention was held at the Hotel Roanoke. A poll at the time showed President Roosevelt leading Republican nominee Wendell Wilkie 68 to 32 percent, causing Roanoke's newspapers to editorialize as to why Republicans would even nominate an opponent for Woodrum given the Democratic strength in the region and state.

Dr. Everette Eldridge Watson, founder of Mt. Regis Sanatorium in Salem, died on August 3 at his home at Mt. Regis. He was fifty-three. Watson, a native of Hillsville,

started Mt. Regis in 1914, and it became the only privately owned sanatorium in the state. Due to ill health, Watson was forced to close Mt. Regis on December 20, 1939.

The 23rd Battalion, US Marine Corps Reserve, was authorized to be organized effective August 1. The battalion would be composed of five units with an authorized strength of sixteen officers and 258 enlisted men (286 with a band). The unit was under the command of Maj. Carleton Penn and Capt. Charles B. Nerren.

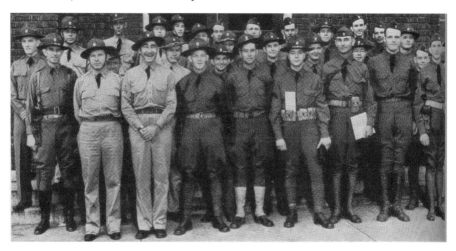

All the members of the 116th Infantry shown here were employees of the N&W Railway in Roanoke, August 1940. *Norfolk-Southern Foundation.*

Roanoke police continued their raids on various city social and athletic clubs in their efforts to seize illegal alcohol and gambling tables. On August 3, the Colonial Club on Day Avenue was targeted, resulting in one arrest and the seizure of several quarts of illicit whiskey.

Landon Buchanan won the Mountain Empire tennis tournament in early August held on the courts at the Roanoke Country Club. Buchanan defeated Deacon Parsons for the title in four sets before 1,500 spectators. Buchanan was from West Virginia and a student at Marshall College. Charley Turner and Curtis Merkel took the men's doubles title.

Division manager William Geoghan of the Atlantic Greyhound (Bus) Lines in Roanoke announced the use of new coaches for travelers. The Greyhound buses featured diesel engines, air-conditioning, stainless steel covers, seats even with the aisle, individual ash trays at each seat, and smoke relief overhead that pulled cigarette smoke from the interior.

Harvey Gray, an insurance executive, was elected chairman of the Roanoke School Board by his colleagues at the board's annual reorganization meeting in August. Rev. E. D. Poe, a Baptist minister, was elected as vice chairman.

Local newspaper reporter Lee Callison interviewed an intriguing guest at the Hotel Roanoke during the first week of August. The guest was four-year-old Faith Hope Charity Harding, daughter of her traveling companions Mr. and Mrs. Harry Harding of Trucksville, Pennsylvania. According to media reports, the little girl had predicted deaths, fires, earthquakes, hurricanes, ship and airline catastrophes, and even President

Roosevelt's third term days, weeks, and sometimes months before such events occurred. The family was on their way to Tyron, North Carolina, where the girl would stay at the Cross and Circle Foundation, an organization dedicated to her ability to predict the future. According to the foundation's funder, Leslie Savage, the girl had begun dictating a series of books "which will tell the history of the next 10,000 years." Savage, also lodging at the Hotel Roanoke, estimated it would take his young subject fifteen years to complete the multivolume project. Declaring her daughter a prophet, the mother shared with the reporter that her first prophecy came when the girl was just eighteen months old. Apparently, the young toddler gained fame when she predicted a school fire in Trucksville one month before it happened. The girl dictated Occult Suasion, a column in the *Nanticoke* (Pennsylvania) *Daily Press*, signing her name with a cross and circle.

The attempts by the Roanoke Library Board to potentially purchase the old post office building from the school board came to an end when it was announced that the S. H. Heironimus Company's offer to purchase the building for $150,000 had been accepted by the school board with the concurrence of the city council. The post office structure was located on the northeast corner of Church Avenue and First Street, SW, and would transfer to the department store company on November 1. The three-story stone building had been erected in 1909, and the plans called for the department store to raze the building to make way for a service station and parking lot for Heironimus customers. The property had come into the possession of the school board by virtue of a swap in 1929. The federal government was given possession of the old Commerce Street school property that was razed for a new post office, and the school board was given the old post office building.

The Roanoke Black Cardinals under manager Chappy Simms met the Tidewater Giants of Newport News for a best-three-out-of-five series for the state Negro League baseball title. The Cards were the Western Virginia Negro champions, and the Giants the Eastern.

Nelson Long, golf pro at the Homestead at Hot Springs and former pro at Blue Hills Golf Club in Roanoke, won the Young Men's Golf Association championship in Roanoke. The fifty-four-hole tournament was played on two courses over two days—Blue Hills and Monterey—with thirty-eight golfers competing for the trophy. Long's score was 214. Ted Fox came in second with a score of 220. George Fulton had won the tournament in 1939.

A new bridge on Lee Highway near Riverjack opened on August 10. The old bridge was removed about two weeks later.

On August 13, Congressman Clifton Woodrum and Maj. Arthur Williams of the army general staff came to Roanoke to inspect the Roanoke Municipal Airport and to confer with the recently appointed committee advocating for its improvement and expansion. Army officials suggested that the airport should be developed as an emergency defense field due to the proximity to Washington and Langley. Such a designation would open the airport to receive federal funds.

In Salem, Harold Depkin announced plans for a second movie theater in the town. He planned to erect a $100,000 theater, to be named The Senator, on the corner of Main and Chestnut Streets.

The Lucky Stone Service Station formally opened on August 14 selling Standard gasoline. The station was located on Nelson Street at Bullitt Avenue, one block east of the Patrick Henry Hotel.

Heavy rainfall on August 14–15 (six inches in twenty-four hours) closed streets and bridges in Roanoke and Salem. Streetcars were immobilized, and fifty persons had to be rescued from Roanoke City Mills via a steam engine and boxcar sent to the mill by the N&W Railway. The Memphis Specials, both northbound and southbound, were delayed due to flood waters covering rail tracks. The Roanoke River crested at 21.6 feet, making it the worst flood in the valley's history since 1907. Flood waters heavily damaged Harris Hardwood in Norwich, the Virginia Railway shops, and the American Viscose plant in southeast.

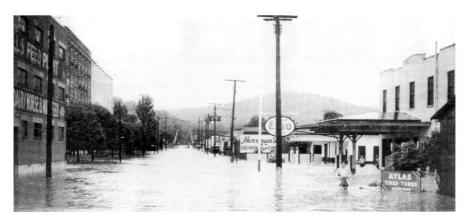

The Roanoke River crested at 21.6 feet; seen here is Jefferson Street with Roanoke City Mills on the left, August 15, 1940. *Virginia Room, Roanoke Public Libraries.*

On August 15, a navy bombing plane being ferried from San Diego, California, to Quantico, Virginia, crashed near Copper Hill on Bent Mountain at 1:30 p.m. in heavy fog. C. C. Simmons, a machinist and passenger in the plane, died at the crash site, while the pilot, Lt. C. H. Morrion, escaped with slight injuries. The single-motor biplane nosed over when the pilot attempted an emergency landing in a field on the farm of Mrs. Cassie Aldridge about a mile off Route 221. The crash site was guarded by a US Marine Corps Reserve unit for investigators. According to the pilot, he had flown the plane from Knoxville, Tennessee, to Chilhowie, Virginia, where he was advised that weather conditions were satisfactory to fly to Roanoke. Simmons was from Quitman, Arkansas.

Roanoke city agreed to accept $12,000 from the state to help erect an armory, pending a positive bond referendum vote by the city freeholders. The estimated cost for the armory project was $280,000. The city was also planning to couple a municipal stadium project with the armory.

The Belmont Service Station had its grand opening on August 16. Selling Shell gasoline, the station was located at 802 Dale Avenue, SE, under the management of R. R. Clingenpeel.

Roanokers took note of the federal war department's announcement that they would construct a $25 million powder plant near Radford that officials estimated would employ five thousand men. Construction was to start immediately and be completed in about ten months. The plant would be constructed by the Hercules Powder Company on a

2,500-acre tract and would operate the plant on a fixed-fee basis. The plant would be able to produce two hundred thousand pounds of smokeless gunpowder daily.

Davidson's Clothiers-Haberdashers celebrated its thirtieth anniversary in late August. Located at 303 South Jefferson Street, the men's store opened on August 20, 1910. The family-owned business offered a sale on linen suits for $5.30, wool slacks at $2.30, Bostonian Oxfords for $6.30, and Straws (summer men's hats) for $1.30. Wool suits were all priced at $30 in honor of the anniversary.

J. M. Oyler won the western district horseshoe pitching contest in Elmwood Park. Oyler had won the 1938 Virginia state tournament. D. J. Smith and G. B. Darnell won the doubles tournament. All advanced to compete in the state championships in Charlottesville.

Roanoke's semipro football team announced initial contracts, mostly with regional college players. The team was being managed by John Godwin. Godwin was making frequent trips to Richmond to meet with the managers of other teams in the Dixie League.

S. H. Heironimus Company advertised the opening of its "College Shop" on Monday, August 19, with a fashion show in collaboration with *Vogue* magazine. The department store trumpeted it had assembled "college clothes that belong to the new, trim, tidy wits-about-her college girl of 1940." Among the styles offered were back-buttoned pinafores, Shetland sweaters, fur jackets of sable-dyed fox, leather gloves, Harris Tweed topcoats, Hockanum flannel knee skirts, and pleated wool skirts in schoolhouse red.

Roanoke College president Charles Smith announced that the college would begin offering during its fall term courses for adult students who were not pursuing a degree. This new policy and program would admit persons as "students-at-large" with all the privileges and access to campus as residential students.

The local "Wilkie for President" campaign office opened in late August in the Patrick Henry Hotel. Local Republicans gathered at the hotel to listen to Wilkie's campaign addresses over the radio. In Salem, the campaign was headquartered at the Fort Lewis Hotel. Both sites offered badges and literature for distribution.

Fort Lewis Hotel, shown here in the 1940s, was at the corner of
Main and Colorado Streets in Salem. *Salem Historical Society.*

With war in Europe, Congressman Clifton Woodrum declared that America should stay neutral and shared his opposition to lending naval destroyers to Britain. "I don't think America is any position to jump into any war with anybody now." Woodrum based his opinion on America's lack of military readiness and public opinion that still held a negative view of aiding European countries under Nazi attack. Woodrum did support the purchase of French and British territories in the Western Hemisphere as a means of supplying funds to those countries and acquiring lands for American interests.

Lakeside offered a special end-of-summer three-cents days, Wednesday through Friday. Regular admission was fifteen cents for adults and ten cents for children. The special fares did not include Mountain Speedway, the Rola Plane, or the pony rides.

The Roanoke City Council authorized the city manager to acquire more land for the Roanoke Municipal Airport on the assumption that federal aid would be received for expansion. The city was interested in acquiring 3.15 acres at the intersection of old Rock Road and the road leading to the airport, and 23 acres of the T. J. Andrews farm.

The Roanoke Theatre promoted "the film sensation of the year," a movie titled *Reefers*. "Tell your children the true facts about dope. Reefers are as dangerous as a coiled cobra, the greatest menace to American youth!" The film was based on case studies from Federal Bureau of Narcotics. The theatre management had separate viewing days for men and women, and no children were to be admitted.

Roanoke officials were notified by federal officials that if they combined a stadium project with the armory, federal monies for the armory would be jeopardized. The armory could be classified as a defense project, and a stadium could not. The stadium had been included by city officials as the facility would provide storage space for the armory.

Vinton town manager H. W. Coleman was physically assaulted by a citizen at the meeting of the Vinton Town Council on August 19. Gus Mahone, a frequent critic of the manager and council, grabbed the back of the neck of the town manager after exchanging words with other citizens and was thrown off the manager by Mayor Crockett. Crockett quickly adjourned the meeting, and, ironically, it was his last official meeting as mayor as he retired from his seat September 1.

Roanoke County Board of Supervisors member Ira D. Chapman died of a heart attack at his home on August 20 at age seventy-three. Chapman represented the Salem district on the board of supervisors, having been first elected in 1936. A farmer, Chapman was a native of Franklin County who moved to Roanoke County in 1917.

Robert Royer, manager of the Academy of Music, gave indications of the coming season's events featuring a dozen road attractions. It was noted that attendance had been declining at the academy for its live theatrical and music shows. The academy was leased by its owners to the Thursday Morning Music Club, which had operated it for the past several years. The only salaried employees at the academy were custodians and stagehands. Royer stated, "This season is going to be the acid test for Roanoke and southwestern Virginia." He indicated that if attendance at shows was good, New York producers would continue to send their shows to Roanoke.

The Kay Lee Shop, a ladies' business-wear store, announced that it would open at the end of September at 305 S. Jefferson Street, where the Lerner Shops was located. The new store was operated by Edward Schlossberg, formerly of Roanoke but living in New York City.

The Roanoke City Council decided to allow voters to approve the armory, stadium, and library capital projects through a bond referendum set for November 5 coinciding with the election. The combined stadium-armory project was estimated by city officials to cost about $560,000. The two projects were separated, as the armory qualified as a defense project, though city leaders hoped that storage at the stadium for military equipment might qualify that project for federal defense funds as well.

An estimated 250 members of the Roanoke Booster Club attended the club's annual outing. In 1940, the outing was to Hot Springs. B. M. Davis was captain of the trip, and he had been organizing the annual trips since 1915. The trips initially began as opportunities for Roanoke's businessmen to promote Roanoke to other cities and groups. By 1940, the trips were more social in nature. The uniform of the Boosters was a dark coat with white trousers and hats with a "Booster" band. A special N&W train carried the Boosters to their destination. During their meeting at the Homestead, the Boosters adopted a resolution in strong support of the armory and stadium for the city, encouraging a positive vote for the bonds in the November 5 referendum.

Directors of the Dixie Professional Football League adopted a schedule with opening games on September 22. The Roanoke Travelers were the newest team in the six-member league. Other cities with teams included Baltimore, Newport News, Richmond, Portsmouth, and Norfolk. The season would run through December 1.

In compliance with the federal law requiring the registering and fingerprinting of aliens, Roanoke postal authorities reported that on the first day the law went into effect (August 27) they registered and fingerprinted ten aliens. The post office was charged with the task by the federal government.

The Royal Crown Boosters won the city softball title, defeating the Bush-Hancock team at Maher Field in a three-out-of-five series. Both teams competed in the state softball tournament.

Hundreds attended a show at the Roanoke Auditorium previewing the new line of 1941 Plymouth automobiles. Other auto dealers throughout the region were advertising that new models of cars would be on their floors in early September.

By late August, Roanoke took the formal step of applying to the WPA for funds to expand and further develop its airport. The city requested $313,900. Congressman Clifton Woodrum further announced that the request had cleared an initial review by the WPA and was now being considered for certification by the war department. Two days later, the *Roanoke Times* in a front-page headline declared, "Roanoke Airport Made Defense Project." The federal war department and WPA had approved funds in the amount of $313,315 for the airport. It was anticipated that work would begin immediately. City officials also indicated that the expansion of the airport would allow the resumption of commercial air service. American Airlines had discontinued service to Roanoke in September 1937, but the airline had indicated a willingness to return should the airport expand to include extended runways and lighting for night activity.

The Roanoke Railway and Electric Company shared that the streetcar service to Vinton would be abandoned by January 1 and replaced with bus service. The plan also included changing from streetcars to buses for the Norwich line by the same date.

In late August flooding again occurred for the second time in the month with rain resulting from a hurricane along the east coast. August 1940 remains at the time of this writing the wettest month in the recorded weather history (since 1900) of the Roanoke

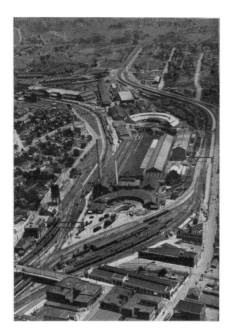

Aerial of the N&W Railway Roanoke
Shops looking east, September 1940.
Norfolk-Southern Foundation.

Valley. A total of 16.71 inches of rain fell during August. According to Roanoke's noted weather observer at the time, O. P. Estes, the driest month on record was August 1930, when less than an inch, 0.69, of rain fell.

Carl Ellison, a resident of Tazewell Avenue, SE, in Roanoke, drowned in the Elizabeth River at Norfolk on August 31 in an apparent heroic attempt to the save the life of another man, Jacob Kunkle of Norfolk. According to Norfolk officials, Ellison leapt from a bridge near Norfolk harbor to try to rescue Kunkle, who had fallen overboard from a ship. Several witnesses described Ellison's attempt.

The 1940 Roanoke Fair, held at Maher Field, opened on September 2. The fair consisted mostly of livestock exhibits and flower and home-economics displays. To draw crowds, fair organizers also contracted for aerial acts, vaudeville troupes, and a midway. Some six thousand attended on opening day, which had as a main event harness racing in which a Roanoke horse, Rosemary Abbe of English and Heishell Stables, won. John L. Goodwin was fair association president. Specific acts were the Mayfair Revue (a female chorus line), Cartier Sisters (aerialists), xylophonist June Boyd, and the Bijou Circus, which consisted of dogs, ponies, monkeys, and a mule. Auto races were held at the end of the weeklong fair, and fireworks were launched nightly.

Dr. C. R. Brown of Roanoke College was named chairman and ex-officio mayor of the Salem Town Council during that body's reorganization meeting. The Vinton Town Council elected Roy Spradlin as mayor.

The Salem-Roanoke Friends professional baseball team finished their season in early September with a 55–62 record, placing third in the four-team Virginia League. The other teams were Lynchburg, Harrisonburg, and Staunton.

On the night of September 3, a huge inferno engulfed the Carter Lumber Company near the intersection of Franklin Road and Brandon Avenue in South Roanoke. The warehouse of the Ramsey Package Company was also burned. Fire companies from Roanoke, Salem, and Vinton battled the blaze, as thousands of onlookers gathered along the N&W Railway tracks. Damage was estimated to be around $60,000. About a dozen persons were treated for injuries, but there were no fatalities.

The Roanoke city manager announced the appointment of a new police chief, James Ingoldsby. Ingoldsby, thirty-three, came to Roanoke from Bristol, Virginia, where he was serving as police chief. He was a native of Kingsport, Tennessee. Ingoldsby's salary with the city would be $3,505. He succeeded C. E. Heckman, who had retired as police chief after eight years due to ill health. Walter Wood was elected by the Roanoke City Council

to another two-year term as mayor, along with Leo Henebry as vice mayor. W. B. Carter attended his first meeting as a new member of the council. The council recognized James Bear, who did not seek reelection, for his many years of public service. Bear had served on the Roanoke board of alderman from 1914 to 1918 and on the city council from 1934 to 1940. Bear also served as the city's mayor from June 2 to August 31, 1938. The city council also accepted an offer of 6.75 acres of land in Norwich from J. B. Fishburn for the purpose of a public park.

Ella Fitzgerald, the "first lady of swing," performed with her orchestra at the Roanoke Auditorium on September 4. The five-hour show included a dance. Accompanying the twenty-two-year-old singer was Taft Jordan, trumpeter. It was announced prior to the show that "white spectators" would also be admitted.

The Roanoke Auditorium was located near the Hotel Roanoke
and would later be renamed the American Legion Auditorium,
c. early 1940s. *Historical Society of Western Virginia.*

Officials with the Shenandoah Life Station (WSLS radio) announced they would begin broadcasting on October 1. The offices, studios and transmitter would be located at the Shenandoah Life building on Brambleton Avenue, with the transmitter on the roof. James H. Moore, from Lynchburg, was the station manager. The 250-watt station was part of a three-station operation, with sister stations in Lynchburg and Danville.

The Roanoke Life Saving and First Aid Crew launched a campaign to acquire an "iron lung" given the deaths in southwest Virginia of young persons from infantile paralysis. At the time of the crew's campaign, there were only three known respirator devices in the state. Julian S. Wise was the crew captain.

Roanoke Democrats opened their campaign headquarters in downtown across from the Park Theatre in a building formerly occupied by Lazarus, Inc., at 510 South Jefferson

Street, in preparation for the 1940 presidential election. Benton Dillard was chairman of the city Democrats.

Two employees of the N&W Railway were presented diamond insignia in recognition of fifty years of service to the railway. Albert Mullen and Pleas Flood were each honored during the annual meeting of the N&W's Colored Veterans Association meeting.

Jefferson and Luckland bowling alleys opened for fall bowling season, with numerous leagues formed. Jefferson Recreation Parlors had reconditioned lanes. Jefferson had fifty-eight teams registered. Luckland, which also had duckpins, had sixteen leagues with eighty-four teams. Jefferson was over Mundy's Cigar Store with an entrance next to Grand Piano, and it also had twenty-one billiard tables.

The high school football schedules for 1940 had Jefferson playing William Byrd, Danville, Maury (Norfolk), Granby (Norfolk), Covington, John Marshall, Andrew Lewis, Petersburg, and E. C. Glass. William Fleming's opponents were Christiansburg, Buena Vista, Blacksburg, Andrew Lewis, Lexington, William Byrd, Martinsville, and Radford. Andrew Lewis was slated to face Bedford, Newport News, Covington, William Fleming, Lane, Jefferson, William Byrd, E. C. Glass, and George Washington. William Byrd's opponents were Jefferson, Schoolfield, Narrows, Clifton Forge, Radford, Pulaski, Fleming, Andrew Lewis, and Martinsville. Addison had contests with Reid (North Carolina), Christiansburg Institute, and Jefferson (Charlottesville), among others.

Fire struck again. This time the Harris Hardwood Plant in Norwich went up in flames on September 9. It was the second lumber yard to catch fire in a month. The fire at Harris consumed the plant's $100,000 planing mill. Hundreds of Roanokers gathered on hills around Norwich to watch the nighttime blaze.

Roanoke city manager W. P. Hunter asked for the resignation of Dr. J. E. Flannagan as director of the city's tuberculosis sanatorium. Hunter claimed the call for the resignation was due to the doctor being in ill health, though others suspected it was for other reasons. The sanatorium had been the subject of controversy since it opened, with claims of poor food, poor medical treatment, and mismanagement. An investigation by state officials, however, had found a few minor concerns but little else. The concerns reached a climax in August when the city council asked the city manager to fire the medical director because it had come to light that an orderly at the facility had been terminated as an employee when he had testified before the state investigating committee. A few days later, Hunter appointed Dr. G. C. Godwin of the North Carolina Tuberculosis Sanatorium to succeed Flannagan.

In Vinton, Walter Wood (mayor of Roanoke) was reappointed by the town council as the town attorney. Wood indicated that if Roanoke City were to ever annex Vinton, he would step down from his position with Vinton. Councilman Joe Pedigo sought to replace Vinton's town manager, H. W. Coleman, but his effort was not supported by his two other council colleagues. The town council adopted an annual 1940–41 budget for Vinton totaling $48,165.

The biggest "dime bank" in the world visited Roanoke. It was an ambulance that had been outfitted temporarily as a bank whereby persons could put coins and paper currency in slots located on the ambulance's exterior. The purpose was to raise funds for the purchase of ambulances for Britain. A local British-American Ambulance Committee, headed by Mrs. John Parrott, coordinated the ambulance's visit. The "dime bank" was parked

downtown at three locations over the course of its one-day stay. Roanokers contributed $403.52 to the cause.

Roanoke native John Henry Walthall was credited with discovering the process by which alumina could be extracted from common clay. His discovery proved invaluable in the manufacturing of aluminum. Walthall had been born in Roanoke in 1900, son of Silas Walthall, and had graduated from MIT. At the time of his discovery, Walthall was working for the Tennessee Valley Authority lab in Alabama.

The first squad of Roanoke's professional football team in the Dixie League was announced. The players included Sam Yeager, John Waynick, Blake Brown, Sam Elliott, Jimmy Capito, Paul Gibson, Pat Patterson, Willard Kiser, Jim Lawless, Bob Stump, Ed Short, Ned Legrande, Vic Bragassa, Johnny Leys, and Alex Lasch. The team was coached by Francis Albert.

On September 14, Lerner Shop opened at its new location, 25 Campbell Avenue, having closed its older store at 305 S. Jefferson Street. The women's clothing store was managed by Mrs. Pearl Moss.

Blue Hills Golf Club changed hands on October 1. The course had been leased the previous five years by Mrs. Alice Taylor. After October 1, the new lease was with Nelson Long, Clyde Johnson, Buddy Clement, and Ralph English. Johnson would serve as the new manager of the course, coming from the Stonewall Jackson course near Staunton. Long was the golf professional at The Homestead resort, and Clement and English were leading amateur golfers in the Roanoke region. Clem Johnston owned the property, and Mrs. Taylor had been associated with Blue Hills since 1931 along with her late husband. Blue Hills had held a $1,000 open tournament in 1939 that attracted well-known professionals, including Sam Snead and Johnny Bulla. It was the first such tournament ever held in the Roanoke Valley. The 1939 tournament had been won by Clayton Heafner of Charlotte, North Carolina.

Roanoke's semipro black baseball team played a four-game series against an all-star white team composed largely of players from teams in the Skyline League. All games were held at Maher Field.

Dr. Charles Smith, president of Roanoke College, announced that construction of a new $75,000 chemistry building would begin. The cost of the building had been provided by an anonymous donor from the Midwest.

Carver School in Salem opened to the public on September 15. Town officials toured the building, a "consolidated school for negroes," that cost $136,000. Theron Williams was principal.

Fred Keffer of Craig County won the champion of the show award in Salem's third fat hog show held at the Neuhoff Packing Company. The show, coordinated by area 4-H Clubs, drew contestants from a five-county area.

A. W. Lescure, seventy-eight, recalled to a newspaper reporter his memories of early Roanoke. Coming to the city in 1890 with the N&W Railway, Lescure said, "Salem Avenue was lined with saloons…that a half-century ago the rowdy crowds here would just as soon shoot you as throw a rock at you." A native of Pennsylvania, Lescure was a member of Roanoke's first paid fire crew, having served as a volunteer firefighter previously. He also served on the city council for fourteen years.

ABC officers destroyed a large distillery near Vinton in mid-September. Officers arrested Vic Gordon, and a search of his property uncovered loaded shotguns, 250 gallons

Theron N. Williams was the first principal of Carver
School in Salem, 1940. *City of Salem.*

of apple brandy, small quantities of whiskey, a gallon of blackberry brandy in his out-house, and a still consisting of a sixty-five-gallon barrel and a thirty-gallon water tank. It was one of the largest illegal stills found in the region.

The Roanoke City Council formulated plans for a November vote by the city's free-holders on a bond issue that would fund a municipal stadium, an armory, and a library. The library was included in the bond issue after council was lobbied by several civic orga-nizations, including the library board, for its inclusion.

Roanoke and Salem Units of the 246th Coast Artillery National Guard were mus-tered into service on September 16. Headquarters and Battery were given physicals at the Roanoke Auditorium, while Batteries G and H were conducted in Salem.

Russell L. Smith, principal of the Harrison School for twelve years, died at the age of sixty-six at the home of Dr. E. R. Dudley on September 16.

Mrs. W. W. Hamby won the city-county women's golf tournament held at Blue Hills Golf Club. Miss Marie Franklin came in second in the field of twenty-two.

The grand jury of Hustings Court submitted to Judge J. Lindsay Almond that Roanoke was home to an "orgy of vice" that was strongly organized and well equipped. The grand jury had heard evidence of mass violations of gaming and alcohol laws by le-gally organized social and civic betterment clubs. Such establishments had been engaged in the conduct of lotteries through baseball pool tickets. The grand jury recommended a vice squad be formed to assist the commonwealth's attorney, and the jury absolved the Roanoke police department of all blame for leaks that tipped off clubs of pending raids. The clubs named in the grand jury's report were the Alleghany, Alpha, Colonial, Paradise, Roanoke Athletic and Pastime, and Uncas. The grand jury went further and reported that the many of the clubs had trafficked in obscene pictures and materials.

Mrs. Roberta Williams addressed the fall membership meeting of the Roanoke Travelers' Aid Society at the Patrick Henry Hotel and advocated for increased funds and staff. According to reports, Roanoke had the second largest society in the country for cities with a population between seventy-five and one hundred thousand. The society was a welfare organization that handled transient cases exclusively. Roanoke's society was established in 1916.

The new Red Hill Baptist Church was dedicated on Sunday, September 22. The new building cost $22,000. The church was founded in 1910 and reorganized in 1934. Rev. H. L. Cooper was the pastor.

The Manhattan Giants won the "colored softball title" in Roanoke for 1940. Team members were H. Easly, S. Mann, J. Lane, N. Barnett, A. Graham, R. Dungee, W. Robinson, T. Pettius, T. Saunders, H. Franklin, R. McFee, J. Robinson, C. Morris, J. Davis, W. Saunders, and Ray Mosby (business manager). The team's record for the season was 27–6.

The Roanoke City-County Public Forum announced their lineup of speakers for the coming months. The forum was a group dedicated to providing citizens the opportunity to hear nationally known speakers on a variety of topics. The lecturers would be Maj. George Fielding Eliot, a commentator for CBS radio news; Channing Pollock, playwright; Louis Fischer, author and foreign correspondent; and Henry C. Wolfe, foreign affairs expert.

WSLS Radio introduced its new station manager, James H. Moore. Moore came from a sister station in Lynchburg. He began his radio career as a tenor soloist for CBS's Dixie radio network and had worked in various positions within radio since.

An inaugural meeting of the Andrew Lewis High School and old Salem High School Alumni Association was held at Andrew Lewis on September 23. Organizers of the association included Ben Chapman, Ruby Bean, O. T. Hartman, and Julia Gunn. James Moyer, a Salem attorney, was elected the association's first president. Thirty-five graduates became charter members.

Members of the Back Creek Social Service Club made and donated sixty gallons of apple butter to Mercy House. The apple-butter making was held at the home of E. I. Grisso.

Members for three local draft boards were recommended by Roanoke mayor Walter Wood to Virginia's governor. Local Board No. 1 served the Jefferson Ward, Local Board No. 2 was concerned with Kimball and Melrose Wards, and Local Board No. 3 served the Highland Park and Raleigh Court Wards. The requirements for board members were that they be males, not members of the armed forces, residents of their respective wards, and at least thirty-five years of age. The board members would oversee the Selective Service registration process that had been recently enacted by federal legislation. Judge Thurston Keister made the recommendations for Roanoke County's board members.

Franklin Lunch had a formal opening at its location at 715 Franklin Road on September 24. Free grapettes and cigars were provided to customers, with music by Richardson's Revelers.

Bob "Suicide" Hayes and his Hell Drivers performed at Maher Field. His main attraction was a jump over sixteen cars into a flaming wall. Hayes's show did not go well, as his car lost control and crashed into the front of the grandstand, injuring three spectators, none seriously, as the crowd of five thousand jumped to their feet. Hayes got out of his

car and checked on the spectators. Upon learning that no one was seriously hurt, Hayes continued the show, successfully jumping the sixteen automobiles.

Sixth District congressman Clifton Woodrum lost a bid to become the House majority leader to J. W. McCormack of Massachusetts. The Democrats had to select a new majority leader following the rise of Sam Rayburn to House speaker. Woodrum received 67 votes to McCormack's 141. Observers saw McCormack's victory as a win by New Deal Democrats as he was the favored choice of President Roosevelt. Woodrum's support largely came from Southern Democrats who were often critical of New Deal policies. Following his defeat, Woodrum moved that the selection be unanimous.

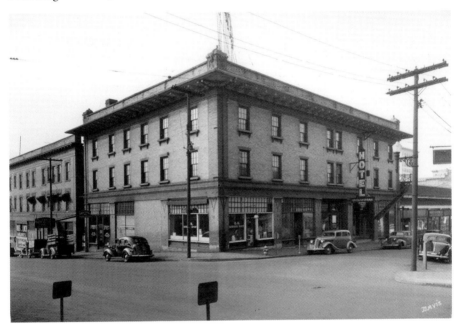

Shenandoah Hotel on Salem Avenue in 1940. The hotel would later become the Hotel Earle. *Virginia Room, Roanoke Public Libraries.*

The N&W Railway offered Maher Field (which it owned) to Roanoke city as the potential site for an armory and stadium, specifying that the land must be used for recreational use. The property consisted of thirty acres and had been purchased by the railway in 1923 for $150,000. The move was seen as the railway's effort to make the stadium-armory project more attractive to those voting in the bond referendum.

The Roanoke Rotary Club purchased an eighty-nine-acre tract of land for $1,500 on the headwaters of Peters Creek for use by the Boy Scouts as an overnight campground. The campground was to be known as the "Billy Bowles Camp" in honor of the late W. B. Bowles Jr., a former club president who had undertaken fundraising for such a purpose.

The N&W Railway completed its $125,000 freight car paint yard in early October. The yard was located on the site of the old Crozier Furnace property east of the Roanoke Shops. The yard was composed of seven 1,300-foot tracks. The N&W reported that it intended to spend $4.7 million on improvements to the West End Yards. The work would

take two years to complete. Major elements included sixty miles of new track, improvement of the south end of the highway underpass at Shaffers Crossing, grading, the realignment of existing tracks, a new hump yard, supplementary engine service terminals, and a new deicing station. Once completed, the expanded yard would become the second-largest independent yard in the nation. The largest was Portsmouth, Virginia.

Armory "Bud" Waite Jr. spoke in Salem about his experience as a radio operator and electrician on the third Byrd Expedition to Antarctica. The talk, given at Andrew Lewis High School, told of the 123-mile trek through blizzards to reach Byrd's observation post. Waite had received the Congressional Medal for his efforts. The speech was under the auspices of the Salem Woman's Club.

Maurice "The Angel" Tillett, billed as the world's ugliest man, returned to the wrestling mat at the Roanoke Auditorium in early October. His opponent was Big Ben Morgan. Tillett was a nationally known figure in professional wrestling, having been widely featured in magazines and movies. The match was promoted locally by Bill Lewis. Three thousand fans came to the event, where Tillett "stalked about the ring like a caveman pictured in school books…snorted like Frankenstein in the movies, and then brought his 'bear hug' to pin Morgan both times."

At 10:00 a.m. on Tuesday, October 1, WSLS officially went on the air, though some test broadcasts had been conducted briefly at night a few days prior. WSLS had contracted with NBC for transcription services but was not officially affiliated with the network. Fred Johnstone was the chief announcer for the station. The station broadcast news at intervals throughout the day, and other regular programs included the "Sunrise Express," a morning music program announced by Jay Owen; "Morning Reveries"; "Civic Calendar"; "Here's to You," an all-request music program; and "Time for Sports" in the late afternoon. WSLS also broadcast the World Series baseball games for 1940 between the Cincinnati Reds and the Detroit Tigers.

At the urging of black leaders, the Roanoke City Council chose to allocate $20,000 of the bond referendum for an expanded library to serve black residents, in addition to a main library, stadium, and armory. The allocation for a library in Gainsboro was made possible by the donation of land by the N&W Railway, as funds for land acquisition were no longer necessitated. The library in Gainsboro was a one-room accommodation that opened December 12, 1921.

One hundred fourteen women participated in S. H. Heironimus Company's crochet contest. The winner was Mrs. L. N. McReynolds of Salem, who crocheted 77 scallops in the one-hour time limit. The world's record was 118 scallops in an hour, set at a recent World's Fair. The contest was held on the third floor as one hundred other women looked on.

Magic City Motor Corporation at 348 Campbell Avenue held a four-day-long exhibit of the bullet-riddled "Death Car" of Clyde Barrow and Bonnie Parker. The display was accompanied by recorded lectures every twenty minutes between 1:00 p.m. and 9:00 p.m., and the theme of the gangster car show was "Crime does not pay!"

The first night high school football game occurred on October 4 under the lights at the Roanoke College field. The opponents were Andrew Lewis and William Fleming High Schools. Lewis beat Fleming, 47–7.

Thomas M. Thomas of "Uncle Tom's Barbecue" was summoned to court in a test case for Roanoke County's dancing curfew law. The county had a "public welfare" law that

prohibited dance halls from operating after midnight. Thomas had intentionally kept his open thirty minutes past the midnight hour at the establishment on Route 220. Judge R. T. Hubard sustained the county's laws, including the one that prohibited the sale of beer and wine past midnight.

Donald A. McKibben, director of choral music at Virginia Tech and choir director and organist at St. John's Episcopal Church in Roanoke, was named director of the Roanoke Symphony Orchestra. The orchestra's concerts were held under the auspices of the Thursday Morning Music Club.

In Salem, the Salvation Army's local officials gathered to begin razing an old home at 813 W. Salem Avenue to make way for their new army citadel. Ironically, the home had been erected in 1865, the same year the International Salvation Army was organized.

The Roanoke Travelers held their first home game at Maher Field. Roanoke's professional football team went up against the Newport News Shipbuilders on Sunday, October 6. Admission was fifty-five cents for adults and twenty-five cents for children. Kinky Darnell was quarterback, and the Travelers won, 7–3.

The Roanoke Chamber of Commerce, along with other civic organizations, formed a committee to promote the stadium-armory-library bond issue. Appointed were James Turner, chairman; Edmund Goodwin and T. X. Parsons, vice chairmen; and B. F. Moomaw, secretary.

The *Roanoke Times* declared its editorial support for the reelection of Franklin Roosevelt as president, noting, however, that "Mr. Roosevelt was most unwise to seek a third term as President." The *Times*, typically supportive of Democratic candidates, often criticized Roosevelt's New Deal programs.

John T. Wood of Norwich was killed as the result of a streetcar accident. Wood was struck by a streetcar as he was walking on Roanoke Avenue and started to cross the tracks. T. E. Forbes, operator of the streetcar, was arrested by police for reckless driving. (The charge was later dismissed.) It was the third streetcar fatality of the year. A few days later, Mrs. Mary Bell Ross of Centre Avenue, Roanoke, was fatally injured by a streetcar at Campbell Avenue. Mrs. Ross was struck by the streetcar as she ran to board it.

The largest plane to land at the Roanoke Municipal Airport in its eleven-year history did so in early October when a Douglas B-23 US Army bomber stopped to refuel on a trip from Orlando, Florida, to Dayton, Ohio. Roanoke officials continued their efforts to prepare the airport for defense funding by purchasing almost twenty-four acres from the Roanoke Orchard Company for $20,000.

Some two thousand Roanokers attended the local kennel club's annual dog show. The best-in-show award went to Bradthorn Bullion, a Scottish terrier, who competed in a field of 225 entries. The dog was owned by Mr. W. S. Smith of Rye, New York.

Judge Thurston Keister of the circuit court appointed Howard Starkey, a tannery manager in Salem, as a member of the Roanoke County Board of Supervisors to fill the unexpired term of I. D. Chapman, who died in office. Starkey had served as a member of the Salem Town Council from 1931 to 1934 and was a past president of the Salem Kiwanis Club.

The first local death from infantile paralysis occurred on October 12 when a three-month-old girl died. Members of the Roanoke Life Saving and First Aid Crew brought the girl from southwest Virginia to a Roanoke hospital.

Gill's Café in the Gainsboro section became the Finney and Gilliam Café in mid-October due to new ownership.

Cab Calloway and his Cotton Club Orchestra performed at the Roanoke Auditorium on October 15.

In Salem, the town council authorized the town manager to proceed with the development of plans for a municipally owned, fifteen-acre park east of the town off Route 117. The park and playground plan envisioned a baseball diamond, basketball courts, and picnic areas.

Under a huge blue canvass, the Ringling Brothers and Barnum and Bailey Circus brought their "greatest show on earth" to Maher Field on October 20 and 21. The circus included fifty elephants, three hundred horses, a giant gorilla, bears, tigers, leopards, panthers, and cougars. The circus consisted of 1,600 entertainers and crew with the entire circus coming to Roanoke on three silver streamlined trains. Thousands of Roanokers lined city streets around Maher Field to watch the circus tents go up, as well as the large group of animals and crew. The production consisted of forty-one tents, nine electric light plants, 283 cages and wagons, and a kitchen that served 4,500 meals per day. For the two Monday performances, thirteen thousand attended, with another eight thousand walking through the exhibits.

Stations in Roanoke City and County opened on October 16 for the Selective Service. Most registration locations were in firehouses, schools, and other public buildings. Local officials prepared for 16,000 men to register, all between the ages of twenty-one and thirty-five. (Actual figures were 8,814 in the city, and 4,857 in the county.) T. Howard Boyer, chairman of the city electoral board, was charged with making certain registration machines were operable. Employers were encouraged to make time available to their employees for registration to occur, while Salem had an "American Citizenship" parade to inspire young men to do their duty. The parade, sponsored by the Salem Woman's Club, began at 10:00 a.m. at Green Street, near Lake Springs Park.

A steel flag pole was dedicated at Maher Field during the football contest between Jefferson and John Marshall High School (Richmond) as part of the "Old Grads Day" on October 19. The dedication ceremony included a performance by the Jefferson drum and bugle corps and the participation of military veterans. Some six thousand attended the dedication event and football game. Jefferson lost the game, 7–0.

Allen Ingles Palmer of South Roanoke held his first one-man exhibit at Milch Galleries in New York City from October 21 through November 9. The artist displayed twenty-five watercolor paintings, having previously received critical recognition at the New York World's Fair, the Art Institute of Chicago, and the Allied Artists gallery in New York. The front of the invitations to the exhibit was of his watercolor of an old African American church near Cave Spring. Palmer had studied with Walter Biggs of Salem. He was the son of Charles Palmer, 701 Lafayette Avenue, South Roanoke.

Several local hospitals were granted "approved" status by the American College of Surgeons in October. They and the number of approved beds were as follows: Burrell Memorial, 44; Gill Memorial, 25; Jefferson, 111; Lewis-Gale, 134; Shenandoah, 59; and the Veteran's Administration, 1,008. It should be noted that the bed count only included those approved for surgical patients, as some hospitals had more beds than in the count listed.

This image is looking southeast toward Mill Mountain from Day Avenue, between First and Jefferson Streets, 1940. *Virginia Room, Roanoke Public Libraries.*

The Republican "colored division" held a meeting in the Methodist Church on Gainsboro Avenue, and the speaker was Judge William Hueston of Washington, DC. The headquarters for the division was 406 Henry Street, NW, with Jacob Reid, a local attorney, in charge.

Baseball organizers in Roanoke enthusiastically sought to have a minor league professional team locate in the city, having not had one since World War I. Their best chance was to gain entrance into the Class B Piedmont League circuit if the November bond issue were to pass. In late October Herb Pennock, director of the Boston Red Sox farm system, came to Roanoke and evaluated various baseball venues. The Red Sox had previously announced they intended to move their farm team out of Rocky Mount, North Carolina. Meanwhile, the Cincinnati Reds were looking to move a farm team to Lynchburg and out of Durham, North Carolina. Standing in the way were the presence of the Salem-Roanoke Friends baseball team, the absence of a financial backer, and lack of an adequate facility.

Roanoke was included in an application with the CAA for an aerial postal pickup route. The application was made by the Aero Pickup Service Corporation, located in Norfolk. The service was that airplanes would retrieve mail bags perched atop designated office buildings while in flight using a hook mechanism suspended from the plane. Thus, the airplane would never stop. There were two proposed routes that included Roanoke, each having Norfolk and Roanoke as terminus points, with a northern route and a southern route.

The S. H. Heironimus Company displayed in their store window one of two mechanical respirators acquired by the Roanoke Life Saving and First Aid Crew. The "iron lung" was one of two purchased by the first-aid crew with the manufacturer donating a third one for infants.

A crayon drawing of John C. Moomaw was presented to Roanoke City Council by his daughter. Moomaw was instrumental in having the Shenandoah Valley Railroad locate in what was Big Lick. During the formal presentation of the portrait, a number of facts were given about that event. Moomaw delivered a petition from Big Lick citizens to the board of directors of the railroad while they were meeting in Lexington in 1881. The petition was carried on horseback by C. W. Thomas from Big Lick to a point near Mill Creek Baptist Church in Botetourt County where he was met by Moomaw, also on horseback, who rode through the night to reach Lexington. According to Moomaw's daughter, her father convened Big Lick's civic leaders—among them were P. L. Terry, Henry Trout, T. T. Fishburn, George Tayloe, M. C. Thomas, Ferdinand Rorer, J. M. Gambill, John Kefauver, W. H. Starzman, James Neal, C. W. Thomas, S. W. Jamison, and C. M. Tuner—suggesting they get a petition and subscribe a sufficient amount to pay the right of way from Cloverdale and offer a terminal site. Those leaders managed to subscribe $10,000 and the petition. Such was then delivered by Thomas and Moomaw.

On October 29, President Roosevelt drew the first serial number in the draft lottery, with the second being drawn by Secretary of War Stimson. The numbers were 158 and 192, respectively. Five men in the Roanoke Valley held the first number and became the first drafted from the area. They were Joseph Scott, George Holland, James Creger, Noel Sink, and Willie Sink (no relation).

Lucy Addison High School held its "Old Grads Day" celebration on November 1 with a parade through downtown and a football game against Parker-Gray High School, Alexandria, at Maher Field.

The first use of an "iron lung" in Roanoke was on October 31, when a physician sought to save the life of a young woman stricken with infantile paralysis. Members of the Roanoke Life Saving and First Aid Crew, who had purchased the device, used it when paralysis that had begun in the legs began affecting the patient's respiratory system. The patient was twenty-eight-year-old Eleanor Caldwell, wife of Frank Caldwell, 1402 Chapman Avenue. She died eleven days later. Hers was the seventh case of infantile paralysis in the city and the first death of a Roanoke native due to the affliction.

At Hollins College, a mock election was held for president. Wendell Wilkie polled 204 votes to Roosevelt's 181. In 1936, the Hollins student and faculty had voted 236 for Roosevelt and 142 for Alf Landon.

On November 4, WSLS radio station became a part of the Mutual Broadcasting System. According to the station manager, the affiliation allowed listeners to have access to national and global news as well as entertainment programming.

N&W locomotive 1206, a Y-6 freight engine, returned from the New York's World Fair in early November and was put back in operation.

The William A. Hunton Branch YMCA, founded in 1927, announced the purchase of the former Odd Fellows building at the corner of Patton Avenue and Gainsboro Road, NW. The building, erected in 1921, had three floors, and the top two were to be used for "Y" activities, with the first floor to be rental space for businesses. L. A. Lee was general secretary of the Hunton Branch. At the time of the purchase, the Hunton Branch was

located at a former residence at 28 Wells Avenue, with that location being opened in April 1928. In the Odd Fellows building was housed the Gainsboro library.

In the presidential election, Roanoke city voters went for President Roosevelt over Wendell Wilkie, 6,942 to 3,553. In Roanoke County, the vote was 3,539 to 2,292 for Roosevelt. Also reelected by a wide margin was Democratic Sixth District congressman Clifton Woodrum over his Republican opponent, Fred McWane. The freeholders of Roanoke city approved the bond issues for the armory, stadium, and library projects. For the armory and stadium, the vote was 3,661 for and 958 against. For the library bond issue, the vote was 2,807 for and 1,392 against. All bond matters had received enthusiastic endorsements from civic, business, and educational organizations throughout the city prior to the election.

World War I veterans who served with the 116th Second Virginia Infantry, Company F, held a reunion at the Patrick Henry Hotel on November 11. The annual reunion was first organized in 1936 by veterans of the company living in Roanoke. The reunion would alternate its meetings between Roanoke and Chase City. The highlights of the reunion were attending the football game between VPI and VMI freshmen at Maher Field and marching in the Armistice Day parade. Leonard Urquhart of Roanoke was the association's president. Roanoke's Armistice Day parade started at 10:30 a.m. from Elmwood Park, north on Jefferson Street to Church Avenue, west on Church to Fifth, north on Fifth to Campbell, and returning to Elmwood Park. Harry Wickes was the marshal. That evening a dance sponsored by the Committee for Patriotic Affairs was held at Hotel Roanoke.

The three-day-long elk hunting season opened in southwest Virginia, covering fifty thousand acres. The closest regions for elk to the Roanoke Valley were Floyd and Giles counties. A herd of thirty elk were jumped near Pearisburg.

The owners of the Salem-Roanoke Friends baseball team asked the Salem City Council to not raise the rent charged for play at the municipal field. The request was referred to the town manager. The baseball management reported that paid attendance during the 1940 season at home games was 38,154, though the team operated at a financial loss. A few days later, Roanoke mayor Walter Wood announced that the New York Yankees and the Brooklyn Dodgers had agreed to play an exhibition game in Salem next April if relocation of the game from Roanoke to Salem was satisfactory. Wood was a member of the Roanoke Lions Club, which had brought the Cincinnati Reds and Boston Red Sox to Roanoke for exhibition games in 1939 and 1940. The 1941 major league game would be in Salem due to the anticipated construction of the stadium-armory at Maher Field in Roanoke.

Roanoke City officials completed the application for the municipal airport to be eligible for development as a Class 3 Field and receive federal WPA funds for the expansion and improvement needed. The city agreed to put up $60,000 toward the total cost of $350,000. At the time, the airport was rated as Class 1. (Class 4 was the highest rating.)

Metropolitan Opera soprano Helen Traubel awed a crowd of 1,400 at the Academy of Music with a two-hour concert. Her appearance was sponsored by the Roanoke Community Concert Association. The soprano returned to the stage for two encores.

Kroger opened its fourth store in the area. The Kroger Grocery and Baking Company opened on Grandin Road, and a fifth store was announced to open at Twelfth Street and Patterson Avenue in January. (The Kroger store was located in what is today the Natural Foods Co-Op.)

The "Military Football Classic of the South" was an annual game between Virginia Tech and VMI played in November at Roanoke's Maher Field. The contest originated in 1894 when the two schools played one another in Staunton. The first contest between the teams to be played in Roanoke was in 1896. The two opponents did not meet for four years after that but resumed the rivalry with a game in Lynchburg in 1900. The next time Roanoke hosted was in 1904, and then Roanoke became the permanent host site in 1913. The 1934 contest was by far the most mediocre, with the contest ending in a 0–0 tie. The 1940 contest was affectionately known as the "Splinter Bowl" due to the wood bleachers at Maher Field. Football fans expressed enthusiasm on returning to Roanoke in 1941 at the new stadium. The 1940 game attracted an estimated twenty-one thousand fans, the largest crowd since 1929. Among those in attendance was Gen. George C. Marshall. VMI won the game, 14–0.

An organizational meeting was held at the Patrick Henry Hotel for local stamp collectors to determine the feasibility of forming a club. The main attraction at the meeting was an exhibit of Big Lick postal covers owned and collected by Lee Williams. The group eventually formed the Lee-Jackson Stamp Club with P. H. Croy as chairman.

The Roanoke Optimist Club dedicated their clubhouse for boys in Norwich in a ceremony on December 3. The cinder block building had showers, a meeting room, and three activity rooms. The clubhouse cost about $3,000. The building was located on a plot owned by the club and adjacent to Norwich Park.

John Goodwin, in charge of the Roanoke Travelers professional football team announced there definitely would be a team in Roanoke for the 1941 season. The Travelers were sponsored by the American Legion. The team had drawn respectable attendance and showed more promise in comparison with efforts in 1938 to launch a Roanoke football team using widely known professional wrestlers.

An induction center for trainees entering the army under the Selective Service Act was opened at 105 W. Campbell Avenue. Capt. N. L. Hahn was in charge of the center. It was estimated that 8,500 men would eventually come through the center from the multicounty region being served by the Roanoke office. The first man inducted at the center was J. R. Taylor from Big Stone Gap.

Charles Miller, an official with the Brooklyn Dodgers baseball organization, came to Roanoke to inspect potential sites for a farm team. Miller looked over Maher Field and was accompanied by Ralph Daughton, president of the Piedmont League.

Through the use of WPA funds, a spillway was constructed for Lakewood Park's pond. The park along Brandon Avenue, Roanoke, would accommodate an outdoor ice-skating rink when the five-hundred-foot stone spillway was completed. Fed by Murray's Run, the pond was drained to accommodate the work. Also being constructed in the park were a picnic shelter, a restroom facility, and four tennis courts.

Workmen began razing the old federal post office building at the corner of Church Avenue and First Street. The building and site had been acquired by the S. H. Heironimus Company for the construction of a possible filling station or parking lot.

W. H. Horn, manager of the Roanoke Street Railway Company, announced that buses would be substituted for streetcars on the Vinton-Melrose line beginning December 27. The company had recently received the thirty-one-seat buses to be used.

NEW POST OFFICE, ROANOKE, VA.

This early postcard shows the old federal post office in downtown Roanoke that was razed in late 1940. *Nelson Harris.*

Progress was occurring on the Salem bypass with the paving of Fourth Street. The bypass would allow traffic to move around the town with the construction of a new highway leaving Routes 24 and 117 near Conehurst and following an old streetcar line across to the Salem turnpike.

Black teachers and principals in Roanoke city public schools asked for equal pay as whites. The request followed a federal court ruling that Norfolk could not discriminate in its pay of public-school employees on the basis of race. The request came in the form of a petition presented to the city school board by the Roanoke Negro Teachers Association. The association wished to achieve parity such that the pay of white teachers was not harmed. D. E. McQuilkin, superintendent, stated that to achieve equal pay involving ninety-two black teachers and principals would cost about $30,000. Based on the previous fiscal year's budget, the average salary difference between a black and white elementary teacher was $271 annually; for high school teachers, it was $323; and for principals it ranged from $652 to $2,483. The petition was presented on behalf of the association by Sadie Lawson (Addison), Ruth Hughes (Harrison), and L. A. Snydor (Addison). The school board referred the petition for future consideration and review by the school administration.

On Sunday, December 1, the G. W. Carver School in Salem was formally dedicated. Dr. Archer Richardson of the Virginia Department of Education was the keynote speaker at the afternoon ceremony. The "consolidated school for negroes" was overseen by Principal Theron Williams. Dr. Carver was invited to attend but could not. However, Carver did send a note that read, "I trust that every pupil will regard the splendid school

building as an opportunity to make their lives count as 100 percent American citizens." The school had been constructed using WPA funds for about $135,000 and replaced a wooden-frame training school building that had been in use for years. About five hundred persons attended the event that was presided over by Rev. C. J. Smith, pastor of First Baptist Church.

Richard's (formerly Factory Outlet Shoe Store) at 20 E. Campbell Avenue went out of business during the first week of December.

The Roanoke College Collegians, a dance orchestra, played for the first time in December and was contracted to play every Sunday afternoon on WDBJ radio. The orchestra consisted of eleven players and a female singer and anticipated playing for dances, civic concerts, and radio broadcasts.

A. Carter of Norfolk won the fourth annual Jefferson bowling alley sweepstakes, claiming the $125 prize. Seventy-two men took part from all across the state.

R. C. Hoffman Jr. announced his retirement as president of Roanoke Gas Company and the election of E. J. Meade to succeed him. Meade had served as vice president of the gas company since 1938. Hoffman stated he would remain as president of the Carolina Coach Company and the Roanoke Railway and Electric Company. Hoffman had been serving as president of Roanoke Gas Company since 1933.

The WPA local district director asked the Roanoke City Council to provide new quarters for the WPA mattress project. The project employed twenty-five women, who worked in a building on Fifth Street but moved due to lack of heat. Recommended as new quarters was a building on the northeast corner of Patterson Avenue and Eleventh Street. The women had produced 1,033 double mattresses and 140 single mattresses, with ticking, cotton, and labor being paid for by the federal government. The city provided a place of work and thread. Without the mattress project, the city manager indicated all the women would have to be provided public relief.

The Roanoke Junior First Aid and Life Saving Crew was organized in September and was formally granted a charter by Virginia in November, being the only junior lifesaving crew chartered in the state.

The Roanoke Arts Alliance submitted a proposal to the city library board that a "civic art gallery" be included in the design and construction of the new library recently approved in a bond referendum. William Paxton, alliance president, suggested that such a gallery could exhibit traveling shows, local works, and host lectures. The alliance offered to maintain the gallery and the exhibits.

The Community Children's Theatre presented a local production of "Snow White and the Seven Dwarfs" December 6 and 7 at the Jefferson High School auditorium. There was a special performance for "colored children" on December 14. It was the theatre's debut performance, having been formed months earlier.

Andrew Lewis High School released their basketball schedule for the 1940–41 season. They would play William Byrd, William Fleming, E. C. Glass, Hampton (Hampton), Jefferson, Lane (Charlottesville), Alexandria (Alexandria), and G. W.-Danville. Jefferson High School's opponents for the season were Rocky Mount, Princeton, Duke freshmen, Charlottesville, William Byrd, E. C. Glass, Andrew Lewis, Danville, and VPI freshmen.

The Vinton Milling Company was completely destroyed by fire on December 7. Firefighters from Roanoke, Salem, and Vinton responded to the blaze, which caused an

estimated $70,000 of damage. R. A. Covington was president of the company and stated that the blaze started in the basement from an unknown origin. The milling company lost all its inventory of wheat, flour, and grains in addition to the four-story structure.

The All City-County football team was named following the conclusion of regular season play. Making the first team were ends John Cassell (Jefferson) and Dave Smythe (Jefferson), tackles Ed McCallum (Andrew Lewis) and Richard Updike (Fleming), center George Moore (Fleming), backs Jack Wilbourne (Lewis), John Gleason (Lewis), Pete Fuqua (Byrd), and Harry Walton (Jefferson).

On Monday, December 9, four schools in Botetourt County were ordered closed until December 20, being under quarantine due to the death of a Fincastle High School student, Helen Firebaugh, from infantile paralysis. The request was made by Dr. W. N. Breckenridge, secretary of the board of health. Ms. Firebaugh died at a Roanoke hospital after just a few hours in an iron lung that had been rushed from Greensboro, North Carolina. The four schools that were closed were Fincastle, Trinity, Asbury, and Pleasant Dale. Further, all families in those communities with children were asked to remain in their homes, and all other public buildings in those sections of the county were closed.

The Roanoke City Council authorized city officials to negotiate with St. Andrews Catholic Church for the purchase of a site at the corner of Patton Avenue and Gainsboro Road, NW, for the location of a new "Negro branch" library. The site was diagonally across from the Gainsboro library and was donated by the parish for library purposes.

In Salem, the town council formally accepted the donation of tract of land on Academy Street from Col. And Mrs. Sinclair Brown with the understanding that the land would be developed as a park and playground for the town. The land donated was adjacent to other property purchased by the town from the Valley Railroad Company.

Roanoke police dumped twenty-eight old "riot bombs" into the Roanoke River from the Wasena Bridge. The bombs had been in the police department's gun vault for many years and had become useless. Before tossing them, the detonator plugs were pulled, and some detonated during the drop. The bombs were made of black rubber, were five inches long, and were shaped like a hot water bottle. The bombs contained tear gas and had been purchased by the department in the mid-1920s.

A dance troupe from Hampton Institute entertained a large group at the Roanoke Auditorium with what was called a "new medium": creative, interpretive dance. The dancers, known as the Hampton Creative Dance, offered interpretation of traditional spirituals, Haitian folk dances, labor rhythms, and human emotions.

Roanoker J. W. "Jack" Moss was appointed as engineer in charge at Washington National Airport. A graduate of Jefferson High School and Virginia Tech, Moss had been associated with the airport since its construction in 1938. At the time of Moss's appointment, National was considered to be one of the most modern and largest airports in the world.

The federal government announced in mid-December that an additional $85,000 had been appropriated for the improvement of the Roanoke Municipal Airport beyond that which was already anticipated. Two other nearby fields, Montvale and Narrows, also received additional grant monies.

The old chimney at the Crystal Spring pumping station was dismantled and replaced by a new smokestack.

This 1949 image of the Crystal Spring Pump Station shows it with the smokestack from 1940. *Virginia Room, Roanoke Public Libraries.*

Twelve self-serve Christmas seals stations were set up in key locations in Roanoke by the Roanoke Tuberculosis Association. The locations where persons could get varying envelopes of the penny seals were the Hotel Roanoke, Hotel Patrick Henry, Ponce de Leon Hotel, First National Exchange Bank, Colonial-American Bank, Morris Plan Bank, Liberty Trust Bank, Mountain Trust Bank, Mundy's Cigar Store, and the Greyhound Bus Depot.

A junior chamber of commerce was organized, and its first meeting held in the Patrick Henry Hotel with a dozen young men in attendance. Griffith Dodson Jr., an attorney, was elected president.

A special committee from Roanoke returned from Washington, DC, and reported that the armory would receive $100,000 in federal funding as the project had been declared a defense project.

Meador Motor Company opened at 8 East Main Street in Salem as a dealer for Desotos and Plymouths.

The Roanoke County Negro Teachers Association formally asked the school board for equal pay with white teachers. The association also had the support of the county's white Parent-Teachers Association. The matter was referred to the superintendent.

Mick-or-Mack Grocery Store No. 1 moved to its new location at 309 Nelson Street (also First Street), SE. It had been formerly located at Church Avenue and Nelson Street.

Edward Marshall of Salem had an article published in *Popular Aviation* magazine about the Roanoke Municipal Airport, titled "Airport in the Blue." The article noted that Roanoke's airport was among fifteen municipally owned airports in the nation (out of six hundred) that had an operating net profit. Marshall attributed the airport's fiscal health to the solid management of Robert Dunahoe. According to the article, Dunahoe had gotten involved in aviation in 1929 when he flew solo in a WACO 9 from a Roanoke cow

pasture. He and Chris Carper did freelance aerial photography in Kansas City. Carper was a commercial pilot with TWA by 1940. Marvin Turner was the airport's assistant manager.

The Virginia High School Literary and Athletic League named Richard Fisher at Andrew Lewis High School to its All-State Football Team. Fisher was a tackle. No other area player made the first team.

Roanoke's postmaster, John W. Wright, died suddenly at age forty-four on December 15. He had been appointed Roanoke's postmaster in 1938. Wright had served in the Virginia House of Delegates representing Roanoke in 1924 and 1926. His widow was appointed to serve temporarily as the city's postmaster.

Employees at Viscose raised $1,400 for needy employees of the Viscose's parent company located in Coventry, England. Coventry had been heavily bombed by Germany.

The City of Roanoke agreed to purchase nearly two acres of land adjoining Maher Field from "Griggs-Barbour interests." The property was on the south side of Franklin Road and Pleasant Avenue and was needed to complete the development of Maher Field. In other city council business of the day, an appeal was made by the Roanoke Hospital Association for a significant increase in their 1941 appropriation to take care of indigent patients. The association requested $10,000, but the city manager had budgeted $7,500.

The Roanoke County Board of Supervisors authorized the planning for a fire station in the Williamson Road area on Grace Street. The total cost of the station was budgeted at $10,000. Businesses along Williamson Road had offered to give their employees leave time in order to train as volunteers for the firehouse.

WSLS Radio offered three days of cooking school during weekday mornings at the Grandin Theatre. The school was sponsored by several businesses with the winner of the cooking school contest receiving a 1941 cooking range.

Roanoke city school superintendent D. E. McQuilkin and school board chairman Harvey Gray proposed to the school board that the salaries of black teachers be equal to those of white teachers in response to a petition presented earlier by the Roanoke Negro Teachers Association. The proposal was to raise black teacher salaries over a three-year period such that at the end of the period all teachers would be compensated equally. The school board adopted the recommendation.

Judge Thurston Keister of the Roanoke County circuit court certified an election order to allow the voters in Vinton to decide in a February 4 referendum whether they wished to continue with their present town manager form of government or revert back to having the town council manage affairs. The certification came as a result of a petition of some 20 percent of registered voters in the town requesting a referendum be held.

The Salem Rescue Squad announced in mid-December a fund drive to acquire an "iron lung" mechanical respirator. Henry Oakey, a Salem mortician, made the first donation of fifty dollars.

The National Youth Association workshop at 208 Centre Avenue, NW, reported that it gave employment to 172 youths in the making, repairing, and laundering of clothing for the US Armed services and the Civilian Conservation Corps. It was the only such NYA workshop in Virginia.

Giles Brothers furniture sore announced that they would relocate their store in downtown from the present site at Kirk Avenue and Second Street to 16–18 Church Avenue,

SE. The move would follow a renovation of the new site and would take place around March 1. The furniture store was owned by Charles Giles and A. P. Martin.

Due to an acute housing shortage in Radford, the Hercules Powder Company chartered a passenger train from the N&W to run daily between Radford and Roanoke for its employees. The morning and evening train made three stops: Salem, Elliston, and Shawsville. Hercules hoped to have a second train for employees chartered with the Virginian Railway. Only Hercules employees could purchase the twenty-five-cent round-trip tickets. Three hundred sixteen employees rode the train, known as the "Powder Special," on its first run.

C. E. Salmons, postal superintendent for Roanoke, stated that Christmas holiday mail peaked on December 20 when the post office handled some 282,000 pieces of mail on that day.

On December 21, the Ideal Service Station, selling Amoco fuel, opened at the corner of Tazewell Avenue and Eighth Street, SE. C. W. Pickle and E. G. Thurman, proprietors, offered free Sun Spot and 7 Up soft drinks to customers.

A local British War Relief Committee was formed shortly after Christmas, headed by attorney Dirk Kuyk with headquarters at 210 First Street, SW. The group started with temporary quarters at the Patrick Henry Hotel. The group's first project was raising funds for a mobile kitchen. The Greek community in Roanoke had also established a war relief effort on behalf of Greece and had raised funds that were sent directly to humanitarian organizations in that country. The first person to donate to the British war relief fund was Ann Holmes of Stanley Avenue in South Roanoke, age nine. She emptied her piggy bank, which contained $1.87.

Federal and local authorities announced that they had successfully raided twenty-four stills in Franklin County during December, destroying nearly nine thousand gallons of whiskey and 52,800 gallons of mash. They had confiscated eight cars and made forty-eight arrests. One of the largest stills (350 gallons) was near Ferrum.

"Old No. 2" was retired during Christmas week at Fire Station No. 1 in Roanoke. The engine had been in service since 1909, when it was horse drawn. Motorized in May, 1918, the fire truck was replaced by a new, twenty-seven-thousand-pound engine equipped with a one-hundred-foot ladder. The new truck could safely hold five men, including one in a cockpit at the rear to steer the back end.

From the Christmas Basket clearinghouse, individuals, businesses, and charities had distributed food and other items to 943 indigent families for Christmas. The director, Ella Brown, reported that there were still three hundred elderly "not taken." The basket warehouse was operated by the welfare department of Roanoke City. Police officers delivered many of the food baskets and toys to the names they were provided.

On December 26, city police shot and killed a suspect they were trying to place under arrest for suspicion of murder. The suspect fired three times at the officers before being shot by them in the 300 block of Madison Avenue, NW. The suspect was James Robertson, twenty-six, who died at the scene. Robertson was in the process of being arrested for the fatal shooting of Ethel Dickerson, thirty-five, of Gregory Avenue, who died the same day. The patrolmen making the arrest were H. T. Stewart and C. R. Allman. The following day, city police witnessed another tragedy when a juvenile they were pursuing for possession of a stolen vehicle and who had a month earlier escaped from the juvenile detention home shot and killed himself near Wasena Bridge as police closed in.

"Aunt Winnie" Divers, believed to be the oldest-living person in Roanoke, died on December 27 at the City Home of pneumonia. She was 119 years old.

Buses began serving the former Melrose-Vinton streetcar line on December 27. The line operated on a fifteen-minute schedule. The changeover to buses was first made on the Franklin Road-Northeast line.

Count Basie, "The Count of Swing," played at a dance for black citizens New Year's Eve at the Roanoke Auditorium from 10:00 p.m. to 3:00 a.m. "Five Hours of Jive" was advertised, with advance tickets being eighty-five cents. White spectators were welcome for sixty-five cents admission.

1941

Foster Funeral Home opened in Vinton on January 1. The funeral home and ambulance service were located in the Masonic building.

Roanoke reported a total of 1,743 births in 1940, making that one of the highest years on record. The highest years were 1924 and 1928, with 1,809 and 1,806 births, respectively. The first birth for 1941 occurred at 2:18 a.m. at the Salvation Army home. In other health-related news, Roanoke reported that there was not a single death from typhoid in 1940, and that was the first year with no such death since health records began being recorded in 1912.

Glen Wilton in Botetourt County began to take on new life when construction began to clear land for a chemical plant and grading for a spur track to connect with the C&O Railway. The plant was associated with the Triton Chemical Company of Delaware, and the company had purchased some 1,831 acres in Botetourt for the plant.

Calvary Baptist Church, Roanoke, celebrated its fiftieth anniversary. The church began in 1891 with 34 charter members in a wood-frame structure. In 1941, membership was in excess of 2,500. The founding of the congregation was spearheaded by E. H. Stewart, and it became the second Baptist congregation in the city. The organizational meeting was held in Mr. Stewart's furniture store on Salem Avenue. The effort gained the support of Roanoke Baptist Church (now known as First Baptist Church). The name "Calvary" was chosen by A. G. Chewning, an employee of Stewart, who had moved to Roanoke from Washington, DC, where he had held membership at the Calvary Baptist Church there. In late January of 1891, the congregation moved from the furniture store to meeting at the YMCA. That year the church purchased a lot on the north side of Campbell Avenue at Sixth Street (directly across the street from the present-day sanctuary) for $6,000 and erected an A-frame wooden structure. By May 1896, a brick church had been erected on the lot. In 1925, the current sanctuary was completed. In 1941, two charter members were still living, including Mrs. A. G. Chewning. Dr. Richard Owens was the pastor in 1941. Some 1,500 persons attended the fiftieth anniversary service.

Leland MacPhail, general manager of the Brooklyn Dodgers, stated that Roanoke was not "out of the running" for a minor league baseball team contrary to earlier reports. MacPhail, during a visit to Roanoke to inspect Maher Field and a lunch with local officials, did acknowledge that his franchise was looking at Durham and Raleigh, but a final decision had not yet been made. The team would be part of the Piedmont League. MacPhail also indicated during his visit that a potential exhibition game between the Dodgers and the New York Yankees could still be played in Roanoke in early April if

stands at Maher Field were available. The stands had been removed due to anticipated construction of a stadium-armory.

The district office of the WPA announced that grading contracts had been awarded for work at Roanoke Municipal Airport to W. E. Graham of Mount Airy, North Carolina. The work involved widening runways, moving hangars, and installing lighting for night flying. Airport manager Bob Dunahoe reported that the facility made a profit in 1940 and that during that year thirty-nine local airplanes used the airport, up from thirty-five in 1939. During 1940, a total of 1,074 visiting airplanes used the airport, 162 students soloed, and 320 local pilots used the airport.

The Trapp Family Singers (the same family loosely portrayed in the film *The Sound of Music*) gave a concert at Hollins College on January 15. The group was composed of the wife, five daughters, and two sons of Baron Georg von Trapp. The singing family had performed throughout Europe, having been discovered during a home performance at Tyrolean Castle, the home of Baron von Trapp. While on temporary visas within the United States, the family was residing in Pennsylvania, and their performance was part of the annual Hollins College concert series.

Margaret Chatham celebrated her eighty-ninth birthday. A resident of Day Avenue, Roanoke, Mrs. Chatham was interviewed as to her early memories of Roanoke. She had come to the area with her husband in 1883 as he was employed by the N&W. Chatham recalled that upon their arrival in the winter, the lawn of the Hotel Roanoke was quite green as it had just been planted. The railroad depot was across the tracks from the hotel at Campbell Avenue and Railroad Avenue (now Norfolk Avenue). She shared that the best stores were along Norfolk and Salem Avenues in the early days and that one used high stepping stones to navigate Salem Avenue due to its muddy condition. She also remembered the stream that ran down Jefferson Street but had since been enclosed in a culvert under the street. Her most vivid memory was the big snow of 1890.

The Roanoke Black Cardinals baseball team met at the office of W. P. Hughes, president, and planned their 1941 season. The season would begin April 6 and close September 14 and consist of twenty-eight home games and fifteen away.

The local committee for British War Relief sold pages from an old German religious book printed in 1492. The book had been donated to the committee, and 310 specimen pages were being sold to raise funds from the committee's office at the Patrick Henry Hotel. Miss Mary Hayward was chairman of the committee.

Local banks reported their statements of condition as of December 31, 1940. Total assets reported were as follows: Roanoke Industrial Loan Corporation, $416,344; Liberty Trust, $2,093,844; First National Bank, $34,520,788; Morris Plan Bank, $27,539,337; Colonial-American Bank, $7,381,540; and Mountain Trust Bank, $7,015,269.

The Roanoke Rotary Club formally launched a campaign to receive donated guns, ammunition, tin hats, and binoculars to ship to Britain for the defense of English homes. Tin hats were requested as there were often injuries due to shrapnel. The campaign was being coordinated through the local British War Relief Committee and was headed by Dr. W. S. Butler.

At a special meeting of the Roanoke City Council, Mayor Wood urged the council to appoint a committee and pass a resolution approving the construction of wooden bleachers for a baseball diamond to lure the Brooklyn Dodgers minor league to Roanoke. There was speculation that for the Dodgers to move a team to Roanoke, the Salem-Roanoke

Friends team of the Virginia League would have to be bought out to clear the way for a Piedmont League team.

As work was underway for the expansion of the N&W Railway West End Yards, comment was made as to the naming of Shaffer's Crossing, the underpass under the yards. City old-timers pointed out that it was Shaver's Crossing, as the name came from John Newton Shaver, an early resident of Roanoke, whose farm back in the 1880s ran along the old Salem dirt road, which crossed the single track belonging to the Virginia & Tennessee Railroad. It was generally believed that the name changed due to typing errors. According to N&W records, the upper roundhouse at the West End was put into service in 1889, and the lower roundhouse came in 1904. On September 15, 1919, the Shaffer's Crossing roundhouse was put into operation. In April 1923, freight engines from West Roanoke were moved to Shaffer's Crossing, which served only the Radford division. In November 1930, freight engines from the Winston division were moved there, and then in February 1932 freight engines from the Shenandoah division were also moved to Shaffer's Crossing. O. V. Parsons was in charge of the expansion of the West End shops for the N&W.

The Power Behind the Nation, a motion picture produced by the N&W in regard to its coal operation, was seen by eighteen thousand persons in twenty-four states during the last two months of 1940.

The Grand Piano Company announced they would be moving to a new location in downtown Roanoke in early March. Located at 309 S. Jefferson Street, the company's new location would be 302 Second Street, on the southeast corner of Second and Kirk. That location had been vacated by the Giles Brothers Furniture Company. The structure Grand Piano acquired was built in 1918 and had thirty thousand square feet of floor space. Grand's piano department would occupy the second floor, which also had an auditorium to seat up to a hundred persons for recitals and concerts. Grand Piano also sponsored a sixty-piece orchestra that would use the auditorium for their rehearsals.

Robert MacGimsey performed for the Roanoke Woman's Club in January. MacGimsey had developed and named the art of "trilloquism," the ability to whistle three tunes simultaneously. He was also the composer of the well-known spiritual, "Sweet Little Jesus Boy."

WDBJ Radio was granted approval to increase its power for night broadcasts from 1,000 watts to 5,000 by the FCC. The station began broadcasting on September 19, 1936, at 5,000 watts daytime and 1,000 nighttime. The increase in power necessitated the construction of a second tower for the station. WDBJ secured its first broadcast license on May 5, 1924, at 20 watts and began broadcasting that same year on June 20. The station was originally owned by the Richardson-Wayland Electrical Company and was the second station established in Virginia. The transmission tower was later moved to the Shenandoah Life Insurance building and the studios to the American Theatre building. In 1936, WDBJ moved to its new building with transmission equipment and studios in downtown. WDBJ announced around the same time that it had a new program schedule for its three regular afternoon programs—*Life Can Be Beautiful, Guiding Light,* and *Ma Perkins.*

The town clock in Salem needed repair, and there was disagreement over who should pay—Salem or Roanoke County. The Salem town manager did some research and found that the four-faced clock in the top of the county courthouse was bought by the county and the Town of Salem jointly in 1910 for $1,065. By agreement, Salem budgeted $25

annually for its maintenance. The clock ran ten minutes behind, a somewhat endearing custom to those in Salem. The town manager's investigation also discovered a bullet hole in one of the faces.

E. D. Heins and Henry Scholz announced they would open a new cigar store and luncheonette at the corner of Jefferson Street and Church Avenue in the spring. They had also acquired the adjoining Mundy's Cigar Company. Mundy's moved one half block to 15–17 West Church Avenue in a building previously occupied by the Witten-Martin Furniture Company. John Mundy, proprietor, stated that his new location would offer a restaurant and cigar store on the first floor, billiards on the second floor, and a bowling alley on the third floor.

Jefferson High School dropped baseball as a school sport for the spring season, citing the sport's financial loss during previous years. With Jefferson dropping the sport, that left only GW-Danville and Andrew Lewis High Schools with baseball teams in the region.

An influenza outbreak in Roanoke in January caused the extension of the school semester by one week for students to take exams. Area hospitals reported that beds were in high demand due to the large number of flu cases. Some school systems in southwestern Virginia closed for a week or more. The Roanoke health commissioner estimated between ten and twelve thousand cases of flu in the city. At Andrew Lewis High School in Salem, one-fifth of the student body was ill and absent from school.

In a meeting with city officials, Larry MacPhail of the Brooklyn Dodgers stated that Roanoke would get a Brooklyn Piedmont League franchise if the city completed the stands and if satisfactory arrangements could be made with Ray Ryan, president of the Virginia League and controller of the Salem-Roanoke Friends baseball franchise. This was MacPhail's second visit to the city in as many weeks. The Virginia League would have to agree to the sale of the Salem team for a Class B Piedmont League to locate in Roanoke. If such could not happen, the Brooklyn farm team would go to Durham. Roanokers were cautioned about being too optimistic, as several years previous the city had been considered a site for the Cardinals minor league team only to have the franchise locate in Asheville.

Heavyweight boxing champion Jack Dempsey came to the Roanoke Auditorium on January 21 to referee a wrestling match between Tiger Joe Marsh and Cowboy Luttrall, an event arranged by local promoter Bill Lewis. Supporting matches were between the masked marvel known as "Black Secret" and Jack Reeder, and Herbie Freemen versus Cherokee Chief Little Beaver.

At Montvale, plans continued for the development of an airstrip. Montvale, formerly known as Buford's Depot and then Bufordsville, was site of a stagecoach stop between Salem and Lynchburg. Paschal Buford operated a tavern in the area. James L. Buford, a descendant, applied for a license to operate a landing field for aircraft.

The local newspapers provided readers diagrams of the parade route for President Franklin Roosevelt's inauguration to a third term. This way, listeners following the radio broadcasts of the event could follow the parade route on the map. In other radio news, Roanoke College graduate Walter Compton, at age twenty-seven, achieved national stature as a radio personality with the Mutual Broadcasting Company as host of the New York–based broadcast "Double or Nothing" that was heard nationwide on Sunday evenings. He also was a Mutual newscaster during the week.

The Ponce de Leon Hotel at the corner of Campbell Avenue and Second Street in the 1940s. *Historical Society of Western Virginia.*

WSLS Radio formally opened its suite of new offices and studio on January 20 on the seventh floor of the Shenandoah Life building. The move was celebrated by the mayors of Roanoke, Danville, and Lynchburg, who delivered addresses.

A ready-to-wear store was opened by the George T. Horne Company at 410 S. Jefferson Street on February 6. The company operated a wholesale and retail millinery business and hat factory adjacent to the new store. The quarters for the new store had been formerly occupied by the Madame Grayeb Shop.

Smead and Webber Pharmacy in Salem put on display in their window an iron lung as a means to rally the town's citizens to contribute toward the purchase of the device for use by the Salem Rescue Squad. The cost of the device was $1,500 and would be called the Bernard-Hale lung in memory of Kelly Bernard and Howard Hale, who were members of the Salem Rescue Squad. The fundraising drive met with success a week later. The purchase of Salem's iron lung brought to three that were now available in the Roanoke Valley. Salem's lung would be overseen by the Salem Rescue Squad. J. E. Carper had been chairman of the fundraising committee.

John C. Parrott advertised for his development, "Prospect Hills," with choice building lots for $1,500. Turner & Turner was offering building sites in Center Hill and Lee-Hy.

Rabbi Solomon Metz of Washington, DC, and leader of the National Zionist Organization of America, spoke to the Roanoke local chapter on January 20 at the Hotel

Patrick Henry. Arthur Taubman of Roanoke was the state chairman for the organization and also offered remarks.

C. M. Sherrill announced the opening of a furniture business slated for mid-February. The business would be known as the Sherill Colonial Furniture Studio and located at 34 W. Kirk Avenue. Sherrill had been the advertising manager for Thurman-Boone.

Miss Ida Redmond of Washington Avenue, Roanoke, had a book of poetry published by Fortuny's Publishers of New York. The work was titled *Thoughts*.

The Book Nook, Roanoke's only exclusive bookstore, relocated to 20 W. Kirk Avenue. In addition to selling books, the proprietor, Alice Huff Johnston, also had a rental library in the store.

The "Powder Special" that took workers from Roanoke to the Hercules plant near Radford was so successful that by late January there were five trains daily on the line transporting an average of 2,100 workers each day. The N&W rented thirty passenger coaches from the Pennsylvania Railroad to meet the demand.

Jeanette MacDonald, a star of stage and screen, appeared at the Roanoke Auditorium on January 25 to a sold-out audience. It was believed to be the largest crowd ever in Roanoke's history for a singer. MacDonald sang classical as well as Broadway arrangements. The only drawback to the evening was the slight presence of tear gas in the auditorium due to a canister exploding earlier in the day when National Guard equipment was being moved to make room for the audience. MacDonald offered numerous encores to the appreciative audience, including her closing rendition of "Indian Love Call." Earlier in the day, MacDonald had been warmly greeted by Roanokers when she stepped from her N&W passenger coach before she was driven to the Hotel Roanoke. Accompanying MacDonald were her agent, a pianist, and her Belgian personal maid.

Lewis-Gale Hospital was located at the corner of Third Street and Luck Avenue in downtown Roanoke in the 1940s. *Virginia Room, Roanoke Public Libraries.*

Students at Jefferson High School circulated and then presented a petition to Roanoke officials that a track be part of the stadium to be erected at Maher Field. An alternative solution proposed by the petitioners was an athletic track at Wasena Park. A track had originally been included in the stadium-armory plans but then was dropped due to budgetary concerns.

The *Kazim Frolics of 1941*, a minstrel show of fifteen acts, was put on by the local Kazim Temple for two nights at the end of January as a fundraiser for the British War Relief Committee at the Academy of Music. Sketches from the program were also broadcast over WSLS. Leroy Smith was the general manager for the event. Some 159 local "performers" contributed to the revue.

Vinton mayor Roy Spradlin strongly encouraged the town's voters to keep the present form of town manager governance, which they had benefited from since 1936. It was the first formal statement by the mayor since petitioners had won the right to place the question on a ballot for a February 4 referendum. The mayor pointed out that Salem and Roanoke were benefiting from having managers, as was Vinton.

Baseball officials with the Virginia League met in Waynesboro and refused to consider a sale of the Salem-Roanoke Friends franchise, closing the opportunity for a Piedmont League team affiliated with the Brooklyn Dodgers to locate in Roanoke for the 1941 season. The decision was unanimous. There was discussion about including teams from Waynesboro and Radford in the league's future.

The Roanoke City Council approved final recommendations for the stadium-armory project, giving the architect, L. P. Smithey, approval to move forward. City manager W. P. Hunter indicated it would take about six months to complete the stadium. The advisory committee for the project, chaired by T. X. Parsons, suggested a physical link between the stadium and the armory and that space be included under the stadium for storage by the National Guard (hopefully helping the stadium to qualify as a defense project and receive federal funds). The advisory committee recommended straight stadium stands versus curved ones with the intent that a curved stand of seats might be built later at the south end. It was believed by the committee that a straight stadium would be more economical, though curved stands would be preferable. The committee also approved reluctantly the relocation of the baseball diamond given the city's recent discussions with Larry MacPhail of the Brooklyn Dodgers. Other recommendations from the committee that were approved by the city council included that the first tread of the stadium be above three feet, that spacing of the seats be twenty-six inches, and that the ramps enter the stadium at the fourteenth level or above. Smithey indicated his firm could have final drawings ready by February 28.

The Raleigh Hotel on West Campbell Avenue was sold to the Roanoke Finance Company for $60,000. The sale included the hotel and two store fronts on Campbell Avenue and Kirk Avenue. The hotel was purchased from the estate of the late M. J. Patsel.

Various delegations appeared before the Roanoke School Board to present critical needs. The PTA of Woodrow Wilson Junior High School asked for an auditorium and gym, which were part of the original plans for the school. Northwest residents asked for improvements to Monroe School and for the construction of a new junior high school in the section. The Central Council PTA sought to raise $3,000 to fund free lunches and milk for indigent students (the city's allocation covered only half the cost).

Maj. John L. Godwin was appointed to command the Roanoke area battalion of the Virginia Protective Force. Four companies would be under his command, three in Roanoke and one in Salem.

William Greenway, noted auctioneer in Roanoke County, died at his home on Hollins Road at the age of eighty-seven on January 29. He was a member of First Church of the Brethren and was a native of Craig County.

The Rev. William Eisenberg, pastor of the College Lutheran Church in Salem, shared with the Salem Kiwanis Club a brief history of Roanoke College. The college's first home in Salem in 1847 was in the old Baptist church that sat on the knoll in East Hill Cemetery. The college then moved to a private residence for a few months before being located in the Salem Academy on the site of the present-day Academy Street School building. (The four-acre property that the college currently occupies was first purchased from William C. Williams on May 5, 1847, and a year later the first structure was erected there.)

A local post (No. 232) of the Jewish War Veterans of the United States was established in Roanoke with a ceremony at the Hotel Patrick Henry on February 5. Myer Becker was elected commander of the local post, and other officers were Josef Cohn, Sol Wilkins, J. H. Weinstein, and Harry Rosenberg. In Salem, the recreation center and library for black citizens was moved from its old quarters on Water Street to the former Roanoke County Training School on the same street.

Philip Shafer of Roanoke starred as one of the principals in the Broadway show "DuBarry Was a Lady." The show ran for fifty-one weeks in New York and began a national tour in early February.

With the addition of teams from Petersburg and Newport News, the Salem-Roanoke Friends baseball team in the Virginia League went from Class D to Class C. It was also announced by league officials that each team would play a 120-game season.

Members of the Roanoke School Board strongly urged the city council to appoint a member from their board to the stadium-armory advisory committee. The motive for the request involved the lack of a track at the stadium that had been requested by school leaders. The council was reluctant to act on the request as the committee had been functioning for some time and was close to completing their work. The council's objections to a track were based on the lack of revenue.

After a spirited debate among Vinton's citizens, the qualified voters defeated a proposal to eliminate the town manager form of government, 271 to 163. The total votes cast represented the largest number ever cast in a municipal election in the town's history, underscoring the importance of the issue. The effort to undo the town manager form of government had been led by Councilman Joe Pedigo. Mayor Roy Spradlin had marshaled those in support of the keeping the present system.

At the Roanoke Municipal Airport, only one man remained with an instructor's rating, Howard Kessler. All other instructors had been hired by the American and Canadian governments as flight instructors. Boots Frantz went to Florida, Charlie Hall to California, Charles Hood to Canada, Hunter Turner to California, George Mason to the Civilian Aviation Board, Bob Garst to Elon College, Sam Sharp to the CAB, and Calvin Hall to Canada. Aiding Kessler in Roanoke was Marshall Harris, who had served as a ground school instructor in Roanoke College's summer aviation program at the airport. Harris was also a ground school instructor for about a hundred Jefferson High School night students.

A 1941 aerial view of Roanoke Municipal Airport shows the Cannaday
home on the far right. *Virginia Room, Roanoke Public Libraries.*

The insurance company Jamison and Company was purchased by Davis and
Stephenson, Inc., both Roanoke firms. Davis and Stephenson were located at 112 W.
Kirk Avenue and had been in business for forty-seven years.

Six units of the 116th Infantry, part of the 29th Division, paraded through Roanoke
on February 8. The servicemen had been mustered into service on February 3. The parade
started at Elm Avenue and moved down Jefferson Street to Church, west on Church to
Fifth, north on Fifth to Campbell, and then south on Campbell to Second Street. There
was a brief exercise at the Municipal Building, where World War I veterans associated with
the 29th Division gave the servicemen a sendoff. The commanding officer of the 116th
was Lt. Col. Frederick Thomas.

National Race Relations Sunday was observed in Roanoke in mid-February with
an afternoon service of several clergymen from various denominations participating in
a service at Greene Memorial Methodist Church. The speaker was Dr. Robert Daniel,
president of Shaw University.

S. H. Heironimus Company held *Luxables on Parade*, a fashion show involving twen-
ty-six models showcasing various designs with Luxable fabrics. "When you make your
own clothes, they're as exclusive and individual as you!" Samuel Spigel, 304 S. Jefferson
Street, advertised frocks for those "Valentine parties that actually gives one the swish of
Cupid's arrows."

The Roanoke Symphony Orchestra, under the direction of Donald McKibben, gave their first performance of the year on February 9 at the Academy of Music. The program was broadcast over WSLS radio. The symphony consisted of thirty-six volunteer musicians, and admission was free. McKibben, choir master at St. John's Episcopal in Roanoke, had succeeded Henry Fuchs, who moved to Richmond the previous year. The symphony was sponsored by the Thursday Morning Music Club.

Professor Miles Master of Roanoke College offered for the first time there a course in "visual education" for those pursuing careers in education. The professor believed the use of slide projectors, a new technology, had the potential for classroom use.

The old Federal building and post office located at the corner of First Street and Church Avenue, was razed in early February. The demolition process had begun in November 1940. The building was being demolished to make space for a parking lot associated with the S. H. Heironimus store. The post office building had been built in 1909. During demolition, the cornerstone was removed, and it yielded nothing.

The San Carlo Opera Company appeared at the Academy of Music, presenting *Rigoletto*. The lead soprano was Lucille Meusel, and the lead baritone was Ivan Pertroff of Bulgaria.

Roanoke mayor Wood informed the city council that he had been informed by Larry MacPhail of the Brooklyn Dodgers that there would not be a team in Roanoke for the 1941 season. Nevertheless, the city would proceed with the construction of a baseball diamond and bleachers as planned in the hopes of attracting a future team.

Radios were marketed by several businesses as being the perfect Valentine's Day gift. Sears, 12 E. Church Ave., offered its table model Silvertone brand for $6.95, and Kingoff's Jewelers carried "the new 1941 Emerson with Miracle Tone." Grand Piano had floor model Philco Radios for $99.95, and the Stromberg-Carlson brand radio was being sold by Dowdy Electric Company, 32 W. Church Avenue.

Salem town manager Carlton Massey authorized the hiring of a fifth officer for the town's police force, thereby allowing the police chief to no longer have to work patrol duties.

On February 11, fire swept through the Johnson Furniture Company at 312 First Street, SE, a block from Market Square. The fire broke out in the basement and was discovered by T. J. Abshire, owner. When firefighters arrived, the blaze had moved up a stairwell to the first floor, trapping four persons on the second floor that was used as a boarding house. Firemen rescued two of the four with ladders, and the other two managed to leave by the back of the building. No one was harmed. Having no telephone, Abshire alerted the fireman at No. 1 Station by running to the station to give the alarm.

The Roanoke radio station of the Blue Ridge Parkway went on the air February 15. The station, with call letters WSEL, was located in the Shenandoah Life building, and its transmitter sat atop Mill Mountain. The two-way radio system was designed to allow communication between rangers, provide weather information, and improve fire protection.

The S&W Cafeteria in Roanoke promoted Thursdays as Family Night. They offered a roast chicken dinner plate for twenty-five cents, music by the Jack Saunders Orchestra, and two animated cartoons for children.

Several hundred Roanokers turned out to ice skate on the Huff mill pond near Copper Hill.

At Virginia Tech, Jimmy Kitts was named as the new head football coach, succeeding Henry "Puss" Redd, who had coached for the previous nine seasons. Kitts came to Tech from Rice College in Houston, Texas. Kitts's team had won the Cotton Bowl in 1938.

Dedication services for the Hunton Branch YMCA building at 436 Gainsboro Road were held during the third week of February. The new quarters had been purchased the previous year. Various groups including the N&W male chorus, the Phalanx fraternity, and several churches participated.

The Salem Library observed its fourth anniversary. It began in 1937 with 35 books and had grown to 2,711 volumes. The library was cosponsored with the town by the Salem Woman's Club. Citizens were encouraged to donate books to the library as a "birthday present" with the goal of surpassing the 3,000-book mark. Mrs. Chester Phinney managed the library on behalf of the Woman's Club. The library was housed in a small brick building on East Main Street at Younger Park.

Members of the Roanoke City Council, Salem Town Council, Roanoke County Board of Supervisors and the Vinton Town Council met for a Dutch treat luncheon at the Hotel Patrick Henry to discuss matters of common interest on February 14. The group named a steering committee composed of the three mayors and county chairman to plan for future gatherings. County supervisor Howard Starkey stated at the meeting that annexation would lead to a "metropolitan area with a single government," though he would probably not live to see it. Salem's mayor offered three issues of mutual concern: economic development, law enforcement, and sanitation. Both Roanoke and Salem officials observed that the construction of the Hercules plant had created "backwash" issues for their police departments. Luther Bell, county board chairman, expressed concern over pollution of the Roanoke River and that his desire was to have the river treated as a park and not be the dumping place for the valley's sewage. The solution, Bell said, was a regional sewage treatment facility.

On the night of February 15, flames swept through the Hillcrest Apartment building at 121 Elm Avenue, SW. No one was injured but the fire caused considerable damage to the fifty-year-old structure. For older Roanokers, they recalled that the home was built in the 1890s and was used for about twenty years as a private hospital by Dr. Charles Cannaday.

Ms. Nancy Page, a former slave and Roanoke's oldest citizen, died at her home, 423 Gilmer Avenue, NW, on February 13 at age 105. Funeral services were held at Bent Mountain.

Hollins College acquired the painting *The Annunciation of the Virgin* by fifteenth-century Venetian artist Girolamo de Santa Croce. The painting was formerly in the collection of Count Alexander Orloff-Davidoff and was purchased by the college from William Randolph Hearst's estate. Two other art pieces, a statue and a piece of stained glass, were also bought from the Hearst collection by the college when they came up for auction in New York. The three purchases were the result of a donation from Mrs. William Jackson for the purpose of acquiring art for the college's Fine Arts department.

The Gilbert and Sullivan Light Opera Company of Roanoke presented *Yeomen of the Guard* at Hollins College in mid-February as a benefit for the local British War Relief Committee.

Roanoke initiated the use of the federal government food stamp program as a means of providing relief to those needing assistance. The program would use WPA and NYA

labor to administer the program, and Roanoke's mayor indicated the program would be discontinued if the WPA were to cease. In other action adopted by the city council, plans for a new city library in Elmwood Park were approved. The new library would be sited near the present Elmwood home that was being used as a library. The architectural firm Eubank and Caldwell of Roanoke had been retained to develop plans that necessitated razing the Elmwood home. The cost for the new building was estimated to be $168,000. The council also authorized the acquisition of a lot on the northeast corner of Patton Avenue and Gainsboro Road from the Catholic Church for the purpose of constructing a new Gainsboro Branch Library. Both libraries were to be built using WPA labor.

The Bibee Grocery chain of Lynchburg announced the opening of a supermarket at 430–432 Luck Avenue, SW, at the end of February. The store became one of the largest in Roanoke at 11,250 square feet. It would be the first Bibee store in Roanoke and the twelfth for the company, which operated stores in central and southwestern Virginia. The location had formerly been Plymale's Giant Market.

John Riddick, principal at Jefferson High School, spoke to citizens' groups advocating for the improvement to the school that he said was "out of date and inadequate." According to Riddick, hundreds of students were held back in lower grades as upper-grade classrooms were too full, that classes were being held in coal bins and storage rooms, and that the enrollment in vocational training had quadrupled the need for more faculty and equipment.

Sarah Craig, forty-two, of Roanoke refused to move to the back of a city bus. Being black, Craig was supposed to sit in a rear seat, but moved to a front seat. The bus driver, A. Buzik, told her to move back to the designated seating. She refused, and an altercation occurred between the two. The case was brought to police court, where Judge Harris Birchfield took the case under advisement.

A $75,000 fireproof theater was under construction on Williamson Road, just south of Tenth Street. The theater was erected by Dan Weinberg, president of Bedford Theatres, Inc., and of the LeHigh Development Corporation. Eubank and Caldwell was the architectural firm associated with the project. The theater would have a seating capacity of seven hundred persons with an anticipated opening in early fall.

Shenandoah Life Insurance Company celebrated its twenty-fifth anniversary with a dinner at the Hotel Roanoke with 350 persons in attendance. The company was organized in 1914 and began business on February 1, 1916, occupying two rooms at 116 W. Campbell Avenue with one full-time employee. The dinner program was broadcast over WSLS.

Jefferson High School hosted a full house for the minstrel show, *Ebony Escapades*, which consisted of an all-student cast. "From the opening chorus, the high school talent kept the audience in highly good humor with black-face dancing, crooning, torch singing and an assortment of novelty numbers," reported the *Roanoke Times*.

Gordon Highfill of Roanoke, a student at Seton Hall, won the sixty-yard high hurdles in the national prep school indoor track championships at Madison Square Garden in New York City. Highfill's time was eight seconds flat.

Nearly four hundred war veterans in Roanoke and Salem completed questionnaires supplied by the American Legion for the purpose of voluntary emergency national defense. Questionnaires had been made available at Legion Post No. 3, American Viscose, Veterans Hospital, Virginia Bridge, and the chamber of commerce office.

Eubank and Caldwell Architects unveiled their drawings for the new city library in Elmwood Park. The design was colonial, brick with white trimmings, two floors, and with room for three hundred thousand volumes. The front facade consisted of a six-column portico with slate roofing. The interior was designed to contain a lecture hall, offices, parents' rooms, and a special room for Virginiana. Architects hoped construction would begin around June 1.

The Streitmann Biscuit Company occupied its new warehouse and offices at 428 Albemarle Avenue, SE. The company had been located at 1600 S. Jefferson Street. The new structure contained a warehouse, offices, and a garage for its delivery trucks that served a seventy-five-mile radius. A rail siding was also constructed. The Streitmann Company had located in Roanoke in 1933 with headquarters in Cincinnati and had become a division of the United Biscuit Company.

The American Legion basketball team defeated National Business College to win the state AAU championship. The game was played in the Roanoke auditorium, and the score was 41–35. Both were Roanoke teams.

The Roanoke City Council formally accepted as a gift Mill Mountain from J. B. Fishburn. The one hundred acres were stipulated to be used as a city park. The mountain had been owned by Washington & Lee University, and negotiations between the city and the university for the purchase of the park over the past few years had been unsuccessful. The acreage had recently been acquired by Fishburn, who in turn donated it to the city for "the use and pleasure of the people." Fishburn also gave permission for the city to donate the park land to the Commonwealth of Virginia or to the federal government for the same intended purpose if the city council should ever desire to do so. (One should note that the Blue Ridge Parkway was under construction at this time.) At the time of the donation, seventy-five acres were in the city, and twenty-five acres were in the county. Adjoining the tract were sixty-four acres owned by the city water department. News reports of the gift noted that only one other city in the entire United States owned a mountain, that being Chattanooga, Tennessee. Shortly after accepting the mountain, city crews began repairing the road up the mountain, clearing it of rocks and debris after months of neglect. Mark Cowen, city parks and recreation director, said he would like to see several cabins built on the top of the mountain for brief stays and for a rebuilt observation tower to replace the one that had burned several years ago. Cowen also proposed refurbishing Rockledge Inn as a community center. The city also eliminated the toll charge to use the road up the mountain as it was now in public hands.

With the transfer of the mountain came much history. The mountain was named for the mill that operated at its base and was owned by William McClanahan, who had acquired the land in 1782. In 1795, McClanahan purchased over three thousand acres that included all of the mountain. Parcels containing portions of the mountain exchanged hands several times over the years. The Mill Mountain loop road opened in 1924, a photo of which appeared in a newspaper in Doorn, Holland, on March 10, 1928. Prior to the road, the incline railway opened on July 13, 1911, and operated for several years.

Mary Walters, age fifty, was fined ten dollars and given a six-month suspended jail sentence for failing to move to the back of a city bus and threatening the bus driver. Walters admitted to being disorderly and stating that someone might kill the driver if he continued asking blacks to move to the rear. Walters had sat two seats in front of two

white boys and was asked to switch seats with them by the driver, E. W. Robertson. The case was heard by Judge Harris Birchfield.

Temple Emanuel held Roanoke's first Institute of Judaism, and seventy-five clergymen attended. The main speaker was Professor Israel Bettan of Hebrew Union College in Cincinnati.

Roanoke city health officials became concerned about the outbreak of measles in the region. The first death, a male toddler, occurred on February 24. The city health director, Dr. C. B. Ransone, strongly encouraged parents to seek immediate medical attention if their children began showing signs of the illness.

Ensign Gordon Maxwell, twenty-three, of Roanoke, was killed in a plane crash in California. The navy pilot was in a two-passenger dive bomber that locked wings midair with another navy plane as the craft were flying at night. Ensign Maxwell was attached to the aircraft carrier *Enterprise*. He was the son of Dr. and Mrs. George Maxwell of Roanoke County, a 1935 graduate of Andrew Lewis High School, and a 1939 alum of Roanoke College. He was interred in East Hill Cemetery, Salem.

Louis P. Smithey, architect for Roanoke's municipal stadium, reported to city officials that construction on the stadium should begin in early May. The twenty-five-thousand-seat facility should be completed in time for the annual Thanksgiving Day football game between Virginia Tech and VMI. Smithey's drawings showed the stadium in a "mule shoe" formation with the intent that ultimately seating would link both sides of the stadium at the south end. At the north end would be the armory that would have "arms" linking directly to the stadium seating so that men could move directly from the stands to the dressing rooms without being exposed to the elements. Smithey said that with the addition of temporary seating at both ends, the stadium could potentially seat thirty-three thousand people. A proposed running track, advocated by the school board, was omitted from the plans. The press box to be built would accommodate thirty-five reporters and have separate rooms for broadcasting and a public address system.

Kroger opened its sixth store in Roanoke at Patterson Avenue and Twelfth Street, SW. As part of its opening, Kroger baked the largest cake ever produced in Roanoke, weighing one hundred pounds, and customers were given a slice.

The Mundy Cigar Store moved from the northwest corner of Jefferson Street and Church Avenue, where it had been located for thirteen years, to its new location at 15 W. Church Avenue on February 27. The business was owned by John P. Mundy.

Stanley Abbott, acting superintendent of the Blue Ridge Parkway, asked the Roanoke City Council to consider linking the Mill Mountain Park to the parkway and said that parkway officials were willing to assist in the planning of such a road.

Roanoke police raided the Ideal Billiard Parlor at 302 S. First Street and seized horse racing forms, nearly $1,000 in cash, drinking glasses, and liquor. Four arrests were made. The parlor had formerly been the Uncas Club and had a history of illegal gambling activity. The city police chief said the astounding thing about the operation was that "it was located in the heart of the city." In questioning the men arrested, police learned that the billiard club had a flash system to warn patrons if police were approaching. Wise to the warning system, police launched a second raid on Ideal two days later, making further arrests and confiscating additional evidence of illegal gambling and alcohol on the premises.

Giles Brothers Furniture opened in its new location at 16 E. Church Avenue, Roanoke. They formerly occupied 302 Second Street, SW, and that building was acquired by Grand Piano.

The Salem Town Council took the first step in creating a five-person planning commission for the town. The commission would be appointed by Salem's mayor after the second reading and final adoption of an ordinance on March 10.

The All City-County high school basketball team resulted in the following selection for the 1940–41 season: Harold Shelor (Lewis), Warren Butterworth (Byrd), Watt Ellett (Jefferson), Billy Flint (Jefferson), Lewis Long (Jefferson), Hugh Tucker (Byrd), D. J. Showalter (Lewis), Robert Doss (Fleming), and Pete Fuqua (Byrd). William Fleming finished the season with the best record at 14–4.

The Roanoke Junior Chamber of Commerce received its charter as a member unit of the Virginia State Junior Chamber of Commerce and the United States Junior Chamber of Commerce at a dinner meeting at the Hotel Patrick Henry on March 4. The dinner speaker was Powell Harrison Jr., president of the state junior chamber. E. Griffith Dodson was the Roanoke chapter's president, and there were sixty members.

Dr. Charles Smith, president of Roanoke College, announced that a new women's dorm would be built on the campus. This announcement coincided with a decision by the college's trustees to increase the number of female students to 125 and to hire a dean of women. The new dorm would house 40 women and be available for the fall semester. The firm of Eubank & Caldwell of Roanoke was contracted to design the new building.

At Hollins College, the trustees hired Philadelphia architect Pope Barney to develop a comprehensive plan for the campus with the thought that one new dormitory, an enlarged library, and a memorial chapel might be added to the campus.

Arthur's Old Vienna Restaurant opened at 13 W. Franklin Road with lunches starting at thirty cents and dinners at fifty cents.

The Community Children's Theater presented *The Seven Little Rebels* at Jefferson High School for two days in mid-March. The production was directed by Clara Black, drama teacher at Jefferson.

Blair Fishburn, former mayor of Roanoke, advised city officials that he would personally pay for the services of F. Elwood Allen to develop a comprehensive recreation plan for the city. Allen had recently completed a similar plan for Baltimore, Maryland.

Roanoke police and ABC officers raided the Roanoke Pastime Club, 9 E. Church Avenue, and arrested a dozen men. Law enforcement seized a gambling table, playing cards, and large sums of cash. This was the fourth such raid by city police in as many weeks.

The farm at Roanoke's municipal almshouse yielded 2,500 young trees. The two-acre almshouse farm and nursery, located near Fishburn Park, produced the trees for the city's parks and streetscapes.

Actress Tallulah Bankhead appeared at the Academy of Music on March 8 in two performances of the play *The Little Foxes*. This was Bankhead's second appearance in Roanoke, having performed at the academy in 1939. The lead actor was Frank Conroy. As for Bankhead's performance, the *Roanoke Times* reported, "Hers is a stage presence of rare magnetism and power."

The N&W Railway announced the purchase of fifteen passenger coaches from the Pullman Standard Car and Manufacturing Company. The purchase was part of the

railway's effort to upgrade passenger service on the Pocahontas and Cavalier trains serving Norfolk and Cincinnati.

Wings over Jordan, a thirty-five-member male black chorus, performed at the Roanoke Auditorium. The chorus was well known, being heard regularly on national radio broadcasts. Their appearance in Roanoke was sponsored by First Baptist Church, Gainsboro, and Jerusalem Baptist Church.

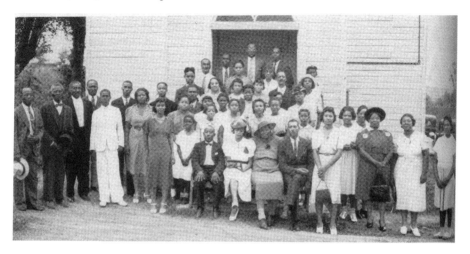

The choirs of Bethel AME Zion and Starkey Churches are shown here in this March 1941 image. *Norfolk-Southern Foundation.*

Officials with Virginia Bridge offered to donate a steel observation tower for Mill Mountain. The Roanoke city manager said he would ask the city council to allocate the funds necessary to build a concrete pad on which the tower could be placed. According to Virginia Bridge, the tower would be between forty and fifty feet high with an observation platform of either ten or twelve feet square with an exterior stairway for access.

Jefferson High School defeated Maury High School of Norfolk to win the state's Class A championship. The score was 48–27. Jefferson had won the Class A crown in 1935. Lewis Long was the top scorer for Jefferson with sixteen points. The game was played in the Roanoke auditorium.

The Skyline Lumber Company, located on Maryland Avenue near Memorial Bridge in Roanoke, purchased the Exchange Lumber Company. As a consequence, Skyline moved its lumberyard from near Memorial Bridge to Third Street, SW, under the Walnut Street Bridge. Skyline was started in 1938.

The Roanoke Kiwanis Club presented eight performances of the Luenen version of the Passion Play at the Academy of Music. The production was performed by the Black Hills Company. Josef Meier played the role of Chrisus, a seventh-generation actor in a German family long associated with the drama. Net proceeds from the production went to support the Kiwanis Club's camp for girls.

The Sampson Paint and Color Store opened at 121 E. Campbell Avenue in Roanoke. The store was a branch of the Sampson Company headquartered in Richmond.

Former world's heavyweight mat champion, Gus Sonnenberg, wrestled a "masked grappler" known only as the Black Secret at the Roanoke auditorium in one of many professional wrestling events promoted by Bill Lewis.

Bill "Big Red" Hancock, captain and fullback of the Roanoke College football team in 1940, announced that he had signed a contract to play professional football with the Detroit Lions. The two-hundred-pound Hancock said he planned to play with the Lions unless he could get a coaching job before the season started. Hancock was a native of Welch, West Virginia.

A mile-long Virginian Railway coal train wrecked on March 11 near the Kumis crossing on the Montgomery-Roanoke County line, pinning a brakeman and a fireman, both from West Virginia. Rescue efforts were led by the Salem Rescue Squad. Oakey's Funeral Service provided ambulance service, taking crewmen to the Roanoke hospital. Members of the crew thought the cause of the wreck was a "cocked" switch that upon contact with the train split the switch. James Steorts, thirty-one, died the following day from injuries he sustained from being pinned in the wreckage. Steorts was from Mullens, West Virginia.

R. P. Moore, former postmaster at Bent Mountain and a merchant at Adney's Gap, died in Greencastle, Indiana.

Mount Union Church of the Brethren at Bent Mountain in the early 1940s. *Virginia Room, Roanoke Public Libraries.*

State officials reported that three camps were being considered for conscientious objectors to the Selective Service, so that those who elected not to serve could give a year's service in civilian work. One of the proposed camps was to be located at Daleville.

The Salvation Army sold its old citadel on the southwest corner of Salem Avenue and Second Street, SW, in Roanoke to the Ponce de Leon Hotel corporation for $16,000. Hotel officials began razing the former Salvation Army building in mid-March. The structure had an illustrious history. The lot on which it sat had originally been patented to Thomas Tosh in 1767 as part of a 292-acre tract. The lot was acquired by William Lewis in 1836, and it passed over time through the hands of William McClanahan and Albert

Read. William Rains held possession of the lot in 1855, the lot being described as "near the Big Lick depot." The first structure on the lot was erected in 1885 by John Davis, one of the few wealthy black men in Roanoke during the city's earliest days. Davis put up a small brick building and operated a saloon for white-only patrons. According to the *Roanoke Times*, "Davis was noted for the white clothes and white apron he wore in the saloon and for his silk hat, Prince Albert coat and gold beaded cane." Davis sold the saloon in 1888, and eventually the building came into the hands of E. R. Woodward and Jerry Nicholas. The men added to the structure, converting it to a five-story hotel in 1894 (Lee Hotel). A fire gutted the hotel in 1902, and the top two stories had to be removed. By then, the building was owned by S. K. Bitterman and was back operating as a saloon and billiard parlor. The upper floors were used as a rooming house for railroad workers. The Salvation Army purchased the building from Bitterman in 1916. Upon its razing, the words "Stag Pool Room" could still be seen faintly on the higher part of the exterior south wall.

On March 14, the Radford Ordnance Works was formally dedicated with speeches by the governor and numerous business and military officials. The plant was of interest to many in Roanoke due to the large employment it provided. The $60,000 chemical plant made munitions that began immediately supplying Britain and was completed three months ahead of schedule.

It should be noted that optometrists were associated with local jewelry stores. Kingoff's, at the corner of Jefferson Street and Church Avenue, advertised themselves as "jewelers and opticians" and employed Dr. Maxwell Berson as their optometrist as part of a department dedicated to eye exams and glasses. Fink's Jewelers, 312 S. Jefferson Street, had a registered optometrist, Dr. Stanley Kline, who offered eye exams and glasses at the store. There were also stand-alone optometrists, including those associated with S. Galeski Optical Company, 30 Franklin Road.

Roanoke's American Legion basketball team, the state AAU champions, went to Denver, Colorado, to compete in the national AAU Tournament. Roanoke's team received a second seed in a field of fifty teams from twenty-six states. Team members were Paul Rice, Forrest Hoke, Bob Spessard, Bob Lieb, Johnny Wagner, Bill Burge, Ed Weddle, Owen Leech, and Boots Haskins. The coach was Bill Judy. The team lost in the third round, bringing to an end their winning streak of twenty-three games.

"Moving Day" for all radio stations across the nation was March 20, when stations would be given new places on the radio dial as a result of an international agreement among several nations that improved reception. WDBJ moved to 960 and WSLS to 1490.

The largest mass flight among Roanoke aviators took place in late March when thirty-five Roanoke aviators using sixteen planes flew in a caravan to Magnolia Gardens in Charleston, South Carolina. The trip was organized by Bob Dunahoe, manager of the airport, in cooperation with the Charleston Chamber of Commerce.

The Roanoke Woman's Club completed a fund drive for Roanoke's cancer clinic in March, collecting $1,377 through booths placed at strategic locations throughout downtown. Mrs. W. P. Jackson was campaign chairman.

State police began an educational campaign in southwest Virginia, including Roanoke and Salem, to alert drivers to the new safety markings on state highways. "Under the system where there are two parallel solid white lines down the center of the highway, no vehicle may cross the lines," explained Lt. R. H. Holland to local reporters. He further

advised of what vehicles could or could not do relative to a broken white line parallel to a solid white line and if the broken line were left or right of the solid line. He further explained the rule regarding a single broken white line. All of this he said was based on solid engineering and a thorough study of sight lines.

Grand Piano Company announced that it had merged with Hash Furniture Company and that the new company would retain the name of the former. The Hash Furniture Company closed out on March 15 at their location at 115 E. Campbell Avenue.

The average production of cows tested among sixty-five regional herds by the Roanoke-Franklin Herd Improvement Association in February resulted in the herd of Holsteins owned by Hollins College to be the best in the region, a title the herd had held for some time.

A Musical Blitzkrieg was billed for March 20 at the Roanoke Auditorium. From 9:30 p.m. to 1:30 a.m., Don Redman and his orchestra played with Louis Armstrong and his orchestra in a dance. White spectators were admitted for sixty-five cents.

The Roanoke Black Cardinals began their spring training on March 20. Chappy Simms was the manager, and Mack Eggleston was trainer and coach. Eggleston was a former player with the Baltimore Black Sox of the Negro National League.

The case against Sarah Craig, who had been charged with violating Chapter 72, Section 5 of the Roanoke City Code, was dismissed by Judge Birchfield. Craig, black, had refused to move to the back of a bus when instructed by the bus driver. Craig was represented by Henry Claytor.

The Viscose Corporation, a British-owned enterprise, was sold to American investors. The company was established in the United States in 1911 and had several large plants, including one in southeast Roanoke. The British sold the company in an effort to raise funds for munitions. At the time of the sale, the Roanoke plant employed 4,100 men and women with an annual payroll of $5.2 million, according to plant manager Leroy Smith. Viscose opened in Roanoke in 1916 with 1,000 employees.

The Roanoke County Board of Supervisors approved a tentative site for erecting a firehouse on Williamson Road near the intersection with Liberty Road.

On March 17, a home owned by W. M. Grisso in the Cave Spring section burned. The home was being rented to an Epperly family at the time.

A contract for moving the two hangars at the Roanoke airport was awarded to W. W. Draper. The hangars were being moved as part of the expansion and improvement of the airport. No. 1 hangar was moved 139 feet, and No. 2 hangar was moved 147 feet from their original positions.

David C. Lionberger, retiree of Virginia Bridge and president emeritus of the Lutheran Orphan Home of the South at Salem, died at his residence, 413 Westover Avenue, SW, in Roanoke. Lionberger was a charter member of the Virginia Heights Lutheran Church when it was organized in 1916. A native of Page County, Lionberger came to Roanoke in June 1906.

The Mountain Dale Lodge of Odd Fellows, 121 W. Church Avenue, Roanoke, held an old-timers night and recognized those that had been members of the lodge forty-plus years. The lodge was organized on August 6, 1886, and had one surviving charter member, Levi Balsbough, who was living in Stone Harbor, New Jersey. At the time of its old-timers night, the lodge had 443 members.

Runway construction at Roanoke Municipal Airport in the
early 1940s. *Virginia Room, Roanoke Public Libraries.*

The Mayo and Bayse Atlantic Service Station opened March 21 at the intersection of
Williamson Road and Hart Avenue, NE. 7 Up and Sunspot were served free to first-day
customers.

Carl B. Short of Vinton was elected chairman of the Blue Ridge Parkway Committee
at a meeting in Bedford.

Dr. Robert E. Speer, a prominent Presbyterian minister known nationally, was
brought in by the Roanoke Minister's Conference to lead a series of religious services in
Roanoke, including at First Presbyterian and First Baptist Churches as well as three nights
at the Roanoke Theater, with his sermons being broadcast live over WSLS radio.

Mrs. Fannie Bringham died at her residence at 503 Kennsington Avenue, SW,
Roanoke, at age seventy-eight. She had been prominent in Roanoke's religious and civ-
ic affairs, having come to the city with her husband in 1883. She was a charter mem-
ber of Virginia Heights Lutheran Church and had served as president of the Women's
Missionary Society of the Lutheran Synod of Virginia. She had also been a charter mem-
ber of the board of Roanoke Hospital, helped establish Roanoke's first public library, and
long served as a member of the library board.

The deed to Maher Field was formally granted to Roanoke City on March 21. The
deed was conveyed to the city by the Virginia Holding Corporation, a subsidiary of the
N&W Railway.

Members of four companies of the Roanoke-Salem battalion of the Virginia Protective Force, some two hundred men, were sworn in at a ceremony at the Roanoke Auditorium. Gen. E. E. Goodwyn of the VPF was on hand for the ceremony.

A. J. Kennard died at his home, 1031 First Street, SW, Roanoke, at age seventy-five. Kennard, a native of England, came to Roanoke as a plumber. In 1915, he formed the Kennard-Pace firm. He was one of the founders of the Roanoke Rotary Club, one of six founders of the Community Fund, past president of the Roanoke Country Club, and president of the City National Bank.

The Roanoke City Council accepted an offer to acquire for $5,250 a strip of land connecting Memorial Bridge and Wasena Park. The land was in possession of the Colonial-American Bank and composed about five acres.

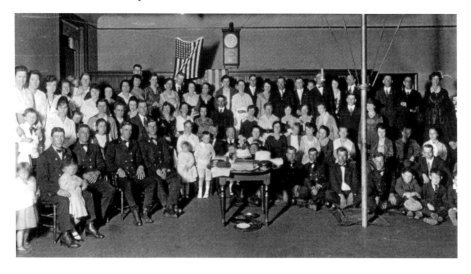

This 1941 photo was taken at Roanoke Fire Station No. 1 of a dinner honoring firemen who had registered for the Selective Service. *Roanoke Fire-EMS.*

In Franklin County, one person out of every four who was eligible for immediate induction into the armed forces was disqualified as they had a felony conviction for bootlegging. That was the analysis from the first seven hundred men who had been classified in the county, according to the Selective Service officials.

Stein's Clothes opened in its new quarters at 216 S. Jefferson Street, opposite the American Theatre, in late March. The store boasted that its clothing was all one price, $16.50. Stein's was part of a national chain of clothing stores. The Roanoke store had opened in 1929 on West Campbell Avenue, where it had remained until its move to South Jefferson Street. Present at the opening of the new store was Joseph Stein, from New York, sole owner of the forty-eight-store chain. Some five thousand attended the formal opening.

A monthly newspaper known as the City Sanatorium News was started by patients and staff at the Coyner's Springs facility. Bernard Seigle was editor, and there were contributors from "the white wing and the colored wing" of the sanatorium. The two-page paper contained columns by physicians, jokes, and poems.

Construction began on a second movie house in Salem at the corner of Main and Chestnut Streets. Harold Depkin indicated that the theatre would seat eight hundred persons, would have a colonial front, and had been let to James Turner and Jack Montgomery. Depkin also owned the Salem Theatre. A name for the new theatre had not yet been made.

In Vinton new street names went into effect. All thoroughfares running north and south became "streets," and those running east and west became "avenues." Those running diagonal were "roads."

The Roanoke Kiwanis Club came to the rescue of Jefferson High School's baseball and tennis teams by donating funds sufficient for the sports to field teams. Previously, the school board had announced the elimination of the two sports due to budget cuts. The high school's golf team remained unfunded.

The 1940 census figures were released, and Roanoke city's population was 69,287, an increase of only eighty-one persons from the 1930 census figure. Roanoke County's population was 41,306, a gain of 7,392 persons since 1930. Within the county, Salem's population was 5,737, and Vinton had 3,455 persons.

Roanoke police raided the Dumas Hotel and made twenty-three arrests for gambling. Police found only one piece of furniture in the room, that being a table with dice around which all twenty-three persons were gathered.

A boiler explosion ripped apart a huge Virginian locomotive and incinerated three crewmen in the early morning hours of April 1 near Stewartsville in Bedford County. The mallet engine and body parts of the crew were scattered across a three-mile radius of the accident. Among the dead was brakeman Hollie Lee Harrison, a former resident of Roanoke. Conductor J. E. Lane of Roanoke was riding in the caboose and was uninjured.

The Witten-Martin Furniture Store opened its new store at 115 E. Campbell Avenue in early April.

A majority of drivers for Garst Brothers Dairy ended their weeklong strike and returned to their routes. The drivers, members of a local teamster's union, returned with the understanding that the dairy was proceeding with additional daytime drivers.

The Bank of Salem observed its fiftieth anniversary, being incorporated on March 25, 1891, and opening its doors on April 3 of that year on a lot opposite Andrew Lewis High School. Charles A. Albert was the bank president in 1941, being the sixth president of the bank in its half-century history.

Roanoke Hardware Company closed its store on Campbell Avenue and consolidated its stock to have one store at 214 W. Salem Avenue, Roanoke.

The N&W Railway announced that in 1940 its freight and passenger traffic showed considerable gains over the previous year, and the company netted $31,383,976. Freight traffic was up 17 percent due to an increased demand for coal, and passenger service increased 9 percent.

The fiftieth anniversary of the Roanoke Elks Lodge was celebrated at the Hotel Roanoke on April 12 with a stag banquet. The lodge was founded on April 12, 1891, and met for three years in rooms at the Asberry Building on Campbell Avenue. After that period, the lodge met at the Gale Building, located on the southwest corner of Norfolk Avenue and Jefferson Street. The Elks Home on Jefferson Street was purchased in 1901, and the Elks moved there permanently in 1902.

The Andrews New Atlantic Service Station opened at Commerce Street and Center Avenue, NW, the first weekend in April. For a full-tank purchase, customers received a large crystal salad bowl.

The Roanoke Gun Club held their opening shoot for 1941. First prize was awarded to A. J. Wright. The Shenroke Skeet Club also held its opening shoot and learned it would host the state championships in the summer, as it was one of the most active skeet clubs in the state. The skeet club's field was located off Peters Creek Road back of the airport.

The Roanoke Black Cardinals opened their baseball season on Easter Sunday playing the Black Tigers of Winston-Salem, North Carolina. The Cardinals' home field was Springwood Park (back of present-day Lincoln Terrace Elementary School). Future games were scheduled against Brooklyn Royal Giants, Wilmington, Delaware, and the Ethiopian Clowns, both of the Negro National League.

Stanley Malcolm won the top prize of fifty dollars in the Luckland Class B Handicap duck pin bowling tournament by bowling a 676. Ed Vaught placed second.

Lawrence Tibbett, lead baritone for the Metropolitan Opera in New York, sang at the Academy of Music. Tibbett had performed in Roanoke in 1933 to a packed audience at the Roanoke auditorium. His appearance was sponsored by the Roanoke Community Concert Association.

The Sportsman luncheonette and sports center opened at the northwest corner of Church Avenue and Jefferson Street in quarters formerly occupied by the Mundy Cigar Company. The owners of the Sportsman were Elmore Heins and Henry Scholz, with Leonard Hodges as manager. The Sportsman opened with a forty-seat soda fountain.

Officials with American Airlines indicated that the company was willing to resume service to Roanoke. Commercial, mail, and passenger service could resume once grading and expansion at the airport were completed. American Airlines had discontinued service to Roanoke in 1937 when the airline converted to the larger Douglas-type aircraft and Roanoke's runways were too short to accommodate them.

The Preddy-Yates Cigar Store in the Ponce de Leon Hotel changed hands when purchased by John Hunter. It became the Hunter Cigar Store.

Former heavyweight boxing champion Jim Braddock and boxer Red Burman stayed overnight in Roanoke during their tour of the south. Braddock defeated Max Baer to hold the heavyweight title for several months before being defeated by Joe Louis. The two boxers dined and stayed at the Hotel Patrick Henry and met with reporters and fans.

Lotz-Windley Funeral Home held their first annual Easter Sunrise Service on the lawn of their funeral chapel. The program was broadcast over WSLS and the message was delivered by Rev. J. G. Saunders of Villa Heights Baptist Church.

City workers removed rails of the Melrose streetcar line beginning at Center Avenue at Fifth Street and began the simultaneous widening of Campbell Avenue between Fourth and Fifth Streets.

The Wallace Brothers Three-Ring Circus performed in Roanoke in mid-April. The circus featured some four hundred performers, elephants, horses, trained seals, and a menagerie of wild animals. Lee Powell, billed as the "original" Lone Ranger of motion pictures, performed on his white horse. Baron Richard Nowak, twenty-three inches tall and age twenty, stood alongside Willie Camper, who stood at eight feet, seven inches and weighed 480 pounds. The entire circus was under the big top at the city fairgrounds, and an estimated four thousand persons attended.

"Cousin" Irv Sharp in the broadcast studio at WDBJ,
1940s. *Virginia Room, Roanoke Public Libraries.*

Charles McNulty hosted a music night at the Roanoke Auditorium with Roy Hall's Hillbilly Orchestra and "Cousin" Irv Sharp of WDBJ. More than four thousand paid admission to hear the program.

P. D. Powell won the Roanoke checkers championship by defeating the defending champion, W. M. Dillard. Powell won the city championship in 1932, 1935, and 1939.

The Roanoke City Council, responding to the chamber of commerce, agreed to proceed with eliminating duplicate street names. Thirteen streets were targeted for immediate change where there had been little resident opposition. They were as follows: Carolina Avenue (Fairmont section) to Kansas Avenue; Crescent Street (Forest Hill section) to Hoover Street; Hampton Street to Wade Street; Linden Avenue (Forest Park section) to Fir Avenue; Massachusetts Avenue (Fairmont section) to Vermont Avenue; Pennsylvania Avenue (Dearwood map) to Utah Avenue; Summit Avenue (Grandin Court section) to Montgomery Avenue; Stanley Road (Weaver Heights section) to Livingston Road; Spring Road (Braddock map) to Quarry Road; Virginia Avenue (Dearwood map) to Georgia Avenue; Valley Road (Crystal Spring section) to Carolina Avenue; York Avenue (Wasena) to Duke Avenue; and Franklin Avenue (South Roanoke) to Stephenson Avenue. There were numerous other duplicate road names, but the council decided to postpone any further changes until a later time.

Rockledge Inn on Mill Mountain was leased to Arthur Rorrer, who had managed it since 1935. This was the first year that the City of Roanoke had full charge of the structure. Rorrer agreed to open the inn on May 1 and dinners, luncheons, and refreshments would be served in the ballroom and on the veranda each afternoon and evening except

on Mondays. There would also be dances on Friday and Saturday nights. The property came into the possession of the city when the mountain was donated for park purposes.

George C. Davis was elected president of the Roanoke Boat Club for its second year of existence. The club sponsored boating activities at Carvins Cove and had ninety members.

Some forty acres of Mill Mountain burned in a forest fire that swept up one side of the mountain before being brought under control by Roanoke and Salem firefighters. The fire was on the southwest side of the mountain and was ignited by a spark from a steam shovel that was grading a roadway.

Six contractors bid on the stadium project in Roanoke. The low bid was submitted by the Blackwell Engineering and Construction Company of Warrenton, Virginia, at $258,000. Five other contractors also made bids. The Roanoke City Council formally awarded the contract to the Blackwell firm a week later, providing a $15,000 bonus if the contractor could have the stadium constructed in time for the VMI versus VPI football game on Thanksgiving Day.

Philosopher and author Will Durant spoke to business executives at a dinner at Hotel Roanoke about matters of war and peace, and the weaknesses and strengths of the United States. Durant expounded on his idea about halting what he called the "contraceptive degeneration" of the American people by sterilizing or segregating the "feeble-minded," and increasing the birth rate among "higher groups in ability" by reducing the economic handicaps of marriage and parenting. On this matter, Durant concluded, "If we breed most among the biologically weak and least among the biologically strong, it seems to me inevitable that there must be decay."

Nathan C. Powell, former member of the Roanoke County School Board, farmer, and merchant, died in a Roanoke hospital at age eighty-four on April 17. Powell moved to the Bent Mountain area with his parents in 1868. He purchased and ran a general store at Air Point beginning in 1890 and then sold it in 1895 to farm some two hundred acres in Floyd County, where he resided until 1909 before moving back into Roanoke County.

Vernon Mackie was named as the manager for the Salem-Roanoke Friends Virginia League baseball team for the 1941 season. Joe Ryan continued in the role of business manager. Mackie had a long history of playing baseball professionally.

Tyrrell's Sunoco opened two new stations, one at Franklin Road and Elm Avenue, SW, and the other at Commonwealth and Gilmer Avenues, NE. These were the fifth and sixth service stations under the operation of Tyrrell's Sunoco.

Roanoke leaders met with officials of the Pennsylvania Central Airlines at the Greenbrier Hotel with the intent of bringing the airline to Roanoke to provide additional service. The meeting had been arranged by the Stone Printing Company of Roanoke.

The Roanoke Black Cardinals played the Brooklyn Royal Giants of the Negro League at Springwood Park on April 20. "Red" Gill and "Big Moose" Willard pitched for the Cardinals. The Cardinals lost, 11–9.

The "Tennessean," the Southern Railway's new streamliner, was announced. It would begin service on May 15 to run from Washington, DC, to Memphis, Tennessee. The new train supplanted the "Memphis Special" and would run upon N&W tracks between Lynchburg and Bristol, with a stop in Roanoke. According to Southern Railway, the Tennessean would consist of three identical trains, each having three straight chair cars, a partition chair car, a baggage-dormitory chair car, a forty-eight-seat dining car, and a

lounge-tavern-observation unit. The Tennessean colors were blue, beige, and green in varying tones. Passengers were served by "attractive Tennessean girls" who had been selected as hostesses and wore blue-and-green gabardine uniforms and berets.

Henry Hensche, a leading portrait artist and instructor of the Cape Cod School of Art at Provincetown, Massachusetts, produced a painting of Roanoke College president, Charles Smith, at the studio of Walter Biggs in Salem.

Ella Fitzgerald and her orchestra performed at the Roanoke Auditorium, having played to a large audience a few months previous. The concert-dance was for blacks only, though whites were admitted, and was festive in that Ms. Fitzgerald celebrated her twenty-third birthday with the audience.

The Elmwood Diner opened at 616 S. Jefferson Street, opposite the Hotel Patrick Henry, on April 20. The diner was a true old-fashioned diner-car-style restaurant. It seated fifty-seven in its forty-six-feet-by-sixteen-feet car and was owned by Paul Hunter. The diner was built by Jerry O'Mahony, Inc., of Elizabeth, New Jersey.

A bedroom suite designed by the Johnson-Carper Furniture Company in Roanoke County was selected by the American Furniture Mart in Chicago as being an outstanding model. The dresser, made of walnut, replaced hardware with finger grooves, and the suite itself was considered to be a trendsetter in contemporary design.

A. J. Rankin, founder of Rankin Jewelry Store in Roanoke, died on April 20 at age seventy-nine at his home in Raleigh Court. Rankin, a native of Ontario, Canada, came to Roanoke in 1899.

The Virginia League opened the baseball season in Salem when the Salem-Roanoke Friends played Lynchburg. The game was sponsored by the Salem Kiwanis Club as a fundraiser for Greek war relief. Some 2,500 persons attended the game, and the mayors of Vinton, Salem, and Roanoke threw ceremonial first pitches. The Salem-Roanoke Friends lost the opener 15–6. Other teams in the league were Harrisonburg, Staunton, Newport News, and Petersburg.

Judge J. L. Almond stated in a ruling that "the gambling situation (in Roanoke) has developed into an abominable racket" and named Ralph Blankenship as its "kingpin." Blankenship had operated the Athletic Club of Roanoke, located at 9 E. Church Avenue, for some time, and the club, among several in downtown, had been raided in the past month. Almond further stated, "The evidence shows that his place of business is a cesspool of hell," and said the place was a "dive."

Roanoke lawyer and education advocate Moss Plunkett announced his candidacy for lieutenant governor of Virginia in the Democratic primary on August 5. Moss's platform was for improved public education and the abolition of the poll tax as a prerequisite for voting. Plunkett was a former member of the Roanoke County School Board and a World War I veteran. He had practiced law in Roanoke since 1919.

The first play offered by the Civic Theatre of Roanoke was *The Show Off* at the Academy of Music. The Civic Theatre was an organization of local amateur actors, but *The Show Off* starred Michael Stuart, a well-known radio and stage actor. Stuart also directed the production. The Civic Theatre was organized to promote and produce live theater, including bringing touring companies from New York.

Mr. and Mrs. Frank Rogers opened their summer home, "Look-Off Lodge," to boarders. The home was located on the ridge of Bent Mountain at Air Point and offered a spectacular view of the Roanoke Valley.

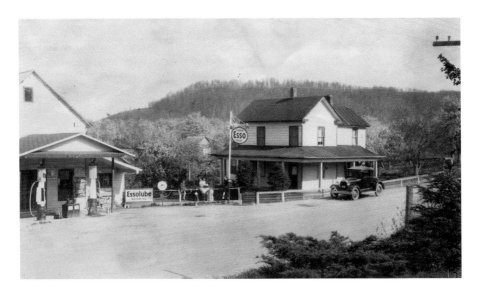

Colonel Fletcher Holt's store at Bent Mountain at the intersection of
Route 221 and Calloway Road, early 1940s. *Dana DeWitt.*

The Roanoke School Board convinced the city council to purchase the W. K. Andrews
property on W. Campbell Avenue as a site for a vocational school. The price was $45,750.
The site was occupied by the Lotz-Windley funeral home.

Lakeside Park and the Lee-Hy Pool opened on May 2 for the summer season. A sea-
son pass to both pools was seven dollars.

The Roanoke County Board of Supervisors asked the Roanoke City Council and the
town councils of Salem and Vinton to adopt uniform ordinances regulating Sunday beer
and wine sales and the operation of public dance halls. The county's ordinances banned
sales of beer and wine on Sundays and prohibited the operation of dance halls past mid-
night and all day on Sundays.

Miss Marie Franklin was elected as the first president of the newly organized Blue
Hills Women's Golf Association.

The wooden grandstands at Maher Field were razed in early May, ending an era of
Roanoke's "Splinter Bowls." The stands were used for decades to host crowds for football,
baseball, track meets, horse races, and fairs. The stands were removed to make way for the
new municipal stadium.

Coal trains of the N&W and Virginian Railway began moving through Roanoke
with the end of a monthlong coal miner strike in West Virginia and southwestern Virginia.
Some 868 N&W employees had been idled due to the strike.

Pollution of the Roanoke River was the topic of a paper presented at the Virginia
Academy of Science in Richmond. Two professors at VPI had placed testing stations along
the river in the vicinity of Roanoke and Salem. They found that every day a local tan-
nery was dumping a hundred thousand gallons of waste into the river; the town of Salem
was dumping raw sewage generated by five thousand persons; and the Viscose plant was

dumping six million gallons of waste. into the river that contained sulfuric acid, sodium, soaps, and acids such that near the Viscose it was devoid of fish.

In the first month of the federal food stamps program in Roanoke, 1,172 persons received stamps. Only two other cities in Virginia were participating, Richmond and Lynchburg.

The newly formed Roanoke Archery Association held its first shoot at a range located on the southeast corner of South Roanoke Park. Fred Johnstone was president of the association. Plans called for a new range to be placed in Highland Park as there was better storage at that park.

Clyde McCoy and his Sugar Blues Orchestra performed at the American Theatre for one day, giving four stage shows.

In a brief ceremony, the cornerstone for the Salvation Army's new citadel at 812 W. Salem Avenue, Roanoke, was set in place on May 4 by Vice Mayor Leo Henebry. Cut into the stone were the words, "To the Glory of God and the Service to Humanity, 1941." The service was broadcast over WSLS. Dr. E. G. Gill was master of ceremonies.

The Roanoke Academy of Medicine adopted a report of its public health committee that recommended Roanoke City hire a full-time clinician at $3,600 per year for the treatment of syphilis. The academy reported that some four hundred cases were being treated weekly.

Directors of the Roanoke Chamber of Commerce adopted a resolution to name Roanoke's airport "Woodrum Field" in honor of Sixth District congressman Clifton Woodrum in recognition of Woodrum's efforts to secure federal funds for the expansion of the airport. The chamber presented its resolution to Roanoke City Council for their consideration.

The Ethiopian Clowns of the Negro League made an appearance in Salem on May 12 when the team played the Roanoke Black Cardinals at the municipal field. Playing for the Clowns was manager and first baseman "Showboat" Thomas.

Robert Smith, incumbent commonwealth's attorney for Roanoke, announced he would seek reelection as a Democrat. His challenger was C. E. Cuddy.

The Jefferson High School debate team won the state championship, Class A division, held in Charlottesville. Team members were Robert Ayers, James Kavanaugh, and Tom Thornton.

Between eight and ten thousand persons attended the Roanoke Food and Home Show held at the Roanoke Auditorium. The show was sponsored by the Roanoke PTA and showcased the latest advancements in kitchen accessories and appliances. Entertainment included a "husband calling" contest, a baby pig giveaway, and the "Battle of Hillbilly Bands."

Mrs. Hiram Dance resigned from the Roanoke School Board, and the term was filled by Mrs. Robert Churchill of South Roanoke.

Over 10,000 persons turned out in downtown Roanoke to view the Southern Railway's "Tennessean" during its six-hour stopover tour on May 15. WDBJ broadcast live from the train during the day. The streamliner was in its tenth day on tour, having left Memphis on May 5. During the ten days, the railway estimated that over 112,000 persons had toured the train during its various stops.

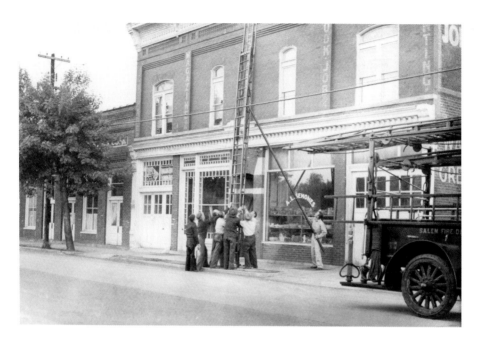

A fire ladder is being raised on College Avenue in
Salem, May 1941. *Salem Historical Society.*

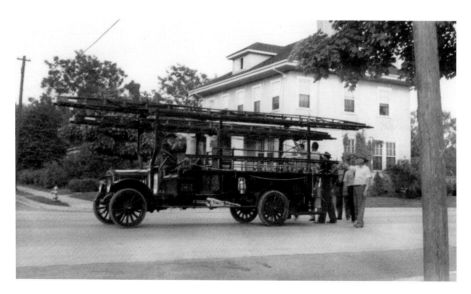

A Salem fire truck on College Avenue, May 1941. *Salem Historical Society.*

Virginia Bridge was awarded a contract to build the longest cars ever built for the N&W Railway. The order was for twenty-five drop-end, mill-type gondola cars, which were used to haul structural steel. The cars were 65½ feet in length inside with a seventy-ton capacity.

Raleigh Court Methodist Church celebrated its twentieth anniversary and reviewed its history. The congregation began on May 16, 1921, when Methodist laymen met at the YMCA in Roanoke. The Sunday School was organized on May 22, 1921, with 87 charter members. The congregation formally constituted a few weeks later on June 5 with 110 members. Membership twenty years later was 1,150.

Fire swept across twenty-five acres on Twelve O'Clock Knob on May 18, but no structures were consumed. The origin of the fire was undetermined. The Salem fire department was aided by sixty CCC workers who came to help from their camp in Catawba.

The Roanoke County Board of Supervisors repealed their ordinance prohibiting the sale of beer and wine on Sundays, responding to a petition of thirty-two tavern owners. The tavern owners argued that the lack of similar ordinances in Vinton, Salem, and Roanoke simply drew customers to other bars and taverns on Sunday.

Tenderized beef went on sale for the first time in area grocery stores when Kroger began selling the product. The meat was provided to Kroger stores from the Neuhoff processing plant in Salem.

The first annual Salem horse show opened on May 23 at Dixie Farms on Route 11. Proceeds from the show were designated for British war relief. The show was sponsored by the Salem Horse Show Association and involved horses from three states and Hollins College.

Cab Calloway and his Cotton Club Orchestra played at the Roanoke Auditorium on May 26, 9:30 p.m. till 1:30 a.m. (It was a Monday night!) Calloway and his band played for a dance in which blacks only could participate, but white spectators were admitted.

A cyclonic wind and dust storm moved across the city, causing damage at the Roanoke airport and in the Hollins area. Winds were clocked at seventy-five miles per hour. The storm ripped apart utility poles, and at the airport the storm ripped off the roof of the Cannaday farm home, dislodged its four brick chimneys and toppled large oaks in the home's yard. A one-thousand-gallon storage tank at the airport was lifted and blown four hundred yards. Fortunately, there were no planes on the field. At Hollins College, one building was heavily damaged, and several barns in the area had roofs ripped off.

The Tinker Bell Pool opened in late May with hours of 9:00 a.m. till 10:00 p.m. The pool advertised the following policy: "No swimming in trunks alone, no intoxicating drinks or undesirable people allowed on premises."

For those that liked weekend dance halls, several operated in the Roanoke Valley. Among them were Blue Ridge Hall at 323 W. Campbell Avenue, the Mill Mountain Club (Rockledge Inn), the Orphan Annie Tea Room on Lynchburg Highway, and the Riverjack.

The Roanoke Country Club hired George Lyman as their tennis professional in an effort to build up their tennis club and tournaments. Lyman, thirty-seven, had taught tennis professionally for ten years in Ohio and Florida.

A bronze plaque with bars bearing the names of eleven Roanoke city police officers who died in the line of duty was unveiled at a police memorial service held at Jefferson

High School. The plaque was purchased by the Police Protective Association and was put on permanent display in the police department lobby.

The Roanoke Black Cardinals defeated the New York Mohawks of the Negro National League in a baseball game at Springwood Park. The score was 9–6. Smokey Boyd pitched for the local team.

Children on Grandin Road near Brice's Drugstore, early 1940s. *Virginia Room, Roanoke Public Libraries.*

The bridge over the N&W Railway tracks at Fifth Street, SW, collapsed in one section on May 27 when a derailed freight car struck one of the steel supports. No one was injured. The bridge was closed two months for repairs.

On Sunday, May 27, President Franklin Roosevelt made a nationwide radio address declaring an unlimited national emergency in view of the wars in Europe and Asia. During the address, the local newspapers reported receiving very few calls and that "in hotel lobbies, cigar stores, restaurants and other public places crowds gathered around the loudspeakers."

Fine's Men's Shop opened at 3 West Campbell Avenue.

Ralph G. Edmunds of Vinton was kidnapped when a gunman forced him to drive to a point on Potts Mountain in Craig County. At that point, Edmunds was ejected from his car, and the kidnapper drove away. Edmunds had been stopped at a residence on Rorer Avenue in Roanoke after making a collection for an insurance policy.

Dr. C. B. Ransone declared that only pasteurized milk should be distributed in Roanoke city. Ransone, the public health director, indicated that two Roanoke creameries were still distributing raw milk. An ordinance had been adopted by the city council, to take effect in 1942, that only pasteurized milk could be bottled in the city.

The Kroger Grocery and Baking Company opened its newest supermarket on May 29 at the corner of Eleventh Street and Moorman Road, NW. It was the twenty-first store in the Roanoke area for the grocery chain.

Doc Edmundson's Atlantic Service Station opened at the end of May at the corner of Pollard Street and Jackson Avenue in Vinton. Opening-day customers received a large mixing bowl, soft drinks, and cigars. At the same time, Harley Bower opened Bower's Service Station at Williamson Road and Lincoln Avenue, selling Shell Gasoline. Customers received a Cannon bath towel and free 7 Up soft drinks.

Roberta Lee Shafer officially closed her dance school with a performance by her students at the Academy of Music. Her older students wore red, white, and blue costumes and tap-danced to patriotic music. Shafer was well known in Roanoke as a long-standing teacher of dance at her private studio.

Hollins College announced plans to expand the facilities on its campus to include a new library, a new educational building, and one or two more dorms.

The Roanoke Chamber of Commerce created a standing committee in late May to advocate for problems and concerns related to the city's black community. The committee was composed of Dr. L. C. Downing, A. L. Coleman, Rev. A. L. James, Rev. William Scott, and C. C. Williams.

The Roanoke Council of the National Negro Congress was formally chartered at a special meeting at Ebenezer AME Church in late May. J. H. Tyree was president of the local council.

Company commanders of the Salem and Roanoke Virginia Protective Force called on area residents to loan to their officers .45 automatics or service pistols. Many of the men who had volunteered did not have pistols, and the commanders stated that all pistols would be duly registered and returned to their owners.

London's Service Station opened in early June on Bent Mountain near the entrance to the Blue Ridge Parkway.

Roanoke city police made a late-night raid on the Peoples Hotel, 111 E. Salem Avenue, on June 1. Twenty persons were arrested, including the hotel manager for operating a "house of ill fame." Most arrests were for drunkenness and statutory charges. Police loaded two automobiles to transport the suspects to headquarters. That same night, police raided an establishment on N. Henry Street for the sale and consumption of illegal whiskey.

The local office of the Virginia state aircraft warning service opened at 309 S. Jefferson Street. The office was being coordinated locally by Crawford Oakey. Oakey strongly urged women to register for the service. The center would receive reports on aircraft from observation posts from all across southwestern Virginia, including observation posts on Bent Mountain, and at Shenandoah Life and Viscose. Any enemy aircraft would be reported immediately to the state headquarters in Norfolk. A few days later, 128 area women registered on the first day registrations were received.

The Roanoke City Council adopted a resolution supporting a third runway at the municipal airport but stated that federal funds would have to be used to pay for it. According to airport officials, nearly $1 million had been earmarked for the airport as a part of national defense funding.

For those readers of the *Roanoke Times*, there were numerous daily comic strips, including *Popeye, Big Chief Wahoo, Our Boarding House, Joe Palooka, The Nebbs, Terry and the Pirates, Gasoline Alley, Tillie the Toiler,* and *Side Glances.*

The Roanoke Railway and Electric Company announced the inauguration of bus service between Roanoke and Glenvar, effective June 13, and the consolidation of the Grandin Court and Wasena bus lines.

Claude Moorman resigned his position as football coach at Jefferson High School due to illness, and the position was filled by Clarence Rorhdanz. Rorhdanz played football for the University of Alabama and had coached at the high school level in Kingsport, Tennessee.

Gill's Hamburger House opened on June 7 on Williamson Road, featuring "The Colossal Hamburger, frosted mugs of buttermilk, real Mexican chili, foot-long hot dogs and barbecue, and sandwiches of all kinds."

The *Roanoke Times*' All City-County high school baseball team for 1941 consisted of Harold Shelor (catcher, Lewis), Billy Flint (first base, Jefferson), Clay Bear (second base, Jefferson), Pete Fuqua (shortstop, Byrd), Harold Garrett (third base, Lewis), Buck Johnson (F, Lewis), Robert Journell (F, Lewis), John Cassell (F, Lewis), John Gleason (pitcher, Lewis), Earl Price (pitcher, Jefferson), and Jack Eanes (pitcher, Byrd).

Some 575 citizens volunteered to be airplane spotters with the state's aircraft warning service. After a weeklong registration drive, Crawford Oakey, organizer, was pleased with the result.

Dr. Manfred Arie of Vienna, Austria, addressed members of the Jewish community in a dinner at the Hotel Patrick Henry. The dinner launched a $10,000 campaign to raise funds for Jewish war relief as part of the national United Jewish Appeal.

Jefferson High School conducted their graduation ceremony on June 12 at the American Theatre for their 484 graduates. Commencement addresses were given by seven seniors—Jack Coulter, Andre Falwell, Gerry Cohan, Earl Neas, C. M. Walters, Charles Houchins, and Betty Cornett. Lucy Addison High School graduated 109 in ceremonies at the Roanoke Auditorium. Six students brought remarks to the class, and they were as follows: Lillian Paxton, David Hamlar, William Preston, Doris Fisher, Clouris Parks, and Fola McCray.

Over seven hundred men and one hundred vehicles camped overnight in Wasena Park, all belonging to the 70th Tank Battalion from Fort Meade on their way to Bristol.

In mid-June the Atlantic Greyhound Lines initiated new deluxe chair coach service between Winston-Salem, North Carolina, and Washington, DC, via Roanoke. The new coaches were equipped with a lavatory, and each carried a stewardess who provided refreshments to passengers.

The nationally known quartet The Ink Spots along with their band, the Sunset Royal Orchestra, performed for a dance at the Roanoke Auditorium on June 19. Tickets were $0.85 or $1.10 at the door. The dance was for blacks only, though whites were admitted for $0.65.

The first tragedy to occur at Claytor Lake, formed in 1940, was the accidental drowning of Nancy Councilman, a nurse in Pulaski and a native of Roanoke. She was twenty-three. The drowning happened when a small boat carrying Councilman and four others capsized. A day later, a Salem family was killed in automobile accident on Route 11. Mr. and Mrs. Paul Reich and their four-year-old son, Milton, were killed when their

automobile collided with a truck and then plunged down a twenty-five-foot embankment. Three other Reich children were seriously injured. The family was interred at Sherwood Cemetery.

The Virginia Bridge Company's offer to erect a steel observation tower on Mill Mountain exceeded the company's original estimate of $1,000. The company asked the city council to appropriate an additional $1,400 for the tower to be constructed, as the plans called for a taller tower than originally conceived.

Joseph Ripley, chief announcer for WSLS, left the station for a similar position with station WOR in New York. Ripley had been with WSLS since the station first aired on October 1, 1940.

The Harriman Memorial gold medal was awarded to the N&W Railway in honor of being the Class I railroad with the best safety record. This was the third time in fifteen years the railway received the award. The medal was presented to the railway's president at the Yale Club in New York City.

The N&W Railway Veterans Association annual meeting in 1941 was held at the Roanoke Auditorium in June 1941. *Norfolk-Southern Foundation.*

Two young people, Mary Edmunds, sixteen, and Henry Adkins, twenty-five, were both killed in a single-car accident on Lee Highway, just west of Lee Hy swimming pool, on the night of June 19. Two other young people in the same car were injured. Miss Edmunds was a student at Lee Junior High School.

Chief observers were announced for the twelve airplane warning service posts in the Roanoke region. The posts were at Viscose, Coyner's Springs, Fincastle, Hollins, Amsterdam, Veteran's Hospital, Back Creek, Hardy's Ford, Bent Mountain, Starkey, and Boones Mill, plus one west of Fincastle.

Over 350 boy scouts held their annual camporee in Fishburn Park. The scouts represented troops in the Roanoke Council.

The US Postal Service announced that several areas would gain city mail service that had been on rural routes. The areas to get the new service were Grove Park, Villa Heights, Weaver Heights, Williamson Road, and Prospect Hills.

A new Roanoke girls' camp, donated the previous year by the Roanoke Kiwanis Club, opened when Salem Girl Scout Troops 22 and 33 began using the camp. The camp's site was near Crockett Springs, west of Salem.

Foundry Service, Inc., was granted a charter by the SCC and began operating in the former twine mill in Norwich. The mill building had been purchased by Frank Graves in 1939. Cecil Graves was the foundry's president.

The Southern Railway announced the addition of Pullman coaches to the "Tennessean." N&W Railway shared that a "Roanoke" car was added to the "Tennessean" and would be part of the northbound train each Friday and Sunday and on the southbound train Saturdays and Mondays.

Roanoke County school officials shared that plans for a four- to five-room addition to Fort Lewis School were being drawn by the architect of the state board of education. The construction of the addition was to be funded through the state's literary fund in the amount of $15,000.

Production of TNT began on one line of the Triton Chemical plant in Glen Wilton in Botetourt County the week of June 29. Virginia Governor James Price inspected the plant along with other state and company officials.

The Roanoke Booster Club elected Dr. E. G. Gill as president and planned for their 1941 goodwill trip to be to White Sulphur Springs, West Virginia.

Sixty members of the Virginia Dare Ambulance Corps, comprising women of Roanoke city and county, drilled regularly at the Roanoke market building auditorium and accumulated equipment that would enable them to give emergency first aid and hospital services under actual war conditions. It was the only such organization of its kind in Virginia. The corps was headed by Capt. Ralph Howell.

Bent Mountain Lake and cottages opened for the season. The recreation spot offered picnic grounds, swimming, dancing, and cottage rentals.

Roanoke City officials stated that dedication ceremonies for the expanded municipal airport would occur in mid-October. They had originally been slated for midsummer.

Some three hundred children took part in the Roanoke parks department's annual bicycle parade on June 27. Most bicycles were decorated in patriotic colors. The parade was sponsored by Montgomery Ward and was routed through the downtown section of Roanoke, terminating in Elmwood Park. A reviewing stand was on the front steps of the municipal building.

The Airport Service Station opened in late June on Williamson Road. R. L. Willis was the proprietor of the station that sold Atlantic-brand fuels. For opening weekend free crystal berry dishes were awarded to customers.

WSLS added two announcers to its staff, Ted Brown and Jimmy Johnston. Brown was a native of New Jersey and winner of an announcing contest held by the radio station, and Johnston was a native of Roanoke. Added as chief announcer was Bob Menefee, known to listeners as "Tom Foolery."

Roanoke Builders Supply, Inc., began offering tours of new homes in the Shadeland Addition off Williamson Road, with four architectural designs available for prospective

Bent Mountain Lake, later Laurel Ranch, in the early 1940s had a pool and clubhouse. *Virginia Room, Roanoke Public Libraries.*

homebuyers. Monthly payments began at $23.50. The company's field office was located at the corner of Tenth Street and Oakland Avenue.

Susie T. Oliver, "pioneer negro teacher," died at her home on Loudon Avenue on June 29. Ms. Oliver had taught in black schools in Roanoke city, Salem, and Vinton since arriving in Roanoke in 1885 until ill health forced her retirement. She was the wife of A. J. Oliver, an attorney.

Dr. Dexter Davis, city physician, resigned to assume a position with the Manhattan Eye, Ear and Throat Hospital in New York. Dexter had served as the city physician since 1939.

The contractor on the Roanoke municipal stadium stated that the stadium would not be ready in time for the Thanksgiving Day football game between Virginia Tech and VMI and that an alternate site would need to be found. The announcement was shared at a meeting of the Roanoke City Council by the city manager with the suggestion that the game be moved for 1941 to Lynchburg, but that both schools had yet to finalize the decision. The stadium delay meant that the contractor forfeited a $15,000 bonus.

Roanoke's registrants in the second draft call numbered 448, well below the expected number. All those who had reached the age of twenty-one were required to register with the Selective Service.

On July 4, Lakeside Park featured Roy Hall and his Blue Ridge Entertainers along with the Happy-Go-Lucky Boys and Tinker Mountain Boys at their pavilion. The park offered music, dancing, and contests, with $250 in prizes. Admission to the park all day was seventy-five cents with the understanding that "drunks and other undesirables would be provided free rides to the Salem jail."

The C&P Telephone Roanoke office experienced the heaviest amount of long-distance calls placed by its operators in their history: 2,682 calls on July 2. The office had trained and employed forty additional long-distance operators since January 1, 1940.

Ray Ryan announced that the Salem-Roanoke Friends baseball club was for sale. Ryan has started the club and was in his third year as the club's president. Ryan indicated that three major league teams had indicated an interest in purchasing the team as well as unidentified local businessmen. Ryan declined to name the sale price.

J. D. Sisson won the annual city-county marbles tournament and competed in the national marbles tournament in Wildwood, New Jersey.

The Roanoke City police chief imposed new rules upon ambulance operators. Going forward, all operators must call police headquarters to notify of an emergency response, and all ambulances would be required to have sirens and flashing red lights.

Pioneer Roanoker William Henry Horton died at his home, "Nestle Brook Farm," at Lynchburg Road and 24 Street, NW, on July 4. He was seventy-nine. Horton came to Roanoke in 1886 and opened a livery stable on the site presently occupied by the *Roanoke Times* building. In 1889, he developed a partnership with John Roberts in the livery business and also engaged in real estate. He was interred at Sherwood Cemetery.

It was reported that nearly one thousand cars used the curving loop road up Mill Mountain weekly since the mountain was donated to the city for public purposes and the toll charge was removed.

The Metropolitan Café opened in its new home at 510 S. Jefferson Street, on July 9. The restaurant was operated by two cousins, Christ Contas and John Tsahakis. The cafe could seat 120 customers and contained a long soda fountain bar for 12 guests. The eatery was decorated with a Spanish theme, including three interior arches. The two cousins had been operating the restaurant in Roanoke since 1936. At the grand opening in its new location, the proprietors offered complimentary roses to ladies and cigars to men.

Engleby Electric Company was awarded the contract for lighting at the municipal airport. Their low bid was $25,380. Lights at the airport were considered critical to its future as they could allow for night flying. City officials hoped much of the cost would be paid for through federal funds.

Local No. 11 of the Textile Workers Union of America asked Roanoke City Council that any plans for a small tower for Mill Mountain be set aside for a one-hundred-foot-tall tower and that it be financed through public subscription. The union indicated it would make the first contribution. The union was responding in support of Virginia Bridge and Iron's request for a larger tower on the mountain, wherein the bridge company had offered to donate $1,000 for such a purpose. The council filed the request for further consideration.

Architect Frank Stone presented drawings of a residence for the director of the municipal sanatorium at Coyner's Springs. The cost would be approximately $9,500. At the time, the resident director of the sanatorium had quarters within the facility.

Actress and radio star Maxine Sullivan performed with Benny Carter and his orchestra at the Roanoke Auditorium in mid-July. The concert and dance were for blacks, but white spectators were also admitted.

The Martin-O'Brien Flying Service in Salem was granted a charter by the SCC to operate as a training school for flight students. The school would begin operating at the Roanoke municipal airport as soon as the renovation and expansion work there was completed. The flying service was owned by Robert Martin and Van O'Brien. The company had two planes, a Piper Cub and a Taylor Craft.

The Bent Mountain Lions Club, Cave Spring district, held their charter night on July 10. The club's dinner was held at Bent Mountain School. The club had twenty-two charter members.

The Roanoke city manager was informed that additional federal funds had been secured for expansions at the airport, including lights and a third runway. The added funds totaled $180,000.

The Lotz-Windley funeral home put a new ambulance into service. The ambulance was built on a Cadillac chassis and was "fully equipped for all types of calls."

Roanoke City and County launched their drive for scrap aluminum on July 21, responding to a national plea that aluminum be collected to aid in the building of fighter planes. It took ten thousand pounds of aluminum to build one plane, and the nation's smelters could not produce aluminum fast enough. The drive was a part of President Roosevelt's national emergency declaration on May 27. The Roanoke campaign had Mayor Walter Wood as honorary chairman and Louis McClung as general chairman. Numerous women's organizations, civic clubs, and school groups volunteered to participate.

Kann's, a women's clothier, moved from its former location of twenty-five years at 32 W. Campbell Avenue to its new location at 309 S. Jefferson Street. The new location was formerly the Grand Piano furniture store. The new store would not open for a few months due to extensive remodeling of the interior.

Roanoke's federal alcohol tax unit gave a year-end report of their activities for the period ending July 1, 1940, through June 30, 1941. The local agents destroyed 143 distilleries, arrested 332 persons, and seized seventy-one automobiles. They destroyed 6,881 gallons of whiskey and 252,220 gallons of mash. December was their most active month.

The Salem Town Council passed the first reading of an ordinance that would renumber houses and rename some streets within the town. Virginia Avenue from Main Street to Oak Street, Louisiana Street from Oak Street to Walnut, and Maryland Avenue from Walnut to a right-angle turn would all become known as Richfield Avenue in honor of "Richfield," the home of Gen. Andrew Lewis. Other planned name changes included Oak Street (Boulevard to Virginia Avenue) to Virginia Avenue; Nancy Street (Louisiana Avenue to Fairview) to Walnut Street; Market Street (Main to Boulevard) to Alabama Street; and East College Avenue to Monroe Street.

About 250 families in the Cave Spring area began receiving their postal service from Roanoke, replacing the rural delivery by the Floyd Star Route. The new route was known as RFD No. 8, and the families involved were notified to change their addresses effective July 16.

Mrs. Frank Long of Roanoke received a literary award from Brazil. She was given the Riograndense Academy of Letters award, that being the highest award presented by the state of Rio Grande do Sol, Brazil. Mrs. Long was given the award in recognition of five books she wrote while living in Brazil with her husband, who was employed in YMCA work there.

Tentative plans for the Melrose Branch Library were approved by the Northwest Civic League at a meeting at Monroe school. The building, colonial in design, was proposed to be built privately and then leased to the city and located at Orange Avenue, Lynchburg Road and 20 Street, NW. At the time, the Melrose Branch Library was housed in a room at Monroe School, but the school needed the space for expansion of its cafeteria.

The proposed plan was to be presented to the city library board and then to the Roanoke City Council.

Roanoke City erected a large wooden collection bin on the front steps of the municipal building in preparation for the drive to collect scrap aluminum. The first donations were two battered cook pans. Shenandoah Life became the first corporate donor, dropping off sixty pounds of scrap aluminum. Boy and Girl Scouts called upon each home in the city between July 21 and 26. For those not at home when the scouts came by, residents were encouraged to give their scrap aluminum to the milkman or to drop off items at a nearby firehouse. The same collection process was also conducted in Vinton and Salem.

An expanded program of venereal disease control was approved by the Roanoke City Council with the appropriation of $1,800 to aid in the employment of a full-time clinic director. The expanded program had been advocated by the chamber of commerce and the Roanoke Academy of Medicine.

The Roanoke County School Board awarded a contract to J. M. Turner for the construction of a four- to five-room addition for Fort Lewis School. Tuner was the low bid at just over $18,000 for the project.

Four hundred delegates attended the annual meeting of the Valley Baptist Association held at Zion Hill Baptist Church in Botetourt County in observance of the association's centennial. Several pastors and missionaries spoke to the delegation. A history of the association had been prepared by Rev. Ed Dowdy of Enon Baptist Church.

Mrs. Mary B. Cooper, sixty-nine, of Salem died on July 22 at her home on East Main Street. Mrs. Cooper had been prominent in Salem's civic and religious affairs. A longtime member of the Salem Methodist Church, she also served as the first president of the Salem Woman's Club. A native of Salem, she was the daughter of Judge and Mrs. William Barnitz and the widow of Thomas Cooper.

Mrs. Virginia K. Wright was nominated to become Roanoke's new postmaster, having served as acting postmaster. She was the widow of John Wright, Roanoke's former postmaster.

Fats Waller played at a dance for black patrons at the Roanoke Auditorium on August 1. Admission was $1.10 at the door. White spectators were admitted for $0.65.

Sons of the Pioneers, leading Western movie stars that included Roy Rogers, appeared at the Academy of Music on August 2 for four shows, accompanied by Roy Hall and his band for what was billed as "Blue Ridge Jamboree."

The N&W Railway reported that national defense had brought a boom to their passenger traffic during the first half of 1941. Traffic was up 264 percent compared to the same period in 1940. One impact was the opening of the Radford ordnance plant and that N&W commuter trains from Roanoke, Bristol, and Bluefield processed over one million passenger tickets to Radford during the period.

Arthur G. Wood, forty-seven, of Bonsack died at the Veterans Hospital on July 26. Wood was a former Roanoke County auditor and World War I veteran. He was involved in numerous civic activities, including chairman of the board of Mercy House and past commander of the sixth district American Legion.

Count Basie and his orchestra played for a dance and a boogie-woogie contest at the Roanoke Auditorium on August 5. The dance was for blacks only, though white spectators were also admitted. James Rushing accompanied the orchestra as the lead vocalist.

L–r, Wayne Watson, Tommy Magness, Roy Hall, Roy Rogers, Woody Mashburn, Bill Brown, Clayton Hall, August 1941. *Ralph Berrier, Jr.*

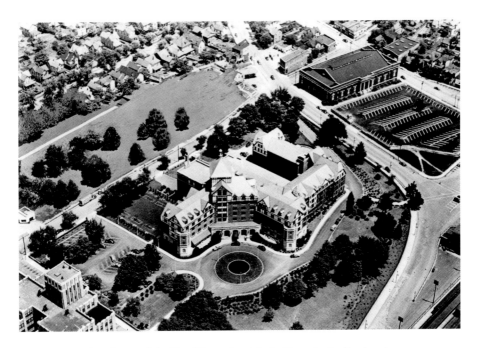

Aerial view of the Hotel Roanoke with the Roanoke Auditorium in upper right, 1941. *Norfolk & Western Railway Historical Society.*

Over one thousand spectators watched Charley Turner, thirty-one, defeat Zane Williams in tennis at South Roanoke Park to win the annual city-county tournament. Turner won the match, 3–2. Dorothy Snedegar defeated Betsy Jennings to claim the women's title. Raymond Humphreys outlasted Robert Turner to win the juniors title. The next day (July 28), Turner and Hubert Berrier defeated Lester Lee and Curtis Merkel to claim the men's doubles championship. Betsy Jennings and Anne Payne defeated Dorothy Snedegar and Anne Via for the women's doubles title.

A five-member board of trustees was appointed for the Roanoke County free public library system, being the first such board to exist. The county's free public library had been sponsored by the Roanoke County Junior Woman's Club, which operated the library from their clubhouse at Conehurst. The club could not continue the library without assistance, so the county board of supervisors agreed to provide funds, with the state WPA providing matching funds for the project as well.

The drive for scrap aluminum was a success, with 14,550 pounds collected in Roanoke City and 13,872 pounds collected in Roanoke County, including Salem and Vinton. The aluminum was sent to a smeltery designated by the US Treasury department.

The Dixie Professional Football League announced their season schedule for 1941, which would run from September 21 through November 23. Six cities had teams: Roanoke, Newport News, Richmond, Portsmouth, Norfolk, and Charlotte.

Some concerned citizens formed a local chapter of Fight for Freedom, Inc, which was dedicated to America entering the European war and reporting subversive activities at home. The organizing group made plans for a membership drive and larger community meeting and rally. S. P. Chockley was made temporary chairman. It should be noted that Virginia's US senator, Carter Glass, was national chairman.

Virginia's governor asked all municipalities in the state to voluntarily comply with the daylight savings time. He had issued a proclamation declaring that all state agencies would voluntarily comply with the program. Roanoke City Council, the county board of supervisors, and the town councils of Salem and Vinton all adopted resolutions agreeing to voluntarily participate in the new time change. All citizens would move their clocks forward one hour for the period of August 10 to September 28. The effort was to conserve electricity for defense purposes.

Congressman Clifton Woodrum informed Roanoke officials that defense funds had been secured for the construction of a third runway at Roanoke Municipal Airport. The amount was $180,000. City officials also agreed to a contract with American Airlines for use of the airport, including exclusive space for the airlines in the repair building.

Tracer threads for submarines were being manufactured at Roanoke's Viscose plant, though the quantities and destinations for the threads were a defense secret. The Roanoke plant was also producing a form of rayon mixed with rubber that lined airplane fuel tanks to prevent the craft from being shot down. While the lining did not stop a bullet, it did seal the bullet hole such that fuel would remain in the tank for the plane to continue flying.

Natural Gas Distributors, Inc., opened its new showroom at 813 Franklin Road, SW, in early August, billing itself as "Home of Pyrofax Gas." Natural Gas served mainly residential customers.

Frantz Orchards advertised the arrival of one thousand bushels of peaches a day to their packing house in Wasena, next door to the Roanoke Ice and Cold Storage.

A gas curfew went into effect on August 3 in Roanoke as it did along the Eastern Seaboard of the United States. Gas stations were asked to sell fuel only between the hours of 7:00 a.m. and 7:00 p.m. to conserve gas for national defense purposes.

Leaks and slow repairs at Muse and River Spring pumping stations caused Roanoke City Council to discuss the possibility of using Carvin's Cove as a potential source for municipal water. The issue was raised by the city manager and the head of the city's water department.

In the local and state Democratic primary, held on August 5, C. E. "Buck" Cuddy had a surprise upset over his former boss to gain the nomination for Roanoke's Commonwealth's Attorney. He defeated Robert Smith, who had held the position for the previous twelve years. The vote was 3,483 to 2,853. In another contested local race, C. R. Kennett defeated Jerry Via for the nomination of city treasurer, 4,729 to 1,286. W. J. Austin defeated Clarence Porter for the nomination for issuing justice, 4,188 to 1,699. A statewide nomination race for lieutenant governor held regional attention as Moss Plunkett of Roanoke County was defeated by state senator William Tuck of Halifax County. As expected, Plunkett carried the Roanoke region by a four-to-one margin but lost statewide. Colgate Darden was the Democratic nominee for Virginia governor.

E. R. Chick, a former member of Roanoke City Council, died at his home on Campbell Avenue, SW, on August 5. Chick was a grocer and had come to Roanoke in 1892 from his native Cumberland County, Virginia. Chick was a member of the city council for twelve years, serving from 1906 to 1918. Funeral services were conducted from Calvary Baptist Church.

Frank G. Woodson, prominent attorney in Salem, died on August 5 as a result of being hit by an automobile. No charges were filed against the driver. Woodson had served as the commonwealth's attorney for Botetourt County from 1912 to 1916 and began practicing in Salem in 1928.

Roanoke City police launched a late-night raid on the Ritz Hotel, 106 E. Salem Avenue, and made several arrests. A week later the hotel manager and others were found guilty and fined for operating a house of ill fame.

The Roanoke Semi-Pros baseball team captured the state championship on August 6 when they defeated the Rayon Premiers 4–3 in the championship game played at Westvaco Field in Covington. George Luck was the team's manager.

Directors of the Roanoke Society for the Blind decided to withdraw from the Community Fund and to close their workshop for the blind at the end of the calendar year. The reason for the closing of the workshop is that state and federal programs were sufficient to meet the needs of the blind, making the workshop unnecessary. The society had been sponsored by the Roanoke Lions Club for many years, and the society would continue its advocacy for the needs of blind persons, including schoolchildren.

Mrs. S. H. McVitty of Salem died at her Vermont summer home on August 7. Mrs. McVitty, formerly Lucy Patton Winton, was a native of Addison, New York, and had made her home at Ridgewood, near Salem, since her marriage in 1905. Mrs. McVitty served on the board of trustees of Hollins College, was one of the founders of the Roanoke Garden Club, member of the local British War Relief Committee, and an active volunteer at Mercy House, Roanoke County. Funeral services were conducted from Salem Presbyterian Church with interment at Laurel Hill in Philadelphia, Pennsylvania. She was sixty-one.

Restricted use of the Roanoke Municipal Airport resumed on August 10. The airport had been closed since April 1 for expansion and improvements. Limited daytime flying would be allowed, though portions of the airport would remain closed due to ongoing work.

Roanoke officials announced the work on the city's main and Negro branch libraries would be delayed as WPA labor was not available for the two projects until the local airport and other defense-related work were completed. About 125 WPA laborers were working on the airport and at the Radford ordnance plant through the Roanoke office.

A nine-hole "gopher golf" course was laid out on the ground of the Veterans' Hospital in Salem. The game was played with a ball the size of a baseball and regulation-length clubs, but the heads resembled croquet mallets. An average tee shot went about 150 yards.

Dr. H. T. Penn was elected president of the newly formed Roanoke Civic League in mid-August. The league had been formed by the merger of two civic associations, the Independent Voters League and the Colored Civic League.

The N&W Railway, Viscose, and Virginia Bridge decided not to adopt the voluntary daylight savings time schedule due to operating and technical issues. Most other businesses in the city decided to follow the lead of the city council and other municipalities and change their clocks accordingly.

The Sinclair Flight Trainer, as part of a national tour, made a three-day stop at Lakeside Park. The machine provided persons with "the thrills of flying." It was a miniature plane that took riders through the motions and sensations of flying in an open-air cockpit. The ride was sponsored by the local agent for the Sinclair Refining Company.

The Barter Theater Players, under the direction of Robert Porterfield, provided several productions during the summer months at Hollins College's Little Theatre. The plays, including "The Old Maid" and "The Male Animal," were sponsored locally by the Hollins College Alumni Association and were well attended by local citizens.

The Cole Brothers Combined Circus stopped in Roanoke on Saturday, August 16, for two performances under their big tent erected at Maher Field. The Cole Brothers circus was one of two railroad circuses touring the nation. The circus tent accommodated 8,500 persons. The circus included performances by horse riders, aerial gymnasts, three herds of performing elephants, and fifty clowns. One of the favored highlights was the Flash Williams troupe of daredevil automobile drivers. Attendance was estimated at fourteen thousand.

Leon Boyer defeated Woody Preston at Springwood Park to win the "Colored City-County" tennis tournament. Sonny Thomas and Ralph Coleman defeated Dr. W. P. Yaney and Woody Preston to win the doubles crown. Gloria Downing defeated Mrs. J. S. Beane to win the women's title, and sisters Gloria and Eloise Downing won the women's doubles play.

The twenty-fifth international Dokkie convention held at the Hotel Roanoke was of interest to many Roanokers, as over a thousand spectators turned out for the contests at the Roanoke auditorium. Further, there was a Dokkie convention parade that moved through downtown with various drill teams, drum and bugle corps, and bands participating. It was estimated that between 25,000 and 30,000 persons lined the parade route.

The Patteson Funeral Home opened in Vinton in the Masonic building at Lee Avenue and Maple Street. The operator of the home was F. F. Patteson, who had been employed by other local funeral homes for many years.

This image shows downtown Vinton in the early 1940s. *Vinton Historical Society.*

Roanoke school superintendent D. E. McQuilkin released cost figures associated with public schools in the city. He noted that the city had spent an average of $55.72 per white pupil on instruction during the 1940–1941 school year and $39.99 per black pupil. Both figures were slightly up from the previous year. Total enrollment had been 9,148 white students and 2,464 black students.

The August issue of the N&W Railway magazine shared that Roanoke's railroad shops would soon release a new kind of locomotive if all remained on schedule. The first of five streamlined "J" Class engines would soon be on N&W tracks if all materials arrived. The magazine reported that these new locomotives would carry the number "600" and would be different from all other locomotives produced due to the unique streamlined nose and hood.

Crane's men's store held its formal opening of its remodeled and enlarged store at 106 S. Jefferson Street on August 15. Bill Dressler was the store's manager. Crane's was part of a national chain of men's clothing stores.

The Colony Shop at 305 S. Jefferson Street opened its doors with a "house warming party" on August 17. The shop was a women's clothing store and offered opening-day customers roses.

John Godwin, team manager for Roanoke's professional Dixie League football team, announced that the team, known as the Travelers, would be coached by Gus Welch. Welch began playing football in 1911 as a teammate to Jim Thorpe with the Carlisle Indians. After serving in the army, Welch coached college football at Washington State and at Randolph-Macon.

More than two hundred Roanoke businessmen and leaders participated in the Roanoke Booster Club trip to White Sulphur Springs, West Virginia. A special passenger train was being provided by the N&W Railway for the occasion.

The Lee Theatre was the new name selected for the theatre nearing completion on Williamson Road at Tenth Street. Mrs. T. E. Whatley of Brandon Road, Roanoke, suggested the winning name and received fifteen dollars and a six-month pass to the movie house. The naming contest was conducted by WSLS Radio, and there were 187 entries. The theatre owners said the opening would be in September.

Dr. Ellison Smyth Jr., a former dean of the faculty and professor of biology at VPI, died at his home in Salem on August 19. He was seventy-seven. Smyth organized and coached VPI's first football team.

Guy Linkous won the N&W Railway tennis championship by defeating Bowyer Baird. The tournament was played on the courts in South Roanoke Park.

The Roanoke Chamber of Commerce, with the assistance of law enforcement, drafted a proposed ordinance for adoption by the Roanoke County Board of Supervisors on the regulation of "tourist cabins." According to the business group, about twenty-five to thirty tourist camps located along highways in the county were regarded as houses of prostitution and were often operated and owned by persons running nearby dance halls.

Roanoke County temporarily leased a warehouse formerly used by the Huggins Nut Company to house a fire engine to serve the Williamson Road community. The building was located on Williamson Road opposite Chatham Street and was leased for one year with the intent that a more permanent site would eventually be secured.

Salem's new theatre, the Colonial Theatre, opened on August 22 on West Main Street at the entrance to Langhorne Place. Its gala premier was a showing of the film *Moon Over Miami* starring Don Ameche, Robert Cummings, and Betty Grable. The theatre had a seating capacity of 750 and a four-hundred-car parking lot. Admission was 30 cents for adults and 10 cents for children. The movie house was constructed for $75,000 and was owned and managed by Harold Depkin. The theatre had both an interior and exterior colonial design with an eighty-foot-wide lobby area. The Colonial had a small stage for live performances that was served by two small dressing rooms. Frank Wiley bought the first ticket. The addition of the Colonial Theatre brought the number of movie houses in the Roanoke Valley to eight. In Roanoke, there were the American, Jefferson, Park, Roanoke, Rialto, and Grandin, and in Salem were the Colonial and Salem Theatres. (The Lee was still under construction.)

The very first meeting of the newly organized planning commission for the town of Vinton was held on August 22. The town council had appointed the commission to develop a six-year comprehensive plan for the community. Carl Short was elected chairman.

Roanoke attorney Moss Plunkett was elected chairman of the Virginia Electoral Reform League. The purpose of the league was to advocate for the abolition of the poll tax in Virginia as a prerequisite for voting.

Glenn Miller and his orchestra performed at the Roanoke Auditorium for a whites-only dance on August 25. The band played from 10:00 p.m. to 2:00 a.m. for an audience of four thousand. Admission was $1.50 for dancers and $1.10 for spectators.

Adams Clothes, a national chain, held a formal reopening of their remodeled store at 104 S. Jefferson Street on August 28. The firm had been located at that site since 1933. Max Barker was the store manager. Five thousand dollars had been invested in the store's front, which featured black structural glass trimmed in chrome metal. Show windows were of a rich black walnut and curly maple. The store offered suits and topcoats for $16.50.

Three buildings in Troutville's business district were destroyed by fire on August 28. The fire consumed B. A. Painter's general merchandise store, the Troutville garage, and the Troutville barber shop. Firemen from Buchanan, Roanoke, and Salem responded to the blaze. Firemen had to dam a nearby creek to have water sufficient to extinguish the fires.

A crowd of about a thousand gathered at Maher Field for the Roanoke City recreation department's "Play Day," an event that marked the end of the city's parks programs for children. Some four hundred children that had participated in the summer program pledged allegiance to the American flag, sang the national anthem, and paraded around a patriotic float upon which stood Uncle Sam. This was followed by a half-hour concert of patriotic songs by the Roanoke civic band.

Lakeside Park advertised "two big days for colored people, September 6 and 7. Sept. 5 is the last day for white people."

Three new lines of 1942 Hudson automobiles were put on display in late August in the showrooms of Roanoke Motor Sales, 400 Luck Avenue, SW. The cars were lower, with running boards. They also featured Drive-Master, a new drive system that made steering easier. Another unique feature was a foot-control radio station selector whereby the driver could change radio stations by a floor button.

The Roanoke Fair opened on September 8 at Maher Field for six days, billing itself as "a real old time agricultural fair." Attractions included nightly fireworks, carnival rides, Lucille Anderson (a high diver), Brooklyn Supreme (the world's largest horse), Kirk's Circus (monkeys, ponies, and dogs), acrobats, and concerts. Four thousand attended opening day. By the end of the week, the fair attracted over 34,000 persons.

Mount Pleasant Baptist Church celebrated its centennial on August 30. The church began with thirty-eight charter members in 1841, and its first building was about a half mile from its present-day sanctuary. Around 1871, a new building was erected where Mount Pleasant United Methodist Church stands today, and both Baptists and Methodists used the structure. It was destroyed by fire in 1891. The current brick sanctuary was erected in 1930, replacing a wood-frame sanctuary that was built after 1891. The congregation was one of sixteen original Baptist churches to form the Valley Baptist Association.

Gus Welch was announced as the coach of the Roanoke Travelers football team by team manager Col. John L. Godwin. Welch was a former professional player and had coached at several colleges.

Nearly five hundred employees and family members of the City of Roanoke attended the annual city employees' picnic held in Fishburn Park. Jim Shilling was recognized for being the longest-serving employee with forty-one years of continuous employment with the city.

Mrs. Margaret Humphries celebrated her ninety-first birthday in September and recalled for a reporter her memory of the Union cavalry raid in Craig County and Salem under General Averill during the Civil War. "The boys (her brothers) were coming down the road on their way to the mill. They met the officers who were leading the raid. Will and George were wearing coon skin caps they had made for themselves. The two officers drew rein and offered to trade their army hats for the boys' caps. The trade was made, and I still think that Will and George came out best," she said.

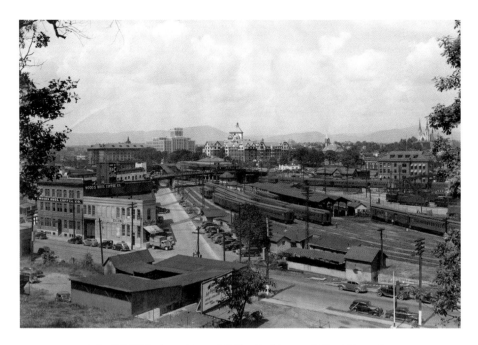

The N&W Railway General Office Building and Hotel Roanoke looking from Church Avenue, SE, September 1941. *Digital Collection, Special Collections, VPI&SU Libraries.*

Listeners of WDBJ Radio made popular a local singing group known as the Blue Ridge Entertainers, who were considered favorites by the station. The band members included Bill Brown, Clayton Hall, Irving Sharp, Roy Hall, Tommy Magness, and Wayne Watson.

The Ink Spots returned to the Roanoke Auditorium for a performance and dance on September 11. They were accompanied by the Sunset Royal Orchestra. The dance was for blacks only, though white spectators were admitted.

The Academy of Music's manager, Robert Royer, announced that two plays and their casts from New York would tour through Roanoke in the late fall. Famous actress Ethel Barrymore and Richard Waring would appear in *The Corn is Green* and Lillian Helman's play *Watch on the Rhine* would star Paul Dukas.

Salem Town Council authorized the purchase of a site for an incinerator located just west of the "open dump" that was north of the town limits. The town council paid about $500 for the five-acre site that was part of the town's long-range plan.

The Roanoke City Council, meeting in a special session on September 9, ratified a ten-year contract with American Airlines for use of the municipal airport and its facilities. The council also set October 13 as the dedication date of the field.

Elbert Carroll, a member of the Roanoke County School Board and the farm superintendent at the Catawba sanatorium, died on September 9 from injuries he sustained on the sanatorium's farm when he was crushed between a wagon and a tree. He had worked on the farm since 1912. His memorial service was conducted from the Catawba sanatorium chapel. He was survived by his wife and their seven children.

More than 350 members of the N&W Railway's veteran's association colored division met for their annual convention at the Virginia Theatre, with lunch at the Dumas Hotel. W. H. Houseman of Roanoke was the convention chairman.

Some 4,500 persons attended the Sears-Roebuck store open house at the 12 East Church Avenue location. The store was celebrating the fifty-fifth anniversary of the national chain and the second anniversary of the local store being in its Church Avenue location. J. E. Hildreth was the store manager.

The Craighead Water Company was granted a charter by the State Corporation Commission to serve residents near the intersection of Route 220 and Starkey Road. The water company would extend lines to the Edgehill and Pinkard Court sections. E. L. Craighead was company president.

Smith Hall, the first women's dormitory at Roanoke College, opened for the start of the new academic year. The dorm was named for Roanoke College President Charles Smith and cost $50,000. The construction of the dorm was received by many as being a long-term commitment by the college to coeducation, as the college had begun admitting women twelve years earlier. The new dorm was designed by the Roanoke architectural firm of Eubank & Caldwell.

Artie Shaw and his thirty-two-piece orchestra performed for a whites-only dance at the Roanoke Auditorium on September 19.

The Roanoke City Council voted to rename the Roanoke Municipal Airport "Woodrum Field" after Congressman Clifton Woodrum, whose efforts to secure federal defense funds led to the expansion and significant development of the airport. The decision was unanimous, with the discussion occurring in closed session. In the same meeting, the council also authorized annexation proceedings to effectively triple the city's footprint. The attempt to annex, if successful, would increase the city's population by sixteen thousand. The city's proposal to annex 20.56 square miles met with immediate opposition from county officials and property owners. One company, American Viscose, retained legal counsel to fight the proceedings, much to the relief of the county as the plant provided a significant source of tax revenue to the county.

The Northwest Civic League advocated for a park in that section of Roanoke city consisting of six vacant lots on Staunton Avenue between Twenty-Second and Twenty-Third Streets. As for the proposed junior high school in northwest, the civic organization adopted a resolution asking that it be named for Clifton Woodrum.

The Roanoke City Council announced that the low bid for the Gainsboro Branch Library was submitted by J. M. Turner for $20,106. Turner was among six contractors that submitted bids for the project.

Jarrett-Chewning Company advertised the display of three new 1942 Studebaker car models at their dealership at 360 Luck Avenue, SW. Other dealerships were showcasing their new model cars as well. Antrim Motors was boasting new Dodges, and Fulton Motor Company had the "New Yorker," a new 140-horsepower Chrysler.

On the evening of September 18, Roanokers witnessed a rare display of the Aurora Borealis (Northern Lights) in the sky. The display was quite intense such that callers jammed the switchboard at the *Roanoke Times* with the news and their observations. Some callers had ominous concerns, given the war in Europe.

WDBJ Radio's Dramatic Guild celebrated its third season with a full lineup of on-air productions. The guild was started by Jack Weldon, the station's program and educational

The Jarrett-Chewning Company at 360 Luck Avenue, March 1940. *Virginia Room, Roanoke Public Libraries.*

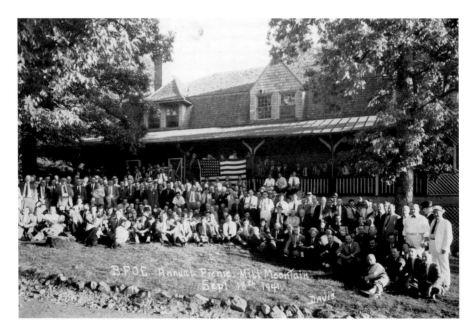

Elks Lodge annual picnic at Rockledge Inn on Mill Mountain, September 18, 1941. *Historical Society of Western Virginia.*

director. The guild provided live dramas to listeners on Wednesday evenings each week, only being off the air in the event of important international or national news broadcasts. The guild consisted of local talent under the direction of Weldon and Paul Reynolds.

West End School in Roanoke was the only "old" school building recommended to be kept in use by a committee evaluating city school structures. West End School was built in 1898 with additions in 1909 and 1925. Though the condition of the school was deemed poor, its location was excellent and thus deserved improvements.

Lorenz Neuhoff Jr., vice president of Neuhoff meat packers in Salem, awarded Lesta Keffer of New Castle the grand championship in the company's annual Salem hog show that was held on September 20.

The Roanoke Pilot Club received its charter in ceremonies at the Hotel Roanoke. The club formally became an affiliate of the national women's service organization. The club had twenty charter members, and Mrs. Aubrey Wallace was the local club president.

Tiny Bradshaw and his orchestra played for a blacks-only dance at the Roanoke Auditorium on September 24. The orchestra was accompanied by Lil Green, vocalist.

Roanoke's "colored fair" opened for six days on September 22 at Washington Park, with the featured attraction being the "Great Leon" in an aerial act. The midway rides were provided by the Lew Henry and Clyde Show, and there were also agricultural and handicraft exhibits.

Congressman Clifton Woodrum withdrew his name from being considered for the chairmanship of the Appropriations Committee in the US House of Representatives. Woodrum had been considered strongly by many of his colleagues, but majority support was behind Congressman Clarence Cannon of Missouri, who became the chairman.

The Roanoke County Public Health Association opened their school medical clinics with the stated goal of immunizing 95 percent of the county's schoolchildren against diphtheria. The clinics had been operating in the schools since 1923.

Traffic moved through the new underpass at Shaffer's Crossing in late September. The underpass eliminated a dangerously curved road.

The Montgomery Presbytery appropriated $1,500 for the construction of a new church in the Williamson Road section. The lot where the new church would be located had been purchased a decade earlier by First Presbyterian Church, Roanoke, for the purpose of starting a mission congregation. This mission effort had been spearheaded by Dr. W. C. Campbell, a deacon at First Church.

Jefferson High School played the first night game in Roanoke's history when they took the field against Maury High School on September 26 at Maher Field. The lights were borrowed from Ray Ryan, owner of the Salem-Roanoke Friends baseball team. Jefferson defeated their Norfolk opponents, 18–15, before an estimated five thousand spectators.

Martha Ann Woodrum, daughter of Congressman Woodrum, completed her first solo flight at the Roanoke airport on September 25. Her instructor was Van O'Brien. Miss Woodrum was employed by WDBJ and was the sixth staff member of that station to fly solo. Other flyers at WDBJ included Keith Webster, Paul Reynolds, Irv Sharp, Ed Lemon, and John Harkrader.

Ezra Buzzington and his Pine Ridge Silver Cornet Comedy Band played at the Academy of Music for an event billed as the Blue Ridge Jamboree. Local talent included the Happy-Go-Lucky Boys and "Cousin" Irv Sharp.

Belmont Methodist Church, corner of Jamison Avenue and Eighth Street, SE, was formally dedicated on September 28. The church began as a mission of Greene Memorial Methodist Church, meeting first in a room above a corner drugstore. The members built a small chapel and then a larger building in 1907 that burned in 1917. Their present building was erected in 1918, but trustees decided it would not be dedicated until its debt had been retired.

Maurice Tillet (a.k.a. "The Angel"), a 275-pound professional wrestler, was the main attraction in his match against Cowboy Luttrail at the Roanoke Auditorium on September 30. Local wrestling promoter Bill Lewis had a three-card bout for fans.

The Lee Theatre on Williamson Road formally opened on Friday, October 3. The theatre had a seating capacity of eight hundred and was managed by Ashton Rudd. Two large murals adorned the interior near the stage. One depicted a classical theme, and the other contained an image of Pegasus and the Flying Horse with a temple in the background. The theatre contained an RCA sound system and modern air-conditioning. The new theatre was owned by the Leheigh Development Corporation headed by Dan Weinberg, which owned and operated some twenty theatres in Virginia. The theatre cost $100,000. The marquee was done by Charlotte Sign Company of Charlotte, North Carolina. On opening night, Bette Davis starred in the film *The Little Foxes*. The next night, the Lee showed what was one of the most controversial films of 1941, Orson Welles's *Citizen Kane*. An estimated seven thousand persons attended opening night, but only eight hundred were admitted to the film. Others were granted access to the building's lobby, concession stand, and given brief tours. Police were called to move traffic along Williamson Road, which was reduced from four down to two lanes as cars parked along the street. Music for the occasion was furnished by the William Fleming High School band, and the ribbon was cut by Miss Eunice Doyle of the school. Jim Johnstone of WSLS radio acted as master of ceremonies. Mrs. T. L. Whatley of Brandon Road, SW, was given a fifteen-dollar prize for winning the naming contest for the theatre, as she had suggested Lee in honor of the Confederate general.

Everett Marshall played at the Academy of Music on October 8, doing a production entitled "Blossom Time."

The Roanoke Gilbert and Sullivan Light Opera Company elected Holland Persinger as its president, succeeding Mrs. Frances Walters. The company announced an upcoming production of *The Mikado*.

Blue Hills Golf Club hosted an exhibition match featuring professional golfer Denny Shute and his partner Ted Fox playing against locals Clyde Johnson and Andy Butcher. The exhibition was sponsored by Montgomery Ward department store. Shute was a British Open champion.

Jan Garber and his orchestra played for a whites-only dance at the Roanoke Auditorium on October 6. The orchestra was accompanied by baritone Lee Bennett.

Blue Ridge Motors, 701 Patterson Avenue, SW, showcased the new 1942 Buick models, and Rutrough-Gilbert Motors, 435 Luck Avenue, advertised the 1942 model Packard, "Clipper." The new Lincoln Zephyr was on display at Magic City Motor Corporation, 345 W. Campbell Avenue.

Lords, a women's clothing store, formally opened at 32 Campbell Avenue West on October 4. Dresses ranged in price from $3.95 to $14.95, fur coats $39.50 to $125, and dress shoes $1.99 to $6.00 per pair.

The Virginia state registrar certified that Mrs. Alma G. Keyser was in fact the first baby born in Roanoke when the town changed its name from Big Lick to Roanoke. Mrs. Keyser was granted a birth certificate showing the date of her birth as being June 23, 1882. Her formal birth document was delayed, as Mrs. Keyser submitted as evidence for the date her family's Bible and an attestation from her older sister. Big Lick became Roanoke on February 3, 1882.

On October 4, a car carrying six members of the William Fleming High School football team flipped and rolled several times in an accident on Route 11 near Glade Spring School outside of Abingdon. The team, in a five-car caravan, was returning from a game in Bristol the previous night. The single-car crash, caused when the driver lost control of the vehicle after going off the right shoulder, killed sixteen-year-old Billy Reedy, who died three hours later at an area hospital, and Charles Powers, fifteen, who died the following day. Others who were seriously injured included George Moore, Billy Munsey, Harry Cronise, and Jennings Booker. Coach Fred Smith, traveling in the last car, was so overcome with grief in reaching the scene that he had to be taken to a nearby residence. Reedy was the orphaned grandson of Mr. and Mrs. F. B. Reedy of Williamson Road, and Powers was the son of Mr. and Mrs. Charles Powers of Old Hollins Road. Their funerals were conducted the same day, with the Reedy service being held at Oakland Baptist Church and Powers's service at Hollins Road Church of the Brethren. There was much discussion by the coaches and principal at Fleming as to whether or not their football season would continue, and the decision was made to continue the season.

The Jack Horner Shop for women opened in its new location at 209 S. Henry Street.

W. C. Stouffer was elected president of the newly organized Civic Theatre of Roanoke, a group committed to bringing operas and plays to Roanoke and uniting various local cultural groups, such as the Roanoke Symphony, the Children's Theatre, the Roanoke Civic Chorus, and the Gilbert and Sullivan Light Opera Company, into a united federation.

Giralda's Cornishman, a Greyhound owned by Mrs. Claudine Dodge of Madison, New Jersey, was crowned the champion at the Roanoke kennel club's annual dog show held at the Roanoke auditorium. Mrs. R. N. Koontz was president of the local kennel club.

The Salvation Army's new citadel and headquarters building at 821 Salem Avenue, SW, was dedicated on October 12. The building and land cost $52,000. Officials with the state and national Salvation Army organization spoke at the ceremony along with local officials. Henry W. Thomas had led the fundraising effort.

The four-day state convention of the Woman's Christian Temperance Union was held at First Baptist Church, Roanoke, with various local clergy participating as well as an address by Mrs. Ida B. Wise Smith, national WCTU president, from Iowa.

The Highland Park School was profiled as part of an ongoing series the *Roanoke Times* was doing on the needs of city schools. The school was built in 1906 and was rebuilt in 1920 following a fire. Only four classrooms on each end of the building were part of

WDBJ studios on Kirk Avenue in Roanoke in the 1940s. *Frank Ewald.*

the original structure. The most prominent issues facing the school were an antiquated heating system and the need for more and larger desks.

On Monday, October 13, Woodrum Field was formally dedicated. From sunrise to 3:00 p.m., a number of aircraft landed at the airport, including an American Airlines Flagship, three planes from the US Navy, three bombers (a B-10, B-23, and B-24) from the US Army, two Grumman Amphibians from the US Coast Guard, two transports (Lockheeds 12 and 14) from the US Marine Corps, and other visiting and commercial craft. At 11:00 a.m., American Airlines offered courtesy flights for invited groups aboard its Flagship, and from 12:30 to 1:30 p.m., there was a buffet luncheon for invitees in Hangar No. 1, sponsored by the Roanoke Junior Chamber of Commerce. At 4:00 p.m., the dedication ceremony commenced on the island south of the hangar apron, with N. W. Kelley presiding. Roanoke mayor Walter Wood formally dedicated the airport as Woodrum Field. Special platform guests included Congressman Clifton Woodrum, WPA director Howard Hunter, Assistant US secretary of commerce Robert C. Hinckley, American Airlines president C. R. Smith, and Maj. Gen. M. F. Scanion of the US Army. Mrs. Walter Wood christened the American Airlines *Flagship Roanoke*, and the N&W Railway band provided music. The Roanoke Homer Racing Club set free five hundred pigeons to return to their lofts with messages. At 7:00 p.m., a banquet was held at the Hotel Roanoke for all dignitaries. An estimated fifteen thousand persons attended the dedication. Among the many activities of the day was the inaugural flight of Mrs. Gillie Harris, who celebrated her ninetieth birthday when she boarded the American Airlines plane for a brief trip over the Roanoke Valley.

With the dedication of the improved airfield, much history was published about the early efforts to establish an airport. Interest began in the mid-1920s, but it was not until 1929 that the city leased land on the farm of Dr. A. A. Cannaday for an airfield. The original lease was for five years and was dated July 1, 1929, and encompassed 136.36 acres. The annual lease amount was $2,500, and the field was known as Municipal Airport. The city purchased the leased land and surrounding property, including a portion of the Andrews farm, on July 2, 1934, for $70,000. Total acreage acquired was 319.36. The city subleased the field to Frank Reynolds and Clayton Lemon from 1929 to 1937. Other tracts of land were added to the airport in 1939 and 1940.

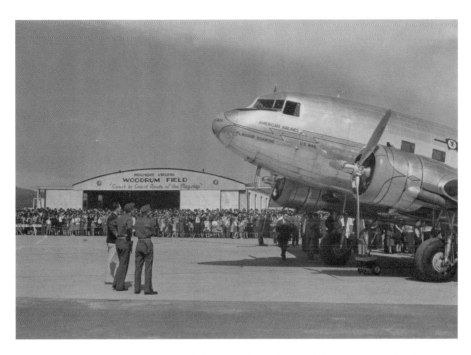

This photo was taken at the dedication of Woodrum Field; American Airlines' flagship *Roanoke* is on the tarmac. *Virginia Room, Roanoke Public Libraries.*

An aerial view of Woodrum Field during the dedication weekend in October 1941. *Virginia Room, Roanoke Public Libraries.*

The dedication ceremony at Woodrum Field; speaking is N. W. Kelley of the Chamber of Commerce. *Virginia Room, Roanoke Public Libraries.*

Prior to the municipal airport, there were a number of dirt fields that served as airstrips, notably Trout Field, near Fairview Cemetery, which operated from 1919 to 1925 and was then replaced by Cook Field along Route 11 between Roanoke and Salem. Cook Field was operated by Clayton Lemon, Frank Reynolds, George Mason, and Bill Geisen for four years. Cook Field become obsolete once the land was leased for a municipal airport in 1929.

Kann's opened its new women's fashion store at 309 S. Jefferson Street on October 16 with a fashion show featuring local high school girls. N. W. Schlossberg was the store's president. The store was designed by J. A. Fernandez of New York City. That night a dinner was given by the Schlossbergs at Hotel Patrick Henry for out-of-town guests and store employees.

Lionel Hampton, "King of the Vibraphone," and his orchestra played at the Roanoke Auditorium for a blacks-only dance on October 15. His appearance was sponsored by the Bing Social Club.

An army plane crashed at Woodrum Field during an early-evening landing at the unlighted field. The pilot and one passenger were not injured. The craft was a Douglas 38-E, made in 1934, and was badly damaged.

Alfred Lunt and Lynn Fontanne starred in *There Shall Be No Night* at the Academy of Music on October 20.

Jenoese White Spradlin was crowned Miss Vinton during the town's tenth annual Homecoming Day event. The event, including a parade and football game, was attended by some 2,500 people from the town. A float by Burlington Mills took first place in the parade.

Roanoke County retained the legal services of R. S. Kime of Salem and Horace M. Fox of Roanoke to represent them in the defense against the city's annexation proceedings.

The Roanoke City Council adopted a resolution urging the Pennsylvania Central Airlines to provide air service to Roanoke at the earliest practicable time. It was also announced that American Airlines would not begin regular service until December.

A new streamlined passenger locomotive, J-600, emerged from the N&W shops on October 20. Black, highly polished, with a Tuscan-red stripe set off by a gold border, the locomotive with a bullet nose was to be used on the Roanoke-to-Bristol run. According to figures released by the N&W, the locomotive could run eighty miles per hour with an estimated 5,500 horsepower and had a chime whistle that gave off a melodious tone, the first change in the whistle sound for N&W in a half century. The locomotive had earlier been scheduled for a completion date of mid-August.

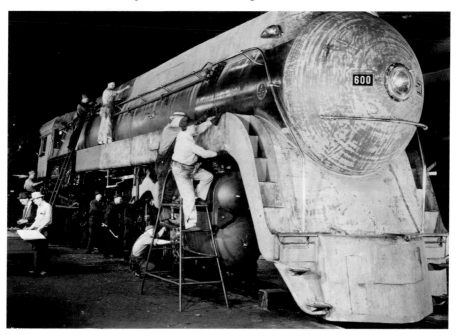

The J-600 in the N&W Railway Erecting Shop at Roanoke, January 28, 1941. *Digital Collection, Special Collections, VPI&SU Libraries.*

Philip Jackra opened the new Jackra Dunbrick Manufacturing Plant on Roanoke Avenue Extension. The plant produced bricks.

Thirteen of the fifteen new passenger coaches purchased by the N&W from the Pullman-Standard Car and Manufacturing Company at a cost of $1 million were received and were soon placed in service on the N&W's two trains between Norfolk and Cincinnati—the Cavalier and the Pocahontas. Each coach had a seating capacity of sixty persons.

Citizens in the Williamson Road section voted at a mass meeting 246 to 3 against being annexed by the city. The meeting was held in the auditorium of William Fleming

High School. Leading the fight was Roy Bible, president of the Valleydoah Civic League, and John Thornton, publisher of the *Salem Times-Register*.

The new chemistry building at Roanoke College was formally dedicated on October 22. Dr. Samuel J. Guy of Emory University addressed about two hundred attendees at the dedication banquet at Hotel Roanoke. Henry M. Lucas had donated the majority of funds used to construct the building.

The Shenandoah Flying Club was formed by a group of student pilots who elected Henry Baldwin as their first president. The club was open only to males.

National Optical Stores Company opened its 106th branch at 40 W. Church Avenue, advertising complete eyeglasses for $3.45.

A full-time fire station opened to serve the Williamson Road community on October 24. Known as Station No. 3, the firehouse was under the direction of Chief William B. Jarrett and sixteen volunteer charter members. In a dedication ceremony, the keys to a new fire truck were ceremonially handed over to Jarrett. H. H. McKenzie was president of the volunteer company. "Food, soft drinks and tobacco were passed out to those attending the event." The temporary station was located on the east side of Williamson Road opposite Chatham Street. A week later, the Roanoke County sheriff located an officer there, effectively creating a sheriff's substation.

State Airlines, Inc., announced plans to use Roanoke's airport as a central stop on its eastern and western flights. Plans filed with the Civil Aeronautics Authority called for four stops per day in Roanoke for passenger and mail service. State Airlines was a feeder airline serving areas not regularly covered by the major airlines.

The 1942 Community Fund campaign exceeded its goal of $151,000 by $1,300. Dr. W. R. Whitman, president of the fund, noted that the campaign was valley wide and supported numerous local charities.

Rutrough-Gilbert Motors provided new Packards for the cast of "The Student Prince" to ride from the train station to their hotels upon their arrival in Roanoke for a performance at the Academy of Music. Actor Robert Davis had the leading role.

Belmont School should be abandoned and a new school built was the recommendation of a state education committee studying the facilities of Roanoke schools. Belmont was the oldest white school in the city system, as the oldest school, Gilmer, was for blacks. According to the committee, the school was in disrepair and a fire hazard. The school had circular fire escape chutes that soiled the clothes of the students during every fire drill despite being cleaned regularly. The school had been built in the 1890s and was located at Dale Avenue and Eighth Street, SE.

Cecil "Pop" Newsome entered a guilty plea to first-degree murder in the shooting death of Grace Davis and the wounding of Edward Miller as they sat in a Roanoke restaurant with Newsome's wife on July 19. Mrs. Davis was shot in the head and died instantly, while Miller recovered from his wounds after several days in a hospital. Judge J. L. Almond Jr. sentenced Newsome to twenty-five years in prison. The incident was attributed to a domestic dispute.

The Roanoke City Council was informed that there were no WPA funds available for construction of a new city library in Elmwood Park, so the council rejected all bids and abandoned the project. Most of the WPA funds were tied directly to WPA labor being available, which it was not due to the declaration of a national emergency tied to war in Europe.

Pennsylvania Central Airlines formally applied with the federal government to stop in Roanoke as part of its service between Detroit and Norfolk. The company was fifteen years old and headquartered in Pittsburgh, Pennsylvania, and boasted a fleet of twenty-one Douglas capital passenger liners. It served thirty-two cities in twelve states.

The USS *Reuben James* was sunk off Iceland on October 31 by a torpedo launched by a German submarine. Aboard the American destroyer was William Harding Newton, twenty-one, of Roanoke. Newton had enlisted in the navy in 1939. Newton was survived by his parents, three brothers, and seven sisters and became one of the first local casualties of World War II even prior to the United States entering the global conflict.

On October 31, Roanoke's last surviving Confederate veteran died at his home at 502 Virginia Avenue in Raleigh Court. James Washington Gwaltney was ninety-six and was also Roanoke's oldest resident. Gwaltney had enlisted in the Confederate army in Tennessee and fought at the battles of Chickamauga and Loudon, Tennessee. After the war, Gwaltney decided to move to Virginia and settled in Big Lick. He was also the oldest voter in Roanoke, having cast his first presidential ballot for Horace Greeley in 1868. This vote was cast at the old Franklin Hotel near the present-day Lynchburg Avenue viaduct in northeast Roanoke. Gwaltney recalled in earlier interviews coming to Big Lick when the depot was nothing more than an open boxcar. He sold tobacco, worked as a carpenter, and was an auctioneer. He was a charter member of Greene Memorial Methodist Church and remembered its original location on High Street. He was interred at Fairview Cemetery.

Some 1,300 persons in Salem attended Halloween festivities on the football field at Roanoke College, an annual event hosted by the town for many years. There were a parade, costume contests, and sporting events, including four boxing matches, sack races, and tire spinning.

H. S. Garman retired from the N&W Railway on November 1 after a half century of service. Garman recalled the day that all railroads switched to a standard gauge in 1896. He began working for the N&W in that same year. He recalled that the Shenandoah Valley Railroad track in Roanoke was four feet, eight inches wide, and the track from Roanoke to Bristol was five feet.

The US Census Bureau reported that according to the 1940 federal population census, Roanoke was the 131st city in the nation in population and 112th in metropolitan population.

Some five thousand residents watched the Jefferson High School "Old Grads Day" Parade that went through downtown.

A three-judge annexation court dismissed Roanoke City's annexation petition, ruling that the ordinance on which the action was based was not legally passed. The entire annexation proceeding was dismissed due to a flaw in the drafting of the ordinance. The judges ruled that the ordinance adopted by the city council had not complied with the city's charter. Roanoke's city attorney stated after the ruling that a revised ordinance would be placed before the city council for adoption to comply with the court's opinion.

The Lucius E. Johnson Camp for Boys was officially renamed Camp Roanoke by the YMCA. The name change was suggested by the son of Lucius Johnson, who felt the camp would become more of a civic asset if its name reflected the area it served.

Erskine Hawkins, writer of the song "Tuxedo Junction," and his orchestra performed at the Roanoke Auditorium on November 4. The dance and concert also featured Jimmie Mitchell, Avery Parrish, and Ida James.

Roanoke city and county voters went to the polls and elected all Democrats to local and state offices. Roanoke delegates Walter Scott and Earl Fitzpatrick easily won reelection, having one opponent, Lawrence Wilkes, a Socialist. In Roanoke County, Delegate Ben Chapman won against R. C. Wertz, 1,211 to 647. In the city, C. E. Cuddy was reelected commonwealth's attorney without opposition.

The Kroger Company opened its newest supermarket at 130 Main Street in Salem on November 6. It was its ninth store in the Roanoke Valley.

The congregation of Second Presbyterian Church celebrated their remodeled facility as well as the fiftieth anniversary of the church's founding. The congregation completed $60,000 worth of improvements to their buildings, including an entirely new choir loft. Only one charter member, John Hart, was still an active member recalling the days of the church's founding in 1891.

Renick Motor Company, 213 Randolph Street, NE, advertised the sale of the 1942 model Willys, "The People's Car."

Trumpeter Charlie Spivak and his orchestra performed at the Lee Theatre on November 10, giving four performances.

United States senator Harry S. Truman stayed overnight at the Hotel Roanoke on November 10, having visited Appomattox Courthouse earlier in the day.

On November 11, Roanoke held an Armistice Day Parade that was halted in progress at 11:00 a.m. for one minute as bugles throughout the parade played "Taps" in honor of the men who died in World War I. The parade was organized by the Committee on Patriotic Affairs and was viewed by an estimated four thousand spectators. The parade was followed by a football game between the freshmen of VPI and VMI (Tech won 12–6) and a dance at the Hotel Roanoke. During halftime of the football game, a plane dropped free tickets attached to small parachutes for the Lee Theatre. Schools, local governments, and most businesses were closed for the day.

Allen Palmer's painting *Sage Brush* took top honors along with Randolph Chitwood's *Circus Rider* at the Roanoke Arts Alliance annual exhibition at the Virginia Galleries.

A fourth airline expressed interest in having service at Woodrum Field. Delta Air Corporation filed an application with the CAA for a new passenger, mail, and freight service from Cincinnati and points west and south in Virginia and the Carolinas. The other three airlines that had filed with the CAA for service at Woodrum Field were American Airlines, Pennsylvania-Central Airlines, and State Airlines.

An employees' fire brigade was formally organized at the American Viscose plant in southeast Roanoke. John Carter was elected as temporary captain for purposes of organizing the force.

The local chapter of the America First Committee, a national coalition of isolationists, began distributing some one thousand pamphlets in Roanoke urging business and civic leaders to speak out against American intervention in the war in Europe.

In Salem, Bob Williams stepped down as president of the Salem-Roanoke Friends baseball team. Owner Joe Ryan became the club's president. Williams had served in the role for three years.

The new Blue Ridge Church of the Brethren at Thaxton was dedicated on November 16 in all-day ceremonies and services. The pastor was M. G. Wilson. A groundbreaking ceremony for the new building had been held on June 15 of the previous year.

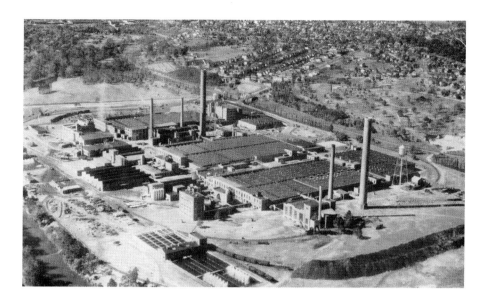

This is an aerial view of the American Viscose Roanoke Plant, undated. *Bob Stauffer.*

Roy Rogers, the singing cowboy of Western films, made a personal appearance at the Lee Theater on Williamson Road for the theater's Saturday morning kiddie show on November 15. Three other members of Rogers's troupe also attended with him.

Joe Palmer and his orchestra performed at the Salem Theatre for three performances, while on the same night, November 18, Al Donahue and his orchestra performed on the stage at the Lee Theater. Both performers and their respective orchestras were popular national radio personalities.

Roanokers began to adjust to an unusual upcoming Thanksgiving Day, as the annual VMI-VPI football game was moved to Lynchburg due to the construction of Victory Stadium, which was not ready for play. The first contest between the two teams in Roanoke was in 1913 in what was named the "Splinter Bowl" as fans sat in wooden bleachers at Maher Field. That game ended in a 6–6 tie. The game was moved to Lynchburg for just one year, much to the comfort of Roanokers. Nonetheless, thousands of Roanokers made the trip to Lynchburg to watch the contest that VMI won 15–10. Attendance was 18,172. There was a Thanksgiving Day football contest in Roanoke, however, as Jefferson played Greensboro High School at Maher Field, losing 6–0.

Due to the numerous raids on illegal stills in and around the Roanoke Valley, bootleg whiskey prices rose considerably. Grain whiskey was bringing nine dollars or more for a five-gallon jug "in the woods" and another two dollars if bought within the city limits. "Sugar whiskey" was selling for $1.50 per gallon "in the woods" and was reportedly in very short supply.

Dr. Spencer Edmunds, pastor of Second Presbyterian Church for eighteen years, announced his resignation to take the same position at First Presbyterian Church, Easton, Pennsylvania.

The J-601 steam engine emerged from the N&W Roanoke shops on November 17 and tested at the West End yards. It would initially run between Roanoke and Bristol and would later be placed in service on the southbound Tennessean and northbound Birmingham Special.

The Roanoke City Council gave final approval to second reading of a revised annexation resolution, with the original having been ruled invalid by the court. The city, as with the original annexation proposal, sought to annex just over twenty square miles of Roanoke County. At the same meeting, the council authorized the city manager to advertise a matter pertaining to the removal of graves at an old cemetery on the airport property.

An all-black first-aid and life-saving crew was formed by a group of young men associated with the William Hunton Branch of the YMCA. Eleven young men composed the Hunton Life Saving and First Aid Crew. Luvelle Taylor was elected to serve as captain, and other officers included Alex Terrell, A. B. Martin, and George Watson.

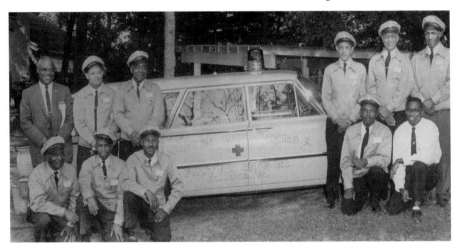

This 1960s image of the Hunton Life Saving and First Aid Crew shows some of those who founded the crew in 1941. *Harrison Museum.*

S. H. Heironimus department store collected gently worn overcoats on behalf of the local chapter of the British War Relief Society, to be sent to England. The coats were needed by home guard units there who were without uniforms.

The Roanoke All-Stars, a black semipro football team whose home field was Springwood Park, had an undefeated season. Not only did they not suffer a single loss, no opponent tied them, and no one scored against them. The team was composed of former high school and college players.

Mrs. Georgine Logan, widow of Joseph Logan, died at her home in Salem. She was the sister-in-law of George P. Tayloe, who resided at the Tayloe family home, "Buena Vista," in southeast Roanoke.

The Wallenda family headlined the Kazim Temple Shrine Circus at the Roanoke Auditorium the week after Thanksgiving. The Wallendas were the best-known flying trapeze artists in the country. The Shriners had engaged the Hamid-Morton indoor circus

organization for the event, which benefited the crippled children's hospital program. The circus was held at the Roanoke Auditorium.

A school board review of Virginia Heights Elementary School's condition yielded some interesting historical data about the school. A brick structure was erected on the hill (present-day location) in 1912 by the Roanoke County School Board (the section would be annexed into the city in 1919) and added to in 1916. The larger building (seen today) was built in 1922.

The Roanoke Travelers semipro football team completed their regular season with only one win. The team was part of the Virginia-based Dixie League.

Roanoke's American Legion sandlot basketball team, the Legionnaires, competed at Madison Square Garden in New York City in the metropolitan AAU Championship tournament but lost 39–33 in their opening game before a crowd of eight thousand. Scoring leaders for the Roanoke team were Hugh Hampton and Bob Spessard.

Nearly fifty cows were removed from Roanoke airport property and taken to a pasture off Cave Spring Road. The cows were housed at dairy barns on airport property, and the barns and silos were to be removed to make way for a third runway. The cows and dairy operation were part of the city's department of public welfare.

Postal officials announced that a third contract mail station would be opened in the Williamson Road area pending submission of bids. Two other contract mail stations were located at Clore's Drug Store on Grandin Road in Virginia Heights and at Stiff's Villa Heights Pharmacy on Lafayette Boulevard.

Roanoke native George Freedom Abrams fought Tony Zale at Madison Square Garden in New York City for the National Boxing Association's 160-pound title on November 28. The fight was broadcast live over WSLS radio. Zale defeated Abrams by decision following a fifteen-round bout and became the first undisputed middleweight boxing champion in a decade. An interesting side note is that Abrams was the first baby born in Roanoke on Armistice Day, and the city's mayor suggested to the parents that his middle name be "Freedom" in honor of his birth date. The parents agreed.

Former world's pocket billiards champion Willie Mosconi gave an exhibition of his talents at the Jefferson Recreation Parlors. Mosconi was on a tour of various pool halls in southwestern Virginia.

The *Roanoke Times'* All City-County football team for 1941 consisted of the following high school players: Dave Smythe (Jefferson), Bob Jett (Lewis), Joe Spencer (Lewis), Dink Engleby (Jefferson), Ed Carter (Byrd), Leroy Etter (Fleming), Charlie Rush (Jefferson), Harold Garrett (Lewis), Harry Walton (Jefferson), Pete Fuqua (Byrd), and L. D. Wilson (Fleming).

Officials at the American Viscose rayon plant in Roanoke reported that their operation produced two million pounds of rayon weekly.

More than a hundred contractors joined the Roanoke Builders Exchange, Inc., which was organized the first week of December. F. H. Vest was chairman of the membership committee.

A study group reported to the Roanoke School Board that Gilmer School should be closed due to the conditions of the building. The oldest portion of the school was built in 1885 and was known as the "Third Ward School" until 1893. It was the second white school organized and the first school to be built by the school board, which was organized

in 1883. Additions were made to the school in 1898 and 1907. Gilmer was used by white children until 1934, closed for a year, and then reopened as a school for black children in February 1936. The school was located at 316 Gilmer Avenue, NE, and at the time of the report was the oldest school building in the city system.

The Roanoke Poultry Association held a poultry exhibition at the Roanoke Auditorium where some 1,400 birds were listed for display. Among them were 812 Cornish hens and the exhibit became the largest exhibition of Cornish fowl in the world according to the American Poultry Association. The previous record was 496.

The Salem-Roanoke Friends baseball team was sold by the Ryan family to S. F. Radke and W. E. Norment, both of Roanoke. The deal was approved by the commissioner of minor league baseball. The two Roanoke men purchased thirty-five of the forty-one shares in the team, and this was their first venture in owning a baseball team.

Roanoke's John Hammond captured first prize of $150 in the Jefferson Recreation Parlors' annual duck pin bowling tournament. Lou Jenkins was second.

Earl "Father" Hines and his orchestra performed for a blacks-only dance at the Roanoke Auditorium on December 3. He was accompanied by Madeline Green and Buddy Eckstein and billed himself as the "trumpet style" pianist. At the Lee Theater, Tony Pastor and his orchestra performed.

The new Vinton library opened in early December, having been delayed by a month due to a missing part for the furnace. The library had five hundred books.

Dorothy Gish and Louis Calhern appeared in three performances at the Academy of Music on December 8 and 9 in a production of *Life With Father*. A reception for Gish was held at the home of Mrs. James Jamison on Walnut Avenue, as Gish and Jamison knew each other when students at Alleghany Collegiate Institute in West Virginia.

The Gilbert and Sullivan Light Opera Company of Roanoke presented *The Mikado* at the Academy of Music. The chorus consisted of fifty-three voices accompanied by a ten-piece orchestra. The light opera company had been formed in 1933, and this was their first production at the Academy of Music.

The Rio Grande Rangers gave a stage performance at the Salem Theatre, and the group featured Paul Ballew, Smiley Wilson, Howard Platt, and Carroll Frady. The group was widely known on radio and based in Texas.

The nation's top tennis players were secured to play an all-star match at Roanoke Auditorium on February 9. The announcement was made by promoters Bill Judy and Charley Turner. The pros slated to appear in 1942 in Roanoke included Fred Perry, Frank Kovac, Don Budge, and Bobby Riggs.

A school study committee suggested that Lee Junior High School be abandoned as a school due its downtown location. The school was one of seven schools the committee was reviewing. While the building was in good condition, the committee felt the school could be adapted as an office building. The school was located at Franklin Road and Second Street (where the Poff Federal Building stands today). At the time of the report, the school had an enrollment of nine hundred students. The school was built in 1912 at a time when the business sector of Roanoke was several blocks away.

In the immediate aftermath of the Japanese attack on Pearl Harbor, the Roanoke city police chief, Maj. James Ingoldsby, reported publicly that there were no Japanese living in the city. "We talked to a few Chinese in town and they told us there isn't a Japanese anywhere near here," said the major. In light of the attack, the *Roanoke Times* and *World*

News printed extra editions to keep readers posted of the latest wire reports such that extra newsboys were called in and massed at the circulation department, and customers formed lines outside the newspapers' headquarters on Campbell Avenue. The local chapter of the America First Committee, a group devoted to an isolationist position, abandoned their commitment and announced unity with any and all patriotic organizations determined to fight Japanese aggression. At the Roanoke airport, all private commercial planes were grounded by the CAA, the purpose being to investigate the citizenship and loyalty of all area pilots. Only military craft were allowed to use the airport until such time as the CAA rescinded its order. The airport was also placed under twenty-four-hour guard, and the airport manager and assistant manager were sworn in as city police officers. WDBJ and WSLS remained on the air past midnight, providing news reports through their respective national networks.

The American Viscose plant in southeast Roanoke granted a five-cent-per-hour raise to all male workers and a three-cent-per-hour raise to females. The new wage scale had been negotiated with company officials by the CIO Textile Workers Union of America. There were 3,600 workers employed at the Roanoke plant.

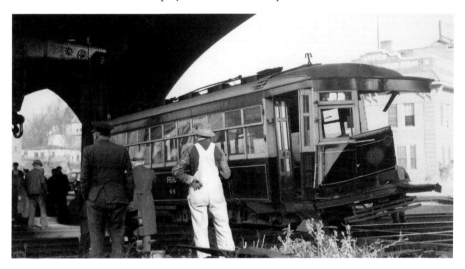

Brill Car No. 44 after a collision with a Virginian Railway locomotive under the Walnut Street Bridge, December 1941. *Virginia Room, Roanoke Public Libraries.*

In Salem, the town council adopted on second reading a comprehensive zoning ordinance to regulate building within the town at its meeting on December 8. No one opposed the first-ever zoning ordinance that contained five districts to regulate various types of and character of businesses.

A large fire destroyed five buildings of the Valley Lumber and the Roanoke Cooperative Company on the night of December 10. The buildings were located on Brandon Road near the intersection with Franklin. Total damage was estimated to be $70,000.

American Airlines officially began regular service to Woodrum Field on December 15, following the installation of their radio service. Officials at Woodrum Field also

announced that private pilots must be relicensed by the CAA by providing fingerprints and letters of reference per new regulations of the CAA.

Roanoke landowner Jacob Hoover died on December 11 at age seventy-six. Hoover came to Roanoke in 1891 and owned a large farm in southeast Roanoke. Much of his land was purchased for the construction of the American Viscose plant. He held the distinction of opening the first cash grocery store in Roanoke, the Spot Cash Grocery, in 1900, and was a developer of the Morningside Heights residential section and a founder of the Ninth Street Church of the Brethren.

The first airmail service with American Airlines launched on December 15. In honor of the occasion, a special cachet bearing the likeness of Congressman Clifton Woodrum was provided. The cachet had been approved by the Chamber of Commerce. Airmail and passenger service with American Airlines officially resumed on that day when a westbound airliner set down at Woodrum Field at 2:30 p.m. Almost 2,500 pieces of airmail was sent out of Roanoke that day on two American Airlines planes. This was the first scheduled stop by American Airlines in Roanoke since August 31, 1937. C. L. Kidd, a postal employee, drove the first bag of airmail to the airport. The first American Airlines passenger plane to come to Roanoke that day was the Flagship Holyoke, which carried sixty passengers to Washington, DC. Kenneth Kemp was manager of American Airlines' operation in Roanoke.

Sidney Small was named the coordinator of all home defense organizations in the Roanoke Valley. Small, an official with the N&W Railway, shared that an office for civil defense would be open soon either in the municipal building or school administration offices.

The US Census Bureau reported that their housing census for Roanoke City showed that the average home rental price was $25.61 per month and that 47.6 percent of all dwellings were owner occupied.

Historic flags that belonged to the Joe Lane Stern battalion of the American Defense League, the home guard of World War I, were presented to the Roanoke-Salem battalion of the Virginia Protective Force, which was charged with the same duties for World War II.

A school review committee report on Jamison School provided some history. The school, located at Jamison Avenue and Fourteenth Street, SE, was built in 1916, with eight rooms added in 1922. By 1941, the school had twenty-four rooms and an enrollment of 765 students. Peak enrollment was in the late 1930s with 1,374 students, prior to the construction of Morningside School.

Pouring of the concrete for the east-side stands at the municipal stadium (later known as Victory Stadium) was completed the second week in December.

Bob Spessard, one of the greatest local men to play basketball, played his last game with the American Legion team on December 13 and was presented a watch by the Legion. Spessard was a basketball star at Jefferson High School and at Washington & Lee College. This was Spessard's last game because he had enlisted in the army.

The US Office of Civilian Defense ran full-page instructions in local papers with large letters asking, "What to do in an air raid?" The ads outlined six steps: keep cool, stay home, put out lights, lie down, stay away from windows, and enlist as a volunteer at the local Civil Defense office.

This is a section of Southeast Roanoke in the 1940s, with
Jamison School in the background. *Mattie Forbes.*

The Roanoke Theatre presented a road show combination film and live performance
Flaming Passion. Billed as risqué and daring, the theatre boasted separate shows for women
and men "due to the delicate nature of these presentations." Rosa Lee appeared on stage,
and the film was *Assassin of Youth*. After showing for two days at the Roanoke, the produc-
tion moved to the Salem Theatre for a special midnight showing.

The final professional wrestling card for the year held in the Roanoke Auditorium
from promoter Bill Lewis was a mat card between Bobby Bruns and The Swedish Angel
and also featured a wrestling match between two women, Mildred Burke and May Weston.

Two Roanoke families were notified that their sons had been killed in action in mili-
tary service. Both were in the navy, and while naval officials could not disclose the loca-
tions of their deaths, it was presumed by the families to be at Pearl Harbor. The two men
were Wilson Brown, twenty-seven, son of Mr. and Mrs. G. L. Brown of Arbutus Avenue,
SE; and Billy Blackwell, twenty, son of Dr. R. J. Poff and Mrs. Grace Blackwell Poff,
Courtney Avenue in the Williamson Road section. They became the first two local casual-
ties of war since the United States formally entered World War II.

Some two hundred local pilots swarmed Woodrum Field on December 16, present-
ing their credentials to have their pilot's licenses reinstated. The flyers had to present
their fingerprints, birth certificates, photographs, and letters of reference to visiting CAA
officials.

The Roanoke city Community Christmas Tree was put in place on December 17
at the Campbell Avenue entrance to the city's municipal building. The nineteen-foot
cedar tree was under the care of the recreation department, and the city provided all-day
Christmas carols over a loudspeaker.

During the final days before Christmas, local merchants were advertising their mer-
chandise. Sears & Roebuck had Elgin bikes for boys and girls at $26.95; Thurman &

Boone launched a 25 percent off sale on toys, such that scooters were $1.98 and wagons were $4.69; Fink's Jewelers carried Bulova watches for $27.50 and a fifty-four-piece silver-plate set for $29.75; People's Drug Stores advertised Woodridge Assorted Chocolates at $1.00 for a four-pound package; and Grand Piano had club and wing chairs for $17.50. At Oak Hall, men's topcoats were $12.95, while Glenn-Minnich's boasted their new apparel in the College Shop department.

Christmas baskets of food, clothing, toys, and other gifts were delivered to nearly six hundred Roanoke families identified by the Christmas bureau of the Community Fund.

Four hundred fifty persons volunteered for civil defense work in Roanoke city on the first day of enlistment; this included 177 women and 273 men. In Roanoke County, the number was 105, but some sections did not give a complete report.

W. E. Norment was elected president of the Salem-Roanoke Friends class D Virginia League baseball club. Norment, along with S. F. Radke, had earlier purchased a controlling interest in the team.

Shenandoah Life Insurance Company, following the practice of many other insurance businesses, announced that it would be adding war risk and travel and aviation exclusion provisions on all policies issued after December 26.

The Norwich streetcar line closed on December 28, and buses were substituted to serve the neighborhood. Only two streetcar lines remained open, the Belmont-West End and the Raleigh Court-South Roanoke.

Roanoke postal officials stated that Christmas mail broke the previous record for volume of mail handled by Roanoke, set the previous year. The 1941 total was 1,631,700 cards and letters.

The J-603 rolled out of the N&W Railway shops on Christmas Eve, the nose decorated with a Christmas wreath. The J-604 was expected to be ready in January. The J-603 was slated to be put into regular service on the Pocahontas, replacing the No. 206 that would begin serving the Cavalier.

The Bing Social Club presented Claude Hopkins and his orchestra in a blacks-only dance at the Roanoke Auditorium on December 26. Tickets were available from the Dumas Hotel, Gainsboro Pharmacy, Gilliam Finney Cafe, Community Drug, and Mae's Inn at Salem. White spectators were permitted.

The Roanoke Crackshots, a black semipro basketball team, played against the Leaksville (North Carolina) Comets in late December. The Crackshots, composed mostly of former college players, was managed and owned by Sam Hylton, the doorman at the Hotel Roanoke. The Crackshots were scheduled to play teams from Norfolk and Hampton over the next several weeks. The team was coached by Sunny Thomas, who also played. Other starters included Leon Curtis, Leon Fields, Jack Campbell, and Charlie Marshall.

Marilene Poff, seventeen, a student at Jefferson High School, died in an auto accident at the intersection of Shenandoah Avenue and Twenty-Fifth Street, NW. Three other occupants in the car were injured.

R. H. Smith, vice president and general manager of the N&W Railway, was promoted to vice president in charge of operations effective January 1. Smith began his career with the N&W in 1910 in the engineering department. The railway also announced that J. E. Crawford, a vice president of the N&W, would retire on December 31. Crawford had been with the railway for thirty-eight years. Crawford was immediately named by

Roanoke officials as priorities officer for the rationing of rubber products in the city given the ration placed on rubber tires nationally, effective January 5. Crawford would be aided by an advisory board that included Horace Wood, Rabbi Morris Graff, and Courtney King.

The Hunton Life Saving and First Aid Crew, sponsored by the William Hunton Branch of the YMCA, elected C. C. Williams as its first permanent president and Luvelle Taylor as its first permanent captain. The officers were to be installed at a public ceremony on January 12.

A review of the Gainsboro School determined that it suffered from the poorest condition of all schools in the city. The school had 480 students that learned in rooms individually heated by coal stoves. The twelve-room, all-black school was so crowded that all students through the fourth grade could only attend for half-day sessions. Further, each teacher had an assignment of fifty-four students. There was no playground, except for a field across the street that belonged to St. Andrews Catholic Church. The school had been built in 1898, and its general condition had been rated by a review committee as "unsatisfactory."

Siegfried Hirsch, a former refugee and German military veteran of World War I, sent his German military medals to the US government's metal-reclaiming project, stating that he was glad to be in the United States and was not supportive of his native country. Hirsch, a resident of Roanoke, had come to America in 1938. He had owned a large department store in Wuerzburg, Germany, and had been forced to sell the store for a fraction of its value. He and his wife had two sons, both students at Highland Park School. Mrs. Hirsch was chairman of the local Americanization Committee.

1942

On January 1, the ownership of the W. C. Hughes department store in Vinton, one of the oldest businesses in the town, changed hands with the purchase of the store by O. Goode of Bedford. The store had been owned previously by Mr. and Mrs. W. C. Hughes since they first opened in 1920.

At the beginning of the year, local banks published their December 31, 1941, financial positions. The following institutions reported total resources or assets: Mountain Trust, $7,932,855; First National Exchange, $41,242,280; Liberty Trust, $2,455,474; First Federal, $2,428,113; Roanoke Industrial Loan, $388,497; Morris Plan Bank, $31,632,700; Liberty Trust, $2,455,474; and Colonial-American, $8,509,790.

A federal policy limiting the production of tires began being felt in Roanoke when Virginia announced a county-by-county tire quota system based on population. For Roanoke (including both city and county) the quota for the month of January was eighty-nine new tires and seventy-five tubes for passenger cars, light trucks, and motorcycles. Auto dealers also temporarily halted the sale of new cars due to reports from Washington, DC, that automobile production would be severely cut due to the war. Some dealerships began the process of reducing their sales staff.

Famous CBS news radio correspondent Edward R. Murrow gave an address at the Academy of Music on January 11. His talk was entitled "Britain and America in the First Year of the War." Murrow had been covering the war in Europe for CBS. The program drew a crowd of seven hundred persons.

The local office for the Office of Production Management (OPM) opened at the Roanoke Chamber of Commerce. The bureau was created to address problems confronting local businesses due to federal quotas and regulations prioritizing needs for the war effort. William Daniel was the field service analyst for the OPM serving Roanoke.

"Longwood," the former Salem home of Mr. and Mrs. Thomas Cooper, went up for sale at a public auction on the Salem courthouse steps on January 10. The home and surrounding acreage were purchased by the town of Salem for $20,000. The home was built in 1904, and there were approximately fifteen acres of land surrounding the home site.

The Rev. William Simmons became the pastor of the Fifth Avenue Presbyterian Church in Roanoke, coming from New York City. The church was founded by Rev. L. L. Downing in 1893, who served the congregation continuously until his death in 1937. The church had been without a regular minister in the interim.

Roanoke city schoolteachers began conducting air-raid drills in their classrooms in January, and the school superintendent encouraged teachers to have students use

The former sanctuary of Fifth Avenue Presbyterian Church was at the corner of Patton Avenue and Third Street, NW, 1940. *Virginia Room, Roanoke Public Libraries.*

blackboards in the room rather than paper for in-class assignments due to the need to conserve paper. In other war-related activity, the Roanoke police chief reported that numerous "enemy aliens" living in the city had turned in cameras and shortwave radios in compliance with federal orders. J. E. Crawford was named as head of the Roanoke tire rationing board. Crawford Oakey was named as chief air-raid warden for the Roanoke area.

The Lee Theatre hosted Dorothy Shaffer, billed as "London's Fastest Tap Dancer," in three live stage shows titled *Revue of Tomorrow.*

Mr. and Mrs. Pat Di Cicco spent the night at the Hotel Roanoke on January 7. Mrs. Di Cicco was Gloria Vanderbilt, the seventeen-year-old heiress to a $4 million fortune. The newlyweds had stopped at the hotel on their way to New York, where they planned

to visit her parents. The nationally known couple had exchanged vows in California on December 28 and were touring in their $10,000 "car of the future," of which there were only ten in existence.

Roanoke was the featured city on Major Bowes's nationally broadcast radio program *Original Amateur Hour* on CBS. Representing Roanoke was Norris Perry, a local baritone and clothing salesman. The broadcast occurred on January 8.

A school review committee advocated closing Norwich School and sending its students to Virginia Heights Elementary. It was the smallest school in the city with four classrooms and an enrollment of 112 students. The school went through the fourth grade.

Sunnyside Awning and Tent Company, 119 Franklin Road, advertised for the early sale of blackout shades for homes and offices. National Business College announced it was giving up its basketball for the 1942 season and probably for the duration of the war as most of the players would be called up for active duty.

Roanoke's Legionnaires basketball team played against the All-American Red Heads, an all-female team that played only male opponents. The game was held in the Roanoke Auditorium. The Legionnaires won, 52–34.

As a demonstration of patriotism, a flagpole was erected on the front lawn of Jefferson High School and formally dedicated in a ceremony on January 14. Each morning at the start of school, the student color guard planned to raise the flag.

Motor vehicle "use" stickers went on sale at the post office in early January. The cost per stamp was $2.09, and the sticker was to be displayed on the rear glass of a car.

Miss Jacqueline Richardson, nineteen, of Hampton Avenue, was employed by the Roanoke police department as a stenographer and became the first female to be employed by the department. She began her duties on January 16.

Roanoke city officials announced that air-raid sirens had been installed at the Crystal Spring pump station.

Hollywood actor John Payne, a native of Roanoke, announced his divorce from Anne Shirley. He and the actress had been married over four years and had a daughter, Julia Anne.

The Roanoke County Board of Supervisors adopted a resolution that was presented to the Roanoke City Council asking that the annexation proceedings against the county be postponed until after the war. The board argued that the annexation process would hinder defense efforts ongoing in the region.

All German, Italian, and Japanese nationals were required to report themselves to the nearest post office for a certificate of identification during the month of February, in accordance with regulations adopted by the Department of Justice. The process was overseen locally by US district attorney F. S. Tavenner.

The Vinton Town Council gave permission for the American Telephone and Telegraph Company to have a franchise for the purpose of laying underground conduit through the town for its new long-distance service between Richmond and Roanoke.

Ten-year-old Claude Bush of the Mount Pleasant section was accidentally killed by his friend, Charley Simmons, eleven, when the two boys began playing with a loaded shotgun in the Simmons home. The coroner ruled the death accidental.

H. C. Nerren retired as manager of the Roanoke Viscose plant effective January 31. He managed the Roanoke operation for twenty-one years. Nerren had come to Roanoke

This January 1942 image shows the interior of the Hotel Roanoke garage. *Norfolk & Western Railway Historical Society.*

in 1917 to oversee the construction of rayon facility. Nerren was succeeded by George Allen.

Norman-Shepherd, Inc., (formerly John Norman, Inc.) began advertising army, navy and marine uniforms, both stock or tailored. The firm was located on South Jefferson Street, over the Park Theatre.

Balochie's Market at 215 Nelson Street opened on January 23. The proprietor was D. C. Balochie, former partner of the Quality Produce Company. The location had previously housed Etzler's Market.

A long-range plan for Roanoke's parks and recreation was presented to the Roanoke Recreation Association. The eighty-seven-page report called for the construction of fifteen additional playgrounds (eleven were in use at the time), three more playing fields, five municipal swimming pools (Highland Park, South Roanoke, Fallon Park, Washington Park, and Fishburn Park), and an eighteen-hole municipal golf course adjoining Fishburn Park. For Mill Mountain, the report advocated the construction of a rustic stone tower at its top, along with picnic areas, an amphitheater, three terraces, renovation of the inn into a recreation hall, hiking trails, and a cafe. The plan had been spearheaded by F. Ellwood Allen, a specialist from the National Recreation Association.

UVA and VPI men's basketball teams played a regular season game at the Roanoke auditorium on January 23. Virginia Tech beat the Cavaliers 42–25.

The Roanoke Ministers' Conference sponsored a two-week-long series of revival services in the city by bringing in Bishop Arthur Moore of Atlanta, Georgia, and president of Wesleyan College. To kick off the event, some five hundred guests attended a banquet at the Hotel Roanoke representing various civic organizations. Some six thousand Roanokers attended the first service held at the Roanoke auditorium.

The Civilian Defense program in Roanoke included an air-raid protection plan with the city being divided into five zones, with each zone having air-raid wardens. The program was coordinated from an office in the city police headquarters, and Crawford Oakey was the city's chief air-raid warden.

Angus Swink, a native of Roanoke, who rose to become president of the Atlantic Life Insurance Company, a position he held from 1929 to 1937, died in Delray, Florida, on January 26. He was born in Roanoke on February 6, 1885.

N. W. Kelley, president-treasurer of the Southern Varnish Corporation, was elected president of the Roanoke Chamber of Commerce, succeeding Frank Rogers.

Lights went out in Roanoke College dormitories at 10:50 p.m. as college president Charles Smith instituted new wartime physical preparedness on the campus for all students, including compulsory physical education classes. A lone bugler sounded a warning ten minutes before the blackout. At 7:00 the next morning, the bugle sounded again, and students were expected to go through "setting up" exercises at 7:10.

Local pilots, grounded since the attack on Pearl Harbor, were able to resume flying at Woodrum Field on January 29, providing they had obtained certification from the CAA inspector.

The Roanoke Truck Depot, Inc., began construction of a $28,000 terminal and warehouse for handling freight on the north side of Lynchburg Avenue, between Fifth and Sixth Streets, NW. J. C. Center was the contractor.

Robin Hood Park on Williamson Road opened its new indoor bowling alley in late January.

The Norfolk & Western Railway announced that it would pay the difference in salaries its employees who are members of the Virginia Protective Force received from the state while on guard duty and what they would otherwise earn with the railroad.

State Senator Harvey Apperson of Roanoke County introduced legislation that would prevent Roanoke City from proceeding with its annexation process citing the war emergency.

Dr. Harry Penn was a dentist and prominent leader in Roanoke's civil rights movement during the 1940s. *Harrison Museum.*

Some 325 newspaper boys began collecting money for defense stamps from customers. The Defense Savings Stamps program was a federal effort to help fund national defense. The stamps were 10 cents each.

A "traffic gun" was first used at Woodrum Field on January 29. The gun threw a red, green, or white light beam on pilots in the air or on the ground, signaling to them what they were to do.

Dr. Harry Penn, a black dentist, formally entered as a candidate in the Democratic primary for Roanoke City Council. He announced on January 31 and became the first black citizen to run for office in the city. At the time of his announcement, he was one of seven primary candidates for three seats. Dr. Penn was supported by the Roanoke Civic League, an organization that represented several black civic organizations. In his announcement, Dr. Penn said, "I believe the colored citizens can be stimulated to unlimited service in helping

improve our city, that they should have representation through a member of their race, and that such a member can and will be of service to the entire community, both colored and white."

Cawthorn Bowen, sports columnist for the *Roanoke Times,* penned his final column for the paper on February 1. In reflecting back on his coverage of local sports, he declared that the "Five Smart Boys" of Roanoke College's basketball program were the greatest team to ever play in the region and that the "Splinter Bowl" played on Thanksgiving Day in Roanoke between VPI and VMI in 1938 was a game for the ages in that the stormy weather ended up being the real star of the match and gave impetus for a new stadium.

Virginia Spratley, ninety-three, of Petersburg was identified as the oldest Hollins College alumna during the college's centennial year. Ms. Spratley attended the college in 1867 and recalled her memories of the school in an interview. She said that in 1867, there were only two buildings (the East and West Buildings). "No boys were allowed on the place," she said, and every Sunday the girls would be taken to a local church for worship services by a four-horse omnibus. She recalled the annual Tinker Day, when students and faculty would hike to the top of Tinker Mountain.

State senator Harvey Apperson argued before his senate colleagues that if Roanoke City's annexation process were to continue, it may result in the loss of the Viscose plant to another state or region. Apperson stated that when Viscose located just outside the corporate limits of Roanoke, it did so to avoid city taxes. Apperson and other county legislators had introduced bills to stop the annexation, citing the war emergency. The next day in the House of Delegates, a House version of Apperson's bill reported out of the General Laws Committee on an 8–5 affirmative vote. Roanoke City delegate Earl Fitzpatrick argued passionately against the bill.

Jack Butler, president of the Academy Players, a local theatre group, announced that Hollywood actor and Roanoke native John Payne would perform as one of the characters in their production of *The Man Who Came to Dinner* at the Academy of Music on February 3. Payne was in town visiting family and agreed to make an appearance during one performance of the play.

A record ten candidates met the filing deadline to run in the Roanoke Democratic primary for three seats on the Roanoke City Council. The candidates were J. C. Martin, J. T. Sutherland, W. B. Clements, Leo F. Henebry, W. M. Powell, Benton O. Dillard, Courtney King, Claude Evans, L. E. Lookabill, and Harry T. Penn.

At the conclusion of the citywide two-week revival services, Bishop Arthur Moore completed his series in an address to a crowd of five thousand persons who packed the Roanoke Auditorium. It was estimated that total attendance for the revival series was seventy-five thousand. Moore had preached a revival in Roanoke previously in 1918 in a tent.

The Roanoke City Council granted permission to the State Corporation Commission to erect a small marker in Elmwood Park in honor of President George Washington's mother. It was to carry the following caption: "At Sandy Point, 7 and ½ miles east, Mary Ball, Washington's mother, spent her youth in the home of her guardian, George Eskridge. There she was married to Augustine Washington in March 1731. She is supposed to have named her eldest son for George Eskridge."

The Roanoke City Council opposed a plan to postpone ongoing construction of the municipal stadium as the raw materials for the project were on site. Blackwell Engineering and Construction Company had been asked by the army to suspend work on the stadium in order to concentrate their men on the installation of a sewage treatment plant at Camp Pickett.

Fred Perry beat Bobby Riggs in an exhibition tennis match held in the Roanoke Auditorium on February 9. The two were playing in an all-star tennis tournament that was touring the nation. Donald Budge beat Lester Stoefen in the second exhibition match. Some eight hundred attended the event, and Riggs spoke at William Byrd High School earlier that day.

In a major victory for Roanoke City, the Virginia House of Delegates killed a bill that would stay the city's annexation proceedings. The vote was forty-three to thirty-eight. Roanoke city delegates Earl Fitzpatrick and Walter Scott had led the opposition to the measure.

A large service station for trucks opened at Third Street and Dale Avenue, SE, where once stood one of the oldest homes in Roanoke, the William Cook property. The home had been built around 1880 by T. C. Blair and sold to Cook in 1891. The station owner was J. G. Holt, who used limestone from the home's foundation to build a wall around the station.

The Safety Motor Transit Corporation began painting city buses and streetcars with "war paint," a brown-green paint believed to aid in camouflaging the equipment. The roofs and sides of the buses and cars received the government-approved paint.

Formal opening services for the new Associate Reformed Presbyterian Church, located at Lee and Lincoln Avenues in the Williamson Road section, were held February 15.

Roanoke restaurant owners began rationing sugar, removing sugar dispensers from tables, and offering one tablespoon of sugar for beverages, cereal, and grapefruit. This was in response to a national sugar rationing program.

Charles Brown, chief registrar for Roanoke City's draft boards, reported that 14,843 men between the ages of twenty and forty had registered. Registration began on October 16, 1940.

B. M. Davis offered to sell the city of Roanoke 5.18 acres of land on Mill Mountain for $1,500. The acreage was bounded on the east by Sylvan Road, on the south by Mill Mountain Incline Railway right-of-way, and on the west by Park Road. Council referred the offer for further study.

Roanoke City formally filed a petition for annexation in Roanoke County circuit court on February 19, with the three-judge trial set for March 30.

The volunteer firemen of Vinton gave notice to the town's elected officials that unless a full-time paid fireman was hired and better equipment guaranteed by March 1, they all planned to quit. The firemen stated that they lacked even one good hose.

The Roanoke School Board approved a list of several capital projects, among them a new junior high school in northwest city estimated to cost $375,000 and a large addition to Woodrow Wilson Junior High School that would create an auditorium and gymnasium for the school.

Dr. Reinhold Niebuhr of Union Theological Seminary in New York was the main speaker at Hollins College for the school's annual Founder's Day celebration. The famed

theologian gave a speech on the need for a worldwide brotherhood in the face of global war. Founder's Day was in honor of the birthday of the college's founder, Charles Cocke, and students and faculty processed to place wreaths on the graves of Cocke and his wife in a cemetery on a hill near the campus.

Nearly 120 homemakers gathered in Smith Hall at Salem to hear a presentation on "How to Black Out a Home in a Practical and Economic Way." The program was sponsored by the Roanoke County home demonstration agents in concert with the Civilian Defense office.

John Mundy, fifty-six, died at his home on Cornwallis Avenue in South Roanoke on February 23. Mundy was a former member of the Roanoke City Council and owner of Mundy's Cigar Company, located at 15 W. Church Avenue. He came to Roanoke in 1900 as a clerk for the N&W Railway and entered other professions before opening his cigar store in 1927. He served on the city council from 1930 to 1934.

Famed pianist Josef Hoffman performed to a capacity crowd at the Academy of Music as he played various pieces from classical composers. His appearance was sponsored by the Community Concert Association, an organization formed in 1932 for the purpose of bringing musical programs to the city.

Some seven hundred delegates from across the state participated in the annual meeting of the Baptist General Association of Virginia convention held in late February at First Baptist Church, Roanoke. The convention adopted a resolution supporting equalization of pay for black and white public-school teachers in the state and the end of racial discrimination in the national defense program.

Two sisters, Ella May and Betty Jane Smith, ages twelve and ten respectively, were killed on February 27 when they were struck by a train, The Tennessean, westbound out of Roanoke, on a bridge crossing the Roanoke River just south of Elliston. The girls raced to escape the oncoming train and were killed just a few feet from safety. The girls were walking home from school.

Appalachian Electric Power sent notices to businesses that after March 1 it would be the responsibility of business owners, not the power company, to turn off lights after 6:00 p.m. during blackouts.

Roanoke short-story writer Nelson Bond addressed the meeting of the Roanoke Writer's Guild at the Hotel Roanoke on March 5.

The Shenandoah Life Insurance Company reduced its board of directors from sixteen to eleven members, and Richard Leftwich was promoted to the position of general counsel for the company. Paul Buford was reelected to another term as board president.

The Roanoke Symphony Orchestra announced that pianist Andor Foldes would present a concert on March 15 at the Academy of Music. The pianist was a native of Hungary, and his appearance in Roanoke was due to his friendship with the orchestra's conductor, Donald McKibben.

In what was believed to be a first, a white man gave a blood transfusion to a black man, Willie Bruce, at Burrell Memorial Hospital, according to Dr. L. C. Downing. The patient had been shot in the back when a pistol in his car accidentally discharged. The transfusion saved Bruce's life, according to Downing. The man who provided the blood for the transfusion had worked with Bruce since 1937, and his name was not provided.

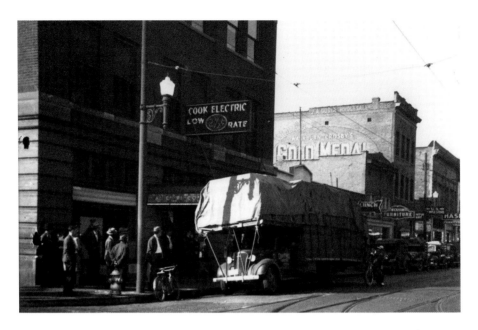

Appalachian Electric Power Company's headquarters were at 129 E. Campbell Avenue in the early 1940s. *Virginia Room, Roanoke Public Libraries.*

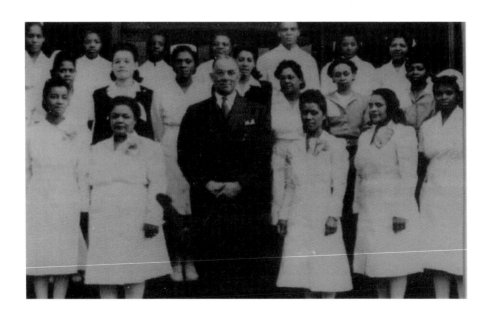

Dr. L. C. Downing and Burrell Memorial Hospital staff members are shown in this 1940s photo. *Harrison Museum.*

The cost of Roanoke city government for 1941 was $38.37 per capita according to city officials. That number was above the 1940 figure of $36.24. According to the city auditor, property tax revenue accounted for 63 percent of the budget. The largest share of the city's budget went for public education followed by debt service.

Members of the new Northminster Presbyterian Church for the Williamson Road section met at William Fleming High School on March 1 for the purpose of formally organizing a congregation. Dr. Charles Logan was the pastor for the new church, having returned from Japan as a missionary. Some seventy-five persons attended the service.

City manager W. P. Hunter publicly announced the air-raid rules and regulations for Roanoke. They were as follows: (1) an air-raid warning signal shall consist of a series of short blasts from sirens, whistles, and other devices and last two minutes; (2) all vehicles in operation must be pulled over to the side of the road and turned off; (3) if a warning occurs between sunset and sunrise, all lights must be turned off until a clear signal is given; and (4) no person shall wear, exhibit, display, or use for any purpose any emblem or insignia used for civilian defense unless approved or authorized by the City of Roanoke. The first official partial blackout night occurred on Monday, March 2, as Roanoke was within the three-hundred-mile inland boundary deemed a target zone by defense officials.

Col. J. Sinclair Brown was named Roanoke County's civilian defense director. Brown was a former delegate in the Virginia House of Delegates, where he served as speaker, and was president of the Farmers' National Bank of Salem at the time of his appointment.

A large number of box turtles arrived from Florida for the junior chamber of commerce's turtle derby held in the Roanoke Auditorium on March 5. The derby was under the direction of Dick Pence and Dick Edwards. Over 150 turtles had been sponsored by various businesses. The event drew eight hundred spectators, and the winning turtle, named Castor Oil, was sponsored by Capitol Drug Store.

The Campbell Avenue Pharmacy held a close-out sale, including store fixtures, as it prepared to end business. The pharmacy was located at 501 Campbell Avenue, SW.

A local branch of the National Association for the Study of Negro Life and History was organized and met at the YMCA in late February. Lewis Sydnor was president, and other officers included Sallye Terrell, Georgia Brown, Ernest Finney, and Dr. L. E. Paxton.

The price for a single copy of the *Roanoke Times* increased from three to five cents on March 2.

The partial closing of the Catawba Civilian Conservation Corps camp was announced for mid-March. The camp was built in 1933, when the CCC was instituted. At the time of the announcement, the camp was housing 125 young men, most of whom would be moved to other camps. The camp had twenty-five buildings and was one of the first constructed in Virginia. Approximately five thousand boys had been trained at the camp in the nine years it was open. In 1939, the repair shop was constructed for working on CCC trucks. Those at the camp had constructed a truck road and path on Catawba Mountain to aid access for firefighting.

Sugar rationing instructions were received by the Roanoke clerk of court on March 4 to be given out with war ration books. First stamps in War Ration Book 1 were to be used for the purchase of sugar.

This is the Civilian Conservation Corps camp at Catawba in 1942. *Virginia Room, Roanoke Public Libraries.*

Roanoke received five inches of snowfall, but schools remained open despite a 30 percent absentee rate, according to the school superintendent. The principal at Jefferson High School attributed his absentee rate not to the inability of students to travel to school but that too many boys were making money shoveling sidewalks.

The State Conservation Commission placed a historical marker for Roanoke in Elmwood Park on March 6. The three-and-a-half-foot square cast-iron marker honored the founding of Roanoke, which was previously known as Big Lick and had also been laid off as a town named Gainesborough in 1839.

The US Army Corps of Engineers shared with Roanoke officials that flood reduction along the Roanoke River was cost prohibitive. The corps had explored the possibility of building a reservoir upstream from Roanoke. The flood in August 1940 had caused an estimated $243,000 worth of damage according to the corps' report. According to army engineers, the worst flood of record occurred in 1877, and another serious flood was in 1889. In interviews, some of the city's oldest citizens told army engineers that the flood of 1877 went well above the present-time Virginia passenger station site.

The students of Jefferson High School presented their annual minstrel show, *Ebony Escapades of 1942*. Jack Weldon was the director of the two-part minstrel and variety production.

Dr. Noah Robinson, physician, died at his home in Vinton on March 5. Robinson came to Vinton from Hillsville. He had been a physician in Vinton for twenty-five years.

The construction of a new Kroger Grocery and Baking Company supermarket was announced in early March. The new store would be located at 105 Grandin Road in the Virginia Heights section on a site presently occupied by the Homewood Apartments building. The apartment structure would be moved back. The store was estimated to cost $75,000. The site had been acquired by R. W. Cutshall, C. R. Reid, and N. F. Muir,

and they in turn will have the supermarket constructed and then lease it to the Kroger Company.

William Fleming High School defeated Christiansburg High School, 43–40, to win the Western Virginia Class B crown in men's basketball. The Colonels were coached by Fred Smith.

Col. Louis Johnson, a native of Roanoke and a former assistant secretary of war, was appointed by the State Department to lead the US advisory mission to India. Johnson, a veteran of World War I, was a former national commander of the American Legion who was appointed assistant secretary of war in 1936 and served in that capacity until 1940.

Dr. George Braxton Taylor, eighty-one, died on March 9 at his home in South Roanoke. Taylor was a Baptist minister, missionary, and author, and he retired from Enon Baptist Church in August 1940. Taylor was instrumental in founding the Sunbeam Society, a children's organization within the Southern Baptist denomination. He had also served on the faculty at Hollins College.

The Roanoke City Council received notice of an intent to donate nearly ten acres of land for a city park from J. B. Fishburn. The tract was located at the head of Cornwallis Avenue in South Roanoke.

The first class to train women for defense work—making guns, ships, and planes—began at the vocational building of Jefferson High School on March 12. Fifteen women enrolled for the forty-hour-per-week training in working with sheet metal according to Roy Newkirk, program director. The same week Roanoke school superintendent placed containers of sand in the hallways of all public schools so students and faculty could be trained in how to use sand to fight incendiary bombs. Further, all school principals were to be trained in Civil Defense to serve as air-raid wardens. The first full air-raid drill was also conducted on that Friday at Jamison School, involving some 680 students being moved to designated locations and then singing "God Bless America" before the all-clear signal was given.

The new postal station for the Williamson Road area opened on March 16 at the Williamson Road Pharmacy.

William Rutherford's *Court House Square*, an oil painting of the courthouse in Fincastle, won first place for oils in the annual AAUW Art Show in Roanoke that was held at the Elks Club. *Deserted Cabin* by A. H. Huntoon of Galax won first place in watercolors. Ingles Palmer won second place for watercolors with his work *Prayer Meeting*.

The All City-County basketball team was named for 1942 and included the following: Bill Flint, forward (Jefferson); Lewis Cunningham, forward (Fleming); John Owen, center (Fleming); Pete Fuqua, guard (Byrd), and Harold Shelor, guard (Lewis). The first team was selected in a poll among the schools' coaches. Top scorer for the season was Billy Flint, who scored 185 points in seventeen games.

Dennis Goode captured the top prize in the annual Jefferson Recreation handicap bowling tournament. Howard Williams was second and Roy Cook third.

Noted American dancer Martha Graham performed along with her dance company at the Academy of Music on March 21. A pioneer of modern dance, Graham's dance numbers contained plot, characterizations, and emotion that often sought to prick the social conscience of the audience. So popular was the performance that the Roanoke audience demanded six curtain calls.

Dr. Howard Creasy was elected president of the newly organized Exchange Club in Roanoke, a civic organization dedicated to various charitable causes. The club met weekly at the Patrick Henry Hotel.

The Grandin Theatre was purchased from the Shenandoah Life Insurance Company by the Newbold Grandin Corporation for $125,000 in mid-March. Officers of the Newbold Grandin Corporation were Dr. J. L. Newbold, president, and H. N. Fix, secretary. Both men resided in Bramwell, West Virginia. For the past ten years, the theatre had been leased by the Grandin Theatre Corporation, headed by William Wilder of Norfolk. At the time of the sale of the theater building, it was unclear if Wilder's lease was to be extended.

A number of changes to street names were made by the Roanoke City Council following a report and recommendation from a chamber of commerce study committee. In South Roanoke, Lafayette became Longview; in Grandin Court, Greenbrier became Brambleton; and in Waverly Place, Berkeley became Gladstone. The changes sought to eliminate duplicate names for streets in the city. The one glaring omission from the council's action was leaving two Virginia Avenues, one in South Roanoke and one in Virginia Heights. In other council action, on March 16, the council visited Eureka Park to examine a site for a possible new junior high school being advocated by the school board.

The Vinton Town Council voted to discontinue the salary and services of its town manager, H. W. Coleman, who had been admitted to the Mountain Home (Tennessee) Veterans Facility on February 9. The council stated that should Coleman wish to return to work, he would have to first confer with the council.

Charles Ballou was hired as an additional announcer for WDBJ radio. Ballou came from WSVA in Harrisonburg.

Some one thousand women were enrolled in and being trained for home nursing as part of the local civil defense effort. Twenty-four classes were at capacity, with several more to be formed.

The Harlem Globetrotters played against a combination of the Roanoke Crackshots and Lynchburg Owls at the Roanoke Auditorium. The Globetrotters were national champions in 1940. Seating for the event was segregated, with a small section reserved for whites. The Globetrotters won the game, 49–27.

Roanoke Girl Scouts sold 14,410 pounds of cookies during their annual sale, exceeding their goal. Troop 7 of Belmont Methodist Church sold the most, with an average of forty-seven pounds sold per girl.

Work on the Roanoke municipal stadium neared completion by mid-March. The final section of concrete was slated to be poured by April 10, with final completion by June 15. The east side was finished and was ready for the installation of seats.

Former heavyweight boxing champion Jack Dempsey returned to Roanoke to guest referee a three-bout card at the Roanoke Auditorium between Bob McCoy and Barto Hill on March 24.

The Curtain Shop moved to its new location at 408 South Jefferson Street on March 25.

The FBI held a weeklong traffic school for local police at the Hotel Patrick Henry so they would be able to chart plans for leading military convoys through Roanoke and other traffic-related matters during wartime. Some seventy-five officers from Roanoke and other communities participated.

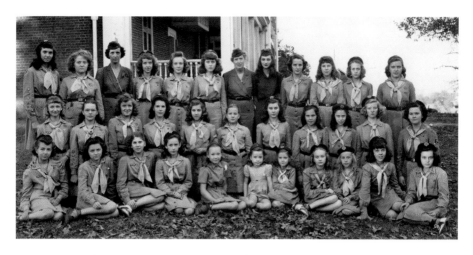

Girl Scouts in the Belmont neighborhood posed in front of the Buena Vista Recreation Center in 1941. *Historical Society of Western Virginia.*

Citizens of the Greenland Hills section in Roanoke County appeared before the Roanoke City Council asking that an arrangement be made whereby they could connect to the city's water supply system. The residential section was being supplied by a private contractor, and those petitioning said that the water supply was insufficient. The Greenland Hills section was being developed by H. E. Sigmon.

Members of Central Baptist Church, Starkey, broke ground for their church in a ceremony on March 24. The Rev. R. L. Chadwick was pastor. Remarks were offered by Rev. Richard Owens of Calvary Baptist Church, Roanoke. Central Baptist was formed in 1905, and at the time of the groundbreaking had a membership of 150. H. D. Aldhizer was the architect for the new structure.

A forest fire burned across nearly six hundred acres on Catawba Mountain, back of the Catawba Sanatorium, on March 24. The fire destroyed a summer cabin, and some one hundred men fought the blaze for a day before containing it. Allan Cochran, superintendent of the Jefferson National Forest, shared that the blaze underscored the lack of manpower to fight forest fires such that he would begin a recruitment campaign among local high school boys to enlist in volunteer fire departments.

The second of sixteen new Y-6-a Mallet freight locomotives came out of the N&W Railway shops and was placed in operation. The first such locomotive was finished in late February.

The Cleveland Symphony Orchestra gave a performance at the Roanoke Academy of Music on March 25. The concert was sponsored by the Roanoke Junior Chamber of Commerce. The symphony was conducted by Artur Rodzinski.

Construction on Roanoke's municipal stadium was temporarily halted in late March so workers could complete the third runway at Woodrum Field and other airport-related projects. The men were being supervised by the WPA.

Roanoke's air-raid filter center was opened on March 26 in the basement of the municipal building. The center had eight dedicated phone lines to receive and place calls to fire and police officials regarding deaths, injuries, and damage in the event of bombing

raids, and a large wall map of the city indicated various emergency shelters and traffic routes.

The new Valley View Free Methodist Church at Hillcrest Avenue and Tenth Street in the Williamson Road section held its formal opening service on March 29. The congregation was organized on January 9. Various clergy from other Williamson Road churches participated in the ceremony.

William L. Shirer, noted foreign correspondent, gave an address at the Academy of Music, about the strength of Nazi Germany. He claimed that a war to defeat them would be protracted. Shirer criticized Americans as being too far removed from the war in Europe and said that a blockade of Germany will not end the war. Shirer was a popular radio commentator with his nationally broadcast *Berlin Diary*.

The "roly-poly comic of the Cisco Kid series" Chris-Pin Martin appeared in person for three performances at the Academy of Music on March 28. With him were his "Mexican Senoritas" performing in a program titled the *Swivel Switch Round-Up Jamboree*.

Men's clothing stores in Roanoke advertised the government-mandated cuff-less pants for the Easter season. All wool suits made or altered after March 30 were prohibited from having cuffs due to war rationing. The Easter style for men was wool pants, plaid sports jacket, vest, and saddle shoes.

Allan Cochran of Roanoke was appointed supervisor of the Jefferson National Forest. Cochran had served in various capacities with the forest service around the United States. Prior to his appointment, he had been the acting supervisor.

The town-owned house, known as the Salem Woman's Club house, went into use as a WPA Day Nursery. The WPA nursery had been formerly located in the Starkey building on Main Street, Salem.

Harry Franklin, noted promoter of black sports teams, announced the formation of a local baseball team, the Manhattan All-Stars. Players included "Shu" McAfee, "Big Mose" Woodliff, "Smokey" Matley, "Fats" Hoosier, "Lefty" Easley, Cris Morris, "Beef" Dunger, Russ Patterson, Johnny Lee, Young Curtis, "Buck" Casey, and Terry Saunders. The All-Stars opened their season on Easter Monday against the Martinsville Cardinals.

Roanoke's Black Cardinals baseball team, which won the Virginia Negro League's championship in 1940 and 1941, began their season Easter Sunday afternoon at their home field, Springwood Park, against Winston-Salem. Chappy Simms was the team's manager, and Smokey Boyd was pitcher. Other team members included George Hampton, George Brown, Layden Williams, Richard Dawson, Harold Easley, James Jones, Clarence Brown, Sykes Robinson, Ralph Hicks, Fred Rice, Archie Quarles, Jessie Motley, and Hubert Perry.

The National Open golf champion, Craig Wood, teamed up with local Joe Jamison and played against another professional golfer, Jimmy Thomson, and his local teammate George Fulton Jr. for an exhibition round at Roanoke Country Club to benefit the local chapter of the American Red Cross. Thomson and Fulton edged out a one-stroke win with Thomson's birdie on the eighteenth hole.

Russ Peters, infielder for the Cleveland Indians, came home to Roanoke the first week in April, having a broken nose and black eye due to a poorly thrown ball during practice. He visited his mother for a couple of days and then was back on the Indians' starting roster.

According to the Federal Home Loan Bank Review, the cost of building a six-room house in Roanoke as of March 1 was $6,300, an increase of $1,244 from its prior benchmark taken in March of 1938.

Jimmy Scribner, nationally known radio personality who was billed as a "one-man show," came to Roanoke and broadcast live from the Pine Room at the Hotel Roanoke on April 3. The broadcast was carried by WSLS and heard nationwide on the Mutual Broadcasting System. Scribner's weekly broadcasts were known as *The Johnson Family*.

Robert Burrell died at his home on Patton Avenue on April 3 at the age of sixty-six. A native of Amelia County, Virginia, Burrell came to Roanoke in 1897 and was a prominent leader in Roanoke's black community and the brother of the late Dr. I. D. Burrell, namesake of Burrell Memorial Hospital.

E. L. Akers took the top prize in the annual handicap tournament at Luckland bowling alleys. The top prize was fifty dollars.

Between forty and fifty acres burned as a fire swept the north face of Mill Mountain on April 5 and threatened the home of Mrs. W. P. Henritze. Heavy clouds of smoke attracted hundreds of spectators, while some seventy-five firemen were used to extinguish the blaze. The following day, a forest fire consumed acres of timber on Twelve O'Clock Knob.

The Roanoke Black Cardinals opened their season by defeating the Winston-Salem Tigers, 19–4, at their home field in Springwood Park. The next game was against the Wilmington, Delaware, Alco Flash.

Roanoke city manager W. P. Hunter appealed to the WPA to provide workers to construct a flood wall in the vicinity of Maher Field. Businesses along the river lobbied city council to proceed immediately with a flood-wall plan to prevent flood damage as occurred in 1940.

Marching with military precision, four companies of the Virginia Protective Force from Roanoke and Salem paraded through downtown Roanoke on April 6 in honor of "Army Day" as thousands watched and cheered. The parade was believed to be the longest in the city's history, with five thousand participants. The parade was complemented by military planes from Woodrum Field flying across downtown. Other elements included the N&W Railway Band, air-raid wardens, the Roanoke police force, local rescue squads, the senior class of Jefferson High School in their caps and gowns, and World War I veterans.

The Democratic primary to nominate candidates for the Roanoke City Council general election was held on April 7, with ten candidates vying for three slots on the party's ticket. In what was termed a very spirited, sometimes bitter, campaign, some 4,454 ballots were cast. The winners were Courtney King (2,367 votes) and incumbents W. M. Powell (2,206) and Leo Henebry (2,189). Rounding out the remaining field were James Martin (1,282), J. T. Sutherland (940), Benton Dillard (913), Claude Evans (754), W. B. Clements (691), Harry T. Penn (424), and L. E. Lookabill (322). Penn was the first black to run for city council in the city's history. J. W. Comer did not seek reelection. The *Roanoke Times* editorialized a few days later, "This newspaper has never approved of choosing Councilmen in a party primary…holding that municipal government should be as nearly nonpolitical as possible and that members of City Council should be chosen in

the general election without regard to partisan politics." The newspaper was responding to the political reality that the Democratic primary was the de facto city council election.

The Valleydoah baseball team opened its season against Roanoke College. Playing for Valleydoah were Bob Hall, Judge Culbertson, Randy Graybill, Francis Scott, Ab Moore, Jimmie Moore, Walker Bolt, Ira Peters, Bill Henderson, Wilmer Bolt, Gene Evans, Ralph Sink, Jack Thomas, Boots Layman, Dick Frisch, Linden Guinn, and Willie Foster. The Valleydoah semipro team played teams from southwest Virginia communities.

For the first time in Roanoke's history, the Russian flag with hammer and sickle was displayed, being part of a backdrop of flags for the speech of China's ambassador, Dr. Hu Shih, to the annual meeting of the Virginia Chamber of Commerce meeting at the Hotel Roanoke.

The Chinese ambassador to the United States shakes hands with
J. S. Easley of the Virginia Chamber of Commerce at the Hotel
Roanoke, April 9, 1942. *Norfolk-Southern Foundation.*

"Longwood" in Salem opened on April 11 as a community center with an open house. Town officials and their wives acted as hosts and hostesses. The center would be used as a meeting place for Salem's various civic organizations.

Fincastle High School was destroyed by fire on the morning of April 11. As it was a Saturday, no students or faculty were present. The structure, built in 1927, suffered an estimated $70,000 worth of damage. Classes at the high school were dispersed to nearby churches for the remainder of the school year.

The Virginia League baseball season announced the start of its season to be May 1. The 130-game schedule would end September 30. Towns with teams included Salem, Pulaski, Newport News, Petersburg, Lynchburg, and Staunton.

The Roy C. Kinsey Sign Company of Roanoke was awarded the contract for the electric sign and scoreboard at the municipal stadium under construction. Their bid was $2,928. The only other bid was submitted by Stanford & Inge Company.

Wes Hillman, associated with Woodrum Field, was named as the manager of the air field at Montvale, effective May 1. Jim Buford was owner of the airstrip.

Garland's formally opened at 15 South Jefferson Street on April 15. The pharmacy was formerly Johnson & Johnson. The drug store offered a modern lunch counter and soda fountain as well as a complete line of Whitman Candies.

Andrew Jackson Tomlinson, age seventy-two, died at his home in the Williamson Road section. He had been one of residents of Big Lick prior to it becoming Roanoke in 1882. Tomlinson came to Big Lick when he was thirteen and first worked at the Crozer Iron Furnace and later at the Roanoke Machine Works.

An aggregate of 4,061,000 passengers were carried on Roanoke city bus and streetcar lines during the first quarter of the calendar year. This was an increase of 10 percent over the same period in 1941.

A warehouse fire gutted the two-story brick building at 30 Wells Avenue, NE, on April 18 that contained the warehouse, garage, and offices of Mundy Brothers Transfer Corporation. The fire attracted several thousand spectators, some of whom were attending a junior chamber of commerce dance at the Hotel Roanoke. Harry G. Mundy, company president, did not provide an immediate estimate of the damage.

Harry Fogleman, coach of the Duke University tennis team, was hired as the summer tennis pro at Roanoke Country Club. Fogleman planned to bring his college team to the club for some exhibition matches against club members.

Cecil Brown, CBS news radio reporter, addressed a crowd at the Academy of Music on the war in the Pacific. Brown assured the audience he believed victory would ultimately belong to the Allied powers but not without significant costs. Brown had been most recently covering the war effort from a post in Australia.

The Roanoke Kennel Club held its annual dog show at the Roanoke Auditorium. The top prize was awarded to a dachshund owned by Mrs. George Gillies of Glen Head, New York. Over two hundred dogs were entered in the show.

The Montgomery Presbytery meeting voted to move a large frame structure that once served as a denominational mission school in Floyd County to the Williamson Road area to be used for a newly organized church there. The meeting also included arrangements for the official installation of Hayden Hollingsworth as pastor of the Second Presbyterian Church in Roanoke. The mission school building was located in Check, known as the Cannaday School.

The Roanoke City Council learned that funding for the new municipal stadium would fall $100,000 short due to the work being done by a private contractor rather than the WPA as had been anticipated. The sum of $250,000 had been allocated to the construction of the stadium, baseball field, fencing, dyke, and drainage, but the total cost was approaching $289,000.

Fire swept through the second floor of the George T. Horne Company millinery shop at 410 South Jefferson Street on April 24. Flames cut off the only escape, forcing several female employees to flee to a ledge. All of the women were rescued with only minor burns.

Congressman Clifton Woodrum was the first passenger for his daughter, Martha Ann Woodrum, when she flew over Roanoke, having earned her pilot's license in mid-April.

On April 27, 7,002 men between the ages of forty-five and sixty-four in Roanoke city registered for nonmilitary service as part of a nationwide registration process for the purpose of determining the sources of production during wartime. There were fifteen registration stations throughout Roanoke, with the busiest stations being the Market Building, the N&W Railway shops, and Raleigh Court Presbyterian Church. Many of those who signed up were veterans of the First World War.

The manager of the Elks Club, E. N. Duvall, was fined $300 for allowing slot machines to operate within the club. The court fine followed a police raid a week prior that seized ten machines. The club sought to defend itself by asserting that the machines raised money for its charitable purposes and were not used for gambling. Judge Harris Burchfield responded that he was confined by state laws in the matter.

Principal Kyle (*right*) of Andrew Lewis High School presents a war relief donation to J. E. Carper (*left*), as Roland Cook (*center*) looks on. *Salem Historical Society.*

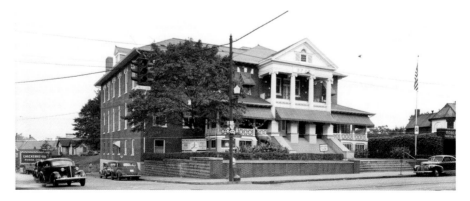

The Elks Club was located at the corner of Jefferson Street and Franklin Road in Roanoke. Image is from 1945. *Virginia Room, Roanoke Public Libraries.*

Roanoke city and county held their first area blackout on the evening of April 28. The test was assessed as being 95 percent successful. The yellow warning signal came around 8:46 p.m., the blue signal at 9:06, the red signal at 9:17, and the all-clear at 9:44. Civil Air Patrol planes flew across the valley during the blackout communicating by two-way radio to Woodrum Field of any violations. This complemented the 168 air-raid wardens on the ground. The blackout required all residents to turn off lights or pull down blackout shades, and all street lights were cut off. Persons were asked, if driving, to pull their cars over and shut off all headlights for the duration of the test. In advance of the test, scores of motorists went to the top of Mill Mountain to view the dimming of the city, such that when the all-clear signal was given, headlights could be seen running the entire length of the road up the mountain. In Salem, the Friends baseball team was scrimmaging the House of David, and the game was halted in the sixth inning. WDBJ and WSLS radio stations broadcast the various blackout signals.

Thurman and Boone Furniture Company hosted an in-store exhibition of formal table settings, with various tables being individually arranged by the home economics departments of the city and county high schools and a few junior high schools. Judges determined which table had the most perfect setting to the set standards of etiquette, and the winner was awarded US Defense Stamps.

Salem held a parade on April 30 to celebrate the US Army Air Corps, which was represented by their band from Bolling Field in Washington, DC. The 84th Company of the Virginia Protective Force also marched in the parade that also included the Salem fire department, the women's rescue squad, and elected officials. The appearance of the Air Corps Band was made possible through the efforts of Salem native Private Ernest (Pig) Robertson, who was stationed at Bolling Field. The Air Corps baseball team also came and played the Salem Friends in an exhibition game that night.

The first of four new city buses recently received by the Roanoke Railway and Electric Company and Safety Motor Transit Corporation were put into service May 1.

A new store, the Jewel Box, opened on May 2 next door to the American Theatre in Roanoke on Jefferson Street. The store was operated by Mr. and Mrs. Goodwin Schlossberg.

Norman Washington (Mac) Phelps, a retired banker and former member of the Roanoke City Council, died on May 1 at the age of seventy-one. Phelps was elected to the city council in 1904 representing the Highland ward, was reelected in 1908, and then chosen as council president by his fellow councilmen. He had retired as vice president of the First National Exchange Bank.

Green Ridge Park opened for the summer season in early May, promoting swimming and boating as activities.

The Pan-American Train Show exhibited at the Virginian Railway Freight Depot on South Jefferson Street May 6–11, and top billing went to a display of "the largest sea mammal ever captured," a sixty-eight-ton whale. Admission was ten cents, with children twelve and under admitted for free. Other attractions at the exhibit included a headless woman and a living mermaid.

The Salem Friends beat the Lynchburg Senators in their opening home game of the Virginia League season. Nearly 2,500 fans attended the baseball game.

Eight boys made finalists for the annual city-county marbles tournament. They were Ralph Davidson (Wasena), Bob Whiteside (Oakland), Andrew Bobbitt (Jamison), Melvin

Manning (Bent Mountain), Joe Clare (Jackson), Johnny Lane (Oakland), Terry Dean (Melrose), and Marshall Ferguson (Back Creek). Defending champion J. D. Sisson lost in a preliminary round. The championship tournament was held in Elmwood Park. The tournament was won by Terry Dean in a three-day final round.

The Roanoke Black Cardinals faced a professional team, the Detroit Black Sox, in Springwood Park on May 3. The Black Sox team was in the Negro National League. The Cardinals were the 1941 Virginia state colored league champions. Playing for Detroit was Rufus Hatton, who was at that time the best catcher in the Negro League. The Black Cardinals won, 8–7.

H. W. Coleman, town manager of Vinton since 1936, resigned due to ill health. Coleman had been a patient at the Mountain Home (Tennessee) veterans' facility for several months. The town council appointed Guy Gearheart, the town engineer for the previous three years, as Coleman's successor.

Registration for sugar rationing began on May 4 in both the city and county. The residents were already used to tire and automobile rationing. Registration was done on the basis of "family units," and nonfamily members in a household had to register separately. Registration occurred mostly at schools over a four-day period.

The Institute of Musical Activities, an organization of black instrumentalists, gave their first concert as a group on May 5 at the Fifth Avenue Presbyterian Church in Roanoke. The Institute was organized by Troy Gorum, and the concert consisted of classical selections.

Moss Plunkett, a Roanoke attorney, formally filed as a candidate to oppose incumbent congressman Clifton Woodrum for the Democratic nomination for the sixth district. Plunkett had unsuccessfully run for the state's lieutenant governor. The primary would be August 4.

A prize-winning photo by Roanoker John Kelley appeared in the May edition of *National Geographic*. The image was titled *Roanoke Reverie* and showed a boy in overalls gazing at the front of a locomotive.

Lakeside opened for the 1942 season on May 8 and also advertised that the Lee-Hy Pool was opening. The ad for Lakeside read in part, "Police officers have been assigned to watch parked automobiles, and patrons must not tamper or make any repairs to any car without first getting permission from an officer. NO sitting in cars, loafing or loitering around parked automobiles."

The Gainsboro Branch Library officially opened on Sunday, May 10, in a dedication service held at First Baptist Church, Gainsboro. Dr. J. M. Ellison, president of Union University in Richmond, Virginia, was the speaker. Other service participants included the N&W Male Chorus, the Addisonians, the Rev. L. L. White. The branch was started in December 1921 in one room of the former Odd Fellows building that was at the time the site of Hunton YMCA. Mrs. Virginia Young Lee was the librarian.

A new pumping engine built by the Roanoke Fire Department went into service at Fire Station No. 1. It was the second such engine built by the department and was painted a battleship gray. The total cost of the engine was $2,000.

Streetcar rails were removed from Franklin Road the first week in May. The project costs were shared between the city and the WPA. During the removal 181 tons of steel were salvaged and sold.

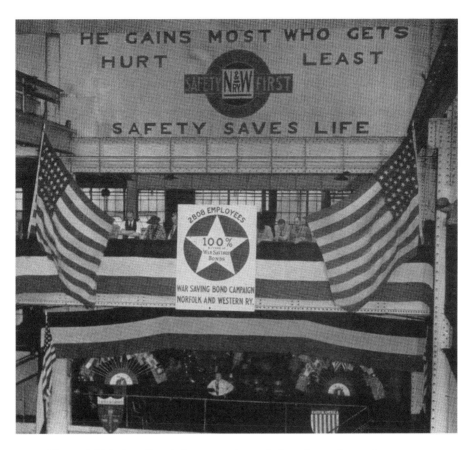

The N&W Machine Shop balcony served as a platform for speakers and musicians during this May 9, 1942, War Savings Bond rally. *Norfolk-Southern Foundation.*

The Gainsboro Branch Library was dedicated and opened on May 10, 1942. Virginia Y. Lee was branch librarian. *Virginia Room, Roanoke Public Libraries.*

The Skyline Baseball League suspended play for the duration of the war. The semipro league consisted of teams from Buena Vista, Altavista, Piney River, Big Island, Brookneal, Bedford, and Appomattox. The league was formed in 1938.

Mitchell Ayres and his orchestra played on stage at the Lee Theatre on May 10. Ayres was a popular radio and screen orchestra leader.

CBS Radio Network carried a coast-to-coast broadcast on May 16 from 1:45 to 2:00 p.m. honoring Hollins College's centennial. The two on-air speakers were Mrs. Thurman Arnold, wife of the assistant US attorney general and a Hollins alumna, and Miss Bessie Carter Randolph, president of the college.

Gas rationing began in Roanoke city and county on May 11, with registration occurring at all city junior high schools and at Lucy Addison High School. In the county, registration was held at the high schools.

An unidentified employee poses with the Appalachian Electric Power Company's appliance demonstration van, c. 1940. *Virginia Room, Roanoke Public Libraries.*

The Appalachian Electric Power Company's demonstration van showcased electrical home appliances, circa 1940. AEPC also held cooking classes in their building. *Virginia Room, Roanoke Public Libraries.*

The USO Lounge opened at the N&W Passenger Station on May 13, 1942.
This image was taken a few days later. *Norfolk-Southern Foundation.*

The formal opening of the United Service Organization (USO) lounge at the Norfolk & Western Railway passenger station was May 13. The lounge occupied a space previously used by a restaurant. Miss Elizabeth Ayers, head of the local Travelers Aid Society, was supervisor for the lounge.

Russell Dollar, a member of the announcing staff at WDBJ Radio, announced he was leaving the station to take a similar position with a station in Hartford, Connecticut. Dollar had been with WDBJ since January 1941. His replacement was Hermann Adkins, a Roanoke native, who came from a station in Winston-Salem, North Carolina.

Only the names of the three Democratic nominees were qualified to appear on the Roanoke City Council election ballot. The Republican Party had no nominees, and no independents registered before the deadline.

The *Roanoke Times* published a special section on the history of Hollins College on May 10 in honor of the school's centennial celebration. The multipage supplement covered the history of the college's founding, sports, academics, faculty, and campus.

The Chesapeake and Potomac Telephone Company began notifying new customers that due to the shortage of copper for telephone wires, party lines were encouraged, as was the practice of the "good neighbor policy," which was to speak briefly, answer promptly, and hang up the receiver securely.

Roanoke Paper Company, a division of Dillard Paper Company, opened at its new location at 120–124 Bullitt Avenue, SE, on May 11. W. L. Wilhelm Sr. was president of Roanoke Paper.

Morris Masinter, chairman of the Committee on Patriotic Affairs "See the Boys Off" Committee gave a pep talk to selectees at the USO lounge. Each selectee was handed a gift box, and this was done by the committee members for each subsequent departure of men to military service.

Gas rationing went into effect on May 16. Nonemergency vehicles were allowed only three gallons per week. With such rationing in place, many local businesses had to reconfigure their delivery and service schedules, and gas ration cards were issued to local motorists.

Joseph Forman advertised the availability of war risk and bombardment insurance for Roanoke property, businesses, and residences. His office was in the Liberty Trust Building.

The Twilight Baseball League opened is regular season on May 17 with a game between Valleydoah and Melrose AC. The league played at William Fleming High School (present-day Breckenridge Middle School) and at Fallon Park. The league had two other teams, Pepsi-Cola and Roanoke Semi-Pros.

The first Red Cross nurse from Roanoke to volunteer for active and foreign duty died in Quarry Heights Hospital, Panama Canal Zone, on May 12. First Lieutenant Eva Virginia Ageon was a graduate of Jefferson Hospital. She was sent to Panama in January.

The Thursday Morning Music Club secured a week's worth of tickets to the new Disney film *Fantasia* that was showing at the Lee Theatre. The sale of the tickets was used by the club to purchase phonographs and records to be used for the benefit of soldiers at Virginia military bases.

Roanoke's Manhattan All-Stars played the Baltimore Panthers at Springwood Park on May 17.

Miss Wada Wade of Roanoke County enrolled in the summer session at Washington & Lee College in Lexington and thereby became the college's first female student in its history. Wade was a student at Randolph-Macon Woman's College in Lynchburg. Admitting females was part of W&L's war acceleration program.

The Sunnyside Awning and Tent Company, Roanoke, was awarded a government contract to produce a hundred thousand pup tents for the military.

Hollins College opened its Centennial Celebration on Sunday, May 17, with a religious service held in the college's Little Theatre. The opening celebration continued throughout the afternoon with a variety of speakers and events, including lectures, a tea, a piano concert by John Powell, and an address by noted philosopher John Dewey. Hollins College was founded in 1842 and had had four names over the course of its one-hundred-year history: School at Botetourt Springs, Valley Union Seminary, Hollins Institute, and then Hollins College. The school was coed until 1851, when overcrowding forced the leadership to drop the admission of males.

(*L–r*) Estes Cocke, General and Mrs. George C. Marshall, and Francis Cocke were at Hollins College's Centennial in 1942. *Archives, Hollins University.*

Hollins College held a Centennial Ball in 1942 to help celebrate the institution's milestone. *Archives, Hollins University.*

This academic procession was part of Centennial Day at Hollins College on May 19, 1942. *Archives, Hollins University.*

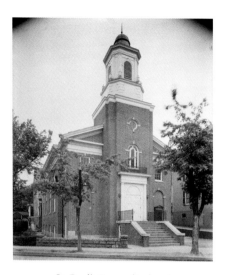

St. Paul's Evangelical and Reformed Church was at 1217 Maple Avenue, SW. Image is from 1945. *Virginia Room, Roanoke Public Libraries.*

St. Paul's Evangelical and Reformed Church, Maple Avenue near Jefferson Street, celebrated its fiftieth anniversary on May 17. The church was organized on June 12, 1892, with fifteen members who rented a room in downtown Roanoke for worship. The congregation's first building was erected in 1895 at the intersection of Franklin Road and Jefferson Street. The Maple Avenue building was constructed in 1927 for $70,000.

Almost five hundred spectators went to Maher Field to see Jimmy Lynch's stunt drivers, billed as "Death Dodgers," perform various feats with automobiles. The show immediately headed west to states where gas rationing was not yet being implemented.

Count Basie and his orchestra appeared at the Roanoke Auditorium on May 22. As part of the concert, there was a Sand Dance contest, with the winner receiving twenty dollars. White spectators were admitted.

The famed violinist David Rubinoff gave a performance at the Academy of Music on May 23 as a benefit for the local Kazim Temple Charity Fund.

Capt. James A. Cox of Salem, a member of the US Army Air Corps, was killed in an airplane accident in Hawaii. His plane crashed during a military training exercise.

The Vinton Town Council received a letter from the former town manager, H. W. Coleman, asking for $300 that Coleman believed he was owed in unpaid salary. Council referred the matter to their town attorney.

Hollywood Scanties was the name of a live stage show performed at the Salem Theatre. Billed as "eyeful of girls, earful of music," the show was a "movie rave-ue in person."

The N&W Railway announced plans to formally abandon a section of track, known as the Catawba branch, from Hanging Rock to Catawba. The abandonment would make possible the widening and relocation of state Route 311 by using the railbed. The only inconvenience cited was the railway's coal-delivery service to the Catawba sanatorium.

Ed Marshall of Roanoke was with a VPI flight instructor in an open-cockpit plane for the purposes of receiving a higher grade on his pilot's license when he yelled back to his instructor to take "control of the plane." Marshall's parachute was too uncomfortable, and he wished to make adjustments. Marshall removed his safety belt to adjust the chute, and the instructor rolled the plane, thinking that was the request. Marshall tumbled from his seat into the air but was able to open his parachute and land safely.

Surveyors continued their work in searching for a road location to connect the Bent Mountain community to the Blue Ridge Parkway. One survey had a road going from Holt's store, while another was on the west side of Bull Run Knob through the farm of James Lancaster.

Christ Episcopal Church, Roanoke, celebrated its fiftieth anniversary on May 24 with special services. When first organized, the congregation met over a store on Salem

Avenue and then moved to a building on Campbell Avenue, near Jefferson High School. Later, the church located to the corner of Commerce (now Second) Street and Church Avenue before moving to its present location on Franklin Road.

Baled paper at the Roanoke Scrap Iron and Metal Company caught fire on the night of May 23 at the company's location at Second Street and Campbell Avenue, SE. The Brenner Supply Company, next door, was also impacted. Seven engine companies and two ladder companies responded to the two-alarm blaze.

The Tinker Bell Pool opened for the summer season on May 24. A season ticket was $3.50, and the pool was open from 9:00 a.m. to 9:30 p.m. except Sundays. "No swimming in trunks alone; no intoxicating drinks or undesirable people allowed on premises," read the ads H. H. Meador was the manager.

The "Queen of Swing," Ina Ray Hutton, and her band played on the stage of the Lee Theatre for four shows on May 24.

Samuel Spigel, 306 S. Jefferson Street, advertised a bomb shelter vault for the storage of customers' furs. "We are the only furriers in Roanoke with such storage facilities on the premises."

Churches and local civic groups, such as the chamber of commerce and Kiwanis clubs, observed a citywide "Go to Church Sunday" on May 24. The effort was heavily endorsed by the editorial boards of local newspapers. The concept was initiated by the Roanoke Ministers' Conference and endorsed by Mayor Walter Wood.

Vinton Baptist Church is shown in this 1942 image. *Vinton Historical Society.*

The *Roanoke Times* printed a special section in their May 24 edition highlighting the one-hundred-year history of Roanoke College. The college was celebrating its centennial with special events and programs the last weekend of May. Activities included an outdoor play, Shakespeare's *The Winter's Tale*; dances; exhibits of artifacts in the library; and

HE'S LISTENING!

DON'T TALK !

LOOSE LIPS SINK SHIPS . . .
GOSSIP VAIN CAN *Wreck a train!*

This World War II–themed ad
appeared in the June 1942 edition of the
Norfolk & Western Railway Magazine.
Norfolk-Southern Foundation.

guest speakers. The main speaker was Dr. T. M. Greene of Princeton University, who spoke in the auditorium at Andrew Lewis High School.

J. B. Andrews, proprietor of Greendale Farms and a pioneer businessman of Roanoke, passed away on May 25 at his home. Andrews was a native of Rocky Mount who came to Roanoke in 1873 when it was Big Lick. He engaged in the wholesale grocery business and banking. In 1888, Andrews, along with Ballard Huff and Frank Thomas, bought out the P. L. Terry & Company store and launched the wholesale grocery business known as Huff, Andrews & Company. He also helped to organize the Trinity Methodist Church. He was eighty-five.

Wrestling promoter Bill Lewis held his last match of the season at the Roanoke Auditorium between two masked rivals, Black Panther and Yellow Devil. Yellow Devil lost the match and, by agreement, was unmasked and revealed himself as forty-year-old Stanley Pinto. The unmasking ceremony was done by Myrtle Brent, who was selected by Lewis for the honor as she had perfect attendance at all the wrestling events.

Roanoke County men organized the first reserve militia in the area, known as "Minute Men." W. E. Paul was elected captain. In the city, Posey Sumner and T. E. Frantz were organizing a company as well. Minute Men were mostly former soldiers and members of sportsmen's organizations, all of whom would know how to handle firearms and "be alert to sabotage and prepared to combat the enemy in guerilla warfare wherever he may be found on the home front."

John Borican, holder of seven middle-distance world records, ran in a five-hundred-yard exhibition race against two local high school athletes, Embree Kennedy and Johnny Wall. Kennedy and Wall were both state champion runners. The exhibition had been organized by Fred Lawson, coach at Addison High School. The event was held in Springwood Park on May 28.

To honor Memorial Day, fourteen planes piloted by local airmen dropped flowers over local cemeteries. There were no parades and most businesses remained open.

Gasoline rationing combined with sugar rationing ruined the bootleg business, according to area law enforcement officials. Both were critical to the illegal enterprise.

Norbert E. Reynolds Jr., age two, drowned in a cement fishpond in the back yard at 610 Maiden Lane, SW, a block from his home. Neighbors and family members looked for the missing toddler for two hours before his body was found.

St. Andrews High School graduated forty-three students in commencement ceremonies held at the end of May. The commencement speaker was Rev. Thomas Martin, pastor and principal of St. Andrews.

The Roanoke navy recruiting office announced that black men were able to enlist for general service in class V-6 with ratings of apprentice seamen, marking the first time blacks were taken into the navy other than as mess attendants.

City engineer John Wentworth was advised that final stages of construction on the municipal stadium would occur only if approved by the War Production Board (WPB) in Washington, DC. The stadium had been classified as a national defense project due to storage areas beneath the stadium created for military use. The WPB had halted construction on all amusement projects in the country, leaving the stadium's status in limbo.

Paul C. Buford, president of Shenandoah Life, delivered the commencement address to the ten graduates of the Roanoke Hospital School of Nursing. He advised them that they should not put career before marriage "should the right chance come along."

Frank Fitch began his fifty-first year of trading and business at the city market. It was June 1, 1892, that Fitch went into the produce business. He bought wholesale produce from the farmers early in the morning and then sold it at retail prices or shipped it to other markets. On that first day, he cleared $1.65. So successful was Fitch that housewives began complaining that he was buying too much produce, leaving nothing for them to purchase. Subsequently, the common council voted that no produce could be purchased wholesale on the market until after noon, giving women time to make their purchases. The board of alderman refused to pass the measure, however. (At that time, there was a two-tier city council.)

Liberty Trust Bank held an open house for the public to showcase its five-month-long remodeling. The bank issued fifteen thousand invitations. The improvements included an acoustical ceiling, night depository, customer coupon booths, and air-conditioning. The bank was organized as Liberty Trust Company in 1921 on Jefferson Street. In 1926, the bank purchased the former First National Bank building. It changed its name to Liberty Trust Bank in 1936.

Members of the Roanoke City Council visited a potential site for the city prison farm in Franklin County. The 602-acre site was ten miles from the city and was for sale for $4,200. The city was interested in consolidating all of its farm operations, which included the almshouse farm and the sanatorium farm at Coyner's Springs. City leaders eventually declined to purchase the property, deeming it too far from the city.

An outdoor bowling game was invented and patented by W. C. Driscoll of Livingston Avenue, Roanoke, and was being produced and sold by a local hardware store. The game was displayed for the first time at the 1942 Inventors Exposition in New York, New York, during the first week in June.

Tony Pastor and his orchestra performed on the stage of the Lee Theatre on June 7, billed as "the top-ranking band of 1942."

W. C. Driscoll of Roanoke demonstrates his patented lawn bowling game that was sold in local hardware stores, June 1942. *Norfolk-Southern Foundation.*

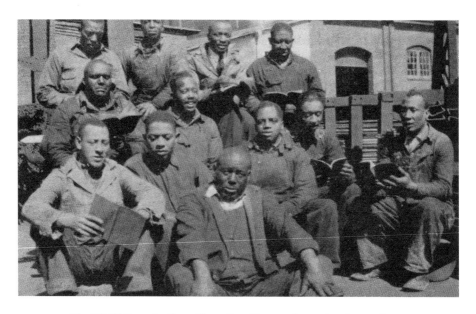

The N&W Roanoke Shops Noon-Day Chorus rehearsed and sang almost every weekday at lunchtime, June 1942. *Norfolk-Southern Foundation.*

William Fleming High School graduated a class of ninety-seven, with students serving as the commencement speakers. Bent Mountain High School graduated nine students at commencement ceremonies. The speaker was Rev. Edward Rees of Belmont Methodist Church, Roanoke. Jefferson High School graduated 580 students, and Lucy Addison High School's graduates numbered 120. Andrew Lewis had 176 graduates.

The N&W Employees' Better Service Club presented humorist Billy Beard along with a gypsy pageant at the Academy of Music on June 5. The pageant included a cast of fifty and a ten-piece orchestra for singing, music, and dancing. Some 1,200 persons attended the event.

The Melrose Christian Assembly Chapel, which cost $8,000 to construct, was formally dedicated on June 7. The chapel was located at the corner of Twentieth Street and Staunton Avenue, NW. Rev. Frank Detwiler was the pastor.

Al Schacht, the "Clown Prince of Baseball," brought his act to Salem for the Salem Friends game against Pulaski. Schacht was a former pitcher and later manager for the Washington Senators before turning to comedy.

Roanoke swore in its first naval recruits on June 7. The ceremony included a parade from the steps of the federal building to the steps of the municipal building in Roanoke. Twenty-two recruits were sworn in by Lt. R. R. Turner of the local recruiting station.

Three men from Tennessee were in a tri-motor plane that crashed on Mason's Knob. None of the men were seriously injured. They had taken off from the airport in Lynchburg and encountered low fog coupled with a downdraft wind.

Salvage for Victory Parties was a variety show held at Salem's Colonial Theatre as a means to inspire residents to salvage scrap metal, rubber, and rags for the war effort. The show was sponsored by the Salem Lions and Kiwanis Clubs. Francis Walters was emcee.

Construction of Roanoke's municipal stadium was halted at Maher Field by orders from the WPB, which declined to grant a construction extension beyond June 6 as requested by the city. The stadium was mostly completed. Remaining work included plumbing and electrical wiring. City leaders requested a work extension, citing the stadium's classification as a defense project given it provided on-site storage of military vehicles and other related equipment.

Hollins College held its one hundredth commencement ceremony on June 9. The graduation speaker was nationally known journalist John Temple Graves II. Earlier in the day, the college president hosted a garden tea for graduates and their families.

Voters went to the polls in local elections. In Roanoke, only Democrats were on the ballot as Republicans chose not to nominate candidates, and there were no independents. Elected were Leo F. Henebry, W. M. Powell, and Courtney King. Henebry and Powell were incumbents. Only 631 citizens voted. In Vinton incumbent Mayor Roy Spradlin was defeated by R. L. Meador, with only eleven votes separating the two men. In Salem, two incumbents, Mayor C. R. Brown and Frank Morton, were reelected without opposition.

James Edward "Deacon" Brown was recognized for his sixty years of service at the Hotel Roanoke. He was presented a fifty-dollar defense bond on June 9. Brown was the assistant head waiter at the hotel. Brown commented, "I've been with this hotel almost ever since it started. I worked in the original wooden building when all we had was 38 rooms, with iron beds, hard chairs and bad lights." The left sleeve of Brown's swallow tailcoat bore the emblem of six gold stars to mark his decades with the hotel. During his tenure with the hotel, Brown had served several important guests, among them Charles

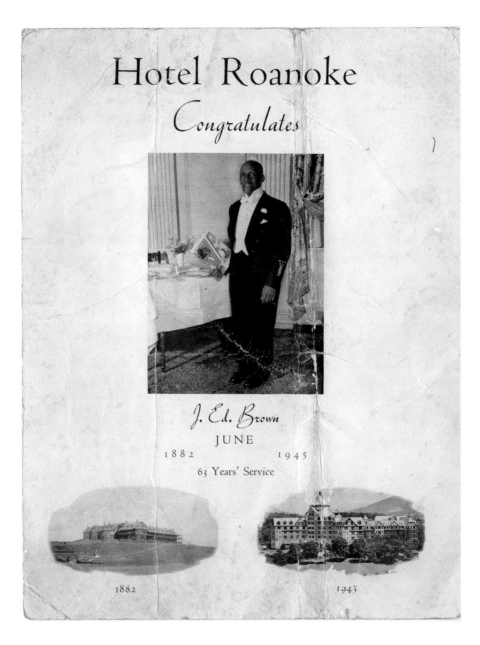

Hotel Roanoke

Congratulates

J. Ed. Brown

JUNE

1882 1945

63 Years' Service

1882 1945

This menu honors James Brown on his sixty-third anniversary with the Hotel Roanoke in 1945. Brown was honored regularly for his longtime service. *Historical Society of Western Virginia.*

Evans Hughes, William Jennings Bryan, J. P. Morgan, Mrs. Calvin Coolidge and Newton D. Baker. Brown and his wife had four children, all of whom were college graduates.

The George D. Hunter Company, 308 Commerce Street, SW, announced it was going out of business effective June 30. War rationing of metals was the cause. The company sold appliances and associated parts.

Workers removed streetcar rails from Roanoke Avenue in Norwich and along Virginia Avenue (now Memorial Avenue). This removed all the rails left from the old Norwich line. Woods Avenue, SW, was also cleared of old track, having been part of the Franklin Road line.

Flag Week was declared in both Salem and Roanoke for the second week of June. All citizens were asked to purchase and display flags from their homes and businesses.

The Volunteer Registered Nurses Association was organized in early June. Mrs. A. M. Groseclose was elected president.

Lionel Hampton and his orchestra appeared at the Roanoke Auditorium for a concert and dance on June 15. Advance tickets were available at Hunter Cigar, Dairy Fountain, Sportsman, Dumas Hotel, Community Drug, Gainsboro Drug, and Gill's Café. White spectators were also admitted.

City buses went on a "skip-stop" schedule mid-June, eliminating some two hundred stops in order to save gasoline. For the few streetcar routes that remained, there was minimal impact.

An old tintype photo turned up among possessions of a Botetourt family that showed the first Native American to attend Roanoke College as a student in 1870. The student was a Choctaw, Jacob Battiece Jackson, who went on to leadership within the government of his tribe. It was believed to be the only image of the student in existence.

Roanoke had a trial blackout dusk to dawn on June 17, in coordination with a statewide blackout. For that night, the American, Rialto, Roanoke, and Park Theatres all encouraged everyone to come and enjoy a movie as their businesses were largely unaffected.

Dr. Charles Smith, president of Roanoke College, announced that the college would participate in an air force training program for military pilots through a program designed nationally by the Civil Aeronautics Administration (CAA). The program would begin on July 1 and involve an eight-week intensive instructional program in both ground school and air training. There would be six eight-week courses offered during the academic year and open to any males between ages eighteen and thirty-seven. All expenses would be paid by the government. Students would not be required to be enrolled in any other college courses.

Glamour Girl Revue performed live on the stage of the Lee Theatre in a three-night engagement. The show boasted seven acts and was a production of Harry Taylor. On the same weekend, Ken Maynard and his horse, Tarzan, performed at the Academy of Music in a show for children. The *Roanoke Times* provided fare for all their newspaper boys to attend, and there was provided the "entire gallery for colored children."

The sixtieth anniversary of the first train of the Shenandoah Valley Division of the N&W Railway to pull into Roanoke was noted in local papers. The event occurred on June 18, 1882, when a train from Hagerstown, Maryland, arrived. Roanoke had changed its name from Big Lick on February 3, 1882. The first train to come to Big Lick arrived on November 1, 1852, when a wood-burning engine carrying both passengers and freight came to the town from Lynchburg over the tracks of the Virginia & Tennessee Railroad.

This aerial view shows the campus of Roanoke College
in 1942. *Archives, Roanoke College.*

Researchers at VPI who tested water from the Roanoke River deemed the river so pol-
luted to be unfit for recreational use. The 120-page report cited domestic and industrial
waste being dumped into the river as the cause for the pollution, with industrial waste
cited as the main contaminant.

The federal War Production Board authorized the completion of the work on
Roanoke's municipal stadium at Maher Field. The WPA apparently deemed the project to
be sufficiently progressed that not completing the work would be unreasonable. City of-
ficials stated the project was two to three weeks from completion before work was halted.

At 12:30 p.m. on June 19, the motor works division of the N&W Railway hoisted
the blue-and-white "Minute Man" flag over the motive power building, signifying that
more than 90 percent of its employees had subscribed to war savings bonds.

Roanoke Boy Scouts went house to house in late June to collect scrap rubber. C. T.
Woodson had been earlier appointed director of the city and county scrap rubber collec-
tion campaign and was encouraging all civic groups to become involved in promoting the
war-related effort.

The first company of the Salem Minute Men was organized at the courthouse, and
Rufus Bowman was elected captain of the group.

A new postal service began on June 20 in Roanoke. V-Mail service had been initiated
nationwide to solely serve those in the military. For those wishing to send letters and pack-
ages to military personnel, a V-Mail form had to be completed.

Charles Ward, treasurer of the Roanoke Fair, announced that the annual fair would not be held in 1942. This was in a response to requests from state and federal officials that farm transportation and agricultural products be used only for war-related purposes for the duration of the war.

The annual camporee of the local Boy Scouts opened in Fishburn Park, with twenty-four troops participating. The annual event involved about 475 scouts and their leaders.

Roanoke City announced that it purchased two tracts in the Carvin's Cove watershed and that additional tracts would be acquired in the near future. The total acreage of the first purchase was 267 acres. The city planned to acquire about 3,800 total acres.

The US postal service formally changed the name of Boone Mill to Boones Mill, conforming with an act adopted by the Virginia General Assembly.

Sherwood Abbey, located in Sherwood Burial Park, was dedicated on June 21. Dr. Charles Smith, president of Roanoke College, was the speaker during the afternoon ceremony. Other participants included local clergy and the organist for the abbey, James Malley. The abbey contained a crematory in addition to the columbarium.

The William Boxley Chapel at First Baptist Church, Roanoke, was dedicated in Sunday-morning ceremonies on June 21 by the pastor and members of the church. The chapel was built in 1941 and furnished in memory of W. W. Boxley, a well-known civic figure in Roanoke, by his family.

The Roanoke company of Minute Men was formally mustered into service as a division within the Virginia Reserve Militia on June 22 at a ceremony in the courthouse. Capt. T. E. Frantz led the group.

The directors of the Roanoke Fair, who had previously announced cancelation of the fair for the year decided to proceed with the annual event but in a limited way. Fair organizers decided to limit the appeal to those within the Roanoke Valley only.

Mrs. Virginia Long was presented a four-star emblem of honor by the members of the Roanoke City Council in recognition that she had four sons serving actively in the military. Mrs. Long was a resident of Albemarle Avenue, SW.

Russ Carlyle and his orchestra performed on stage at the Lee Theatre on June 28. The show also featured the Carlyle Glee Club, the Dixieland Six, and the Rhythmaires.

Roanoke city patrolman W. D. Adams arrested a fugitive that had been on the run for eighteen years. Leonard Sandridge, forty-two, was captured when the patrolman spotted his car in Roanoke. Sandridge had been living under an alias in Charlotte, North Carolina, and was wanted for robbery, abduction, and assault charges. Sandridge had also escaped from prison in Florida, where he had been serving a sentence on unrelated convictions. When apprehended, Sandridge reportedly told Adams, "I'm glad that it's all over." Sandridge had jumped bond in Roanoke on October 12, 1924, when he was arrested for the burglary of the Garland-Sisson Drug Store at Franklin Road and Marshall Avenue, SW. Sandridge had returned to Roanoke on several occasions, using his alias, and on one such visit, he was with a touring tightrope group that performed at Lakeside Park.

George D. Hunter, prominent businessman of the Roanoke Valley, was killed when he fell from a second-floor balcony when the porch railing gave way. The porch was on a house on East Main Street, Salem, that Hunter was having converted to apartments and had been formerly occupied by the Minor Oakey funeral home. Hunter was sixty years old and the proprietor of George D. Hunter Company, located at 308 Second Street, SW.

Congressman Clifton Woodrum stands beside a Fairchild 24 in this undated image. Woodrum soloed at Congressional Airport in 1942. *Virginia Room, Roanoke Public Libraries.*

Congressman Clifton Woodrum soloed at Congressional Airport at Washington, DC, for the first time on June 30. The congressman had been taking early-morning flying lessons. His daughter was also a pilot. "With a daughter putting pressure on me like that, what else could I do?" was his comment to reporters.

An "Independence Hop" was held at the Roanoke Auditorium on July 3, featuring Tite Jenney and his Harlem Night Hawks Orchestra. Vocalists were Warren Evans and Delores Ennison. The hop went from 11:00 p.m. to 3:00 a.m., and white spectators were admitted.

Over the Virginia Bridge Company's Roanoke plant was hoisted the Minute Man flag issued by the US Treasury Department that indicated all of the plant's 850 employees had purchased war bonds through the payroll allotment program.

E. K. Mattern, executive for Roanoke County, handed in his resignation to the board of supervisors as he had been called up for active duty. Supervisors also considered a long-term leave of absence for Mattern. Mattern had been county executive since April 1939. He also served as the county's chief engineer.

Miss Margery Moore made what was believed the longest solo flight by a woman from Woodrum Field when she flew to Cincinnati, Ohio, on July 2. The six-hour flight involved one stop in Ashland, Kentucky.

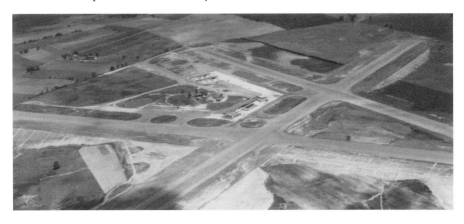

This 1942 aerial of Woodrum Field shows the A-configuration of runways. *Virginia Room, Roanoke Public Libraries.*

Don Bestor and his orchestra performed on the stage at the American Theatre on July 6. Bestor had played on national radio programs, including the Jack Benny Show.

Camp Tree Top, a YWCA camp near Glenvar, opened for its final summer season. It had been a camp for twenty-one years. The YWCA had raised funds for a new camp just a few miles from Tree Top. Camp Tree Top had its beginnings in 1921 when a committee investigated the possibilities of a summer camp. In May of 1921, camp shacks had been erected, and the first summer camp for girls opened.

Roanoke city's new bus garage, located on Campbell Avenue between Twelfth and Thirteen Streets, SE, opened the first week of July. The garage cost $78,000 and was used by the Safety Motor Transit Corporation and Roanoke Railway and Electric Company.

Several local female pilots met at the Hotel Patrick Henry to form a Roanoke chapter of Women Flyers of America. Jean Greenwood and Mrs. R. D. Martin led the group, and it was the first chapter in Virginia and the tenth in the nation.

On the stage at the Salem Theatre on July 9 was a return engagement of the *Hollywood Scanties*, an almost-all-girl revue. The show featured the Howe sisters, Ned Haverly doing sand dances, Pat Patricia, and Bud and Ethel with their wonder dog "Oscar."

Garrison Wood, a former member of the Roanoke County School Board and Board of Supervisors, died on July 9 at the home of his daughter. He was eighty-six. Wood held the distinction of the being the longest-serving elected official in the history of Roanoke County. Wood was born near Bonsack in 1856. He was first elected to the school board in 1904 for an eight-year term. He served on the board of supervisors for eighteen years, relinquishing his seat in 1935.

Former Roanoker and current superintendent of public schools for Columbia, South Carolina, Cline Flora, was elected president of the National Education Association at the association's annual convention in Denver, Colorado.

The new concrete bridge on Route 11 between Roanoke and Salem opened to traffic. The bridge across the Roanoke River was a project of the state highway department.

Carlton Massey was appointed coordinator of civilian defense in Roanoke County, succeeding Lt. E. K. Mattern, who was called to active duty. Mrs. Jack Burress was selected to head the women's volunteer clerical division, and Mrs. H. U. Butts was named chief of civilian mobilization in the county.

The Roanoke Black Cardinals played the Detroit Zulu Giants of the Negro National League at Springwood Park. The undefeated Cardinals beat the Detroit team 15–4. The Cardinals were on a twenty-nine-game winning streak, having last been defeated in July 1941.

The Norfolk & Western Railway announced it would begin removing track on the last five miles of its Catawba branch line in Roanoke County and give the right of way to the state for future highway development. The line, abandoned from Hanging Rock to Catawba Station, would mean the closing of the Catawba Station, though a new loading facility would be built at Hanging Rock. The line was used for hauling supplies to the Catawba sanatorium, but the need for rail was eliminated when a paved road over Catawba Mountain from Salem was completed. For a period, the railway ran a passenger train on the branch line but that was discontinued in May 1936 due to only two passengers on average using the service.

A new and enlarged Peoples Service Drug Store at Franklin Road and Jefferson Street formally opened on July 14. The drug store included a forty-eight-seat soda fountain that was behind an eighty-foot-long counter. Lee Angell was the store manager.

More than five hundred employees of the Walker Machine and Foundry Corporation and their families enjoyed a company picnic on Sunday, July 12. White employees and their families picnicked at Lakeside, and black employees and their families picnicked in the dining hall at Washington Park.

The first-ever review and inspection of the Roanoke City police department occurred at the new municipal stadium. The largely ceremonial occasion drew one hundred friends and family members of the officers.

There was a watermelon giveaway at Groat's Grocery on July 15, 1942. *Historical Society of Western Virginia.*

An inspection of the Roanoke City Police Department occurred at the municipal stadium on July 16, 1942. *Virginia Room, Roanoke Public Libraries.*

The professional Dixie Football League announced it would not hold a season. The war and the rationing of tires and gas prevented the cities from fielding teams. Roanoke was one of six teams in the league last year. Only Richmond and Norfolk had decided to have teams.

The Harris-Cannaday mission school near Check in Floyd County was moved to Williamson Road to provide a church for the new Presbyterian congregation there. The school, a large frame building, had been operated by the Montgomery Presbytery for several years.

The Grandin Theatre announced that all men in active military service would be admitted for free as a standard policy during the war.

Dr. L. G. Richards of Roanoke took individual honors at the fortieth annual Virginia Trapshooting tournament held by the Roanoke Gun Club. Richards had won the state championship eight previous times.

The Blue Ridge Post 434, Veterans of Foreign Wars, opened their new chapter house at 1906 West Avenue, SW. The dedication program included Congressman Clifton Woodrum as speaker. The home had previously served as the grand residence for Lee Powell.

July 21 was announced as the primary day for collection of metal scrap within Roanoke city in an effort to aid national defense. The city made arrangements for trucks to pick up scrap from curbsides and transport it to local junkyards. Roanoke County also conducted a scrap-metal drive, with citizens being directed to certain collection points.

The Roanoke City Council reappointed two members to the school board, Marcus Theirry and P. S. Hawthorne. Residents of northwest Roanoke had presented a petition with three hundred signatures lobbying for a resident from their section to be placed on the board, Mrs. C. B. Wade.

Henry Glasgow died at his home on Westover Avenue on July 22 at the age of sixty-eight. Glasgow was in the real estate business and Baptist church affairs. In 1913, he partnered with Page Bowling to form the firm Glasgow and Bowling. Glasgow served as a trustee at the Baptist orphanage in Salem and as vice moderator of the Baptist General Association of Virginia.

A total of 287 tons of scrap metal were collected by Roanoke city and county during a weeklong drive.

The Eighth Battalion of the Virginia Protective Force engaged in a mock military battle when the battalion divided itself into "red" and "white" armies and moved against each other on Catawba Mountain.

Horace M. Fox, Roanoke attorney and Masonic leader, died at his home on Cornwallis Avenue on July 28 at the age of sixty-two. For many years he was assistant counsel for the Virginian Railway before going into private practice in Salem. He was part of Roanoke County's legal team in arguing against annexation by Roanoke City.

Dr. Hubert Sydenstricker, a Methodist minister and district superintendent for the denomination, died at age sixty-five on July 30. He had also served as minister at the Trinity Methodist Church in Roanoke.

The main work on Roanoke's municipal stadium concluded at the end of July. The Blackwell Engineering and Construction Company announced their work was done and that only minor work remained, such as grading to be done by the city.

Federal agents in Roanoke reported that moonshiners being hampered by sugar rationing had turned to corn syrup and molasses with good results. Moonshiners reportedly

were buying molasses at ninety cents a gallon, with a five-gallon can supposedly equal to one hundred pounds of sugar in whiskey making.

Carl Hoff and his orchestra performed on the stage of the Lee Theatre on August 2. Hoff had been heard nationally on radio on Lucky Strike's *Parade of Stars* program.

For the first time in local theater history, two cinemas showed the same film. The Grandin Theatre and Lee Theatre showed 20th Century Fox's *Footlight Serenade* during the week of August 8. One reason for the studio booking two local theatres for the same film may have been the appeal of the movie's star, John Payne, a Roanoker. The film also had an additional local connection as former Roanoker Jack Roper had a minor role. Roper was a heavyweight boxer who fought Joe Louis in California and played a boxer in the film.

Charles Fox, former mayor of Roanoke, died on August 3 at the age of seventy-three. A pharmacist, Fox was a partner in the drug store known as Fox and Christian, which operated on the west side of Second Street, and then later became Fox and Patsel Drug Store and relocated to the southeast corner of Second Street and Salem Avenue in the building formerly occupied by the Charles Lyle Drug Company. In 1895, Fox was elected to the common council of Roanoke for the First Ward, serving two terms. In 1922, he was elected to the five-person council, serving consecutive terms until he was elected mayor in 1930. He served as mayor until 1932.

Democrats in the Sixth Congressional District resoundingly renominated incumbent congressman Clifton Woodrum in a spirited primary election that pitted the incumbent against Moss Plunkett. Plunkett waged an aggressive campaign, accusing Woodrum of not being supportive enough of President Franklin Roosevelt and acting against the interests of labor. The primary result was Woodrum 13,754 and Plunkett 2,284.

The City of Roanoke was able to raise the Minute Man flag of the Treasury Department over the municipal building as 90 percent of employees were participating in the payroll allotment plan for the purchase of war bonds.

The Women's Volunteer Corps conducted a house-by-house canvass in Roanoke to promote the purchase of war bonds the week of August 9. The effort was directed by Mrs. M. P. Breeden.

The side yard of Mr. and Mrs. J. C. Pugh of 215 Lincoln Avenue, Williamson Road section, was the site of an addition to their home that functioned as a community play-house, dance hall, classroom, and community center. Known as the "Me House," the addition was constructed from Catawba stone by stonemasons Frank Solocako and John Krensky, both from Yugoslavia. The two stonemasons had been responsible for the stone work of the First Presbyterian Church in South Roanoke when it was built in 1929.

Miss Robbie Burton captured the women's singles championship in the annual city-county tennis tournament, defeating Mrs. Dorothy Hancock.

Due to the lack of golfers, Blue Hills Golf Course closed in mid-August, citing gas rationing and local golfers serving in the military. This left only two courses available for play: Roanoke Country Club and Monterey.

Accommodations were made for the start of the new school year for disabled children to attend West End School in Roanoke. Known as the Crippled Children's School program, parents from both the city and county could apply for their children to attend.

The Roanoke Black Cardinals beat the Atlanta Black Crackers of the American Negro League 9–2 at their home field, Springwood Park on August 16. The Atlanta team was on tour. The victory was the twenty-fifth consecutive win for the Cardinals.

A delegation of Methodist ministers from Roanoke appeared before the Roanoke City Council and objected to the sale of alcoholic beverages in city parks. While such sales were prohibited in all city parks, Maher Field was exempt from the prohibition due to a contract the city had with the American Legion for the operation of the upcoming Roanoke Fair. The council delayed taking action on the Methodist ministers' concern.

Virginia Bridge Company, the largest steel fabricating plant in the south, was awarded the Army-Navy Production Award for its "remarkable production record." Virginia Bridge was a subsidiary of US Steel.

The Roanoke City Council authorized the construction of a new building or the remodel of the Cannaday home at Woodrum Field to accommodate the state office of the Civilian Pilot Training Program of the CAA.

Roanoke conducted its third blackout on the night of August 18, complying with a statewide blackout. City officials reported overwhelming compliance. The blackout began with the red signal at 9:40 p.m. and lasted until 10:38 p.m., when sirens signaled the all-clear. Only one minor incident was reported with the blackout: one of the air-raid wardens was found to be "under the influence" and immediately replaced.

US secretary of the treasury Henry Morgenthau Jr. spoke to a capacity crowd at the Roanoke Auditorium on August 20. It was to be the first official event held in the new municipal stadium; however, rain forced the event to be moved to the auditorium. Morgenthau's 6:00 p.m. speech was carried live by all local radio stations and heard across the nation over the NBC network. The secretary's visit was prompted by the response of business and industry in enrolling employees in war-bond payroll plans. In what was called a "war bond rally," a community choir led the crowd in singing "God Bless America" and the "Battle Hymn of the Republic." N. W. Kelley, president of the Roanoke Chamber of Commerce, was master of ceremonies. Morgenthau boasted that Roanoke "was a city other cities will try to follow" in the war-bond effort. Following the event, a dinner for the treasury secretary, hosted by Congressman Clifton Woodrum, was held at the Hotel Roanoke.

Kroger held its grand opening for its newest store, located at 119 Grandin Road, SW, on August 21. Martin Brothers was the general contractor for the building. In celebration of the event, the grocery store offered five hundred loaves of bread free to the first customers and suckers for children as well as 1,800 Persian seedless limes. Advertising for the store boasted half-cent keys on their cash registers and a full-service bakery.

Blue Barron and his orchestra and revue performed on the stage of the American Theatre on August 23. The concert featured Clyde Burke, Jimmy Brown, Charlie Fisher, Billy Cover, "Tiny" Wolf, 3-Blue Notes, and The Glee Club. Barron had just finished three weeks of sell-out concerts in New York City.

The Roanoke Fair opened on August 24 at Maher Field. The fair featured performances by dancer Dorothy Blair, "the darling of New York night clubs"; Pocahontas, an Indian horse; a mile-long midway; J. J. Bower's game farm exhibit; Victory Ranch All-Girl Revue; and Carlos's Circus of trained Whippets and Greyhounds.

Mrs. Aline Glendy Darst of Roanoke was selected by US secretary of the navy Frank Knox to christen the navy's newest destroyer, the USS *Sproston*. The destroyer's christening ceremony was held at Orange, Texas. The destroyer had been named for Darst's cousin, the late John Sproston.

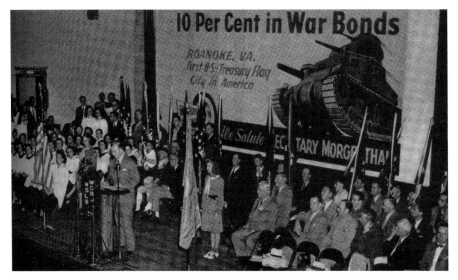

This shows the speakers' platform when US treasury secretary Henry Morgenthau Jr. spoke at the Roanoke Auditorium on August 20, 1942. *Norfolk-Southern Foundation.*

Republicans in the sixth congressional district chose not to oppose the incumbent congressman Clifton Woodrum, a Democrat, for reelection, citing unity in the war effort.

Construction on the Blue Ridge Parkway was halted due to the war. Parkway Superintendent Stanley Abbott said that only maintenance on those already-constructed areas would occur until the war's end.

The Chesapeake and Ohio Railway announced in late August that it was closing the Craig Valley branch line, which extended from Eagle Mountain to New Castle, a distance of 26.41 miles. The line had operated at a loss since 1933.

Lakeside offered "3 cent days" meaning that all rides were available for that amount, except the Mountain Speedway, Rola Plane, and live ponies. They also advertised that Sunday, September 13, would be "Colored Day" at the amusement park.

J. W. Comer was recognized by his Roanoke City Council colleagues for eighteen years of public service as a member of the council. Comer did not seek reelection. At the same meeting of the council, Walter Wood was reelected by his colleagues as the city's mayor. Leo Henebry was reelected vice mayor.

The City of Roanoke reached an agreement in early September with the Pennsylvania-Central Airlines, Inc., for the airline to operate a training school at Woodrum Field. The city agreed to repair the old Cannaday farm home on the airport property for use by the airline. The airline agreed to pay the city $185 per month rent. By operating a flight school in Roanoke, city officials hoped that may lead to Penn-Central providing passenger service in the future.

In Salem, the town council elected Frank Morton as mayor. In Vinton, the town council elected Joe Pedigo as mayor. Each mayor's term was for two years.

Alphonso Boyer won the Magic City tennis tournament against Willie Preston. The all-black tournament was played at Washington Park. Boyer won the tournament in 1941.

Funeral services were held for "Little Baby X," an infant that was abandoned at a Roanoke hospital a month prior. The service was attended by less than a dozen people on September 4. The infant girl was found on the steps of a local hospital in a paper carton on August 10. She was interred at Evergreen Cemetery. The cemetery donated the burial plot, and Frank Wertz donated a floral spray for the casket. Rev. Charles Gentry conducted the graveside service. A granite marker was donated by the Magic City Granite Works. William Lotz furnished the casket. City officials had no leads in the case.

The Salem Hardware Company formally opened in its new location on September 5 at what was formerly the Oakey Building on Main Street. Russell Johnson was general manager.

The Maggie L. Walker Ambulance Corps was organized, and it was the first such ambulance corps in Virginia. Over a thousand persons attended the induction service held at the Roanoke Auditorium. The corps was tasked with setting up a first-aid station and securing an ambulance. The corps began its organizing process in early March under the auspices of the Junior Woman's Club. Dr. E. D. Downing of Burrell Memorial Hospital was the corps' commanding officer.

State Trooper W. S. Tinsley was killed in an auto wreck while responding to a call on the evening of September 5. Tinsley died at the scene. He was on his way to investigate another auto accident near Dixie Caverns. He was killed in front of the Riverjack, west of Salem on Route 11.

Widening and repair work on Route 220 near Red Hill began in early September using convict labor. A convict camp was erected near Red Hill, having previously been in Bland County. The camp held about a hundred convicts.

The Roanoke County Public Library system, established in 1941, reported a total circulation of over thirty-five thousand books in its first year. The library system was sponsored by the Roanoke County Junior Woman's Club.

Some 6,500 persons went to Roanoke's municipal stadium on September 8 to hear actress Greer Garson bring a patriotic war message in an effort to sell war bonds. A bright afternoon sun baked the crowd but did not diminish their attention. The Jefferson High School band played the national anthem, and state senator Leonard Muse introduced Garson as "Hollywood's greatest movie actress." Garson urged the crowd to do their part in buying war bonds. "This is an all-out war," she shouted from the platform.

Roanoke native and Hollywood actor John Payne came to Roanoke and spoke at a war-bond dinner at the Hotel Roanoke on September 9. Having come to Roanoke to visit his mother, Payne took time to address a gathering of women's war-bond committees. Earlier in the day, Payne made a surprise appearance at the public-school teachers' institute at Jefferson High School and then toured downtown. Crowds were so thick that traffic was halted.

Miss Martha Ann Woodrum became the first woman in Roanoke and, according to CAA records, in the state to earn a commercial flying license. She was the daughter of Congressman Clifton Woodrum.

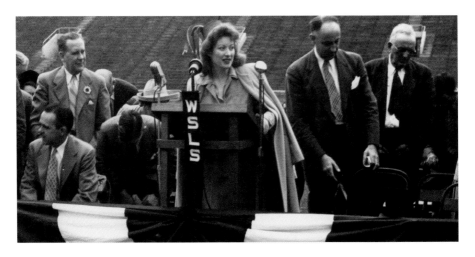

Hollywood actress Greer Garson spoke at a War Bond Rally at Victory Stadium on September 8, 1942. *Historical Society of Western Virginia.*

Camp Bowles, a gift of the Roanoke Rotary Club to the Boy Scouts, was dedicated on September 10 as a monument to the late W. B. Bowles Jr. The camp was located in the Green Ridge section of Roanoke County, two miles from Hanging Rock.

One of Roanoke's first motorized fire trucks, a steamer known as No. 499, was sold for scrap as part of the war effort. The truck had been out of use but was kept at Station No. 3 as a relic of Roanoke's past. Acquired in 1907, it was one of the first fire vehicles as the city converted from horse-drawn fire carriages. It had been built by the American-LaFrance Fire Engine Company.

The first football game in Roanoke's municipal stadium was held on September 12. Jefferson High School defeated William Fleming High School 33–0. The crowd in the twenty-five-thousand-seat, $300,000 stadium was 4,465, far short of what was anticipated. The game was a benefit for the city's sandlot football program and raised an estimated $800 for the sandlot league.

Nationally known educator Dr. William Pickens spoke to an all-black war-bond rally at the Roanoke Auditorium on September 13. The address was sponsored by the Maggie L. Walker Ambulance Corps. Pickens rallied the crowd by stating, "If America loses this war, everything that the Negro has gained and everything that he ever hopes to gain will be lost." Pickens was a leader of the NAACP.

Charles Lindsey Sr., sixty-three, president of the Lindsey-Robinson and Company in Roanoke died at his home on Robin Hood Road after a brief illness on September 16. The same day another prominent Roanoker, Levi Davis, eighty, died at his home on Wellington Avenue. Davis had served as Roanoke's postmaster. Both men had been involved in the business and civic life of the city.

H. B. McManaway was named acting police chief for Salem, succeeding Chief R. C. Frier, who had entered the US Navy.

Virginia Tech played Catawba College in Roanoke's municipal stadium on September 19. This was the first college-level football match to be played in the facility. Tickets were $1.10 for adults, $0.55 for children, and $0.55 for "colored patrons" as seating was

segregated. Tickets were available at Hunter's Cigar, Mundy's, Roanoke Cigar, and The Sportsman. Tech won against the Catawba Indians 28–14 before an estimated crowd of three thousand persons. It was the opening game of the season for the Gobblers.

A minute of prayer daily was honored in Vinton at the request of the ministers there. One long blast of the fire siren announced prayer each day at 5:30 p.m. All Vinton merchants agreed to the request, stating that sales would be halted for one minute when the siren sounded.

Melrose baseball club won the Twilight League championship, beating Valleydoah.

In response to about eighty employees of the N&W Railway and Virginia Bridge & Iron, Abbott Bus Line of New Castle began offering three buses daily from New Castle to Roanoke via the Catawba sanatorium.

The first class in the Penn-Central Airlines pilot training school arrived in late September in preparation for the start of the school at Woodrum Field on October 1. Maj. J. H. Dubuque was the director of the school.

A convict camp was relocated from Bland County and was set up along Route 220 about two miles south of Roanoke for the rebuilding of the highway. The highway was improved by convict labor from its intersection at Starkey Road to a point near the Welcome Valley tourist camp.

Roanoke native and Hollywood actress Lynn Bari announced she was filing for divorce in Los Angeles, California, from her manager-husband Walter Kane. The couple wed in 1939.

Elmer Jones of Craig County won the annual hog show at Neuhoff and Company meat processing plant in Salem. The annual "biggest hog" contest was sponsored by the area's 4-H Clubs.

The City of Roanoke donated its World War I cannon, which was once owned by the American Legion and sat in Elmwood Park, to the scrap-metal campaign. Pressure had been put on both Roanoke and Salem to donate their cannons (Salem's was in front of the courthouse) to the campaign.

The Roanoke City Council appointed two committees to handle affairs related to the municipal stadium. A five-member committee was appointed to supervise the management of the stadium and the game schedule. An eleven-member committee was appointed to arrange for a program to formally dedicate the new stadium. Judge J. L. Almond was appointed chairman of the latter group.

The Roanoke County Board of Supervisors acted upon a recommendation for the site of the new Cave Spring Fire Station. The site was on land adjoining Grigg's Service Station, with J. W. Griggs being appointed chief of the station. The firehouse was to be a two-story, cinderblock building constructed by J. W. Griggs and W. H. Witt and leased by the county.

Dancing Around, a "girlie-go-round revue," appeared on the stage of the Roanoke Theatre for four shows on September 23.

The Stone Printing and Manufacturing Company donated a sixty-year-old printing press to Roanoke's scrap-metal campaign. It was one of the earliest presses in Stone's collection and weighed nearly five thousand pounds. At one time, the late Edward Stone had considered placing the old press, originally used in Lynchburg, atop the company's building as an ornament.

This 1949 image shows the Stone Printing and Manufacturing Company
that was located on North Jefferson Street. *Salem Historical Society.*

Roanoke police chief James Ingoldsby Jr. was commissioned in the US Navy and charged with permanent shore patrol of the Fifth Naval District. The city manager announced that Captain of Detectives H. Clay Ferguson would serve as acting police chief during Ingoldsby's absence.

Longtime Roanoke businessman Joseph Engleby Sr. died at his home on September 23 at age eighty-six. Engleby was a member of the Engleby Brothers, a plumbing and heating business. Engleby came to the city in 1880.

At the convict camp on US Route 220 south of Roanoke, Lawrence Collingsworth, a convict, was shot dead by Officer Henry Hicks when Collingsworth tried to run from the camp in what officials said was an escape attempt.

Several thousand elementary school children crowded into the Roanoke Auditorium on September 25 and took the pledge to become Junior Commandos in preparation for collecting scrap metal, waste tin, and fats for the war program. The children were to deliver pamphlets to homes and help collect donated metal and tin. Sydney Small, civilian defense coordinator, administered the oath. The proceeding was broadcast live by WSLS.

Roanoke's first class of nurse's aides completed their courses at Roanoke Hospital. The twelve students took eighty hours of work, forty-five of which were spent on hospital duty.

National figures released by R. L. Polk & Company of Detroit ranked Roanoke's First National Exchange Bank as being 283rd among the nation's 300 largest banks. Its total resources were in excess of $41 million.

A schedule of charges for use of Roanoke's municipal stadium was set by the city council. The city would get 8 percent of gross receipts from college and high school

football games, and 10 percent of the gate for professional football games. The rates had been proposed by a stadium advisory committee that had been recently appointed.

Members of the month-old Williamson Road Life Saving Crew were named, and they included F. C. Hensley, E. S. Honaker, N. Pearson, W. J. Lotz, H. W. Scruggs, L. L. Ageon, P. C. Light, Mrs. L. Ageon, K. Craig, N. W. Robertson, and J. E. Saunders.

A contract for concessions at Roanoke's municipal stadium was awarded to Harry Avis. Avis had previously handled concessions at Maher Field from 1921 to 1928 and been handling concessions for the more recent VPI-VMI Thanksgiving Day football games.

Roanoke's theatres joined the scrap-metal campaign by hosting "metal matinees" where patrons were admitted free if they brought three pounds or more of scrap metal.

Lucy Addison High School played its first football game in the municipal stadium on the afternoon of October 2 against Jefferson High School of Charlottesville. Addison won, 36–0.

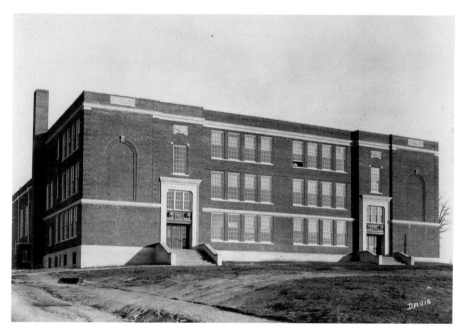

This image shows the Lucy Addison High School in the 1940s. *Virginia Room, Roanoke Public Libraries.*

The Salem Boy Scouts conducted a house-to-house canvass in their town to collect scrap metal and tin for what Salem billed as the campaign's "rally days." Two city trucks followed the path of the scouts, collecting what was donated.

Dr. Beverly James, a druggist for seventeen years in the black community, died. Burial was in Bluefield, West Virginia.

The seventy-fifth anniversary of First Baptist Church, Gainsboro, was held on October 4 and was followed by a weeklong celebration of evening services. The Rev. Arthur James was the pastor.

This early 1940s image shows the interior of the Community Drugstore on Henry Street where Beverly James (*middle*) was druggist. *Virginia Room, Roanoke Public Libraries.*

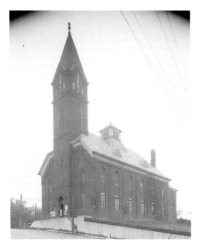

First Baptist Church, Gainsboro, on N. Jefferson Street is shown here in the 1940s. It was destroyed by fire in 1995. *Virginia Room, Roanoke Public Libraries.*

Roanoke City and County came to an agreement on annexation, avoiding a legal fight. The county agreed to give the city four square miles, and the city agreed to defer all other annexation proceedings for three years. The war loomed large in securing the agreement so that local governments could focus on more pressing concerns related to civil defense and other matters. The areas annexed under the agreement included Prospect Hills, Chestnut Hill, Colonial Heights, Stafford Court, Oak Hill, Lakewood, Center Hill, Bluefield Heights, the estate of the Garst heirs, the Persinger estate, and Virginia Heights Extension, all in the south and southwest side of the city. Other areas included Arlington, Grove Park, Forest Park, Villa Heights, the Nineteenth Street School site, part of Washington Park, Lucy Addison High School, Morningside Place, portions of Mill Mountain, and the Riverland Road addition. Excluded from the annexation were Vinton,

Williamson Road, East Gate, the American Viscose Plant site, and large farms north of the city. The original annexation suit sought to acquire slightly over twenty square miles.

The Colonial Furniture Shops, located at 309 W. Campbell Avenue, conducted a "Quitting Business Sale" in mid-October.

The first blood plasma bank in western Virginia, and only the third one in the state, was established at Lewis-Gale Hospital. The hospital had acquired special equipment for the "plasma room."

Vinton celebrated a successful scrap-metal campaign with a parade and rally at William Byrd Junior High School. Mayor Joe Pedigo addressed the crowd and thanked the citizens for their patriotism. The town collected an estimated fifty tons of scrap.

J. J. Newberry Company, a 5-10-25 cent store on Main Street, Salem, opened its newly renovated store on October 10. The store had been expanded to occupy the former quarters of the Salem Hardware Company that had moved across the street. Henry Sanderson was the store manager.

Roanokers turned in 3,025,823 pounds of scrap in the scrap-metal drive, exclusive of industrial scrap. Stuart Miller was chairman of the Scrap Metal Salvage Committee.

William G. Richardson, formerly of Roanoke, visited relatives living in the Raleigh Court section. Richardson had served as the American vice consul in Manchuria before Japan attacked China. He had recently been appointed as American consul to Brazil. Richardson was the son of Rev. W. L. Richardson, the first pastor of Belmont Baptist Church.

Lois Reed won first place in the Victory Garden Exhibition contest held by twenty-five Roanoke County 4-H Clubs at the YWCA. The contest was sponsored by Sears and Roebuck Company.

American Viscose Corporation's Roanoke plant observed its twenty-fifth anniversary in October. It was completed in October 1917 and was only the second rayon plant and first in Virginia to be built. The plant was expected to produce some 600 million pounds of rayon in 1942.

The Vinton Elementary School was officially named the Roland E. Cook School by the Roanoke County School Board. The school's namesake taught at the school for about five years prior to his becoming superintendent of the county school system in 1906. Prior to the new building, the former school was a wood-frame building consisting of five to six rooms.

The Chesapeake and Potomac Telephone Company announced that new customers would have to share service on party lines as the company could no longer get materials to enlarge the phone system.

The committee tasked with overseeing Roanoke's municipal stadium reported a deadline of October 22 for members of the public to submit proposed names for the sports facility. All submissions were to be sent to Judge J. L. Almond, Hustings Court, Municipal Building. According to the committee, the name "Victory Stadium" was leading. Other popular names were "Memorial Stadium," "Military Stadium" and "Roanoke Military Stadium."

The Harvest Festival in Salem, held at Longwood, brought in $317. The festival, promoting victory gardens, was sponsored by several Salem-area garden clubs.

This undated George Davis photo shows Victory Stadium, which was used for several months before being officially named and dedicated. *Frank Ewald.*

Lt. Dumas DeShazo of Roanoke was awarded the Silver Star for heroism in an aerial attack on Rabaul on August 12. He and his crew were credited with downing four Japanese planes in addition to sinking or damaging four Japanese ships in the harbor.

Brothers C. B. and J. K. Halsey started the first mushroom farm in Virginia near Hollins. The Halseys claimed their farm would produce up to forty thousand pounds of mushrooms annually. The first customer to receive their mushrooms was the Hotel Roanoke. Other customers were scattered throughout the state.

Virginia Tech and Kentucky played to a 21–21 tie in a football game at Roanoke's municipal stadium on October 17. An estimated ten thousand fans attended the game in the twenty-five-thousand-seat stadium. Kentucky had been favored to win.

The 1942 Community Fund drive benefited six social service organizations in Roanoke. They were the Roanoke Family Service Organization, the Mary Louise Home, Travelers Aid Society, Salvation Army, Children's Home Society, and Goodwill Industry and Gospel Mission.

The Roanoke City Council took action to condemn parcels of land needed for the development of Carvins Cove as a city water source. City officials said fourteen parcels of land totaling 1,190.25 acres had been sought for a purchase price of $52,135 but without success. The land did not include an old cemetery or a small church that were in the vicinity and had been considered by the city. The city had successfully acquired some 2,000 acres from surrounding owners. If the condemnation is successful, the city would begin clearing the cove and cleaning the reservoir and filling it to the required level for sweetening.

Morris Harrison, a pioneer Roanoker and jeweler for over a half century, died on October 22. He resided on Woods Avenue, SW. He was seventy-five. A native of Lithuania who had been trained in Germany, Harrison came to Roanoke in 1888 and on August 8 of that year hung out his shingle, "M Harrison, Jeweler," at a drug store on Salem Avenue. He moved his business to larger quarters in 1890 and then again in 1914 to 23 W. Campbell Avenue. In 1926, his jewelry store opened at 207 S. Jefferson Street, where it remained at the time of his death.

A blacks-only USO lounge was formally opened in connection with the Hunton Branch YMCA on October 23.

The annual campaign for the Community Fund was launched in late October. The campaign goal was $142,327. R. W. Cutshall was the Community Fund president.

Elbert Morehead, former member of the Roanoke County Board of Supervisors, died at his home at Catawba on October 25 at the age of seventy. Morehead served on the board of supervisors for sixteen years and was a successful farmer in the Catawba section.

The Dobson & Company store on East Church Avenue suffered major damage by a fire on October 26. Seven engine and two ladder companies were called to the scene. The store dealt in general merchandise, including fire salvage and bankrupt stock.

The Roanoke City Council unanimously adopted a recommendation from a committee tasked with proposing a name for the city's municipal stadium. The committee, chaired by J. L. Almond Jr., suggested the name "Victory" become the name of the stadium, with Maher Field remaining intact as the name for the entire plot. Judge Almond in his report to council stated: "After the dawn of peace, with victory achieved and the project at Maher Field completed, it is recommended that this name be reviewed in light of the completed project and other conditions then existing." Thus, "Victory Stadium" was intended to be a temporary name. Almond reported that his committee reviewed thirty-one names submitted by the public. Maher Field was named for an early president of the N&W Railway, N. D. Maher, and the committee felt that designation should remain in honor of the railway's donation of the land. The stadium's formal dedication occurred on Thanksgiving Day.

This image shows the Third Platoon, Roanoke City Police Department, in 1942. *Roanoke City Police Department.*

Residents of the Green Hill section of Roanoke County announced their opposition to being annexed by the City of Roanoke, even though they had been granted access to the city's water supply. R. L. Price was the spokesman for the group. The annexation of the suburb included about fifty homes, and the appeal of the residents was to be heard in Circuit Court.

St. John's Episcopal Church, Roanoke, observed their centennial on Sundays, November 1 and 8. Six stained-glass windows depicting the life of Christ were dedicated as part of the observance, and it was noted that the sanctuary was fifty years old, having opened for its first service in November 1892. The congregation began at the "Brick Church," opposite the Monterey Golf Course, where an Episcopal minister from Bedford occasionally conducted services as early as 1834. By 1840, another minister was conducting Episcopal services in "Old Lick" (Roanoke) in a frame building erected that year. The name was given as St. John's at that time, and the frame church was located on Hart Avenue. The frame church was replaced by a brick church in 1855. In 1852, the Salem parish was established, with St. John's and Salem as preaching points. Around 1874, the congregation purchased two lots near the municipal building but later exchanged them for two lots on the southwest corner of Second Street and Church Avenue and a Gothic brick church was erected in 1876. The congregation worshipped there for over two decades before exchanging again their church property for lots at the corner of Jefferson Street and Elm Avenue, completing the sanctuary there in 1892.

Democratic congressman Clifton Woodrum was easily reelected to his Sixth District congressional seat with almost 90 percent of the vote over a little-known opponent, Stephen Moore of the Socialist Party.

A three-judge annexation court ruled in Roanoke City's favor, awarding almost all the territory desired by the city, some 4,093 square miles of Roanoke County. The county did not contest the annexation as the boundaries had been previously agreed upon to present to the court. This did not prohibit individual citizens from opposing the annexation. The new territory would officially become part of the city on December 31.

The annual Community Fund campaign exceeded its goal by collecting nearly $143,000. The fund supported a variety of civic and social service organizations.

Metropolitan Opera stars Hilda Burke and Suzanne Fisher appeared in a production of *La Boheme* at the Academy of Music. The production was sponsored by the Thursday Morning Music Club. The cast included seventy actors accompanied by a thirty-member orchestra.

Hip Hip Hooray, a Vaudeville-style show came to the Roanoke Theatre in mid-November. The show featured show girls, The Three Tones musical singers, and Superman Polo demonstrating superior acts of strength.

Roanoke physicians asked the public to call their offices in the morning if attention was required for house calls. Physician ranks in Roanoke and Salem had been thinned by doctors serving in the military. Many of the physicians had ceased even making house calls due to the increased patient load and were requiring patients to come to their offices.

Armistice Day in Roanoke was somewhat subdued compared to prior years due to the war effort. Most businesses remained opened and operating, so the parade was not held. Maj. Gen. Charles Kilbourne of VMI did give an address at the Roanoke Auditorium in an event sponsored by the Committee on Patriotic Affairs.

Construction on the Northminster Presbyterian Church in the Williamson Road area commenced mid-November. Dr. Charles Logan was pastor of the sixty-five-member congregation. Lumber for the church came from the dismantled Canaday Mission School near Check in Floyd County. The brick veneer would be completed after the war.

Local merchants began their Christmas displays early, noting delivery delays, rationing, and the need to accommodate customers who intended to send gifts overseas to men serving in the military.

A fire swept through the Capital Drug Company, 10 E. Campbell Avenue, on November 15. The drugstore had just completed stocking its shelves for the Christmas season, and everything except bottled items were considered lost.

George S. Luck, prominently identified with Roanoke sports, died at his home on November 18. Luck had managed Maher Field and the Roanoke Auditorium when both were properties of the N&W Railway.

Toyland at Sears, 10 E. Church Avenue, opened for the Christmas season on November 20. The department boasted Lionel trains, scooters, dolls, toy furniture, tricycles, and automobiles as part of their vast inventory for children.

On stage at the Salem Theatre for a midnight show on November 21 only was the nineteenth annual edition of *Brown Skin Models*, a revue that featured twenty-three performers in the "greatest all colored show." The advertisement read "Balcony reserved for colored people." That same weekend Bobby Byrne and his orchestra performed at the Lee Theatre.

Ebony Escapades of 1942, Jefferson High School's annual minstrel show, occurred the third weekend in November. The cast included over one hundred faculty and students.

Mundy Motor Lines, a prominent highway carrier in southwestern Virginia, moved to its new headquarters terminal at 701 Seventh Street, NE. The new terminal cost $44,000 and was designed to handle one million pounds of freight per day. The company was founded by Harry Mundy with a horse and wagon making $1.50 per day. At the time of the new terminal, the company had 110 pieces of rolling stock and employed 175 drivers. The company also owned a garage on Shenandoah Avenue, NW. The former terminal had been at 30 Wells Avenue, NW.

Because of sold-out hotels in Roanoke, residents were encouraged to house VMI and VPI cadets in their homes for the Thanksgiving football game between the two schools. Some one hundred homes were needed to accommodate the cadets. The housing effort was headed by the chamber of commerce.

The Civilian Pilot Training program at Roanoke College was so successful that the classes were being offered full-time at the college and limited to enlisted men only. Since its inception in 1939, the program had trained over one hundred students. C. H. Raynor was the program coordinator. Flight School was offered at Woodrum Field for participants.

Luther Bell, chairman of the Roanoke County Board of Supervisors, was elected president of the League of Virginia Counties at the organization's annual meeting held at the Hotel Roanoke.

A Messerschmitt 109E, a Nazi fighter plane, was put on display in downtown Roanoke for four days during the Thanksgiving weekend. The craft was displayed at 608 S. Jefferson Street. The plane had been shot down over Coventry, England, in November 1940, and was being shown under the auspices of the Naval Aid Auxiliary. Roanoke was

the tenth city on the plane's national tour. It was estimated that over twelve thousand Roanokers viewed the plane.

Thurman and Boone Company offered closeout specials on their newest line of dining room accessories: asbestos table pads.

Gene Jones and his Cotton Pickers performed a concert at the Roanoke Auditorium on November 26. Various black-owned businesses offered advance ticket sales including the Dumas Hotel, Gainsborough Grill, and Community Drug Store.

Judge J. L. Almond presided over the dedication of Victory Stadium on November 26. The much-anticipated event preceded the Thanksgiving Day football game between VMI and VPI. Almond suggested that the name "Victory" was born of civic spirit to that day when the United States and its allies would prevail over the Axis powers. Other speakers included Mayor Walter Wood and Congressman Clifton Woodrum. Music was provided by the Sons of the South, the VPI band, and the N&W Railway Negro Chorus. As for the football game, VPI defeated VMI 20–6. The cadets had arrived by train and paraded onto the stadium grounds, VMI preceding VPI. Both schools' cadets performed alternating drills to the patriotic emotions of the crowd. The dedication program was broadcast live on WDBJ Radio. A few days after the dedication ceremonies, Almond submitted an expense report to the city for the event, which totaled $162.50.

The Thanksgiving Day football game between Virginia Tech and VMI, shown here in 1942, was an annual tradition for many years. *Historical Society of Western Virginia.*

The Gilbert and Sullivan Light Opera Company and its partner, the Civic Theater of Roanoke, announced the opening of their winter season would be two performances of *Robin Hood* at the Academy of Music the first weekend of December.

Coffee rationing began on November 30, with one pound of coffee every five weeks per individual. An "individual" was defined as any person age fifteen and older. Sugar stamps were used to purchase coffee. Items being rationed in the twelve months since Pearl Harbor included tires, autos, gas, sugar, meat, dairy products, canned goods, dried fruits, clothing, housing construction, toothpaste tubes, refrigerators, musical instruments, electrical appliances, lawn mowers, typewriters, and jukeboxes.

Samuel Goode Oakey, longtime funeral director, died in a Roanoke hospital on November 29 at the age of sixty-nine. "Mr. Sam," as he was known by many, was born in Salem in 1873, the son of John M. Oakey, the pioneer funeral director of the Roanoke Valley. In 1892, Oakey apprenticed himself with the firm of Oakey & Woolwine, a funeral business owned by his father and uncle. Oakey also helped support the Roanoke Life Saving and First Aid Crew.

A fire at a nightclub in Boston, Massachusetts, that claimed 449 lives caused Roanoke fire officials to conduct inspections of all area clubs, dance halls, and other public buildings to make certain fire escapes and other exits were adequate. City officials also reviewed codes and ordinances and discovered that there were no fire ordinances as such, giving the fire department authority over public gathering places.

Dr. John Flannagan, forty-three, died of a heart attack in Wytheville. Flannagan had served as director of the Catawba Sanatorium and Mount Regis Sanatorium in Salem.

Travel restrictions, a result of gas rationing, suspended league play by Roanoke Valley high school basketball teams. The teams had to arrange their own schedules with local schools and hoped a few opportunities might exist to play out-of-town high schools.

The Tenth Street Extension sandlot football team edged out Raleigh Court by a score of 9–6 in the city sandlot championship played in Wasena Park. Several hundred spectators braved near-zero temperatures to enjoy the game. Tenth Street star players included John Divers, Rayburn Journell, and James Burd. The following evening (December 4), some five hundred sandlot football players attended an awards banquet at the Jefferson High School cafeteria, where they were addressed by Coach Frank Murray of the University of Virginia football program.

The first arrest made by a female police officer in Roanoke happened on December 4. A man walked into police headquarters drunk and asked to be locked up. Miss Jackie Richardson, police department clerk and stenographer, took advantage of her first opportunity to make an arrest.

The Roanoke Civic Ballet with Mrs. James White as president announced the desire to solicit interest in having a local ballet company. The new group held a meeting at the Hotel Patrick Henry for interested persons to attend and assist with planning, and the intent was to offer an initial ballet performance in March.

Jacqueline Cochrane, internationally known aviatrix, addressed the Roanoke chapter of Women Flyers of America at the Hotel Roanoke on December 7. Ms. Cochrane was a three-time winner of the International League of Aviation trophy. Martha Ann Woodrum was the local chapter's secretary.

This is the Jackson Park Sandlot Football Team in 1942. The coach was Sam Elliott (*far right, back row*). *Roy Minnix.*

In the event the Virginia Baseball League does not operate during 1943, Roanoke may become a member of the Piedmont League. This was the sentiment of the S. F. Radke of the Salem-Roanoke team.

The Community Children's Theatre, under the direction of Clara Black, gave a production of *Peter, Peter, Pumpkin Eater* to several hundred children at the Academy of Music. The Children's Theatre was under the auspices of the Civic Theatre.

The war labor board authorized a three-cents-per-hour raise for workers of American Viscose retroactive to May. The pay increase included some 3,500 employees at the company's Roanoke plant.

Between three and four hundred men from Camp Pickett in Blackstone spent the weekend of December 12–13 in Roanoke as guests in the homes of Roanoke citizens who made their residences available for free. The highlight of the weekend was a dance at the Hotel Roanoke. The men were brought to Roanoke on Greyhound buses.

The Virginia Heights Baptist Church choir was heard coast to coast over the Mutual Network from 5:15 to 5:30 p.m. on December 16. The choir was under the direction of J. Alton Hampton, who was also an announcer at WSLS Radio. Mrs. Lewis Logwood accompanied on the piano.

The N&W Railway urged all persons to limit their travel on passenger trains due to the heavy use of the service by military personnel. The railway braced for its largest Christmas travel in its history.

Minor league baseball officials in Virginia met in Richmond on December 13 to discuss the possible merger of certain leagues, namely the Virginia and Piedmont Leagues.

The potential merged league would consist of six to eight teams, including teams from Salem and Lynchburg.

The Copenhaver Funeral Home, 430 W. Church Avenue, was purchased by Vaughan-Gwyn, Inc., an operator of several funeral establishments throughout the state of Virginia.

The Virginia League voted to suspend play for the duration of the war, meaning that the upcoming baseball season for the Salem-Roanoke Friends for 1943 came to an end. League teams were experiencing a shortage of players and, with gas rationing, an inability to travel.

Col. Carlos Romulo, aide-de-camp to Gen. Douglas MacArthur, spoke to a large audience at the Hotel Roanoke on December 18, sharing his experiences as the last American military officer to leave the Philippine peninsula of Corregidor as it was being overrun by the Japanese. "You here in Roanoke do not know what it is to do without. You do not know," stated the colonel.

The St. Louis Cardinals baseball franchise, one of the largest in the nation, announced they were considering moving their Class B team from Asheville, North Carolina, to Roanoke for the 1943 season. Art Routhzong of the Cardinals toured Roanoke in the company of officials associated with Salem-Roanoke Friends baseball team. The baseball officials toured two sites, Salem Park and Maher Field. Asheville was a member of the Piedmont League.

Roanoke's three liquor stores were stripped bare of domestic whiskeys the weekend prior to Christmas despite a regulation announced by the state ABC board that customers would only be limited to purchasing one quart of whiskey per day.

This December 16, 1942, image shows the interior of the First National Exchange Bank on South Jefferson Street in Roanoke. *Virginia Room, Roanoke Public Libraries.*

The N&W Male Chorus sang "I've Been Working on the Railroad" for the system-wide radio broadcast on December 21, 1942. *Norfolk-Southern Foundation.*

The N&W Railway Better Service Club sponsored a thirty-minute radio program on wartime railroading broadcast by both local stations, WDBJ and WSLS. The program was also aired on eighteen other stations across six states. The program consisted of live interviews with employees of various divisions and departments of the railway.

Roanoke County Fire station No. 4 officially went into service within the Cave Spring district on December 20. J. W. Griggs was chief of the fire station, and W. H. Witt was assistant chief.

W. P. Hunter, city manager of Roanoke, was recognized by the Virginia Municipal Review magazine as being the longest-serving city manager in the Commonwealth. Hunter took the position of city manager in October 1916.

Through the generosity of two anonymous donors, Burrell Memorial Hospital was able to acquire much-needed X-ray equipment.

Local postal officials reported that the 1942 Christmas mail set an all-time record high for the amount of mail processed and delivered. Mail receipts during the Christmas season exceeded the previous year by $4,000.

The Bing Social Club presented Louis Armstrong and his orchestra at the Roanoke Auditorium on December 28. The event included dancing. Tickets for blacks were $1.00 and for "white spectators" $0.65. Advance tickets were available at various businesses in the Gainsboro and Henry Street sections of the city.

1943

At the close of business on December 31, 1942, the following banks reported their assets: Mountain Trust, $9.5 million; Colonial-American National, $10.3 million; Liberty Trust, $2.6 million; First National Exchange, $43.3 million; First Federal Savings and Loan Association, $2.5 million; and the Morris Plan Bank of Virginia, $32.2 million.

Readers of the *Roanoke World News* enjoyed numerous daily comic strips, including *Life's Like That, Henry, Blondie, Ripley's Believe It or Not, Jasper, Tin Hats, Smilin' Jack, Lil' Abner, Toots and Casper, Moon Mullins, The Gumps, Dick Tracy, Mickey Finn,* and *Little Orphan Annie.* The *World News* was an afternoon newspaper and did not publish on Sundays.

Local ABC stores reported that they were once again out of whiskey due to New Year's buying. Local ABC officials promised to restock shelves quickly as this was the second time in two weeks whiskey was not available.

The Baptist Orphanage in Salem marked its fiftieth anniversary in 1942, though no celebration occurred due to the war and transportation issues. The orphanage received its first children on July 9, 1892, and had since cared for over 2,000 children who had come through its doors in the five decades since opening day. In 1943, there were 260 children residing at the orphanage. The institution operated a farm and a dairy.

Luther Bell sold his interest in Bell Brother Orchards on January 4 to his brother Howard Bell. The orchard was located in the Back Creek section of Roanoke County.

Roanoke City officials reported that its streetcars and buses increased their number of paid rides by three million in 1942 over 1941, mostly due to gas and tire rationing that discouraged the use of automobiles.

Capt. J. B. Franklin became the director of the Penn-Central Airline's flight training school at Woodrum Field, succeeding Maj. J. H. Dubuque. The flight school was held in the Cannaday home, which had been remodeled for that purpose.

Dr. George Washington Carver died on January 5. With his passing it was noted that Dr. Carver had visited Roanoke in 1932 and addressed students at Jefferson High School and Hollins College. It was also noted that Carver School in Salem was named for him.

Roanoke health officials reported a total of 2,379 births in Roanoke hospitals in 1942, an increase of 374 from the prior year. It was not known at the time of the report how many babies were born to residents within the city versus those living outside the city.

The Valley Railroad Company sold certain lands and rights of way in Roanoke County to the Chesapeake Western Railway. The sale had to do with property associated with a projected railway dating to 1866 which, if completed, would have run from Harrisonburg to Salem. The line was completed to Lexington but was never finished to

Salem. Some grading that had been done for the railway was still visible from Peters Creek Road.

Dorothy Jennings became the first full-time female announcer at WDBJ Radio. The native Roanoker, age twenty-five, replaced a male announcer who was serving in the military.

The City of Roanoke filed in Botetourt County court plans to condemn 930 acres around Carvin's Cove reservoir. The acreage represented the amount of land the city had been unsuccessful in negotiating with local landowners for its sale.

The Office of Price Administration announced it would be conducting local checks on leisure driving that had been prohibited by federal regulation. Agents said they would check various points around the Roanoke Valley for violators.

H. W. Starkey of Salem was elected chairman of the Roanoke County board of supervisors, replacing L. D. Bell, who had been relieved of those duties due to military service. A successor to Bell had yet to be appointed by the circuit court.

Former Roanoke city councilman Edmund Morris, seventy-nine, died at his home in South Roanoke on January 10. Morris's service was conducted from his residence on Wellington Avenue. He had served on the city council in the 1920s and '30s.

Copenhaver Funeral Home at 430 W. Church Avenue became the Vaughan-Guynn Funeral Home on January 10, as the latter had purchased the former. The firm advertised ambulance service for $1.00 and caskets ranging in price from $50 to $450.

The Roanoke Street Railway and Safety Motor Transit manager, W. H. Horn, announced new schedules for streetcars and buses operating in the city due to the increased amount of ridership. Meanwhile, movie theatre managers reported that attendance had remained stable since the ban on pleasure driving had taken effect. Managers stated that persons were walking, taking streetcars, and riding bicycles to see the movies.

Reginald Bible of Roanoke, a Jehovah's Witness, was sentenced by a federal judge to three years in prison for violating the Selective Service Act.

In Jackson, Mississippi, the federal government decided to prosecute a case of lynching of a black man by white men. Local attorneys in Jackson refused to participate in the prosecution, claiming it was federal violation of state rights. The Justice Department sent Frank Coleman, of Roanoke's, to Jackson to prosecute the charges.

Roanoke city manager W. P. Hunter told the city council that the runways at Woodrum Field needed to be lengthened so Roanoke could take advantage of more intensified aviation activity. Mayor Walter Wood readily concurred, and Hunter was directed to provide costs to enhance the airport.

William Appleton, president of the American Viscose Corporation, came to Roanoke to participate in honoring those in the company's Roanoke plant who had been employed there for twenty-five years or more. The banquet was held at the Hotel Roanoke.

Lionel Hampton and his orchestra performed at the Roanoke Auditorium on January 18. The blacks-only dance went from 10:00 a.m. to 2:00 p.m. White spectators were admitted for half price.

H. A. Tayloe was appointed to represent the Cave Spring district on the Roanoke County Board of Supervisors, filling a seat vacated by Luther Bell, who was in active military service. The board also voted to make H. W. Starkey their permanent chairman for the year.

The First Federal Savings and Loan Association completed the purchase of a building formerly occupied by the Southeastern Finance Corporation at 34 W. Church Avenue, Roanoke. First Federal announced that it planned to move into the building, vacating its location at 124 W. Kirk Avenue.

The Roanoke City Council acknowledged a gift of land of 9.6 acres by J. B. and Grace Fishburn to be used for park purposes. The land was located at the intersection of Cornwallis and Wellington Avenues in South Roanoke. At the same meeting, the council also approved giving all schoolteachers in the city a raise of five dollars per month regardless of their current salaries.

Officials with the Civil Aeronautics Administration shared with Roanoke leaders that Woodrum Field could not be developed to handle army air force planes after the war. To bring the airport to military-use standards would mean having an airport similar to those in Chicago and New York, according to the manager of Woodrum Field. Such an expense would not be realistic for Roanoke.

Louise Thaden, nationally known aviatrix, spoke to the Roanoke Lions Club meeting at the Hotel Roanoke. Thaden had won the first women's air derby in 1932 and the Bendix transcontinental air trophy in 1936.

For the first time in its history, Roanoke College graduated a class of one. President Charles Smith presented a diploma to Francis Fogarty of Massachusetts. Fogarty had been drafted by the marines but had completed his coursework. By the time his grades were recorded, Fogarty was overseas and could not take his final exams. Professors agreed, however, to award him a degree based upon other classwork. While on leave, Fogarty returned to campus for a one-man graduation ceremony in the college president's office.

Postal contract station No.1 closed on January 22 in Virginia Heights. The post office was located in Clore's Drugstore on Grandin Road. Dr. Philip Clore had indicated a desire not to apply for an extension of the contract when it expired.

Canada Ice Cream Company in Roanoke closed due to rationing on the ingredients imposed by the war effort. The Roanoke plant employed about fifty persons in the summer and twenty during the winter season. Company owner Clarence Canada stated he did not produce any other milk products other than ice cream and could not sell sufficient volume to keep the plant in operation.

The Roanoke City Council met in special session to discuss bringing a Piedmont League baseball team to Roanoke. The owners of the Salem-Roanoke Friends team of the suspended Virginia League met with city leaders. The council considered the cost of adding bleachers to Maher Field to accommodate play and other factors. Herb Pennock, director of the farm system for the Boston Red Sox, came to Roanoke to evaluate the field and Roanoke's potential to have a team. Congressman Clifton Woodrum also sent word to city leaders that would assist in getting materials for bleachers and other needs associated with hosting a team.

Count Berni Vici and his NBC Recording Orchestra performed for two nights on the stage of the Roanoke Theatre for a program titled *Slice of 1943*. The advertisements boasted ten star acts of radio and stage.

Two meat stalls in the Roanoke city market building were engulfed in flames on January 24. The cause of the fire was undetermined.

Hundreds of Roanokers stood in line to register for liquor rations. The war effort had limited one pint of whiskey per adult, as an example. Most ABC stores had run very low

on product due to the Christmas and New Year seasons, so customers crammed into the stores upon their being restocked.

Herb Pennock, affiliated with the Boston Red Sox (though a former pitcher for the New York Yankees), came to Roanoke on January 28 to meet with Stanley Radke and others interested in bringing a Red Sox farm team to Roanoke for the 1943 season. Pennock was interested in a Virginia site to transfer a Red Sox farm team from Greensboro, North Carolina. With Pennock's visit there was much discussion about the history of professional baseball in Roanoke. Roanoke last had a team in 1912. Roanoke's first ballpark existed in the 1890s and early 1900s, had bleachers that seated about a thousand spectators, and was used for games of the Virginia League. That league consisted of teams from Roanoke, Norfolk, Portsmouth, Richmond, Danville and Lynchburg. The ballpark was sited where the Virginian Railway's roundhouse was located along Jefferson Street (near the present-day intersection of Reserve Avenue and Jefferson Street). The Virginia League had formed in 1895 and was reorganized in 1906. The league folded at the end of the 1912 season. Roanoke's team moved its field from the original location just mentioned across to Maher Field after the 1906 season in order to use the grandstand that had been erected by the Roanoke Fair Association at that location. It was not the ideal setting as the grandstand had been erected for viewing a racetrack, not a baseball game. According to local baseball patrons, home plate at Maher Field was located across the racetrack, and the slope of the track caused rainwater to pool in the infield. After the Virginia League folded in 1912, the only professional baseball played in Roanoke was exhibition games by national teams. In 1914, the Detroit Tigers, with Ty Cobb on its roster, played the Boston Braves. During professional baseball's absence, there were a few opportunities that Roanoke might secure a farm team. The Washington Senators' officials visited Roanoke several times before moving a franchise to Charlotte, North Carolina. Branch Rickey, owner of the St. Louis Cardinals, eyed Roanoke in 1934 but opened his franchise in Asheville, North Carolina. In 1937, Herb Pennock of the Boston Red Sox talked with city and N&W Railway officials (the N&W Railway owned Maher Field) but opted for Greensboro, North Carolina, instead.

The Chili Shop at 6 E. Walnut Avenue began delivery service at the end of January. The restaurant operated from 11:00 a.m. to 11:00 p.m.

Roanoke's Academy of Music announced on January 30 it was closing. Inserted in a printed program of a performance by the Don Cossacks Chorus was information alerting patrons that the academy would close at the conclusion of its current season on June 1. The closing was due to lack of patron support. R. C. Royer, manager, wrote, "Roanoke does not support cultural events sufficiently to keep the Academy open." The Academy of Music was opened in the 1890s and had operated for the past several years with support from the Thursday Morning Music Club, the Civic Theatre of Roanoke, and the generosity of the owners. The academy was built in 1892 and remodeled by the Thursday Morning Music Club in 1928. The seating capacity was 1,384. As an aside it was noted that the Roanoke Civic Theatre organization had been formed in 1941 in an effort to boost the sustainability of cultural organizations. Brought under the umbrella of that organization were the Gilbert and Sullivan Light Opera Company, the Academy Players (formerly the Little Theatre), the Civic Chorus, the Children's Theatre, and the Roanoke Symphony Orchestra. The Roanoke Civic Theatre had a membership goal annually of one thousand but had never attained it, adding to the academy's struggle. With

The interior of the Academy of Music is shown in this March 1943 image.
The manager was R. C. Royer. *Virginia Room, Roanoke Public Libraries.*

the announced closing of the academy emerged wonderful memories of the productions held over the course of its history and the "conveniences" afforded the visiting actors participating in productions. One such convenience was a buzzer backstage that would be pushed between acts to alert the bartender at the Kimball Hotel across the street that the actors were coming over for drinks and to begin mixing the cocktails. The arrangement reportedly operated like clockwork, and the acts always resumed on schedule.

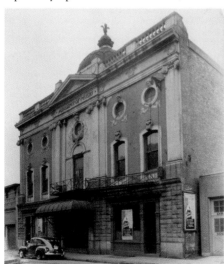

The Academy of Music was located on W. Salem Avenue in Roanoke, March 1943. *Virginia Room, Roanoke Public Libraries.*

Rev. Dr. A. L. James, pastor of First Baptist Church, Gainsboro, addressed the Roanoke Ministers' Conference and called for racial justice and equality and a frank discussion of racial matters.

The Roanoke City Council considered on a first reading an ordinance proposed by the Commonwealth's Attorney C. E. Cuddy that no one under the age of eighteen be allowed to play or loiter in pool rooms or billiard parlors. Cuddy was acting in response to complaints about such activity from the community. In other action, the city council approved funds for the construction of a temporary baseball field in an effort to gain a berth in the Piedmont League. City officials had negotiated terms with league officials and prospective team managers, including use of the old wooden stands

that were used by the city before the construction of Victory Stadium and that the stands would be "broken" at home plate.

A citywide effort to encourage the planting of Victory Gardens in backyards and vacant lots resulted in nearly 1,500 residents attending various neighborhood gardening clinics led by Professor A. G. Smith of VPI. Mrs. E. D. Poe was chairwoman of the Victory Garden Committee of the local Office of Civilian Defense.

Military pilots rather than civilian pilots would be trained in the future at the Penn-Central Airlines flying school at Woodrum Field. The announcement was made to coincide with the arrival of forty army flyers from Missouri. The ground school was held in the old Cannaday home on the airport grounds.

Local newspapers reported the crash of an army plane at the Peaks of Otter on February 3. The crash killed five men, and the flight had originated from Columbia, South Carolina. The fiery crash had been witnessed by nearby residents as the plane flew into Sharp Top around 9:20 p.m. The bodies were so badly burned and mangled that only one passenger could be identified. According to military officials, the men aboard were 2nd Lt. Paul Pitts, twenty-one; 2nd Lt. William McClure, twenty-two; 2nd Lt. George Bennings; 2nd Lt. Henry Blackwell, twenty-two; and Cpl. Peter Biscan, twenty-nine. The bodies were handled by M. P. Carder funeral service of Bedford. The bodies were shipped to their respective homes on February 7 by train with a military escort.

Walter B. Garland purchased the Clore's Drugstore located at 128 Grandin Road, Virginia Heights, in early February. Mrs. Virginia Wright, postmaster, announced that Garland had agreed to provide a contract postal station in the drugstore. This became the tenth store being operated by Garland in the city.

This is the 1940s interior of Garland's Drugstore on Grandin Road, formerly Clore's Drugstore. *Virginia Room, Roanoke Public Libraries.*

The meeting of the Lutheran Synod of Virginia was held February 3–5 at St. Mark's Lutheran Church in Roanoke. It was the 114th annual meeting of the synod.

Frank B. Thomas, former president of the F. B. Thomas Company, died at his home on Campbell Avenue, SW, on February 6. He was eighty-four. Thomas, a native of Montgomery County, Virginia, came to Roanoke in 1887 and in time became a partner in the Huff, Andrews and Thomas stores. Later he opened his own dry goods wholesale store that he ran until 1934.

Roanoke: Story of City and County was released by the Virginia Writers' Project of the Works Projects Administration. The four-hundred-page volume was printed by Stone Printing, Roanoke. The book was produced under the sponsorship of the Roanoke City and County school boards.

Fort Lewis Baptist Church in Glenvar was damaged by fire on February 7, and the cause was determined to have been a heat source in the church basement. Three fire companies responded, pumping water into the basement from a nearby stream and cutting a hole in the auditorium floor to access the fire when the basement door area became too hot for the firemen.

Baseball officials in New York announced that Roanoke was given a berth in the Class B division of the Piedmont League, effectively replacing Greensboro, North Carolina. In the division were five other teams from Richmond, Portsmouth, Lynchburg, Norfolk, and Durham, North Carolina. Discussions were still be held about moving Durham's team to Newport News, Virginia. The 140-game season would open on May 4 and conclude on September 7.

Sadler Cast Metals of Yonkers, New York, purchased the abandoned Morice Twine Mill in Norwich with plans to remodel the mill into a metal working plant. No date was given for when the plant would open. The mill was purchased from Frank Graves of Richmond, Virginia. The building was erected in the 1890s by the Norwich Lock Company, from which the section derived its name. Later it was occupied by the Roanoke Cotton Mills Corporation. The Morice Twine Mill operated in the structure through 1939, at which time the mill was purchased by Graves and became a plant of the Foundry Service, Inc., until 1942.

The first "control tower" at Woodrum Field was an eight-foot-square structure on top of the Cannaday farmhouse accessed from the roof, 1943. *Virginia Room, Roanoke Public Libraries.*

Detailed specifications for the construction of a temporary airport traffic-control shed on the top of the former Cannaday home at Woodrum Field were presented to the Roanoke City Council at the request of the CAA. The eight-foot-square shed would serve the airport until a permanent tower could be erected. The shed would contain radio control apparatus and spotlights to guide those without radio.

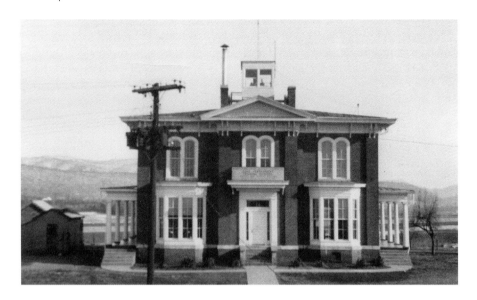

Seen here in 1944 is the former Cannaday farmhouse with the airport control tower on top of the roof. *Virginia Room, Roanoke Public Libraries.*

The new Cave Spring volunteer fire department reported that they were now providing around-the-clock fire-response service with sixteen members.

The Roanoke City Council was informed by US military officials that the runways at Woodrum Field were long enough to support military aviation and thus there was not a need to extend them. The council was also presented with the idea to discard the ward system for its local elections due to the recent annexations and the confusion of trying to redraw the wards.

The Rex Manufacturing Company at 306 Salem Avenue, SW, was sold to a work glove manufacturer based in the Midwest. The new company would assume control on April 1 according to Rex Manufacturing Company president J. W. Comer.

Due to gas rationing and a ban on pleasure driving, Capt. H. C. Ferguson, acting police superintendent for Roanoke, asked that several traffic lights be removed and others simply be turned to always blink a yellow caution signal.

The *Roanoke Times'* Sunday editions carried a large, multipage society section. Readers could benefit from Emily Post's *Good Taste Today*, Alice Hughes' *Woman's New York* about fashion, the *Kathleen Norris Says* advice column, Betty Clarke's *Homemade Beauty*, Beatrice Fairfax's *Advice to the Lovelorn*, and other nationally syndicated columnists and feature writers.

Roanoke's Junior Commandos were treated to a free showing of *Road to Morocco* at the American Theatre. Nearly 1,800 boys and girls attended. The Junior Commandos collected fats, scrap metal, and other items necessary for the war effort. The goal was to have a commando in every block of every city neighborhood.

The Trapp Family Singers, a group of eight Austrian family members, performed at the Academy of Music on February 22. The singers performed mostly sacred and folk music and were led by Baroness Maria Augusta von Trapp. The group performed in traditional Austrian dress. The family had performed at Hollins College in 1941.

A completed census of the territory annexed by Roanoke City at the beginning of the year showed a population in the area that totaled 2,965 residents. That number was 300 more than had been estimated at the time of the annexation.

The Roanoke City Council, responding to petitions from citizens in outlying areas, decided to loosen the rules that had forbidden hog raising. The council reverted back to an old policy of not banning the practice provided hog pens were not within nine hundred feet of a residence. This met with the approval of the public health commissioner.

Rev. George Ziegler died at his home on Piedmont Avenue in Salem on February 24. The minister was pastor emeritus of South Salem Christian Church. He served the congregation for fourteen years before retiring in 1939. He was seventy-six.

"Old Gabriel"—the N&W Railway shop whistle that called workers to the Roanoke Shops, announced the lunch hour, and quitting time for fifty-nine years—was deemed to be a model siren by federal and state officials. The sound of the whistle was pitch perfect for air-raid warnings such that authorities in at least sixteen communities were having sirens built using the blueprint and specs of "Gabe."

Samuel McVitty of Ridgewood Farms, Salem, donated some seventy manuscripts to Hollins College, many of which dated back to the sixteenth century. The donation was made in memory of his wife, Lucy. Mrs. McVitty was a trustee of the college from 1926 until her death in 1941.

The Ballet Russe de Monte Carlo Company performed at the Academy of Music on February 27. The lead dancer was Leonide Massine. Ballerinas included Alexandria Danilova and Mia Slavensha.

The Shenandoah Club observed its fiftieth anniversary on February 27 with a buffet dinner for its membership.

The Rev. A. H. Hollingsworth, pastor of Second Presbyterian Church, Roanoke, delivered the keynote address at a dinner opening the $104,000 campaign for the local chapter of the American Red Cross on February 28, held at the Hotel Roanoke. Paul Buford was the campaign chairman. The local effort was part of a nationwide drive to raise $125 million for the organization.

A fifty-acre tract of land at the foot of Elm Street near Roanoke Street in Salem was leased by Roanoke College from the Baptist Orphanage to be used as an auxiliary air field for the instruction of naval air cadets. The field was used by the Martin-O'Brien Flying Service, which trained the cadets, and was mostly used for practice landings. The main field for training cadets was Woodrum Field.

Jay McShann and his orchestra performed on March 3 at the Roanoke Auditorium and featured blues singer Walter Brown. Advertised as "the greatest jump band since Count Basie," the concert and dance were for black patrons only, though whites could be spectators.

Junior Grocery beat Fink's 38–31 in overtime to capture the Roanoke city A League basketball championship held at the Market Auditorium gym.

The Roanoke City Council adopted a salary increase for municipal workers. For those on a salary, earnings would increase up to five dollars per month, while those being paid hourly would move from forty-two to forty-three cents per hour.

Mrs. Texas Gladden of Salem had several recordings of her singing folk songs added to the collection of such music at the recording lab of the Library of Congress. Gladden

had been singing for decades in Salem and throughout southwestern Virginia. The recordings were made by Al and Elizabeth Lomax.

WDBJ Radio announced the premier of the CBS network's newest radio show, *Milton Berle*. Presented by Campbell's Soups, Berle's program was Wednesday evenings 9:30 to 10:00.

Funeral services for William Wood were held at Bristol, Virginia, on March 4. Wood was the last surviving member of the VMI cadets who fought at the Battle of New Market during the Civil War. He was ninety-seven.

Back in the 1880s, when the iron business was strong throughout the American South, there existed houses commonly called Furnace Row. The row houses were built for the iron workers and managers. During that period there apparently were two such iron furnaces in Roanoke, one in Norwich and the other just east of the N&W Railway's shops beside the rail tracks. One local newspaper noted that the only Furnace Row structures still in existence from that period were in Norwich and could be seen entering Norwich from Patterson Avenue before making the turn to cross the Roanoke River.

Robert Crichton, secretary to the Tuskegee Institute Service Magazine, died at his home in Roanoke on March 7. Crichton had a tailoring and laundry service business on Henry Street through 1940 before retiring. He had traveled extensively through Europe and had a tailor shop in London at one time. He had also been the personal tailor for Jack Johnson, former heavyweight boxing champion.

In the annual Gold Medal basketball tournament held at the Market Auditorium gym in Roanoke, the Boys' Club upset Junior Grocery 49–48 on a late basket by Rex Mitchell. The tournament consisted of various company teams, high school teams, and recreation league champions.

Jimmy Scribner, a local radio personality for WSLS, played all the roles in his comedy *Johnson Family*, which was broadcast five nights a week. On March 9, Scribner's fun-loving routine was broadcast coast to coast over the Mutual Broadcasting System from the stage of the Roanoke Auditorium. The show was sponsored by Roanoke City Mills.

The job of converting the old railbed left from the discontinued Catawba line into a section of the 311 highway was not going to be easy, contractors reported. The railbed from Hanging Rock to the foot of Catawba Mountain was practically without grade but was not wide enough for vehicular traffic. Further, the widening would have to be done by fills not cuts.

A novel physical fitness program was launched by Roanoke's recreation department. Known as the "Fitness Cavalcade," the days-long event was held at the Roanoke Auditorium and featured local high school and college students dancing, running, racing, boxing, wrestling, and doing other sports and activities. The first night 1,100 spectators watched the events. One of the biggest attractions at the event was John Canty, N&W shop employee, who was national champion wheel roller. He astounded audiences with his control of an eight-hundred-pound railroad wheel with one hand.

Hofheimer's shoe store opened at 305 South Jefferson Street, Roanoke, on March 18. The store was part of a Virginia chain of stores by the same name. F. A. Brady was store manager.

The Dupont Service Store opened a new store at 120 W. Church Avenue, Roanoke, on March 15. This store was relocated from the corner of Henry and Luck Streets. Store manager was Hugh Bryan.

Airport manager Bob Dunahoe announced that he was banning persons from airport grounds on Sundays due to their interference with airport activity. Watching military planes land and take off and milling around them on the tarmac had become a popular Sunday recreational activity such that the manager felt the situation called for the prohibition.

On March 20 Ethel Barrymore, New York stage actress of the famed Barrymore theatrical family, appeared at the Academy of Music in a production of *The Corn is Green*. It was the last road show to be booked by the academy due to its announced closing at the end of the season. Barrymore had first appeared on the academy stage back in 1902 in *Captain Jenks*.

Dr. Walter Binns, pastor of First Baptist Church, Roanoke, was chosen to serve as president of William Jewell College in Liberty, Missouri. The Baptist college announced Binns as their choice to serve as the school's ninth president. Binns had been pastor of First Baptist Church since 1931.

The federal ban on pleasure driving came to an end on March 22. The ban ended due to the belief that everyone was under gas rationing and they should be allowed to use their gas ration as they pleased. Further, local and state officials had been reporting difficulty in determining clear-cut distinctions between pleasure driving and that which was necessary.

Piedmont League baseball officials announced that Heinie Manush would manage the Roanoke Red Sox for the 1943 season. Manush had managed the Greensboro, North Carolina, team in 1942 and was thus being retained with the team's move to Roanoke. In 1942, his Greensboro team had won the league championship.

The annual Roanoke police ball was held at the Roanoke Auditorium with an estimated 3,200 persons in attendance.

The Roanoke public health director and city police embarked on a campaign to stop the rise in the spread of venereal disease in the city, as some four thousand cases were on file with the health director. The program targeted prostitutes, those found guilty on charges of solicitation, and those who were found guilty of running houses of ill fame. Further exacerbating the problem were men on leave from military duty who had contracted a venereal disease while in service. Those found guilty of criminal sexual activity were sent to a city farm, hospital, or jail for treatment. They were pressed for the names of partners who were in turn contacted by a public health nurse or city policeman for a required exam.

Broadway Scandals, a live stage show, was at the Roanoke Theatre on March 24 and 25. The Hal Sands production boasted "an amazing parade of Vaudeville acts, including Ray & Harrison, Judson Cole, and Sally Long." Most prominent in the ads were scantily clad women, all part of the four stage shows.

Claude T. Moorman, thirty-eight, former chemistry teacher and coach at Jefferson High School, died after a thirty-month battle with a blood infection. Moorman taught at Jefferson for thirteen years and coached the football team from 1937 through 1941.

The Cleveland Symphony Orchestra gave two performances at the Academy of Music on March 27, with one of the performances being broadcast live nationally over the CBS radio network. The orchestra's appearance in Roanoke was sponsored by the Community Concert Association. Rudolph Ringwall was the conductor.

The Carver High School, Salem, basketball team went undefeated in their regular season. Some six hundred fans watched the last game of the season in the Carver gym,

where the home team defeated Booker T. Washington High School of Staunton 33–26. Carver's coach was J. Thomas Paine.

The Roanoke Black Cardinals announced their open tryouts with practices at Washington Park. H. M. "Chappy" Simms was manager for the coming season. Officers of the club were W. F. Hughes, president; Harry Franklin, secretary; and Herbert Brown, treasurer.

The Roanoke Woman's Club celebrated its twentieth anniversary in late March. The club was the child of the Women's Civic Betterment Club. Organized in 1923 as a women's organization, having separated from the chamber of commerce, it became incorporated in 1927. The club purchased property at 1501 Patterson Avenue and established the grand home as both a clubhouse and school for disabled children, the first such school organized in the country.

The Hippodrome Thrill Circus opened for a six-night run at the Roanoke Auditorium on March 29. The circus was sponsored by the Roanoke Junior Chamber of Commerce. Some twenty-one acts appeared in two sawdust rings, including trained monkeys, trapeze artists, and high-wire aerialists. Opening day featured a circus parade through downtown Roanoke that involved bands from several local schools.

Judge Earl Abbott in Roanoke County circuit court confirmed the report of the commissioners in the condemnation suit of Roanoke City to acquire land for the development of Carvin's Cove. Consequently, the city attorney delivered to the court a check for $54,830 for the 915 acres of land. This ended the protracted proceedings for the acquisition of the land, most of which would be flooded to create a reservoir.

W. S. McClanahan & Company celebrated their fiftieth anniversary as a general insurance and security bonds firm. Their offices were located at 28 W. Campbell Avenue.

Roanoke attorney Moss Plunkett, a former candidate for Congress and Virginia lieutenant governor, announced his ongoing effort to abolish the poll tax and therefore his candidacy, opposing the incumbent state senator Harvey Apperson in the Democratic primary to be held on August 3. A few days later, Apperson announced he would seek reelection. Both men would compete for the Twenty-First-District senate seat nomination.

Dr. E. G. Gill presented Sally Firey of the Salvation Army with a gold-leaf Bible at a surprise testimonial dinner given in her honor by the Roanoke Lions Club. Business leaders and city officials attended the event at the Hotel Roanoke, which recognized Firey's work for thirty-three years beginning when the Salvation Army arrived in Roanoke.

The initial performance of the newly formed Roanoke Civic Ballet was held at the Academy of Music on April 9. *Aurora's Wedding* was the production.

Will Osborne and his Hollywood Orchestra performed on the stage at the Lee Theatre, and on the same weekend the Tennessee Ramblers gave a performance on the stage of the Roanoke Theatre. The Tennessee Ramblers were a popular novelty "Hillbilly band" that had played music for the movies of Gene Autry and Tex Ritter.

Heinie Manush, manager of the Roanoke Red Sox baseball team, arrived in Roanoke on April 7 to begin his duties of leading the Piedmont League team. Manush had played in the major leagues for seventeen years before becoming a minor league manager. It was the first time Manush had ever been to Roanoke. After visiting Maher Field's baseball diamond, he called it "the perfect setup."

This 1945 image shows the intersection of Jefferson Street and Franklin Road, which included the Park Theatre and the Jefferson Street Pharmacy. *Virginia Room, Roanoke Public Libraries.*

Two watercolors and pastels by Allen Ingles Palmer were among thirty-six paintings accepted by the American Water Color Society at its seventy-sixth annual exhibition in New York City. The Palmer paintings were titled *Southern Winter* and *Revival Days.*

A second war-loan campaign was launched in Roanoke city with a goal of $4,153,900 in bonds to be sold. W. J. Jenks, president of the N&W Railway, spearheaded the local campaign.

The Roanoke County School Board voted to essentially close the Newtown School for black children in Salem and transport the students to Carver School in Salem. The Newtown School lacked running water and was in need of paint and structural repairs. The board felt the better financial decision was to transport students to the new Carver School rather than improve Newtown.

The Roanoke City Electoral Board, chaired by Howard Boyer, presented to the city council a redistricting plan to incorporate the newly annexed areas. The plan realigned the city from five to six wards with a total of eighteen precincts. The new ward was to be called South Roanoke. The other five preexisting wards were Kimball, Melrose, Raleigh Court, Highland, and Jefferson. The council voted to accept the plan, noting it would be temporary.

J. P. Burnett, operator of the Luckland Bowling Alley, Roanoke, was acquitted by a jury on three charges of operating a bowling alley on a Sunday. The case was viewed as a test of a 164-year-old Virginia "blue law" that prior to the jury's acquittal had prohibited such activity. The jury ruled, however, that bowling was "reasonably essential" to the

economic, social, and moral life of the citizens, a standard handed down by the Virginia Supreme Court in a "blue law" ruling pertaining to amusement parks.

Junious Williams, twenty, was shot and killed by Roanoke police as he fled from the rear of Roanoke Paper Company building on Bullitt Avenue, SE. The police stated that Williams was suspected of stealing and failed to stop at police command. Williams was struck by two bullets and collapsed a block away, after which he managed to crawl under a parked car. The police identified Patrolman Paul Vest as being the officer who fired at Williams.

W. Lee Brand, prominent Salem business and civic leader, died at his home at the age of eighty-two on April 19. Brand was formerly president of the Brand Shoe Company, Roanoke, and vice president of the Comas Cigarette Machine Company, Salem. From 1930 to 1933, he was US Marshal for the western district of Virginia. His funeral was conducted at the Salem Presbyterian Church.

Victory Stadium was the site for a large cattle auction on April 20. An estimated nine hundred cattlemen and their spouses assembled under the east stands as the Virginia Hereford Breeders Association held their annual cattle auction. This was a first for Roanoke, as the association normally conducted their annual action in the barns at Virginia Tech. The auction was moved to Roanoke to take advantage of better rail access.

Globe Brewing Company of Baltimore, Maryland, placed ads in local newspapers announcing they would no longer be distributing their Arrow Beer to the Roanoke Valley due to government restrictions related to the war effort.

"Cousin" Irv Sharp and "Uncle" Roy Hall's *Blue Ridge Jamboree* program was broadcast Saturdays from 7:00 to 7:30 p.m. on WDBJ Radio and was sponsored by Wright Furniture Company, Roanoke.

The Roanoke Red Sox held their first exhibition game April 24 against Valleydoah of Williamson Road, winning 5–1. It was the first time the public could see the Red Sox team in action, though no formal roster had been announced. A rematch was held the next day, and the Williamson Road team won 8–3. The same weekend, the Roanoke Black Cardinals played their first game of the season in Springwood Park against the Pond Giants of Winston-Salem, North Carolina. The Cardinals lost 5–0.

Two naval aviation students and two instructors associated with the Roanoke College air cadet training program were killed near the airfield in Montvale on April 27. The midair collision of two planes occurred about a mile east of Buford's Airport in Bedford County. Those killed were Wing Wong, thirty-two, a Chinese instructor from New York City; Clarence Copen, twenty-two, a Roanoke College student from Huntington, West Virginia; D. D. Isenburger, an aviation instructor who lived at Montvale; and R. A. Wright, a student from Norfolk, Virginia. The aviation program at Roanoke College was affiliated with the navy.

Lt. James William Pflueger, one of the first Roanokers to be killed in World War II, was memorialized when the second camping unit at Camp Bowles was named after him. Camp Bowles was the Boy Scout camp given by the Rotary Club of Roanoke. The camping unit was donated to the Boy Scouts by Pflueger's father.

The McCormick-Deering Store, a firm that was operated by International Harvester, was succeeded by Shackelford-Cox Truck & Machinery Company. The store was located at 405 Shenandoah Avenue, Roanoke.

Naval aviation cadets were numerous on the campus of Roanoke
College during the war years, 1943. *Archives, Roanoke College.*

Professional baseball returned to Roanoke after a decades-long drought with the opening game for the Roanoke Red Sox on May 4 at Maher Field against the Lynchburg Cardinals. This was the first home game for the Red Sox in the Piedmont League. The starting lineup for the Red Sox was Don Edwards, center field; Donald Dix, right field; Joe Douglass, left field; Al Gardella, first base; Dusty Rhodes, second base; Mike Sabena, third base; Jack Crosswhite, catcher; Phil Poole and Al Nalley, pitchers; and Preston Reynolds, shortstop. Much fanfare accompanied the opening game, with the Jefferson High School band and the American Legion drum-and-bugle corps providing music. Three mayors participated in a ceremonial start to the game: Walter Wood, Roanoke; J. F. Martin, Salem; and Joe Pedigo, Vinton. The Red Sox won in a come-from-behind victory, 5–3, in front of an estimated crowd of 4,500.

Roanoke mayor Walter Wood announced he would be a candidate for the Virginia House of Delegates in the city's Democratic primary. Both incumbent state legislators, Earl Fitzpatrick and Walter Scott, had previously announced bids for renomination and reelection.

Lakeside Park opened for the season on May 7, though the Lee-Hi swimming pool opened a few days earlier. The Lakeside ad read, "All drunks and other undesirables are warned not to trespass."

The Cave Spring Water Company was ordered to appear before the State Corporation Commission on May 17 for failure to give adequate water to its customers. In April, the state Health Department sent notices to the company's customers alerting them that the water being provided was not safe for human consumption. The department had instructed the water company to build a wall between the road ditch and the spring that provided the water. D. B. Ferguson was president of the water company.

A large forest fire consumed significant acreage on the south side of Catawba Mountain May 5 and 6, east of the old Camp Triangle. Volunteer firemen were able to contain the blaze, and brush burning was cited as the cause.

Benjamin Chapman, member of the Virginia House of Delegates representing Roanoke County, announced that he would not seek reelection. He had been a member of the assembly since 1936.

St. Andrews Catholic Church, the oldest Catholic Church in Western Virginia, marked its fiftieth anniversary May 9 and 10, with special services, an anniversary mass, and a pageant that honored the congregation's founder, Father John William Lynch. Lynch held the first Catholic services in a railroad passenger coach.

The Gwaltney Tire & Battery Company opened at the corner of Walnut and Maple Avenues, SW. The company occupied the AMOCO service station at the location on May 9.

Mrs. John White Acree, widow and resident of Salem, helped launch a navy ship named in honor of her husband. The destroyer escort, the *Acree*, was launched from US Steel's federal shipyard in Newark, New Jersey. Acree had been killed in action in the Pacific. Acree had been the captain of the University of Virginia state championship football team in 1938.

A special Mother's Day program was held at Victory Stadium on May 9, with some four hundred attending. Service mothers were given a special honor, and music was provided by the Jefferson High School band.

The parking lot at Woodrum Field was paved, much to the gratitude of patrons and aviators. The unpaved lot generated dust and chuckholes. The areas around the hangars were also paved. The total cost was $543.

One of the few baseball diamonds in northwest Roanoke had been plowed by victory gardeners with the permission of the school board, which owned the diamond. Residents of the section complained to city officials that it eliminated one of the only diamonds in the section. The baseball field in question was located at Nineteenth Street and Carroll Avenue. The city manager recommended that the victory gardeners be reimbursed their expenses and the ball diamond be put back.

Count Berni Vici's *Stardust Revue* appeared on the stage of the Roanoke Theatre. The show boasted dancing, singing, comedy, and novelty acts. The stars were Selma Claire and Muriel Burns and the NBC Orchestra, Jack Powell Jr., Floyd Christy & Company, and several others from vaudeville and radio.

Furman B. Whitescarver, a Salem attorney, announced that he would seek the post vacated by Benjamin Chapman in the Virginia House of Delegates. Chapman had earlier announced he would not seek reelection due to his serving in the military. Whitescarver had made an unsuccessful attempt for the seat in 1935.

"I Am an American Day," a federal observance to spark patriotism initiated by President Roosevelt, was observed with a program at Victory Stadium on Sunday

afternoon, May 16. An evening banquet was held at the Patrick Henry Hotel. At the stadium gathering, Virginia's lieutenant governor, William Tuck, addressed the crowd.

Roy Hall, a local radio talent and musician with the Blue Ridge Entertainers, was killed in an auto wreck on May 16 when his car hit a tree in Eureka Park. A companion, Martha Ferguson, was seriously injured. Hall died at the scene. Hall was heard regularly on WDBJ, having come to Roanoke from his hometown of Marion, North Carolina.

A military plane crashed about twenty-five miles from Roanoke on Potts Mountain in Craig County near the border with West Virginia. All men aboard the craft were killed and their remains taken to New Castle. The crash occurred on May 16, and those killed were the flight surgeon, Maj. James Citta of New Jersey; Maj. Robert Bell of Pennsylvania; and Capt. Jere Wells of Georgia. The plane was on a routine navigation flight when it hit the mountain.

The federal government filed a condemnation action in court in order to obtain 309 W. Campbell Avenue for army training purposes. The suit was brought against J. F. Barbour, the building's owner, and Leila Fers, who was leasing the building as a dance hall. Under a 1942 law, the federal government could take immediate possession of a building it deemed necessary for war preparation. Barbour had refused to break the lease, thereby necessitating the suit.

The Tinker Bell Pool opened for the season on May 22, with hours of operation being 10:00 a.m. to 8:30 p.m. H. H. Meador was the manager of the pool, which also offered free picnic grounds. Ads read, "No swimming in trunks alone; no intoxicating drinks or undesirable people allowed on premises."

Five local companies of the Virginia Reserve Militia, known as "Minutemen," received national and company colors in a ceremony at the Roanoke Auditorium on May 30. Guest speaker for the ceremony was Adjutant General Gardner Waller.

Eddie Durham and his All-Girl Band performed for a dance at the Roanoke Auditorium. The blacks-only dance did permit white spectators. Durham's band advertised as "beautiful girls playing hot jazz."

Horace Mayhew, Roanoke's city sergeant, died unexpectedly at his home on May 25. Mayhew was fifty-five and had served as city sergeant for over twenty-five years. He was elected to the post in 1917, defeating the incumbent, T. R. Tillett. He had been reelected several times since without opposition.

Principal J. D. Riddick of Jefferson High School announced that the school's new head football coach would be Al Boyer. Boyer had been the assistant coach under former head coach Rudy Rohrdanz, who was serving with the navy.

Watson Sadler took over the Maurice Twine Mill in Norwich and converted it to a dehydrating plant for cabbage, apples, and other farm products. Sadler made tours around Roanoke County with the extension agent to discuss his dehydration plant and process. It was noted that Sadler was paying twenty dollars per ton for cabbage.

Eugene Mitchell, thirteen, won the annual city-county marbles tournament. Runner-up was Russell Richards. It was the fourteenth year of the tournament, and the marble rings were in Elmwood Park.

The postal service divided the city of Roanoke into postal zones and asked patrons to include the zones on their return addresses or on addresses for mail sent within the city. (The zones were precursors to today's zip codes.) The zones and their assigned number were as follows: Raleigh Court, Virginia Heights, Wasena—15; South Roanoke—14;

Highland Park, West End—16; Northwest—17; Williamson Road—12; Southeast, Garden City—13; and downtown—11.

A new fire engine, built by members of the volunteer Williamson Road Fire Department was put into service the end of May. The engine was capable of delivering 250 gallons of water per minute from hydrants or streams. The engine carried ladders, a seven-hundred-gallon booster tank, hand chemical pumps, and a one-and-a-half-inch hose. The fire chief was Ben Jarrett.

The Maggie L. Walker Ambulance Corps was recognized on the occasion of the one-year anniversary in a ceremony in Washington Park. Dr. L. C. Downing of Burrell Memorial Hospital presided over the ceremonies. One of the many accomplishments of the corps was the creation of a first-aid station in northeast.

Three persons were injured in a plane crash at Woodrum Field on May 31. The plane, attached to the Civil Air Patrol, flew to Roanoke from an army base in Kentucky. The plane approached the runway too low, and the wheels caught a fence and flipped the plane. Injured were Lt. Howard Turpin, a CAP pilot; Pvt. Warren Turpin; and Warren Turpin, father of Pvt. Turpin.

City work crews making improvements to Maher Field dug up a human skeleton about four feet below ground. While creating a dugout for the baseball field, crews unearthed a grave believed to be that of a Native American. In addition to bones, small shells were also discovered. City health commissioner C. B. Ransone examined the remains of bones and teeth and quickly determined they were human. There were four to five pieces of skull, a section of femur, and a rib bone. A few days later, an elderly county resident informed Ransone that the bones were not those of a Native American but that there was a graveyard in the vicinity of Maher Field. J. W. Smith of Catawba stated that his mother had told him that an old graveyard was located in the flat plain upon which Maher Field was located. Smith's great uncle, Jim Gleason, had lived near the Maher Field site and had purchased the land from Pattson Hanmer many years ago. Smith theorized that the bones were from a family cemetery.

Tiffany Toliver, a prominent black civic leader in Roanoke, died at age fifty-four on June 1. Toliver operated a barber shop in the old Terry Building, which was later razed to make way for a bank. He died in Washington, DC, where he was engaged in the cemetery business.

Judge J. L. Almond appointed Edgar Winstead to serve the remaining term of Horace Mayhew, deceased, as city sergeant. Winstead had been chief deputy for thirteen years.

Sigmund Romberg and his forty-four-piece orchestra performed at the Roanoke Auditorium on June 5. Romberg was widely known for his radio broadcasts, and his show featured singers Marie Nash, Grace Ponvini, and Michael Edwards.

Cedric Foster, a nationally known radio commentator, spoke at the Academy of Music on "Global War." The program was sponsored by Christ Episcopal Church.

Rev. Father Philip Grasso, the first graduate of St. Andrews to become a priest, sang his first high mass at St. Andrews Catholic Church on June 6. He graduated from St. Andrews High School in 1937. A reception for Grasso was held following the mass in St. Vincent's Home on North Jefferson Street.

The Sweethearts of Rhythm, an all-female band and singers, performed for a graduation dance on June 9 at the Roanoke Auditorium for all graduates of Carver and Addison

High Schools. The band advertised as "Negro, Indian, Chinese, and Mexican." Admission was $1.25, with white spectators admitted for $0.75.

On June 13, the Ink Spots gave two performances at the Roanoke Auditorium, billing themselves as "red hot and blue from Harlem." Those touring with the Ink Spots were Sister Rosetta Tharpe, Red and Curley, and Peg-leg Bates. The group was accompanied by Lucky Millinder and his orchestra.

The Pine Room at the Hotel Roanoke was converted to a lounge for those military fliers receiving training in the Penn-Central Airlines school at Woodrum Field. Membership cards were issued to the trainees and faculty.

The Salem Full Fashioned Hosiery Mill announced plans to buy off bonds that were sold in 1938 by a holding company for the mill to acquire lands and build a factory. Furman Whitescarver, of Salem Industries, Inc., stated that the mill had accomplished its goals and the bonds would be purchased.

Nelson Bond, a Roanoke author, won the $2,000 grand prize in a nationwide radio script contest sponsored by the *Dr. Christian* radio program heard over CBS. His wife, Betty Bond, also was among twelve other winners, receiving $250. Bond's winning play script was titled "The Ring" and was about the black market. Bond was a prolific writer for magazines and first began his script writing with the WDBJ Dramatic Guild.

Approximately 450 Boy Scouts attended an overnight Camporee held in Fishburn Park the weekend of June 12.

Jefferson High School graduated 406 students in its commencement ceremony, held in the American Theatre. Student speakers included Fred Wright, Shirley Rubenstein, George Dragon, Hazel Hairfield, Charles Lemon, and James Kavanaugh. Andrew Lewis High School held its graduation exercises in the school auditorium. Dr. Charles Smith, president of Roanoke College, addressed the graduates, as did Betty Jean Peck, salutatorian, and Annie May Roberts, valedictorian. Addison High School graduated sixty-two students in a ceremony held in the Roanoke Auditorium. Student speakers included Walter Coleman, David Whitlock, Elnora Williams, and Goldie Belcher.

Roanoke resident William Williams, twenty-three, was found dead in a hotel in Norfolk; the cause of death was strangulation. Police officials in Norfolk suspected foul play, as they believed the body had been placed to stage a suicide. Williams was a graduate of Jefferson High School and a former employee of Fallon Florist before moving to Norfolk. Three days later the Norfolk coroner stated that Williams had died due to strangulation by a person or persons.

The Lutheran Synod of Virginia placed a marker at the original site of Roanoke College, one mile west of Mt. Tabor Lutheran Church near Staunton. The college had been founded in 1842 in the parsonage of Mt. Tabor under the leadership of Rev. D. F. Bittle and Rev. C. C. Baughman. The school moved to Salem in 1847 and was chartered as Roanoke College in 1853.

Citizens appeared before the Roanoke County School Board to urge that Starkey School and Ogden School not be merged. The board was considering consolidating the two schools. The citizens presented petitions signed by over 370 residents urging keeping the two schools open.

On June 14 a Flag Day parade was sponsored by the American Legion in downtown Roanoke for the purpose of promoting the sale of war bonds. The 5:00 p.m. event moved along Jefferson Street, south on Campbell to end at the municipal building. R. W. Irvin

was the parade marshal. Parade entrants included scout troops, military reserve units, veterans' organizations, city officials, and a variety of civic organizations.

Wayne McDaniel, assistant superintendent at the Baptist Orphanage in Salem, died on June 13. He had worked for the orphanage for fifteen years. He was a native of Andrews, North Carolina.

A fire severely damaged the Wright Furniture Company on June 15. The store was located at 119–121 East Salem Avenue, Roanoke, and owned by Roy Wright. Two firemen were overcome by smoke inhalation battling the blaze, but there were no other injuries.

A violent hailstorm hit the southwest section of Roanoke city on June 17, uprooting old oaks in Highland Park and collapsing a wooden railroad tipple in Norwich erected by the Roanoke Concrete Company plant there.

The Kroger Store at 601 Eleventh Street, NW, closed on June 19. It relocated and reopened across the street on June 24 at 604 Eleventh Street, NW. At the time, there were eighteen Kroger groceries operating in the Roanoke Valley.

An examination of city records by the health department revealed that on June 8, 1942, Mary C. Watson of 417 Patton Avenue, NW, died at the age of one hundred thirteen. The department officials reported that to be the second-highest age ever reported in the city. The highest age at death was reported several years prior for C. C. Williams, also of northwest Roanoke.

The Botetourt County Board of Supervisors postponed consideration of closing the Carvins Cove Road, requested by the City of Roanoke, for the purpose of flooding the area to form a permanent reservoir for the city.

The murder of Roanoker William Williams Jr. in a Norfolk hotel room was solved on June 22 when Ersel Dye, twenty-three, confessed to the crime to Norfolk police. Dye claimed the two men got into an argument, and that led to Dye strangling Williams by his necktie.

The Wake Island, a US Marine Corps recruiting trailer, came to Roanoke on June 23. The effort was to recruit women into the USMC women's reserve unit. To qualify, women must have had at least two years of high school or business college and be between twenty and thirty-six years of age. The pay grades were the same as for men.

The Roanoke City parks and recreation department held their annual pet shows in Wasena and Jackson Parks. Some five hundred persons attended the Jackson Park event.

Roanoke mayor Walter Wood purchased the first bond on July 1 in an effort to spur another million-dollar war-bond-sale campaign. The mayor purchased his bond from a window on the fifth floor of the State and City Bank Building, downtown. A member of the junior chamber of commerce was on top of a ladder extended to the window from a ladder truck from Fire Station No. 1. The purchase was made while four heavy bombers from Woodrum Field soared overhead.

Responding to citizen complaints about low-flying planes, airport manager Bob Dunahoe said he would more strictly enforce CAA guidelines that all aircraft be above one thousand feet from the ground.

The Garner Aviation Service at Woodrum Field was granted a charter by the SCC. Fleetwood Garner was president of the company and had been formerly associated with Buford Field at Montvale.

The Silver Gable Tourist Court was located along Route 11, west of Roanoke, 1943. Route 11 was the main north-south highway for the region. *Bob Stauffer.*

Gloria Downing of Roanoke was ranked fifth in the nation in the Girls Singles Division by the American Tennis Association.

An appeal was made for a crash truck at Woodrum Field to aid in future plane crashes there. While there had been few crashes and no fatalities, airport officials felt they must be prepared. Fallon Florist donated a Cadillac automobile to the City of Roanoke Fire Department with the understanding that it would be converted for such a purpose. However, the cost of conversion and equipment needed was estimated to be around $3,400.

Roanoke city's tuberculosis sanatorium won accolades from the American College of Surgeons during an inspection by the organization in early July. The city sanatorium was located at Coyner's Springs and had X-ray equipment. The facility opened in 1939 for the care of indigent patients, but it had also served those who could pay. It had sixteen staff persons and averaged a daily patient census of forty-five, with an average stay of twelve months. The outpatient department averaged fifty patients daily. Dr. Grover C. Goodwin was the sanatorium superintendent.

T. X. Parsons, prominent Roanoke attorney and Republican activist, died in a local hospital on Jul 3 at the age of forty-seven. Parsons was a native of Grayson County, Virginia, a veteran of World War I, and a former assistant US district attorney. Parsons had been an unsuccessful Republican candidate for Congress, trying to unseat Congressman Woodrum.

O. D. Creasy Jr. of Vinton was posthumously awarded the Distinguished Flying Cross medal for heroism at the Battle of Midway. Creasy was stationed aboard the USS *Hornet* and was among thirty men in a torpedo squadron that did not return.

Woodrum Field's first crash truck, shown here in 1943, was a modified 1939 Cadillac donated by Fallon Florist. *Virginia Room, Roanoke Public Libraries.*

Mrs. O. D. Creasy is presented an American Flag; her son, O. David Creasy Jr., was the first casualty from Vinton in World War II. *Vinton Historical Society.*

American Airlines, Inc., appealed to the CAA for new routes such that Roanoke's Woodrum Field would become a major crossroads stop should the new routes be approved. One new route was from Detroit to Miami.

Dr. R. C. Geringer, head of the venereal disease control clinic for the City of Roanoke, urged city officials to impose a curfew as a means of curbing venereal diseases. His comments were prompted by the closing of the prophylactic station at the clinic, a joint operation between the city and the US Army medical corps. Geringer suggested a 10:00 p.m. curfew, stating that there were over five thousand known cases of syphilis in the city.

Martha Ann Woodrum became the second woman in Virginia and the thirty-second in the nation to receive her rating for instrument flying.

A double funeral was held at First Baptist Church, Gainsboro, for Staff Sgt. Norwood Langhorn and his wife. Langhorn was training at the Tuskegee Army Flying School when he and his wife died in a house fire near the school.

A mile-long army convoy moved through the streets of downtown Roanoke on July 9 en route to Maher Field. The convoy contained a variety of military vehicles arriving for a weeklong exhibit at Maher Field to help promote the war-bond-sales effort in the valley.

Roanoke's two oldest postal clerks were interviewed by local papers and shared the many changes they had seen in mail service. Charles McCown had been a postal employee since 1903, and Errett L. Turman had been a mail clerk since 1902. Both men cited the post office no longer being surrounded by livery stables and wagon lots, self-feed canceling machines, parcel post service growth, and a set work week as being signs of progress.

For the first time since Prohibition, Roanoke was dry of beer on July 10. Store shelves literally were empty due to the large quantities purchased and fewer suppliers of beer due to war-related transportation issues. Most retailers attributed the shortage to the presence of the military convoy at Maher Field.

At its meeting on July 12, members of the Roanoke City Council expressed support for purchasing the Academy of Music and operating it as a municipal facility. The terms were that the city would purchase the academy and all its equipment for two-thirds of its value, meaning a price of $13,500. The remaining one third of the ownership would be donated to the city by J. P. Fishburn. The vote was three to two. The topic of ownership had been broached some weeks prior in executive session. Various civic organizations volunteered to establish a board of trustees to oversee the operations and maintenance of the building should the terms of the arrangement be successfully worked out between the city and the academy's owners.

The operation of the city jail was criticized by state officials who conducted a site visit. Among the items cited as needing to be addressed were the following: too much confidence being placed in jail trustees, police officers being allowed access while carrying a sidearm, food services, and sanitation.

The Roanoke City Council retained the services of Alvord, Burdick, and Howson of New York to develop preliminary engineering plans for Carvins Cove reservoir. The contract with the firm was for $800.

Mr. and Mrs. G. L. Brown of Roanoke received a posthumously awarded Purple Heart for their son, Benjamin Brown, who was killed in the Japanese attack at Pearl Harbor in 1941.

The Sadler Roanoke Corporation announced that it expected its dehydration plant in Norwich to begin operations in early August. The company had purchased the old Norwich Twine Mill building and had converted it to dehydrate fruits and vegetables.

Roanoke College purchased the home at 236 High Street, Salem, for the purpose of creating a girls' dormitory. The home had belonged to Miss Janet Ferguson, the college librarian. The remodeled home would incorporate a lounge, study room, suite for the matron, and rooms for fifteen to eighteen girls.

The Botetourt County Board of Supervisors voted to close six miles of state highway 601, extending northward from Carvins Cove dam in order that the City of Roanoke might begin development of the city's reservoir.

Pvt. Lawrence Wright of Roanoke was reported by military officials to have died of dysentery in a Japanese POW Camp. Notice was sent to Wright's brother, Ralph, of Roanoke.

The installation of Roanoke's Dr. E. G. Gill as the international president of the Lions Clubs was in Cleveland, Ohio, in July 1943. *Historical Society of Western Virginia.*

Dr. E. G. Gill of Roanoke was installed as the new international president of Lions at the Lions' 27th Annual International Convention in Cleveland, Ohio, on July 22.

A former naval depot guard shot and killed five persons in Utah. Among the dead was Judge L. V. Trueman, who two months prior, had granted a divorce to the shooter's wife. Judge Trueman, fifty-three, was a native of Roanoke and a former employee of the N&W Railway. He also served a term in the Florida legislature.

Bonnie Baker along with Tommy Reynolds and his orchestra gave a stage performance at the Roanoke Theatre on July 29.

The City of Roanoke, a four-motored B-17 Flying Fortress that was bought and paid for by Roanoke bond purchases, was officially christened at Woodrum Field on July 25. The bomber plane, with a crew of nine, flew in from its base in Florida. The crew was given a luncheon at the Hotel Roanoke. The christening ceremony included a speech by Norman Kelley, past president of the chamber of commerce, and floral christening for the plane by Miss Gene Bohn, representing the Professional Women's Club that raised significant amounts in war-bond sales. Kelley replaced the principal speaker, Congressman Clifton Woodrum, who was ill and could not attend the event.

The local office of the War Food Administration admitted that potatoes it had purchased to help regulate prices were rotting in a local warehouse, and carloads were being dumped into the Roanoke River near Memorial Avenue Bridge. Nearby residents had complained about the stench of the rotten produce. The old Noland warehouse near the

bridge was the storage site. WFA officials said future potato shipments would be removed quickly to stores and retailers.

Mr. and Mrs. Joel Grisso were formally notified that their son, Pvt. William Grisso, was killed in action on March 20 in North Africa. Grisso had attended Andrew Lewis High School in Salem and operated the Wasena Barbershop prior to entering military service.

George Denison was appointed acting general manager of the Hotel Roanoke on July 30 by N&W Railway officials. Denison was standing in for the former manager, Kenneth Hyde, who had been commissioned in the navy.

This July 1943 image shows the lobby of Hotel Roanoke with its summer furniture. *Norfolk & Western Railway Historical Society.*

In a spirited August 3 Democratic primary for the Virginia House of Delegates, Roanoke mayor Walter Wood edged out incumbent Walter Scott. At this time, Roanoke city had two delegates in the General Assembly. The primary results were Earl Fitzpatrick, incumbent, 2,017 votes; Wood, 1,630 votes; and Scott, 1,528 votes. Scott had served in the legislature from 1932 to 1934 and again since 1938. In Roanoke County, the Democratic primary for the Twenty-First Senatorial District had incumbent Harvey Apperson receiving 2,384 votes to Moss Plunkett's 540 votes. In Roanoke County, the Democratic primary for sheriff had incumbent Emmett Waldron defeating John Morgan 2,709 to 403. In the county's Democratic primary for commonwealth's attorney incumbent Eugene Chelf won over Edward Richardson by a margin of 408 votes. In the same

Peacock Alley in the Hotel Roanoke was a well-known corridor to the hotel's
regular guests and staff, July 1943. *Norfolk & Western Railway Historical Society.*

primary held for the Salem magisterial district for the county board of supervisors, incumbent Howard Starkey defeated challenger R. D. Hurt 1,013 to 465. All winners stood for general election later in November. There were no Republican primaries.

The Colonial Theatre in Salem opened its annex on August 7. The annex was adjacent to the theatre's lobby and held dances, amusements, and "fountain service."

The federal government took possession of the air motive shop at Woodrum Field using authority granted for such during wartime. The facility, known as Hangar No. 2, was under lease from the city by Clayton Lemon. The building was to be used in connection with the training of military personnel.

The two-day Virginia Trapshooting Tournament championship was won by Roanoker H. D. Guy. The tournament was held at the Roanoke Gun Club's shooting range.

Delta Airlines announced from its Atlanta, Georgia, headquarters on August 7 that it planned to serve five new cities after the war, with one of the five being Roanoke. Delta made application with the CAA to add new postwar routes and stops. Roanoke would be on Delta's Atlanta to New York service and the Cincinnati to Norfolk route.

Lt. George Carper of South Roanoke was killed in an airplane crash on August 7 near Brooks Field, Texas, where he was an aviation instructor. He was a graduate of Jefferson High School and the son of Mr. and Mrs. Harry Carper.

Dr. J. B. Clayor built a camp near Green Ridge Park in Roanoke County for the sole use by black Boy Scout troops. The camp had a swimming pool and clubhouse. In

addition to scouts, the camp was also used by black YMCAs and other black organizations. The facility was called "Camp Wagon Wheel" as the entrance was adorned with a large white wagon wheel.

Hubert Barrier won the annual city-county tennis tournament held in South Roanoke Park. Barrier defeated perennial champion Charley Turner in straight sets. The doubles tournament was won by Barrier and Bill James, who defeated Turner and Dudley Colhoun.

The Roanoke City Council voted unanimously to acquire the Academy of Music at its meeting on August 9. The vote stated the terms of the sale were not to exceed $13,500 for the building and equipment. The vote was a response to an offer made to the city by the academy's ownership group.

Dr. Ralph Brown, retired physician and civic leader of Roanoke, died on August 9 in a local hospital. Brown was seventy-six. He was past president of the Roanoke Academy of Medicine and was associated with Jefferson Hospital. He was a native of Anderson, South Carolina, having come to Roanoke in 1893.

Dr. W. B. Foster, who organized Roanoke's first public health department around 1910 and served as its director for fourteen years, died in Richmond on August 10 at age sixty-five. Foster was employed in that city as the assistant public health commissioner. He was a past president of the Roanoke Academy of Medicine.

Col. James P. Woods of Roanoke was elected rector of the board of visitors for VPI at the board's meeting on August 11. Woods had been a member of the board of visitors since 1924.

The Lee Theatre on Williamson Road became part of the leased chain of theatres managed by the Newbold Circuit of Bramwell, West Virginia. This arrangement linked the Lee with the management of the Grandin Theatre such that the Grandin managers would oversee the Lee Theatre's operations.

In early August the US Army moved its induction station in Roanoke to 309 W. Campbell Avenue, occupying all four floors of the former Colonial Furniture Company building. Maj. Tommy Thompson was director of the center.

The Roanoke Community Concerts Association announced three upcoming performances in Roanoke: the National Symphony Orchestra, popular radio baritone Robert Weede, and the Metropolitan Opera's soprano Mona Paulee.

Christine Chatman and her jitterbug band performed at the Roanoke Auditorium on August 10. The blacks-only dance also admitted white spectators.

Over two hundred exhibits were shown at the Victory Fair held in Jackson Park. The participants were all residents of southeast Roanoke, according to the city parks and recreation department, sponsor of the event. The fair exhibited raw vegetables, canned items, and various hand-sewn textiles such as quilts, bedspreads, and needlepoint.

Buddy Johnson and his orchestra, along with Ella Johnson and Andrew Snyder, performed at the Roanoke Auditorium on August 20. The dance was for blacks only, though white spectators were admitted.

The Salem Town Council voted to ban the sale of beer and wine on Sundays after September 19. The ordinance was adopted at a special meeting convened for the sole purpose of considering the matter.

Pfc. David Bane of Route 2, Salem, was listed as being killed in action by military officials. Bane was killed in the North African theater.

The Salem community cannery opened on August 23 for use by Salem and Roanoke County residents. The cannery was located in the former school for blacks on Water Street, Salem. E. A. Harding was in charge of the cannery.

The Big Outdoor Show, a weeklong event, kicked off on August 23 at the Horton Circus Grounds located at Twenty-Fourth Street and Melrose Avenue, NW. The show featured a midway operated by Marks Shows, Inc., a "mile-long pleasure trail" that included twenty rides and shows. Shows were the High Hat Revue *Pretty Girls That Dance*, a Harlem Club minstrel show, and a circus sideshow of "curious people and human oddities," including "Zoma, the wild girl."

R. C. Royer, manager of the Academy of Music, announced that Boris Karloff would do a one-night performance at the venue on September 13 in the stage hit, *Arsenic and Old Lace*. It was the first scheduled event since the City Council of Roanoke voted to acquire the Academy.

The Roanoke City Council voted to construct a $20,000 hangar at Woodrum Field to house the Virginia Airmotive operations of Clayton Lemon, given the federal government's condemnation of Hangar No. 2 for military purposes. The council also voted to lease the old Gregory School for purposes of a nursery school for black children in the northeast section of the city.

Almeta's Beauty Shop opened on August 27 at 124 Church Avenue, SW. Operators were Kate "Kittens" Stewart and Judy Ryan.

Elva Dyson, thirty-six, was shot by R. W. Cook inside Cook's radio store at 112 Second Street, SE, on August 28. Dyson died two hours later in a local hospital.

Dr. E. Stanley Jones, prominent missionary to India and well-known author, addressed a conference of Brethren churches held at First Church of the Brethren in Roanoke. Jones, a Methodist, also spoke to an overflow crowd at Greene Memorial Methodist Church in Roanoke during his visit.

Ivin Williams, three, was fatally struck by an automobile while crossing Lakeside Road near the Edgewood Supply Company on August 29. The Salem boy was with his mother and two other children at the time of the accident. The driver of the vehicle that struck the boy raced from the scene and an intensive hunt by the sheriff's department led ultimately to the arrest of four persons: F. W. Dudley, driver of the car; and three passengers, Peggy Price, Walter Karpowich, and Roscoe Conner. All were charged with manslaughter. The four were found and arrested due to Price confessing to a neighbor that she was in the car when it struck the boy. Dudley was later charged with one count of manslaughter and one count of leaving the scene of an accident.

On September 1, WSLS moved to 1240 on the radio dial.

Nathaniel Hairston, thirty-one, of Rutherford Avenue, NW, was shot in the abdomen by Clyde Ingram, twenty-one, a boarder at Hairston's home. Hairston died days later, and Ingram was charged with murder.

The Salem Bowling Center announced the opening of six new lanes on September 4. The center was located at Main and Broad Streets and had both ten and duck pins. The center was operated by the R. L. Carper Company and connected with the Automat dance hall. The bowling lanes were on the ground floor.

Boy Scouts from Salem, Vinton, and Roanoke were enlisted to help harvest apples in orchards located in Botetourt County due to the shortage of manpower. The scouts were housed at the campus of Daleville College in three different groups during the month of September. Scout officials estimated nearly 175 participants.

First Church of the Brethren, located at Eighth Street and Loudon Avenue, NW, celebrated its fiftieth anniversary on September 5. A meeting to establish that church was first held in August 1893, gathered in a hall over a buggy factory on Third Street, SE. On October 14 of that year, a Sunday school was organized and a building program launched. The congregation helped start three other Brethren churches in the region: Hollins Road in 1915, Ninth Street in 1923, and Central in 1923.

Judy Kayne and her ten-gentlemen orchestra gave a live stage performance at the Roanoke Theatre on September 8. Other performers included Charlotte Joyce, Rondo Carver, Jessie Elliott, and Chris O'Brien.

The Roanoke City Council adopted a plan of operations for the Academy of Music developed by a special committee and gave final approval to the appropriation of $13,500 for acquisition of the academy and its contents at their meeting on September 7. The plan of operations stated that the city would lease the building to a nonprofit organization; that the rent would be $750 annually; that the rent would be earmarked for repairs and maintenance of the academy; and that the finances of the academy could be reviewed at any time by city officials.

The Pennsylvania-Central Airlines filed papers with the CAA that would make Roanoke a key airport in their proposed route expansions. Roanoke was targeted to be a key stop on the Buffalo, New York, to Miami, Florida, route, among others.

W. J. Jenks chaired the third war-bond campaign held in Roanoke. The goal was to raise $7.248 million in war-bond sales, representing Roanoke's share of Virginia's quota.

Pvt. Burger Gish, thirty-three, was killed in action in the North African Theatre, according to a war department telegram received by his parents, Mr. and Mrs. J. R. Gish of Melrose Avenue, NW. He was a graduate of Jefferson High School, Class of 1930.

The Roanoke War Products Exhibit opened September 10 at the Roanoke Auditorium for a weeklong show that was sponsored by the chamber of commerce. The show was an effort to promote the sale of war bonds by highlighting what local companies were doing to help serve the war effort through the display of their products and services.

Salem and Roanoke County officially launched their war-bond campaign by holding a community sing on the lawn of the county courthouse on September 11. Mrs. G. G. Peery led the singing of mostly patriotic songs, and the main speaker was R. F. Hough, superintendent of the Baptist Orphanage.

Shown here is Gilmer Avenue, NW, in the 1940s, with Reliable Service Grocers at left center of the image. *Roanoke City Police Department.*

P. T. Mallory, known to VPI cadets as "Tim the Presser," shared with local reporters the story of how he was responsible for Tech's team being known as the Gobblers. Mallory said he went to work for VPI in 1908 as a servant, coming from Canton, Ohio. He noticed the football team's mascot was a turkey, so he started calling the team the Gobblers in front of the cadets whose uniforms he pressed at the laundry. "The president called me up to his office one day and asked me whether I would be willing to try to train a turkey to drill on the football field for the annual game played in Roanoke." Mallory agreed to try, and making a harness for the turkey, he was eventually able to get the gobbler to follow a few simple directions. Game day arrived for the Roanoke match—sometime in the 1930s as Mallory could not recall the specific year—and Mallory was asked to get his trained turkey to strut on the field during halftime. "I started out on the field and when the turkey began to drill as he was trained," Mallory said, "it was too much for those VMI boys. They just sorta flowed out on to that field and headed my way. Leadin' em were two bulldogs on a leash held by a VMI cadet. I could see that those bulldogs were going to tear my turkey to pieces, so I directed the gobbler down the sidelines away from the hounds." According to Mallory, the VPI cadets began emptying the bleachers to protect their prized turkey. Police had to separate the teams and cadets. Asked what happened to the turkey the VPI team had so well defended, Mallory replied, "The coaches and I got together and ate him for Thanksgiving dinner. That turkey sure was good." Nevertheless, the gobbler tradition and name were launched.

Bob Royer of the Academy of Music announced that Boris Karloff's appearance in *Arsenic and Old Lace* was sold out in advance, with the exception of twenty-five tickets remaining for "colored patrons." In an effort to support the war-bond campaign, Royer said that Karloff would autograph programs after the show for those who purchased war bonds at a booth in the lobby.

The Roanoke City Council authorized the city manager to employ day laborers to begin clearing out brush and trees from Carvins Cove in preparation for the reservoir. The city manager had estimated the cost of cleaning the basin to be $60,000. The council also appropriated $14,000 for the improvements to runways at Woodrum Field.

Methodists on Bent Mountain decided to build a new church on a lot purchased for them by Grace Terry Moncure. Ms. Moncure also proposed that the new church building reflect the contributions of Henry Lawrence, who was instrumental in founding the Methodist church there. The congregation agreed the new church would be The Lawrence Memorial Methodist Church.

The Roanoke Red Sox were eliminated from the Piedmont League playoffs when they were defeated four games to one by the Portsmouth Cubs in the fifth game of the series, played at Maher Field. The Cubs were the defending champions.

Jefferson and Fleming High Schools opened the high school football season with a game on September 18, with Jefferson defeating Fleming 51–0. Proceeds from the game benefited the sandlot football program in Roanoke.

N. W. Kelley, president of the Southern Varnish Company in Norwich, assured city officials that the stench coming from his plant and being the subject of neighborhood complaints was being dealt with as the company was learning from other companies how to better handle the processing of "congo."

The Civic Academy Association was formed by city officials to serve as a board of directors for the Academy of Music under municipal ownership. F. G. McGee of the

N&W Railway was selected as president, with other officers being R. C. Royer, business manager; Stuart T. Saunders, vice president; W. J. McCorkindale Jr., treasurer; and Mrs. D. P. Hylton, secretary. Several other persons were named to the board of directors.

Clarence Milton Oakey died at his home on Grandin Road following a heart attack on September 22. He was sixty-one. Oakey was president of John M. Oakey Funeral Service and son of the founder. A native of Salem, Oakey had been previously employed as a railroad surveyor before joining his father's firm. He was also president of the Roanoke Life Saving and First Aid Crew. He was predeceased by his brother, Samuel G. Oakey, who died on Nov. 29, 1942.

Flares suspended from parachutes dropped from airplanes will be made by the CCC Central Repair shop in Salem, military officials announced. The shop, located on Indiana Street, employed about twenty-five men and one hundred women.

Eastern Airlines, Inc., filed with the CAA to expand its domestic routes using the Roanoke airport. Roanoke would be part of the expanded system between Detroit and Miami.

George W. Sheffey was noted for having been a barber in Roanoke for fifty years. His first shop was located in the former Terry Building and was at the time in the Colonial American Bank Building that replaced the Terry Building when the latter was razed. Sheffey, sixty-nine, had cut hair for six N&W Railway presidents, as well as that of William Jennings Bryan.

The Community Drug Store, located at 40 High Street, announced its reopening. Miss Lalage Jones was the pharmacist and manager.

Employees of the Roanoke Weaving Company were given the first issue of a new monthly newspaper that would be provided to them. Employees were encouraged to participate in a name contest for the publication. Everette Thurman was the editor.

Greene Memorial Methodist Church recognized W. C. Brunner for a remarkable achievement. He had perfect Sunday school attendance for fifty years.

The WDBJ Dramatic Guild celebrated its fifth anniversary in late September. The anniversary was honored by the on-air performance by the guild of Nelson Bond's play *Al Hadden's Lamp*. The guild's first production was aired September 28, 1938. Jack Weldon originated and directed the guild.

King Kolax and his band performed at the Roanoke Auditorium on September 30. Kolax was presented by the Play Boys Social Club of Roanoke. The concert and dance went from 10:00 a.m. til 2:00 a.m. on a Thursday night.

The Negro division of the Salem Public Library, housed at Carver High School, promoted recent titles pertaining to the war. Theron Williams was Carver's principal and often promoted the library and its offerings.

Roanoke city manager W. P. Hunter marked his twenty-fifth anniversary in the position on October 1. He was the longest-serving manager in Virginia and the fourth-longest-serving manager in the United States. The city manager form of government was adopted by Roanoke on October 1, 1918.

Lewis-Gale Hospital was selected under the Bolton Act for the training of nurses. The hospital began the process of accepting applicants to the nurse cadet corps from the 110 nurses who were employed in its nurse training school.

An animal-oddities show opened at Campbell Avenue near Third Street, SW, for a ten-day run. "Free giant open air menagerie…as featured by Ripley" was the advertising.

Mae's Inn on Alabama Street in Salem was a popular restaurant and juke joint in the 1940s. *Salem Historical Society.*

Ethel Mae Myers (*left*) was the operator of Mae's Inn in Salem in the 1940s. *Salem Historical Society.*

Milk rationing began October 1 in the Roanoke area, though dairies were not yet fully informed as to the details of the program. Dairies and creameries commented that home deliveries would not be affected but that restaurants, hotels, and other public facilities would feel the rationing immediately.

A saber that was taken from a captured Nazi officer would be presented to the person who bought the most war bonds during a program aired on WDBJ. Irv Sharp's Bond Party broadcast began at 11:15 p.m. on October 2 and continued until people stopped calling in buys. Sam Golden won the saber with his commitment to buy $10,000 worth of bonds.

K. Mark Cowen resigned as Roanoke city parks and recreation director after fourteen years of service on October 2, with an effective date of November 1. Cowen had accepted a similar position with the city of Birmingham, Alabama.

The Virginia State Guernsey Sale was held at Maher Field on October 5. The sale included seventy-one registered Guernsey cattle and two bulls. Louis Merryman and Sons were the sales managers.

The Roanoke City Council authorized a new location for the Melrose branch library from the basement of Melrose School to a vacated Kroger grocery store at the corner of Melrose Avenue and Eighteenth Street. The cost of reconditioning the store and moving the book stock was estimated to be $1,000.

On October 8, the Postal Telegraph merged with Western Union for Roanoke deliveries. The postal service stopped its telegraph services and its employees were transferred, by contract, to Western Union.

Virginia Military Institute defeated Clemson 13–7 in a game played at Victory Stadium on October 9. An estimated five thousand fans occupied the twenty-five-thousand-seat stadium.

Cedric Foster, nationally known radio news commentator, spoke to a large audience at the Roanoke City-County Public Forum on October 9 at the Academy of Music. His speech, entitled "No Room for Complacency," explored what he believed would be a protracted, difficult fight against Japan.

The Roanoke Viscose Plant disclosed that it was making fabric for tires for the US military. The department tasked with producing the special fabric was staffed by all women, and for the first time in Viscose's history, women were made to wear slacks instead of skirts, as was previous company policy, for safety reasons.

Sylvester Paul Seifert, former mayor of Roanoke, died at his home on October 11 at the age of seventy-four. Seifert, a retiree of the N&W Railway, was a native of Lebanon, Pennsylvania, who came to Roanoke in 1890. He was first elected in 1897 as a member of Roanoke's Common Council (an earlier version of local government) and served continuously on that body until 1904, when he was elected to the board of aldermen. He was an alderman for ten years. During that time he served briefly as mayor in 1912. He ran for city council in 1930, gaining the most votes, and was selected by his council colleagues to serve as mayor again at that time. He did not run for reelection in 1934.

Air Transport Corporation conducted its first flight out of Roanoke on October 15, going to Lynchburg and then to Richmond. According to company officials, it was the first intrastate airline to provide regular flight service.

Blue Ridge Airlines, Inc., also began service the same week, with Roanoke on one of its routes. The airline was headquartered at Harrisonburg, Virginia, and operated two passenger planes.

Mrs. Gladys Belzer, mother of actress Loretta Young, visited friends in Salem, Mr. and Mrs. J. Rappe Myers Jr. Belzer lived in Beverly Hills, California.

Mayor Walter Wood resigned from the Roanoke City Council due to his nomination for higher office. Councilmen then elected R. W. Cutshall by unanimous vote to complete Wood's unexpired term. They also elected Leo Henebry to serve as mayor and W. Courtney King as vice mayor. Cutshall was past president of the Roanoke Merchants Association, Roanoke Kiwanis Club, and the Community Fund.

Carmen Amaya and her gypsy dancers appeared at the Academy of Music on October 23. Ms. Amaya was promoted as a "female blow torch" due to her famous talents as a flamenco dancer. The twenty-two-year-old South American native appeared with other members of her family in the show.

Rep. Clifton Woodrum was known as the "flying congressman" by his colleagues and others in Washington, DC, due to his solo flights and piloting himself from Roanoke to the nation's capitol on a regular basis.

The Roanoke chapel of the Church of Jesus Christ of Latter Day Saints (Mormons) dedicated on October 24 its chapel at 1525 Patterson Avenue, SW. The dedication was conducted by Elder Charles Callis, a member of the Council of Twelve Apostles. In addition, Ellis dedicated the Hoges Store Chapel on October 21 and the Back Creek chapel on October 22.

Roanoke City exceeded its third war-bond sale campaign. Sales topped $8 million, with the goal having been $7.3 million.

The city-renovated "colored nursery" at the Gregory School officially opened on October 25. The project was launched by two women who had appeared before the city council on behalf of the formerly WPA-operated school. The women pleaded for councilmen to visit the former Gregory Avenue School and see for themselves its deteriorated condition, which some did. That spurred the city's involvement and upgrade of the school.

A four-year-old girl was struck and killed by an automobile in the 600 block of Murray Avenue, SE, on October 21. Nancy Ann Saunders died at the scene, making her the third pedestrian killed by an auto in the city in 1943.

Second Lt. Leroi Williams of Roanoke was killed in a midair collision of two P-39 Airacobras near Selfridge Field, Michigan, while training with the 199th Fighter Squadron of the 332nd Fighter Group.

Roanoke Gas Company began advertising the first series of "Wartime Cookery Classes" with its home economics instructors in its nutrition classroom on Wednesday afternoons for six weeks. Topics included "Dried Beans and Peas in New Costumes," "Wartime Fashions in Thanksgiving Menus," and "Dine and Sup with St. Nick."

Locomotive No. 605, J-1 Class, rolled out of the N&W Railway Roanoke shops on October 23 to be placed in regular service. There were a couple of differences between the 605 and previous J Class locomotives due to war rationing. The streamlining cowling was left off, and the locomotive was not equipped with roller bearings on the rods.

The Roanoke City Council authorized a three-year lease for a new location for the Melrose Branch Library; it was to be housed in a former Kroger grocery store for $60 per month.

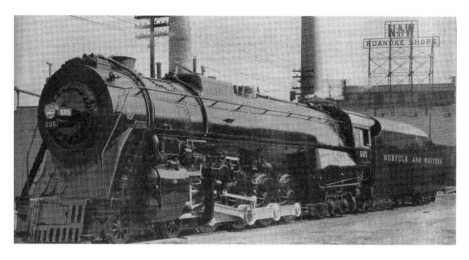

No. 605 rolls out of the Roanoke Shops on October 23, 1943. War rationing prevented this J-Class from having streamlining cowling. *Norfolk-Southern Foundation.*

Bertram Lee Ragland with the US Navy was lost at sea in the South Pacific when his ship, the USS *Meredith*, was sunk by the enemy on October 15, 1942. The navy confirmed his death as official in a telegram to his mother, Mrs. Pearl Ragland of Eleventh Street, NW.

George Economy, chairman of the Greek War Relief Committee, announced that a relief campaign was soliciting children's clothes to be sent on mercy ships to Greece. Donation booths were located in the Joseph Spigel Store and at S. H. Heironimus.

Navy Day was held at Jefferson High School on the afternoon of October 27, with speeches and recruitment efforts including a parade by naval personnel in downtown Roanoke. Vice Adm. O. L. Cox was the main speaker for the occasion.

Dedication ceremonies were held on November 1 to dedicate the newly constructed bridge over the Roanoke River connecting the Viscose plant with Garden City Road. LeRoy Smith, plant manager, cut the ribbon. The original bridge was built in 1916, followed by a second in 1917. The second bridge was abandoned and salvaged with the opening of the new bridge, which was privately owned by Viscose.

Eddie Durham and his "All Star Girl Band" played for a concert and dance at the Roanoke Auditorium on November 3. The show featured The Four Durhamettes and Jean Starr. The all-black dance did admit white spectators for half price.

In the elections of November 2, Roanoke County Sheriff Emmett Waldron defeated John London, 2,628 to 493. Howard Starkey was elected Salem district supervisor over C. W. Hancock, 1,178 to 326. H. A. Tayloe defeated B. F. Garner for the Cave Spring district supervisor seat, 296 to 237. Starr Webber lost to A. M. Bowman Jr. for county treasurer, 2,288 to 858. The only other contested race was for Catawba district supervisor, in which incumbent T. O. Richardson tied with write-in candidate A. E. McNeil, seventy votes each. McNeil ultimately won the election by a lot drawing at the courthouse.

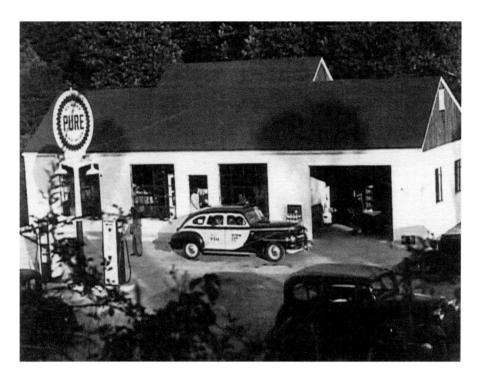

B. G. Finnell & Sons' store was located on Route 221 at the foot of Bent Mountain, seen here in the 1940s. *Virginia Room, Roanoke Public Libraries.*

For House of Delegates, Salem physician Eugene Senter lost to incumbent Furman Whitescarver by a margin of 690 votes. Also reelected was Senator Leonard Muse. In Roanoke City, Earl Fitzpatrick was reelected and Walter Wood, former mayor of Roanoke, was elected to the House of Delegates.

Lt. H. Powell Chapman Jr. of Roanoke was reported killed in the Pacific while in the performance of duty. Chapman was a member of the Naval Air Reserve. He was twenty-seven.

The town of Vinton held a "gas-less" parade as part of their annual homecoming day festivities on Saturday, November 6. Mayor Joe Pedigo led the procession, which included bicyclists, pedestrians, and horse-drawn buggies. William Byrd played Blacksburg High School at Leggett Field later that day.

"From all indications, electric shock therapy should be given every consideration in the treatment of mental disorders," was the statement of Dr. Louis A. Cibelli of the Salem Veterans Administration facility in an address to the Roanoke Dental Society. Cibelli added such therapy should only be administered to patients under the age of fifty-five who are in good physical condition.

The recently completed Northminster Presbyterian Church on Williamson Road was formally dedicated on November 7. Dr. Charles Logan was the pastor. The church was organized in 1942 and initially met at William Fleming High School.

The junior chamber of commerce presented airport officials a check for $400 toward the cost of a crash wagon needed at Woodrum Field. The emergency crash vehicle was being created by retrofitting a Cadillac donated by Frank Fallon.

Mrs. A. D. Hurt was appointed as acting treasurer for the town of Salem. Hurt had been a longtime employee of the town. The position was vacant due to the previous treasurer being appointed as town manager.

Count Berni Vici presented his production *Show Time* on the stage of the Roanoke Theatre on November 10.

Busey Overstreet of Roanoke was officially listed as killed in action by US Navy officials. Overstreet was aboard the USS *Hornet* when it was sunk in the Santa Cruze Islands in October 1942.

A survey of the larger banks indicated that between $300,000 and $400,000 would be distributed when Christmas Club funds would be released beginning November 22.

The Harmonica Rascals gave three performances at the Academy of Music on November 13. The group was an all-harmonica ensemble that promoted themselves as a "riot of fun, music and nonsense."

The clearing of Carvins Cove was underway by mid-November with a force of twenty men working to clear underbrush for the water reservoir. J. R. Vaughan was the foreman. It was estimated that it would take three years for the basin to fill once the valves on the dam were closed.

The original New York cast of *Porgy and Bess* presented the opera for two nights at the Academy of Music on November 15 and 16. Performers included Todd Duncan, Etta Moten, Avon Long, and the Eva Jessye Choir.

Jack, the Roanoke city police department's mascot, died on November 13. Jack was a stray dog that took to the officers, who often fed him. Eventually he was allowed to roam police headquarters and sleep there. Jack often accompanied the foot patrolmen as they made their late-night rounds through downtown.

Removal of streetcar rails along Franklin Road began in mid-November primarily due to complaints from motorists about the rough condition of the street.

Melissa Reed, thirty-eight, of Rutherford Avenue, NW, was found deceased with a gaping wound to her throat. A witness identified her assailant as Rora Penn, fifty, and police conducted a search for him. Upon being located, Penn confessed to the crime, saying it was the result of a quarrel. Penn was later sentenced to life in prison for the crime.

The Comas Cigarette Machine Company in Salem became the first Roanoke County industry to receive the army-navy E-Flag for war production efficiency. The award was presented to company employees in a ceremony at Andrew Lewis High School. The company had produced steel castings for an aircraft carrier, the USS *Essex*, in record time.

Eastern Airlines became the next airline to seek CAA approval to service the Roanoke airport when the company filed for such in mid-November with the federal agency.

The Melrose Branch Library officially moved into its new quarters at 1801 Melrose Avenue on November 18. The branch was started in 1927 as a deposit station and was staffed by volunteers at that time. In 1929, the library was moved to the Monroe School, where it had been until this relocation.

The Larry Dow Pontiac Company opened at 509–513 Second Street, SW, on November 21. George Yeager was the service manager for the dealership. The new

The N&W Railway did a regular radio broadcast over WSLS and other stations in the service region of the railway, November 1943. *Norfolk-Southern Foundation.*

dealership was in the former Elliot Pontiac headquarters. Dow moved to Roanoke from Pontiac, Michigan.

With the labor shortage in Roanoke County, farmers were asked to write the county extension agent to see if German prisoners of war could be brought in should there be sufficient need. The prisoners would need to be housed as well as have work. There would be one guard for every three prisoners, according the county agent, J. R. Williamson.

The University of Maryland defeated Virginia Military Institute in the Thanksgiving Day football game at Victory Stadium. The 2:30 p.m. game was played before a crowd of seven thousand fans in the twenty-five-thousand-seat facility. The score was twenty-one to fourteen. The football used in the opening kick-off was auctioned for use in purchasing war bonds. The winning bid of $33,000 was made by Roanoke businessman E. C. Tudor. It was the largest such sale for a game ball for war-bond purchases in the state.

A traveling stage production of the comedy *Abie's Irish Rose* held a two-night run at the Academy of Music after Thanksgiving weekend. The two main actors appearing in the play were Walter Cartwright and Raymond Greenleaf. Greenleaf had acted with the Jack X. Lewis shows at the Jefferson Theatre back in the early 1920s.

Richard Goria, sixty-four, died at his home on Clarke Street, SW. Goria was a Syrian immigrant who came to Roanoke as a child with his parents. He was later engaged for many years in the city in the wholesale grocery business.

The twenty-second annual poultry show was held at the Roanoke Auditorium the first week in December. Some two thousand fowl from across twenty-two states were shown.

The Northwest Voters League met for two hours at Carter's Grocery on Melrose Avenue and decided to make the organization a permanent body. They elected W. R. Debusk as chairman.

A fire at Oakland School on Williamson Road did about $1,000 worth of damage, according to fire officials. It was the second fire at the school within three weeks.

The Bush Farm, shown here in the 1940s, was located
near Vinton. *Vinton Historical Society.*

The *Ebony Escapades of 1944* was presented at Jefferson High School on December 3. The minstrel show was performed by a cast of fifty-eight students under the direction of Jack Weldon to a packed house.

Dr. C. B. Ransone, the Roanoke City health commissioner, died unexpectedly in his office on December 3. He had been the city's health commissioner since 1924. He was fifty-six. Ransone was a native of Matthews County, Virginia, and he succeeded Dr. Brownley Foster on October 1, 1924, when Foster became the health commissioner for Newport News, Virginia, that year. Dr. G. C. Godwin was named as acting health commissioner by the city manager.

Work on a new section of Route 220 near Clearbrook School was proceeding slowly due to a heavy demand for convict labor on farms and highway maintenance. The 1.5-mile section of the new highway would be delayed for several months, according to transportation officials.

Jimmy Scribner and his *Johnson Family* shows played to standing-room-only audiences for three nights at the Academy of Music.

Tiny Bradshaw, "King of the Jitterbug," and his orchestra played for a dance at the Roanoke Auditorium on December 6. Bradshaw was accompanied by blues singer Lil Green. The all-black dance did admit white spectators.

John Scruggs, fifty, was struck and killed on his way to work by a Southern Railway passenger train at the grade crossing at Norfolk Avenue and Fourteenth Street, SE. Scruggs was employed by the Virginia Bridge and Iron Company. Several persons were at the crossing and were waiting for an eastbound train to pass, and when the last car cleared, Scruggs stepped across the tracks and was killed by the westbound Southern train. He was survived by a wife and three children.

The building of the crash truck for Woodrum Field would be delayed four months due to lack of materials, reported airport officials. Roanoke Fire Chief W. W. Mullins said little could be done to speed the process.

Pvt. Clovis Buck was reported killed in action in Italy on November 3, according to military officials who notified his mother, Bessie Buck, of Kenwood Blvd. Pvt. Raymond Fielder of Vinton was reported killed in action in Italy on November 5, according to military officials.

Plans for Lynchburg Avenue to become a four-lane highway of concrete and asphalt began in mid-December with the city engineer stating that rights-of-way were being obtained so the road project could begin. City officials said the project would be among the first of the city's postwar initiatives.

John Temple Graves III, a well-known columnist for Southern newspapers, addressed the student body of Roanoke College and, later the same day, Roanoke's Executive Club. Graves spoke about the war and postwar America, warning his listeners that the federal government could easily become a bloated bureaucracy after the war ends due to wartime programs not coming to an end.

The William Fleming High School Colonels were declared the basketball champions of the B Class for the western section of Virginia.

Jefferson High School released its basketball season schedule. The Magicians would play John Marshall, Thomas Jefferson, William Byrd, Danville, E. C. Glass, and Andrew Lewis with most teams being played against twice. A few days later, William Byrd did the same, and their opponents for the upcoming season would be Fleming, Jefferson, Lewis, and Radford.

Gentlemen Be Seated was the title for the Roanoke Kiwanis Club's minstrel show held on December 13 at the Academy of Music. Proceeds from ticket sales went to helping a girls' camp in Shawsville. The show would also travel to various army camps in western Virginia.

Jo Ann Higgins was fined five dollars by the Hustings Court for violating the Sunday "blue law" that forced businesses to be closed on Sundays. Higgins opened the Peanut Store, of which she was the manager, on a Sunday and sold peanuts. The law, enacted by Virginia in 1779, stated that no business shall operate on a Sunday. Higgins's defense attorney argued that the Peanut Store was on the same footing as a movie theatre that sold candy in its lobby. Ironically, the Peanut Store was located adjacent to the Roanoke Theatre, a point not lost on Higgins's attorney.

Members of the Roanoke City Council assured Robert Mason, representing the young people of Roanoke's First Presbyterian Church, that singing from that church's belfry would not violate the city's noise ordinance. Mason said that in previous years the youth would ride buses and sing Christmas carols throughout neighborhoods, but due to gas rationing that would not be possible. Thus, he had made arrangements for microphones and other amplification equipment to be placed such that the group would carol from the belfry.

The Pennsylvania-Central Airlines signed a contract with the US Navy to provide naval air cadet instruction at Woodrum Field. The airlines already had a contract to do the same with the army. The Naval Transitional Training School officially opened on December 21 in ceremonies at the airport that featured Capt. P. T. Ward, chief of naval aviation training, as speaker.

Thomas Jenrette became head of Roanoke's city recreation department. A native of Marriette, North Carolina, he came to Roanoke from Greensboro, North Carolina, where he was head of that city's recreation department.

Mrs. Hazel Blackburn Garst was sworn in as Roanoke's first female police officer on December 17. She officially began on January 1. The thirty-one-year-old mother of three became a patrolman after being selected by acting police chief Capt. Clay Ferguson. The Roanoke City Council had authorized the employment of females as police officers a few weeks prior to Garst's appointment.

Nelson Bond, well-known writer in Roanoke, had another radio script accepted for national broadcast. "Hot Copy" was accepted for the O-Cedar Mop Company's presentation of drama that aired weekly over the NBC-Blue Network.

A brush fire broke out on Buck Mountain December 21 that was believed to have been started by an area resident burning debris. Firefighters were able to contain the blaze, which burned for two days.

Dr. Richard Gerringer, director of Roanoke's venereal disease clinic, reported to city officials that the disease was rapidly spreading in the city. Soldiers and sailors traveling through the city were both contracting and spreading the disease. Gerringer believed there were at least 1,600 cases in the city.

Nearly a hundred women from Roanoke left on Christmas Day to attend a dance at Camp Pickett that night so the soldiers there would have dance partners. Buses carrying the women had been chartered by the camp and the local office of civilian defense in Roanoke.

John T. Cash, prominent officer with the local federal alcohol tax unit, announced his retirement effective December 31. Cash was credited with breaking up an estimated 2,100 illegal stills during his tenure of thirty years. An institution among his fellow officers, Cash could provide vivid details of activities during Prohibition. "Pappy" Cash, as he was called by colleagues, participated in his first raid on a still in Pulaski County. He once walked eighteen miles with a prisoner, escorting him from his still to lawmen in Christiansburg. The last raid he performed was in 1941 on a still near Little River in Floyd County. Cash was the father of fifteen children and planned to retire to Staunton.

Dr. Leigh Buckner, a prominent Roanoke physician who practiced in the city for nearly sixty years, died at his home on Franklin Road on Christmas Day. Buckner came to Roanoke in 1886 along with Dr. Frank Wood, a dentist, and opened an office on Salem Avenue. He often traveled on horseback to see his patients. A native of Louisa County, Virginia, Buckner helped staff the Roanoke hospital when it first opened its doors.

S. H. Heironimus, founder of the store that bore his name, died in Hagerstown, Maryland, on December 26. Heironimus opened his first store on Commerce Street in the early days of Roanoke being in partnership with a Mr. Brugh. He later bought out Brugh. In 1913, he sold his interest to Robert Lynn, though the store continued to bear his name. Heironimus was born in Paw Paw, West Virginia, in 1861. He was unmarried and had no children.

President Franklin Roosevelt issued an executive order two days after Christmas that placed all railroads under federal control. American railroads, including the N&W

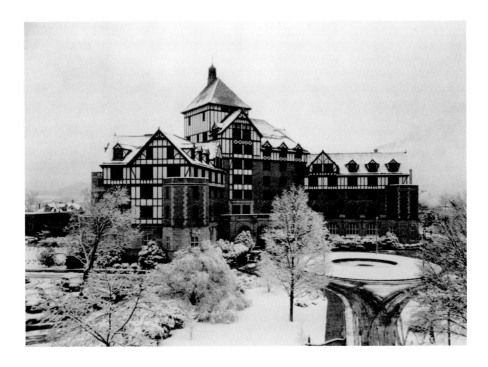

A snowfall blankets the Hotel Roanoke in this photograph dated
December 29, 1943. *Norfolk & Western Historical Society.*

Railway, would be managed by the War Department. President Woodrow Wilson had
done the same during the First World War.

Buddy Johnson and his orchestra performed for a dance at the Roanoke Auditorium
on December 30. Featured singers were Ella Johnson and Andrew Sinclair. The blacks-
only dance admitted white spectators for half price.

New Year's Eve dances were held at the River Jack, with Gene Jones's Jive Bombers play-
ing music, and at the Blue Ridge Hall, with the Coon Hunters providing entertainment.

1944

The first baby of 1944 was born at 12:09 a.m. at Roanoke Hospital, the daughter of Mr. and Mrs. E. R. Sexton of Southeast Roanoke.

Garnett G. Hill was reported by the US Navy as having drowned in the performance of his duties. Hill was the son of Virginia Hill of Roanoke. The date of his death was given as December 12, 1943.

The accounting firm of Crawford, Stull and Company became Fred P. Edwards Company on January 1. The company had been operating in Roanoke since 1938.

Swan White Laundry opened at 211 Park Street, NW. The hand-service laundry was owned and operated by Mrs. M. E. Davis and Mrs. A. B. Keeling.

Banks published their year-end reports for 1943. The banks and their total assets were as follows: Colonial-American National, $10.7 million; Mountain Trust, $11.4 million; Liberty Trust, $3.0 million; First National Exchange, $49.3 million; and Morris Plan Bank of Virginia, $31.0 million.

The Roanoke City Council authorized the lease of a hangar at Woodrum Field to Clayton Lemon for five years for the purpose of operating an airplane repair shop. The monthly rental was for $150. The lease would take effect as soon as the army released the hangar.

Rev. A. H. Hollingsworth Jr., pastor of Second Presbyterian Church, Roanoke, was elected president of the Roanoke Ministers' Conference for 1944.

Congressman Joseph Bryson of South Carolina and Sam Morris, a radio personality, led a Prohibition rally at the Roanoke Auditorium on Sunday, January 9. Bryson had introduced legislation in Congress to prohibit the sale of alcohol for the duration of the war.

Lt. Col. Ralph Hale of Salem was killed in an airplane crash one mile south of Bolling Field, Washington, DC. He was interred at Arlington National Cemetery.

Louis Armstrong was scheduled to play for a dance at the Roanoke Auditorium on January 10. The event was sponsored by the local chapter of the Delta Sigma Theta sorority, but the show was cancelled "due to circumstances beyond the control of the sponsors."

Two women were burned to death and two soldiers critically injured in an accident on Catawba Mountain Road on January 9. The pickup truck in which they were passengers turned over and caught fire, pinning the two women inside. Mrs. George Stevens of Moneta and her sister, Estalene Sarver of Roanoke, perished at the scene. George Stevens and Pvt. William Brown of Massachusetts were both taken to Shenandoah Hospital. A double funeral for the sisters was held at Hollins Road Church of the Brethren.

James Gibson, an employee at Stone Printing, created a cartoon character, "Red," that was picked up by *Redbook* magazine. The first installment was in the January edition.

Francis Ballard starred in *Grumpy*, a musical comedy at the Academy of Music during the second week of January. The production was sponsored by Roanoke's Civic Academy Association.

Thomas M. Thomas was sentenced to two years in prison for theft of interstate shipments of gasoline. According to prosecutors, Thomas stole 3,747 gallons of fuel. Thomas operated Uncle Tom's Barbecue, which was located just south of the Roanoke city limits.

Roanoke city held its first blackout drill of the year on January 11, when the sky was lit by a "bomber's moon," meaning visibility was high.

The Betty Lou Shoppe at 7 W. Campbell Avenue announced it was closing and commenced a going-out-of-business sale on October 14.

The dearth of legal whiskey in the Roanoke Valley had bootleggers making serious money. Local papers reported that illegal whiskey was selling for ten dollars a gallon. Much of the whiskey being sold had been purchased in DC or Maryland and was being resold in Roanoke for a handsome profit.

Sgt. Moss Plunkett Jr. was reported as having been struck and killed by a motorcycle on November 30, 1943, while stationed in the South Pacific with the US Army. He was the son of Mr. and Mrs. Moss Plunkett of Roanoke County.

The federal government returned the nation's railroads to private ownership effective midnight on January 19. According to federal officials, the White House announced that an agreement had been reached with all railroad unions that there would be no strikes or other stoppages during the war.

The Grandin Theatre conducted a war-bond campaign with the goal of selling 944 bonds—one for every seat in the theatre. Further, the theatre offered a pair of nylon hose to the woman buying the most bonds.

Ensign David Robertson Boyd was killed when his plane crashed on the east side of Poor Mountain during a routine training flight on January 17. Boyd was training at the Preston Glenn airport at Lynchburg. Authorities believed the pilot became lost in low fog that had encircled the mountain.

American Houses, Inc., announced its plan to open a manufacturing operation in Norwich. The firm had leased part of the property of the Roanoke-Sadler Company, formerly the property of the Maurice Twine Mill. The company had various manufacturing plants across the country.

Mrs. Sarah Johnson Cocke, widow of Lucian Cocke, died at her home on Orchard Hill on January 20. Cocke had authored short stories for the *Saturday Evening Post* and other magazines. She was one of the organizers of the Woman's Civic Betterment Club, an organization that championed many progressive causes within Roanoke. A native of Alabama, Cocke served as a member of the Roanoke Planning Board and helped bring about the city's public health department.

The Roanoke Civic League, an African American organization, announced plans to try to secure black policemen for the city of Roanoke through a petition drive. Dr. Harry Penn was president of the league.

The Ballet Russe de Monte Carlo appeared at the Academy of Music on January 26. The ballet was accompanied by its own orchestra and consisted of sixty singers and dancers. The ballet performed was *The Red Poppy*, a Russian ballet. The performance was an abridged version, as the original would last several hours.

The American Legion acquired a post home when it purchased property located at 430 W. Church Avenue, Roanoke. Post No. 3 acquired what was formerly a funeral home. The structure was built in 1926 as a funeral parlor with living quarters on the second floor. On the Luck Avenue side of the property was a six-car garage and parking lot. The purchase price was $18,000.

Harvey T. Hall, a prominent attorney in Roanoke and affiliated with the Virginian Railway, died on January 24 at his home in Roanoke County. In 1918, Hall served as president of the Virginia Bar Association.

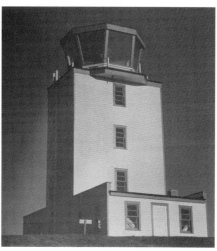

The sixty-foot CAA control tower at Woodrum Field became operational in January 1944. *Virginia Room, Roanoke Public Libraries.*

Grand Ole Opry star Roy Acuff and his Smoky Mountain Boys gave a performance at the Roanoke Auditorium on January 27. Other performers included Pap and his Jug Band, Jimmie Riddle, and Ford Rush. Tickets ranged from $0.65 to $1.10.

Ted Dalton of Radford won the Republican nomination to replace Senator Harvey Apperson in the Virginia Twenty-First Senate District that encompassed Montgomery, Roanoke, and Franklin Counties. Apperson had been appointed to a post with the State Corporation Commission.

J. B. Williamson, county extension agent, announced that he planned to meet with Roanoke County fruit growers to determine the need for the use of German POWs. Preliminary plans were to use an old CCC camp near Catawba for the prisoners and possibly a temporary tent camp elsewhere in the county. Williamson further stated that the German prisoner labor would not be shared with Botetourt County as that county planned to have its own camp.

Lt. E. Harrison Heath Jr. of Roanoke was killed January 18 in the South Pacific. First Lt. Edgar Allen was killed in the line of duty while serving in the Marine Corps. Allen was from Roanoke as well.

The new sixty-foot control tower at Woodrum Field was put into service in late January. The tower cost $30,000. The CAA occupied the ground floor, and a weather station was on the second floor. The temporary control tower that was placed on top of the Cannaday farmhouse was dismantled.

Roanoke College was notified by the military that the naval aviation training program at the campus would officially conclude there on June 30. There were ninety-two other colleges across the country that also received similar news. The navy indicated it had ample facilities to train pilots.

The British War Relief Society of Roanoke closed its office in late January. During the three years it functioned, the organization had managed to send some six tons of clothing to Britain. The society had been headquartered in the Patrick Henry Hotel. It was formed

in December 1940 by citizens who initially established a clothes depot at Heironimus in downtown Roanoke.

The Bent Mountain Mutual Telephone Company reported that it would buy a lot and build a house for its switchboard operation. The Williams family had operated the switchboard for twenty-one years.

The Carvins Cove reservoir continued to move forward, necessitating the razing of several structures. Among them were farm homes and the fifty-year-old Cove Alum Baptist Church. The Roanoke city manager proposed that a recreation center be established at the reservoir, noting that such a center would not conflict with the purpose of providing water for the city. The center, according to W. P. Hunter, could provide a venue for swimming, boating, and fishing, though large boats would be prohibited.

Carl Tate, an unemployed bellhop, was shot and killed on January 30 Tate, thirty-two, was confronted by Owen Wright, a special police officer employed by the Hotel Roanoke, in the driveway of the hotel. The two men exchanged words around some clothes that Tate was carrying, which Wright believed to have been stolen. As the men walked toward a police box, a fight ensued, and Tate drew a knife, prompting Wright to fire his pistol.

Mr. and Mrs. Stanley Crockett, ages twenty-seven and twenty-four respectively, were killed in a single-car auto accident on Route 11 near Murray's Store eleven miles north of Roanoke on January 30. The Crocketts lived on Woods Avenue, SW, Roanoke.

Roanoke city manager W. P. Hunter appointed city clerk L. D. James as the coordinator for the Office of Civil Defense. He succeeded Sydney Small, who resigned the post.

Dr. Harry T. Penn, a black dentist, announced he would be a candidate for the Roanoke City Council subject to the local Democratic primary. He was the sixth candidate to announce for the two seats. This was Penn's second attempt to be elected to the council.

Ted Dalton of Radford was elected in a close race to the state senate, representing the Twenty-First Senatorial District. Dalton's main competitor was Fred Hoback of Salem. The seat was vacant due to the resignation of Sen. Harvey Apperson to assume a seat on the State Corporation Commission. The vote was Dalton 2,846 to Hoback's 2,786. Other candidates in the race included Bradie Allman of Rocky Mount, 1,063 votes; Squire Chitwood, 729; and Robert Noell, 355.

Helping to promote the Fourth War Bond Loan campaign, Hollywood actress Miss Leslie Brooks, along with actor Edgar Buchannan, appeared in Roanoke on February 2. The pair were given a police escort into the city, first stopping at city hall and then proceeding to WSLS and WDBJ radio stations to broadcast messages encouraging the purchase of war bonds. Their visit to city hall was aided by performances from the Jefferson High School and Lee Junior High School bands.

Sgt. Furman McDonald, home on leave, died in a head-on collision with a Mason-Dixon truck near Lakeside Park on February 4. His wife, Marguerite, died several hours later from injuries she sustained as a passenger.

Dr. Peter Marshall, pastor of the New York Avenue Presbyterian Church, Washington, DC, spoke for the opening night of the Roanoke Christian Mission on February 5 at First Baptist Church, Roanoke, to a standing-room-only crowd. Marshall spoke nightly through the week as part of an interdenominational crusade sponsored by the city's Protestant clergy and churches.

Henry J. Fowler of Roanoke was appointed as an advisor to the "Harriman Mission" in London due to his expertise in war production as a legal counsel. The mission was formerly headed by Averill Harriman before his appointment as ambassador to Russia. The mission's purpose was to coordinate lend-lease and other war-related matters between the United States and Britain.

The Roanoke chapter of American War Dads was organized on February 7. Composed of men whose sons and daughters were serving in the military, the chapter held its inaugural meeting at the Elks Club and elected Arthur Clay as president.

The Alpha Mu Sigma Chapter of Delta Sigma Theta sponsored a dance at the Roanoke Auditorium featuring Fletcher Henderson and his orchestra. The blacks-only dance, held on February 10, did permit white spectators. Henderson was billed as "America's greatest arranger."

The Don Cossack Chorus from Russia gave a one-night singing and dancing performance at the Academy of Music on February 10. The group consisted mainly of Russians who fled their country after the fall of the imperial government.

For two nights, February 15 and 16, stars of the Grand Old Opry performed at the Roanoke Auditorium. Presented by J. L. Franks, the lineup included Ernest Tubb, the Texas Troubadours, Pee Wee King, Little Becky Barfield, Spike and Spud, and Minnie Pearl. Admission was seventy-five cents to any of the five shows.

Capt. Clay Ferguson, acting Roanoke police chief, reported that a cold case dating to 1936 had been resolved. The case involved the murder of Emily Miles by Harvey Drew. Drew was indicted for the murder but fled the city shortly thereafter, eluding police ever since. Ferguson reported that based on fingerprints provided to the FBI, it was learned that Drew had died on December 12, 1941, in Atlantic City, New Jersey, from injuries he sustained in an assault.

Louis Jordan and his Tympany Five played for an all-black Valentine's Day dance at the Roanoke Auditorium.

Hubert Reynolds of Garden City, Roanoke, an engineer for the Virginian Railway, was killed instantly on February 13 when his six-car train crashed head-on into a 110-car freight train within the city limits. No other persons were injured.

The little community of Carvin's Cove officially ceased to exist on February 14 when Roanoke city manager W. P. Hunter sold all the remaining buildings in the community at auction. All total, five structures were sold, including two homes, for a total of $629. The terms of sale called for high bidders to raze the structures and remove them from the site.

Howard Scoggins, formerly of Roanoke, had been serving as director of the Hans Crescent Red Cross Club in London and returned to Roanoke for a brief visit as part of a nationwide tour in which he was engaged by the American Red Cross to promote the work of the organization. Scoggins was president of the Scoggins Brokerage Company of Roanoke.

The junior chamber of commerce sponsored the six-night run of the Hippodrome Thrill Circus at the Roanoke Auditorium the last week of February. Proceeds benefited the Williamson Road Life Saving Crew and Roanoke's Minute Men.

The Rev. George Bannard, author of the famous hymn "The Old Rugged Cross," spoke at Greene Memorial Methodist Church on February 21, being sponsored by the Salvation Army. Joining him was gospel singer Hannah Dalstrom.

The Southernaires, a famous radio quartet, appeared at the Roanoke Auditorium on February 22 as a benefit performance for the Hunton Branch YMCA.

The National Symphony Orchestra and its Dutch conductor, Hans Kindler, gave a concert at the Roanoke Academy of Music on February 24. The symphony's appearance was sponsored by the Community Concert Association. Kindler was brought back on stage and had the symphony give five encore performances due to ovations from the audience. Two nights earlier, *The Gay Nineties Revue* production was at the academy with Broadway stars Lillian Leonard and Joe Howard in the leading roles. Howard was a sixty-year veteran of the stage, and during intermission he was presented a large birthday cake on stage in honor of his seventy-seventh birthday. Taken by surprise, Howard was at a loss for words—no small feat considering he wrote 527 songs and twenty-eight musical comedies and had emceed thousands of radio broadcasts and shows. The cake and party had been arranged by Bob Royer, manager of the academy. The cake was formally presented by Roanoke mayor Leo Henebry.

On February 26, film actor Bela Lugosi appeared at the Academy of Music in the comedy *Arsenic and Old Lace*. The play's costars included Jean Adair, Jack Whiting, and Macolm Beggs. The play was promoted as Lugosi's "farewell tour."

Residents of Raleigh Court complained again to the city council about odors from the Southern Varnish plant in Norwich. Some six hundred residents had filed complaints with the city. The council, upon recommendation from the city attorney, agreed to seek a remedy through the courts.

The Gilbert and Sullivan Light Opera Company presented its tenth production, *H.M.S. Pinafore*, at the Academy of Music in early March. The local company featured Sue Deaton and Everett Thurman Jr. in the lead roles.

The Roanoke city and county Red Cross launched its 1944 War Fund drive in March with an address by Lt. Gen. Alexander Vandegrift. The general's comments were broadcast live over local radio stations. The fund drive goal was $173,000.

Miss Mary Pearson, a student at Hollins College, won first prize in a nationwide short-story contest sponsored by Harper's magazine.

Construction of four new buildings at the Veterans Administration facility was announced with construction set to start in the summer. The buildings would add six hundred beds and a 40 percent increase in personnel. All the buildings would be for continuous care.

The Roanoke chapter of the Sigma Theta sorority petitioned the Roanoke City Council to begin employing black police officers. The council referred the matter to the city manager at its meeting on February 28.

Radio personality Morton Downey was on a national war-bond tour when he broadcast live from the Hotel Roanoke on February 29. WSLS made the local arrangements for Downey's program, which normally aired from New York City. A small audience was admitted via advance tickets provided by WSLS.

Roanoke police officials announced they were making concerted efforts to rid sections of the city of prostitutes. Military officials were also aiding local police. Women arrested for suspicion of prostitution were typically sentenced to six months in jail for vagrancy.

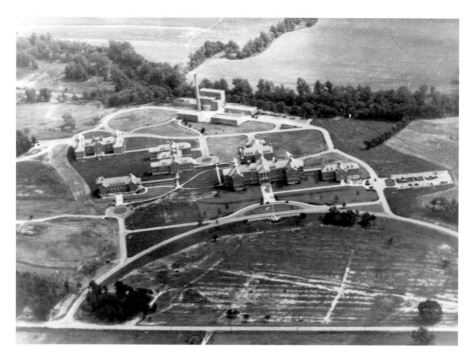

This 1940s aerial view shows the Veterans Administration
Hospital campus. Entertainers often went to there to perform
during stops in Roanoke. *Salem VA Medical Center.*

Samuel Spigel moved to temporary quarters following a fire at their store in late February. They relocated to 307 S. Jefferson Street from 306 S. Jefferson Street. Fire damaged the second and third floors of the furrier and women's apparel store.

Roanoke Red Sox officials announced that Edward Popowski would replace Heinie Manush as a team manager when the 1944 season began. Manush was moved up the ladder in the Boston franchise to manage the Red Sox farm team at Scranton, Pennsylvania.

Lt. Glenn Pipes of Roanoke received local media attention due to a military report that stated that he and another pilot chased two German fliers literally into the streets of Berlin while engaged in air combat over the city.

Roanoke mayor Leo Henebry, along with his council colleagues, complained publicly that city taxpayers were underwriting Roanoke County's use of the city's police radio operation and that 40 percent of all city fire calls were into the county. Consequently, he asked the county officials review their fiscal commitment to help alleviate the city's burden of providing such services to Roanoke County.

The William Fleming Colonels basketball team captured the Class B title of the western district by defeating Graham High School of Bluefield, 31–22.

Mady Christians, well-known actress of stage and screen, appeared at Hollins College's Little Theatre on March 17. Christians presented *Great Moments from Great Dramas.*

The Salem Lions Club presented their ninth annual minstrel show in mid-March in the Andrew Lewis High School auditorium. The minstrel show was a fundraiser that

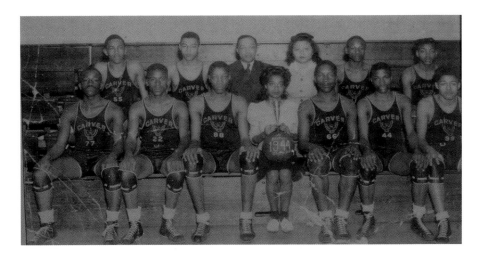

The Carver School's basketball team won the Western District
High School Championship in 1944 under Coach Thomas
Payne (*middle, back row*). *Harrison Museum.*

included blackface comedians and a forty-member chorus. Funds raised purchased eye-glasses for indigent children in Salem schools.

A meeting to organize a local chapter of the National Negro Congress was held at the Hunton Branch YMCA on March 13. Mayme Brown, national president of the Congress, addressed those in attendance.

The final road show of the theatrical season for the Academy of Music was *Junior Miss*. The Broadway show was based on a series of stories that appeared in the *New Yorker* magazine. Those touring with the show included Lois Wilson and Patricia Peardon. In a separate show at the academy, the Roanoke Concert Association sponsored an appearance by Metropolitan Opera baritone Robert Weede on March 13. He was accompanied by Alexander Alexay.

Two N&W Railway trains collided head-on on a siding near Rocky Mount on March 13, injuring scores of passengers, some of whom were taken to Lewis-Gale Hospital. There were no fatalities. A railway spokesman attributed the collision to "a confusion of orders."

The Roanoke City Council voted at their mid-March meeting to install separate toilet facilities for blacks at Maher Field, paying for the expense by adding to the rent it charged to the Roanoke Baseball Club. The new toilet facilities had been requested by the baseball organization as none were provided for black patrons.

The Hunton Life Saving and First Aid Crew celebrated their third anniversary at their headquarters in the Hunton Branch YMCA. The celebration included the announcement of the addition of a resuscitator to its equipment.

Leading aviation writers from around the United States toured Woodrum Field in mid-March, gathering information to write feature articles on the naval transitory training program at the airport. There were only two schools in the country training navy pilots for transitory work: Roanoke and Fort Worth, Texas.

A sandbag barricade that had been in place on the west end of the ground floor of Roanoke's municipal building for two years was removed in mid-March. The barricade

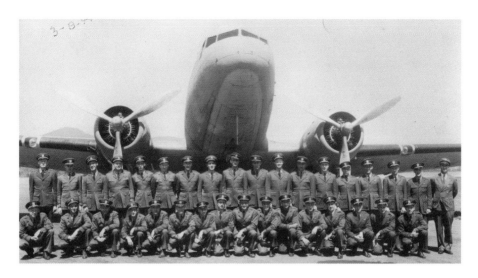

A class of naval aviation cadets posed in front of a C-47 at Woodrum
Field on March 13, 1944. *Virginia Room, Roanoke Public Libraries.*

had been put in place to protect the police department's communication room in the
event of a bombing raid.

The Biggest Little Band in America, under the direction of radio personality John
Kirby, performed for an all-black dance at the Roanoke Auditorium on March 20. The
show also featured Roanoke's Charlie Shavers.

Residents of the Greenland Hills section met at the Coffee Pot Tavern and formed the
Greenland Hills Civic Association. About 150 residents attended the March 20 meeting.
H. E. Tuttle was elected president.

The Roanoke City Council approved the construction of a $500 garage at Woodrum
Field to house the new crash truck for the airport.

Wrestling returned to the Roanoke Auditorium after a several-months hiatus. Scotty
Hawkins was the new promoter for the sport locally. The opening card on March 22 fea-
tured Joe Perrelli of Dallas, Texas, and Bud Westbor of Richmond, Virginia. The main at-
traction was a match between Herb Welch of Tennessee and Dr. Carl Neilson of Alabama.

The Fulgent Company plant at Salem closed in late March. The New Jersey–based
company stated that its primary product, flares suspended from parachutes, were no lon-
ger in demand by the military. The plant opened in September 1943 in the CCC Central
Repair Shop building and employed approximately 125 persons.

Wright Furniture Company sponsored the *Saturday Jamboree* heard every Saturday
night on WDBJ, with Cousin Irv Sharpe as emcee.

Vernon Flory, radio religious personality, conducted a weeklong prophecy lecture
series at the Academy of Music. Sponsored by the Bible Auditorium of the Air, Flory
preached on how the global war was predicted in Scripture.

The Piedmont League released its official baseball schedule for 1944. In addition the
Roanoke Red Sox, other teams were from Norfolk, Portsmouth, Richmond, Newport
News, and Lynchburg. Of the 140 games scheduled, half would be played during the day.

Mrs. Rosa L. Smith was sworn in as Roanoke city's second female police officer on March 31. Capt. Clay Ferguson, acting police superintendent, gave Smith a gun, badge, and whistle following her swearing in.

The Golden Eagles Service Club, dedicated to the memory of Alvah "Dick" Price, who served as a player-coach of a basketball team bearing that name, opened in early April at 128 W. Campbell Avenue, Roanoke. The club was opened daily to provide free food and service to men and women in the military. A lounge with cots was also created for those needing a few hours rest while awaiting trains.

The labor shortage was so severe in Roanoke that the city manager had to seek permission from the city council to acquire a piece of ditch-digging equipment to install water mains as no one applied for ditch-digging positions.

Robert W. Cutshall and W. B. Carter, both city council incumbents, won the Democratic Party primary election to stand for the general election in May. The April 4 primary had three challengers. The votes were as follows: Cutshall, 2,355; Carter 2,069; W. R. Harbour, 1,705; Owen Arnold, 837; and Dr. H. T. Penn, 537. This was Penn's second bid for a council nomination; he was the first black to seek the post when he ran in 1942.

W. B. Dillard sold his long-running drug store in Salem, corner of Main and College Avenue, to Minor D. Webber in early April. At eighty-one, Dillard decided to retire, though the new owner stated he planned to continue operating under the store's name, W. B. Dillard Drug Company. Dillard had opened his drug store on May 10, 1886, with a partner, J. S. Persinger, whom he bought out in 1903, and changed the name from Dillard and Persinger to the W. B. Dillard Drug Company. Webber had been a druggist in Salem for thirty-five years.

The Roanoke Black Cardinals began their 1944 season with a game against the Pond Giants of Winston-Salem, North Carolina, in Springwood Park on April 10, winning 9–6. On the same day, the Roanoke Red Sox began their spring training under new manager Ed Popowski.

Pvt. Clyde Harshbarger, twenty-nine, of Hollins died on March 2 from wounds he received in action at Anzio beachhead. His parents were notified in mid-April by the military. He had been employed at Roanoke Mills prior to entering the service.

Dr. G. C. Goodwin announced his resignation on April 11 as health commissioner for Roanoke city and director of the tuberculosis sanatorium. His resignation took effect June 1. Goodwin came to Roanoke in 1940 to serve as sanatorium director.

John Strickler of Roanoke was nominated by regional Republicans as their Sixth District candidate to oppose in the upcoming general election Clifton Woodrum for Congress. Strickler was a Roanoke attorney and chairman of the Roanoke City Republican Committee.

A Roanoke frozen-food locker plant was under construction in what was previously a garage at East Campbell Avenue and Eighth Street. When completed, the plant would have one thousand lockers to keep fruits and vegetables frozen for wholesale. It was anticipated the plant would be open by June 1.

The Jewel Box store inside the American Theatre building held a closeout sale in April as their lease had been sold.

The Rev. Bob Childress of Buffalo Mountain was elected moderator of the Montgomery Presbytery in a meeting held at Roanoke's First Presbyterian on April 18.

Childress's ministry would later be told in a widely read book titled *The Man Who Moved a Mountain.*

The navy notified Mrs. Clara Ballou of Eleventh Street, SW, that her son William Ballou was lost at sea. He had been missing in action since April 8, 1943, and was presumed dead. Ballou had four brothers still serving in the navy.

Broaddus Chewning announced the 1944–45 concert series for the Roanoke Community Concert Association. Four concerts were scheduled, including performances by the National Symphony Orchestra and Leonard Warren of the Metropolitan Opera.

A vastly increased air service of which the Penn-Central Airlines hoped to be a part was forecast by Penn-Central president C. B. Monro in an address at the Hotel Roanoke. PCA had been operating a training school at Woodrum Field. With increased routes, PCA anticipated more travel in and out of Woodrum Field.

Federal military inspectors visited the CCC Camp at Catawba in anticipation of bringing around two hundred German POWs to be housed there to work in area orchards during the fall. The camp was deemed appropriate for war-prisoner housing. In response, the Roanoke-Botetourt Fruit Growers Association met to learn the process of receiving war laborers.

The Boston Red Sox announced that their organization would conduct baseball clinics for young boys in towns and cities where they had minor league teams, including Roanoke. The clinic would be conducted for a week in June and offer young boys the opportunity to be trained and coached by major league players.

Anita Wood of the Roanoke City Welfare Department said there was a new casualty of war not found on military lists: children abandoned by their mothers when their husbands or partners were away in service. Wood said the aid of the courts and public was critical in order to locate the mothers or fathers. Children who had been deserted were placed in orphanages or boarded in private homes. Wood reported that the children's bureau of the welfare department had 113 children under their care.

Roanoke city manager W. P. Hunter outlined for the city council some $10 million worth of postwar projects for the city. Among the items listed by Hunter were water supply system ($2 million), libraries ($225,000), Maher Field improvements ($517,000), sewage system ($1.75 million), streets and storm drains ($1.83 million), park improvements ($296,000), bridge construction ($681,000), new schools and school additions ($1.7 million), and other minor items. The council queried the manager on tax revenues to pay for the list and discussed the need to potentially raise the tax rate from its $2.50 per $100 real estate valuation.

The Roanoke Ministers' Conference urged residents to "repair to their churches upon the announcement of the invasion, for prayer and meditation." Headlines suggested that an Allied invasion of Europe was being planned.

Brief ceremonies marked the start of the Piedmont League baseball season on opening home night, April 29. The mayors of Roanoke, Salem, and Vinton spoke when the Roanoke Red Sox took on the Lynchburg Cardinals. Roanoke mayor Leo Henebry threw out the first ball following the formal introduction of Red Sox team members to the fans. The previous night, the Cardinals edged the Red Sox 8–7 in the first game of the 1944 season. At Maher Field, the Cardinals won again, 4–3.

The city marbles tournament was held April 29 in Elmwood Park, with boys divided into ten leagues. Over eighty participated and thirty qualified for the all-city-county tournament to be held in Elmwood Park on May 13.

Film and stage star Jeanette MacDonald made her second appearance in Roanoke when she gave a performance at the Roanoke Auditorium on May 4. Her appearance at the auditorium three years prior had set an attendance record. (The previous record was set in 1919 by John MacCormick.) Her prior performance had a minor distraction when a national guardsman accidentally set off a tear gas canister in the auditorium's basement. Nonetheless, MacDonald continued to sing. At the May 4 concert, some 2,700 persons packed the auditorium in what local newspapers called "the event of the year."

The congregation of a newly organized Christian mission in Williamson Road held their first service on April 30. The congregation was composed mostly of members from Belmont, First, and Melrose Christian Churches. Rev. Stanley Dysart spearheaded the church plant.

First Lt. Henry L. Francis Jr. was killed in a plane accident in Tulsa, Oklahoma. His parents, of Patterson Avenue, SW, were notified by military officials. Francis was a bomber pilot stationed at Woodward Army Airfield.

A stage show came to the Grandin Theatre on May 2 featuring the seven dwarfs from *Snow White*. The 8:30 p.m. event was a thirty-minute act of "comedy, music, magic and dancing." The screen attraction that night was Tallulah Bankhead in *Lifeboat*.

Mrs. Eva Price was selected as Roanoke city's entrant in the Virginia War Mother of 1944 contest. Price was a volunteer in numerous local military-related organizations and had lost a son, Dick, in the war. She had also served for fifteen years as a Red Cross volunteer.

The Roanoke City Council considered in closed session the purchase of the streetcar and bus system. The purchase was advocated by Councilman Courtney King, and council was not opposed to exploring King's proposal. The city's first transit system was chartered in 1887 when the Roanoke Street Railway Company was formed. The first line traversed seven blocks starting on Jefferson Street, near the railroad station, up to Campbell Avenue to Commerce Street and up to Church Avenue to Fifth Street. The first car to run was borrowed from a contractor doing rail work in Salem and was held until the company's first car could arrive. The early rails were laid on unpaved streets, and the equipment consisted of a few mules and soapbox-style passenger cars. The first electric car was put in service in June 1892. The Safety Motor Transit Company was organized in 1925 when 135 jitney operators got together, forming the corporation. The company was then sold to the Central Public Service Company of Chicago in 1928, and a few years later, that company's stock was acquired by the Consolidated Electric and Gas Company. Consolidated bought controlling interest in the Roanoke Railway and Electric Company, thus King's interest in exploring the transit company's purchase for local control.

Dr. Robert Garthright, one of the longest-practicing physicians in Roanoke County, died in a local hospital on May 2. A resident of Vinton, Garthright was known as "The Daddy of Vinton" and was the first fifty-year member of the Vinton Masonic lodge.

The Golden Eagles Service Club Center announced its opening for May 14. Congressman Clifton Woodrum spoke at the ribbon cutting. The service center was located at 128 W. Campbell Avenue.

After getting off to a 0–6 season start, the Roanoke Red Sox finally won their first game on May 4, defeating the Newport News Dodgers in an away game, 7–4.

The Green Shadow, who had not been defeated and thus had not been unmasked in two years, was the headliner for Scotty Dawkins's wrestling card at the Roanoke Auditorium on May 7. It was the Green Shadow's first appearance in Roanoke.

A "Clothes for Russia" drive began in early May in both Roanoke city and county, sponsored by the parent-teacher associations. The goal was to collect seventy-five thousand pounds of clothing and 19,500 pairs of shoes. All schoolchildren were urged to solicit their families and neighbors.

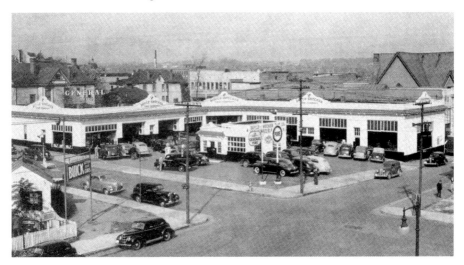

This 1944 image shows the Boyle-Swecker Tire Company at the intersection of Third Street and Church Avenue, SW, in Roanoke. *Salem Historical Society.*

Pvt. W. O. Cassell was killed in action in Italy on February 6 according to information provided his parents by the War Department. He was a resident of Tenth Street in the Williamson Road section and a graduate of William Fleming High School.

Lakeside Park opened for the season on May 12 as did the Lee Hi Pool. In advertisements, the owners of Lakeside declared, "We are not selling any intoxicating drinks at either Lee Hi Pool or Lakeside and not entertaining drunks or mixing different nationalities."

An extension recreation center was formally opened on May 8, located next to the Phyllis Wheaton YWCA, and there were weeklong open-house activities to celebrate the occasion each evening. The center was located in the vacated St. John's Methodist Church.

The world's largest hog made an appearance at the Market Auditorium in Roanoke. Named Buffello, it weighed an estimated four tons and was four feet tall and eight feet long. Admission to the May 14 viewing was fourteen cents.

American Airlines officials remarked to the city-county chamber of commerce meeting that a proper terminal facility was needed at Woodrum Field that could house administration offices, communications, and accommodate the public.

Mrs. Eva Price was named Virginia's War Mother of the Year of 1944. Price, a resident of Rorer Avenue, had been nominated by Roanoke to compete for the statewide title.

Ground was broken on May 10 for the first of four new buildings being erected at the Veterans Administration hospital. The contractor was Caristo Construction of Brooklyn, New York.

Allena Sue Strauss, a Jefferson High School student, was killed in an automobile accident near Cloverdale on May 12. Three other students were injured in the single-car accident: Dodson Cundiff, H. B. Oliver, and Elsie Corvin. The students were returning from an outing in Botetourt County when the driver, Cundiff, lost control of the car on a curve. Funeral services for Strauss were held at Melrose Methodist Church with a standing-room-only crowd in attendance.

Welders who had staged a walkout at the Virginia Bridge Company plant in Roanoke on May 12 voted to resume work as negotiations continued with management. Some two hundred men were part of the local steelworkers' union involved in the labor dispute.

Charter members of the Chi Delta social sorority at Roanoke College held their first formal meeting at the Hotel Patrick Henry on May 13. Sixteen women composed the group.

The Golden Eagles Service Club was formally opened by the Roanoke War Mothers Club on May 14. The club was dedicated to the memory of Dick Price, son of Mrs. Eva Price, Virginia's War Mother of 1944, and ninety-one other sons of Roanoke who had died thus far in the war. Congressman Clifton Woodrum spoke at the opening. The club was located on West Campbell Avenue.

After hearing Roanoke architect Frank Stone describe the Academy of Music as a "fire trap," the Roanoke City Council voted for plans to remodel the sixty-five-year-old structure at a cost of $25,000.

Acting under recent legislation adopted by the Virginia General Assembly, the Roanoke County School Trustee Electoral Board appointed six to the county school board for varying terms. Those appointed were L. N. Mosley, Lester Whitmore, E. T. Kirkwood, Mrs. Frank Thomas, W. E. Meadow, and J. F. Hughes.

Rev. Dr. E. D. Poe announced he would step aside from the Roanoke School Board when his term expired, having been a member since 1935. Dr. Poe was pastor of the Belmont Baptist Church and stated he simply did not have enough time to devote to board duties.

Walters Printing and Manufacturing Company occupied its new quarters at 21–23 West Kirk Avenue in mid-May. The printing company had operated for twenty-one years from the first floor of the Shenandoah Life Insurance Company building.

Pvt. William Weaver was reported killed by military officials in a telegram to his parents, residents of Salem Avenue, SW. Weaver was killed in the North African theatre. He had two brothers still serving.

The *City of Roanoke*, a Flying Fortress purchased by citizens through a war-bond effort, was completely overhauled and ready for combat. The plane had been reconditioned at Robins Field in Georgia. The plane was christened at Woodrum Field on July 25, 1943, and had been used in Africa since then before needing an overhaul.

Roanoke's annual observance of I Am an American Day was held on May 21 at the Academy of Music with an address by Governor Colgate Darden Jr. of Virginia.

Other participants included the Jefferson High School band, Girl Scouts, Boy Scouts, the Virginia Reserve Militia, and the junior drum and bugle corps of the American Legion.

A Japanese suicide submarine used in the attack on Pearl Harbor was placed on exhibit at the corner of Jefferson Street and Church Avenue. The captured sub was on tour with the Bundles for America, a home-front relief society. The sub was eighty-one feet long and originally weighed forty tons before it was stripped and mounted to a diesel truck and trailer.

Lt. James Glenn, thirty-two, of Arlington Road, Raleigh Court, was killed on May 20 when his Flying Fortress caught fire in training exercises at Lockbourne army base in Ohio. Glenn was a student at Roanoke College before entering service.

The Roanoke City Council authorized the city library board to purchase land on Melrose Avenue between Twenty-Third and Twenty-Fourth Streets as a site for the Melrose Branch Library in the postwar era. The site consisted of two lots valued at $1,000 each.

Dr. A. G. Evans of Radford was offered the post of commissioner of health for Roanoke city at a salary of $6,000 per year. Evans was the public health officer for Giles and Montgomery Counties and the staff physician at the Hercules Powder Plant.

The Phelps Water Company, a private entity, was available for an option to purchase for $250,000 under a proposal presented to the city council. The company served the Williamson Road section. C. W. Francis had the exclusive listing.

Pfc. Harold Webster was reported killed in a telegram sent to his parents, residents of Mountain Avenue, SW. He was killed in the North African theatre.

Sought for over five months by Roanoke police, Harry W. Nichols, thirty-one, was finally arrested when he came to Roanoke on furlough from Camp Howsie, Texas. Nichols had been indicted in connection with the death of William Brown, sixty, in a hospital in December 1943.

V. G. Whittington was made president of the newly organized Norfolk & Western Railway-Valleydoah baseball league. Four teams played in the loop, and the opening ceremonies were held at the baseball field of William Fleming High School on May 28. The league replaced the Twilight League that concluded last season. The four teams were named: the Yankees, Giants, Dodgers, and Roanoke Firemen.

Melvin Manning of Bent Mountain won the city-county marbles tournament. His coach was G. O. McGhee, principal of Bent Mountain School. Manning won a fifty-dollar war bond. He defeated Ralph Davidow of Woodrow Wilson in the tournament, which concluded in Elmwood Park on May 27.

Churches in the northwest section of Roanoke announced opposition to dances at the city's recreation center in that section and their intention to withdraw support for the center. The three churches were Melrose Methodist, Melrose Baptist, and Melrose Presbyterian. Rev. George Amos of Melrose Methodist stated, "Our church has always opposed dancing as not in keeping with Christian principles—every reference to dancing in Scripture shows that disaster has been connected with it." A dance program for the city recreation center in Raleigh Court had been announced but with no opposition from the churches in that section.

Pvt. James Kelley of Salem was killed in action in Italy on May 7, according to information received by his widow from the war department.

Rev. Richard Niebuhr of the Yale Divinity School delivered the baccalaureate sermon at Hollins College on May 28. Niebuhr was a well-known speaker, author, and theologian.

For the first time in the history of Lucy Addison High School, two students graduated with perfect academic records. Principal S. F. Scott announced that the students were Elaine Dodd and Victoria Croan.

A verbal spat occurred at a meeting between the Roanoke City Council and School Board. The chairman of the school board, Harvey Gray, had previously indicated that board's desire to receive revenue being generated from local taxes on alcohol sales. This prompted a response from Councilman W. M. Powell, who stated, "The school board is going far afield with this idea of using liquor profits for educational purposes. You are throwing the schools into the hands of the liquor stores. It has dangerous implications and we can't have conditions whereby the more liquor that is sold the more money we have for schools…The people of Roanoke want the principles of sobriety and temperance in our school system." Powell was supported by his council colleagues in the sentiment.

The city-owned Academy of Music was declared "reasonably safe" by the city council following some upgrades to the building recommended by the fire chief and others. The council appropriated additional funds to make other safety-related improvements beyond those already achieved.

The Central Housing Corporation of Roanoke took over the Franklin Heights Apartments, the city's largest apartment complex. The CHC was headed by Arnold Schlossberg, a local attorney. Others involved included Sterling Williams, E. G. Overstreet, and George Via. The apartments were constructed in 1939.

Roy Crawford, twenty-three, was shot by county deputies near his home in the Cat Hill section of Roanoke County, near Salem, on May 30. Crawford was an escaped military prisoner, having been convicted of desertion. Crawford was shot by Deputy Sherriff R. T. Biggs while Crawford was in the act of a home burglary. The shotgun wounds were not fatal.

The Natalie Beauty Salon opened on July 1 at 6 West Kirk Avenue under the management of Irma Porter. Ads offered the Helene Curtis Cold Waves permanents for ten to twenty-five dollars.

Sister Rosetta Tharpe and Don Redman and his orchestra performed at the Roanoke Auditorium for an all-black dance on June 1. White spectators were admitted.

Harry Allason, a greens keeper at Roanoke Country Club, was arrested on May 31 for shooting two boys swimming at the club. The boys were wounded when Allason tried to scare them by firing bird shot in their direction as they were swimming in the club pool after the club had closed for the evening.

Female employees in the Roanoke municipal building banded together to complain about discrimination. Their specific complaint was that male employees were allowed to smoke, but city policy prohibited female employees from smoking on the job, forcing many to smoke in restrooms secretly.

A "Patriotic Temperance Mass Meeting" was held at Jefferson Street Baptist Church, cosponsored by the Roanoke Rescue Mission. The main speaker was former Georgia Congressman William Upshaw, who had also been the dry candidate for president.

Mal Hallett and his big-band orchestra performed at the Roanoke Auditorium for an all-white dance on June 5.

The Women's Land Army opened its Roanoke campaign the first week in June to enroll women ages eighteen and up to help harvest peaches and apples in Roanoke and

Botetourt Counties due to war-related labor shortage. Farmers and orchardists needed some five hundred women to work during the month of August and through early October. D. A. Tucker was in charge of the recruitment effort.

The Roanoke chapter of the American Red Cross announced the opening of a canning center at 18 East Campbell Avenue for mid-June. The center would operate four days a week. Women with produce from the city market or their personal Victory Gardens would be allowed to use the center, one cooker per person.

William Tedder, fourteen, drowned in Tinker Creek on June 3. The boy was swimming at the Monterey Golf Club. The medical examiner believed Tedder hit his head when he dove into the creek.

Theodore Paskel, twenty-three, a taxi driver, was shot and killed by one of his passengers near the entrance to Spring Park in Northwest Roanoke on June 4. Arrested for the murder was S. C. Rainey.

The Central YMCA observed the one hundredth anniversary of the YMCA movement on June 7. The keynote speaker was the president of the YMCA of Memphis, Tennessee. The Roanoke YMCA was established on March 10, 1883, on the site of the Western Union office. The Y later moved to Salem Avenue and then to Campbell Avenue in 1888, having purchased the lot on which the American Theatre would eventually be constructed. In 1892, the old Trinity Methodist Church, located on Kirk Avenue between Jefferson and Henry Streets, was bought and on rollers moved across Kirk Avenue to the south side, where it was remodeled into the Y. The Central Y of 1944 was built in 1915.

Special invasion services were held by churches throughout the Roanoke Valley on June 6, and reports were that sanctuaries were standing-room only as families and friends of those serving in the military attended in large numbers. Attendance was so significant that retail stores and theatres reported few customers during the service times. The Invasion Day services were prompted by the Allied invasion of France and other places as Allied forces crossed the English Channel for the assault.

The Sadler-Roanoke Corporation, a dehydration plant in Norwich, was sold for $90,000 to Roanoke Dehydrators and Packers. The latter was an enterprise of F. W. Willis, Ray Smith, and Frank Graves, all locals.

The Grandin Theatre and Jefferson Theatre advertised "invasion newsreels" documenting the complete Allied preparations for the invasion of liberation up to the moment of embarkation. The newsreels preceded all movie showings.

Francis Ballard, director of Roanoke's Civic Academy Association, was placed under contract for the summer season at the John Drew Memorial Theater in Long Island, New York. Ballard was given leading roles in the theater's summer plays.

Dr. W. B. Dillard, pioneer druggist in Salem, died at his home on College Avenue on June 9. He was eighty-two. Dillard was born in Salem in 1862, the son of physician Dr. T. H. Dillard. The younger Dillard established the Dillard Drug Company, which he operated for fifty-eight years. He established the business on May 10, 1886, with J. S. Persinger. Dillard bought our Persinger in 1903. His wife was Katherine Crawford Oakey of Tennessee.

Minor Oakey joined the John M. Oakey funeral service, representing the third generation of the family. For prior years, he had worked at the Whitten Funeral Home in Lynchburg.

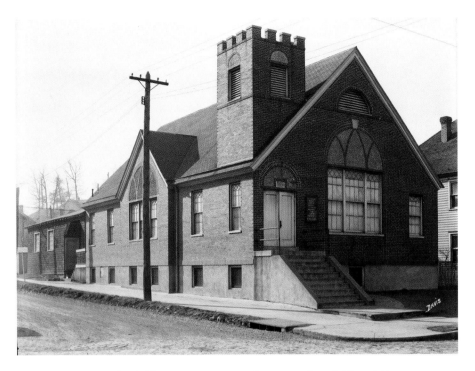

Churches held Invasion Day Prayer Services on June 6. This 1940
image shows Belmont Christian Church on Jamison Street, SE,
in Roanoke. *Virginia Room, Roanoke Public Libraries.*

Clifford Hampton of Roanoke just missed being the first man ashore for Invasion Day in France according to the Associated Press. The coast guardsman was pulled away by his commanding officer when his real age was discovered—sixteen. Hampton was the son of Rev. and Mrs. Millard Hampton of Hart Avenue, NE.

W. B. Carter and R. W. Cutshall easily won reelection to the Roanoke City Council on June 13. The votes were Carter, 561; Cutshall, 542; and Lawrence Wilkes, Socialist candidate, 42. Carter and Cutshall were Democrats.

For two nights, June 19–20, the WSM *Grand Ole Opry* show came to the Roanoke Fairgrounds with a tent show that featured Bill Monroe and his Blue Grass Boys. Other performers included Clyde Moody, Chubby Wise, Cedric Rainwater, String Beans, Curley Bradshaw, Little Sally Ann, and Tomie Thompson.

The first nose-in hangar that was completed in December 1943 at Woodrum Field was believed to be the only hangar of its type constructed, according to Woodrum Field officials in a press statement issued in June. The hangar was designed by Lee J. Bregenzer of the Penn-Central Airlines. A nose-in hangar allowed only the nose of a plane to be out of the elements for maintenance and repair. Given the shortage of material during the war, the nose-in hangar was a welcome addition to the airport's facilities.

The new telephone switchboard at Bent Mountain was completed in early June and put to use. The new switchboard was manned by Mr. and Mrs. King of the Bottom Creek.

The nose-in hangar at Woodrum Field was completed in December 1943 and was the first of its type in the country, 1949. *Virginia Room, Roanoke Public Libraries.*

WDBJ Radio marked twenty years of broadcasting in mid-June, being the second station in the Roanoke Valley to go on the air. To mark the occasion, the station did a special half-hour show that included local singers, a brief address by Roanoke's mayor, and comments from the station manager. WDBJ went on the air on June 20, 1924, when Ray Jordan played "Turkey in the Straw" on his fiddle as fellow employees of the Richardson-Wayland Electrical Corporation listened from seven miles away. The electrical corporation owned the little radio station at that time. House radios in 1924 were of the homemade variety, with only one factory-made radio in the entire valley being in the residence of S. H. McVitty near Salem. The original transmitter was in the rear of the Richardson-Wayland building at 106 W. Church Avenue, with broadcasts of one to two hours per day initially. The station launched with a twenty-watt transmitter. Later the studio moved to the Grand Piano Company, then to Thurman & Boone, and next to the American Theater building. Other locations included the Shenandoah Life Insurance Company facility and Kirk Avenue.

The local chapter of the Red Cross announced that their canning center would open for the summer Tuesdays through Fridays, with Thursday afternoons set aside for "colored patrons."

Pvt. Fred McDaniel was killed in action in Italy on March 29, according to a telegram received by his parents from military officials. McDaniel was from Roanoke and had been employed by the Radford Ammunition Plant before entering the service.

Roanoke county orchardists were informed that some two hundred foreign laborers would be available for the fruit harvest. The laborers were to be housed at the former CCC camp near Salem. For an orchardist to receive such labor, he must be in need of at least twenty-five such men.

Mrs. H. A. Bass of Roanoke was named editor of the *Virginia Club Woman*, a magazine of the Virginia Federation of Woman's Clubs. With Bass serving as editor, the magazine would be published in Roanoke.

VFW Post 1264 ladies' auxiliary presented a letter to Roanoke's mayor demanding that conditions at the city's juvenile detention home be investigated. Complaints included that the building was not clean, needed repairs, and contained inadequate plumbing. Further, the auxiliary stated that the children there were confined inside with improper supervision. Rooms that measured six by ten feet contained both beds and a toilet with little space between them. None of the basins in the washroom were in working order, and all shower stalls were clogged. The letter prompted a tour by a newspaper reporter and City Councilman W. M. Powell, who concurred with the assessment.

Salem officials said that the cannery in their community, located in a former African American school on Water Street, could produce 1,046 cans daily. The cannery was open every weekday and fully equipped with processors and pressure cookers. Blacks could only use the cannery on Monday mornings and Thursday afternoons.

The Boston Red Sox opened a baseball tryout camp at Roanoke for the weekend of June 23–25. Scouts from the major league ball team, under the supervision of Elmore Yoter, put players through various drills and conditioning routines at Maher Field. This was one of five tryout camps for the Sox's farm teams being held around the country. Thirty boys attended the camp and participated in intrasquad games.

The Virginian Café in Salem opened for business on June 23 on East Main Street. The café had formerly been Brown's Café. Roy Hobbs was the proprietor.

For the first time in the Roanoke YMCA's history, coed swimming was allowed at its pool on June 24. Ladies could swim in the "males only" pool from 8:00 to 9:30 a.m. The decision to allow women swimmers was made by Leslie Blankenship, the Y's physical education instructor.

First Presbyterian Church, Roanoke, celebrated its fifteenth anniversary of their South Roanoke building by retiring its $40,000 debt through a creative financing campaign that had members pay off the debt through war bonds. The congregation occupied its new sanctuary on June 23, 1929, when it relocated from Church Avenue and Roanoke Street, SW. Dr. Robert Lapsley Jr. was the pastor of the congregation.

The Town of Salem held a pet parade in Longwood Park in late June, and blue ribbons were awarded to children with various kinds of dogs, cats, rabbits, and other animals. The pet show and parade was part of the town's summer recreation program.

Pfc. Claude Moore Jr. was reported killed in action in the South Pacific. He had lived with his grandparents in the Virginia Heights section of Roanoke and was serving with the marine corps.

James A. Flora, prominent businessman, died at his home on July 1 at age sixty-one. Flora was a builder and contractor and had constructed many homes in the Raleigh Court and South Roanoke sections of Roanoke city.

The new sixteen-thousand-ton Standard Oil Company of New Jersey oil tanker was christened in Chester, Pennsylvania, on July 1, given the name *Esso Roanoke* after Roanoke, Virginia. The *Esso Roanoke* had a cargo capacity of 5.9 million gallons and was immediately put in service carrying fuel for the military.

Pvt. Andrew Conner and Pfc. Robert Slump were both reported killed in Italy. Slump was killed on May 1 and Conner on June 8. Conner was an Andrew Lewis graduate, and Slump was a resident of Roanoke County.

Paul Bernstein announced the opening of the Bern's Loan Company Pawn Shop at its new location at 11 S. Jefferson Street for July 8. Frank Miller was the store manager.

Charlie Monroe and his Kentucky Pardners brought their big-tent radio show to Salem and Vinton, July 13 and 14 respectively. Monroe had a nationally broadcast show from station WHAS in Louisville, Kentucky, and was on an eastern tour of the United States.

The Golden Gate Quartet, known both from radio and film, performed a show at the Roanoke Auditorium on July 14. They were joined by Selah Jubilee of Raleigh, North Carolina, and the N&W Railway Male Chorus.

On July 16, the Roanoke Tractor and Equipment Corporation became Rish Equipment Company. W. T. Sherman was also named manager, and Lon Rish was president. Rish was located at 405 Centre Avenue, NW, and also had locations in Charleston, West Virginia; Richmond, Virginia; Clarksburg, West Virginia; and Cincinnati, Ohio.

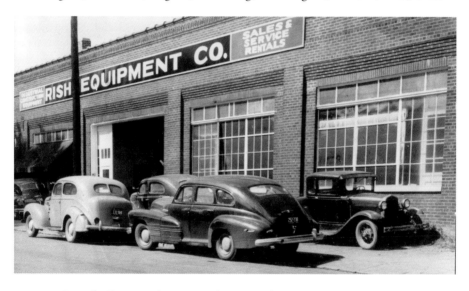

Roanoke Tractor and Equipment became Rish Equipment in 1944, located on Centre Avenue, NW, in Roanoke. *Roanoke City Police Department.*

R. C. Royer, manager of the Academy of Music, was appointed to a national committee to advise and assist the army in arranging entertainment programs for hospitals. The committee was formed by the National Theatre Conference at the request of the War Department.

"Keep your children in your own backyard" was the advice of Roanoke's health commissioner, Dr. A. G. Evans, due to increased cases of infantile paralysis. While Evans indicated he did not consider the problem to be an epidemic, he was concerned about six recent cases in the city in mid-July. As a result of the cases, the city's two indoor swimming pools were closed by the YMCA and YWCA. Further, the city parks department banned children under the age of fifteen from being in municipal parks until the situation abated.

Charles Moore, Roanoke water manager, denied rumors that Carvins Cove was incapable of holding water. He cited geological surveys dating to 1924 as evidence of thorough, long-term research.

The action of the credentials committee of the state Democratic Party in denying seven black delegates seats at the convention prompted a response from three black delegates from Roanoke who were part of the seven. A meeting of the Roanoke Civic League, an all-black organization, was called to air the grievances and determine a course of action. The meeting was held at the Hunton Branch YMCA. The three Roanoke delegates involved were Dr. H. T. Penn, Mrs. Lula Cawthorne, and R. W. Clark. The credentials committee had invoked a party platform that stated only white delegates could be seated at a state convention.

Maj. John Sours of South Roanoke was killed in action on June 6 during the first day of the D-Day invasion of France. Sgt. Russell "Jack" Ingram was also killed on the same day in the same invasion. The Ingram family resided on Church Avenue. Hollins resident Sgt. James Wright also died during the France invasion, along with Capt. Sherman Burroughs of Roanoke.

More than a dozen men walked off their jobs at the Virginia Brewing Company in mid-July as part of a labor dispute. Despite the challenge, the brewing company continued production by replacing the striking workers with new employees.

In addition to those previously named, the War Department notified other Roanoke Valley families that their sons had died on June 6 in the D-Day invasion of France. The men were Sgt. Herman Aldred, Pvt. Clifton Lee, Master Sgt. Rudolph Obenshain, Sgt. Alvin Webster. Technician Eugene Pandlis, and Sgt. Manuel Weeks.

Harold E. Powell, sixteen, was shot to death on July 18 at Fairfax Avenue and Eleventh Street, NW. Powell lived with his parents on Hanover Avenue. Arrested for the crime was William Smith of Fairfax Avenue.

The sixteen-member Prairie View College Coeds all-girl orchestra performed for a dance at the Roanoke Auditorium on July 20. The blacks-only dance did admit white spectators.

The State Corporation Commission granted a charter for the real estate entity Forest Hills Corporation. The Roanoke corporation was headed by Earl Simms and A. T. Loyd.

George Light, forty-four, of Norfolk was found guilty by a jury in the murder of Mrs. Ross St. Clair of Roanoke. St. Clair had been shot on June 10.

A woman jumped to her death from the eighth floor of the Boxley Building onto Luck Avenue shortly after 9:00 a.m. on July 21. Her husband had reported her missing the previous day.

An infantile paralysis isolation ward opened on July 22 at Roanoke Hospital under the joint supervision of hospital authorities and the public health commissioner. At the time, there were seven known cases locally, but Roanoke had been designated as headquarters for Southwestern Virginia for the care of those afflicted.

Pvt. Enoch Lunt was reported killed in action on May 12 by the War Department. Joseph Gregory Jr. was killed in a plane crash on Oahu Island on July 17, according to his relatives.

The Roanoke Woman's Club proposed to the Roanoke City Council that a war memorial should be planned and erected at the appropriate time on Mill Mountain. The memorial should be a tower, and the entire summit should be developed as a memorial park, according to the organization's president, Mrs. D. P. Hylton. The council decided a committee should be appointed to discuss all war memorial proposals.

Two more Roanokers were reported killed, according to the war department. Pvt. Walter Sink Jr. died from wounds sustained on D-Day, and Pvt. James Kesler was killed in France on June 18.

The Roanoke City Council unanimously appointed M. A. Smythe, vice president of National Business College, and Mrs. G. L. Campbell, prominent PTA leader, to the Roanoke School Board.

Roanoke councilman Robert Cutshall announced he would withhold his vote to spend money on a pipeline for Carvins Cove until the cove is completely filled with water, thereby allaying his fears that the cove cannot retain water.

The Roanoke City Council expressed its desire that the city's juvenile detention home close and that city police be instructed not to make arrests of children except in extreme cases. The council voiced its opinion following a meeting with state child welfare officials and after hearing from citizens about the deplorable conditions at the detention home.

Pfc. Ernest Loyd Jr. was killed in action in France on July 8. Technician Swanson Altice of Garden City was killed in action in France on June 6.

John M. Snyder, a pioneer businessman in Roanoke, died in Pennsylvania on July 26. Snyder came to Roanoke, then Big Lick, in 1869 and was one of the organizers of the Snyder, Hossler and MacBain department store that later became MacBain's. He then became engaged in the shoe business, Snyder and Stoll, located on Jefferson Street between Salem and Campbell Avenues. He also worked for a period for the N&W Railway.

The body of Lt. David R. Oakey of Salem was recovered from mountains in Colorado. The army pilot was flying a B-26 Marauder when the plane crashed on November 18, 1943. Five others aboard the flight were killed also. Oakey was a graduate of Andrew Lewis High School and the son of W. R. Oakey.

Wheel rolling artists of the N&W Railway gave a novelty performance at the Hotel Roanoke on July 29 as part of the Virginia Press Association annual convention. The wheel rollers maneuvered eight-hundred- and nine-hundred-pound locomotive wheels through lighted candles, sliced watermelons with wheel edges, spinning the wheels with one hand, and balancing a wheel on one edge while standing on top. The N&W wheel rollers were legendary for these feats, and many at the convention filmed them in action, with the footage to be used by MGM, Paramount News, Movietone News, and Acme Pictures. The N&W wheel spinners had also won competitions against spinners from other East Coast railroads.

Capt. Walter Schilling was killed in action on June 6 in France. He was an employee of the Viscose plant. Sgt. Dwight Johnson was killed in action on June 6. Staff Sgt. Howard Nichols was killed in action on June 16 in France. Corp. Jack Simms was killed in action on June 6 in France.

Everette Thurman, Roanoke Civic Theater singer, was signed for tenor roles by New York producers for a national fall tour of the opera *Traviata*. Thurman was well known by local theater and opera patrons for his performance in Roanoke over several years.

Hall Studios, operated by Mr. and Mrs. Curtis M. Hall, opened on August 1 at 413 S. Jefferson Street. The studio was advertised as "one of the most modern studios in the country, traditional and ultra-modern posing, beautiful mirrored backgrounds." The Halls had formerly been with Gilliam Studio.

Roanoke Shops wheel rollers John Canty, Pleas Casey, Charles
Wiley, and Thomas Campbell perform for the Virginia Press
Association, July 1944. *Norfolk-Southern Foundation.*

Lakeside and Lee-Hi swimming pools, both owned by the Roberts family, closed for
the summer on August 6. The early closures were in cooperation with the health depart-
ment due to the infantile paralysis outbreak.

Pvt. Harvey Smith was killed in action on June 6 in France. Pvt. Howard Gross was
killed in action in France on June 10. Pvt. Leonard Lucado of Salem was killed in action
on July 10 in France. Capt. William Pingley Jr. of Salem was killed in action in France on
July 8. Pvt. John King of Roanoke died from illness in England on July 13.

Clyde Lawhorn of Vinton was killed on August 3 when he was crushed by a bulldozer
on a construction job at the Johnson-Carper Furniture Company on Hollins Road.

Guy "Pinkey" Spruhan was appointed head coach for football and basketball at
Andrew Lewis High School, Salem. Jim Peters, who served as head coach for the 1943
seasons, was appointed assistant coach. Spruhan had served as a head coach at Roanoke
College and at VMI and had previously been with the Salem school from 1913 to 1918.

Alexander Bolden, seventy-four, of Salem died August 3 at his home on Chapman
Street. Bolden was retired from the Virginian Railway and was a longtime lay leader of the
Shiloh Baptist Church.

The Virginia State Trapshooting Tournament was held at the Roanoke Gun Club in
early August. Among locals who won were Jack Wright (high overall) and Willie Craige
(high gun at sixteen yards). Judge John Hart of Roanoke was elected president of the state
association for the coming year.

Pvt. Sheldon Nichols of Roanoke County was killed in action in France on July 16.

Dr. J. Manning Potts preached his farewell sermon at Greene Memorial Methodist
Church on August 6. Potts had been appointed by the national Methodist denomination

to head their "Crusade for Christ" campaign, an effort to raise $25 million for denominational reconstruction work after the war. Potts's new office was in Chicago.

One hundred widely published photographs of the US Armed Forces in action were exhibited at Roanoke Photo Finishing for the first two weeks in August. The photos were taken during actual military engagements and included pictures of the suffering of war, wrecked enemy installations, bombed ships, prisoners of war, and the killed.

Lucky Millinder and his orchestra performed at the Roanoke Auditorium on August 8. Accompanying the band leader were Judy Carol and Blues Harris. The blacks-only dance permitted white spectators.

The Roanoke School Board went on record unanimously approving of open sessions for their meetings and allowing interested persons to appear before the board and express constructive criticism. At the organizational meeting, Leroy H. Smith was elected board chairman.

Pfc. George Reynolds of Salem was killed in action on Saipan on July 9. Capt. James Jarrett, thirty-three, of Roanoke was killed in action in France on July 25. Jarrett had established the Jarrett Brokerage Company in Roanoke. First Lt. Donald Roman of Roanoke was killed in action over France on July 11. Pfc. A. E. Janney of Poages Mill died from wounds on July 12 in France. Pvt. George Bohon of Salem was killed in action in France on July 15. Pfc. Oscar Carroll of Salem was killed in action on July 15 in northern Burma. Pfc. Elmer Smith of Roanoke County was killed in action in Italy on July 1.

Roanoke police, responding to a neighbor's complaint, entered a home in southeast Roanoke and discovered a six-year-old girl chained by the ankle to a bed and her three-year-old and twenty-month-old brothers alone in the house. Police waited in the home until the thirty-five-year-old mother arrived thirty minutes later. City welfare agents took charge of the children and the mother, Bessie Taylor, was charged with cruel and inhumane treatment of a minor.

E. E. West Jr. of First National Exchange Bank was elected president of the City-County Forum for the coming year. The forum stated its largest membership in its history. The forum regularly brought nationally known speakers to Roanoke to address topics of interest on a variety of subjects.

Norman-Shepherd, Inc., men's clothier, announced their opening at a new location, 505 S. Jefferson Street, ground floor, on August 10.

Fun Haven, the city recreation center in Raleigh Court, was closed by city officials due to the cases of infantile paralysis in Roanoke.

Roanoke's member of the Virginia House of Delegates, Earl Fitzpatrick, was named a state campaign chairman for the Roosevelt-Truman ticket and all congressional nominees. State headquarters were in the John Marshall Hotel in Richmond.

Randolph Whittle, a juvenile and domestic relations judge in Roanoke, submitted his resignation to the Roanoke City Council when the council refused his request for a pay raise. Whittle had asked that his salary be increased to $6,000 annually and that he become full time. Whittle at the time was employed part time for $1,300.

The Roanoke County School Board voted at their August 12 meeting to consolidate Starkey School and Ogden School to better provide for the students and reduce expenses. The board did not adopt specific details of the consolidation pending further work by the school administration.

(*l–r*) Nelson Simpson, Omer Simpson, O. C. Simpson Jr., Francis Simpson, and a neighbor get up hay on Simpson's farm near Bent Mountain, 1944. *Nelson Harris.*

Doctors and nurses at the infantile paralysis isolation ward at Roanoke Hospital reported some success with their treatments. Infants admitted stayed at the ward for two weeks before being transferred to hospitals in Charlottesville and Richmond. Care involved wrapping the infants in a "hot pack" to relieve muscle strain. The hot packs were refreshed every two hours. Older children and teenage victims were placed in iron lungs that had been provided by the Roanoke Life Saving and First Aid Crew. The state health department allotted $3.50 per day for care, with additional medical expenses paid by the National Infantile Paralysis Foundation. Roanoke had twenty-one cases of infantile paralysis, and the ward had twenty-seven patients total, two of whom were in iron lungs.

A reception honoring Sister Bertranda on the occasion of her fifty years of service, most of it at the St. Andrew's School, was held on August 15 at St. Andrews Catholic Church. A native of Kentucky, the sister came to Roanoke in 1908 and began teaching at St. Andrew's Hall, a three-room structure built in 1898.

Fred Hobback, speaking on behalf of the Salem Chamber of Commerce, asked the town council to consider acquiring land for a Salem airport sufficient to serve the air cadets being trained at Roanoke College. At the time, cadets were having flight instruction at Woodrum Field or at Montvale. Hobback stated the chamber also believed that such an airport could also serve civilian fliers.

Fred Kirby and his Briar Hoppers from Charlotte, North Carolina, performed on the stage at the Roanoke Theatre on August 16. Their performances were often played nationally on the Columbia Network.

B. B. Robertson, charter member and assistant fire chief of the Salem Fire Department, died on August 15 at age sixty-six. Robertson had been assistant fire chief since 1934.

Col. Marcellus Johnson Jr., former president of Lewis-Gale Hospital and assistant to the chief surgeon for the N&W Railway, was appointed head of the largest army hospital in England.

The Roanoke City Council adopted emergency water restrictions in mid-August due to drought conditions and the fear that the Crystal Spring reservoir would go dry.

Staff Sgt. George Yeager Jr. of Roanoke was killed over France July 16 with the army air force. Pfc. Huntington Paul was killed in action in France on June 30.

School officials in Roanoke announced that Woodrow Wilson, West End, and Highland Park Schools would open for the school year with new cafeterias, though obtaining equipment was proving difficult. Previously, the food for Highland Park and West End had been prepared in the kitchen at Jefferson High School and transported.

The Detroit Giants and the Atlanta Black Crackers, teams of the Negro League baseball, played each other at Maher Field on August 23. A cosponsor of the game was Fred Lawson, who brought the game to Roanoke as a test to see if other such games would draw a crowd. A section of the bleachers was reserved for whites. The Crackers beat the Giants 15–4.

An isolation ward for the treatment of black patients suffering from infantile paralysis was opened at Burrell Memorial Hospital. At the same time, city health officials reported that deaths from the paralysis in the city stood at five. Burrell's isolation ward was a one-room cottage at the back of the hospital. Prior to the ward, black polio victims were treated in their homes. The cottage would have a capacity for five beds.

The Salem Lions Club weighed in on the issue of Salem developing a town airport by urging caution and arguing that public funds should not be expended for a facility to be used mainly for private flyers versus commercial aviation.

Percel Johns, thirty, was shot and killed in a cabin on Twelve O'Clock Knob near Salem on August 20. A companion, Edward Setliff, who was with Johns claimed the death was accidental. Upon further investigation, however, Setliff was charged with murder. Charges against Setliff were later dismissed by a judge.

Baer's, Inc., a women's clothing store, was purchased by H. K. Turner. A. C. Baer sold his store at 109 W. Campbell Avenue in mid-August; he had begun the business in 1941.

The Roanoke City Council authorized various purchases of land surrounding Woodrum Field for expansion of the airfield in the future. The city purchased almost five acres from the Roanoke Orchard Company and some twenty-eight acres from Clayton Lemon.

Approximately one hundred German prisoners of war were made available to work in the orchards of Roanoke County from the Salem Camp. Their work was scheduled to start in early September. Some of the Germans were working on the Carvins Cove reservoir, but they would be made available for the apple harvest.

German POW Camp bus is near Salem in this 1944 photograph. The German prisoners worked in orchards and on the Carvins Cove reservoir. *Salem Historical Society.*

The Town of Salem announced a drive to acquire two iron lungs, and the Williamson Road Life Saving Crew also announced a fund drive for the purchase of one of the respirators.

Woodrum Field became a critical link in the chain of ferrying wounded soldiers to hospitals. Battle casualties from overseas were often flown to Woodrum Field where they were kept overnight in ambulance planes. The Roanoke airport was often better able to handle such air traffic than other surrounding fields, especially with the Veterans Administration hospital nearby that could provide short-term medical care during the layovers.

Dr. A. G. Evans, Roanoke health commissioner, announced that plans for a polio isolation ward at Burrell Memorial Hospital had been abandoned due to a lack of nurses. Evans said all black children afflicted with infantile paralysis would be sent to St. Phillips Hospital in Richmond for care. Evans reported that only one black nurse had volunteered for the Burrell isolation ward.

Pvt. James Burke of Roanoke was killed in action on August 4 in France. Aviation cadet Billy Lane of Roanoke was killed in a plane crash near Carlsbad, New Mexico, on August 24. Pfc. Randolph Francis of Roanoke was killed in action in France on June 11.

Officials at Woodrum Field announced that the airfield had been upgraded to Third Class status with the installation of better lighting. The lighting included boundary lights, obstruction lights on hangars, and contact lights set flush in the runways. Floodlights were also in use on the aprons.

Nat Towles and his orchestra performed at the Roanoke Auditorium on September 1. The blacks-only dance also included performers Irene Miles and Joe Timmins.

Ensign Horace Bass Jr. of Roanoke, who was posthumously awarded the Purple Heart, had a destroyer-escort named after him, as announced by the secretary of the navy. Bass's widow had left Roanoke and was living in California.

Woodrum Field, shown here in the 1940s, was upgraded to Third Class status with improved runway and boundary lighting. *Virginia Room, Roanoke Public Libraries.*

Roanoke County postponed the opening of schools by one week due to the polio outbreak. Schools opened on September 15. Roanoke Hospital's isolation ward for infantile paralysis was overcrowded by the end of August. The ward was designed for twenty-five patients and was housing thirty-three patients from the region.

Lt. Col. Eugene Venable, Roanoke, was killed in a plane crash in Prestwick, Scotland, on August 27. Pfc. Erie Wimmer, Roanoke County, was killed in the Pacific on August 11. First Sgt. Edward Walton was killed in action on July 15. Pvt. Fred Webb of Callaway was killed in action in the Pacific. Pvt. Eldridge Weaver of Roanoke was killed in action in France on July 27.

Granville Hash—founder, treasurer, and president of Grand Piano Company—died at his home on Day Avenue on September 1. Hash was eighty-one. A native of Grayson County, Virginia, Hash was a member of the Hash-Fields Manufacturing firm in Mouth of Wilson. In 1908, he sold his half of that business to his partner and came to Roanoke, where he established the Roanoke Furniture Company on South Jefferson Street. In 1910, he sold his interest in that furniture company and organized the Grand Piano Company. Hash also served as a director of the Colonial-American National Bank.

Roanoke mayor Leo Henebry was unanimously reelected as mayor by his city council colleagues in their meeting on September 1. Courtney King was elected as vice mayor. The Salem Town Council elected Frank Morton and O. G. Lewis as mayor and vice mayor respectively. For both bodies, the mayoral term was two years.

The Salem Rescue Squad announced they had exceeded their fund drive and purchased two iron lungs and a trailer to transport the lungs.

The Roanoke School Board delayed the opening of public schools until September 18 based upon information from public health officials and their mutual concerns about the polio outbreak.

Mrs. Pendleton and Miss Pauline Poff advertised the opening of their new Powder Puff Beauty Shop on the third floor of the Rosenberg Building in Roanoke. They "specialized in cold waves," and machine wave ranged from $3 to $12.

Ernest Miller, operator of the Star Market, died at his home in Roanoke on September 2.

Roanoke Hospital reported two deaths due to polio, bringing the hospital's total to five. City health officials said there were thirty-three cases in the hospital. The hospital's isolation ward was beyond capacity, so new cases were being sent to a hospital in Lynchburg. One family had three children diagnosed with polio, with one of the children stricken fatally. In Salem, there were five cases, three from the same family.

Staff Sgt. Joseph Clyburne of the Williamson Road section was reported killed in action on November 11 in North Africa. Lt. Richard Crawford of Roanoke was killed in action in France on August 2. Pvt. Howard Mattox of Vinton was killed in action on August 17 in France. Pfc. Douglas Clark of Roanoke was killed in action in France on August 8. Second Lt. John Dunlap of Roanoke was killed in action in Italy on August 15. Pvt. Robert Payne Jr. was killed in action in France on August 16. Sgt. Billy Thomas of Vinton was killed in action on February 5. Second Lt. William Stewart of Roanoke was killed in France on August 5. Pfc. Joseph Adams of Roanoke was killed in action on August 12 in France.

The interior of Mitchell's Clothing Store is shown in this 1944 image. Mitchell's was one of many men's clothiers in downtown Roanoke. *Nelson Harris.*

After strong protests from parents, the Roanoke County School Board revoked its previous decision to combine the Ogden School and Starkey School.

A number of private flying schools and services were operating at Woodrum Field, including Hicks-Kesler Flying School, with instructors Jack Hicks, Paul Kesler, and Cricket Thomas; the Martin-O'Brien Flying Service; and Garner Aviation Service.

Residents of the Williamson Road Sanitary District No. 1 voted in favor of Roanoke County issuing water bonds to purchase the Phelps Water Company. The vote was 322 to 209. The county was authorized to issue bonds not to exceed $225,000.

Walter Minnix, sixteen, of Roanoke died from electrocution while working in a shop of the Art Sign Services on First Street, SE. Minnix was in his second day on the job.

A committee of the Roanoke Chamber of Commerce urged the business association to launch an effort to provide public housing for low-income residents. The committee said there were some six hundred shanties, shacks, and substandard homes in Roanoke city that should be razed.

Dr. Charles Smith, president of Roanoke College, announced the enrollment for the 1944–45 school year to be approximately 200 students—125 males and 75 females— with about half being freshmen. Due to the war, enrollment was about half of prior years.

Henry Wallace, vice president of the United States, visited Roanoke on September 8 as part of a national listening tour to familiarize the Roosevelt Administration with postwar planning at the local level. Wallace interviewed Roanoke's mayor about Carvins Cove reservoir, local industry, libraries, armory, and other municipal projects. Wallace predicted that China would be a major player in international trade should Roanoke industry wish to consider that market. Wallace left the next morning to address workers at the Radford munitions plant.

The first annual Vinton horse show was sponsored by the Vinton Lions Club on September 9. The strictly amateur show featured exhibits by local stables. Professor Ralph Hunt of VPI was the judge. The event was held at Leggett Field.

Roanoke County school officials further delayed opening the schools until September 22, citing concerns about polio cases.

D. Robert Hunt, former commissioner of the revenue for Roanoke, died on September 8 at his home on Campbell Avenue. He was sixty-eight. Hunt served as commissioner from 1914 to 1934. He was involved in numerous civic and charitable organizations.

A $100,000 expansion of Roanoke City Mills on S. Jefferson Street was completed in September. The expansion included a fourth floor and added grain storage. The operation had a maximum daily feed production of 1,060 tons and grain storage up to 175,000 bushels, according to J. W. Ring, president.

This undated George Davis photo shows Roanoke City Mills along South Jefferson Street in Roanoke. *Virginia Room, Roanoke Public Libraries.*

Plans for a real estate development in the Lee Hy Court section were presented to the Roanoke City Council. The subdivision plans called for several streets, as presented by Herman Sigmon.

A fire at the Roanoke County home of Mr. and Mrs. A. B. Hughes on September 12 killed four of their children. The two-story wood-frame home was located on the Catawba-Blacksburg Road. The children ranged in ages from six to fourteen. The father and an uncle were taken to Lewis-Gale Hospital with severe burns as a result of their efforts to try and save the children. Two other children in the family survived. A mass funeral for the children was held at the Shiloh Church in the Catawba Valley.

The Roanoke School Board postponed the opening of schools again, extending the start date to October 2 due to ongoing polio cases in the area. The school board also cancelled the first two football games of Jefferson High School for the same reason.

Two teams from the Negro League played at Maher Field on September 14. The Black Crackers of Atlanta played against the Newark (New Jersey) Eagles. On September 15 and 16, the Black Crackers played the North Carolina All-Stars of the same league at Maher Field. Over the next few days, games at Maher Field occurred between the Cleveland Buckeyes and Baltimore Eagles, and the Black Crackers and New York Cubans. This series of games was part of a national postseason tour by teams from both the Negro American and National Leagues.

Sgt. 1st Class Henry Fillzenia of Roanoke was killed in action on June 11. Pfc. Eugene Shelton of Roanoke was killed in action in France on June 16. First Lt. R. B. Knapp was killed in action in France on August 23. Pvt. Durwood Flint of Roanoke died from wounds he received while fighting in France on August 16.

Samuel Spiegel, Inc., moved back to its original store in mid-September having been displaced by a fire earlier in the year. The store had relocated for five months to 307 S. Jefferson Street but was able to return to 306 S. Jefferson Street.

R. B. Williamson, county extension agent, reported that between 175 and 200 German prisoners of war would be able to assist with apple crops in the fall and other farm work, if necessary. "War prisoner labor is proving to be more and more satisfactory as farmers are learning how to handle the men," Williamson stated.

William J. Smith was found not guilty by a judge of murdering Harold Powell, sixteen. Judge Lindsay Almond ruled that Smith was acting in defense of his home.

Stage Sweepings, a magazine published by the Civic Theatre Association of Roanoke, rolled off the presses with its inaugural issue on September 15. Columnists were Kay Lee, Nelson Bond, and Francis Ballard.

Professor Howard M. Jones of Harvard University addressed the opening convocation for Hollins College. Jones's topic was "Are Women's Colleges for Women?" Jones traced the history of female colleges and their contribution to the rise of women's emancipation, but he added, "If we have in mind the education of the average American girl, who quite honestly only wants a job until she gets married and has a home, I wonder if we would today simply duplicate the curricula of our men's schools. Women are the retail buyers of the nation; and they chiefly maintain their homes." Thus, Jones asserted that a women's college should provide training for home duties and around interests that could occupy women's "leisure time."

The German POW Camp at Catawba was formerly used by the Civilian Conservation Corps before World War II, 1944. *Salem Historical Society.*

The German POW Camp at Catawba was one of two such camps in the
Roanoke Valley, with the other being at Salem, 1944. *Salem Historical Society.*

The German POW Camp at Catawba housed some of the two hundred
Germans whose orchard labor was coordinated by the Roanoke
County extension agent, 1944. *Salem Historical Society.*

N& W Railway passenger locomotive J-605 changed class from J-1 to J due to the addition of the streamline "skirt." Streamlining of the remaining five J-1 engines, numbers 606 through 610, would be completed before December 1, according to N&W officials. With the addition of the skirts, the J-1 class would cease. The skirts had been prohibited due to steel rationing.

On September 18 a record of over six inches of rain fell in seventeen hours, flooding many streams and creeks in the area. Hit hardest were residents along Goose Creek in Vinton, where several homes had to be evacuated.

The Roanoke City Council elected Mrs. Odessa Bailey to a judgeship for the Juvenile and Domestic Relations Court. She had been employed for seventeen years with the US attorney for Western Virginia and was licensed to practice law in 1934. The vacancy occurred when council voted three to two to not reappoint Judge Randolph Whittle. Bailey was then elected by a vote of four to one.

Plans to purchase more lands adjacent to Woodrum Field were unveiled by city officials as part of a master plan for the airport. Lands belonging to the Coulter family and the Patrick heirs were discussed in order to improve and extend runways.

With a decline of reported infantile paralysis cases in the city, the Roanoke School Board decided to start schools on September 27 and backed away from an October opening, as previously scheduled.

Gail Patrick, a Hollywood actress, became a temporary resident of Roanoke as she came with her husband, Lt. A. D. White, for a monthlong stay at the Hotel Roanoke while he completed flight training at Woodrum Field.

Robert Belcher, age four, was struck and killed by a truck on Lynchburg Avenue, NE. The truck driver, Lonnie Statton of Forest, was charged with reckless driving and manslaughter.

Staff Sgt. John Dillon of Roanoke was killed in action in France on August 20. Capt. George Curry of Roanoke died from wounds received at Saipan, Japan. Second Lt. Teddy Roundtree Jr. was killed over the southwest Pacific. First Lt. Heyward Ball of Roanoke was killed in action over the Philippines on September 1. Pvt. William Potter of Roanoke was killed in action in France on June 9. Seaman Paul Sublett of Roanoke died on September 14 with the sinking of the destroyer *Warrington* due to a hurricane in the Atlantic.

The Race Relations Commission of Roanoke went on record as favoring the naming of black policemen to the Roanoke police force and the appointment by city council of a commission to investigate the housing facilities in Roanoke. The commission's stance on police was prompted by a petition of four hundred signatures presented to it by the Roanoke Civic League, a black organization, advocating the hiring of black officers.

Harry D. Guy Sr., a former member of the Roanoke City Council, died September 22 at age eighty-two. Guy came to Roanoke in 1892 with the N&W Railway and served as a member of the Common Council from 1895 to 1899, later serving on the city council and school board.

The comedy *Kiss and Tell* came to the stage of the Academy of Music for a two-day run September 26–27. The production starred silent screen actress Lila Lee along with Walter Gilbert and June Dayton and a supporting cast from Broadway. The producer was George Abbott.

An auction was held to dispose of Stone Castle and its contents on October 3. The home, on sixty-seven acres, was located between Salem and Roanoke on Deyerle's Lane,

Route 683, near the Belle Aire Court, Windsor Hills, and Lee-Hi Court subdivisions. The sale was handled by J. G. Sheets & Son, Roanoke.

The poll tax test suit filed by Dorothy B. Jones against the Roanoke City registrar was dismissed in US District Court on September 25 after Attorney General Abram Staples, representing the registrar, filed an amendment to the bill of complaint holding that a poll tax would not be assessed upon any person turning twenty-one years of age after January 1 as a prerequisite for voting. Moss Plunkett represented Mrs. Jones. Jones asserted that her right to vote was denied as she refused to pay the $1.50 tax. Jones, who was black, believed as did others that the tax sought to dissuade minority and low-income voters.

Some seven hundred citizens signed a petition that was presented to the Roanoke City Council on September 25 in support of hiring blacks as policemen. The petition, presented by the Race Relations Commission, was referred to the city manager. The petitioners asked that black policemen be appointed to patrol black neighborhoods. Dr. Harry Penn spoke on behalf of the biracial commission, as did Rev. Edward Dowdy, a white clergyman.

John Dillon of Roanoke was lost at sea on September 11 when he was serving aboard the destroyer *Rowan*, which was sunk in the Tyrrhenian Sea. Pfc. David Stump died from injuries sustained in a motor vehicle accident in Coventry, England, on August 30. Sgt. Fred Gunter of Roanoke County died from wounds received in France on September 8. Pvt. Charles Wright of Vinton was killed in action in France on September 1. Lt. Mac Basham of Roanoke was killed in action on August 28. Pvt. James Atkinson of Roanoke was killed in action in Italy on September 1. Staff Sgt. Edwin Hill of Roanoke was killed in action on June 6 in France.

L. R. Howsan, an engineer from Chicago, branded as groundless rumors that Carvins Cove would not hold water, citing previous tests demonstrating the dam was quite sufficient for the reservoir. Howsan's firm had been engaged by the city for design of the reservoir, and the engineer reported to the council that there would be five times the amount of water going through the dam daily than was necessary to meet the city's water needs.

A whiskey famine hit Roanoke in late September as whiskey rationing impacted the local ABC stores. The state ABC board had slashed whiskey rations by half.

US soldiers stationed in France sent a letter to the *Roanoke Times* requesting that local girls send them pinup photos as they were tired of looking at Hollywood starlets. "We are seeking a new and real pinup girl, which we will be able to call our very own…We would like for contestants to send us a photo of themselves…We here will decide the winner. The winner's picture will be put on the gun which will soon be going through Berlin." According to the letter, five men of the group were from Roanoke, and had a subscription to the *Times*.

Cootie Williams and his orchestra performed for a blacks-only dance at the Roanoke Auditorium on October 3. Williams had previously been with Duke Ellington's band. Joining Williams was vocalist Eddie Vinson.

Cash contributions of nearly $4,000 were given to aid Mr. and Mrs. A. B. Hughes, whose home in the Catawba Valley burned, resulting in the death of four of their children. Various organizations had solicited aid for the family, which also resulted in their receiving clothing and furniture as well as funds to build another home.

The touring production of *The Merry Widow*, starring Marion Bradley and Nancy Kenyon, came to the Academy of Music October 10–11.

W. H. Kennett purchased the Folden Star Market at 111 Market Square and renamed the establishment as the Packing House Market Company. Kennett had formerly been with Kroger. W. F. Sale Jr. purchased the Morrison-Sale Tire Company outright, and it became Cap Sale's Tire Service, 18 Bullitt Avenue, SW.

Pvt. Guy Smith of Roanoke died August 8 from injuries sustained in France. Petty Officer John Sowder of Salem was lost at sea on September 11. Capt. George Davidson of Roanoke was killed in action in Holland. Capt. Gordon Brooks of Roanoke was killed in action over China on September 23. Sgt. Wilson Newman of Vinton was killed in action in France on September 18. Pfc. Clarence Simmons of Roanoke was killed in action in Germany on September 22.

The Roanoke county extension agent reported a severe shortage of labor to harvest apple crops in the county. Unless persons signed to help, it was estimated that forty thousand bushels would go to waste.

The Roanoke County School Board acquired land for postwar building sites. The board purchased the W. W. Graham property near the northwest town boundary of Salem for $5,000 for a future grade school.

A fire destroyed the five-story feed mill of Roanoke City Mills, Inc., on October 8, and the damage was estimated to have been $250,000. Fire officials attributed the quick spread of the fire to flammable feed materials. At the time, the mill was undergoing a $100,000 expansion and renovation. Mill officials said they would rebuild.

Leroy Flemings of Baltimore, Maryland, and Stoney Lewis of Washington, DC, fought in a professional middleweight boxing match at the Roanoke Auditorium on October 12. Four preliminary bouts were also held, including two bouts between locals.

Thomas B. White, sixty-one, of Roanoke died in a house fire at 10 E. Salem Avenue on October 12. Four others in the home at the time managed to escape.

The Community Concert Association opened its season with French violinist Zino Francescatti, who played on the "Hart" Stradivarius reportedly made by the Italian master in 1772. The violin performance was held at the Academy of Music on October 13.

An architectural drawing of the proposed filter plant at Carvins Cove appeared in the *Roanoke Times* on October 15. The design was for the building to be located on a knoll of the former Miller property off Old Plantation Road. The building was Jeffersonian in design and was selected from three sketches submitted to the Roanoke City Council by Louis Howson.

Pfc. Darden Harman of Salem died on October 8 in the Pacific. Pvt. Clarence Turner of Roanoke was killed in action in Italy on October 1. Sgt. George Zimmerman of Roanoke County was killed in action on November 26, 1943, over France. Pvt. Woodrow Martin was killed in action in France on October 14. Sgt. Joe Sturdivant of Roanoke was killed in action over England on September 13. Pvt. James Price of Roanoke was killed in action on September 4 in France.

"The Mansion" at Green Hill, a Colonial home built in 1776, was auctioned on October 26. The estate contained the home and 114 acres and was located two miles west of Salem and one mile west of Fort Lewis. Its owner was Clare Quesenberry. According to advertisements, The Mansion was a two-story brick residence with bricks imported from England, brought by boat to Lynchburg, and then hauled to Salem by wagon. The walls and partitions were solid brick, twenty-two inches thick, and contained original plaster. The wide-board floors were from Norwegian spruce. On the grounds was a smaller brick

structure that originally served as slave quarters and later as a school house. The auction sale was handled locally by C. W. Francis & Son.

The troubadour Joe Howard came to the Academy of Music on October 17 and brought with him the Gay Nineties Radio Revue, which included radio personalities Shaw and Lee, the Four Mangean Belles, Danny McCurtin, the Carnegie Quartet, and Allen and Drake.

One of the biggest distilleries discovered by law enforcement was destroyed just outside the Roanoke County line near Boones Mill. The still had a six-hundred-gallon capacity. Agents destroyed two thousand gallons of new corn mash, 2,400 pounds of corn meal, and five hundred pounds of barley malt. The moonshiners made their escape minutes before revenue agents arrived.

First Federal Savings and Loan Association offered a contest to award a fifty-dollar war bond to the person guessing when the war with Germany would end. "To the person guessing the nearest to the date, hour and minute when the armistice is officially declared between Germany and the Allies" was to be awarded the prize.

The Baltimore Yard of the Bethlehem Steel Company ran numerous large ads soliciting applications from men and women in the Roanoke area to work at its shipbuilding division, citing urgent needs. The company offered to pay transportation costs and housing facilities.

An army C-64 plane crash-landed in bottom land adjacent to the Roanoke River near Route 11, six miles west of Salem, on October 20. The plane glided under high tension wires, and none of the seven passengers and crew was injured. The plane had left Woodrum Field for Pittsburgh and reported engine trouble at seven thousand feet while over Shawsville. The plane attempted to return to Woodrum Field when the pilot decided to crash land.

Miss Margaret Keeler was chosen "Miss Vinton for 1944" during the halftime of the homecoming football game between William Byrd High School and Martinsville. The crown was presented by Congressman Clifton Woodrum.

C. J. Thomas, sixty-one, of Vinton was killed by a hit-and-run driver on US 460 on October 20. According to the sheriff's deputies, Thomas was dragged about seventy yards and met instant death. Two weeks later, the Roanoke County sheriff announced that four persons were determined to be in the car and had been arrested. The driver was identified as a soldier, William Quarles, who the passengers claimed was en route to Europe. The car involved was identified after a search by authorities based upon local listings of owners of 1934 and 1935 Chevrolets. Upon determining the car's owner, the brother of the driver confessed to the hit-and-run.

A. L. Holland and Fred Rice extended a call to any black football players that might wish to play professionally to meet at the Hunton Branch YMCA.

Believing that the significance of Armistice Day no longer existed, the Roanoke City Council voted to appropriate no funds for celebration of the day to the Patriotic Affairs Committee and considered a move to strike the day from the list of holidays for municipal employees. Councilman W. B. Carter summarized it best: "There is nothing to celebrate—we are now fighting the same nation."

The SCC granted a charter to Hilltop, Inc., an entity organized to build a forty-room, twenty-bath home for elderly white women on land adjacent to Fishburn Park after the war. The Roanoke City Council would have to give final approval at the appropriate

time. The women would be admitted as "guests" and would not be charged for room and board unless determined otherwise by the board of directors. The guests must be members of a Christian denomination and would be allowed to play cards, smoke, and "engage in moderate drinking but not habitual or excessive drinking," according to organizers.

The property occupied by the Elmwood Service Station across the street from the Hotel Patrick Henry on S. Jefferson Street was acquired by Paul Hunter from the Gale estate for $160,000.

Pfc. Walter Emerson of Roanoke was killed in action in France on August 8. Sgt. Royall Witt of Roanoke County was killed in action in France on September 15. Second Lt. Charles Snyder of Roanoke was killed in action in Holland on September 22.

A German prisoner of war working in the Weeks orchard near Troutville escaped on October 25. Guards believe he secured a change of clothes. Lt. Sam Fields, in charge of the POW Camp at Catawba, conducted a large-scale search for the prisoner. The prisoner was identified as Hermann Neumann, twenty-one, who spoke little English. The search lasted for two days before Neumann was spotted along a highway by a resident of the Coyner Springs area. Roanoke police as well as armed private citizens joined the search, and one fired twice at the prisoner before he made yet another escape from authorities. Militia guards were posted along US 460 at various points. Finally on October 29, the prisoner was caught as he surrendered himself to Sam Smelser, a farmer, in the Webster section. Neumann walked up on the porch of Smelser's home with his hands above his head, identified himself, and said he wanted to go back to the camp.

The switchboard at the *Roanoke Times* was jammed the night of October 25 when it received between three and four hundred calls from frightened Roanokers who had heard over their radios a call for all Virginia Reserve militia to report to the Roanoke armory for an "emergency." The militia was indeed being called out to help search for an escaped Nazi prisoner, but many seemed to think the state was under invasion. The *Times* likened the evening to the night Orson Welles broadcast his *War of the Worlds* over the airwaves, providing a theatrical rendering of a Martian invasion.

The "Firepower Caravan" came to Maher Field on October 28. It consisted of World War II artillery, army trucks, and jeeps, and featured speeches by returning veterans and music by a twenty-eight-piece band from Camp Pickett. The caravan was on a tour in Virginia and the Carolinas.

The War Memorial Committee in Roanoke, chaired by Dr. Hugh Trout, announced several proposals for a war memorial after the war's conclusion. One leading idea, offered by the library committee, was to make the proposed new library in Elmwood Park a memorial and to construct a swimming pool in the park to make it more of a recreational center to highlight the memorial. Another suggestion under consideration was the creation of a civic amphitheater in Highland Park as a memorial.

Professional boxing came to the Roanoke Auditorium on November 2. Main bouts of eight rounds included Ernest Butler versus "Kid" Howell and Leroy Fleming versus Freddie Welch. The all-black event did advertise "reserved seats for white people."

The Twin Sisters Club presented an all-black dance at the Roanoke Auditorium on November 1 with Andy Kirk and his Clouds of Joy swing band. Vocalists were Guen Tynes and Bend Jenkins.

This 1940s aerial shows Elmwood Park. Plans for the park were often controversial, with many uses proposed during the 1940s. *Virginia Room, Roanoke Public Libraries.*

Mack Barlow Jr. was in serious condition at Burrell Memorial Hospital after being stabbed in his head. Police arrested James Winbush. Barlow was the manager of the Dumas Hotel and was on duty at the time of the stabbing, which caused paralysis.

Sgt. Derewood Basham of Roanoke was killed in a glider accident in England on October 13. Sgt. Aaron Bowling of Roanoke was killed in action in France on July 18. Sgt. George B. Harris Jr. of Back Creek was killed in action in France on July 31. Sgt. Ralph Morgan of Salem died on October 18 from wounds that he had received in Italy.

The War Production Board issued a suspension order on November 3 to Advance Stores, Inc., of Roanoke charging "willful violation" of WPB regulations. The board stated that Advance had made unauthorized purchases of bumper jacks, tire gauges, and other automobile accessory items. The suspension was for the period of November 13 through January 13, 1945, and prohibited the company from making orders for certain items.

A new plant was announced for Salem that would employ sixty persons beginning in February 1945. The Jeffreys Laboratories, Inc., stated they would construct a two-story, brick building at Fourth Street near the Hester Coal Company. K. W. Lawrence, Salem, was the contractor. The company was headed by George Jeffreys, who started a small-scale lab in Salem in 1940.

Goodwill Industry and Gospel Mission announced their intent to acquire property at 11 W. Salem Avenue, Roanoke, that was occupied by the Nolan Company. The purchase price was $50,000. Goodwill officials said the purchase was due to their need to expand operations.

The *Roanoke Times* editorial board opined in the November 5 edition that the newspaper would not take a position in the coming US presidential election between incumbent Franklin Roosevelt and challenger Thomas Dewey. "That we have declined to take sides in the campaign…should constitute an effective guarantee of the integrity of our news columns."

These N&W employees lined up to apply for Blue Cross health
insurance from Edith Davis in October 1944. Premiums were
five cents per day. *Norfolk-Southern Foundation.*

Pvt. Donald Keesling of Roanoke was killed in action in Germany on October 15.
Fred C. Perdue of Hollins was killed in action in France on September 30. Sgt. Dexter
Wohlford of Roanoke was killed in action in Italy. Pvt. George Trimmer of Roanoke
died in England on October 9. Preston Johnson of Roanoke was killed in action in the
Pacific. Sgt. Walter Gibson died from wounds in France on October 8. Clyde Vaughan of
Roanoke was killed in the Pacific. Pfc. Benjamin Hubbard of Vinton was killed in action
in France on June 9.

V. T. Carr and Mrs. Maggie Willis of Floyd County were critically injured when the
truck they were in was struck by an N&W Railway passenger train near the Roanoke-
Montgomery County line on November 6.

In the election held on November 7, Roanoke city voters approved a $2 million bond
issue for the Carvins Cove water project, 7,697 to 1,846. The city vote in the presidential
election was Roosevelt 7,347 and Dewey 5,095; for Congress, Clifton Woodrum received
8,653 to John Strickler's 3,174. The only precincts in the city that Dewey won were
South Roanoke 1 and 2. In Roanoke County, Roosevelt garnered 3,380 votes and Dewey
3,146 votes. For Congress, county voters gave Woodrum 3,973 and Strickler 2,374; thus,
the Democrats swept the Roanoke Valley. Incumbent congressman Woodrum also won
reelection in the Sixth District.

The popular radiocast of the Barn Dance Revue gave a two-night performance at
the Roanoke Auditorium on November 10–11. The cast included Rufe Davis, Charlie
Althoff, Hickory Nuts, and the Campbell Sisters.

George Markley, a pioneer Roanoke businessman, died on November 11 at age sev-
enty-eight. Markley came to Roanoke in 1887 and opened a mercantile business with his
brother. In 1896 he established a plumbing firm under his name and served as treasurer
of St. Mark's Lutheran Church, Roanoke, for fifty-five years.

The Roanoke County School Board announced the acquisition of two postwar building sites. A sixteen-acre tract near Cave Spring was under purchase contract from J. A. Minton, and a Tinker Creek grade school was being planned for property acquired on Hollins Road from the Greenwood family.

The all-male, black chorus Wings over Jordan performed at the Roanoke Auditorium on November 15. The gospel concert also included the Gethsemane Choral Ensemble from Cleveland, Ohio, and Paul Brickenridge, Olive Thompson, Martha Spearman, and Whilette Firmbanks.

The Salem Town Council shelved plans for a municipal airport because the land Salem was interested in obtaining from the Baptist Orphanage would not be reduced in price. Further, the orphanage said it was not interested in leasing the land.

Roanoke City Council member W. M. Powell asked that the city consider a curfew. Powell cited recent arrests of minors for being drunk in public, including a thirteen-year-old girl arrested at 2:00 a.m. The council referred the matter to the city manager.

Elmer Dillon of Mount Pleasant was killed while at work at the N&W Railway on October 14. He was crushed between a derrick and prefabricated car side at the East End Shops.

The 1944–45 season of the Roanoke Civic Theatre officially opened on November 17 with the production of *Guest in the House* at the Academy of Music. Miss Anne Weaver starred as "the guest." Francis Ballard directed the production.

Jack Garst & Son at Boones Mill ran ads in Roanoke papers that read: "To farmers and landowners—prisoners of war from the Salem and Catawba Camps are now available to cut pulpwood. Persons having pulpwood to cut within twenty-five miles of these camps should contact us immediately, contractors for this labor."

Seaman 2nd Class Donald Carr of Roanoke was killed in action in the Pacific. Cpl. Dallas Moody of Vinton was killed at Noemfoor, New Guinea, on October 26. Pvt. Lewis Morris of Roanoke died in Atlanta, Georgia, on November 18. First Lt. Charles Harris of Roanoke was killed in action in Italy in August 1943. He had been reported as missing for over a year.

The Sixth War Loan Campaign was launched in Roanoke in mid-October with a fundraising goal of over $6.6 million. Col. W. J. Jenks, president of the N&W Railway, was the general chairman of the effort.

The Rev. Clyde Forney, pastor of the Central Church of the Brethren, was elected president of the Roanoke Ministers' Conference for 1945. Another matter taken up by the conference at their meeting was opposing the sale of beer and wine on Sundays.

Rev. Sidney Ballentine, retired Lutheran minister, died at his home in Vinton. Ballentine graduated from Roanoke College in 1891 and had served several Lutheran congregations in the Roanoke Valley as an interim during his retirement, including many years at Kittinger Chapel at Back Creek. He was seventy-nine.

Roanoke city manager W. P. Hunter reported back to the city council at their November 20 meeting that it was not the appropriate time to appoint Negroes to the police force due to war emergencies and other conditions. Hunter's report was in response to a petition that had been presented to the council at an earlier meeting advocating for the appointment of black police officers. Mayor Leo Henebry added that council did not have the authority over such matters as the hiring of police officers and that authority was vested with the city manager.

The oldest citizen of Botetourt County died on November 19. Mary Ann Bannister died at age 108 at the home of her son near Buchanan. The mother of ten children was born in 1836 and "retained all of her faculties until the last." Her funeral and burial were conducted at "the Colored Baptist church near Indian Rock."

The world-famous magician Blackstone performed for three nights at the Academy of Music November 25–28. His show had a bunny matinee for children featuring live rabbits and was billed as "the show of 1001 wonders," including his famous Hindu rope trick.

Mrs. Eileen Evans of Loudon Avenue, Roanoke, made a new effort to challenge the Virginia poll tax by filing suit against the state in US District Court in Roanoke. Evans alleged she had been denied her Constitutional right to vote when she sought to cast a ballot at her Melrose precinct in refusing to pay the tax. Representing Evans was Moss Plunkett.

The Virginia Supreme Court accepted the retirement of Judge Beverly Berkeley from the Roanoke City Law and Chancery Court. The judge's term did not end until 1951, but the judge asked that his retirement be accepted due to ill health.

The 1944 All City-County Football Team included the following players: Frank Shelor, end, Andrew Lewis; Richard Poole, end, William Byrd; George Manuel, tackle, William Fleming; Stuart Barbour, tackle, Jefferson; Wayne Gray, guard, Byrd; Bill Bynum, guard, Jefferson; Alvin Thomas, center, Jefferson; Clay Blankenship, back, Jefferson; Guy Spruhan Jr., back, Lewis; Richard Callison, back, Fleming; and Keith Bohon, back, Jefferson. The team was selected by a committee of coaches. Players from Carver and Addison high schools could not qualify due to being black schools.

The Roanoke Viscose plant secured a second army contract for the assembling of more than a million fuse boosters. The average daily production would be eight thousand by the end of the year, plant officials stated. The contract would extend for the duration of the war, and Viscose had employed twenty women to work on the assembly line for the project.

The Heller Kindergarten at the Hunton Branch YMCA is celebrating Thanksgiving in this 1940s photograph. *Virginia Room, Roanoke Public Libraries.*

A fire threatened the Cavalier Hotel at 106 East Salem Avenue in Roanoke on November 29. The fire began in the basement, and by the time firefighters arrived, flames had reached to the top floor of the four-story brick building. No one was injured.

The Thanksgiving Day football game at Victory Stadium was played between the University of Maryland and VMI. The cadets lost 8–6 to Maryland.

Cpl. Earl Rucker of Roanoke was killed in action in New Guinea on November 8. Staff Sgt. Lawrence Furrow of Bent Mountain died from wounds in Germany on November 10. Pfc. William Watson of Roanoke was killed in action on November 12 in France. Pfc. William Myers Sr. of Salem was killed in action in Italy on October 23. Pvt. Oscar Robertson of Roanoke was killed in action in France on November 16. Pvt. James Arnold of Roanoke was killed in action in France on November 18. William Topham, USNR, of Roanoke was killed in action in the Pacific on November 24, 1943, having been reported as missing in action for a year. Pvt. Russell Smith of Roanoke was killed in action in France on November 18. Cpl. Frederick Nover of Roanoke was killed in action in Germany on November 22. Pvt. John Eanes of Roanoke was killed in action in France on November 11. Pvt. Sammie Kidd of Roanoke was killed in action on October 8 in Germany.

Phillip Moore, forty-five, was killed by a blow to the head in a fight at a restaurant on Ninth Street, SE, in Roanoke. Upon investigation, city police served arrest warrants on two soldier brothers who were in Roanoke on leave. Private Roy Holdren, eighteen, was charged with murder, as was Private Ernest Holdren, nineteen.

Roanoke's city manager presented a proposed 1945 budget to the city council. The budget totaled $3,015,788 and was the first time in the city's history a budget had been in excess of $3 million. The budget included an increase of $5 per month in wages for city employees.

Rose Page Welch, mezzo-soprano of Chicago, performed at the Academy of Music on December 5. Her appearance was sponsored by the Ninth Avenue Christian Church, Roanoke.

Members of the Roanoke Women's Army Corps recruiting staff made a home in Center Hill into "barracks" as they were housed in the home of Col. John Goodwin, who was stationed in Washington, DC.

L. B. Hodges, fifty-five, was shot and killed at the O'Henry tourist camp on Route 11 in Roanoke County on December 8. Henry Stanley, proprietor of the motel, confessed to the crime, stating that the shooting followed an argument wherein Stanley had accused Hodges of stealing his wallet. Hodges was married and had eight children. Two days later, Stanley committed suicide in the county jail.

WDBJ Radio filed an application in early December with the Federal Communications Commission to construct a ten-thousand-watt FM broadcasting tower to be located on Bull Run Knob in the Bent Mountain section just beyond Air Point.

Members of the Vinton Recreation Commission asked permission of the Roanoke County School Board to construct a swimming pool on the grounds of William Byrd High School. The request was recommended for further study.

West End Methodist Church celebrated its thirty-fifth anniversary on December 10. Present for the occasion were Rev. Harry Wheeler, former pastor, and Bishop W. W. Peele of Richmond. The church was organized in 1909 and conducted its first services over a

store on Twelfth Street near Patterson Avenue. A chapel on Thirteenth Street was erected in 1923 and dedicated in 1936.

Pfc. Barker Webber of Roanoke was killed in action in France on November 12. First Lt. Henry Brightwell of Roanoke died from wounds he received in Germany on November 21. Lt. J. S. Gordon of Roanoke was killed in action on November 12. Pvt. Junior Rogers of Roanoke was killed in action in France on November 29. Pvt. Lewis Elgin of Roanoke was killed in action in India on November 25.

Blair Gearhart, thirty-one, died from stab wounds he received in a fight at a local café on December 9. Arrested for his murder was a taxi driver, O. A. Huffman, twenty-seven.

The body of Walter Kingery, sixty-one, of Boones Mill was found alongside Route 220 at Back Creek in Roanoke County on December 10. Sheriff's deputies at first thought Kingery had been struck by an automobile, but the county medical examiner said the injuries were consistent with being struck violently over the head with a heavy instrument. Robbery did not appear to be a motive as Kingery had money in his pockets.

The Hercules Powder Company announced a change in company policy permitting the hiring of blacks for the production of ammunition. Company officials stated they planned to recruit some 2,500 black workers from the Roanoke region for their New River ordnance plant.

Robert Dunahoe Jr. resigned as manager of Woodrum Field in order to accept a position in the airport division of the Civil Aeronautics Administration. City officials indicated Donahoe would remain at Woodrum Field through January.

Smiley Burnette, Gene Autrey's sidekick, appeared at the Roanoke Auditorium for two shows on December 15. The performance featured eight acts, all with a western theme, including Calico Kitty and the Tom Cats.

Hilltop, Inc., a nonprofit organization that will sponsor and operate a home for elderly ladies in Roanoke, was organized in mid-December. Mrs. R. W. Cutshall was president, and James Turner was vice president. According to the articles of incorporation, Hilltop would be a residence for white women over age sixty.

A recreation hall was constructed at the Catawba prisoner-of-war camp for the guards and officers stationed there. The hall was forty-four by twenty feet, with a fireplace made of Catawba stone. The hall served as a daytime lounge and was dedicated with the assistance of the Roanoke USO.

Staff Sgt. Robert Patsel of Roanoke was killed in action in Germany on November 21. Pvt. Claude Jennings of Hollins was killed in action in France on November 8. Pfc. Adolphus Stone of Roanoke was killed in action on November 26 in France. Capt. John O'Hearn Jr. of Roanoke County was killed in Germany on November 28.

Famous pianist Alec Templeton gave a concert at the Academy of Music on December 19. Templeton had a weekly radio program broadcast nationally by CBS on Sunday nights.

The J-610 steam engine of the N&W Railway was being used by the Pennsylvania Railroad on their Chicago-Crestline run, pulling such streamliners of that railroad as the Trail Blazed, The Admiral, Liberty, Manhattan, and Broadway Limited. The Pennsylvania Railroad had requested to borrow a J-Class engine for trials. Though it never ran at top speed on N&W lines, the J-610 had reached speeds of between 110 and 113 miles per hour with the Pennsylvania Railroad.

The navy announced that it would not renew its contract with the Penn-Central Airlines for the naval air cadet training program in operation at Woodrum Field. Thus,

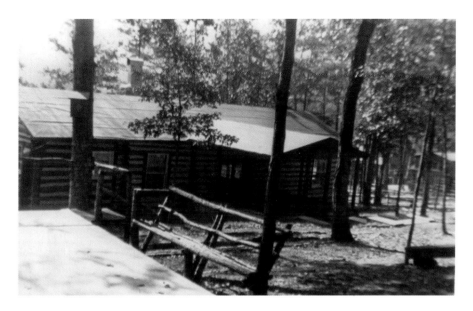

This 1944 image shows the recreation hall that was constructed by the prisoners at the German POW camp in Catawba for the guards and officers. *Salem Historical Society.*

Penn-Central officials stated that their training program would conclude on or before January 18, 1945. The school had been at the Roanoke airfield for over two years and was developed by Penn-Central when the navy initiated the Naval Air Transport Service.

Jerusalem Baptist Church held a note-burning service on December 15 as the congregation had paid off its mortgage.

Roanoke native and Hollywood film actor John Payne announced on December 17 his engagement to actress Gloria DeHaven. Payne had divorced Ann Shirley in 1943 and had been honorably discharged from the army after two years of service.

The Roanoke City Council denied a request for a leave of absence for airport manager Robert Dunahoe, who had sought to replace his resignation with a leave request. The council denied the request in that it would have violated city personnel policy as leaves were only granted to employees for military duty, not civil service. The council did express appreciation for Dunahoe and stated that he would be welcomed back to his old job if the position was open.

The Roanoke School Board at its meeting on December 18 went on record opposing receiving federal funds to subsidize lunches for those unable to purchase them. Leroy Smith, board chairman, spoke for the board in questioning the report of school principals that there were 375 indigent children in the system, adding that jobs were plentiful for those parents able and willing to work.

The twenty members of the crippled children's school at West End School were treated to a Christmas party at the Hotel Patrick Henry by the Roanoke Junior Woman's Club on December 19.

Rev. Lanneau White of St. Paul Methodist Church declared in a sermon broadcast over WDBJ, "I refuse to segregate any person in my church and I will gladly go to jail for

breaking the separation law." White's sermon was part of the station's weekly *Back Home Devotional Hour*, in which local clergy were asked to participate. "The colored man loves America, but he hates and despises the laws which give him an inferior status as a citizen. The law of segregation as practically applied is a perpetual insult to colored Americans and an abomination to the Lord." White was in his fifth year at St. Paul's. Two weeks after the broadcast, the station manager asked him to "go a little easy on controversial subjects."

William Bynum, a guard on the Jefferson High School football team, was named to the Virginia all-state Class A football team.

Pfc. Ray Snyder of Roanoke was killed in action in France on December 4. Pvt. A. L. Manning of Bent Mountain was killed in action in Germany on December 1. Pfc. Ralph Jones of Roanoke was killed in action in Germany on November 19. Sgt. Joseph Baxter Jr. of Roanoke was killed in action in Germany on November 22. Pfc. Joe St. Clair of Vinton was killed in action over Holland on October 22. Pvt. Gray Shanks of Roanoke was killed in action in France on November 16.

The Bing Social Club sponsored a blacks-only dance at the Roanoke Auditorium on December 26 featuring Mandy Ross and his "Walkin' Rhythm" Orchestra. White spectators were admitted.

Sidney Patsel, twenty-five, of Hollins was struck and killed by a car on US 11 near Hollins College on Christmas Day. Patsel, a soldier, had recently returned from duty overseas. No charges were brought against the driver, Emmett Jones, as a witness stated that Patsel had stepped in front of the car with no chance for the driver to avert the collision.

Plans for a third radio station in Roanoke were announced in late December by William Barnes of Martinsville. The SCC had granted a charter for the radio station, and FCC approval was pending. Roanokers involved with the proposed station as officers of the corporation included Randolph Whittle, John Cunningham Jr., L. J. Boxley, and H. L. Lawson Jr. The radio station would be affiliated with NBC. The two other radio stations, WDBJ and WSLS were affiliated with CBS and the Blue Network respectively.

The Roanoke City Council instructed the city manager to take all means necessary to prevent Roanoke citizens from suffering during the coal shortage, including taking coal from the basement of the municipal building and delivering it to needy citizens by truck. Police were asked to follow up on requests for coal and determine if the need was legitimate, which meant that a resident was sick, or there were children in the home, or the resident was aged.

Mrs. Laura Horton, sixty-two, of Salem was critically injured when she fell beneath the wheels of a Roanoke streetcar on December 30 in front of the *Roanoke Times-World News* building. Horton's hands became crushed, necessitating the amputation of several fingers on each hand. She also suffered a brain contusion, broken ribs, a fractured arm, and knee injuries.

The First National Exchange Bank provided its statement of position ending December 31. It had $58.8 million in assets. Colonial-American National Bank reported assets of $13.9 million. Mountain Trust Bank reported assets of $15.1 million, and Liberty Trust Bank reported $3.8 million.

A drive to recruit civil air cadets was announced by Capt. Wes Hillman, commanding officer of the Roanoke chapter of the Civil Air Patrol. Hillman said he wanted to make

Roanoke city and county youth "air-minded" as part of the ground school and flight training. There were 120 such students in 1944.

Officials of Roanoke City Mills, Inc., let a contract for the rebuilding of a new feed plant to replace the one destroyed by fire. The contractor was Jones-Hettelsater Construction Company in Kansas City, Missouri. J. W. Ring, mill president, said construction would begin in early January. The new plant would have the largest output of prepared feed of any plant south of the Ohio River.

1945

The first baby born in Roanoke for the new year was a daughter of Mr. and Mrs. Murray Midkiff of Endicott. The girl was born at 1:00 a.m. at Lewis-Gale Hospital.

Mrs. Laura Horton of Salem, who had fallen under a streetcar in Roanoke a few days earlier, died from her injuries at a local hospital. She was sixty-two.

The largest receipts at the Roanoke post office ever recorded in its history were reported for 1944 by Mrs. Virginia Wright, postmistress. Wright attributed the record volume to the mail going to servicemen. Total postal sales for Roanoke were $793,602.

Two cars of emergency coal arrived in Roanoke on January 2, with more anticipated as the severe coal shortage deepened in Roanoke. The city registrar was tasked with receiving requests from needy residents soliciting fuel.

Second Lt. Carlisle Craig of Roanoke was reported as killed in action on December 18, 1943, in the North Atlantic. He had previously been reported as missing. Pvt. Roy Arthur of Roanoke was declared dead, having been missing in action in Italy since December 22, 1943. Pfc. Joseph Stanley Jr. of Roanoke was killed in action in Germany on December 9. Pfc. Earl Baldwin of Vinton was killed in action in Germany on December 23. Pfc. Lewis Woodson of Roanoke was killed in action in Luxembourg on December 18.

The Roanoke City Council approved $5,000 for lunches for indigent school children and rebuked the school board for failing to take advantage of federal funds for that purpose. The council urged the board to try the federal lunch program in a few schools to see how it worked.

Roanoke city successfully sold $1,585,000 in water system improvement bonds at a rate of 1.32 percent, the lowest in the city's history of bond sales. This was another step in the city's process of developing Carvins Cove reservoir.

Cora Bell Cole, thirty-four, was reported to have been slashed to death in her kitchen at 808 Fairfax Avenue in Roanoke. The mother of five was believed to have been assaulted by James Petty, according to police officials.

The Harder Reed Bus Service announced its schedule for 1945. The service operated a regular bus between Roanoke and Dublin for "the transportation of white employees" to and from the Hercules New River ordnance plant. The plant had begun hiring blacks in 1944, but the bus service would not accommodate them.

The General Platoff Don Cossack Chorus performed at the Academy of Music on January 6. The musical bill of fare included Greek Orthodox liturgical music, folk melodies, Cossack songs, Red Army songs, and operatic music.

The Morris Plan Bank released its financial position as of December 31, 1944, reporting assets of $43.2 million. First Federal Savings and Loan reported assets for the same period of $3 million.

Bob Bowen and T. Caldwell announced the opening of their Roanoke Farm Supply Center at 29 Church Avenue, SE, Roanoke in early January.

A delegation of doctors appeared at the Roanoke City Council meeting on January 8 stating that they expected the city to pay for the care of indigent clinical and bed patients in the future. At the time, the city was paying a daily rate of $3.50 per patient for hospitalization plus costs for drugs, X-rays, and heat treatments. Under the plan submitted by the doctors, they would no longer perform treatment and surgery without a fee. Speaking for the delegation was Dr. Charles Irvin, who intimated that the doctors' appearance was precipitated by the council's recent action of increasing the professional license fee levied upon the medical profession and others.

L. C. Hodge, state forester, met with Salem officials to discuss establishment of a town forest on the Mowles farm, just south of Mount Regis, which was owned by the town. The town council authorized the reforestation of 30 acres on the farm primarily to protect the watershed of Mowles Spring that furnished water supply to south Salem. The entire farm was approximately 287 acres.

The Roanoke City Council granted permission for Hilltop, Inc., to erect a home for older ladies on a tract of land in Fishburn Park. The home would be built when materials became available after the war, according to a letter from Hilltop officials.

Marshall Harris, a thirty-three-year-old aviation instructor, was appointed manager of Woodrum Field on January 8 by the city manager. Harris assumed responsibilities on January 16, taking over from Robert Donahue, who had taken a job in Washington, DC. Harris was a graduate of Roanoke College and was an instructor in the naval training program there. He was also employed with the Garner Aviation Service.

Betty Compson, a well-known Hollywood actress, came to Roanoke for a week to promote a cosmetic line. Compson was affiliated with Republic studios and began making films in 1915, retiring from acting in 1944. She had also performed numerous times on Broadway.

Odell H. Dooley, seventy-three, of Salem died in a local hospital on January 9. Dooley was the proprietor of Dooley Printing, which he established in 1923 on College Avenue.

Roanoke dentists joined with physicians in alerting the Roanoke City Council that they would no longer treat indigent patients without a fee. The dentists delivered their concerns in a letter and indicated it was a response to the council's increase in professional license fees.

Sgt. Russell Holt of Callaway was killed in action in France on December 17. Pvt. W. W. Spencer of Roanoke was killed in action in Germany on December 18. Sgt. Earl Smith of Vinton was killed in action in Leyte on November 30.

An auction was held on January 16 for all the furnishings and equipment of the Colonial Club, 602 Day Avenue, SW. The owner of the building also put the home up for auction as well. The sale was handled by Sheets & Greenway Auctioneers. The home did not sell on the day of auction due to the bids being too low.

Pvts. Roy Holdren, eighteen, and Ernest Holdren, nineteen, brothers from Bedford County, were found guilty by a jury in Hustings court of voluntary manslaughter in the death of Philip Moore, forty-five, of Roanoke. They were each sentenced to five years in prison, the maximum sentence allowed.

The Vinton Theater Corporation was granted a charter by the SCC in mid-January. Those involved with the corporation planned to erect a movie house in Vinton following the war.

The development of Mill Mountain into a war memorial gained ground when an architectural rendering of the proposed war memorial monument appeared in the January 14 edition of the *Roanoke Times*. The memorial was one of several under consideration by the city's War Memorial Committee. The Mill Mountain memorial was a tower of Catawba stone with a light radiating from the top. The foundation of the tower would consist of two to three floors, one of which would contain the names of those killed in service, while another floor would hold "all the trophies, relics or souvenirs" from the war as well as a Virginia Room displaying through photographs and exhibits the notable places of the state. The name "Memorial Park" would be erected in neon letters on the rim of the Mill Mountain overlook, which could be seen from miles around. The grounds would have gardens, a fern house, a bird sanctuary, a clubhouse, and an amphitheater. This particular memorial was being advocated by the Roanoke Woman's Club.

Capt. William McCauley, formerly of Roanoke, died from wounds in Germany on December 30. Sgt. Cecil Rhodes of Salem was killed in action in Germany on December 7.

Andrew Bryant, forty-four, was struck and killed by a hit-and-run driver on Franklin Road on January 14. Bryant and his wife were walking near the Franklin Heights Apartments on the way to church. J. F. Cawley of Roanoke was eventually arrested by Roanoke police and charged with manslaughter and drunk driving. Cawley's car had jumped a curb and struck a tree about a half mile from where Bryant was killed.

Andre Falwell of Roanoke was killed in action in Luxembourg on December 25. Pfc. Clinton Menefee, formerly of Vinton, was killed in action in France on December 10.

The J-610 steam locomotive of the N&W Railway returned to Roanoke January 17, having been loaned to the Pennsylvania Railroad for trial runs between Chicago and Pittsburgh.

Clearing of brush and debris, which permitted impounding of water in the Carvins Cove dam, was completed on January 18. German POWs and local labor were used for the clearing process.

Editors at *Reader's Digest* announced that a forthcoming issue would contain an article about the Roanoke Life Saving and First Aid Crew authored by James Kilpatrick of Richmond and Charles Hamilton. The life-saving crew was a first in the nation and had been a model for other communities nationwide.

"Three Squares A Day" was the title of an article detailing the cafeteria of the Roanoke Viscose Plant in the January edition of the *American Restaurant Magazine*. The article described the cafeteria layout and its history, noting that the Viscose's cafeteria opened on July 28, 1917, when it first served seven Viscose officials and within a week was serving some two hundred employees. Between 1924 and 1929 some 3,000 meals were served daily. In 1944, the number had dropped to 2,000. That number was broken down to 1,000 noon meals, 450 evening, and 400 at midnight. The seating capacity of the main cafeteria was 625. A cafeteria for black workers was separate, serving 150 meals per day.

With the treatment of infantile paralysis being a major concern in Roanoke, a greater emphasis was placed on the local March of Dimes campaign. The local campaign's goal was set at $10,000. The campaign netted $3,500 in 1944.

Julian S. Wise was the founder of the Roanoke Life Saving and First Aid Crew. Here he makes a presentation to a civic group in 1948. *Norfolk-Southern Foundation.*

The Roanoke City Council gave final approval to its 1945 operating budget on a three-to-two vote. The dissenting votes were based on opposition to certain raises of ten dollars per month being granted city employees.

The Roanoke Academy of Medicine delivered a report to Roanoke city officials of their review of the local health department. The academy recommended the hiring of six additional nurses, two more sanitary inspectors, and a specialist at the tuberculosis sanatorium, and the development of prenatal clinics.

John Riddick, principal of Jefferson High School, announced his resignation effective at the end of June. Riddick had accepted the position of president of the Blackstone College for Girls in Blackstone, Virginia.

Oval Huffman, ex-soldier and taxi driver, was found guilty in Hustings Court of second-degree murder in the death of Blair Gearheart last December. He was sentenced to twenty years' imprisonment.

Stuart Saunders, president of the local Rotary Club, spoke before the Roanoke Chamber of Commerce on January 23 and advocated for better recreational facilities in

the city and use of its natural resources. "Our most serious sin has been neglect to use our recreational resources. Not only have we done little or nothing with such natural assets as Mill Mountain and the Roanoke River, but we have been singularly remiss in giving recreational value to our parks and other facilities." In another address before the Chamber, Lt. Col. Clem Johnston advocated for the elimination of the Roanoke River as a place for the disposal of raw sewage.

Roy Acuff and his Smoky Mountain Boys performed at the Roanoke Auditorium on January 25 along with others from the *Grand Ole Opry*, including Pap and his Jug Band, Sonny Day, and Ford Rush.

The southwest corner of Church Avenue and Henry Street was purchased by the Morris Plan Bank of Virginia as an initial step to erecting a modern bank building after the war.

The cafeteria committee appointed by the Roanoke School Board was given permission to further investigate having the federal free lunch program at Lucy Addison High School on an experimental basis. The board advocated the program, but it had been met with skepticism by members of the Roanoke City Council.

Five iron lungs were returned to their owners by the Roanoke Hospital in late January. The lungs had been obtained to deal with the infantile paralysis epidemic. The lungs had been borrowed from medical facilities in Covington, Lexington, Hot Springs, and the C&O Hospital at Clifton Forge.

Appalachian Electric Power Company began advertising in late January information pertaining to the prohibition of electrical outdoor advertising and display lighting effective February 1. The ban was due to a federal regulation in the wake of a nationwide coal shortage.

Staff Sgt. Andrew Johnson Jr. of Roanoke was killed in action in France on December 10. First Lt. Hilary Hedrick was killed in action over Germany in March 1943. He had previously been reported as missing. Lt. Cary Gray of Roanoke was killed in action in France on June 17.

The initial copy of a newsmagazine published by the Viscose Company for its employees was published in January. The *Crown Rayon News* had previously been in a newspaper format, but company officials went to a slick, monthly magazine layout that was printed in New York City.

The Bing Social Club sponsored an all-black dance at the Roanoke Auditorium on January 30 that featured music by Hot Lips Page and his orchestra.

Marshall Harris, new manager of Woodrum Field, informed the Roanoke City Council that the number of planes refueling at the airport had increased sixfold and he did not have the manpower to service the planes. Harris had been hiring high school boys to handle the fueling operations, but they could only work after school.

Staff Sgt. Harold Pillow of Roanoke was killed in action in Belgium on January 14. Sgt. James Millikin of Roanoke was killed in action in the Philippines on June 3, 1942. He had been reported as missing. First Lt. George Harris formerly of Roanoke was killed in action over Europe on December 12. Carlton Chapman of Salem was killed in action in Europe. Sgt. Daniel Montague of Roanoke was killed in action in Belgium on December 10.

Robert House, former principal of Andrew Lewis High School from 1929 to 1935, died at his home in Kingsport, Tennessee, on January 30. He was also a past president of the Virginia Education Association.

Dean Hudson and his Spotlight Orchestra performed on the stage of the Lee Theatre on February 4. Special vocalists included Frances Colwell and Ralph Hill.

Thomas Jenrette, Roanoke City recreation director, advocated for the development of a recreation area on the top of Mill Mountain following the war. Jenrette stated in a talk before the Roanoke Woman's Club that a recreation area would complement the club's proposed war memorial for Mill Mountain. Jenrette suggested a stone observation tower, an outdoor auditorium, and renovating or replacing the old hotel building (Rockledge Inn) as part of the plan.

The Roanoke School Board purchased an additional four acres of land in the northwest section of Roanoke for the site of the proposed Northwest Junior High School. The property purchased from the W. K. Andrews estate was situated north of Carroll Avenue between Nineteenth and Twentieth Streets and was adjacent to five acres of land fronting Carroll Avenue that had been previously purchased by the school board in 1937.

Pvt. Robert Thomas of Roanoke was sent home after serving nearly sixteen months in the army. A captain located Thomas near the front lines in Germany and sent him home after it was discovered he enlisted when he was fifteen but claimed to be eighteen.

Congressman Clifton Woodrum of Roanoke announced on February 5 that he would be a candidate for the US Senate if the incumbent Carter Glass chose not to run

Lt. E. H. St. Clair is shown in the cockpit of his fighter plane, *The Roanoke Magician*, in England in 1945. He flew over thirty combat missions. *Norfolk-Southern Foundation.*

for reelection. Woodrum had served in Congress for twenty-three years and had earlier declined to run for governor.

N&W Railway locomotive No. 134, a K-2, emerged from the Roanoke Shops on February 5 with a new look for that particular line of locomotives. No. 134 was the first of its class to have a new hood over the boiler with blue-black, Tuscan red, and gold paint, similar to the J-Class locomotives. According to railway officials, the new look for the K-2 and K-2-A mountain-type passenger engines was to make them more visually appealing for modern standards.

Pvt. Elwood Etter of Hollins was killed in action in France on January 8. Sgt. James Saunders of Roanoke was killed in action in Germany on January 20. Pvt. Paul Crowder of Roanoke was killed in action in France in November. Pvt. Ernest Bowyer of Vinton was killed in action in France on November 29. Pvt. William Brattan of Roanoke was killed in action in Luxembourg on January 19. Pfc. Edward Prillaman of Roanoke was killed in action in the Pacific on January 12. Pvt. Linwood Hall of Roanoke was killed in action in France on January 25.

Wrestling promoter Scotty Dawkins inspected the wrestling ring of the Roanoke Auditorium to make certain it was substantive enough to hold a 625-pound wrestler from New York known as "Blimp" Levy. Levy was in the headline bout on February 8 against Bill Dusin.

The Army Ferry Command discontinued its use of Woodrum Field as a refueling stop. The loss of the army's activity meant a $3,000-per-month drop in airport revenue. Further, the CAA notified city officials that the airport tower would have to be discontinued if the city did not take over the costs of its operation.

Roanoke's Gilbert and Sullivan Opera Company production of Victor Herbert's *Red Mill* was staged at the Academy of Music in mid-February for two nights. In addition to the fourteen-member cast, the production also had a chorus and orchestra. The production was directed by Francis Ballard.

On February 14, the stage revue *Gags and Glamour* performed at the Roanoke Theatre. The show featured "blackface comic Bob Padgett" and magazine models "The Glamourettes."

A wrestling match between "Blimp" Levy and "The Angel" was held at the Roanoke Auditorium on February 13. Levy had just wrestled several nights ago at the auditorium. The Angel was billed as the ugliest man in wrestling. The match was promoted by Scotty Dawkins.

J. B. Ragland, eighty-three, died on February 12 in a local hospital. Ragland was a Roanoke pioneer who established a cigar manufacturing operation in Roanoke in 1881, a business he maintained for over six decades.

Roanoke attorney Moss Plunkett continued his legal efforts to abolish the poll tax. Plunkett had filed a federal suit challenging the election of over seventy congressmen, including Clifton Woodrum. Punkett asserted that any jurisdiction that required a poll tax was thwarting voters unconstitutionally. Plunkett sought to depose a number of members of the US House of Representatives, and in mid-February he requested depositions from four United States Senators: Harry Byrd (Virginia), Tom Connally (Texas), Kenneth McKellar (Tennessee), and Theodore Bilbo (Mississippi). The depositions were to be taken in Washington, DC; however, all four senators refused to comply with the request to

be deposed. Almost all poll taxes were levied in Southern states, and Plunkett believed it was used to discourage blacks and the poor from voting. Plunkett was representing Mrs. Eileen Evans of Roanoke in a suit against the election judges of the Melrose Precinct, Roanoke, for denying her a vote due to an unpaid poll tax. Plunkett was also president of Southern Electoral Reform League, a national lobbying group dedicated to the elimination of the poll tax.

Pfc. Richard Dillon of Roanoke was killed in action in France on January 25. Pfc. Richard Bow of Salem was killed in action in Europe. Pvt. Newton Mullens of Salem died from wounds he sustained at sea. Pvt. William Saul of Roanoke was killed in action in France on September 6. Pfc. Earl Downs of Roanoke died from wounds received in the Philippines on February 9. Sgt. Elmer Gumm of Roanoke was killed in action in Belgium on December 21.

Rep. Clifton Woodrum informed city officials that Woodrum Field would continue to be used by the Army Ferry Command as a refueling stop for at least five more months.

Charles Houston, chief counsel for the Association of Colored Railway Trainmen and Locomotive Firemen, who had successfully argued the Tom Tunstall case before the US Supreme Court, spoke to a mass meeting at St. Paul's Methodist Church in early February.

The N&W Railway reported record increases in passenger and freight traffic during 1944 as compared to 1939, the year prior to the European conflict. Railway officials stated that the railroad carried 48 percent more freight in 1944 compared to 1939 and 390 percent more passengers. In 1944, the N&W passenger count was 5,135,000.

For Valentine's Day, there was a square-and-round dance and beauty contest at the Blue Ridge Hall, 323 W. Campbell Avenue, with music provided by the Coon Hunters. There was also a Valentine's square dance at Victory Hall, 318 Commerce Street, NW, with music by Bill Argabright and his entertainers.

Southern Congressmen were advised it was their "right and duty" to ignore the request of Moss Plunkett to depose them. The advice was contained in a letter sent by the chairman of the US House Judiciary Committee, a Congressman Sumners of Texas.

Herndon Slicer, pianist, along with Dexter Mills, Gere Rose, and Francis Robinson, gave a midnight stage show at the Lee Theatre on February 17.

Billed as America's No. 1 all-female orchestra, the Darlings of Rhythm featuring jazz vocalist Helen Taborn, performed at the Roanoke Auditorium for a blacks-only dance on February 19.

The Angel wrestled Texan Jack O'Brien at the Roanoke Auditorium on February 22. The Angel from New York had defeated the Blimp in a recent match in Roanoke.

James Petty, thirty-four, pled guilty in Hustings Court to the murder of Cora Belle Cole, thirty-four. Petty killed Cole in a knife attack in her home on Fairfax Avenue, Roanoke, on January 3.

The Hotel Roanoke had a unique guest for the winter: Harold Birnie of New Rochelle, New York. Birnie became a footnote in history by being the first person in the United States to obtain a driver's license, which was issued to him on May 15, 1900. Because automobiles were so new, Birnie was not issued a license to operate a vehicle but a "steam boiler." The 1900 license was good for one year and could be revoked for insobriety. According to Birnie, he had never received a ticket in his forty-five years of driving.

The number of servicemen and women who visited the USO lounges at the N&W Railway passenger station and the black USO lounge on Randolph Street totaled 117,464 during 1944, according to the Traveler's Aid Society, which helped oversee the lounges.

The National Symphony Orchestra from Washington, DC, performed at the Academy of Music on February 23. The symphony was conducted by Dr. Hans Kindler. The appearance of the National Symphony was part of the 1944–45 season sponsored by the Community Concert Association. A midafternoon concert was attended by over one thousand school children from Roanoke prior to the evening concert.

Technician James Gibbs of Roanoke was killed in action in Germany on February 8. Pfc. Curtis Sowers of Roanoke County was killed in action in Germany on December 19. Staff Sgt. William White of Roanoke was killed in action in France on January 22. Staff Sgt. Robert Bowers of Roanoke was killed in action over Europe in February 1944. He had been initially reported as missing in action.

A booklet was mailed to those associated with the Civic Theatre subscription announcing the formation of a new and larger local theatrical group. The booklet was the work of Nelson Bond, a professional writer, and Kay Lee, a radio writer. The booklet invited recipients to an open house at the Academy of Music to receive information. Bond and Lee stated that the Civic Theatre was to be "junked" to make way for a new group to be known as the Academy Guild.

A local chapter of the National Association of Evangelicals was formed in late February by several ministers and lay persons who had attended a conference at Ghent Brethren Church, Roanoke. The Rev. C. E. Winslow of First Church of the Nazarene was elected as president of the Roanoke Association of Evangelicals.

A soup cooker blew up at the S&W Cafeteria on February 23, shattering two plate-glass windows along Jefferson Street in Roanoke. Some three hundred persons were in the cafeteria at the time of the incident, but no one was seriously injured.

Residents of the Masons Creek section of Catawba complained that German prisoners of war were not being supervised by armed guards, prompting a complaint to the federal government. Residents near the prison camp complained that prisoners were allowed to work without armed escorts, and the same residents said they feared for the safety of their families. Those that worked directly with the prisoners, however, said they never felt threatened and confirmed that they did not carry firearms when transporting or supervising the prisoners.

The Luck property at the corner of Church Avenue and Third Street, SW, was purchased by the Boyle-Swecker Tire Company. The purchase price was $73,000. The property was purchased in anticipation of postwar expansion.

A committee was formed to explore payments to hospitals for the care of indigent patients referred by the Roanoke Department of Public Welfare. That department had recommended that a fee of $6,000 per year be given to the Roanoke Hospital and $1,000 per year to Burrell Memorial Hospital. The city council took the recommendation under advisement and referred it to the city manager for a later response.

Fred Obenchain of Roanoke County drowned at sea on February 20 while serving in the military.

Ernest Light, secretary-treasurer of Brotherhood Mercantile, purchased all the stock of the Airheart-Kirk Clothing Company in late February and became president of that company on February 28.

Frank Stone and John Thompson, Roanoke architects, were awarded the contract for the design of the new junior high school to be constructed in northwest Roanoke. It was estimated the project would cost around $300,000 by school board officials.

Capt. Roy Kerr, former director of the Civic Theater of Roanoke, was killed in a plane crash in England on February 6. His stage name was Michael Stuart.

The N&W Male Chorus, under the direction of Troy Gorum, gave a concert at the Academy of Music on March 1. The chorus was organized in 1936.

Jerry Tolley, age four, was killed instantly when struck by a tractor trailer in front of his home on Shenandoah Avenue on March 2. According to police, the child was playing with others when he darted in front of the truck.

Andrew Lewis High School defeated Jefferson High School 45–30 to win the western division basketball title. Dave Miller and Guy Spruhan were leading scorers for Lewis.

The Third Annual Hippodrome Thrill Circus sponsored by the junior chamber of commerce came to the Roanoke Auditorium for a weeklong run in early February. The eighteen-act circus featured The Great Gregoresko ("the man who hangs himself and lives"), Will Hill and his performing elephants, the Henderson Trio jugglers, Silvers Johnson, Herdink Troupe, the Fraziers, clowns, and Torielle with his liberty horses.

The Young Men's Shop, a new clothier, opened at 7 West Campbell Avenue, carrying the following labels: Marlboro, Reis, Varsity, Botany, Cheney, Stetson hats, and Swank jewelry.

William Fleming High School defeated Christiansburg 33–31 in the Class B basketball tournament finals on March 3.

E. B. Broadwater, a dean at Roanoke College and former principal of Andrew Lewis High School in Salem, was named as the new principal for Jefferson High School by the Roanoke School Board. Broadwater's appointment took effect July 1 for the 1945–46 academic year.

V. T. Carter Grocery on Montrose Avenue, SE, was awarded a twenty-five-dollar war bond for one of the best war-bond display windows in Virginia during the sixth war loan campaign.

The regular meeting of the Roanoke branch of the NAACP met and reported that a fifty-dollar donation had been made to the Wendell Willkie Memorial Building Fund and to the Virginia Electoral Reform League. Members were also encouraged to vote against having a limited constitutional convention in the state.

The Roanoke City Council approved the proposed annual appropriations to Roanoke and Burrell hospitals for indigent patient care in the amounts of $5,000 and $1,000 respectively.

Wasena residents appeared before the Roanoke City Council in opposition to the proposed rezoning of lots across the street from the Roanoke Ice and Cold Storage plant. The cold storage owners were seeking an expansion for a garage to house their vehicles.

In light turnout on March 6, Roanoke city voters rejected the question of a proposed limited constitutional convention for Virginia by a count of 793 to 419. In Roanoke County the margin was much closer, with 452 against to 416 in favor. The constitutional convention centered upon removing constitutional provisions for personal registration and poll tax payments for military service personnel. Statewide, Virginians favored the convention by a three-to-two margin.

Andrew Lewis High School's varsity boys' basketball team lost in their bid to continue advancing in the state Class A tournament when they were defeated at home by George Washington High School, Alexandria, by a score of 35–30.

A Roanoke woman and her family were liberated from a Japanese war camp in the Philippines in February. According to military reports, Rev. and Mrs. Henry Bucher and their four children, Anna, Henry, Priscilla, and George, were liberated by American troops. The Buchers were stationed on Hinan Island off China as Presbyterian missionaries. They were in Manila in 1941 at the time of the Japanese invasion of that country.

Pfc. Garland Jennings of Roanoke was killed in action in Germany on February 23. First Lt. Benjamin Mills of Roanoke was killed in action in Germany on February 24. First Lt. Philip Naviaux of Roanoke County was killed in action in Germany on February 26. Staff Sgt. Jesse Saunders Jr. of Roanoke died from wounds received in Luxembourg on February 27. Pfc. William Scott died aboard a troop ship sunk in the Atlantic.

Elaine Berrie, Broadway actress, appeared in the Michael Stuart Players' production of *Ladies in Retirement* at the Academy of Music on March 23 and 24.

William Fleming High School's boys' basketball team defeated Graham High School 31–30 to win the Class B western division tournament on March 9 in Bluefield.

Stanley Radke, president of the Roanoke Red Sox baseball team, announced that the team would conduct spring training in Durham, North Carolina, beginning in early April. The team chose that location in order to train with the Durham Red Sox. Both were farm teams of the Boston Red Sox.

The board of directors of Hilltop, Inc., a proposed home for older ladies, met opposition at the meeting of the Roanoke City Council due to the location for the home being on a four-acre tract in Fishburn Park. Among those in opposition were the Roanoke Recreation Association, the Greenland Hills Civic Association, and nearby residents. The council appointed a committee to work with Hilltop for alternative sites. The day after the meeting, the council received a letter from Moss Taylor on behalf of the Hilltop board informing the council that the board had decided to abandon the entire proposition in light of the opposition, and those in opposition were invited to provide housing for the elderly.

Juvenile delinquency in Roanoke city had reached such proportions that downtown businesses began employing off-duty policemen to guard their buildings against vandalism in the late afternoon. Some restaurants complained that students from Jefferson High School were taking up all the booths and seats, leaving little room for paying customers. The downtown merchants appealed to the Social Services department of the city to develop a solution.

On the stage at the Lee Theater on March 15 was a performance by Herndon Slicer, who conducted the Lee Amateur Show along with the Lee Glee Club.

The Roanoke Black Cardinals began their spring training on March 20 in Springwood Park under manager Chappy Simms. The first game was slated for Easter Sunday against Pond's Giants from Winston-Salem, North Carolina.

Congressman Clifton Woodrum went on record as opposing Virginia's poll tax, calling it "outmoded, outdated…and a blot upon the fair name of Virginia." Woodrum made his comments to a Richmond newspaper on March 16, a few days in advance of a special session of Virginia's General Assembly.

Several bands and local veteran organizations participated in a parade in downtown Roanoke on March 17 in connection with the army air forces' movie *Winged Victory*, which began a run in local theatres. Proceeds from the movie benefited army charities.

The Rev. Vincent Waters, formerly of Roanoke, was appointed bishop of Raleigh, North Carolina, in an announcement by Pope Pius from Vatican City. Waters had attended St. Andrews School in Roanoke.

Roanoke mayor Leo Henebry along with others formed a corporation to seek a license to operate a radio station in Roanoke when the wartime freeze on applications is lifted. Henebry was president of the company that was chartered as the Blue Ridge Broadcasting Corporation. This was the second such Roanoke firm to announce a planned postwar radio broadcasting station. The other was the Virginia Broadcasting Corporation, headed by a former judge, Randolph Whittle.

Peter Freuchen, Swedish explorer and author and a member of the Danish underground, spoke to the Roanoke Executives Club at the Hotel Roanoke on March 23. Freuchen's topics were arctic adventures and his escape from the Gestapo.

The town of Vinton acquired the estate of C. J. Cook, which consisted of twelve acres and a Colonial-style home, for development of a park and community center. The property was purchased from the Cook heirs and was located on Washington Street. The purchase was made on a recommendation from the town's War Memorial Committee and was to be dedicated to the seven hundred residents of the town that had or were serving in the military during World War II.

Trailways bus lines announced in mid-March that an extra bus would be put into service for the Roanoke-Galax route.

State Senator Leonard Muse of Roanoke announced that he would cosponsor with Senator Ted Dalton of Radford a bipartisan measure to abolish the poll tax in Virginia at the upcoming session of the General Assembly.

Louis Jordan and his orchestra performed for a blacks-only dance at the Roanoke Auditorium on March 21. Jordan was known for his very popular "Is You Is or Is You Ain't My Baby?" among many other radio hits he had recorded.

Wrestling promoter Scotty Dawkins announced the card for several bouts at the Roanoke Auditorium on March 22. Among the wrestlers appearing were Dave Levin (a.k.a. "Jamaican Butcher Boy"), Ernest Johnson, The Black Shadow, Jack LaRue, and Jack O'Brien. Dawkins promoted the event by suggesting that spectators may see what had never been seen: the unmasking of The Black Shadow.

Sammy Kaye and his "swing and sway" orchestra performed at the Roanoke Auditorium on March 24 for a whites-only dance.

Lt. Edward Quinn of Roanoke died in England from illness. James Hurt, US Coast Guard, was killed in an auto accident in Naples, Italy, on January 26. Pvt. Joseph Stanley of Salem was killed in action in Germany on December 3. Pfc. Charles Milliron of Salem was killed in action in France on June 6. Pvt. Nathaniel Williams of Roanoke was killed in action in Germany on March 8. Staff Sgt. James Gregory of Roanoke was killed in action in the Pacific on March 3. Sgt. Robert Roope of Hollins died March 1 from wounds he received from action in Germany. Pvt. Edward Benson Jr. of Roanoke was killed in action in the Pacific on March 22. Russell Baldwin of Roanoke died from illness at the Great Lakes Naval Training Station on March 29. Pfc. Charles Terrell of Roanoke was killed in an auto accident in Michigan.

The Piedmont Baseball League announced the 1945 schedule. Each team would play 140 games, evenly split between home and away. The season would run April 26 through September 9.

A work by Miss Margaret Reinhart of Roanoke was chosen for the Tenth Virginia Artist Exhibition held at the Virginia Museum in Richmond.

Rev. William Rollins purchased the Third Avenue Baptist Church for $2,600 and planned to organize another church there. The building had been vacated by a white congregation.

The Cleveland Symphony gave a concert at the Academy of Music on March 25. A portion of the concert was nationally broadcast over the Mutual Broadcasting System.

Miss Dorothy Owens was fatally wounded in an accidental shooting in her home on Mountain Avenue on March 23. Owens had a small-caliber pistol on her nightstand, and when she went to cut off the alarm clock, she hit the revolver, discharging it, according to police. She was thirty-five.

The men of Virginia Heights Lutheran Church on Grandin Road began excavating the basement of their church for Sunday school rooms in late March. The men were committed to doing the work themselves using shovels and picks. The church had raised $30,000 for the materials needed.

Virginia Heights Lutheran Church, shown here in the early 1940s, was located on Grandin Road near the Grandin Theatre. *Virginia Room, Roanoke Public Libraries.*

The ballroom of the Hotel Roanoke was the setting for a nationally broadcast *Sunday Serenade* program of Sammy Kaye and his orchestra on March 25. Kaye and his band had performed the night before at the Roanoke Auditorium.

The Roanoke City Council authorized the employment of an additional caseworker for the Department of Public Welfare to help handle an increasing number of cases referred to the department by the court regarding abused and neglected children.

An Easter dance was held at the Roanoke Auditorium on March 30 that featured pianist Sony Boy Williams and his band. Another featured performer was Little Beau and his saxophone.

Sgt. Victor Sisson of Roanoke was killed in action over Dutch New Guinea on January 27. Pvt. James Blankenship of Roanoke was killed in action on Black Island on March 22. Robert Spillan of Roanoke was killed in action on Iwo Jima. Second Lt. Frank Coleman was killed when a rifle grenade exploded at Camp Blanding, Florida, on March 31.

W. Courtney King, vice mayor of Roanoke, was elected president of the Roanoke Bar Association for 1945 at a meeting at the Hotel Patrick Henry.

Douglas Nininger, director of instruction for Roanoke County Schools and former principal at William Fleming High School, was elected by the Roanoke County School Board to become the system's next superintendent effective July 1. Nininger succeeded Roland Cook, who had held the post since 1916.

The opera *Martha* came to the Academy of Music on April 4 with Marguerite Piazzi starring in the lead role. The touring opera had a cast of sixty-five and a twenty-six-member orchestra. (Piazzi became ill the day of the performance and was replaced by Laura Castellano.)

The southwest corner of Campbell Avenue and Commerce Street, Roanoke, was purchased by Dr. Potter Richards in late March. The property, known as the Gale estate, was acquired for $57,500. The property contained several businesses, including Roanoke Shoe Hospital, Roanoke Cigar Company, Foster and Caudill barber shop, and Baltimore Tailors.

The Roanoke Civic Ballet presented *Swan Lake* at the Academy of Music on March 5.

The Roanoke City Council's proposal to build a playground for black children at Jackson Avenue and Sixteenth Street, SW, was met with opposition by white property owners in the West End section who claimed via petitions that such a move would lower their property values. The council referred the matter to the Roanoke Recreation Association for further study. The council had previously instructed the city manager to acquire twenty-nine lots for the playground and recreation area. At the same meeting, black residents spoke on behalf of the initiative, stating that there was no recreation area for their children in that section of the city and that no whites lived north of Salem Avenue.

Pfc. Edward Light of Roanoke County was killed in action in Germany on March 17. Pvt. Murrell Weaver of Roanoke died on March 5 from wounds received in action on Iwo Jima. Pfc. Willis McMinis of Roanoke was killed in action in Germany on March 19. Pfc. Joe Milton of Roanoke County was killed in action in November in Europe. Warren Lucas of Roanoke County was killed in action in the South Pacific. Pfc. Earl Oliver of Roanoke was killed in action at Iwo Jima on March 13.

Henry Martin died April 1 at his home on Denniston Avenue, Roanoke, at age sixty-one. Martin was past president of the American Brokerage Company and a former chairman of the Roanoke City School Board.

In early April, Dr. Harry Penn and an unnamed minister received threatening letters from the Roanoke Lodge of the Ku Klux Klan. The letter stated in part that the men were to refrain from speaking publicly or they would be taken "for a ride." The FBI, Roanoke police, and the local NAACP joined in an investigation of the matter.

Several planes returned to Woodrum Field, having reported no signs of a downed navy plane. The search had been going for three days since witnesses reported seeing a navy plane explode in the air and crash in the mountains several miles northwest of Lynchburg. Further, a navy pilot had also reported that a plane flying alongside him at the time of the eyewitness report banked into a cloud formation and never reappeared. It was believed the plane was en route from Cherry Pointe Marine Air Base, North Carolina, to Woodrum Field.

The first of eight new mallet freight engines built by the Lima Locomotive Works in Ohio was delivered to the roundhouse of the Virginian Railway in Roanoke on April 5. The new engines would pull coal trains between Roanoke and Norfolk.

A proposed forty-thousand-capacity national cemetery was in the "conversation stage," according to Congressman Clifton Woodrum. The Roanoke site was one of several suggested by the quartermaster general's office in Washington, DC. The military began surveying the nation for sites to inter the dead from World War II.

Floyd Cheatham, nineteen, was fatally injured when he was pulled into a worm-type elevator loading machine at the Cinder Block, Inc., plant on Cleveland Avenue, Roanoke, on April 4.

Col. Carter Burgess of Roanoke, former assistant secretary of the general staff at Allied supreme headquarters in the European theatre, was named to assist the State Department in organizing the secretariat of the United Nation's conference in San Francisco. Burgess had been employed by Stone Printing Company in Roanoke before being called to active duty in 1941.

Complaints were made to the Roanoke County School Board about unsanitary conditions at South Salem School. According to some parents, the school swarmed with flies during warm months, and raw sewage from the school traveled several feet above ground before running off into the Roanoke River. Further complaints centered on nearby cow stables and hog pens.

Trevor Bacon, vocalist, appeared with Tab Smith and his orchestra for an all-black dance at the Roanoke Auditorium on April 9.

Pvt. Harold Pace of Vinton was killed in action in Germany on February 23. Lt. Billy Layman of Roanoke County died as a result of a motorcycle accident at Waycross Army Air Field, Georgia, on April 10.

Roanoke's city manager entered into a contract with Atlantic Western Airlines, headquartered in Danville, for office space at Woodrum Field for flight service that began on April 15.

The Roanoke Theatre advertised a stage show on April 11 called an "all-star vodvil revue" with a production titled *Red Hot and Lovely*. The ad also promoted blackface comedians.

The Homestead Grays of Washington, DC, and the Newark Eagles of Newark, New Jersey, played an exhibition baseball game in Springwood Park on April 15. Both teams were members of the Negro National League. The Grays had won the league championship in 1944. The Grays won, 11–10.

At 5:49 p.m. on April 12, Roanokers heard four stunning words broadcast by WDBJ: "President died this afternoon." The teletype was read aloud by a local announcer conveying the death of President Franklin Roosevelt in Warm Springs, Georgia. At 5:54 p.m., regular broadcasting was interrupted with network details. The *Roanoke Times* switchboard

was jammed for over an hour with calls inquiring as to the validity of the news. The flag at the Veteran's Administration Hospital was immediately lowered upon hearing the broadcast. Roanoke's mayor asked all Roanokers to observe a moment of silence at 4:00 p.m. on April 14 in recognition of the start time of the president's funeral, and the Roanoke Ministers' Conference held a special prayer service at that same time in Greene Memorial Methodist Church. All movie theaters in Roanoke closed until 5:00 p.m. in respect of the national funeral observance.

Jefferson High School presented its seventh annual minstrel show, *Escapades of 1945*, on April 13 and 14 in the school's auditorium. The cast was comprised of 150 students under the direction of Mac Johnson.

Nearly thirty residential lots were formally acquired by Roanoke City in mid-April for the creation of a proposed playground and recreation area for black children along Jackson Avenue and Sixteenth Street, SW. While the sale had been pending, opposition had developed to the playground from white residents of the West End section. Meanwhile, the Roanoke Recreation Association, chaired by B. J. Fishburn, was reviewing the park's status due to the matter of opposition being referred to the group by the city council.

Boxing returned to Roanoke after a long absence on April 17 at the Roanoke Auditorium. The night included six bouts of amateur boxing promoted by Byron Johnson. Among those boxing were Johnny Hodges of Roanoke, William Pitzer of West Virginia, and area high school athletes.

The first female professional wrestlers to appear in Roanoke squared off against one another on April 19 at the Roanoke Auditorium. The women, comprising two tag teams,

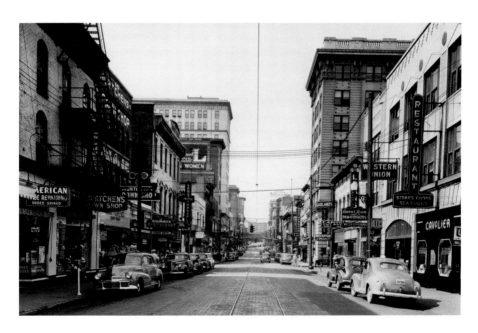

This image is looking south on Jefferson Street in the 1940s. The Cavalier Restaurant is in the front right. *Virginia Room, Roanoke Public Libraries.*

were Virginia Valentine, Ann Miller, Rose Evans, and Nell Stewart. Local promoter Scotty Dawkins also included matches between Sonny Meyers and the Black Shadow.

Rex Mitchell, assistant city parks and recreation director, announced that the Knothole Club would exist for 1945 for boys under the age of twelve. The club got tickets to all home games of the Roanoke Red Sox for a small admissions fee and sat together with adult leaders.

Two German prisoners of war escaped from the camp at Catawba on April 14, and armed patrols began an immediate search along Masons Creek with the assistance of the FBI.

Staff Sgt. Luther Stone of Roanoke was killed in action in the Philippines on April 4. Sgt. Norman Robertson of Roanoke was killed in action in Europe on November 9. Cpl. Glen Beckner of Roanoke was killed in action in Germany on March 29. Lt. Eugene Puckett Jr. of Salem was killed in action over Engers, Germany, on February 14. Pvt. Clyde Childress of Roanoke County was killed in action in Germany on April 4. Sgt. Charles Doran of Roanoke was killed in action in Germany on April 5. Pvt. Ulysses Weeks of Roanoke was killed in action in Germany on December 24.

State Senator Leonard Muse of Roanoke announced on April 15 that he would seek the Democratic nomination for lieutenant governor. He became the third candidate to enter the race for the nomination.

A navy flier identified as Lt. Commander Anderson Little was killed instantly when he parachuted from a plane near Hardy. The plane continued for a half mile before crashing in a field belonging to A. M. Starkey. The April 16 incident was witnessed by several on the ground, who reported the plane seemed to have engine trouble, and that the pilot's parachute did not open when he leapt from the aircraft at low altitude.

A small cyclone struck near Peters Creek on April 17, uprooting trees and lifting a barn into the air. Resident J. J. Bower said the wind event violently shook his house such that his family thought the structure would collapse.

The Roanoke Theatre hosted a stage show "Stork Club Scandals" described as a "tornado of beauty" along with Deacon "Slim" Williams, a blackface comedian.

American Homes, Inc., in Roanoke announced a contract to provide and ship two thousand precut houses to Britain to provide relief to those living in bombed-out cities. Various house parts were being manufactured around the country. The parts, including those from Roanoke, were shipped to Huntington, West Virginia, where they were assembled and then deconstructed for shipment overseas.

Pillis Brothers Grocery, a wholesale business in Roanoke, was sold to J. K. Harrison of Pulaski and began operating under the name of Virginia Foods of Roanoke, Inc.

Moss Plunkett, Roanoke attorney and head of the Southern Electoral Reform League, announced that he would run for the Democratic nomination for governor in the party's August primary. He became the second candidate to announce in opposition to Lt. Governor William Tuck. Plunkett called upon "all liberals" in the state to vote for his candidacy.

Helen Faville, who started her dancing career in Roanoke, made quite an unexpected appearance at the Los Angeles Symphony Orchestra's performance in Los Angeles on April 19. Faville leapt from her back-row seat at the Arturo Toscanini concert, slipped unnoticed to the stage, and danced to the music of the famed conductor before she was cornered by police and led away. Her appearance, or intrusion as viewed by most, made

headlines in West Coast newspapers and shocked the six thousand in attendance, who at first applauded before realizing she was not part of the program. The symphony continued to play as three policemen corralled her.

St. Paul's Methodist Church, corner of Park Street and Gilmer Avenue, NE, held a Victory Sunday on April 22 when they burned a $4,000 mortgage note. The congregation began in 1880 with the Rev. Thomas White in a rock building on what became known as Lynchburg Avenue. The congregation then purchased a church building on the corner of Henry and High Streets, NW. That structure was razed, and a new church was built on the same site by the St. Paul's congregation. While the new church was being erected, the congregation met in Penn's Hall, later the Church of God and Saints in Christ. The church moved to its present location in 1915 due to ongoing membership growth, purchasing the former St. James Methodist Church from the Melrose Methodist Church for $16,000. Some two thousand persons attended St. Paul's on Victory Sunday.

The Clyde Beatty Circus came to the Roanoke Fairgrounds on April 24, claiming to be the "largest trained wild animal circus in the world." The main attraction was Clyde Beatty himself, a nationally known animal trainer. Attendance at the two shows was estimated at fifteen thousand.

Maj. David Stuart of Roanoke died in Belgium on April 14 of coronary occlusion. Cpl. Marshall Jones of Roanoke County was killed in action in Germany on April 9.

Sydney Small was elected as Roanoke's delegate to the state's constitutional convention, defeating James Martin in the special election held April 24. In Roanoke County and adjacent counties, Sinclair Brown was elected over Moss Plunkett.

Clayton Lemon, Roanoke aviator, purchased Dixie Caverns for $22,500 at an auction on April 24. Lemon indicated he planned to do some repair work to the grounds and open the caverns to the public in late spring. The caverns had previously been owned by Paul Coffman of Berwind, West Virginia, who had closed the caverns to the public when the war began.

Four persons were fined and jailed for running an illegal speakeasy at 1502 Gilmer Avenue, Roanoke. Harvey Spangler, Roy Spangler, Bertha McCarty, and Eva Britton were all given fines ranging from $100 to $700 and sentences ranging from one month to one year in jail.

Sunday, April 29, was declared a "C-Day" in Roanoke city and county as residents were encouraged to place bundled clothes on their porches for distribution in Europe for war refugees. The clothing was picked up by Minute Men, the Virginia State Guard, and various civic clubs, or persons could take clothing to the YMCA, YWCA, or fire stations.

The Roanoke Red Sox began their regular season by winning their opening game against the Lynchburg Cardinals 9–8 at Lynchburg on April 26.

The Cupid Beauty Shop opened over Woolworth's in downtown Roanoke on May 1. Proprietors were Mrs. R. J. Hammer and Miss Thelma Spraker.

The Valleydoah Baseball League opened its regular season on April 29. The five teams and their managers were as follows: Valleydoah, Rip Ferguson; Finks, Paul Compton; Greyhound, Curtis Puckett; Virginia Bridge, V. A. Clark; and N&W Railway, Joe Woods. Many of the games were played at Fleming Field.

Maj. Joseph Boxley of Roanoke was killed in action in Germany on April 14. Sgt. Frank Lunsford of Roanoke was killed in action in Germany on April 17. Carey Cullen of

Roanoke died of wounds on April 28 that he had received in Germany. He was a patient at Baker General Hospital in Martinsburg, West Virginia, at the time of his death.

Julian S. Wise submitted to the Roanoke City Council a letter of resignation from the Roanoke Fire Department. Wise had been employed with the fire department for thirteen years and had served for sixteen years as head of the Roanoke Life Saving and First Aid Crew.

The Virginia Theatre on Center Avenue, NW, was heavily damaged by fire on April 30. Emmett Nabors was the theater manager and stated that the fire was discovered at 7:00 a.m. and damaged the stage, offices, and projection room.

The Roanoke City Council authorized the city manager to engage in conversations with the owners of the Roanoke Red Sox and an architect on developing postwar improvements to the baseball field (Maher Field), including new stands, showers, locker rooms, and concession facilities.

Pvt. Lorenza Swartz of Roanoke was killed in action in Germany on April 13. Pvt. Cleo Robertson of Roanoke was killed in action in Germany on April 21. Pfc. Cloyse Hall of Roanoke was killed in action in Germany on April 18. Pfc. Emmett Journell of Roanoke County was killed in action in Germany on April 24.

The Jefferson Theatre and Grandin Theatre held special showings of film taken by Russian and American troops that had liberated concentration camps. "German Murder Camp Scenes—Due to the stark horror contained in these authentic newsreel scenes we do not recommend it for children," read the advertisements in early May.

Drug stores and other businesses that sold cigarettes agreed to cooperate with Roanoke City police. They would sell cigarettes at various intervals throughout the day to prevent long lines, which blocked sidewalks and doorways and had to be broken up by police.

William Austin Sr., a justice in Roanoke for thirty years, died at his home on May 3. He was seventy-three. Austin had served as an issuing justice since 1916 and had been consistently reelected to that post.

The Ninth Avenue Christian Church purchased from the First Church of the Brethren a brick church building on Loudon Avenue, NW, in early May.

Leroy Hardison and his Carolina Cotton Pickers performed for a blacks-only dance at the Roanoke Auditorium on May 4. The Jive Orchestra also featured vocals by Ed Sneed and Cecil Grove.

The Pittsburgh Crawfords of the National Negro Baseball League played the St. Louis Stars of the American Negro Baseball League at Maher Field on May 8. The Crawfords won 16–9.

On Tuesday morning, May 8, readers of the *Roanoke Times* saw a welcome front-page headline: "War in Europe Over!" Germany had officially and unconditionally surrendered at 2:09 p.m. on May 7.

Three sailors were sentenced to seven years each in prison for an attack upon Roanoke City's jailer, William Fitzpatrick. The three men were being held in the Roanoke jail on charges of stealing an automobile when they tried to make an escape. Fitzpatrick was taken to a local hospital, where he received stitches to his face.

The management of Lee Hy Pool and Lakeside announced both places would open on May 10. "We are not selling intoxicating drinks at either Lakeside or Lee Hy nor entertaining any drunks. This applies to both men and women," read the advertisements.

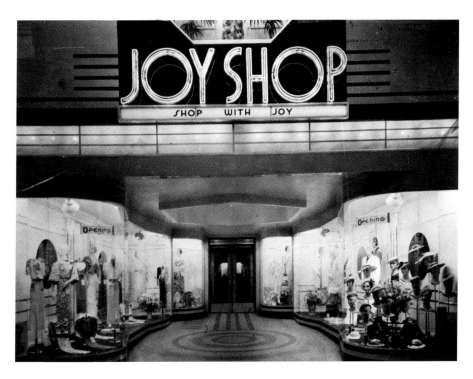

The Joy Shop was at 27 W. Campbell Avenue in this 1945 photo.
The store later relocated to corner of Campbell and Jefferson
Street. *Virginia Room, Roanoke Public Libraries.*

The Roanoke City Council decided to abolish the position of issuing justice, given the recent death of the officeholder. The duties were given to the civil and police justice.

Dr. T. J. Hughes was elected as president of the Roanoke Academy of Medicine for 1945–46.

Pvt. Jack Brown of Roanoke died on April 20 from wounds that he received in action in the Philippines. Petty Officer Guinn Bailey of Roanoke was lost in action in the Pacific on April 7. Capt. John Crawford of Roanoke was killed in Europe on May 2.

V-E Day was celebrated in Roanoke following President Harry Truman's radio address at 9:00 a.m. on May 8, announcing the unconditional surrender of Germany. Almost all businesses in downtown Roanoke closed for the day. Restaurants remained open but ceased selling beer and wine. Churches held evening prayer services as celebrations of thanksgiving. Further, the brown-out was lifted, allowing business signs and theatre marquees to be lit at night. Celebrations were somewhat tempered due to the ongoing war in the Pacific.

The Roanoke Theatre had one of its typical stage shows on May 9. *Meet the Girls* featured the Trudy Russell Dancers and Cotton Watts, a blackface comedian.

The real estate firm of Fowlkes & Kefauver began advertising house lots in their new developments of Rosalind Hills and Orchard Hills in the southwest sections of Roanoke city.

Babe Sharkey wrestled the Black Shadow at the Roanoke Auditorium on May 10. According to local promoter Scotty Dawkins, the match had been arranged by popular request. Other matches included Jimmy Colefield versus George Barkley, and Chief Sammy Simms against Herbie Freeman. Sharkey won the match against the Black Shadow and provided Roanokers what they had long been waiting for: the Shadow being unmasked. When referee Chuck Jones removed the mask, the person was revealed to be W. M. Baxter of Arkansas, a former professional football player.

Judge Beverly Berkeley died at his South Roanoke home on May 11 at age sixty-five. The retired judge had ceased his time on the bench in December 1943 due to ill health. He was first appointed a judge in 1909.

The Dale Avenue Fundamental Baptist Church opened on May 13 at 1018 Dale Avenue, SE. Rev. Floyd Barber was pastor.

Stars of the *Grand Ole Opry* came to the Roanoke Theatre stage on May 13. Performers included Pee Wee King, Minnie Pearl, and the Golden West Cowboys.

Two Negro League teams played against one another at Maher Field on May 14: the Homestead Grays of Washington, DC, and the New York Black Yankees. Featured players included Josh Gibson and Buck Leonard. The Grays won, 16–6.

George St. Clair of Roanoke County was killed in action in the South Pacific. Lt. Warren Irvin of Roanoke died in a hospital in England on April 19. Pfc. Clarence Kingery of Roanoke was killed in action on January 9. Emory Fry Jr. was killed in action over Belgium on September 19, 1944. He had previously been reported as missing.

A B-29 based in Guam was named *City of Roanoke* by her crew in early May. The bomber was used in missions targeting industrial and military complexes in Japan. The crew voted for the name because their airplane commander, Capt. Herman Smith, was from Roanoke. The name was painted on the plane's nose on a flag, the pole of which pointed to Roanoke on a map.

A baby just seventeen days old was abandoned at a Roanoke hotel in mid-May. The infant was taken to a local hospital for care. The hotel management stated that a woman claiming to be from Chicago had been a resident at the hotel for several weeks, telling other guests she was a war widow. The woman gave birth to her child in a local hospital and then returned to the hotel for several days before leaving on a train, according to police. Police said evidence suggested the mother may have gone to New York. C. E. Cuddy, commonwealth's attorney, indicated that the child's best interests would be served with a local adoption. Following the infant's hospital care, the child was placed with the Children's Home Society of Virginia.

Wading pools in Salem, one for black children and another for white children, were delayed by the Salem Town Council. The pool for black children was proposed to be constructed on White Oak Alley, and the one for white children either at Longwood Park or in the Bottom section.

A new civic organization was launched on May 3 and quickly enrolled some 1,200 members. The Southwest Civic League elected J. P. Foy as president, and membership was limited to white citizens living in the area bounded by the N&W Railway tracks, Jefferson Street, the Roanoke River, and Twenty-Fourth Street, SW.

Three female employees of the Roanoke Viscose plant were chosen as "pinup" girls for a mid-May edition of *Look* magazine. The three that were pictured in the popular national magazine were Mary Capito, Roberta Sisson, and Dorothy Bowling. The women's

photos were spotted by *Look* editors in the Viscose magazine that regularly featured female employees as "hometown pinups."

Special services were held at Raleigh Court Methodist Church in Roanoke on May 19 and 20 to commemorate the mortgage note burning and dedication of the sanctuary. The congregation was formed in the Central YMCA on May 16, 1921.

Two employees of the N&W Railway machine shops died on May 18 from injuries received when a small gasoline tank near where they were working exploded. The two men were James Thomas, seventy-three, and Leslie Barger, forty-two.

Pfc. Richard Clarkson of Roanoke was killed in action in the Philippines on March 30.

Formal dedication services were held on May 20 for the Melrose Pentecostal Holiness Church. The church was located at the corner of Hanover Avenue and Tenth Street, NW, and was organized April 5, 1910.

The Interracial Commission of Roanoke City adopted a new constitution and new name in May. The group's new name was the Roanoke Commission on Interracial Cooperation. The commission was composed largely of clergy, educators, and civic leaders from both Roanoke city and county who advocated cooperation and understanding among and between blacks and whites.

The Roanoke County Library Board announced the opening of the Williamson Road Branch Library for the week of May 20. The branch library was located in a room of the Williamson Road Fire Station. The first library service provided to outlying areas in the county was made by the Roanoke Junior Woman's Club library in 1933, when a small unit was opened at Cove Hollow in the home of Miss Mary McDaniel, who took charge of the books and distributed them in her neighborhood. Eventually other branches were opened. The Williamson Road branch was managed by Mrs. Paul Matthews.

Plans for the erection of a food-processing plant in Roanoke were unveiled at a meeting of the city council on May 21. The plant's proposed location was the northeast corner of Lynchburg Avenue and Ninth Street, NE. The plant's owner and manager was T. H. Beasley.

Maston Moorman was elected by the Roanoke City Council to be the assistant civil and police court justice. The position was created when council dispensed with the elected position of issuing justice.

The Roanoke County Board of Supervisors voted to abandon plans to purchase the Phelps Water Company at their meeting on May 21. The water company served the Williamson Road section and other northeast areas. The board was responding to a recommendation made by board-appointed attorneys, who reported that they could not discern clear titles to water company properties.

Local revenue agents reported that due to sugar rationing, moonshiners had turned to corn syrup as a substitute for making illicit whiskey. On a recent raid at a still, nearly nine hundred pounds of corn syrup had gone into making 2,350 gallons of mash.

Four new twenty-seven-seat coaches went into service with the Safety Motor Transit Corporation in Roanoke. The bus system purchased the new coaches, which were equipped with side exits, from the Ford Motor Company.

Judge William Henson, eighty-one, died at his home in Radford on May 22. Henson came to Roanoke in 1909 to practice law and later served as general counsel of the Shenandoah Life Insurance Company in Roanoke.

The first section of an N&W Railway passenger train collided with the back of a local freight train just east of Bonsack on May 23. Several passengers and one crew member were injured but none seriously.

Roland E. Cook, retiring superintendent of Roanoke County schools, was honored at a flag-raising ceremony at the Roland E. Cook School in Vinton on May 30. The ceremony also served as a dedication of the school that had been given Cook's name three years ago. The school was the oldest in Vinton and at one time was used as the Vinton High School.

The last of Roanoke's auxiliary fire companies, established under the Office of Civilian Defense in August 1944, was disbanded May 27. The last to disband was No.6 on Jamison Avenue, SE.

Dr. Katherine McBride, president of Bryn Mawr College, delivered the commencement address at Hollins College, where sixty-four students graduated. Her speech was titled "Women of the New War Generation." McBride expressed her belief that greater opportunities would exist for women after the war than they did before the conflict.

Johnny Mack Brown, a well-known Hollywood actor in westerns, visited Roanoke on May 30 and performed at the Roanoke Theatre as well as visiting polio patients in local homes and hospitals. Brown did various rope tricks with a troupe of other actors. He was touring the southeastern United States to visit camps and hospitals.

Tiny Bradshaw and his Jersey Bounce Orchestra came to the Roanoke Auditorium on June 1 to play for a blacks-only dance. He was advertised as "King of the Jitterbugs."

Pvt. Robert Pritchard of Roanoke died in Germany on May 14.

Plans for a postwar, ten-thousand-watt FM radio transmitter were announced by WSLS. The station had purchased a site on Poor Mountain, and the tip of the transmitter would exceed the elevation of Peaks of Otter in Bedford County. WDBJ Radio had previously announced the purchase of a site on Bent Mountain for location of their future FM transmission tower.

Thomas O'Connor retired on June 1 from the N&W Railway after sixty-two years of service. He was first employed in the Roanoke Machine Works at the age of fourteen as a "hammer boy" in the blacksmith shop. His start date was May 14, 1883. He retired as the assistant foreman in the Roanoke Shops. O'Connor held the record for the longest tenure of any N&W Railway employee.

The crippled children's ward at Roanoke Hospital opened in early June. The twenty-one patients that were in the isolation ward were transferred to the new ward. The new ward included a clover-shaped water tank that allowed children afflicted with polio to receive physical therapy as the agitated water massaged their muscles. Children were lifted into the pool with hoists. The entire ward consisted of three ward rooms, one infant room, the physiotherapy room, kitchen, and waiting room.

D. T. Buck, Roanoke County farm assistant, announced that the two hundred German prisoners of war being held at two camps would be available for farm labor during the summer and fall seasons, even though Germany had surrendered. On June 6, Hans Metz, a POW at the Salem Camp, escaped while cutting pulp wood near Elliston. FBI agents joined the search. He was caught a few days later about three miles west of Elliston by the sheriff of Montgomery County and returned to the Salem camp.

Jewell and Burdette Radio and Electrical Repairs opened on June 11 at 411 Park Street, SW.

Square Dancing was offered every Wednesday, Friday, and Saturday nights at Victory Hall, 318 Commerce Street, SW, with music provided by Bill Argenbright and his entertainers.

Automobile owners were notified that they no longer needed to display gas ration stickers on their windshields, effective August 1.

Russell Cook, area supervisor for the Victory Farm Volunteer program, reported that boys age fourteen and over, at least five feet four inches tall, and weighing not less than 120 pounds, were still needed for volunteer farm labor in Roanoke city and county. They would receive a small wage and live with the farm families that requested their services.

The "Blue Network" of national radio stations announced a name change to the American Broadcasting Company effective in mid-June. WSLS was an affiliate of the Blue Network.

Mrs. A. L. Kidd, secretary of the Mutual Benefit Association of the Roanoke plant of American Viscose, was awarded the highest honor the company bestowed upon an employee, the Samuel Salvage Award. Kid traveled to New York City for the company's presentation at the Empire State Club.

Local aviators began buying army surplus planes at Woodrum Field in early June. To fly the planes, pilots must have had at least five hours of solo flight time. Most of the planes were open-cockpit primary trainer aircraft.

Clem High, freight conductor for the N&W Railway, was killed on June 11 when an eastbound freight train ran into a local freight train engaged in switching cars at a plant siding a half mile east of the Bedford station. Rail traffic was halted for four hours along the line. High was a resident of Roanoke city. Others injured included Raymond St. Clair, Henry Parrish, and B. E. Kessler.

The Roanoke City Council ended a long-running and controversial matter by adopting an ordinance that banned the sale of raw milk in the city effective July 1, 1946. Physicians and the local board of health advocated for the ban, while dairy farmers and distributors opposed the ban, asserting that raw milk was not the cause of disease.

Melvin Manning of Bent Mountain was the Roanoke city-county marbles champion for the second straight year. Manning took the final matches from Hylton King, also of Bent Mountain.

Marble tournament players at Bent Mountain School in 1945.
Marble tournaments were highly competitive and quite popular
in the 1940s. *Virginia Room, Roanoke Public Libraries.*

The store of Marvin "Fats" Reed was along Route 221 near the foot of Bent Mountain and was typical of the rural groceries. *Lou Emma Richards.*

Traveltown swimming pool at Cloverdale announced in mid-June they were open. "A clean pool for clean people" and "no drunks allowed" read their advertisements.

The Roanoke School Board, meeting at Lucy Addison High School, heard concerns from the black community. Dr. Harry Penn, president of the Addison PTA, lobbied the board for a junior high school, a new building to replace Gainsboro School, bus service for black children living in the southwest section of the city, and an elementary school in southwest. As for Gainsboro School, Penn pointed out that there had been no major repairs or improvements there for forty-seven years, and it was being heated with stoves.

The Tennessee Ramblers performed on the stage of the Roanoke Theatre on June 20. The group was well known on national radio and had appeared in several movies. The Ramblers featured Jack Gillette, Cecil Campbell, Don White, and Roy Lear.

Pvt. James Brinkley, a Roanoke native, was killed in action in Germany on April 26. Lt. James Atkinson of Roanoke was killed in action in the South Pacific on May 31.

Rockets from Radford, an army recruiting show, was announced for Maher Field on June 25. Speakers included veterans and others as well as a display of military munitions. The show was an effort to recruit for the Radford Ordnance Works.

Wooden barracks for black troops were completed at the Veterans Hospital in June. The barracks housed some one hundred men serving as attendants at the facility. The buildings were named "Camp Jordan" after Col. E. W. Jordan, manager of the hospital. Construction on four continuous-care buildings at the Veterans Administration Hospital was progressing, with some construction, paving, and landscape work being done by sixty German POWs.

Bert Spencer was recognized for twenty-two years of continuous service at the Hotel Roanoke as the hotel's official "train meeter." It was estimated that Spencer met an average of twelve trains each day, 365 days a year. That equated to 96,360 trains during his tenure. Spencer stated he had carried the bags of many famous people, including Eleanor Roosevelt, President Howard Taft, several Virginia governors, and various Hollywood

luminaries. Prior to joining the Hotel Roanoke staff in 1923, Spencer had been a Pullman porter. He said he had no plans to retire.

An "old time all day" meeting was held at the Primitive Baptist Church at 1502 Staunton Avenue, NW, on June 17 for the dedication of the church due to the members having paid off the note. The congregation was organized on February 17, 1900, and had been in two prior locations. Elder John Hall presided at the service. The church was for many years under the oversight of the Bellview Primitive Baptist Church near Cave Spring. The first building was located at the corner of Franklin Road and Third Street and was used until 1911. Following the sale of that structure, the congregation built a larger church at Eighth Street and Campbell Avenue, SW, where they remained until 1939, when they held their first service in the new church on Staunton Avenue in February of that year. The Staunton Avenue church had a seating capacity of five hundred.

Samuel F. Scott, principal at Lucy Addison High School, announced his resignation to accept a position with a large construction firm in Jamaica, Long Island, New York. Scott became principal at Addison in September of 1939, having come from Virginia Union University in Richmond, where he was an associate professor.

Earl "Fatha" Hines and his orchestra performed for a blacks-only dance at the Roanoke Auditorium on June 20. His orchestra featured Arthur Walker and Scoops Cary.

Atlantic Western Airlines advertised their same-day return flight service from Roanoke to Richmond. The airline also served Danville and Lynchburg.

James Taliaferro was fatally wounded with an axe in his home on Fourth Street, NE, on June 19 and later died at Burrell Memorial Hospital. Charged with his murder was William Franklin.

First Lt. Paul Bent Jr. of Roanoke, was killed in action over Italy in early April. Seaman Terry Crawley of Roanoke County was reported accidentally drowned. Cpl. Otey Schilling Jr. of Roanoke was killed in action on Okinawa on June 13. Lt. Col. Frank Holland and 2nd Lt. Andrew Pace, both of Roanoke, died when a Japanese POW ship on which they were traveling was sunk in the China Sea in October 1944. They had previously been reported as missing.

The Indianapolis Cardinals of the Negro American Baseball League played the Brooklyn Brown Dodgers of the United States League in a doubleheader at Maher Field on June 24.

Capt. William Miller from Camp Pickett took charge of the POW camp at Salem in late June. His predecessor, Capt. George Dailey, returned to Camp Pickett.

Pfc. Leon Leonard of Roanoke was killed in action on Okinawa on April 29.

Roanoke City Mills neared completion on its new plant in late June. Company officials stated that it would be the largest feed-manufacturing plant east of the Ohio River. The new facility had a production capacity of fifty tons of feed per hour.

George Via, a realtor and civic leader in Roanoke, died at his home on Carter Road on June 24. He was forty-nine. He was an active member of the Optimist Club and helped to establish the club's recreation center in Norwich.

Some members of the *Grand Ole Opry* returned to perform on the stage of the Roanoke Theatre on June 27, including Pee Wee King and his Golden West Cowboys and Minnie Pearl.

"No city that has taken the forward step of using Negro policeman has found it necessary to rescind its action," was the report of Dr. Thomas Allen of Richmond in an

address to the Roanoke Commission on Interracial Cooperation in late June. Allen, affiliated with the Virginia Council of Churches, spoke to the commission at their meeting at the Central YWCA and stressed that when servicemen returned home, they would need to see equality and democracy in practice as the principles for which they fought abroad.

The Selah Jubilee Singers from New York performed at the Roanoke Auditorium on June 29. The group was well known on the NBC radio network.

Meat rationing was no problem at the Veterans Administration Hospital. Their on-site hog farm produced some two thousand pounds of fresh meat weekly to serve the patients and attendants at the facility. All food, including grain, was produced on the hospital grounds.

The Salem Community Cannery on Water Street opened on July 2 for the third consecutive year. James Peters was supervisor of the county canneries. The cannery was opened for whites on Tuesdays, Wednesdays, and Fridays, and for blacks on Mondays and Thursdays.

Dr. Murray Kantor, rabbi at Beth Israel Synagogue in Roanoke, announced his resignation in early July. Kantor accepted the position of rabbi for a synagogue in Winston-Salem, North Carolina.

Art Sargent emceed a Fourth of July program on the stage of the Lee Theatre. Performers included Margaret and Shirley Harmon, Clyde "Happy" Grant, Paul Ramo, Charlie Draper and his Blue Ridge Mountain Boys, the Eades Sisters, Roger Elmore and his Melody Makers, Betty Musselman, Madeline St. Clair, and Betty Coleman, among others.

The Atlanta Black Crackers played a doubleheader against the Little Rock Travelers at Springwood Park on July 4. Both teams were affiliated with the Negro Southern Baseball League.

Dr. Russell Williams, a Salem physician, purchased the Longwood Avenue hospital property in Bedford from Dr. H. R. Hartwell. Williams renamed the medical facility Bedford General Hospital and took charge of its operations.

A fifty-five-year-old granite monument to Roanoke's growth standing on East Church Avenue on a hill opposite the N&W Railway shops was moved to the central part of the city. It was known informally as the "Mayors' Monument" as it listed all the city's mayors and their times of service.

An all-star extravaganza of singing and dancing came to the Roanoke Auditorium on July 10, featuring some of the nation's best-known black entertainers. Those who performed included the Nicholas Brothers, Dizzy Gillespie and his orchestra, the comedy team of Patterson and Jackson, June Eckstine, and Lovey Lane. In addition to the performances, there was also a dance for those in attendance. The blacks-only dance tickets were available at the Dumas Hotel, Community Drug, Gills Café, Paul's Grocery, and the Dining Car Club.

Roanoke city exceeded its goal in the purchase of E Bonds in the seventh war-bond campaign. The city had an E Bond quote goal of $2.5 million and sold $150,000 in bonds beyond that mark. H. O. Nicholson was chairman of the local war finance committee. Roanoke County also exceeded its goal by 10 percent.

The Benson Apartments at the corner of Franklin Road and Albemarle Avenue, SW, were sold by the builder, B. M. Phelps, in early July to Frank Flanagan of Radford. The

original portion of the twenty-four-unit apartment structure was built in 1931 with an addition in 1940.

The Roanoke Branch of the NAACP successfully conducted a membership drive and secured 1,110 new members. Justina Spencer was the campaign director, and she alone enrolled 206 new members.

The Roanoke City Council was informed that military police would be sent to Roanoke when such personnel were available. At the behest of local law enforcement, the council had requested the presence of military police to handle matters pertaining to off-duty soldiers in Roanoke.

The Salem Planning Commission recommended to the town council two sites for public swimming pools. A pool for white children was recommended for a knoll east of the wooded section in Longwood Park, and a pool for black children was suggested for the corner of Fourth and Alabama Streets. The town council asked the town manager for cost estimates for both pools.

Nelson Bond's radio script "Murder in the Rough" was broadcast nationally over ABC on the program *The Sheriff* on July 13.

The Salem softball league hit its stride midseason, with five teams drawing a significant number of spectators to the games. The five teams were Salem Creamery, Salem Army Guards, Neuhoff, Town of Salem, Hosiery Mill, and Catawba Guards.

Miss Gladys Hunt, twenty-one, of Roanoke was one of three fatalities resulting from an explosion at the Radford Ordinance Plant on July 13. Hunt died from her injuries at a hospital in Radford on July 16.

Madeline Morton, twenty-two, of Salem was fatally stabbed on July 16. Two suspects were arrested.

The Nashville Black Vols and the Chattanooga Choo-Choos played against one another in an exhibition game at Maher Field on July 19. Both teams were members of the Negro Southern Baseball League. Pitching at the game was one of the nation's foremost black professional baseball players, Smoky Joe Williams.

Pvt. Roy Hylton of Roanoke died on December 20 from wounds he had received the day before in a German POW camp.

Dr. Justin Plummer was named resident physician at Burrell Memorial Hospital and assumed those duties on July 19. Dr. L. C. Downing was the hospital's superintendent. Plummer was a graduate of Howard University and the Howard Medical School.

Rev. Samuel Naff, pastor of the South Roanoke Baptist Church, died on July 18 following a lengthy illness. Naff came to the church as its minister in 1939.

The development of the top of Mill Mountain into a war memorial park was formally presented to the War Memorial Committee on July 19 by representatives of the Roanoke Woman's Club. Dr. Hugh Trout, chairman of the committee, expressed the sentiment of the committee that one memorial would be recommended that would be "all inclusive" of both black and white service members. Apparently, some memorial suggestions were that such memorials be separated. The Mill Mountain tower proposal was all inclusive.

Lucky Millinder and his orchestra played for a blacks-only dance at the Roanoke Auditorium on July 27. A special feature of the evening was the singing of Sister Rosetta Tharpe. White spectators were admitted for half price.

Fred Kirby and his WBT Briarhoppers along with the Carolina Playboys performed on July 25 at the Roanoke Theatre.

Roanoke city leaders announced the opening of the canning centers in the city for the summer. Canneries were offered at Jackson Junior High School, Monroe Junior High, Woodrow Wilson Junior High, and Lucy Addison High School. There was also a canning center operated by Appalachian Electric Power Company. Alice Marshall was the home economics director for the city and was tasked with overseeing the canning center operations.

Lakeside Park closed on July 21 for the summer due to the "excess profit tax" according to park owner H. L. Roberts. Roberts also said that the additional amusement tax and labor shortage added to the decision to close earlier than usual for the season.

A lightning strike on the north corner of the power house in the N&W Railway East End Shops caused a fire with considerable damage. Flames shot twenty feet in the air, and power was cut to the railway's general offices, shops, and the Hotel Roanoke.

Sgt. Herbert Tayloe of Roanoke County was killed in an accident at Pine Castle Air Base in Florida on July 22.

Due to America's lend-lease arrangement with China, three Chinese engineers arrived in Roanoke in late July to study the operations of the N&W Railway for twelve months. The Chinese were W. M. Wang of Fuklen, China; Sei-Fong Cheng of Chungking; and F. L. Wang.

Maria Dillon, a licensed astrologer, advertised her hours at the Patrick Henry Hotel and that the hotel was her permanent location. Readings were three dollars.

A large brick structure that formerly housed the Crystal Spring Ice Company, just south of Albermarle Avenue and Third Street, SE, was gutted by fire on July 24. The building adjoined the Continental Can Company and had not been in use for a few years.

Pvt. Robert Harris from Clarksdale, Tennessee, was fatally stabbed in the N&W Railway passenger station on July 25. Pvt. Philip Strickland from Birmingham, AL, was arrested in connection with the stabbing. According to police, the soldiers were both on leave and argued over a woman who was traveling with them. Harris died at Burrell Memorial Hospital.

Sherwood Cemetery presented *The Abbey Hour*, a series of Sunday afternoon organ concerts by Dr. Robert Stevens in its Sherwood Abbey Chapel.

The Mobile Alabama Shippers and the Greensboro Black Yankees played a doubleheader at Maher Field on July 30. Both teams were affiliated with the Negro Southern Baseball League.

John Windel Jr. of Roanoke was instantly killed when his light Taylorcraft plane crashed on the slope of a mountain near Hemlock Dell, seven miles west of Salem. A passenger, Ray Cox, seventeen, was injured. Windel had just graduated from Jefferson High School a month prior and about that same time had earned his pilot's license.

Members of the Ninth Avenue Christian Church moved into their new building on Loudon Avenue in late July. The church had been purchased from the First Church of the Brethren. The Rev. D. W. Heath was pastor of the Ninth Avenue congregation.

Congressman Clifton Woodrum released a statement on July 31 announcing that he would not seek reelection to Congress and would resign his seat before his term ended in order to go into private business. Woodrum had recently been named president of the American Plant Food Council, a national trade association. Woodrum indicated he would retain his residence in Roanoke.

The Bradley and Benson Combined Circus and Rodeo came to the Roanoke Fairgrounds on August 2 for two performances. The emcee was Mrs. Tom Mix. Performers included rodeo clown Swede Johnson, Lillian Gillian and her lions, and Professor Lee Houston and his boxing kangaroo, as well as trapeze artists, jugglers, ponies, and clowns.

C. N. Snead announced the opening of his new advertising agency in early August. Snead had formerly been with Houck Advertising and prior to that was the city editor of the *Roanoke Times.*

The "Big 3 Unit" performed for a blacks-only dance and show at the Roanoke Auditorium on August 7. The performers were Deek Watson and his Brown Dots, Savannah Churchill, and Luis Russell and his orchestra, which included vocalist Buggs Milton. White spectators were admitted for half price.

Rush Martin of Roanoke was killed in action in the Pacific on August 3.

Robert McCray, twenty, of Roanoke was killed in an auto accident at the intersection of Routes 24 and 117 at Peters Creek on August 5. He was taken to a hospital but died within hours. He was a rising senior at Roanoke College. A passenger, Robert Kasey, seventeen, was injured.

Russell Poff announced in early August that he was the new owner and operator of Poff's Esso Service Station at the corner of Franklin Road and Brandon Avenue.

The Roanoke City Council engaged the services of the engineering firm of Horner and Shifrin from St. Louis, Missouri, to develop a master plan for Woodrum Field. The airport had been subject to various public and private interests vying for space, runways, and hangars. The council adopted the proposal as a recommendation from the airport study committee, which was chaired by N. W. Kelley.

Two challengers unseated incumbents in the Democratic primary for nominations to the Virginia House of Delegates representing Roanoke. The August 7 primary gave victories to Lt. Commander Walter Scott and James Bear, both former members of the House. Those losing were Earl Fitzpatrick and Walter Wood. Fitzpatrick had served in the House since 1938, and Wood was completing his first two-year term. The returns were as follows: Scott, 2,697; Bear, 2,501; Fitzpatrick, 2,262; and Wood, 2,205. In the statewide primary, Roanoker Moss Plunkett lost to William Tuck for the gubernatorial nomination, and Roanoke's state senator, Leonard Muse, lost to Charles Fenwick for the lieutenant governor nomination.

An army P-47 fighter plane on a routine training mission from Millville, New Jersey, crashed on the Bushong farm at the east end of the east-west runway at Woodrum Field on August 8. The pilot, Lt. Robert Gaines, was slightly injured.

Joe Webb and his orchestra performed for a blacks-only dance at the Roanoke Auditorium on August 15. Joining Webb was singer May Belle, "America's real boogie woogie queen of the blues." White spectators were admitted for half price.

Pianist Henry Scott performed on August 18 at the Hotel Roanoke. Scott was known for concert satire, swing, and pantomime. His appearance was sponsored by the Jaycees.

Grand Ole Opry comic "Duke of Paducah" gave a stage performance at the Roanoke Theatre on August 15. He brought with him his "all-star radio show" cast.

Six sisters who were separated in Roanoke in 1896 had a reunion, and two of the sisters had not seen each other for fifty-eight years. The Graham sisters were split apart when their father moved from Roanoke to Missouri. Eventually four returned to Roanoke, but

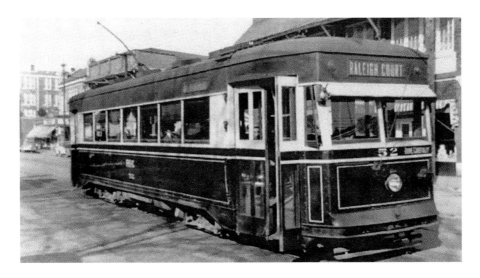

Shown here is Car 52 on Grandin Road near Westover Avenue in 1945.
After the war, streetcars began to be replaced by buses. *Bill Volkmer.*

two went west. The reunion was the first time all the sisters had seen each other in person since 1896.

The Roanoke County School Board voted to solicit Randolph Frantz, a local architect, for preliminary plans for a proposed Cave Spring High School and for an addition to Andrew Lewis High School.

The Safety Motor Transit Company extended bus routes into Prospect Hills, Grandin Court, and Virginia Heights in August in response to citizen requests. While Virginia Heights already had bus service, the lines were extended beyond Grandin Road.

On the morning of August 15, readers of the *Roanoke Times* read a banner headline that had been anticipated for several days: "Japanese Surrender Accepted by Truman." Plans for V-J Day were immediately implemented. Businesses closed for two days, and a celebration in Victory Stadium that afternoon at 4 p.m. was preceded by an American Legion-sponsored parade through downtown. Two unique entries were the center of attention. One was an old truck bearing two open caskets, each containing a skeleton representing the enemy. The other was the entry of the Williamson Road life-saving crew, consisting of a casket containing a window display dummy dressed as "Tojo" with a dagger through his heart. Congressman Clifton Woodrum and Rev. Robert Lapsley addressed the celebration at the stadium. Lapsley was representing the Roanoke Ministers' Conference. An estimated ten thousand attended, led by Herman Larson in singing the National Anthem, the "Battle Hymn of the Republic," and other patriotic selections. That evening the Salvation Army Band performed a concert of sacred music in Elmwood Park. In Salem, a parade was held that went from Langhorne Place to Municipal Field for an afternoon concert. Dr. Charles Smith, president of Roanoke College, addressed the gathering of two thousand citizens. The Salem parade consisted mainly of military and veterans' organizations, Scout troops, staff of the Veterans Hospital, and the fire department and rescue squad.

A Victory Parade was held in downtown Roanoke on August 15, 1945, the day
after the surrender of the Japanese. *Historical Society of Western Virginia.*

A crowd is in front of the Municipal Building in Roanoke to watch the Victory Parade.
Businesses closed for two days to celebrate. *Historical Society of Western Virginia.*

The American Viscose Life Saving Crew marched in the Victory Parade, seen here moving east along Campbell Avenue. *Virginia Room, Roanoke Public Libraries.*

Many Roanokers learned of the Japanese surrender via radio on the evening of the fourteenth. Automobile horns blared, fireworks were set off in backyards and farms, and thousands descended upon downtown Roanoke as pedestrians carried pots, pans, buckets, and any other metal household object to bang and drum to celebrate the announcement. Streetcar lines were blocked such that buses had to be used in their place. And for the first time since 1918, the bell in Firehouse No. 1 rang out. Laymen rushed to churches to ring steeple bells in neighborhoods, and servicemen on leave in the city snaked through the market area in enthusiastic impromptu victory parades.

Fergus Bowman, seventy-two, one of the partners in Bowman Bakery and a son of the founder, Alex Bowman, died at his home in Roanoke on August 14. Bowman was a native of Scotland who came to Roanoke in 1888.

DeMoss Taylor, a well-known Realtor, died at his home in Roanoke on August 16. He was seventy-three. A native of Franklin County, Taylor served as president of the City National Bank in Roanoke from 1913 to 1914 and then established the City Development Corporation, which he was operating at the time of his death. Taylor acquired a well-known West Virginia resort, Old Sweet Springs, and then sold it to that state after he had restored it. He had also tried to develop Hilltop, a home for older women, in Fishburn Park but abandoned the idea due to opposition.

It was revealed that since September 1944, the Virginia Foundry on Ninth Street, NE, had been making parts for the atomic bombs that were dropped on Japan. The

foundry produced precision parts that were used in the bomb itself and in the assemblage. O. G. Huffman, foundry owner, stated that he and the workers were unaware that the parts they were producing were for that project, as the drawings were kept secret. One particular part was nicknamed the "bird cage" by employees because of its appearance.

The commanding officer of the Radford Ordnance Works and New River Ordnance Works announced that by the end of August, the entire work force of the two plants would be released. This action affected many in the Roanoke Valley who worked at the two plants.

Roanoke City police set a period of four days for fireworks to be allowed in the city to celebrate the conclusion of the war. Police officials announced the set period in response to citizens making noise complaints.

Baltimore Tailors, located at 138 Campbell Avenue, SW, announced they were going out of business. Manager Jerry Via stated that the building they leased had been sold and that the war rationing program had limited their supplies such that they could not continue.

Cpl. Russell Boyd of Roanoke died from wounds received in an auto accident in France on July 27. Horace Clark, USNR, of Roanoke was killed while riding a roller coaster on Long Island Beach, New York, on August 18.

Cost of construction of the Carvins Cove water project was estimated to be between $1.6 and $1.7 million, according to bids opened by the city manager. The cost represented a 35 percent increase over prewar estimates. The city council accepted low bids from seven contractors for work including pipe construction, filter plant construction, filter equipment, valves, and other items.

Twenty additional German POWs were allotted for harvesting corn and picking apples in Roanoke and Botetourt Counties. The POWs were housed at camps in Salem and Catawba. The additional prisoners brought to fifty-five the number of German POWs at the two camps.

Richards Dry Cleaning opened in West Salem, opposite the Log Inn, the week of August 19.

On August 22 the federal Civil Aeronautics Board approved direct-carrier air service for Eastern Airlines, Inc., that included intermediate stops in Roanoke.

James "Deacon" Brown, an assistant head waiter at the Hotel Roanoke for sixty-two years, died on August 22. He was eighty-five. Brown began his career at the hotel as a kitchen assistant. During his time at the hotel, he had served many notable guests, including Charles Evans Hughes and William Jennings Bryan. The *Roanoke Times* editorial board called Brown "a venerable institution" who was "rich in the esteem of all who knew him."

Robert M. Clarke, USNR, of Roanoke, was killed November 8, while aboard the USS *Canberra*, which had been torpedoed by the Japanese. Staff Sgt. John McVey of Roanoke was listed as killed as he had been missing in action over Germany since March 6, 1944. He was a turret gunner on a B-17.

Mae's Beauty Nook opened on August 24 at 615 Franklin Road.

Another popular proposal for a war memorial was put forth in late August. The idea of a Roanoke War Memorial Library was presented to Roanoke's War Memorial Committee by the city's library board as the library staff was already engaged in the process of gathering and preserving war service records and other items pertaining to the

local support of the war effort. The library board had previously presented plans for a new library, and the new building would become a war memorial.

Building lots were advertised for Virginia Heights Extension, specifically on Roanoke, Berkley, Virginia, Northumberland, and Maiden Lane Avenues. House lots ranged between $200 and $600.

Hollywood star of movie westerns Brad King held a show on the stage of the Roanoke Theatre on August 29. The show also included "his saddle pals" Eddie Patterson and Smiley Marvin.

Capt. Beverly Smith of Vinton was killed in action over Kuyushu on July twenty-eight. He was a P-51 pilot.

The warehouse of the Virginia Scrap Iron and Metal Company at 1600 S. Jefferson Street caught fire on August 29. The three-alarm fire resulted in an estimated $100,000 worth of damage. The company was owned by Ike Cohen of Roanoke and his brother, Abe, of Lynchburg.

Tex Ritter, well-known American singer and balladeer, performed at the Roanoke Auditorium on August 30. His show was called *Western and Hillbilly Jamboree* and included cast members the Milo Twins of the *Grand Ole Opry*, Dubb "Cannonball" Taylor, "Slim" Andrews, and Bonnie Dodd.

Christine Chatman and her boogie orchestra performed for a blacks-only dance at the Roanoke Auditorium on August 31. Chatman was a recording artist with the Decca label.

David Hull, president of the Virginia Iron, Coal and Coke Company in Roanoke, died at his home on August 30. Hull was seventy-three. He was also active in civic affairs, including service as a trustee of Hollins College and a member of the board of visitors at UVA.

The War Manpower Commission announced in early September that the two German POW camps in the Roanoke Valley would close in the fall. The Salem camp and the Catawba camp would close on November 1. The two camps housed two hundred Germans who provided farm labor. The Salem camp was government owned, being used previously as a truck repair shop for the Civilian Conservation Corps.

Warren Bryan, USNR, of Roanoke County was killed in a plane crash near Haltsville, California.

An architectural rendering of the Vinton War Memorial Library was printed in the September 2 edition of the *Roanoke Times*. The proposed site for the library was a twelve-acre site on Washington Street, and the building's costs were to be funded through a $10,000 subscription campaign. A Victory Rally was held on September 3 on the site to launch the campaign. The guest speaker at the rally was Judge Lindsay Almond.

Stepin Fetchit, billed as "Hollywood's latest comedian in rhythm," performed at the Roanoke Auditorium on September 7. Joining him for the stage show were Laura Horne, pianist Sammy Price, and trumpeter Frank Humphries and his orchestra.

The Nashville Black Vols and the Knoxville Grays, both affiliated with the Negro Southern Baseball League, played at Maher Field on September 5.

The Roanoke War Memorial Committee heard another presentation for a proposed war memorial for Roanoke: designating the proposed armory to be erected at Maher Field

as a memorial. While the committee received the proposal, they set a fixed deadline of December 31 for any other proposals.

Billie Holiday, Joe Guy and his orchestra, Sid Catlett, and Al Casey performed in a 10:00 p.m. to 2:00 a.m. show at the Roanoke Auditorium on September 12.

"Cousin Wilbur" and the Tennessee Mountaineers from the *Grand Ole Opry* performed at the Roanoke Theatre on September 12.

An architectural rendering of the proposed armory and its relation to Victory Stadium appeared in the September 9 edition of the *Roanoke Times*. In the drawing, the river end of the stadium was enclosed, making the stadium U-shaped, with the armory on the opposite end. The armory and stadium addition were presented to the War Memorial Committee as a proposed war memorial for the committee to consider. The proposed armory included a memorial room complete with large bronze tablets to contain the names of those who served, along with flags and war-related memorabilia. In addition to being a training facility for the National Guard, the proposed armory was also suggested as a venue for entertainment, concerts, and civic gatherings as it included a drill hall and auditorium with stage. The auditorium had a seating capacity of 4,200. J. E. Crawford chaired the group that presented the grand design to the committee.

Cpl. William Mason of Roanoke was killed in an automobile accident while stationed in Italy on June 24. First Sgt. John Furrow Jr. of Roanoke was killed in action on January 1 over Germany.

Woody Herman and his orchestra performed at the Roanoke Auditorium on September 11. His leading vocalist was Frances Wayne. The whites-only dance did admit black spectators for half price.

Lotz Funeral Home opened its newest chapel the week of September 9 at 650 Campbell Avenue. The chapel had two reposing rooms, a two-hundred-seat chapel with an adjoining family room, and a Hammond organ.

The Roanoke City Council held a number of executive sessions and paved the way for the Roanoke Railway and Electric Company, Safety Motor Transit Corporation, and the Lynchburg Transit Corporation to merge.

The Knoxville Grays of the Southern Negro Baseball League played the Pittsburgh Crawfords of the Negro National League at Maher Field on September 13 and 14. Fred Lawson was the local promoter, and a section of stands was reserved for white spectators.

The Fireman's Protective Association, an organization for the benefit of Roanoke city fire personnel, received a charter from the State Corporation Commission.

An application was filed with the FCC by the Virginia Broadcasting Corporation for a construction permit to operate a third radio station in Roanoke. The permit was for a one-thousand-watt station.

Ernest Johnson and Bad Boy Brown wrestled before a large audience at the Roanoke Auditorium on September 13. In a second match, Jack O'Brien won over Chief Saunooke.

Claude Evans advertised the opening of his Evans Esso Service at Cave Spring in mid-September.

Reid & Cutshall, Heironimus, and Dowdy Electric Company all began advertising the Bendix Automatic Home Laundry: "fills itself with water, washes clothes, triple rinses them, damp dries them, empties itself, cleans itself, shuts itself off." They all offered in-store demonstrations of the new machine.

Eastern Airlines officials announced in mid-September that Roanoke would offer direct flights to Detroit and Miami beginning November 15 when Eastern Airlines would begin operating that air service.

Fred Maxell of Starkey was charged on September 19 with the murder of Burley Grubb of Roanoke County. The shooting occurred in Pinkard Court the previous day.

The Roanoke City Board of Health proposed to the War Memorial Committee erecting a city health center as an appropriate war memorial. The proposed health center would cost an estimated $100,000 and would include health department offices, clinics, and labs. No site was suggested.

Lt. Robert Angell of Roanoke died February 25, 1944, while a prisoner of the Japanese.

Benny Carter and his orchestra performed for a blacks-only dance at the Roanoke Auditorium on September 24. The dance was sponsored by the Bing Social Club. White spectators were admitted for half price.

Western radio and movie actor Ray Whitley performed at the Roanoke Theatre on September 26, having starred in the film *Oklahoma Wranglers*.

Sherrill's, an interior decorating store that carried antiques and reproduction furnishings, opened at its new location at 22 West Church Avenue on September 23.

Aubrey Wallace, prominent in Roanoke civic and business affairs, died on September 25 in a local hospital. Wallace, fifty-nine, was a native of Hinton, West Virginia, and was formerly employed by the N&W Railway and by the Veterans Administration Hospital.

Detective Sgt. Joseph Jennings of the Roanoke city police force was shot with his own gun on September 26 when engaged in a scuffle with a local youth, Frank Spence. The bullet entered his chest, struck his spinal column, causing paralysis. Jennings was taken to Lewis-Gale Hospital.

A physical therapy department for Roanoke Hospital was secured through a generous $50,000 donation for that purpose by Mr. and Mrs. Charles Lunsford.

Everette Thurman, Roanoke tenor, signed a contract to sing the lead in the Shubert production of *Love in the Snow* that was scheduled to open in New York City on December 1.

Erskin Hawkins and Tuxedo Junction Orchestra performed for a blacks-only dance at the Roanoke Auditorium on October 1. White spectators were admitted for half price.

Big Lick Motors opened at 615 Commerce Street, SW, Roanoke, on October 1. It advertised itself as distributors for Willys brand of cars, trucks, jeeps, and farm equipment. Alvin Childress Jr. was the general manager, and Sy Caudill was the service manager.

The C&P Telephone Company announced in late September plans to add a three-story and basement addition to its building at the corner of Third Street and Luck Avenue, SW. The $300,000 addition was designed by architect M. C. Lee of Richmond, and work was intended to start by year's end.

The Virginian Railway announced the purchase of four General Electric Company electric locomotives to be used on its electrified service between Roanoke and Mullens, West Virginia. The new locomotives connected with mallets of the 900 Class and the 2-8-4 steamers produced by Lima Locomotive Works for freight hauls between Roanoke and Norfolk.

Cpl. Joseph Findley of Roanoke was officially listed as dead. He had been listed as missing in action during the invasion of Holland in September 1944. Ensign Robert Hobart of Roanoke died at sea on September 18 as the result of a typhoon in the Pacific.

Thomas Jenrette, city recreation director, outlined proposed improvements to Roanoke parks before the Roanoke Recreation Association. On the list were converting a barn in Fishburn Park into a rec center; painting and repairing Rockledge Inn on Mill Mountain; installing new furniture and a basement shower at Buena Vista house; constructing a softball field and picnic area for Lakewood; and building a new park in northwest.

Officials at Hotel Roanoke unveiled plans in late September for a renovation of the hotel at a cost of over $1 million. The expansion and improvements included the complete replacement of one wing, air-conditioning the entire hotel, installation of Turkish baths, adding a fountain room, modernizing the radio equipment, and general restoration of public spaces. The project was slated to begin December 1 and conclude by October 1946. The original portion of the hotel was built in 1882 with only thirty-eight rooms, with an addition in 1888. In 1916, a three-story, seventy-two-room addition was built on the old east wing site. In 1931, a four-story addition was constructed to replace the old north wing along with a modern sixty-car garage.

Lt. John Washburn of Snow Creek, Franklin County, learned that he was one of the last men to drop a bomb on Japan. In a letter to his parents, Washburn wrote: "I was over Tokyo when I heard the news of the Japanese surrender. We had just made an attack and were pulling out of our dive when our ship called us back by radio to say the Japs had surrendered. So ours was the very last attack on Tokyo."

Grandin Court Baptist Church was organized the first week of October, with charter members being received during nightly services. The Rev. H. W. Connelly, former pastor of Melrose Baptist Church, was the week's speaker. The meetings were being held in a temporary building on Brambleton Avenue at Spring Road. The formal organization occurred on October 7.

This 1945 photo shows the first chapel of Grandin Court Baptist Church on Brambleton Avenue at Spring Road, SW. *Grandin Court Baptist Church.*

The Catawba POW Camp that was supposed to close on October 1 remained open as 80 POWs were serving farmers in Roanoke County. The camp's closing date was postponed until November 16, and the Salem camp's closing date was postponed until November 30. There were 148 German POWs at the Catawba camp and 148 at the Salem camp. Some POWs were scheduled to leave prior to the camp closing dates.

Sgt. James Baldwin of Roanoke was killed in action in Holland on October 4, 1944. He had previously been reported as missing.

Roanoke's War Memorial Committee received another proposal for a war memorial, that being a large marble rotunda in Elmwood Park. The proposed rotunda was suggested to be similar in design to the Lincoln Memorial in Washington, DC, and also that at the University of Virginia. Local architect Ben Eubank along with a group of veterans submitted the concept that had an estimated cost of $250,000. Eubank's design called for a white marble rotunda approximately four hundred feet back from Jefferson Street with an approach the width of Jefferson Street. The interior of the rotunda would contain a large transparent globe with interior lighting to show all continents. Around the wall of the rotunda would be names of those that died in military service, as well as the possibility that families could place the ashes of those killed within the wall.

Two German POWs who had escaped from a camp in Michigan were caught in Roanoke on October 3 by city policemen. The prisoners had ridden box cars to the city. Railway workers had spotted what they thought were escaped convicts on railway property and notified police.

Members of Raleigh Court Presbyterian Church observed their twenty-first anniversary on October 7 by dedicating their church, which was announced as debt free. The church was organized in October 1924 with 156 charter members. A meeting on June 5, 1924, was held in the Raleigh Court Methodist Church to determine interest in forming a Presbyterian church.

The University of North Carolina played Virginia Tech in football at Victory Stadium on October 6. The game was the season opener for Tech. The Virginia Tech band performed in front of the municipal building downtown and then paraded to the stadium for pregame ceremonies. UNC won 14–0. Attendance was six thousand in the twenty-one-thousand-seat stadium.

Sgt. Thomas Youell Jr. of Roanoke was presumed dead by military officials. He is believed to have died in Holland in September 1944 when he went missing in action. Second Lt. Joseph Holcomb was killed over Germany on April 26, 1945.

Congressman Clifton Woodrum informed Roanoke City leaders that federal funds were not available for an armory. Woodrum reported that unless grants or other monies became available via programs to provide employment for veterans, he did not foresee any future federal funding for the project.

Virginia Cab Company officially changed its name to Yellow Cab Company of Roanoke, Inc., on October 10. The fifty-cab company resumed operating its full fleet, as war rationing had curtailed the use of cabs nationwide. "Dial 7711 for a Yellow Cab" read its advertisements.

At the auction sale of the Booker T. Washington birthplace and surrounding lands, an unknown buyer, S. J. Phillips, had the highest bid at $7,160. Phillips stated to auctioneers that he was an agent for S. B. Huff of the Nehi Bottling Company in Roanoke. Per terms of the auction, Phillips presented a $500 check signed by Huff. The check was

drawn from the Nehi account. Both Phillips, who was black, and Huff were represented by Al Hughson, a Roanoke attorney. Two weeks later, Phillips announced from Tuskegee, Alabama, that he planned to make the property a shrine to Washington.

Western movie actor Jimmy Wakley performed on stage at the Roanoke Theatre on October 10.

A "Negro Scout O-Ree" was held in Washington Park on October 13. It was the very first program of this type to be held for the seven black Boy Scout troops in Roanoke. The seven troops were comprised of eighty-four boys. According to local Scout leaders, the Scout O-Ree would mirror the Boy Scout Jamboree held every spring. About 120 scouts and leaders participated.

The touring production of the Broadway play *School for Brides* came to the Academy of Music on October 13. The play starred Lester Allen, Ethel Britton, Warren Ashe, and Mady Correll, all of whom had performed the play on Broadway.

Civic leaders in Vinton held a groundbreaking ceremony on October 13 for the construction of a municipal swimming pool in Vinton War Memorial Park. Miss Margaret Keeler, who was "Miss Vinton of 1944," and town mayor Joe Pedigo turned the dirt.

Hot Lips Page and his orchestra performed for a blacks-only dance at the Roanoke Auditorium on October 15. Page had formerly been with the Artie Shaw Orchestra. White spectators were admitted for half price.

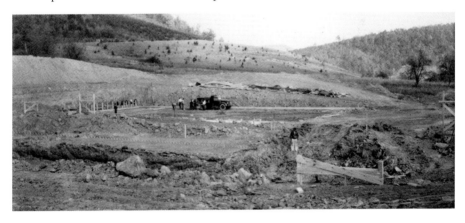

This is looking northeast across the Carvins Cove filter building and settling basins in October 1945. *Western Virginia Water Authority.*

Roanoke city councilman Robert Cutshall announced in mid-October that he was resigning from the council prior to the end of the calendar year. Cutshall wished to devote his energies full time to his furniture business. Cutshall was elected in 1943 to an unexpired term and reelected in 1944 to a full, four-year term.

A new American Legion group, Veterans Facility Post No. 202, was presented its charter during an installation ceremony on October 17 in the facility's recreation hall.

Olde Dominion Manufacturing Company began offering a new item never offered before in Roanoke: home and farm food freezers. The cabinet freezers were produced following the lifting of war restrictions. Carl Windel was president of the company and indicated his plant would be manufacturing the freezers for a national market.

Beginning in its October 14 edition, the *Roanoke Times* launched a regular weekly feature called "Aviation News and Activities at the Airport." The editor noted that much activity was occurring at Woodrum Field along with the development of commercial aviation in general that readership would follow the column with interest. At the time five flying services were based at Woodrum Field: Bohon Aviation, Hicks-Kessler Flying School, Hunter Aviation Services, Martin-O'Brien Flying Service, and Woodrum Flying Service. Frantz Flying Service was awaiting airport expansion. Marshall Harris was airport manager.

The Ringling Brothers and Barnum & Bailey Circus came for two days to Maher Field on October 18 and 19, with two performances each day. Features included Alice in Circus Wonderland, musician Deems Taylor, nine elephants, sea lions, leopards, a ballerina on horses, gorillas Gargantua and Toto, the Great Wallendas on the high wire, gymnasts, a hundred clowns, and a circus band. The circus arrived by three trains. The first train consisted of three stock cars, sixteen flat cars, and three coaches drawn by a Class 2100 N&W mallet engine. The second train had three stock cars, eighteen flat cars, and nine coaches; and the third train had four stock cars, eleven flat cars, and twelve coaches.

In the Bent Mountain section, Roscoe Craighead sold his store to Roy Gearhart and purchased the store of Riley Poff at Copper Hill.

Some two thousand persons attended a temperance rally at the Roanoke Auditorium on October 14. The event was sponsored by the Roanoke Ministers' Conference and the local chapter of the Women's Christian Temperance Union. The speaker was Bishop Edwin Hughes of Washington, DC, a Methodist.

A new bus went into service on the Roanoke-Starkey bus line as well as an extension of the line itself in mid-October. An additional application for an extension had been made to provide service to Cave Spring and Campbelltown. Charles Hubbard operated the line.

The Roanoke City Council directed the city manager to solicit bids for enclosing the east stands of Victory Stadium and for creating a reservoir at Carroll Avenue and Twenty-First Street, NW. The enclosing of the east stands at the stadium was time sensitive as officials from the Hotel Roanoke were planning to use the stands for storage of equipment and furnishings during the hotel's upcoming renovations. Further, the enclosed area would serve the proposed armory.

The touring production of *Angel Street* with its New York cast came to the Academy of Music on October 18. The lead roles were performed by Viola Keats and John Adair.

D. W. Bradley, manager of Roanoke's Sears store, opened a new Sears farm store directly across from the main store in the first block of East Church Avenue on October 18. The farm store included a life-sized dairy barn model, a saddle department, farm machinery, and live poultry.

Lt. Gilbert Perry of Roanoke was killed on October 9 by a typhoon at Okinawa.

Congressman Clifton Woodrum announced that he would officially retire from Congress on December 31. His letter of retirement and resignation was sent to Virginia Governor Colgate Darden and Speaker of the US House of Representatives Sam Rayburn.

A navy air show was given at Woodrum Field the week of October 21, which involved the fighter squadron of the USS *Yorktown* doing various maneuvers throughout the week for the general public.

The N. W. Pugh Company announced in late October a $250,000 remodeling plan for their downtown Roanoke store at Campbell Avenue and First Street, SW. Store officials stated that the work would begin before the end of the year. The remodeling plans, which included an additional sales floor, were developed by Paul Behlas and Associates of New York. Plans included the installation of two elevators, expansion of the fourth floor, and air-conditioning on all four floors, according to N. W. Pugh Sr., company president.

The Peters Funeral Home located at 2408 Williamson Road opened in late October. L. L. Peters was president and operator, and the funeral home was located in what was formerly a private residence.

Mrs. Billy Sunday, widow of the famous evangelist, addressed a women's Christian business organization at the Hotel Roanoke on October 21.

The Methodist Church at Bent Mountain sold its property to N. C. Thompson with the understanding that he would not occupy the church building until next September to allow the Methodists to complete construction of their new church near Bent Mountain School. It was also understood that the Primitive Baptists would be allowed to use the Methodist church prior to September, however.

John Barbour, prominent Roanoke contractor, died at his home in South Roanoke on October 22. Barbour came to Roanoke in 1889 and was a contractor for homes, apartment buildings, two hospitals, and several schools in Roanoke.

The Roanoke School Board authorized the purchase of two tracts of land for future schools at its meeting on October 22. One tract was 5.5 acres and located at the northwest corner of Fifth Street and Lynchburg Avenue, NW. The other was 11.3 acres located on Spring Road and Woodlawn Avenue, SW.

Construction of a Boy Scout camp for blacks was given approval by members of the Roanoke executive council of Boy Scouts. No definite decision on a site was made, though several were said to be under consideration.

Staff Sgt. James Shaw of Roanoke was reported as dead, having been listed as missing in action since February 1944. Shaw was aboard a B-24 lost over Austria.

Cal Shrum and his Rhythm Rangers performed on stage at the Roanoke Theatre on October 24. Others included in the show were Alta Lee and the Rhythm Ranger Trio.

The first new model automobile to be seen in Roanoke since 1941, when the government stopped all auto production, arrived at Magic City Motors in late October. Before being displayed, the new 1946 two-door Ford sedan was garaged at the home of W. M. Mayhew in South Roanoke, president of the dealership, until it could be officially displayed on October 26. Identical models were also displayed at other area Ford dealerships, including Wiley-Hall Motors on West Main Street, Salem.

The University of Virginia played Virginia Tech in football at Victory Stadium on October 27. UVA won 31–13. Approximately twelve thousand attended the afternoon game.

Allan Edelman, age five, of Williamson Road area was found hanging in a small tree near the Mary Lou Apartments. His death was believed to have been caused from climbing the tree with his knapsack and then losing his footing and becoming caught in the straps of the pack.

The Belk-Leggett department store chain, headquartered in Charlotte, North Carolina, announced in late October they had acquired a twenty-year lease for 112 W. Campbell Avenue, Roanoke. At the time of the announcement, the building was occupied

by Montgomery Ward. The Belk-Leggett lease was to start March 1, 1946. The Campbell Avenue building was owned by S. D. Ferguson.

Lt. Randolph Peale of Roanoke was reported dead, having been missing in action since April 1, 1944, when he was a pilot on a B-24 in the European theater.

C. P. Stephenson and W. R. Aldridge announced the opening of their new furniture store, Stephenson & Aldridge, at 111 E. Campbell Avenue in late October. Stephenson had formerly been with Morgan-Eubank Furniture, and Aldridge had been with Wickham Furniture Company.

In late October radio-air history was made in Roanoke when Irv Sharp of WDBJ broadcast live during the navy air show at Woodrum Field from the passenger seat of a Stinson Voyager being piloted by Martha Ann Woodrum.

This photo was probably taken at the navy air show at Woodrum Field in October 1945. The boys are (*l–r*) Lawrence Hall, Buddy Wingfield, Raymond Hall. *Raymond Hall.*

The *Atlantic City Follies of 1946* came to the Roanoke Auditorium on October 30. The fifty-member cast included Marva Louis, Peg Leg Bates, and Colridge Davis and his orchestra.

Pfc. Harris Almond of Roanoke died on October 18 in a hospital in France. Pfc. David Puckett Sr. died in Germany on October 8.

Pianist Jimmy St. Clair and his orchestra played for what was billed as "Roanoke's First Big Annual Halloween Dance" at the Roanoke Auditorium on October 31. The Wanderers of the Wasteland also performed.

The Williamson Road Water Company formally took over the Phelps Water Company on October 31. The purchase price was $250,000.

James McGhee, sixty-four, was shot and killed in front of his home on Morton Avenue, SE, on October 31. Arrested for the shooting was Theodore Grubb. Grubb claimed he shot in self-defense.

Ten acres burned on Buck Mountain on November 2, but firefighters were able to bring the brush fire under control within a day.

In early November, Clinton Poff opened a garage at the Air Point post office for general repair work.

Police investigated the death of Alvin Casey, age seven, of the Dundee section, who was killed when he fell from a school bus at Buzzard Rock ford on November 2. According to reports, the bus was overloaded, and as it rounded a turn, the bus door swung open, and Casey was thrown into the road and suffered a fractured skull.

Ten children were injured when a dump truck hit a school bus in the Bent Mountain section on November 2. Four children required hospitalization. According to reports, the bus was parked at the Bent Mountain post office off the road when it was hit by a dump truck that swerved after hitting a car.

The McAvoy Music House opened at 108 W. Church Avenue in Roanoke and carried the Baldwin line of pianos.

Virginia Bryarly opened the Wag-N-Bark boarding kennel at 101 Williamson Road on November 4.

Danish pianist and humorist Victor Borge performed at the Academy of Music on November 5. He was also joined by his twenty-six-piece orchestra. The *Roanoke Times* noted a humorous incident during the concert. "It was unfortunate but doubtless unavoidable that the spotlight went wrong in the last half of the program and (Borge) was compelled to play and conduct with his side to the audience in the shadows, only fly lights serving to illuminate the stage…The principal made a joke of that by holding a lighted match before his face when he took the bow after the first number in which the spot failed."

Grand Ole Opry star Jimmy Selph came to the Roanoke Theatre on November 7, giving a stage performance of his hillbilly comedy *The Mountain Scandals*. Barbara Jeffers of *National Barn Dance* fame was also in the cast.

Local agents with the federal Alcohol Tax Unit reported that regional moonshining was on the rise. Since war rations had been lifted, moonshiners were able to get sugar and tin containers in ample supply. In the month of September, agents had destroyed eighteen stills in the Roanoke area. The agents also reported that moonshine whiskey was selling for ten dollars a gallon "in the woods," with much of it being sent to North Carolina and West Virginia.

Rev. Richard Owens, who had served as pastor of Calvary Baptist Church in Roanoke for twenty-six years, announced his retirement effective January 6, 1946. The church's membership was 2,500.

In the statewide election for governor, lieutenant governor, and attorney general held November 6, Roanoke County voted 1,256 for Tuck (D) and 1,328 for Landreth (R) for governor; 1,341 for Collins (D) and 1,231 for Marshall (R) for lieutenant governor; and 1,353 for Staples (D) and 1,213 for Parsons (R) for attorney general. In Roanoke city, the votes were as follows: Tuck, 1,865, and Landreth 1,932; Collins 2,101 and Marshall 1,661; and Staples 2,184 and Parsons 1,634. Democrats swept the elections statewide. In the House of Delegates races, nominees Bear and Scott in the city were unopposed as were all local constitutional offices. In Roanoke County, delegate Furman Whitescarver was reelected without opposition.

Cab Calloway and his Cotton Club Orchestra played for a blacks-only dance at the Roanoke Auditorium on November 10. Calloway was joined by Dottie Saulters, vocalist, and Jonah Jones and his Cabdrivers. White spectators were admitted for half price.

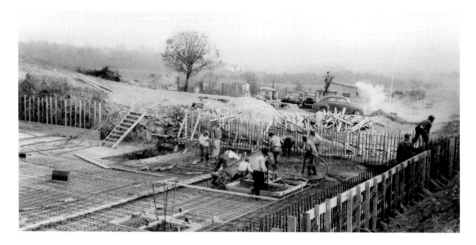

This image shows the second pour of concrete at the City Farm Reservoir in November 1945. Municipal infrastructure projects were significant after the war. *Western Virginia Water Authority.*

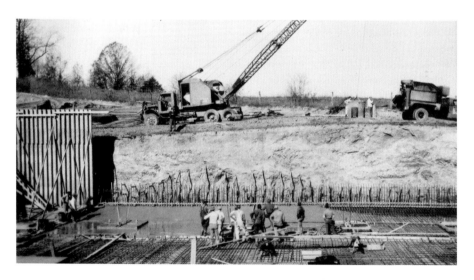

This shows the pouring for the floor on the west side of the City Farm Reservoir in November 1945. *Western Virginia Water Authority.*

A proposed master plan for Woodrum Field was presented to the Roanoke City Council on November 8. The plan called for a three-stage, $3.7 million expansion and improvement of the airfield. The council deferred action on adopting the plan pending formal approval of the plan by the Civil Aeronautics Authority. The plan called for the realignment of runways, expanded hangars, and a new terminal facility.

The rebuilt Virginia Theatre reopened on November 11. Emmett Nabors was manager.

Federal officials announced that the Catawba POW camp would close on November 15.

Pvt. Frank McGrady of Roanoke County was reported as dead, having been previously listed as missing in action while crossing the Rhine River in Germany on March 25, 1945.

The Roanoke City School Board proposed a war memorial auditorium be built in the central part of the city. The proposal was formally submitted by the board to the War Memorial Committee. The school board suggested a three-thousand-seat facility be erected between Sixth and Seventh Streets, SW, as a civic auditorium. The school board and administration asserted that the Roanoke Auditorium was being taken over by the N&W Railway and a new one was needed, given the limitations of school auditoriums.

Roanoke College held a memorial service on its campus on November 14 to remember the thirty-two men of Roanoke College who died during World War II.

Benny Goodman and his orchestra appeared at the Roanoke Auditorium on November 16. Members of the orchestra included Red Norvo, Charlie Queener, Morey Feld, and Mike Bryan. Liza Murrow was vocalist. Blacks were permitted to view from the balcony.

The "Great Silver Fleet" of Eastern Airlines began operating at Woodrum Field on November 15. The fleet provided direct service from Roanoke to Miami, Jacksonville, Cleveland, Akron, and Detroit. Direct regional flights went to Greensboro, High Point, Columbia, Charlotte, Charleston (West Virginia), and Savannah. To celebrate the inauguration of Eastern Airlines service to Roanoke, the airlines' president, Capt. Eddie Rickenbacker, spoke to an audience of two hundred gathered at Woodrum Field for the occasion. Roanoke was the intermediate stop on Eastern's Detroit-Miami flight. Rickenbacker stated, "It's been a long time since I've been here in Roanoke, for I knew this area well during the first days of the automobile; but it's an even greater pleasure paying a visit to Roanoke in the new air age."

Famous aviator Eddie Rickenbacker (*left, foreground*) came to Woodrum Field for Eastern Airlines' inaugural flight there on November 15, 1945. *Virginia Room, Roanoke Public Libraries.*

This was a homecoming scene at the N&W Railway Passenger Station on November 15, 1945. *Digital Collection, Special Collections, VPI&SU Libraries.*

W. C. Cobb, forty-eight, of Roanoke was struck and instantly killed by a Roanoke Railway and Electric Company bus on November 16 at Jamison Avenue and Ninth Street, SE. Cobb was engaged in cleaning the streetcar tracks when the bus struck him.

Tabernacle Baptist Church in the Edgewood section celebrated the dedication of its sanctuary on the occasion of it being debt free on November 18. The congregation began in May 1927, when five lots were acquired for $3,000. The first worship service was conducted in the open air by Dr. E. D. Poe of Belmont Baptist, Roanoke, on June 5, 1927. A temporary structure was erected that year, and the congregation launched with 87 charter members. Ground was broken for the sanctuary on March 18, 1939, and cost $18,000. In 1945, membership totaled 855.

"Cootie" Williams and his orchestra performed at a blacks-only dance at the Roanoke Auditorium on November 20. The famous trumpeter and band leader brought with him singer Ella Fitzgerald. White spectators were admitted for half price.

Rev. Vere Rogers of First Christian Church, Roanoke, was elected to serve as president of the Roanoke Ministers' Conference for 1946.

On Thanksgiving Day, VMI defeated Virginia Tech 7–0 in football at Victory Stadium. The rivalry was renewed after a two-year hiatus due to the war. An estimated twenty-three thousand spectators attended the game for the "Military Classic of the South." Roanoke police called in fifty extra officers to manage traffic to and from the stadium. The best seats for the game were given to boys who carried typewriters and cameras for the press, as they were then allowed to watch the game from the roof of the press box.

The Rev. William F. "Billy" Graham, a field representative for Youth for Christ, International, spoke at Greene Memorial Methodist Church in Roanoke on Saturday, November 24. The program included music, singing, and a quiz game. Graham's appearance was part of formally launching a Roanoke Youth for Christ organization. Some two hundred persons attended the event. The next day, Graham spoke at West End Methodist Church in the morning and then at the United Brethren Church in the evening.

The Army Ground Forces "Victory Loan" train arrived in Roanoke on November 25. The train was welcomed in a ceremony that featured patriotic singing by the forty-member N&W Railway Negro Male Chorus and speeches by railway and city officials. The seven-car train was a kind of museum carrying artifacts and weaponry related to World War II. Among the items on display were Herman Goering's jewel-studded marshal's baton and the documents signed by the Japanese for their surrender. An estimated six thousand persons visited the train during its one-day stop.

The Moore-Williams Company, a men's clothier, announced they had leased the former Oakey's Funeral Home building at 124 W. Campbell Avenue and would relocate to that site in January. The funeral home had been vacant for several years since the Oakey firm had relocated to West Church Avenue. Lewis Moore was president of the clothier.

The Roanoke City Council became sharply split over naming a replacement for the seat vacated by Robert Cutshall. In its meeting of November 26, two names were advocated: Edmund Goodwin and N. W. Kelley. Given that Cutshall remained silent and indicated he would be abstaining, the council was evenly divided between the two men and adjourned with no decision. Ironically, both Goodwin and Kelley had indicated publicly that they had no interest in being appointed.

The comedy *A Soldier's Wife* came to the Academy of Music on November 30 for one show. The touring production starred Mary Hull and Dean Norton in the lead roles, with a supporting cast of Eleanor Barrie, Polly Adair, and George Cavan.

The Pittsburgh Symphony Orchestra performed a concert at the Academy of Music on November 29. The symphony's appearance was sponsored and promoted by the Roanoke Community Concert Association. Earlier that day, the symphony performed for some 1,300 schoolchildren at the academy.

The annual Roanoke poultry show opened in late November with some eighty different breeds of chicken on display in the Roanoke Auditorium. The show featured the

A water line is being installed at Twenty-First Street, north from Hanover Avenue, NW, in November 1945. *Western Virginia Water Authority.*

A water line is being installed along Loudon Avenue, NW, to Third Street in November 1945. Such projects were backlogged during the war. *Western Virginia Water Authority.*

world's largest display of Cornish fowl in that 1,100 of the 1,800 birds on display were of that variety.

The Don Cossack Chorus performed at the Academy of Music on December 1. The twenty-seven-member troupe of Russian singers and dancers was organized in 1926 and had given over four thousand concerts worldwide since its founding.

Minnie Pearl and Pee Wee King returned to the Roanoke Theatre for a midweek performance on the theatre's stage of their *Grand Ole Opry* comedy and music on December 5. They were joined by the Golden West Cowboys, a singing group.

The All City-County varsity football team for 1945 was named and consisted of the following players: Freeman Jenrette (Byrd), left end; Tommy Moore (Jefferson), left tackle; Walter Bishop (Byrd), left guard; Ralph Austin (Fleming), center; Robert Fracker (Fleming), right guard; Frank Beahm (Fleming), right tackle; Bill Manuel (Fleming), right end; Dicky Bunting (Lewis), quarterback; Albert Wilson (Fleming), left halfback; Randolph Cole (Fleming) right halfback; and Charles Williams (Jefferson), fullback.

William Gallagher Jr., USNR, of Roanoke was declared dead by the navy. Gallagher had been reported missing when his destroyer, the USS *Pittsburg*, was torpedoed and sank on March 1, 1942, in Bali Strait off Java.

Robert Jennings, seventy-eight, died at his home in Roanoke on December 2. Jennings was a widely known furniture dealer who opened the first furniture store in Roanoke in 1888. The store was known as the Jennings-Bloxton Furniture Company and was located on Salem Avenue.

"Boots" Frantz began advertising his flying service at Woodrum Field in early December. Frantz offered a presolo course for seventy-five dollars.

Les Brown and his orchestra performed at the Roanoke Auditorium on December 7. Brown was known for his popular hit tune "Sentimental Journey." The whites-only dance admitted black spectators for half price.

The sleek, high-powered 1942 Mercedes-Benz sedan used by Hermann Goering was put on display at the Roanoke Auditorium on December 8. The car's display was sponsored by the local war finance committee and the junior chamber of commerce. According

to Warren Kinsey, chairman of the war finance committee, the display was a fundraiser for his committee's work in selling and promoting war bonds.

Thomas Reed of Roanoke was declared dead by the navy. Reed had been missing since his ship, the USS *Johnston*, was sunk off Samar Island, Philippines, on October 25, 1944.

The New York cast of *Rebecca* performed their play at the Academy of Music on December 8. The cast included Bramwell Fletcher and Ethel Griffies in the lead roles.

Dr. Harry Penn was elected to the Roanoke Democratic City Committee from the Melrose Ward in a mass meeting held at the Hotel Roanoke. He became the first committeeman elected within the Sixth District since Reconstruction. He was unanimously elected by the five hundred in attendance.

Plans for a community center for blacks were announced in early December by H. J. Fekas, president of Modern Enterprises Company. The center's site was to be at Wells Avenue and First Street, NW, and to include a seven-hundred-seat theater, stage shows and dancing, and several stores. Fekas indicated the center would be completed by the summer of 1946.

The Roanoke Children's Theater performed *The Christmas Nightingale* for three nights on the stage of Jefferson High School. Two nights were for white children and the other for black children.

The Appalachian Baseball League suggested that they may expand their league from four to eight teams for 1946 to possibly include Salem. Apparently, Salem leaders had expressed an interest in fielding a team as the minor league team, the Red Sox, had moved to Roanoke.

The Salem Theatre had the magician "Buck" perform for three nights on its stage. According to advertising, those attending watched Buck walk through a door's keyhole, escape a Hindu torture chamber, and use the puzzle rings of China.

Bill "Bojangles" Robinson and his revue came to the Roanoke Auditorium on December 12 for two performances. Joining Robinson were Ada Brown and The Four Knights. One half of the auditorium was reserved for black patrons and the other half for whites.

Lawson Suttles Jr. of Roanoke went to Hollywood to become an actor and took the screen name of "Johnny Blake. Trying to be a young leading man, the nineteen-year-old was screen-tested by Warner Brothers and Columbia Studios. Suttles was seeking to join two other Roanokers, Lynn Bari and John Payne, in becoming a leading actor.

Mrs. Fannie Redd, who was born to slave parents at "Greenfield" in Amsterdam, Botetourt County, and was well known in Salem, died at the home of her son at the age of one hundred on December 12. Redd often recalled riding to a grain mill when Yankee soldiers came through the valley during the Civil War. She was buried at Greenfield.

Trumpeter Frank Humphrie and his orchestra performed for a blacks-only dance at the City Market Auditorium on December 14. The show also included the singing group The Red Caps. White spectators were admitted for half price.

Persons interested in establishing a Methodist church in the Grandin Court section met at the home of Mr. and Mrs. A. R. Taylor on Guilford Avenue on December 16.

Judge J. Lindsay Almond Jr. was nominated by Sixth District Democrats to be their nominee to succeed retiring congressman Clifton Woodrum. He was nominated without opposition. The Republicans nominated George Revercomb Jr. of Covington as their

nominee at a meeting held in the Hotel Roanoke. He, too, was nominated without opposition, and his brother was a sitting United States senator representing West Virginia.

Rev. E. C. Crumpacker, seventy, of Roanoke County was killed in automobile-truck crash on US 460 east of Roanoke on December 15. Crumpacker was a prominent orchardist and was well known as an interim minister for several Brethren churches during his lifetime.

Ensign James Hedrick, USNR, of Roanoke was reported dead by the navy, having been missing in action from the carrier USS *Intrepid* since October 29, 1944.

Charles L. Bentley Jr. announced the opening of his new State Brake and Lubrication Company at 39 Tazewell Avenue, SE, in mid-December. He offered Amoco Gas, and he had previously operated Bentley Service Station before entering the military.

Rock is being excavated for the northeast wall of the Filter Plant
Reservoir in November 1945. Postwar water infrastructure
improvements were critical. *Western Virginia Water Authority.*

Russ Carlton and his orchestra performed for the annual Firemen's Ball held at the Roanoke Auditorium on December 18. The ball was sponsored by the Firemen's Protective Association.

Equipment for two-way radios for five Roanoke County police cars was approved by the board of supervisors. The antenna was placed on Mill Mountain to facilitate county-wide coverage.

A full chamber of the United States House of Representatives heard Rep. Clifton Woodrum deliver a farewell address to his colleagues, after which he received a warm round of applause. In his remarks, Woodrum advocated for benefits for members of Congress, including a pay raise and a pension plan. He also stated that Congress should only convene five to six months during the year and no longer.

A 250-voice boys' choir from eleven Roanoke city elementary schools was joined by the choirs of Jefferson High School, Woodrow Wilson Junior High, and Lee Junior High for a Christmas concert at the Jefferson High School auditorium on December 19.

The first black Cub Scout pack in Roanoke was formed in mid-December at the Jerusalem Baptist Church. Pack Number 116 had Jesse Loveless as Cubmaster.

Donald Rowe, president of Rowe-Jordan Furniture Corporation, announced in late December that his firm would erect a factory for manufacturing upholstered living room furniture in Roanoke. The new firm would establish temporary quarters at 515 Norfolk Avenue, SW, until the new factory was built. The Roanoke architectural firm of Eubank & Caldwell was engaged to design the facility. Donald Jordan was vice president of the firm.

Two Roanokers were selected to ferry Gen. George C. Marshall to and from China in his diplomatic work there. Capt. William Carpenter and Master Sgt. Harry Payne served as pilot and flight engineer respectively. The plane was one used by Winston Churchill and had been recently overhauled at Great Falls, Montana.

With a recent snowfall, eight streets in Roanoke city were set aside and designated for sleigh riding. The streets were Moorman Road; Fifth Street, NW; Elm Avenue, SE; Stanley Avenue; Fourth Street, SW; Center Hill Drive; Longview Avenue; and Eighteenth Street, SW.

Carvins Cove dam is still under construction in this December 3, 1945, image. The cove greatly expanded the city's water supply. *Western Virginia Water Authority.*

A baby boy was abandoned on the front porch of Amanda Long, 116 Thirteenth Street, SW, on December 21. Police sought to identify the child and locate the mother. Long expressed interest in adopting the child if the parents could not be found.

Reuben Lawson opened his law practice at 403 Gainsboro Road, NW, in mid-December. He was a native of Danville.

E. E. West Jr., assistant cashier at the First National Exchange Bank, was named as the successor to Robert Cutshall on the Roanoke City Council. Cutshall had tendered his resignation to be effective December 31, and council had gone through a contentious process of naming a replacement to fill the unexpired term. The council decided with unanimous consent to appoint West, who assumed his duties on January 7, 1946. West was active in several civic organizations.

Lucky Millinder and his orchestra performed for a blacks-only show and dance at the Roanoke Auditorium on December 26. Joining him were the Deep River Boys, Savanah Churchill, and Annisteen Allen. White spectators were admitted for half price.

A circus of vaudeville wonders called *Atomic Scandals* came to the stage at the Roanoke Theatre on December 26. According to advertisements, the show included the Great Darrell, a European magician; twelve bewitching maids of mystery; Delores, the girl

with the transparent body; Marcita, who diminished to one-fourth her size; Cecilia, who floated like a balloon; Dr. Weird's Chamber of Horrors; and the walking dead.

The William Hunton Branch YMCA became debt free just a few days before Christmas, and Hunton Y officials scheduled a celebration for the next month. The building was constructed in 1921 at a cost of $28,000. A campaign to eliminate some $3,200 of remaining debt was launched in the summer and proved successful.

Roanoke City and County's delegation to the Virginia legislature indicated they were in favor of repealing the poll tax during the 1946 session of the General Assembly.

Tommy Manguss of the *Grand Ole Opry* appeared with the Southwestern Troubadours at the Blue Ridge Hall, 323 W. Campbell Avenue, for a Christmas night performance and dance.

Judge Lindsay Almond Jr. resigned from the Hustings Court due to his being the Democratic nominee for the Sixth District congressional race.

Gladys Layman announced the opening of her new restaurant in Garden City near Garden City School in late December.

Rev. Alfred Berkeley, rector of St. John's Episcopal Church since 1926, died at the rectory on Orchard Hill on December 26. He was sixty-five. He was a native of Jackson, Tennessee, and was active in many civic and charitable organizations in Roanoke.

Staff Sgt. Marvin Parsons of Roanoke was reported dead by the army. Parsons had been missing in action since May 19, 1942, at New Guinea.

Roanoke city and county both exceeded their Series E war-bond quota goals. There were a total of eight war-bond drives, and Roanoke never failed to reach its quota. H. G. Nicholson was chairman of Roanoke's War Finance Committee.

The Roanoke City Council asked the city's delegates to the General Assembly for a charter change that would allow the city council to grow from five to seven members. There had been discussion to move to a nine-member body. Council members believed that by enlarging the number of seats on the city council, underrepresented sections of the city would be better served.

Valley Roofing Corporation announced the opening of their new warehouse and shop, effective December 31. The new location was 1607 S. Jefferson Street. They had previously been located at 225 Shenandoah Avenue, NW.

The Sunnyside Awning and Tent Company announced that it would erect a new building to house its company in 1946. The awning company was located at 119 Franklin Road, SW, and they planned to erect a new facility for $40,000 in the 600 Block of First Street, SW, with goal of occupying the new quarters in the summer. Sunnyside was founded in 1908 by the Temple family.

James Ingoldsby returned to his position as superintendent of the Roanoke City Police Department on January 1, 1946. Interim superintendent Capt. H. C. Ferguson returned to his previous position with the detective bureau. Ferguson served in the interim capacity for three years while Ingoldsby was in the military.

The camp and hospital troupe of the Roanoke Civic Theater that was organized by Robert Royer was formally recognized for its work in entertaining troops. One such recognition came from the Woodrow Wilson General Hospital in Staunton, which thanked the forty-five-member troupe for "outstanding morale building activities." Royer organized the troupe in 1942 and during its three-year existence the group traveled some ten

thousand miles, giving performances before some half-million soldiers. The troupe often performed at Camp Pickett and at the Veteran's Administration hospital near Salem.

Roland E. Cook, seventy-one, who served forty years as Roanoke County schools' superintendent, died on December 30. He began his career as an educator in 1896, when he was appointed a teacher for the Norwich School, then in Roanoke County. He became superintendent in 1906. In 1906, there were 95 teachers in sixty-five schools, and by 1945 there were 307 teachers in twenty-nine schools, thereby illustrating the tremendous period of change overseen by Cook within the county school system.

Effective December 31, the Morris Plan Bank of Virginia changed to a new name, Bank of Virginia. It had been known as Morris Plan for twenty-six years. The bank had been first established in Richmond in 1922 and had since expanded to operate in six cities in Virginia, including Roanoke.

The directors of the Dixie Professional Football League met in Richmond and established a ten-game schedule for 1946. The league consisted of franchise teams in Richmond, Norfolk, Portsmouth, Charlotte (North Carolina), Newport News, and Roanoke. The league suspended play during the war. Applications for expansion teams had been received from Knoxville (Tennessee), Greensboro (North Carolina), Atlanta (Georgia), and Asheville (North Carolina), but there appeared little interest from the directors in expanding the league, though no final decision was made at their meeting.

1946

The Roanoke City Council approved the purchase of the Grove Park water system from Elmore Heins at a cost of $100 per customer. Heins had installed the system prior to the area being annexed.

Second Lt. Robert Gleason of Roanoke was reported as guarding Nazi war criminals at their trial in Nuremberg, Germany.

Daily passenger service between Norfolk and Charleston, West Virginia, via Roanoke by the Virginian Railway was announced by William Ayers, general agent. The new service was to start January 13. Previous passenger service required an overnight layover at Roanoke.

Sanitary Laundry and Cleaners opened a new office at 1306 S. Jefferson Street during the first week of January.

Sammy Kaye and his orchestra performed at the Roanoke Auditorium on January 7. Joining him were vocalists Billy Williams, Betty Barclay, Arthur Wright, Susan Allen, and Ernie Rudisell.

Plans for a new two-story, $50,000, Indiana limestone store for George T. Horne and Company were announced on January 7 by Dewey Wynn, president-owner. The new building, designed by Eubank & Caldwell of Roanoke, would be located at 410 S. Jefferson Street. Horne and Company, a women's clothing store, had first opened in Roanoke in 1933.

At Bent Mountain, Mr. and Mrs. N. C. Thompson sold the stocked goods from their store to Mr. and Mrs. Barton, who took charge of the Thompsons' store.

The Camp Peery Pirates beat the Old Dominion Rebels 53–47 in a basketball game on January 8 at the Roanoke Auditorium.

The Roanoke Ministers' Conference strongly opposed the exclusion of sending relief clothing to the nations of Germany and Japan. Several agencies were collecting locally, but the organizers had refused to send clothing to the two Axis nations. The local ministers felt the exclusion immoral given the dire needs of the citizens of those countries.

Plans for a new apartment building on Grandin Road were presented to the Roanoke City Council on January 7. The twenty-or-more-unit complex was presented by Walter Wood, representing the Raleigh Court Land Company. He sought a rezoning for the east side of the 400 Block of Grandin Road, noting another apartment complex was nearby.

All stock and securities of the Roanoke and Lynchburg transit systems were purchased by S. A. Jessup of Charlottesville on January 8. The Roanoke transit system was composed of two separate corporations, the Roanoke Railway and Electric Company and the Safety Motor Transit Corporation. At the time of the sale, the Roanoke Railway and Electric Company operated eighteen streetcars within Roanoke City and forty-three buses

serving the suburban areas. The Safety Motor Transit Corporation operated twenty-five buses within the city limits.

William Chattin, thirty, of Blue Ridge was found shot to death off Yellow Mountain Road by local police. Sheriff Emmett Waldron of Roanoke County said law enforcement had no suspects. Chattin was employed by a local service station and had been reported missing a few days prior to the discovery of his body. After further investigation, Roanoke County authorities believed that Chattin had been kidnapped from the service station where he was employed, taken to woods off Yellow Mountain Road, robbed, and then shot three times.

The new Vinton chapter of the Veterans of Foreign Wars was organized on January 10 at a meeting held at the Vinton municipal building.

The Salem Baptist Church announced plans to build a $100,000 educational building adjacent to the sanctuary on Broad Street.

The following financial institutions reported liabilities and assets as of December 31, 1945: Roanoke Industrial Loan Corporation, $343,660; Mountain Trust Bank, $17.35 million; Colonial American National Bank, $17.278 million; Liberty Trust Bank, $6.073 million; Bank of Virginia, $52.716 million; and First National Exchange Bank, $71.326 million.

The same killer who robbed and shot to death William Chattin struck again on the night of January 10, when Roy Rice was murdered. Rice was employed as a bookkeeper for the Seven-Up Bottling Company in Roanoke and was found dead in a field eight miles south of Lexington with a bullet in his back. Both Rice and Chattin were murdered under similar circumstances as both appeared to have been kidnapped, robbed, and killed.

Texas Ruby from the *Grand Ole Opry* along with Curley Fox and the Fox Hunters performed on the stage of the Roanoke Theatre on January 16.

Second Lt. Shelby Scott of Roanoke County was killed in a plane crash in Bad Homburg, Germany, on December 29, 1945.

Mrs. Diane Taylor, secretary for Congressman Clifton Woodrum for many years, was appointed Congresswoman Pro-Tem under a 1935 Virginia statute. Taylor acted in the interim capacity until Woodrum's successor was determined in a special election and then seated. She could do everything except cast votes in the US House of Representatives.

Carl Buckner of Roanoke purchased the store of Mrs. Oakley King, which was located in the Bottom Creek section of Roanoke County.

Walter Tolley of Roanoke was killed by a hit-and-run driver on the Rocky Mount Road one mile south of the Roanoke city limits. He was thirty-seven, and no arrests were made.

A "Salute the Champ" event was held in the Roanoke Auditorium on January 16 to honor boxer Joe Louis in person. Joining the champ were Lois Russell and his orchestra, "pinup girl" Betti Mays, and movie actor Ralph Cooper. The blacks-only dance portion of the event did admit white spectators for half price.

At their meeting on January 14, the Roanoke City Council had serious discussions about the need to erect an addition to the municipal building. Complaints were received from constitutional officers, notably the clerk of court, who stated he no longer had room for storage of records.

Roanoke city police offered a reward for any information pertaining to the slaying of Roy Rice. They had few leads.

Elmer Jenkins of Roanoke turned himself in to local authorities and said he was the driver in the hit-and-run accident that killed Walter Tolley. Jenkins confessed as patrolmen were on their way to his home to examine his automobile. He was placed in the Salem jail on a charge of manslaughter.

Allen's Jewelers announced it was going out of business, effective January 31. The jewelry store was located at 305 S. Jefferson Street, Roanoke. The Tinsley Jewelry Company announced its new location at 310 Second Street, having moved from 124 Campbell Avenue.

Roland Hayes, nationally known African American tenor, presented a concert at the Roanoke Auditorium on January 18. His appearance was sponsored by the Fifth Avenue Presbyterian Church, Roanoke, as a fundraiser for their building campaign. A crowd of seven hundred attended the concert.

Fred Shear, eighty, of the Williamson Road section was struck and killed by an automobile driven by Henry Sloan of Roanoke on January 16. Shear was a native of Switzerland and had lived in the county for over forty years.

A literal gun fight broke out in downtown Roanoke on January 17 when city police officers were trying to make an arrest in the 300 Block of West Campbell Avenue. Officer W. B. Carter was struck in the right shoulder by a .38 caliber bullet fired by Edgar Wise of Vinton. Before Wise could fire a second shot, Detective Sgt. Harold Yates pumped two .38 caliber bullets into Wise, striking him in the right wrist and left back. Yates and Carter were attempting to bring Wise into custody as a suspect in a shooting on Salem Avenue earlier that same day. Wise was admitted to Lewis-Gale Hospital, where he died the next day. Carter recovered from his wound.

C. E. Reynolds and T. M. Brooks announced the opening of the Gospel Tabernacle at 14 Street and Wise Avenue, SE, on January 20.

Carlyle Dean of Roanoke County was struck and killed by an automobile on Brambleton Avenue moments after he stepped off a school bus on January 18. Mrs. Ola Tolston was the driver of the car. Dean was eight.

Robert Daugherty, a fifty-five-year-old filling station attendant, became what law enforcement believed was the third murder victim of a killer who had previously murdered two other individuals in kidnappings and robberies. Doughty was found shot to death in the office of Wiley-Hall Motors service station at Salem. He had been shot in the back in the early morning of January 19. Due to the nature of the crime and the weapon used, authorities believed Doughty's killer might have been the same person who killed William Chattin and Roy Rice. Police reported a $2,000 reward for information leading to the killer of Doughty.

Excavation for an expansion of the Roanoke Weaving Company began in mid-January. English Construction Company of Altavista was the contractor. The weaving company was an affiliate of Burlington Mills. The weaving company's original plant was built in 1936 and had gone through five expansions.

William Connelly and Frank Agnew purchased the seed and feed business of J. M. Harris Company and announced the new name of Agnew and Connelly. The business was located at 301 Nelson Street, SE. The J. M. Harris Company decided to go into wholesale dog food and pesticides and erected a large warehouse under the company's name at 415 Third Street, SE. Agnew and Connelly also purchased the former Harris

Company warehouse at Third Street and Mountain Avenue, SE. Harris Company had operated in Roanoke for over fifty years.

R. W Brown Furniture Company, located at 22 E. Campbell Avenue, announced in mid-January they were going out of business.

Tony Pastor and his orchestra performed for a whites-only dance at the Roanoke Auditorium on January 22. Vocalists were Ruth McCullough and Dick Dyer. Black spectators were admitted for half price.

A mortgage-burning ceremony for the William Hunton Branch YMCA was held at First Baptist Church, Gainsboro, on January 20. Dr. L. F. Palmer from Hampton Institute was the keynote speaker for the occasion.

A fire damaged the Roanoke Concrete Products plant in Norwich on January 20. V. B. Mountcastle said the plant would be repaired and reopened soon.

The Vinton Furniture and Electric Company opened in late January at the corner of Lee and Maple Streets in Vinton.

About 450 workers at the Virginia Bridge Company in Roanoke went on strike as part of a nationwide strike of steelworkers. The plant closed with the exception of the office. At Walker Foundry in Norwich some two hundred workers walked off their jobs.

The Wheelbarger Brothers Cycle Company and Amoco Station opened at 1814 Williamson Road on January 22. The company sold Indian motorcycles.

The Roanoke County Board of Supervisors rezoned some twenty-two acres located on the north side of Lakeside between Mason's Creek and the N&W Railways tracks to light industrial to allow Herbert Thaden of Thaden Engineering Company to erect an "ultra-modern" furniture factory on the site. The factory would produce molded plywood furniture.

In the special election to fill the unexpired term of Clifton Woodrum, Lindsay Almond Jr. of Roanoke was elected. The Democrat beat his Republican opponent, George Revercomb Jr., by a vote of 10,898 to 6,275.

A house fire at 1414 Wise Avenue, SE, on January 22 killed seven-month-old Rebecca Bryant and severely injured her two–year-old brother, Timothy. The children's father, who was at the back of the house when the fire started, raced in to the flaming rooms to rescue his children but was repelled by the heat. Fire officials stated the cause could not be determined. Timothy Bryant died the following day due to severe burns. A double funeral was held at Melrose Baptist Church with burials at Blue Ridge Church.

J. E. Smith was robbed at gunpoint at a filling station at 717 South Jefferson Street on the night of January 24. The unmasked robber stated, "I've killed two men," before he fled on foot. Police immediately launched a search, but there was some doubt if the robber was the person being sought in connection with three robbery-related murders as he was unmasked and did not seem to operate in the same manner consistent with the three other crimes. The following night, an ex-serviceman was robbed at gunpoint in Vinton by two armed men who fled in an automobile.

WDBJ Radio's main on-air personality began broadcasting daily on January 28 with various programs. "Cousin" Irv Sharp did the *Funny Money Man* Monday through Friday at 12:30 p.m., *Irving Sharp Entertains* Tuesdays and Thursdays at 6:15 p.m., and continued his *Saturday Jamboree* at 6:15 p.m.

Magic City Plating Company, specializing in copper, nickel, and silver plating, opened on Ninth Street, SE, in late January.

Rise Stevens, opera singer and movie actress, performed at the Academy of Music on January 31. Stevens had appeared with Bing Crosby in the movie, *Going My Way*.

Logan's Antique Barn opened February 1 on Route 11 in the Glenvar section. The building had been formerly occupied by W. O. Goodwin's store.

Two Roanoke County youths were arrested near Christiansburg and admitted to the slaying of Robey Daugherty in Salem on January 19. The two youths were Thomas Harrison and James Dillon. Harrison was a resident of Salem, and Dillon was residing at Harrison's home. A young woman traveling with the pair was also detained by police. According to police, Harrison was the one who entered the service station, robbed, and then shot Daugherty. The break in the case came when state police spotted a Pontiac abandoned on Brushy Mountain that they soon determined had been stolen. James Slusser of Roanoke was visiting his father near the mountain and saw the two men walking along the mountain highway. Thinking that strange, Slusser soon learned an abandoned vehicle had been located nearby. Later that same evening, Slusser and his wife passed the same two men on the highway en route back to Roanoke. Slusser immediately turned around and reported the suspicious men to the Christiansburg police, who in turn found the men eating at a tourist cabin on Route 11. The youths admitted to stealing the Pontiac, and Christiansburg authorities then contacted deputies in Roanoke County, who transported Harrison and Dillon to the Salem jail for further interrogation. It was in Salem that the youths confessed to the robbery and murder of Daugherty, with police subsequently finding the handgun used in Harrison's home. Both youths refused to admit to anything beyond the Daugherty incident.

The Roanoke City School Board considered at its meeting on January 29 the purchase of one hundred acres of land owned by the Kazim Temple and lying between Grandin Court and Raleigh Court as the site for a new senior high school. While school officials did not see the need for all one hundred acres, administrators suggested that land not needed for a high school could be used for park purposes.

The office equipment, yards, building, and part of the construction equipment of the Roanoke branch of the road-building firm Sam Finley, Inc., was acquired by W. B. Adams and F. C. Tate in late January. Both Adams and Tate had been affiliated with Finley. Their new firm was the Adams and Tate Construction Company.

Smith's Cab Service began operations in late January, primarily serving the Williamson Road section.

Buford Rakestraw Sr. died on January 31 in a local hospital following a long illness. Rakestraw owned Rakestraw's Dry Cleaning and Dyeing Service and Rakestraw's Parcel Delivery. He established his delivery service in 1922 and his laundry business in 1925. He was fifty-eight.

"King of the Comedians" Happy Bobbitt and his Melody Rangers performed on the stage of the Salem Theatre on February 1.

A small fire damaged the lobby of the Roanoke Theatre and the adjacent Peanut Store on February 1. The fire broke out in the basement of the Peanut Store.

Willmer F. Dillard of Roanoke graduated from Boston University's law school. He was elected treasurer of his law class and was the first black to hold that position.

The Magic City Athletic Club was organized in early February by Eugene Sweeney and "Bunk" Sweeney at 111 E. Church Avenue, Roanoke, for organizing and promoting professional boxing matches.

Andor Foldes, piano virtuoso, gave performances at Hollins College's Little Theatre during the first week in February. Foldes was a native of Hungary who had performed with all the major symphonies of Europe.

Roanoke County authorities announced the arrest of a third suspect in the killing of Robert Daugherty. The young man was a resident of Salem, but his name was not released to the public.

Three members of a Mitchell B-25 medium bomber were killed when their plane crashed within fifty feet of the top of Green Ridge, less than two miles from Woodrum Field. The crash occurred on February 3. The plane was en route from Rome, New York, to Knoxville, Tennessee, when it developed engine trouble and called the Roanoke airport to make an emergency landing. The pilot made an initial run at the airport but pulled up, realizing he had overshot the runway. Marshall Harris, airport manager, watched the plane crash. "The wing gasoline tanks exploded. Huge flames quickly enveloped the crash," Harris stated. The Williamson Road and Roanoke Life Saving Crews retrieved the bodies. The three men killed were Lt. Victor Lewis, twenty-eight, of Loveland, Ohio; Sgt. C. A. Christie, twenty-four, of Syracuse, New York; and Staff Sgt. Z. E. Fournier of New Bedford, Massachusetts.

A scene akin to the Wild West occurred in the lobby of the Patrick Henry Hotel on February 4. Levi Stott and Jack Sanderson approached the front desk around 1:30 a.m. and requested a room. Charles Guthridge, desk clerk, informed them no rooms were available. The two men then proceeded to destroy furniture in the hotel lobby and assaulted Guthridge. Roanoke police officers C. M. Porter and W. F. Strain arrived at the scene. As Officer Porter entered the lobby, Stott tore the officer's gun from its holster who then ordered Strain to hand over his gun to Sanderson. Stott backed the officers out of the lobby onto the sidewalk, where he fired a shot at Porter's feet. The shot attracted two other police officers walking downtown beats, one of whom, N. E. Mills, fired three shots into Stott. Sanderson quickly surrendered, and Stott was taken to a local hospital. Both men were charged with various offenses.

Rev. Harry Gamble was called as pastor of Calvary Baptist Church, Roanoke, on February 3. Gamble was pastor of First Baptist Church in Statesville, North Carolina.

Ewald's Pharmacy at 711 S. Jefferson Street, was sold in early February. Its prescriptions were transferred to Thornton-Creasy Pharmacy at 513 S. Jefferson Street.

J. C. Carper, a ward at Convict Camp No. 10, just south of Roanoke City on Rocky Mount Road, threatened to kill a civilian in downtown Roanoke and drew his gun on one of two police officers when they were arresting him. Carper was subdued when one of the officers struck him on the head with the butt of his pistol.

A proposal for enlarging the membership of the Roanoke City Council from five to seven members was abandoned in the Virginia General Assembly.

Pollard Taxicab Corporation opened for service on February 6, headquartered at Church Avenue and Henry Street. Their fleet consisted of 1946 Fords and Mercurys.

Thousands of men, women, and children stood in line for hours following an advertisement by the N. W. Pugh Company that they had in stock 2,818 pairs of nylon hose, but only one pair per customer. The material for nylon hose had been rationed during the war.

The N&W Railway announced that it planned to close the Roanoke Auditorium for public use after March in order to use the building for the storage of furnishings and

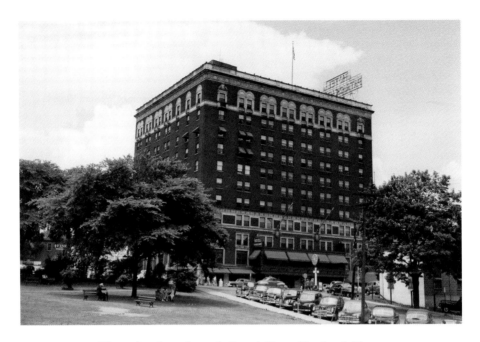

This 1940s photo shows the Patrick Henry Hotel on Jefferson
Street, with the northwest corner of Elmwood Park in the
foreground. *Historical Society of Western Virginia.*

equipment from the Hotel Roanoke during the hotel's summer renovations and remodeling. Those most impacted were wrestling promoter Scotty Dawkins and Noel Dalton, who promoted amateur boxing. The railway owned the auditorium through a subsidiary, Virginia Holding Company.

The 125-year-old Gwaltney house on Virginia Avenue in Virginia Heights was dismantled the second weekend in February. The home, erected in 1820, was believed to be the second-oldest home in Roanoke. Its demolition was to create space for the construction of a grocery store. The home was built by Patterson Hannah, who called the homestead "Solitude," and it was the only home in Virginia Heights and Raleigh Court for many decades. Hannah included a racetrack on his estate, where Evergreen Cemetery was eventually located. The oldest home in Roanoke was believed to be "Lone Oak" at 1525 Franklin Road, SW. The original site of "Solitude" was owned by Erwin Patterson, who claimed the site was an early Indian trading post. From 1910 to 1944, the home was owned by J. W. Gwaltney and then after his death by S. R. Allen. The outer brick walls were eighteen inches thick, and the interior walls were twelve inches thick.

The Dixie Professional Football League dropped Roanoke from its list of six cities that would be participating in the 1946 season. The league, meeting in Richmond, replaced Roanoke with Greensboro, North Carolina. League directors hoped to bring Roanoke back into the Dixie circuit for 1947 if an eighth team could be found.

The Roanoke City Council authorized the city manager to work with the Federal Housing Administration to erect seventy-five emergency housing units and twenty-five

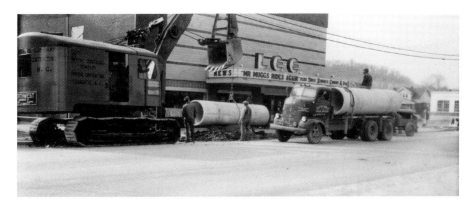

A city work crew unloads a thirty-six-inch concrete pipe on Williamson Road; the Lee Theatre is in the background, February 1946. *Western Virginia Water Authority.*

trailers on the city farm property to relieve temporarily the housing shortage in the city, which was impacting ex-servicemen.

The USO Club on South Jefferson Street, Roanoke, announced it would be closed by March 31.

The N&W Railway resumed sleeping cars between Bristol and Richmond on February 16.

The development of Mill Mountain and Carvin's Cove as outdoor recreation areas with camping facilities was advanced at a meeting of the Roanoke Recreation Association. Other ideas advocated were acquiring more lands for city parks, developing an eighteen-hole municipal golf course, and more recreational centers.

Salem's town clock, located atop the county courthouse, was electrified on February 12, making its timekeeping more reliable. The clock was placed on the courthouse thirty-six years prior. The electrification was done by Tower Clock Service of Springfield, Illinois.

Barr Brothers, a jewelry store chain, acquired the S. Charles Wolff jewelry store at 4 East Campbell Avenue. Barr Brothers had stores in Portsmouth, Newport News, Norfolk, Suffolk, and Cape Charles.

Three prisoners awaiting trials in the Salem jail sawed their way to freedom on February 13. Two were captured within hours of their escape near the rail yard of the N&W. The third was captured three days later at a residence in southeast Roanoke.

The Fulton-White Truck Company opened as distributors for White trucks on February 15 in a newly constructed building at Shenandoah Avenue and Fifteenth Street, NW. The company was owned by George Fulton, who also owned Fulton Motors, a dealership affiliated with Chrysler and Pontiac.

The Roanoke Chamber of Commerce formally opposed increasing the membership of the Roanoke City Council from five to seven members, believing that enlarging the council would possibly return the body back to a ward system of election.

Workers at Virginia Bridge and Iron Company and Walker Foundry returned to their jobs following the end of the national steel workers' strike.

The YWCA began operating a Sperti Irradiation Lamp that tanned skin using ultraviolent and infrared rays. The device was approved by the American Medical Association

for tanning skin and relieving fatigued muscles. The lamp was in a special room with an attendant at the YWCA for those wishing to have an appointment.

A fire destroyed the warehouse of the Virginia Scrap Iron and Metal Company at the corner of Mountain Avenue and Third Street, SE, on February 17.

Count Basie and his orchestra performed for a blacks-only dance at the Roanoke Auditorium on February 20. White spectators were admitted for half price.

Souvenir hunters and vandals scavenged for parts from the wrecked B-25 bomber on Green Ridge such that investigators were hampered in their efforts to evaluate the crash site. Military officials cautioned that anyone caught with parts from the plane and wreck debris would be punished.

A fire destroyed a church and a residence in the Slate Hill section on February 20. The residence of Mr. Robin Hale and the Slate Hill Missionary Baptist Church were both burned to the ground by the time volunteer fire crews arrived on the scene. The cause of the fire that began at the church was unknown.

Engle's Grocery opened on February 22 at 3402 Williamson Road. The proprietor was O. C. Engle.

Over five thousand persons attended the annual Policemen's Ball at the Roanoke Auditorium on February 22. Music was provided by Jimmy St. Clair and his orchestra.

The "Ole" Virginia Barn Dance was a regular event on Saturday nights at the city Market Auditorium. On Saturday, February 23, music was provided by Patsy Jean and her Hillbilly Pals. Special guests that night included Saford and Clayton Hall.

Jimmy Dorsey and his orchestra played for a whites-only dance at the Roanoke Auditorium on February 25. They were billed as the nation's number-one dance band. Black spectators were admitted for half price.

A contract for the construction of a two-story brick-faced building for the Cooperative Seed and Farm Supply was awarded to John Senter, Roanoke contractor. The building site was Fourth Street and Mountain Avenue, SE. The building's cost was estimated at $140,000.

E. T. Barringer announced that he was planning to re-form the Magic City Band, a local black musical group.

The Roanoke Paint and Glass Company moved its headquarters from 104 Church Avenue, SW, to 10 East Church Avenue on February 26. It had been at the former location for thirty-five years.

Benn Rabinof, violinist, and Sylvia Smith, pianist, gave a concert at the Academy of Music on February 26. The performance was sponsored by the American Legion Post No. 3.

The Salem Lions Club announced they would perform their annual minstrel show for the tenth straight year. The 1946 show was scheduled for mid-March at Andrew Lewis High School and benefited the Lions' various sight programs.

The third annual performance of the Roanoke Civic Ballet was presented at the Academy of Music on March 1 with sixty participants. The two ballets were *Winter Moods* and *Arabian Nights Dream*. Elinor Worst was ballet president.

The former CCC and German POW Camp at Catawba was offered for sale to Roanoke City to help address its acute housing shortage. The sale price was $35,000, but it was rejected as the city council believed the site and buildings to be impractical for such a purpose.

In early March the German POW camp in Salem had fifty-three prisoners who were providing labor at the Veterans Administration Hospital.

The Toddle House, formerly Hull-Dobbs House, opened in late February at a new location, 1202 S. Jefferson Street.

A fifty-acre forest fire occurred on Buck Mountain, near Starkey, in late February.

Daily through-service sleeping cars from Roanoke to Norfolk was resumed by the N&W Railway on March 2.

Sanitary Laundry and Cleaners opened another laundry on February 28 at Church Avenue and Third Street, SW. It was their third laundry in the city.

The Haven Restaurant moved from the corner of First Street and Church Avenue to 309 First Street, SW. Its former location had been acquired for the new Bank of Virginia building.

The location of a new plant of the Rowe-Jordan Furniture Corporation was announced as being in Salem on a tract of land purchased from the Virginian Railway Company, south of the tracks and just east of Colorado Street. Company officials stated the plant's construction would begin in early April.

An additional 201 German POWs arrived at the Salem POW Camp, bringing the total number housed there to 154. The prisoners were used for construction labor at the Veterans Hospital in Salem and for work affiliated with the West Virginia Pulp and Paper Company.

Guinn's Conoco Service Station opened on March 1 at Eleventh Street and Third Avenue, NW. Auto-Bath, a car wash service, opened on the same day at 108 Albemarle Avenue, SE.

The Salem Town Council authorized the installation of lights at Municipal Field to enhance recreational use of the field and the athletic program at Andrew Lewis High School.

The reconversion of the Pine Room at the Hotel Roanoke began the first week of March. The lounge had been converted into a tap room for the servicemen receiving flight training at Woodrum Field. The reconversion of the Pine Room back to its prewar luxury was part of the larger renovation occurring at the hotel. In addition to work at the Pine Room, hotel officials announced the creation of the "Fountain Room" below the main dining room that would serve as a lounge for teenagers.

Donald Dame, a twenty-eight-year-old tenor with the Metropolitan Opera, performed at the Academy of Music on March 4. His appearance was part of the Roanoke Community Concert Association's series.

In 1946 there remained three fountains in downtown Roanoke, all reminders of a bygone horse-and-buggy era. One fountain was on Second Street at the east end of the N&W Railway freight station, and that was removed by construction crews to make way for the Carvins Cove water main. It was moved just a few feet from its original location. A second fountain, known as the "dog mouth" fountain, was located on Salem Avenue near the city market building. The third fountain was located across from the N&W passenger station. The first fountain, which was relocated, was presented to the city in 1910 by the National Humane Alliance in honor of its founder, Norman Lee Ensign. The presentation was part of a number of such presentations being made to American cities at that time by the society. The location had been selected by then-mayor Joel Cutchin. The fountain across from the passenger station was erected by public subscription to honor Frederick

Kimball, pioneer president of the N&W, following his death in 1903. Little was noted about the history of the dog mouth fountain, other than that it had a high trough for horses and a low trough for dogs.

The Rev. Van F. Garrett accepted the call to Christ Episcopal Church in Roanoke. He was to begin his duties on May 1.

A mass meeting of interested citizens was convened by the chamber of commerce on March 5 to draft a ticket to stand for election to the Roanoke City Council. Some 150 persons attended the event at the Patrick Henry Hotel. A committee was selected to present a council ticket and present that ticket at a follow-up meeting on March 18.

Thomas Harrison was found guilty of murder by a Roanoke Circuit Court jury on March 5 after a two-day trial for the murder of Robert Daugherty. Judge Thurston Keister pronounced a sentence of death by electric chair for the twenty-year-old, a punishment sought by the commonwealth's attorney, Eugene Chelf. Though Harrison proclaimed his innocence, and his defense attorney, Holman Willis Jr., asserted a defense of Harrison being feeble minded, a signed confession and a ballistics match of the bullet used to slay Daugherty to Harrison's gun convinced the jury of its final verdict. Judge Keister set the execution date for Monday, May 20, in Richmond.

John Wentworth, Roanoke city engineer, prepared a report for the city council that would renumber 65 percent of the homes in the city as part of a city master plan. The majority of the residences affected were in the south half of the city. There were also proposed changes to certain street names. The council delayed action on the report until there were public hearings.

Accordion player Graham Jackson, whom President Franklin Roosevelt said was his favorite entertainer, entertained some three hundred Lions and their wives at a banquet at the Patrick Henry Hotel on March 7.

Lt. Walter Davis of Roanoke County was declared dead by the War Department. Davis went down when his bomber collided with another bomber in a formation returning from a raid over Palau Island. Sgt. Charles Sweet Jr. of Roanoke County was declared dead by the War Department after being listed as missing in action two years before during a bombing mission over Truck Island.

Child evangelist Glorice Turner, age five, spoke at the evening worship service of Melrose Methodist Church on March 10.

Master Sgt. Stephen Goggin of Roanoke was killed when a B-29 bomber crashed in New Mexico the first week of March.

Otis Shepherd of Baltimore, Maryland, took first place in Luckland Bowling Alley's open duckpin tournament on March 9. Steve Lindamood of Roanoke took second.

Roanoke's Old Dominion Rebels won the state AAU basketball championship held at the Roanoke Auditorium on March 10. They defeated Little Creek 67–51. Leading scorers for the Rebels were Bob Spessard, Rex Mitchell, Paul Rice, and Johnny Wagner.

Stars of radio's *Grand Ole Opry* came through Roanoke the third week in March. On March 13 and 14, Robert Lunn and his gang—"Tiny Grayson," Homer, Johnny, and Shorty—along with Jack Lane performed on the stage of the Lee Theatre. On March 14, Frankie "Pee Wee" King, Minnie Pearl, Golden West Cowboys, Becky Barfield, and Spike & Spud performed at the Roanoke Auditorium.

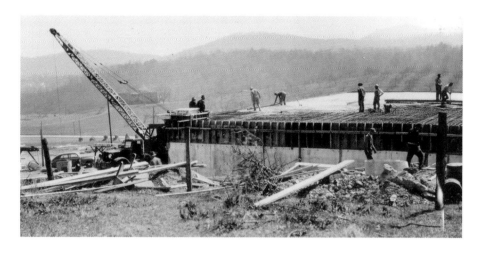

This is the last pour for the roof of the City Farm Reservoir. The city almshouse is in the left background, March 1946. *Western Virginia Water Authority.*

Donald Bolt, twenty-one, an ex-serviceman, was killed in an auto accident at the intersection of Shenandoah Avenue and Twenty-Fourth Street, NW. Bolt resided in Garden City.

The Trading Post on Starkey Road closed for business in mid-March. The store was reopened as Ogden Cash Grocery by Carl Huff.

The lifting of the ban on secrecy allowed information to become public pertaining to Roanoke's role in the manufacture of the atomic bombs that were dropped on Japan. In the early fall of 1943, Virginia Bridge and Iron in Roanoke was given a War Department assignment for secretly manufacturing thirty-one thousand tons of a wide variety of steel shapes. Delivery was to be made to Oak Ridge, Tennessee. Virginia Bridge and Iron worked night and day shifts, doubling their manpower, to produce their assigned steel parts. The parts were moved to Oak Ridge on one thousand freight cars. Virginia Bridge and Iron started the war with thirty welders, and at the height of war production, the company was employing three hundred welders. The company had the honor of receiving the American steel industry's first Army-Navy E Award. The late Beverly Sneed of Roanoke was posthumously awarded a bronze lapel pin engraved with "Manhattan Project" and "Atom Bomb" as he served as vice president and sales manager for the company during wartime production. In addition to steel parts for the atomic bombs, Virginia Bridge and Iron also manufactured 272 Bailey bridges used by American and British troops.

Thomas Harrison, convicted killer of Roby Daugherty, slashed his wrists and arms with a shaving razor while awaiting transfer to Richmond for his execution. His attempt at suicide was not successful.

Sleeping car service between Roanoke and Washington, DC, was restored on March 16 by the N&W Railway.

C. K. Lemon Sr. began promoting the sale of house lots in his new subdivision development, Manchester Court, in mid-March. The development was located on Lee Highway between Roanoke and Salem.

Northwest Produce Market opened at 505 Eleventh Street, NW, on March 15. Herman Obenshain was the proprietor.

The Gill Memorial Eye, Ear, and Throat Hospital became affiliated with the Eye-Bank for Sight Restoration of New York City in mid-March and began performing cornea transplants for the blind, a procedure previously unavailable in Roanoke.

Gill Memorial Eye, Ear, and Throat Hospital on Jefferson Street pioneered cornea transplants for the blind in the region, 1946. *Historical Society of Western Virginia.*

The play *Life with Father* came to the Academy of Music on March 18. The touring production starred Carl Benton Reid and Betty Linley.

O. C. Watts opened Watts Hardware at 1119 Williamson Road on March 18.

Tab Smith and his orchestra performed for a blacks-only dance at the Roanoke Auditorium on March 18. White spectators were admitted for half price.

Lenwood Gallion opened Gallion Welding Company at 701 Lynchburg Road on March 18.

A nonpartisan ticket was selected in a meeting of civic, business, and political leaders for the June Roanoke City Council election. The meeting was hosted and convened by the chamber of commerce in a follow-up to previous meetings expressing a desire to have a more progressive and cooperative council. The three candidates selected for the ticket were incumbent Mayor Leo Henebry, insurance agent R. H. Mullikin, and attorney Richard Edwards. Edwards was also a candidate in the Democratic primary. A day later, Edwards declined to run on the nonpartisan ticket, opting to stand in the Democratic primary election.

The Roanoke City Council adopted a master plan presented by the city planner to renumber houses in the city, a move necessitated by duplicate street names and annexation

over the years. There was also discussion of changing some street names in order to prevent duplications, but no action was taken on that issue at the March 18 meeting.

The Old Dominion Rebels basketball team lost in their opening game of the national AAU basketball tournament held in Denver, Colorado. They were defeated by a team from Portland, Oregon, with a score of 58–48.

Staff Sgt. Flanders Callaway Jr. of Roanoke was declared dead by the military, having been previously reported as missing in action over Iwo Jima since August 14, 1944.

Several automatic weapons brought home by servicemen as war trophies had been registered with the Roanoke office of the federal alcohol tax unit, but authorities believed many more such weapons had not been registered. Failure to register an automatic weapon or render it unserviceable resulted potentially in a fine of $2,000 or five years' imprisonment.

The FCC authorized the Blue Ridge Broadcasting Corporation to operate a new radio station in Roanoke at 250 watts. J. K. Ring was president of the broadcasting corporation and stated that work would begin in late March to erect a transmitter on South Jefferson Street just south of Roanoke City Mills.

The Adams Men's Shop opened on March 21 at 104 S. Jefferson Street.

This is a 1946 view across the Roanoke City Farm with the Pest House on the knoll (*center, background*) where smallpox patients were once treated. *Historical Society of Western Virginia.*

Mrs. Willie Caldwell, civic leader and a former Republican National Committee member, died at her home on King George Avenue at the age of eighty-six on March 21. Caldwell organized the Civic Betterment Club in Roanoke in 1907, a women's organization that advocated for social progress such as school improvements, playgrounds, sanitation, and the hiring of John Nolen to develop a master plan for Roanoke.

Kraft Foods Company of Chicago announced on March 21 plans to construct a new $150,000 distribution center in Salem. The site for the new plant was the corner of West Main Street and Mill Lane.

Dr. Eugene Senter, a candidate for Salem Town Council, advocated that Salem become an independent city in order to have better schools and protect itself from any potential annexation by Roanoke.

Bethany Christian Church had a groundbreaking on March 24. The site was one block east of Williamson Road near William Fleming High School (present-day Breckenridge Middle School), where the one-hundred-member congregation had been meeting.

Clarke Wray opened a new Texaco service station at 339 Luck Avenue, SW, on March 23.

R. R. Long and S. C. Fisher purchased and reopened a grocery a 553 Marshall Avenue, SW. The new name was Long & Fisher Food Market.

Morris McCaffrey of Roanoke, USNR, was declared dead by the military. He had been missing in action since January 29, 1945, serving aboard the submarine *Swordfish* in the Pacific.

A recommendation that Roanoke College resume football only when other colleges join them in strictly nonsubsidized competition was made by a special committee to the college's board of trustees. Roanoke College athletic officials believed there was little chance of football resuming at the college in the fall term.

The N&W Railway launched a "Name the Train" contest on March 24 to solicit names for its new streamliner from Norfolk to Cincinnati. The award for best name was $500 plus ten prizes of $25 each for other names favored by the company. Deadline for entries was midnight, March 30. The new streamliner would cut by three and a half hours the trip between its termini. The train would be powered by the new Class J steam locomotives and have five air-conditioned coaches, a tavern lounge car, and a diner.

St. Paul's Methodist Church, Roanoke, held a mortgage-burning service in mid-March. Bishop A. P. Shaw was the guest speaker.

Tommy Tucker and his orchestra performed for a whites-only dance at the Roanoke Auditorium on March 26. Sections were reserved for "colored spectators."

Lt. Eugene Keen, navigator in the air corps, was declared dead by the military. He was declared missing over Wewak, New Guinea, on June 19, 1944.

James Manning, retired superintendent of the Roanoke Police Department, died in a local hospital on March 23 at age sixty-nine. Manning, a native of Floyd County, entered the police force in December 1905 and rose through the ranks to become superintendent in 1928, retiring on August 31, 1934.

The Roanoke Stamp and Coin Company opened at 6 E. Tazewell Avenue on March 30. Ernest Baldwin was president of the company.

Lewis-Gale Hospital acquired property at the southwest corner of Church Avenue and Third Street, SW, from the Times-World Corporation for a possible addition to the hospital. The property included a residence.

Serious controversy emerged, lasting many weeks, over dealing with two Virginia Avenues in Roanoke, one being in South Roanoke and the other in Virginia Heights. Neither neighborhood wished to surrender their street's name for a variety of reasons. Various compromises proposed by city staff and members of the city council were met with opposition.

Plans for a new industry in Roanoke were submitted to the city council on March 25. A rock wool manufacturing plant was proposed at 816 Lynchburg Avenue, NE, opposite the Virginia Bridge Company. The matter arose during a rezoning hearing.

Roanoke's third radio station, which would be owned by the Blue Ridge Broadcasting Corporation, was to have the call letters WROV. Lambert Beeuwkes was named as general manager.

The International Sweethearts of Rhythm, an all-female orchestra of "Chinese, Indian, Mexican and Negro girls" performed at the Roanoke Auditorium on March 29 for a blacks-only dance, with white spectators admitted for half price. It was the last show at the auditorium before it was closed by the N&W Railway to serve as a storage facility during the remodeling and renovation of the Hotel Roanoke.

Bertha Strange, thirty-four, was brutally murdered with a hatchet in her home on Sixth Street, NE, on March 26. She died at Burrell Memorial Hospital. Police suspected her ex-husband, Lewis Morgan, of the slaying due to the account given by her teenage son, who was also assaulted.

The "citizen's ticket" for Roanoke City Council elections became complete when a third candidate, Robert Meybin, joined Leo Henebry and R. H. Mullikin. Meybin was general manager of the Virginia Bridge and Iron Company. The third slot became vacant when Richard Edwards opted out to remain a candidate in the Democratic primary for city council.

The Roanoke Red Sox held their first workout of the spring season in Bennettsville, South Carolina. The squad of fifty-one drilled in the morning, and then another team from Scranton used the field in the afternoon.

An explosion occurred at the James River Oil Company, 1516 Cleveland Avenue, SW, that destroyed two gasoline storage tanks, a tank truck, and a garage and three trucks owned by the adjacent Roanoke Coal Company. The March 29 blaze started from a spark in an electric motor in the pumping house.

Dr. George Moore, physician, died at his home on Wells Avenue at the age of forty-six on March 29. He had practiced in Roanoke for twenty years and was a member of the staff at Burrell Memorial Hospital. Pallbearers were members of the Magic City Medical Society. An estimated five thousand persons attended his funeral, many from outside Virginia.

Leigh B. Hanes was elected president of the Roanoke Bar Association for 1946.

Work on razing the oldest wing of the Hotel Roanoke was completed at the end of March, and the foundation for a new wing was being laid.

Some 250 doctors from across the United States and Canada arrived for the nineteenth annual weeklong spring graduate course at Gill Memorial Eye, Ear, Nose and Throat Hospital. Lectures were held in the ballroom of the Patrick Henry Hotel. It was the largest attendance since the spring graduate class program was launched.

Ernest Tubb gave two performances at the Academy of Music on April 1. Others from the *Grand Ole Opry* that were part of the show included the Texas Troubadours, Short Brothers, "Dot and Smoky," Johnny Sapp, Kemo, and Jack Drake.

Miss Faye Johnson of Vinton was reported missing and believed killed in the tidal wave that struck Hilo in the Hawaiian Islands on April 1. She was teaching school there. Johnson was living in a seaside cottage with three other teachers, and only one survived.

The survivor described from her hospital bed watching helplessly as the cottage and her roommates were swept out to sea.

Railroading's first all-welded alloy coal hopper made its initial appearance in Roanoke on April 1 following its completion in the Virginia Bridge Company's shop. It was displayed at the N&W passenger station before beginning a multicity tour across the United States. Its red, white, and blue paint job added to its appeal.

The Wonder Bar Night Club opened on Route 11, seven miles north of Roanoke, in early April. The proprietor was S. D. "Doc" Mullins.

In a very light turnout, Richard Edwards, Benton Dillard, and A. R. Minton were nominated as the Democratic slate for the Roanoke City Council elections. Only 1,509 votes were cast, as many Democrats had been encouraged to stay home in order to support the chamber of commerce's "citizens' ticket" in the general election. The previous Democratic primary for city council, held in 1944, had 4,161 ballots cast. The vote totals were Edwards, 1,137; Dillard, 1,115; and Minton, 1,078. One other candidate, Owen Arnold, received 702 votes.

Some one thousand acres of timber were consumed by a forest fire on Poor Mountain in early April. No dwellings were damaged. Some ninety firefighters were engaged to combat the flames.

Thomas Harrison, convicted of the murder of Roby Daugherty, was transported to Richmond state prison on April 2 to await his May 20 execution. Harrison continued to maintain his innocence.

First Lt. George Pierpoint of Salem was declared dead by the military. He had been reported missing in action by the AAF since August 31, 1944. He had been stationed in China.

Carter Burgess of Roanoke was named assistant to Jack Frye, president of Trans-World Airlines.

Joe Liggins and his Honey Drippers Orchestra performed at the City Market Auditorium on April 8 for a blacks-only dance. White spectators were admitted.

The Salem POW Camp officially closed on April 6, and the sixteen German prisoners still there were sent to Camp Pickett.

At Hales Ford in Franklin County, a groundbreaking ceremony was held on April 5 for the memorial to Booker T. Washington. Participants included Booker T. Washington III, the grandson of the famous educator; John Washington Jr. of Tuskegee Institute and nephew of the educator; S. D. Ferguson of Roanoke; the Addison High School choir; and Delegate Virgil Goode of Rocky Mount.

An Army Day parade was held in Roanoke on April 6, and all veterans were asked to participate and wear their uniforms.

A proposal to erect an ice cream distribution and storage plant by Southern Dairies at the intersection of Franklin Road and Avenham Avenue in Roanoke was met by neighborhood opposition. The plant's proposed site was in the "Y" at the intersection.

James Dillon pleaded guilty in Circuit Court for his role in the robbery and murder of Roby Daugherty of Salem on January 19. Dillon's accomplice, Thomas Harrison, had been convicted earlier of actually killing Daugherty. Judge Thurston Keister imposed a sentence of ninety-nine years' imprisonment.

Stan Kenton and his orchestra, *Look* magazine's "Band of 1946," played at the City Market Auditorium on April 10.

Sammy Snead, Byron Nelson, Jimmy Demaret, and Jug McSpaden played an exhibition match at Roanoke Country Club golf course on April 9. This was part of a tour that several golf professionals were making at clubs around the country. A driving contest preceded match play. Admission to watch the foursome was $2.50. Snead and Demaret played Nelson and McSpaden to a draw in the four-ball match play. Nelson carded a sixty-six followed by Snead with a sixty-seven. Snead drove 290 yards to take top honors in the driving contest. A crowd estimated at one thousand watched the match.

A campaign to develop a Williamson Road–area war memorial recreation and health center was given a boost by the public release of an architectural drawing of the proposed $70,000 facility that appeared in the *Roanoke Times* on April 7. The proposed center included an auditorium and gymnasium, health clinic, club rooms, lounge, Boy and Girl Scout dens, snack bar, bowling alleys, kitchen, and locker rooms. A master plan for the surrounding grounds included a swimming pool, ball fields, and horseshoe pits. The war memorial center had the endorsement of several civic and business organizations in the Williamson Road section.

A fifteen-year-old girl, Josephine Moorman, was arrested by Roanoke police on a charge of murdering her week-old infant son and concealing the body in a woodshed. The girl confessed to police that she had given birth to the boy at her home and then smothered the newborn.

A bill that passed the US House of Representatives in early April provided $343,000 for the construction of an airport at Salem and $57,000 for an airfield at Vinton. The bill also stated that Virginia would have to supply funds. The bill was sent to the Senate.

Claude Evans and Earl Evans advertised their Evans Esso Station on Route 221 at Cave Spring in early April. "If you need gas or emergency service after 10:30 p.m. just knock on the door."

Movie comedian and ventriloquist Max Terhune and Elmer performed on the stage of the Roanoke Theatre on April 10. They were joined by the musical group the Pine Ridge Boys.

A master plan for the development of Woodrum Field was unanimously adopted by the Roanoke City Council on April 8. The plan was drafted by the firm of Horner and Shifrin from St. Louis, Missouri. The plan principally called for relocating buildings, adding runways, realigning and extending certain runways, and erecting obstruction lights on several mountains in the region. The seven-year plan called for over $500,000 worth of improvements.

Hundreds of Roanokers went to Woodrum Field on August 9 to view a four-motored C-54 Douglas Skymaster. The plane was at the field for only twenty minutes. The plane was a gift from the late President Roosevelt to then prime minister Winston Churchill for his private use and then returned to the United States following the war. It was outfitted for additional service and use by Gen. George C. Marshall and was being so used when it landed at the Roanoke airport. The pilot was Capt. Billy Carpenter of Roanoke.

Opposition from the residents of Idlewild, Kenwood, Blue Ridge Heights, and Halliahurt neighborhoods prompted the town of Vinton to voluntarily set aside its efforts to annex those areas.

Bishop Ralph Cushman of the Methodist Church delivered a series of lectures at Greene Memorial Methodist Church during the second week of April.

A C-47 takes off from Woodrum Field. The former Cannaday home, CAA tower, and terminal building are in the background, c. mid-1940s. *Virginia Room, Roanoke Public Libraries.*

The "Young Roanoke Sings" Chorus, seen here in 1946, was heard weekly over the WSLS radio station. *Nelson Harris.*

Fowlkes & Kefauver began advertising the sale and development of residential lots in their subdivision Vinyard Gardens near Idlewild Park.

Mick-or-Mack announced plans to open a new grocery in the Lipes building at 105–107 Virginia Avenue, South Roanoke, by June 1.

Bibee's Super Market opened its third store at 2106 Williamson Road on April 11. The other two stores were located on Grandin Road and Luck Avenue in Roanoke.

An estimated one thousand rats were killed in one night with poison spread at a city dump on Franklin Road at the Roanoke River in Roanoke's efforts to eradicate a rat infestation. The city's health commissioner had pleaded with city leaders to address the problem throughout the city.

Sidney's Balcony Dress Shop opened at 501 S. Jefferson Street on April 13.

Robin Hood Bowling Alleys opened on Williamson Road on April 13.

John Hunter, proprietor of Hunter's Cigar Store in the Ponce de Leon Hotel, announced that he would open a café in a basement room of the hotel formerly used as billiard hall. The café would open around May 1 and be called The Boiler Room, with a seating capacity of around a hundred with a menu of seafood, sandwiches, salads, beer, and wine.

The Roanoke Recreation Association announced in mid-April that Rockledge Inn on Mill Mountain was available for public use and that reservations could be made by groups and organizations. Arthur Rorer had a contract for the inn on the weekends that he used for sponsoring dances.

An exhibition pro baseball game between the Cleveland Indians and the New York Giants for April 12 at Maher Field was cancelled due to an all-night rain that made the field unplayable. Both teams waited in their hotel rooms to see if the weather would break and had to leave by train the next morning. The game was promoted by Stanley Radke, president of the Roanoke Red Sox. An expected crowd of ten thousand was disappointed.

O. Goode, J. P. Muddiman, and G. L. Seay opened Electric Service Corporation, a sales and service store for General Electric appliances, at 28 W. Church Avenue on April 15.

Frank Fallon, florist, died at his home on April 13. He was seventy-two. Fallon was a native of Staunton who came to Roanoke in 1899 and opened a seed store on Jefferson Street. A year later, he moved his store to Luck Avenue and expanded the business to include a florist shop. He soon thereafter erected large greenhouses on Williamson Road. The florist shop later moved to Jefferson Street and then to Church Avenue. Fallon donated a thirty-acre tract of land to Roanoke in the 1920s for a park that bore his name. Each year he sponsored a picnic there for the children living in southeast Roanoke. Fallon was unmarried and made his home in the Ponce de Leon Hotel.

Recreational facilities on the Blue Ridge Parkway were officially reopened on April 14 along a 162-mile section near Roanoke. The parkway had been closed during the war due to restrictions on leisure travel.

Members of the Associate Reformed Presbyterian Church in the Williamson Road section held a note-burning ceremony on April 14 in honor of paying off the mortgage on their original building. The church was located at the intersection of Lee and Lincoln Avenues, one block east of Williamson Road. The building had cost $20,000.

Mrs. Mary Louise Bernadine, former WAC, was the first female in Roanoke to buy a home with a GI loan. Her home was 1621 Eighth Street, SE.

Roanoke realtor Frank Craig was interviewed at the age of eighty-nine. Still conducting business, Craig recalled his early days in Roanoke and his vision for real estate developments beyond the city limits. He opened up the Williamson Road section in June 1922, and he recalled standing in a field of wheat "up to my knees" on a hill where Virginia Heights School was eventually built and directed a man "who was laying out the

lots." He came to Roanoke in 1889 and first worked as a policeman before going into real estate ventures.

The Roanoke City Council took action at their April 15 meeting to establish a pension system for all municipal employees, with the exception of school employees, and to replace the costly retirement for firemen and police on a more solid footing. The retirement plan for fire and police had been adopted in 1926.

"Cupid" Davis and his All American Hillbilly Barn Dance gave a show at the Roanoke Theatre on April 17. The show's cast included the Hatfield Sisters, Brad Malone, Curt Blair, Kentucky Slim, Wanda Lee, the Stacy Twins, and The Gilberts. All were well-known radio personalities and singers.

A crowd gathers outside the Grandin Theatre on Grandin Road, SW, in April 1946. Brice's Drugstore is next door. *Virginia Room, Roanoke Public Libraries.*

Bob Wells and his Texas Cowboys performed on the stage of the Lee Theatre on April 18.

The Driscoll Food Products Company opened at 1117 Williamson Road on April 18. The company processed Tom's Potato Chips.

Leonard Scott, sixty-three, of Dry Branch won the Name the Train contest held by the N&W Railway for its new streamliner. Scott's submission of "The Powhatan Arrow" was selected from over one hundred thousand entries. Scott was a retired N&W employee. Railway officials also announced that the Powhatan Arrow would make its maiden run between Norfolk and Cincinnati on April 28. When asked how he came up with the Powhatan Arrow, Scott replied, "I just figured that since the N&W already has a train named Pocahontas, maybe they would like another Indian name for the new streamliner.

Powhatan was Pocahontas' father and was a famous Indian chief. 'Arrow' fits right in with the Indian idea…and there it was."

About fifty acres of woodland burned across Yellow Mountain on April 18. Firefighters were able to control the blaze within a few hours. The cause of the blaze was a truck fire.

The Roanoke Black Cardinals semipro baseball team opened their 1946 season on April 21 in a game at Springwood Park against the Nashville Cubs of the Negro Southern League. The Cardinals won, 6–4.

The Great Sedell Troupe, an acrobatic group, performed at the Roanoke Theatre on April 24 as part of the *Revue of Tomorrow* show.

A poll conducted by the Roanoke Chamber of Commerce in mid-April revealed the number-one issue identified by Roanoke's citizens as their top concern was improved garbage collection, and condemning unsafe housing placed second. Cleaning up the Roanoke River was third. Some twelve thousand citizens took part in the survey.

The Virginia Hereford Breeders' Association held their annual show and auction at Victory Stadium on April 20. Sales amounted to over $37,000.

The Roanoke City Council received updated figures for two municipal projects at their meeting on April 22. The cost for a new main library was $255,000 according to the local firm Eubank & Caldwell. The cost for an armory and new baseball field at Maher Field was $917,000.

The AFL Central Labor Council in Roanoke launched a weekly newspaper, the *Virginia Labor News*. E. C. Poston was named as editor.

With the arrival of the Powhatan Arrow, the N&W Railway was granted permission by the SCC to discontinue two passenger trains between Lynchburg and Roanoke and Roanoke and Bluefield, effective April 28. Trains No. 11 and 12 served the Lynchburg-Roanoke route, and Trains Nos. 1 and 2 Roanoke to Bluefield.

The Roanoke Red Sox held their opening game for the 1946 season on April 26 in Lynchburg against the Lynchburg Cardinals. Red Sox manager Eddie Popowski revealed his starting lineup: Henry Reynolds, center field; Milward Quinn, right field; Virgil Stallcup, shortstop; James Dendinger or Carl Shawver, left field; Bill Martin, first base; Eddie Popowski, second base; Edward Wayne, third base; Charley Byrd, catcher; and Charley Dyke, pitcher. The Red Sox faced a 140-game schedule in the Piedmont League. The Red Sox won, 9–2.

Western screen comedian "Cannonball" and his "Country Cousins" performed on the stage of the Roanoke Theatre along with singer Tex Harding on May 1.

The Sparks Circus gave two performances at Maher Field on April 30. The circus featured wild animal acts with leopards, cougars, jaguars, pumas, elephants, and chimps. Human performers included acrobats, jugglers, contortionists, tight-wire artists, and clowns.

A committee seeking a fair trial for accused German collaborator Draja Mihailovich in Belgrade flew eighteen US airmen to testify in the trial. The airmen were shot down over Yugoslavia and were rescued and protected by Mihalovich's rebel forces. Many in the United States felt the rebel leader was being falsely accused in a predetermined trial. One of those eighteen airmen was Sgt. Gerald Wagner of Roanoke County.

Roanoke native Lt. Col. John Cassell, head of the 25th Replacement Depot in Japan, met with Mayor Nakayoshi of Juri, Japan, in Okinawa to discuss repair to the region.

C. C. Spaulding, president of the North Carolina Mutual Life Insurance Company, spoke at Second Baptist Church, Roanoke, on the afternoon of April 28. His address, as president of the largest black-owned insurance company in the world, was sponsored by Addison High School PTA. Spaulding commented, "The traditional Southern attitude towards the Negro is being revolutionized because liberal whites are becoming ashamed of the conditions that exist." Spaulding called on blacks and whites to join forces to eradicate prejudice and discrimination.

The Powhatan Arrow's maiden trip through Roanoke on April 28 attracted several thousand spectators. The westbound train pulled into Roanoke at 12:35 p.m. and the eastbound train at 6:30 p.m. Leonard Scott, who had won the Name the Train contest, boarded the westbound train as a trip to Cincinnati was part of his being the winner of the contest. Hundreds watched along Shenandoah Avenue, at the Jefferson Street crossing, and from the Tenth Street Bridge.

The N&W Railway's Powhatan Arrow leaves Roanoke on her maiden run on April 28, 1946. *Digital Collection, Special Collections, VPI&SU Libraries.*

The Roanoke City Council rezoned from business to residential a triangle-shaped section of property at the intersection of Franklin Road and Avenham Avenue after a significant protest from neighbors in response to the potential building of a dairy plant on the parcel.

Paul A. Wood Construction Company was issued a building permit in late April to construct two apartment buildings on the 300 block of Longview Avenue in South Roanoke. The three-story buildings were to be of Colonial design.

An ensemble of western singers from film and radio performed at the Lee Theatre on May 2. The cast included Jack Sparks and his Hollywood Hotshots, Buck Buchannon, Oscar Turner, Johnny Gable, Jimmy Watson, and Pee Wee Walter.

Lewis Morgan was sentenced to thirty-five years in prison for the hatchet slaying of his ex-wife, Bertha, and the wounding of her seventeen-year-old son.

A recently passed city ordinance went into effect on May 1 whereby restaurants and drug stores serving food were required to display an "A," "B," or "C" card according to how they met sanitary requirements. Some 250 establishments were given cards.

Eddie "Mr. Cleanhead" Vinson and his orchestra performed for a blacks-only dance at the city market auditorium on May 3. Accompanying the orchestra was vocalist Mamie Ferguson. White spectators were admitted.

Sgt. Wiley Munsey Jr., of Roanoke was declared dead by the military. He had been missing in action over Tokyo since April 14, 1945.

The Daleville College property was offered for sale for $27,500 in advertisements that listed the ten-acre property as containing a three-story administration building, a three-story boys' dormitory, a two-story girls' dormitory, a gymnasium, and three residences.

A gigantic tent that could accommodate three thousand persons was erected in Maher Field on May 7 for a *Grand Ole Opry* show with the headline star being Roy Acuff and his Smoky Mountain Boys and Girls. Other performers included Pap and his Jug Band, Ford Rush, and Tommie Magness.

The former CCC camp at Catawba that had also been used as a German POW camp was purchased by the Roanoke-Botetourt Cooperative, Inc., to be used as a labor camp for workers engaged by orchardists in harvesting their apple and peach crops. T. J. Andrews of Roanoke was the cooperative's president. The camp could accommodate up to four hundred persons.

Kay's Ice Cream advertised two new stores in Roanoke, 1304 S. Jefferson Street and 124 Grandin Road. Ads stated: "Modern fountain and booths in both stores." Kay's brand ice cream was made daily at its plant at 1306 S. Jefferson Street.

John W. Hancock, Jr., Inc., of Roanoke was awarded a large franchise contract to provide Quonset huts to the Great Lakes Steel Corporation. Hancock erected a Quonset hut at McClanahan Place in South Roanoke to serve as an office and model hut to demonstrate its civilian use.

Bill Grassick and his band came to the City Market Auditorium on May 8. He was joined by vocalist Betty McHugh.

Congressman Adam Clayton Powell Jr. addressed a mass meeting at St. Paul's Methodist Church on May 9. His speech was "Winning the World Peace." Powell asserted that America won the war through unity, but that disunity along matters of race at home should not stand.

Lakeside Park and Lee Hy Swimming Pool opened on May 10 for the season. Their advertisements read, in part, as follows: "We do not mix nationalities."

Kane Furniture Company opened on May 11 at 22 E. Campbell Avenue, Roanoke. The president and general manager was Sam Kane.

Medical Arts Optical Company opened on May 11 in the Patrick Henry Hotel. J. H. Hickey was the optician.

Lucky Millinder and his orchestra performed for a blacks-only dance at the City Market Auditorium on May 14. Vocalists included Bill Johnson and Anasteen Allen. White spectators were admitted.

Edward Fisher, thirty-nine, of Fairview was killed when his car was struck by Virginian Railway passenger train No. 4 on a grade crossing at Cleveland Avenue and Seventeenth Street, SW, on May 13.

The state board of pardons and reprieves denied a petition by Thomas Harrison of Roanoke County for a reprieve from his state execution set for May 20. Harrison had been convicted in the January 19 slaying of Roby Daugherty.

The Roanoke Round Table of Christians and Jews was formed on May 17 during a dinner meeting at the Patrick Henry Hotel. The organization consisted of Protestant, Catholic, and Jewish laity and clergy. The steering committee consisted of James Moore, Anselm Miller, and Arthur Taubman.

The Roanoke City Council directed the city manager to develop a plan for lights at Victory Stadium. The council's request was prompted by a number of recreation and athletic groups with an eye on Jefferson High School's opening football game slated for early September.

Elmore Heins and associates purchased the Rialto Theatre at 9–15 E. Campbell Avenue, Roanoke, for $225,000. Prior to becoming a theatre, the building had been a billiard parlor and bowling alley. The Rialto opened there in 1919. The theatre was purchased from the estate of William R. Martin.

Salem Scout troops held their annual spring camporee at Longwood Park on May 18 and 19. The Roanoke spring camporee was held at Fishburn Park.

At noon on May 17, water went over the spillway at Carvins Cove dam 328 days after the dam gate was closed. The water level had been inching higher to the eighty-foot crest mark as water officials eyed the moment when water would first trickle over the dam. Skeptics had suggested that the dam would never fill, so the water event was widely celebrated by proponents of the dam. The dam was closed, and the reservoir began to fill on June 23, 1945.

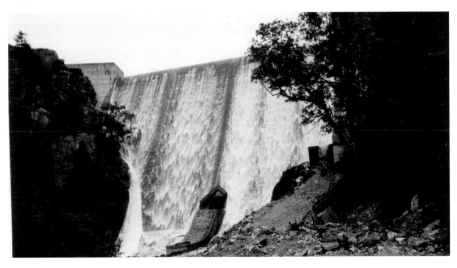

This photograph was taken three days after water first went over the Carvins Cove dam spillway. It took 328 days for the reservoir to fill. *Western Virginia Water Authority.*

Blankenship and Davis, an ophthalmic firm, opened at the corner of Church Avenue and First Street, SW, on May 18. The partners were J. C. Davis and E. M. Blankenship, both of Roanoke.

A rodeo was held in Victory Stadium on May 21 and 22, combined with the Late Lucky Teeter's Thrill Circus. The event boasted fifty-two different events with 162 performers and two hundred bucking horses and Brahma bulls. Advertisements promised one hundred dollars to anyone who could ride the Brahma bull "Big Sid" for ten seconds. Tickets were available at Henebry's Jewelers.

The parents of Thomas Harrison, scheduled for electrocution, made one final plea for reprieve to the state on the basis that their son was mentally retarded. Three psychiatrists had testified at the trial that Harrison's mental abilities were that of an eight-year-old. The pardon and parole board refused the request.

The new baseball field at the Veterans Administration Hospital was dedicated on May 21. The hospital team played host to a Texaco team in their A-league baseball game. Dr. Peter Peffer, hospital manager, threw out the first ball, and music was provided by the Monroe Junior High School band. The mayors of Roanoke, Salem, and Vinton also participated in the dedication ceremonies.

After thirty-six years in business, Roanoke Jewelry Company, located in the Ponce de Leon Hotel building, closed its doors in May with a weeks-long closeout sale.

The Rev. L. L. White, pastor of St. Paul's Methodist Church, Roanoke, was named as one of the nation's top-twenty-five outstanding young Methodist ministers by denominational officials. Nominees were provided by the denomination's many seminaries.

Mrs. Ruth Taborn died at the home of her daughter, Mrs. Ocie Jennings, on May 18. She was born in the Cave Spring section on March 15, 1841, and had lived her entire life—105 years—in the Roanoke Valley. At the time of her death, she was believed to be the oldest living person in Roanoke city.

The Roanoke Black Cardinals defeated the Raleigh (North Carolina) Greys in both games of a doubleheader played before six hundred fans at Washington Park on May 19.

The state carried out the execution of Thomas Harrison on May 20. Harrison had been convicted of killing Robert Daugherty, a Salem gas station attendant. Harrison was put to death in the electric chair at the state prison in Richmond. The time of his death was 7:41 a.m. Harrison's father had visited on Saturday, and a spiritual advisor had visited Monday morning, the day of his death. One local witness to the execution was Roanoke County Sheriff E. E. Waldron. Harrison was interred in Evergreen Cemetery in Roanoke.

The Candle Glo Beauty Salon opened at 2101 Williamson Road on May 21. Miss Louise Jarrett was the owner.

Thomas Harrison of Roanoke was executed by the state on May 20, 1946, for the murder of Salem gas station attendant Robert Daugherty. *Nelson Harris.*

Miss Lucy Courey opened her Lucy's Restaurant at 716 Park Street, SW, on May 21.

Drury Armistead, a furniture dealer in Roanoke, died on May 21 at the age of seventy-one. Armistead organized Phelps and Armistead Furniture Company in Roanoke in 1912.

Farmers National Bank of Salem observed its seventy-fifth anniversary with an open house at the bank. The bank was chartered on May 23, 1871, and was the oldest bank in the state west of Lynchburg.

Salem entered a baseball team in the four-team Blue Ridge League and held their opening game on May 22. The other teams included Radford, Galax, and Mount Airy, North Carolina. The roster for the Salem Red Sox was as follows: Noel Cashier, shortstop; Chet Wyzkiewicz, infielder; Vernon Mackie, manager; Don Krupa, pitcher; Robert Abbott, outfielder; Mike DePriest, pitcher; Jack Kimp, infielder; Earl Price, pitcher; Ed Wise, outfielder; Joe Koren, outfielder; Wally Shrocki, infielder; Wayne Stewart, second base; Dick Kalal, shortstop; Ed Wayne, third base; Serge Schuster, catcher; and Sandy Saunders, infielder.

The Standard Advertising Corporation purchased the Art Sign Service, 210 Nelson Street, SE. Standard was a Roanoke-based company with a neon sign plant in Bristol.

The Roanoke Rose Society held its first rose show since 1941, and several hundred attended the event held at the Hotel Roanoke.

The Patchwork Players organized into a full-time summer theatrical group to present plays from June through September. The group consisted mostly of college students. The group had informally produced plays the previous summer in the gardens of Mr. and Mrs. A. A. Farnham on White Oak Road in the Prospect Hills subdivision. Francis Ballard served as director for the group.

The Colonial Theatre in Salem hosted on its stage on May 25 the "National Radio Jamboree" featuring the Oklahoma Cowboys along with western film and radio comedians.

An auction was held on May 28 at Poplar Forest, a former home of Thomas Jefferson in Bedford County. According to the auction company, several pieces of furniture from the home that were part of the sale belonged to Jefferson.

A number of Memorial Day events occurred in the Roanoke Valley. Vice Adm. Daniel Barbey spoke at Sherwood Park's amphitheater on May 26. On May 30 at the Veterans Administration Hospital there were baseball and softball games, a band concert, and a memorial service in the chapel. On May 30, a memorial service was held in Elmwood Park with Congressman A. L. Almond Jr. as speaker, along with concerts by school and church choirs.

Jimmy Hayes and Guy Broyles opened a used-car business, Southwest Motors, at 536 Rorer Avenue, SW, on May 25.

The Roanoke City Council unanimously adopted a city-funded pension plan for all municipal employees, excluding schoolteachers, to take effect July 1. An existing pension plan for the city's police and fire departments remained in place and was not a part of the new plan.

Six youths at the Virginia Industrial School for Boys at Beaumont were charged in conspiracy with the killing there of a supervisor, Clarence Hubbard. Among the six youths charged were two from Roanoke, Garwod Trenor and Freddie Caves. Trenor was also charged for the murder.

Josephine Moorman, fifteen, who had been charged in the suffocation of her newborn was given a five-year jail sentence.

A home built in 1828 near Vinton and belonging to the estate of R. L. Funk was sold at auction on May 28. The Queen Anne brick home had nine fireplaces, walnut trim, winding staircase, and hand-carved doors and mantels.

Robert H. Smith was appointed president of the N&W Railway at the May 28 meeting of the company's board of directors in Philadelphia, Pennsylvania. Smith had been vice president of operations and succeeded William Jenks, who had served as president since 1936. Smith began his career with the railway on July 1, 1910, as an axeman and chainman in the railway's engineering department in Roanoke.

Sunnybrook Subdivision, also known as the Boxley farm, was put up for auction on June 5. The property consisted of forty home sites and tracts along with two corner business lots. The property was located one mile west of Hollins College at the intersection of Highway 11 and Route 601.

The junior chamber of commerce's fourth annual Hippodrome Thrill Circus opened for a weeklong run at Maher Field on May 30. The circus featured the Rudynoff family with the dancing stallions, the "American Eagles" high wire act, the Pierrot and Pierre skating act, the "Congress of Clowns," and dogs and ponies.

Traveltown Swimming Pool at Cloverdale opened for the season on May 30. Ads touted "city bus service to and from Cloverdale each hour."

Wright Furniture Company in Roanoke advertised that all high school graduates in the Roanoke Valley could receive a miniature Lane cedar chest by presenting their card at the store.

Goode's 5 and 10-cent Store opened in Vinton on June 1.

N. W. Pugh Company announced they had resumed delivery service that had been suspended during the war. Their trucks went out twice daily, with morning purchases delivered that afternoon and afternoon purchases delivered the following morning. Salem and Vinton deliveries were made three days per week.

L. D. James, Roanoke city clerk, submitted his letter of resignation to the city council on May 31 to take effect June 30. James had been clerk since October 1, 1934. The council-appointed officer did not elaborate on the reason for his resignation other than to say, "I'm going fishing."

Ernest Keffer won the annual spring golf tournament at Roanoke Country Club, carding a seventy-two-hole score of 275 over the multiday event.

Eicky Bayse opened Bayse Esso Station at 24 Street and Melrose Avenue, NW, on June 1. He had formerly operated an Esso station on Peters Creek Road.

The Roanoke Black Cardinals played the Baltimore Grays in a doubleheader at Springwood Park on June 2.

Leaders of the Roanoke YWCA launched a capital campaign to raise $54,000 to pay off the debt on the Y's building, which had been constructed in 1926. The original YWCA building had been at 415 Third Street (formerly Roanoke Street).

The trustees of Roanoke College accepted the recommendation of a special committee that football not resume at the college.

Atlantic Greyhound Company announced on June 3 that it would immediately comply with a ruling of the US Supreme Court that banned segregated seating on buses traveling across state lines. Greyhound served Roanoke. The case had come from a Virginia

resident, Irene Morgan, who had lost the argument against segregated seating before the Virginia Supreme Court but had won on appeal to the US Supreme Court.

Vernon Mackie resigned as manager of the Salem Red Sox baseball team and was succeeded by Noel "Red" Casbier. Mackie resigned due to a salary dispute.

Kenneth Furbush, fifty-three, of Vinton died on June 4. Furbush was a well-known druggist operating White Front Pharmacy in Vinton and Furbush Drug Stores on Patterson Avenue and Williamson Road.

The Villa opened for dining and dancing on June 5 on Route 460 near Villamont.

The Shenandoah Life Insurance Company sold its seven-story building at Kirk Avenue and First Street, SW, to a group of investors, but company officials announced they would continue to lease the building from the new owners. The property was sold for $600,000 to C. W. Francis Jr., Edmund Goodwin, Frank Hancock, and Edward Ould. The building was initially constructed as three stories in 1911 by the Anchor Company to house the Roanoke Gas and Water Company. At one time, during construction of the municipal building, the structure housed the Roanoke courts. The building was also home to the WSLS radio station.

The Graham-White Manufacturing Company at 723 Third Street, SW, purchased the Princeton Foundry and Supply Company in Princeton, West Virginia.

Harvey Howell opened a restaurant on Bent Mountain in early June. His ads read, "Relax in cool mountain breezes…It's new…It's different."

Paul Reynolds was named program director and Irv Sharp was appointed studio director for the radio station WDBJ, which was owned by the *Roanoke Times* and *World-News*. Their effective start date in their new roles was July 7.

The Rowe-Jordan Furniture Corporation reported on June 8 that it had completed its move from 515 Norfolk Avenue, SW, in Roanoke to 1228 Indiana Street in Salem. The site was temporary pending completion of the furniture company's new plant near the Colorado Street Bridge in Salem.

Nine local aviators filed for a charter from the state to begin a new air freight and passenger service out of Roanoke. The new entity was Virginia Air Transport. Eugene Sweeney was president.

Dr. Doris Janes became the first woman optometrist in Roanoke when she opened in Room 205 of the Rosenberg Building the first week of June.

Piney Grove Christian Church celebrated its centennial on Sunday, June 9. The church was located just south of the intersection of the Starkey and Rocky Mount Roads. It began in a log structure on in late May of 1846 and held union services for Methodists, Presbyterians, and Lutherans who resided in the Ogden community. The Christian congregation was organized on May 7, 1905. Original ministers for the Piney Grove Church were Gideon Scherer, Lutheran, and Urias Powers, Presbyterian. The original pulpit Bible from 1846 was displayed as part of the homecoming activities.

The Roanoke City Council accepted a bid from the Jefferson Electric Company for the installation of permanent wiring and flood lights at Victory Stadium. The contract was for $24,000. Jefferson Electric guaranteed that the work would be completed by September 1. The council was informed that Jefferson High School would play night football games in September and October but afternoon games in November due to the weather.

Piney Grove Christian Church was located at the intersection of
Routes 220 and 419. It was later razed, 1946. *Nelson Harris.*

In one of the most spirited Roanoke City Council races in years, the Democratic ticket captured two spots and the "Citizens' Ticket" that had been backed by the chamber of commerce and other organizations garnered one in the June 11 election. The two Democrats elected were Richard Edwards and A. R. Minton, with the third spot going to R. J. Meybin, who edged out Democrat Benton Dillard by four votes. Edwards was an attorney. Minton had a retail meat business, and Meybin was a vice-president of the Virginia Bridge and Iron Company. The tallies for each candidate were as follows: Edwards, 3,998; Minton, 3,304; Meybin, 2,998; Dillard, 2,994; Richard Mullikin, 2,368; Leo Henebry, 2,365; W. M. Powell, 1,344; H. F. Stoke, 981; Lacy Edgerton, 757; and Silas Switzer, 609. Henebry and Powell were both incumbents, with Henebry the sitting mayor. Henebry had run on the Citizens' Ticket while Powell had run as an independent. The total number of voters was 7,498.

In the Salem Town Council race, Mayor Frank Morton and James Moyer were elected. Both were incumbents. Two challengers were Dr. E. W. Senter and Maynard Dooley. Vote totals were as follows: Moyer, 716; Morton, 430; Senter, 301; and Dooley, 145. In Vinton, Norman Dowdy unseated incumbent R. L. Meador by one vote, 113–112.

During the night game on June 10 between the Roanoke Red Sox and Norfolk, a bench-clearing brawl occurred. Roanoke police had to assist the umpires and managers in breaking up the fight.

Two crewmen and one passenger were killed when the Powhatan Arrow left the tracks on a sharp curve at Powhatan, West Virginia. One Roanoker, Mrs. Frank Ling, was among the injured.

Dr. Peter Peffer, manager of the Veterans' Administration Hospital, spoke about the care given to the veterans by the staff there in address to the Roanoke Kiwanis Club. The

various treatments outlined by Peffer were as follows: electro-shock treatments for certain types of mental illnesses; insulin shock treatment; conditioned reflex treatment for alcoholism; fever and chemotherapies for various kinds of syphilis; prefrontal lobotomies; and more traditional therapies, rehabs, exercises, and recreational activities. The number of patients at the hospital at the time of Peffer's talk was 1,710.

Kay's Ice Cream announced the opening of a new store at the corner of Church Avenue and Third Street, SW, on June 14.

The 1946 wrestling season came to an end in mid-June with promoter Scotty Dawkins announcing his last card. The *Roanoke Times* editorial board welcomed the news. "Wrestling fans are in a class to themselves. It is the only sport we know of where the participants can manhandle the referee and get away with it. In fact some of the loudest cheers come from the fans when a wrestler takes hold of the referee and deposits him into the third or fourth row of spectators."

Carlton Short, general manager of the Times-World Corporation, died of a heart attack on June 14 in a hotel room in Washington, DC, where he was attending a meeting of newspaper executives. He was fifty-seven. Short had been the general manager since 1936.

Magic City Household and Hardware Company opened at 1601 Williamson Road on June 15.

The Roanoke Chamber of Commerce recommended that Roanoke City Council reactivate the City Planning Commission, which had been defunct since 1932 when five of its members resigned. The chamber pointed out that a city ordinance called for the existence of the commission.

John Fitzgerald, an air-traffic controller at Woodrum Field, was photographed on the job shirtless and sweating. He claimed he and his coworkers had the hottest jobs in the valley as the control tower was not air-conditioned and was open to the sun all day. The day of the photo, June 15, the temperature inside the control tower was 113 degrees.

Roanoke's police chief, J. F. Ingoldsby, announced in mid-June the appointment of the department's first black policemen, Woodrow Wilson Gaitor and Lonnie A. Caldwell. Both were military veterans. The police chief said the appointment of the two men was in response to repeated calls by black community leaders for such a step and followed the recent hiring of black policemen by the cities of Norfolk and Richmond.

A. W. Cheatwood began operating boat tours around Carvins Cove in mid-June. Rides were fifty cents aboard the *Queen of the Cove.*

The first barracks-type emergency housing units for veterans began being erected in mid-June on the property of the Roanoke city farm. Contracts for the foundations were awarded to the Carlin Company of Roanoke. Some six hundred applications had been filed for those seeking housing within the complex.

Vinton mayor Joe Pedigo resigned his office on June 18. The Vinton Town Council accepted the resignation and immediately appointed Nelson Thurman to serve the reminder of Pedigo's council term. Pedigo said he resigned because he was unable to reside in Vinton and maintain a four-hundred-acre dairy farm in Bedford County. Ross McGee was elected by the town council to serve as mayor.

Some 150 women affiliated with the AFL Ladies Garment Workers union went on strike at the Puritan Mills, 330 W. Campbell Avenue, on June 18. A spokeswoman said

Woodrow Gaitor was one of the first two black men to be appointed officers with the Roanoke City Police Department in 1946. *Nelson Harris.*

Lennie Caldwell, along with Gaitor, was the other black police officer to be appointed, ending decades of a whites-only police force. *Nelson Harris.*

the women were out on strike due to an accumulation of grievances against the company, which manufactured ladies' apparel.

Butner Brothers opened at 1610 Williamson Road on June 20. C. B. Butner and Seth Butner were proprietors of the plumbing, heating, and appliances establishment.

The Plaza Restaurant's Amber Dining Room held a grand opening on June 21. The restaurant specialized in Chinese, Italian, American, and seafood dishes. The Amber Room, 3011 Williamson Road, seated up to 250 persons.

Formation of a Negro unit of the Roanoke County chapter American Red Cross Gray Ladies Corps was announced; it would serve the black patients at the Veterans Administration Hospital.

The new bus garage to serve the Roanoke County school system was completed on Alabama Street in Salem in late June. The $10,000 garage serviced the fleet of twenty-eight buses.

Kay's Ice Cream began advertising a brand-new flavor—Butterbrickle—in late June.

Dr. Wade Bryant, pastor of First Baptist Church, Roanoke, and Dr. E. D. Downing, were elected as president and vice president, respectively, of the Roanoke Commission on Inter-racial Cooperation.

An explosion rocked downtown Roanoke on June 22, injuring five persons. The blast came from the Junior Grocery at 205 Franklin Road, SW, and effectively leveled the store. Lee Junior High School sustained considerable damage as well. The blast occurred at 6:47 p.m., and the cause was initially undetermined. Police and fire officials stated it was miraculous that no lives were lost, considering two women had been trapped in the rubble. Those taken to Lewis-Gale Hospital were Louise Aesy, Lucille Burchett, R. C. Ratcliff, Mrs. Tinsley Morris, and H. J. Deese. Thousands thronged downtown the following day to view the damage.

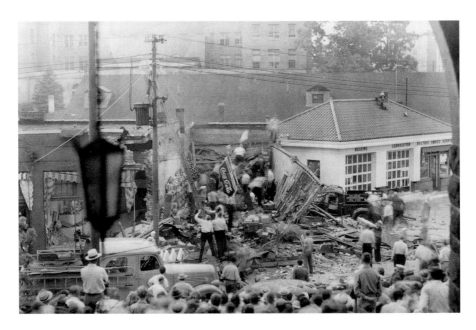

This image shows the aftermath of the fireworks explosion that leveled the Junior Grocery on June 22, 1946. Dow Pontiac is in background. *Roy Minnix.*

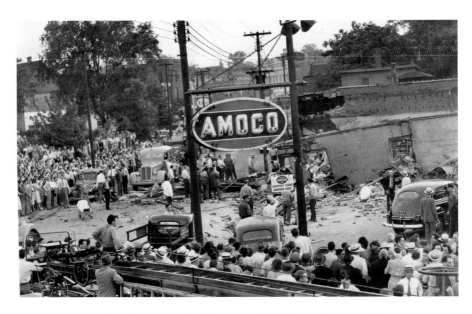

A crowd gathers to view the destruction of the Junior Grocery explosion and the debris scattered along Franklin Road. *Roy Minnix.*

The Salem Red Sox left Salem on June 25 when the town council decided against temporary lights at the municipal ball field. The management of the team wanted to be able to play night games, so the team transferred to Lenoir, North Carolina, and became the Lenoir Red Sox. The team had also suffered from poor attendance while at Salem.

Lindsey-Robinson and Company, a flour and feed manufacturer, announced a $150,000 expansion of their Roanoke plant. When completed the mill would have four independent mixing units, with a combined capacity of fifty-five tons per hour. C. G. Lindsey Jr. was company president.

A local unit of the Caterpillar Club, a famous national organization for those who had ever made an emergency jump from an aircraft, was announced in late June. An organizational meeting was set for July 14, and some forty veterans had been contacted. The organizer was James Basham.

First Presbyterian Church, Roanoke, held a dedication service for its sanctuary on Sunday, June 23. Presbyterians did not dedicate sanctuaries until all debt had been paid, and First Church achieved that milestone on its $135,000 building. The sanctuary had been erected at McClanahan Place in South Roanoke in 1926. Dr. Robert Lapsley Jr. was pastor. Special speaker for the occasion was Rev. Thomas Young of Memphis, Tennessee, who was pastor of First Church from 1924 to 1930. A brief history of the church was provided, including its various locations. The first location was in northeast Roanoke on the former Lynchburg Road when the city was called Old Lick, and the church was named Old Lick Presbyterian. The second location was on Church Avenue (the frame chapel being moved there from Lynchburg Road), and then the chapel was moved again to Norfolk Avenue (in 1946 that chapel was being used by the Jerusalem Baptist Church). In 1929, the first service was held at the church's current site in South Roanoke.

Two days after an explosion at the Junior Grocery, one of the injured, Richard Ratcliff, was charged by Roanoke police of malicious wounding in connection with the incident. The grocery, located at 205 Franklin Road, had a large display of fireworks in the front window, and investigators believed that Ratcliff lit a fuse on one of them through a crack in the window. This led to the explosion. Emmett Aesy was the store's proprietor, and he reported having 3,456 small torpedo bombs, 720 two-shot repeater tornadoes, and 432 aerial bombs of three types. All the fireworks were piled together for a display. Police also reported traffic congestion at the site, with cars steadily streaming by to view the damage. Fire officials also assessed the damage to nearby and adjacent structures, with their report as follows: Mayfair Gift and Art Shop, 207 Franklin Road, south and east walls demolished; H. J. Holdren Electric Refrigerator Store, 209 Franklin Road, south wall cracked; Moore Radio Shop, 211 Franklin Road, south end of building blown out; F. E. Fielder residence, 213 Franklin Road, south end of structure blown out. Windows were blown out at the Larry Dow Pontiac dealership at 509 Commerce Street, and the same was true for the Post Office Café, Pitzer Transfer, and the west side of Lee Junior High School.

At its regular meeting on June 24, the Roanoke City Council passed an ordinance that effectively and immediately banned the possession, sale, or shooting fireworks in the city limits. The exceptions were fairs and other forms of entertainment where the use of fireworks was to be done under professional supervision. According to police, the fireworks at the Junior Grocery had been analyzed by the labs at Viscose and the Radford Munitions Plant and found to contain TNT, as most fireworks did at that time.

The Record Shop opened on June 26 at 1136 S. Jefferson Street selling new and used records. The opening-day special was six records for one dollar.

Augustus Chapman, twenty, of Roanoke was killed in an automobile accident just west of Cave Spring on June 23.

The building indebtedness of the Phyllis Wheatley Branch YWCA was paid off in late June with a $1,000 gift from C. C. Williams. To recognize the gift, the name of the branch was changed to the Lula Williams Memorial Branch YWCA in honor of the donor's deceased wife. Mrs. Williams was a charter member of the branch.

The first full cargo of air freight arrived at Woodrum Field on June 27 when a two-motor C-47 transport landed carrying a shipment of farm equipment for Renick Motor Company in Roanoke.

Cannonball, a Western movie comedian, and his Country Cousins performed on the stage of the Salem Theatre on June 28.

The eleven-day strike at Puritan Mills came to an end as management and the union agreed to terms of a new contract.

The Vinton Town Council adopted an ordinance prohibiting fireworks in wording almost identical to that adopted by the Roanoke City Council.

The Roanoke Black Cardinals played the Beckley, West Virginia, Indians in Springwood Park on June 30.

N. W. Pugh Company launched a new radio program that was heard at 1:00 p.m. Monday through Friday on WDBJ. *The Wishing Well* was hosted by Harriet King and invited listeners to send in a letter, forty words or less, that described an article from Pugh's that had been purchased and was well liked. Judges scored letters on the basis of sincerity and originality. Each week Pugh's "made someone's wish come true," as the winner was awarded merchandise from their store.

The War Department released figures on those lost in World War II. According to the department's count, the losses for Roanoke county and city were as follows: 191 were killed in action, 25 died of wounds, 73 died in non-battle-related causes, 25 under "presumed dead," and one was missing, for a total of 315.

Tiny Bradshaw and his Kobsery Bounce Orchestra performed at the Roanoke City Market Auditorium on July 3. White spectators were admitted.

Mayor Leo Henebry was directed by members of the Roanoke City Council to select five men from a list of ten that had been submitted to him by the city manager to compose the City Planning Commission. The commission had been inactive for several years, and business leaders had advocated for its reestablishment.

The Trailer Inn opened with twenty-four-hour service at 306 Third Street, SE, on July 3. The restaurant also delivered.

The Roanoke Black Cardinals played a doubleheader against the Baltimore Panthers in Springwood Park on July 4. They played the Raleigh Clippers on July 7.

The Vinton Lions Club held their third annual Vinton Horse Show on the grounds of William Byrd High School. Some one hundred horses were entered from three states.

Fink's Jewelers acquired the property occupied by Patterson Drug Company at 308 S. Jefferson Street. Fink's was at 212 S. Jefferson Street. No information was given as to when Fink's intended to relocate.

The south span of the Norwich Bridge over the Roanoke River collapsed on July 5 as fire swept the wooden flooring. Damage to the bridge was estimated at $10,000. The city

engineer stated that a pedestrian walkway would be put in place until the bridge could be rebuilt. The bridge was constructed in 1891 by the Pittsburgh Bridge Company, but the city had placed a new floor in it in 1941.

The Roanoke Gun Club hosted the Virginia state trap shoot tournament. Miss Ruth Cuthbert of Winchester won the ladies handicap, hitting 90 out of 100. R. R. Miller of Roanoke was top man in the doubles, hitting 90 out of 100. C. J. Renner of Winchester was tournament champion, hitting 376 out of 400.

The Patchwork Players announced they would perform plays at city parks over the summer, with their opening night being at Highland Park on July 8. Other parks included were Norwich, Eureka, and Washington. The twenty-three-member theater group also performed sketches on Tuesday and Wednesday evenings at the home of Mr. A. A. Farnham in Prospect Hills.

Edward Martin, twenty-six, was fatally injured when he fell under the wheels of a moving coal hopper on July 7. Martin was employed by the N&W Railway at Shaffer's Crossing as a laborer in the mechanical department.

Algie Vaden, fifty-seven, of East Gate was shot and killed by a blast from a single-barreled shotgun. Frank Green of East Gate, and son-in-law of Vaden, was charged with murder.

The Metropolitan Café, 510 S. Jefferson Street, celebrated its fiftieth anniversary by offering souvenirs to all patrons, plus a slice of birthday cake to all lunch and dinner customers.

Sgt. Leroy Aulthouse of Roanoke was declared dead by the military. He had been missing in action over France since June 5, 1944, having been a B-17 aerial gunner.

The Roanoke Booster Club announced they would resume their annual trips. The club had suspended the trips during the war. Their trip for 1946 would be September 10 to the Homestead at Hot Springs, and the trip would be limited to the first 250 who registered. Dr. E. G. Gill was club president.

The Patterson Drug Company acquired the business of the Henry Street Pharmacy on July 10 and planned to move to those quarters at Church Avenue and First Street, SW, in August. A. T. Canada was manager of the Patterson Drug Company.

Billy Eckstine and his orchestra performed for a dance and show at the City Market Auditorium on July 11. White spectators were admitted.

Judge Stanford Fellers of the Law and Chancery Court dismissed a lawsuit against Roanoke mayor Leo Henebry and others by M. C. Franklin that questioned the validity of the deed to Maher Field, conveyed by the Virginia Holding Company, a subsidiary of the N&W Railway, to the city of Roanoke. The complainant, Franklin, and others sought to stop further development in and around Victory Stadium, claiming the city did not hold certain rights to do so.

Federal postal officials approved a request from Roanoke's postmaster, Mrs. Virginia Wright, that a postal substation be established in the Raleigh Court–Virginia Heights area. The substation would be the first in Roanoke, though contract stations had operated in stores and other businesses for many years.

A fire swept the attic of the Yellow Cab Company, 200 Shenandoah Avenue, on July 11, causing $5,000 worth of damage.

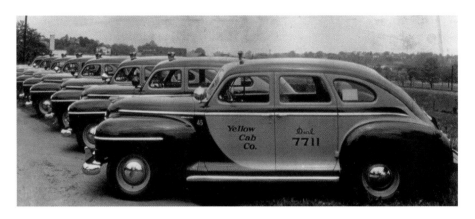

The new fleet of 1946 Plymouths for the Yellow Cab Company is parked along McClanahan Avenue, SW. *Virginia Museum of Transportation.*

An All-Day Air Festival was held at the Montvale Airport on July 14. Participating aviators included Don Pollard, Karl Stein, Herbert Gilliam, and other former army and navy pilots doing acrobatics, racing, stunts, and passenger rides. The show was sponsored by Moore-Williams Clothing Company, 124 W. Campbell Avenue.

Z. T. Kyle announced his resignation as the principal of Andrew Lewis High School, Salem, at the conclusion of the school year. He had been principal at Lewis since 1939.

Jimmy Trinkle and Thurston Angell of Roanoke won the state junior doubles tennis championship at Byrd Park in Richmond on July 12.

Three persons lost their lives in drowning on the same day, July 13. Noah Smith, thirty-six, drowned while trying unsuccessfully to save his son, Jackie, who had slipped from an inner tube as they floated down the Roanoke River near Lafayette. Both were from Roanoke. In a separate incident, Howard Collins, thirty, of Cave Spring drowned at an abandoned rock quarry on the old Garst Mill Road near the intersection with Route 221.

The Crescent Amusement Company offered shows, rides, and a midway at the back of the Vinton Weaving Mill from July 15 to 20. The company advertised nine modern rides, seven clean shows, and a man shot from a cannon nightly at ten.

The bridge at Tenth Street, SW, over the N&W Railway tracks was opened on July 13, having been resurfaced and refloored.

Roanoke County Sheriff Emmett Waldron rode into Salem on horseback on July 14. Residents near the Riverjack service station reported a horse wandering the roadway. The sheriff responded to the call, put his belt around the horse's neck, and with a saddle provided by a passing motorist rode his suspect into Salem hoping someone would claim the animal.

The Roanoke Black Cardinals defeated the Salem Red Birds 11–6 in a game at Springwood Park on July 14.

A five-man city planning commission was named by Roanoke mayor Leo Henebry on July 15. The appointees were B. N. Eubank, B. F. Parrott, W. J. McCorkindale Jr., Frank Turner, and Warren Hobbie. The appointments came from a list of ten names submitted to the mayor by the Roanoke City Council.

Mrs. Lockie Green, eighty, of Christiansburg was instantly killed when she was struck by an N&W Railway passenger train and hurled to the pavement below at the Lynchburg Avenue viaduct on July 15. The engineer said he applied the emergency brakes and blew the whistle, at which point the woman took two steps and stood motionless with her back to the train.

The Roanoke County Board of Supervisors took the first step in adopting an ordinance banning the possession, use, and sale of fireworks in the county. Their action was modeled after similar action by the Roanoke City Council.

The Kennett School of Commerce, corner of Campbell Avenue and Third Street, SW, announced on July 17 their new name as the Virginia Southern College. The school would have two departments: the Accountancy and Business Department would still be called the Kennett School of Commerce, and the Stenographic and Secretarial Department would be the School of Secretarial Training.

The Vinton Town Council gave approval for the Roths theatre chain to build a new theatre on Pollard Street. When opened, it would be the town's first theatre.

A two-month-old infant boy was abandoned in an automobile in the parking lot of the Hotel Roanoke on July 17 and was taken to Roanoke Hospital. The infant had been left on the front seat of a car of a couple who had parked at the hotel. The baby was wrapped in clothes. and a bag of infant supplies was also on the car seat. It was reported in good health.

S. H. Clark of Roanoke was elected grand president of the Association of Colored Railway Trainmen and Locomotive Firemen at the group's biennial convention at the William Hunton YMCA branch.

The restaurant Chicken in the Rough opened at 1508 Williamson Road, with operating hours of noon to midnight every day except Tuesdays. "Every bite a tender delight."

Charles W. Thomas, known as "the Paul Revere of Roanoke," died on July 19 at his home on Stanley Avenue in South Roanoke at the age of ninety-one. Thomas was the man who carried $10,000 on horseback in 1881 when as town sergeant he rode at night to a point near Buchanan with a check and a resolution from the town of Big Lick urging the directors of the Shenandoah Valley Railroad to make Big Lick the railroad's terminal. The directors, meeting in Lexington, were so impressed by the offer and the means of its delivery that they chose Big Lick over Salem, thereby assuring Roanoke its railroad future. When Big Lick became Roanoke, Thomas served two terms as city treasurer.

Charlie Cobler, forty-two, of Roanoke was killed instantly on July 20 when a car in which he was a passenger was broadsided by a city bus at Dale Avenue and Eighteenth Street, SE, just two blocks from Cobler's home. The bus driver was charged by police with reckless driving and manslaughter. Two days later, Cobler's brother and the driver of the automobile that was struck, George Cobler, forty-eight, died from his injuries in a local hospital.

The Second Baptist Church, 25 Centre Avenue, NW, underwent repairs and alterations costing about $10,000 in late July, including a new copper roof on the bell tower. The church was established in 1884. One of the early church buildings was destroyed by fire before the present structure was built. Church membership was around three hundred.

Ensign John Peterson of Roanoke was aboard the USS *Furse* when atomic bomb experiments were conducted as part of Operation Crossroads at Bikini. Peterson said he took no chances. "I hid down in the bottom of my boat."

A Roanoke chapter of Alcoholics Anonymous was formed and a post office box mailing address provided for those wishing to learn information about meeting times and locations. It was the first such chapter in the Roanoke Valley.

Mrs. G. O. McGhee resigned as principal of Bent Mountain High School in mid-July, desiring to serve on the faculty only. James P. Woods Jr. of Roanoke was appointed to succeed her.

These haystacks are prominent along Tinsley Lane at Bent Mountain in this mid-1940s image. *Virginia Room, Roanoke Public Libraries.*

Mae Williams of Gainsboro Avenue, NW, was fatally stabbed outside a Henry Street restaurant on July 21. James Palmer was charged by local police with the stabbing.

The Roanoke Artificial Limb Company, Inc., opened on July 24, at 615 15 Street, SW. The company offered artificial limbs made of metal and willow wood. O. J. Bruce was manager.

The Blankenship Block Company, manufacturers of concrete blocks, opened on the premises of H. H. Carter Lumber Company, corner of Brandon Avenue and Franklin Road, on July 24.

The first Roanoke Soap Box Derby was held on July 24 for those between the ages of eleven and sixteen. The day included a prederby parade at 10:30 a.m. through downtown Roanoke with the first heats at 2:00 p.m. The course was on Richelieu Avenue in South Roanoke between First and Fifth Streets. The derby was cosponsored by the Roanoke Optimist Club and Johnson-McReynolds Chevrolet. City police strung ropes along the course to keep onlookers off of it. The Magic City Soap Box Derby was covered live by WDBJ and WSLS radio stations. The starting ramp was constructed by the city Parks and Recreation Department, and Mayor Leo Henebry served as chief of the judges who presided over the awarding of trophies. The winner was David Poage, fourteen, of the Villa Heights section, who edged out Charlie West of Virginia Heights. Some three thousand persons lined themselves along the course to watch the event. Poage qualified to go to the National Soap Box Derby Championship Race in Akron, Ohio, in August.

Roanoke's first two black policemen were assigned beats on July 23. The police chief said the assignments marked "a new experiment" for Roanoke. Both officers, Woodrow Gaitor and Lonnie Caldwell, were assigned beats in black neighborhoods.

New works for the bell tower clock at Greene Memorial Methodist Church were installed on July 23. The new motor-driven mechanism replaced an old system of weights that turned the hands of the clock.

Peterson-Baker Company, radio and electronic service, moved from their former location on Church Avenue to 1107 S. Jefferson Street.

Miss Elizabeth Pettrey of Roanoke had her script titled "Squeegee" broadcast nationally over the Columbia radio system on July 24 on the *Dr. Christian* series that starred Jean Hersholt.

Johnson's Amoco Station opened at 1028 Tazewell Avenue, SE, on July 24.

H. M. Bell resigned his position as principal of Lexington High School in Rockbridge County to become the next principal at Andrew Lewis High School in Salem beginning July 1.

The Dollar Store that opened in October 1945 at 127 W. Campbell Avenue was reorganized and succeeded by Becker Apparel in late July. Hersh Coplon was the manager for Becker.

In a stunning turnaround in the Roanoke City Council election held on June 11, a recount of the third- and fourth-place candidates saw a reversal of the winner. Originally, Benton Dillard had placed fourth, narrowly losing to Robert Meybin. The recount showed a major discrepancy in one precinct, and the official tally was Dillard with 3,006 to Meybin's 2,996 votes, a margin of twelve votes. Only ballots for Dillard and Meybin were recounted. Meybin accepted the outcome. The recount was conducted by court-appointed election commissioners. Some sixty-five votes were voided by the commission. Dillard, a Democrat, joined two other Democrats elected on June 11, Richard Edwards and A. R. Minton. The new councilmen's terms would begin September 1.

The aurora borealis, also known as the northern lights, flashed across Roanoke's skies on the night of July 26, according to weather officials at Woodrum Field.

The Roanoke Black Cardinals played the Pond Giants of Winston-Salem in Springwood Park on July 28. The Cardinals won, 14–0.

Fairlawn, the home and estate of Joseph C. Moomaw on Cove Road, consisting of a stately residence and ninety-three acres, went up for auction on July 29.

A new 415-acre Roanoke Boy Scout camp for blacks opened for its initial season. The camp was located in Franklin County, and it was the first time black scouts had a permanent site for a summer camp.

Woodson Pontiac announced the opening of its new location at Main and Bruffey Streets in Salem for July 29. They also carried a complete stock of new home and auto radios.

Silas Green from New Orleans, an all-black singing and comedy show, came to the Academy of Music on July 31. The cast included Butterbeans and Susie, Dinah Scott, Jelly Jones, Collar Nipsie, the Whippetts acrobatic team, and the Silas Green band.

The Orchard Heights subdivision just off Route 11 between Roanoke and Salem went up for auction on July 31. At the time of the auction, thirty-three homes were under construction on the forty-eight tracts.

Trumpeter "Hot Lips" Page and his orchestra gave a performance at the City Market Auditorium on August 1. Vocalist was tenor Orlando Roberson. White spectators were admitted.

Kilroy with his "Hubba-Hubba Revue" of "girls, gags, fun and music" came to the stage of the Salem Theatre on July 31.

The erection of the sixteen-unit "Negro veterans' emergency housing project" began the first week of August on Jackson Avenue at 16 Street, SW.

WDBJ Radio was given a conditional construction permit on August 1 for the building and operation of a frequency modulation (FM) station. WDBJ was one of only two stations in Virginia to receive such a permit. WSLS and WROV had permit applications pending before the FCC.

W. Albert Coulter was named the new principal for William Fleming High School, succeeding Mrs. R. S. Powell.

John Loyd, fifteen, was killed in a car accident near Mount Pleasant School on August 2. Three other boys in the car were injured. William Bandy, fifteen, of Roanoke County was the driver.

The Howard Coal Company began operating in Norwich in early August at 607 Warwick Street. The company tipple handled over six hundred tons of coal.

The Prairie View All-Girls Orchestra, all college coeds, performed at the City Market Auditorium on August 5. White spectators were admitted.

Lawrence Transfer and Storage began promoting their new warehouse and terminal on Gillespie Road off Williamson Road. The warehouse was twenty-five thousand square feet.

The Moomaw Farm located off Hershberger Road in Roanoke County was transferred by deed from Mr. and Mrs. Leland Moomaw to the trustees of the Bridgewater-Daleville College. Some forty-three acres were given to the college "for the purpose of Christian education." The property included the farm, the large residence, tenant houses, and four large greenhouses. The Moomaws had a long association with Daleville College.

Reid and Cutshall Furniture Company was sold to Thurman and Boone for $150,000 on August 3. Reid and Cutshall had operated at 211 Campbell Avenue, SW, and all furnishings, fixtures, and inventory were transferred with the sale. The store would close, as the Veterans Administration had leased the building. Reid and Cutshall opened in 1924. Thurman and Boone Furniture opened in Roanoke in 1893, making it the oldest furniture company in the city.

Silent film star Nicholas Donaev, also known as Kolya, paid a weeklong visit to friends in Roanoke in August. The screen actor and novelist was quite popular in the 1920s era of film.

Bittle Library at Roanoke College boasted a brand-new piece of modern library equipment—a microfilm reader. It was the first library in the region to have one.

"Johnny Non-voter" was ceremonially "buried" on the lawn of the Roanoke municipal building as a "dead citizen" on August 5. The elaborate funeral was promoted by the Roanoke Junior Chamber of Commerce as a means of getting Roanokers to vote in the Democratic Party primaries for Congress on August 6. A "funeral procession" wound through downtown.

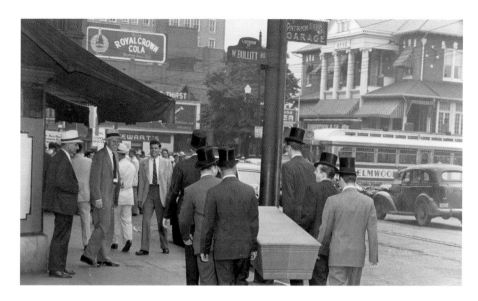

The funeral procession for "Johnny Non-Voter" moves along Jefferson Street. Note the Elmwood Diner and Elks Lodge in background. *John Ewald.*

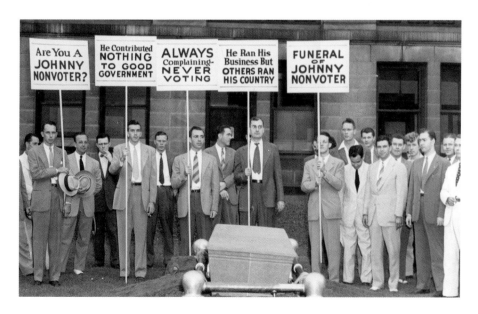

The funeral procession for "Johnny Non-Voter," seen in front of the Municipal Building, was a 1946 voter-participation effort by the Jaycees. *John Ewald.*

Martin's Sunoco Station opened on August 6 at Campbell Avenue and Tenth Street, SE.

The *Big Ford Radio Quiz Show*, sponsored by Magic City Motor Corporation, was broadcast live from the Grandin Theatre by WDBJ on August 8. Cash prizes were awarded to teenage students who answered the most questions correctly. The emcee was Irv Sharp.

In the Sixth District Democratic Party primary on August 6, Congressman Lindsay Almond Jr. of Roanoke defeated John Goldsmith of Radford by an initial vote of 19,188 to 8,071. In Roanoke city, Almond bested Goldsmith 5,730 to 2,384. In Roanoke County, Almond won 2,366 to 1,141.

The Virginia Broadcasting Corporation bought fifty acres of land in Salem as a site for a new transmitter. Most of the acreage purchased belonged to the McClung family.

Mrs. Beatrice Harris and Toby Ann Harris, both of Roanoke, were killed in an auto-truck collision near the N&W viaduct at Montvale. Four others were injured and taken to Burrell Memorial Hospital. Both women who were killed were on their way home from a funeral.

A couple stepped forward to claim a baby boy that had been abandoned in a parked car at the Hotel Roanoke on July 17. The couple, working with police, were the maternal grandparents, who were from Floyd.

Mick-or-Mack Grocery began erecting a one-floor store in the 100 Block of West Campbell Avenue in early August. The grocery was being built by Dr. George Lawson, who had secured a long-term lease from Mick-or-Mack for use of the building upon completion. Mick-or-Mack was using the new location to replace their store on First Street, SW, near Church Avenue, which had closed.

WROV, Roanoke's newest radio station, announced their office location as the sixth floor of the Mountain Trust Building as construction began on their station.

Final surveys for the extension of the Blue Ridge Parkway between Bent Mountain and Roanoke connecting with the parkway in Bedford County were completed in the first week of August. Construction was not expected to begin for another year.

Lords, 32 W. Campbell Avenue, announced the opening of their new girls' department featuring a large assortment of dresses, skirts, sweaters, jerkins, jumpers, and suits.

Roanoke Ready Mix Concrete Company announced on August 8 that their Salem plant was operational and ready to serve customers.

Jimmy Trinkle and Thurston Angell won the city-county men's tennis doubles title, junior division, at the South Roanoke courts. They defeated the Rogers twins.

The installation of parking meters in downtown Roanoke caused persons to park farther away from the central area of downtown. A series of photographs in the *Roanoke Times* on August 10 showed empty streets with meters and jammed streets without them, such as Marshall Avenue. The city had begun installing the meters in midsummer.

Hodges Lumber Company, 518 Shenandoah Avenue, NW, purchased adjoining property on August 9 for the expansion of their operation. The six lots acquired were at Sixth Street and Shenandoah. The company's vice president, J. W. Hodges Jr., stated that the property would be used for a warehouse and new offices.

The playground at Norwich School was expanded through the purchase of adjacent lots from Mr. L. F. Moore.

"Religious Education Day" was Sunday, August 11. Congregations donated to a $10,000 campaign of the Roanoke Ministers' Conference to fund a voluntary religious

education program for fourth, fifth, and sixth grades at all elementary schools in Roanoke city.

Three Mick-or-Mack Grocery stores announced they would provide nurseries for infants and toddlers in their stores as a convenience to shoppers.

The Hoffman Tire Company opened at their new location on August 12 at 375 W. Salem Avenue in Roanoke.

C. B. Halsey launched his own company in mid-August, wholesaling canned goods to restaurants, hotels, colleges, and hospitals in Virginia and North Carolina. Halsey had purchased the Barrow-Penn and Company business located at 109 W. Norfolk Avenue, where he had been employed for some time.

Landon Buchanan defeated Charley Turner to claim the men's singles championship in the Roanoke city-county tennis tournament. Some one thousand fans watched the match in South Roanoke Park. In the junior division, Jimmy Trinkle defeated Thurston Angell. Juanita Reed defeated her sister, Wanda, to claim the women's singles championship. All matches were concluded August 11.

Fire swept through a large sheet-metal warehouse on Pleasant Avenue, SW, between Jefferson Street and Franklin Road, on August 12. H. L. Lawson Jr. was owner of the building.

R. H. Smith, president of the N&W Railway, in an address to the Roanoke Junior Chamber of Commerce stated that following the Battle of the Bulge in February 1945, the N&W carried the heaviest traffic of any railroad in the United States. The N&W carried its own wartime load plus those of northern railroads that had been hampered by winter storms at that time.

Mrs. E. C. Sisson of Detroit and Mr. J. C. Sisson of Roanoke purchased the former Daleville College property and announced plans to immediately convert the former college buildings into apartments.

The two-week camping period slated for August at the new Roanoke Negro Boy Scout Camp was cancelled due to a lack of materials needed for additional construction. The 415-acre camp was located sixteen miles southeast of Rocky Mount.

Dr. H. T. Penn was elected president of the newly organized United Political Organization in Roanoke at a meeting on August 13. The UPO was established to engage Roanoke's black citizens in civic affairs. Other officers were A. R. Hunter, George Lawrence, Mrs. Drucilla Franklin, and Mrs. LeRoy Neely.

B. F. Barrow, senior partner in the wholesale grocery firm of Barrow-Penn and Company, announced the sale of his interest in the company to the estate of his partner, the late Ernest Penn, who had died in May.

Dr. James Dudley, health officer for Newport News, was named the new health officer for Roanoke by the city manager on August 14. Dudley succeeded Dr. A. G. Evans.

The N&W reported shipping three hundred boxcar loads of peaches from Roanoke, Bonsack, Cloverdale, and Starkey, providing an indication of the season's bumper crop.

Salem's municipal field was prepared to become lighted for evening baseball and football games as eight steel poles arrived by rail on August 15. Town manager Frank Chapman stated that the lights would be ready within ten days.

David Poage arrived by air in Akron, Ohio, on August 15 to compete in the National Soap Box Derby competition. His car had been shipped by rail. Nat Spigel, Roanoke chairman of the derby, accompanied Poage.

Al Boyer, head football coach at Jefferson High School from 1943 to '45, resigned to become assistant coach at Tennessee State Teachers College at Johnson City.

A public hearing held by the newly seated Roanoke City Council on ideas to raise some $500,000 in new revenue drew anger from citizens who showed up. The August 16 meeting drew about thirty speakers who bitterly opposed an increase in the real estate tax rate and an increase in the sales tax.

H. L. Roberts advertised in mid-August that Lakeside Park would close for the season on September 4 and Lee Hy Pool would close on September 2. "Lakeside will re-open on September 6, 7 and 8 for colored people."

Dr. Craig Earl, known on national radio as "Professor Quiz," brought his radio show to the Academy of Music on August 19 for a weeklong stay in the city. The quizmaster made eighteen personal appearances in the city and broadcast his show live from the academy, during which contestants won prizes.

Plans to immediately construct fifty-five new homes in the Virginia Heights and Colonial Heights neighborhoods as a response to the critical housing shortage for veterans were announced by Lonza Rush of the R. L. Rush and Son realty firm.

WDBJ Radio's "Cousin" Irv Sharp launched a new radio program to be broadcast for one year on over one hundred stations. Sharp played the keyboard, providing fun and music for fifteen minutes. His standard introduction to each show was as follows: "Hello! How are you? The Dr Pepper Bottling Company and your good friend, your neighborhood Dr Pepper dealer, present a quarter hour of informality." Sharp had signed a contract with the Dr Pepper Company and had already begun providing them with jingles to promote the soda drink. As part of his contract, a national tour was planned for Sharp to meet distributors.

Two men escaped serious injury when their plane, a Culver V, hit an apple tree in an orchard at the end of the north-south runway at Woodrum Field on August 18. The men were flying to Hot Springs and were flown there later in the day by "Boots" Frantz. The plane was a total loss.

David Poage, Roanoke Soap Box Derby champion, was defeated in the first heat at the nationals in Akron, Ohio, on August 18. The race was run before one hundred thousand spectators and broadcast locally by WDBJ.

The War Memorial Committee forwarded its final recommendation on August 19 to the Roanoke City Council for a memorial to honor those who fought and died in military service during the Spanish-American War, World War I, and World War II. The committee recommended that a monument be erected on Mill Mountain at an estimated cost of $250,000 to be raised by a public campaign. Dr. Hugh Trout, chairman, stated that the recommendation had only one member of the committee opposed, who intended to submit a minority report. According to Trout, the committee shied away from a memorial that had utilitarian value as the memorial aspect would be lost over time to the function. As an example, Trout cited the committee's review of nine existing memorial hospitals and found no one could inform the committee why they were memorial institutions. A memorial on Mill Mountain would provide a sanctuary for meditation and prayer, be designed by an architect in consultation with local arts groups, and have recreational development on the mountain surrounding the monument. The committee was created by a council ordinance on September 4, 1944, and had been working steadily for over a year. The committee considered seven suggestions in total, and they were as follows:

development of Mill Mountain as a memorial park with an observation tower; a memorial wing to be added to the new library in Elmwood Park; an armory at Maher Field; a memorial building in the form of a Grecian temple with an open-air amphitheater in Elmwood Park; a civic auditorium for public and school use; a health center; and a public arch near the plaza in front of the main post office.

The Roanoke Board of Zoning Appeals ruled on August 19 in favor of the Central Manufacturing Company's request to erect 114 houses for war veterans on thirty-four tracts in the Virginia Heights section. The recommendation was forwarded to the Roanoke City Council to rezone the land encompassing the entire area between Roanoke Avenue and Maiden Lane, from Fauquier Street to Burks Street.

City workers drained the pond at Elmwood Park to clear ten years of debris and trash. Hundreds of goldfish were transferred to a pond at Fishburn Park, and carp were sent to the Roanoke River.

The Roanoke County Board of Supervisors unanimously adopted an ordinance banning the use or sale of fireworks, effective September 15. The board also authorized at their August 19 meeting a $35,000 shop addition to William Fleming High School per the school board's request.

Leonard Hale was named the head football coach at William Byrd High School.

Six teenage boys from Roanoke who had stolen $1,000 and used the funds to travel to the Canadian border were retrieved by their parents in Springfield, Massachusetts. The boys had been arrested by police there when they were down to the last $10.

New England's largest brewery announced that Shenandoah Distributing Company of Roanoke was handling the distribution of Narragansett Lager and Ale.

William Cyphers of Roanoke launched his Special Delivery Service Company using motorcycle delivery trucks that he had seen in Okinawa during the war. Cyphers planned to expand to include a funeral escort service when more equipment became available. He delivered packages anywhere in the city for twenty-five cents.

John Payne and his wife, Gloria DeHaven, visited Payne's mother in Roanoke in late August. Payne, a native of Roanoke and a well-known Hollywood actor, had most recently appeared in the film *The Razor's Edge*. DeHaven's next film was to be *Summer Holiday*.

Leigh Hanes, a Roanoke lawyer and poet, had his lines published on the cover of *Coronet* Magazine. Against the backdrop of Mount Hood at sunset were these lines penned by Hanes: "Mountains have a dreamy way/ Of folding up a noisy day/ In quiet covers, cool and gray."

The First Church, United Brethren in Christ, held a debt-free dedication and note burning on Sunday, August 25. The church was located at the corner of Mountain and Ferdinand Avenues, SW.

Georgie Abrams, a native of Roanoke and living in Washington, DC, won a close decision over Steve Belliose in the ten-round main fight card at Madison Square Garden on August 23. There were no knockdowns.

The Cloverdale Mill along Route 11 was profiled in the *Roanoke Times* on August 25. The mill was 130 years old, having been built by the Langhorne family of Lynchburg and at the time of the article still had many original timbers. Water from a mile-long race formed by Tinker Creek turned the large mill wheel at eight revolutions per minute. The wheel was forty-five years old. The "corn rock" was over a hundred years old and came

from England. Originally, the rock was part of the mill at Poage's Mill on Bent Mountain Road.

The Wasena Civic League was reorganized in late August by John Breslin. The league had been inactive for several years.

Officials at Woodrum Field began the installation of airway marker beacons around the valley in late August. The beacon locations were as follows: Twelve O'Clock Knob, Little Brushy Mountain, middle of Brushy Mountain, east end of Brushy Mountain, west end of Green Ridge, ridge over the dam at Carvin's Cove, Tinker Mountain, and Reed Mountain. The beacons were located to allow night flights.

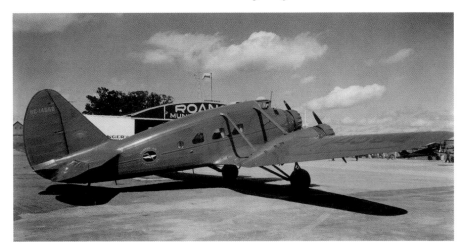

Modern Air Transport, seen here at Woodrum Field in 1946, was one of several regional and national carriers that served the airport. *Virginia Room, Roanoke Public Libraries.*

"The first Roanoker to enter Berlin as a member of the Allied Armies" title was given to Talbott Taylor of Roanoke by the Life Underwriters Association. It carried an award of a ten-dollar war bond. Taylor was a sergeant with the 750th Tank Battalion attached to the Second Army.

George Fulton Jr. won the Roanoke Country Club annual golf tournament on August 25, defeating Aulick Burke.

The Roanoke Black Cardinals defeated the Bishop State Liners of Keystone, West Virginia, 10–7 in Springwood Park on August 25.

The Roanoke City Council agreed on a first reading to place before the freeholders in a November 8 referendum a $2.5 million bond issue. The amount included improvements and additions to the public schools. Removed from the bond issue were proposed baseball stands, armory, swimming pools, and library.

The Rev. Richard Beasley announced to his congregation in Knoxville, Tennessee, on Sunday, August 25, that he had accepted a call to serve as the rector of St. John's Episcopal Church in Roanoke. His start date was to be in mid-November.

Kay's Ice Cream announced the opening of another store at 1210 Williamson Road in late August.

Opposition to the War Memorial Committee's report and recommendation to the Roanoke City Council began to mount, with some veterans wanting representation on a revamped committee and other citizens suggesting a poll be conducted to determine the public's views. Roanoke mayor Leo Henebry defended the committee but also stated that while the report had been received by the city council, no formal decision on its implementation had been made. Leading the opposition by some veterans was Murray Stoller.

The annual three-day southeastern regional conference of the Church of the Brethren convened at Central Church of the Brethren, Roanoke, in late August. Nearly one thousand delegates from eleven states attended.

Claude W. "Dickie" Dickerson of Roanoke had a small role playing the part of a sailor in the movie *Without Reservations*. The film starred Claudette Colbert and John Wayne. He had also been cast in *Magnificent Doll*, which had not yet been released.

Acquisition of the new 413-acre Boy Scout camp for blacks in Franklin County was announced by R. M. Culver, Roanoke Scout executive. The land was purchased for $2,426 from C. W. Lawhead of West Virginia. The purchase marked the first time black scouts in the region had a permanent camp.

Lake Rosenberg announced an extensive remodeling of his Oak Hall clothing store at the corner of Jefferson Street and Campbell Avenue, SW. The plan included interior remodeling as well as new entrances and exterior improvements.

Kann's held a fashion show of early fall and winter clothing at the Grandin Theatre on Friday night featuring local models in "an informal panorama of the season's newest in sport and dress clothes." The fashion show preceded the movie *Without Reservations*.

Karson's Ecstasies of 1947, with seven Vaudeville acts and featuring Mardell's Gorgeous Hubba Hubba Girls, came to the stage of the Roanoke Theatre on August 28.

A Roanoke City Council–appointed committee examining ways to increase revenue for the city submitted their report identifying five tax sources that could generate an estimated $420,000 annually. Among those recommendations were to create a 5 percent luxury tax on furs and jewelry, eliminate the 1 percent deduction for paying real estate taxes early, and add a 1 percent penalty to taxes paid late.

A conditional permit to operate an FM station was granted to the Blue Ridge Broadcasting Corporation of Roanoke by the FCC on August 30. The corporation's station, WROV, planned to erect its FM transmitter on the highest point of Fort Lewis Mountain west of Salem. The transmitter was to be three thousand watts, and the area served would include over one million people.

Patterson's Drug Stores opened a new store on August 31 at Henry Street and Church Avenue in Roanoke.

Rush Anderson was named principal of Carver High School, having been a former dean at the Christiansburg Industrial Institute. A native of Beckley, West Virginia, Anderson was a graduate of Bluefield State Teachers College.

The Roanoke Black Cardinals played the Baltimore Grays on September 1 and 2 at Springwood Park. The Cardinals' record was twenty-four wins and only nine losses, giving them claim to the independent championship title for southwestern Virginia. Team members were Sykes Robinson, George Williams, Fred Rice, Harold Easley, George Hampton, Hubert Perry, James Jones, Clarence Brown, Frank Boyd, George Brown, Rudolph McAfee, Ralph Woodliff, Richard Dawson, Earl Boyd, and Francis Green.

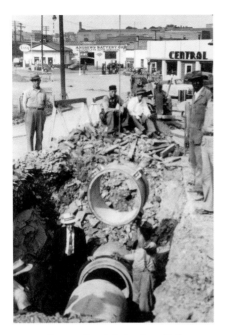

A water line is being installed along Centre Avenue in northwest Roanoke in September 1946. *Western Virginia Water Authority.*

The Lulu Williams Branch of the YWCA held a mortgage-note-burning ceremony at St. Paul's Methodist Church on September 2.

Wilson Electric Company, formerly J. B. Wilson Electric Company, announced the opening of their new shop at 1001 Hanover Avenue, NW on September 1.

Salem's Penguin Club played the Hosiery Mill in Salem's Class A Softball Championship under the new lights at Salem's municipal field on Labor Day. It was the first game played under the lights, and proceeds benefited the Salem Rescue Squad.

Mayfair Gift and Artware Company reopened at 207 Franklin Road after being damaged by the explosion that destroyed the neighboring Junior Grocery in June.

John Long, fifty-four, an employee of Roanoke Gas Company, was severely burned over his entire body when his clothing was sprayed with flaming gasoline while he attempted to start a truck at the company's plant on Kimball Avenue on August 31. He died two days later.

Dedication ceremonies for six new classrooms at Cave Spring Methodist Church were conducted on September 8. The original church was constructed in 1854 using slave labor. Present membership was 150.

The request of the Salem Transit Company to operate intraurban bus service was rejected by the Salem Town Council in favor of an offer by the Roanoke Railway and Electric Company to expand and improve service already given Salem. The expansion would include service to the Veterans Administration Hospital and Lee Highway routes.

The Dudley Manufacturing Company's building at Laurel Terrace, Williamson Road, neared completion. The company manufactured all types of refrigeration, restaurant, hotel, and industrial supplies. The company was headed by Mr. and Mrs. R. L. Dudley, who also had Dudley Store Equipment Company on Salem Avenue, SE.

Roanoke City Mills, Inc., achieved maximum operation capacity in early September with the new eleven-story feed mixer mill in operation.

Fred Jewell, twenty-four, of Roanoke was declared dead by the military. He had been missing at sea with the crew of the USS *Bullhead* since August 13, 1945.

The new General Electric warehouse opened at 515 Norfolk Avenue, SW, in early September. The warehouse housed wholesale distribution for Roanoke and Lynchburg.

Dr. Fred West defeated Landon Buchanan in straight sets to win the singles tennis championship of the annual Roanoke Exchange Club invitational tournament held at Roanoke Country Club. Malcolm Fox and Ed Kilgus of Baltimore, Maryland, won the doubles tournament.

Richard Edwards served as Roanoke's mayor and was the youngest mayor to be appointed under the city manager form of government. *Historical Society of Western Virginia.*

Richard Edwards was elected president of the Roanoke City Council and ex-officio mayor by his council colleagues in their organizational meeting on September 2. A. R. Minton was elected vice president. At the same meeting, the council appointed Richard Pence as civil and police court justice, succeeding Judge Harris Birchfield who had served since February 7, 1930. In Salem, Oscar Lewis was elected mayor by the town council, succeeding Frank Morton. James Moyer was elected vice mayor. In Vinton, Ross McGee was elected mayor by his colleagues on the town council along with Norman Dowdy as vice mayor.

At the age of thirty-five, Richard Edwards became Roanoke's youngest mayor under the city manager form of government. However, Edwards was not the youngest mayor in the city's history. That distinction went to Lucian Cocke, who was twenty-five when he was elected the town's mayor in 1884. Cocke died in 1927 and was elected mayor by popular vote, not by the town council.

Bowles Bake Shop opened on September 5 at 1856 Williamson Road, two doors down from the Lee Theatre.

The Roanoke Eagles semipro football team began practicing at Washington Park in early September under Coaches Kies, Gill, and Mitchell. The team consisted mainly of former Addison football stars as well as college students and military personnel. Opponents would be Norfolk, Richmond, Bristol, Portsmouth, and Lexington.

Rabbi Tobias Rothenberg assumed his duties as rabbi for the Beth Israel Synagogue. The synagogue had been without a rabbi for over a year. His previous assignment was in Middletown, New York.

The Roanoke Red Sox clinched the Piedmont League pennant for 1946 with a win over Portsmouth on September 5.

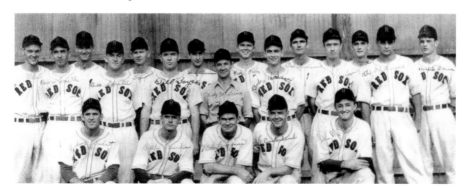

The 1946 Roanoke Red Sox team, affiliated with the Boston Red Sox, won the Piedmont League pennant that year. *Historical Society of Western Virginia.*

The final link in Roanoke city's water system with Carvin's Cove reservoir was completed on September 6. The connecting pipe was lowered on Centre Avenue between First and Second Streets, SW.

E. M. Coulter announced his resignation as president of National Business College in Roanoke. He had served in that capacity for forty-five years. Coulter came to Roanoke in 1888 to work for the college, which at that time was located on the third and fourth floors of the former Bear Building on Salem Avenue at Jefferson Street, where it remained for thirteen years. In 1901, Coulter purchased the school. The college erected its own building at 11 Church Avenue in 1909 and stayed there for ten years before relocating to 10 Franklin Road, the former home of the Eagles fraternal organization. In 1926, the school expanded to the third and fourth floors of the Coulter Building. At the time of Coulter's resignation, the college had eight hundred students and faculty members. Coulter was succeeded by M. A. Smythe.

Morning Star Baptist Church held a mortgage-burning ceremony on September 8.

Tyrell's Sunoco Service Station advertised it was open for business on September 7, 6:00 a.m. to midnight. The station was located at Franklin Road and Brandon Avenue at "The Old Mill."

September 8 was "Eddie Popowski Day" as the Roanoke Red Sox played their last regular season game. They had already won the Piedmont League pennant. They defeated Newport News 8–2 in front of 2,954 fans at Maher Field. They won eighty-nine games during the regular season.

Approximately 250 Roanoke businessmen left from the N&W Railway station on September 10 for the first peacetime Roanoke Boosters Club trip in five years. The trip was led by Dr. E. G. Gill, president of the organization since 1935. A special six-car passenger train provided by the N&W took the participants to the Homestead at Hot Springs, where, according to Gill, "Roanoke would be sold to Roanokers." Prior trips sought to promote Roanoke to those outside the valley, but Gill felt it was appropriate to renew business relationships and promote opportunities to those within the valley given the postwar boon in production and material.

Seventy-five new Packard Clipper taxis rolled into Roanoke, having been purchased by Yellow Cab Company and Pollard Taxicab Corporation. The cabs were to be the first of their kind in the south, according to the Packard Motor Company.

At least twenty-two persons were injured in a two-car collision at the bottom of one of the inclines on the roller-coaster at Lakeside on September 8. All were admitted to Burrell Memorial Hospital. According to a sheriff's deputy, a second section of cars collided with a first section on the coaster. It was the last day of the season for the park and had been reserved as a "Negro Day."

Guy Linkous won the N&W Railway tennis tournament, defeating Dukie Duerson on the South Roanoke courts in three straight sets.

The case against Richard Ratliff of Vinton was sent to the grand jury on September 9 in connection with the fireworks explosion that destroyed the Junior Grocery. Key testimony was given by Charles Aesy Jr., assistant manager of the store. Aesy who was on the sidewalk nearby, testified that he saw Ratliff standing at the window with a lighted match.

William Law, bus driver, was acquitted of manslaughter charges related to the deaths of two men on July 21 when his bus collided with their car.

Al Jolson made a brief visit to Roanoke, spending the night of September 11 at the Patrick Henry Hotel. Jolson was en route to New York City to witness the premier of Radio City Music Hall's *The Jolson Boy*.

A group of Roanoke County farmers formed the Roanoke County Vegetable Growers Association on September 12 at an organizational meeting held at the Patrick Henry Hotel.

Eighteen teenage boys were brought before a judge in the Juvenile and Domestic Relations Court on charges of hazing stemming from their beating younger boys with belts as an initiation into their ranks at a Roanoke junior high school.

McAvoy Music House held a formal opening at their new location, 817 S. Jefferson Street, on September 13.

Wasena Confectionary opened in mid-September at 213 Main Street, Wasena.

The Virginia Rabbit Marketing Cooperative, 1322 Jamison Avenue, SE, was profiled in the September 15 edition of the *Roanoke Times*. The cooperative was fifteen years old and supplied three hundred rabbits per week for household consumption. A new building was being erected on Lynchburg Road to assist with increasing demand. The rabbit skins were shipped to New York, where furriers made them into mittens, felt hats, and coats. J. T. McLain of Roanoke was president of the cooperative.

Wertz and Smith Optical Company opened at 613 S. Jefferson Street (Patrick Henry Hotel building) on September 16. F. E. Wertz was owner.

The Roanoke City Council had a heated meeting on September 16, as the topic was the city manager, W. P. Hunter. Hunter was informed by a majority of the council that he was to be replaced and was asked to appoint D. R. Taylor, head of the water department, as his assistant. The understanding was that Taylor would serve as assistant to be trained to become Hunter's successor when Hunter retired. The council could not come to complete agreement on the arrangement, and the city manager stated that Taylor must formally apply for the job being mentioned.

Clinton Poff's garage on Bent Mountain opened in mid-September near the Bent Mountain School. His assistant was D. L. Lancaster.

Arrangements were made for Quonset huts to be erected at Woodrum Field to house at least thirty planes. This was in response to a recommendation from the city's airport committee.

"Sunset Carson" appeared on stage at the Roanoke Theatre on September 18 for four shows. The western movie star was accompanied by ropers, comedians, and cowgirls.

James Ingoldsby resigned as Roanoke's police chief effective October 1 in a mid-September announcement made by Roanoke's city manager. The police superintendent left office to pursue private enterprise. The city manager named Detective Clay Ferguson as Ingoldsby's successor. Ferguson, fifty-seven, had been with the city police department for twenty-four years.

Campus Cavern was opened at Roanoke College with a grill, soda fountain, juke box, and light snacks. The Cavern was outfitted in knotty cypress paneling with a twelve-foot chrome soda counter. It was located in the basement of the commons dining hall.

Norman-Shepherd, men's clothier, opened their new Boy's Store on the Second Floor of the store at 505 S. Jefferson Street.

Lt. Max Crowder of Roanoke was killed in a plane crash at Washington National Airport on September 20.

Sixty home sites in the Westchester section along Grandin Road Extension went up for auction on September 21, advertised as the valley's newest subdivision. The land was referred to as "the old Brady place" in ads.

Altizer's Beauty Shop opened at 616 S. Jefferson Street, opposite the Patrick Henry Hotel and over the Elmwood Service Station, on September 23. Virginia Altizer was the owner.

John Payne and Lynn Bari, both former Roanokers, costarred on CBS's *Radio Theatre* with an adaptation of "Sentimental Journey" that was broadcast nationally on the evening of September 23.

The 1946 Roanoke Fair, sponsored by American Legion Post No.3, opened on September 23 at Maher Field for five days. The fair included a cattle show, agricultural exhibits, a "Miss Roanoke Fair" contest emceed by Irv Sharp, the Johnny Jones midway exposition, and nightly fireworks. The Jones midway shows were aerialists, trained bears, clowns, Georgiana Dieter, a Broadway revue, and a dog act. Other attractions were the Del Rios ("the world's smallest family"), a minstrel show, carnival rides, motorcycle daredevils, and a railroad show. Mrs. M. M. Lucas was named "Miss Roanoke Fair."

A. S. Wade's Economy Oil Station opened at Thirteenth Street and Tazewell Avenue, SE, on September 27.

The Roanoke Red Sox lost to the Newport News Dodgers four games to two in the Piedmont League Championship playoffs. The Sox had won the regular season.

A lingerie and sportswear shop, Carole, opened at 304 First Street, SW, on September 28.

Construction began on a new maintenance garage for Mundy Motor Lines at the northeast corner of Seventh and Mill Streets, near Virginia Bridge and Iron Company.

Members of the Johnny Jones Exposition in town for the Roanoke Fair visited Evergreen Cemetery to pay their respects to C. D. Scott's grave. For many years Scott owned and operated Scott Shows, which toured mostly in the South. He died in Rochester, Minnesota, in 1944.

A charter for the Youth Council of the Roanoke branch NAACP was granted by the national organization. The youth council had twenty-nine charter members and was organized by a local attorney, Reuben Lawson.

The Lawrence Memorial Methodist Church, Bent Mountain, celebrated its fiftieth anniversary as it conducted its final service in the wood-frame church that had been sold to the Primitive Baptists. The Methodists were building a new church near Bent Mountain School. The Methodists met in the school for an interim period while their new church was under construction. The Methodist Church at Bent Mountain was in existence as far back as 1867, when a Reverend Boon conducted a revival service that year, increasing the church's membership from eight to eighteen. By April 1876, Henry and Elizabeth Lawrence were leaders in the congregation, and Mr. Lawrence was Sunday school director. When some men on the mountain began to construct a "groggery" (saloon), Lawrence raised funds to purchase their building, giving the church its first permanent home, and Needmore (the former name of the Bent Mountain post office) had a church rather than a saloon. The log church was called Meadow View Methodist Church. The Terry family donated land for a new church in 1895, and the wood-frame church was dedicated in September 1896. This church was then sold to the Primitive Baptists for the Methodists to relocate to their new building. One interesting note is that in 1926 Mrs. Elizabeth Whittle Terry sought to establish an Episcopal congregation at Bent Mountain

and contributed $500 for that purpose. Upon her death and with the Episcopal mission not having materialized, her contribution was given by her daughter to assist the Methodists with their new building.

The pastor and members of Poages Mill Church of the Brethren announced their hope to be in their new sanctuary by January 1. The 177-member congregation was in the process of completing a $12,000 church building complete with a "mother's room," where moms with babies could watch and hear the service. A wood-frame church, dating to 1900, was on the property and would adjoin the new church once completed.

The ninety-three-acre estate of the late Joseph Moomaw on Cove Road was purchased by the Giles Realty Company for the purpose of creating a new residential development. The property was known as Moorman Springs and contained a two-acre lake.

The Book Nook, 20 W. Kirk Avenue, held a book signing with Nelson Bond on his latest release, *Mr. Mergenthwirker's Lobblies*, which was published by Coward McCann.

The N&W Valleydoah baseball team defeated the Roanoke Black Cardinals four games to three to win what was billed as the "city championship." Most of the games in the series were played at Springwood Park.

The movie comics Huntz Hall and Gabriel Dell appeared live on stage at the Roanoke Theatre on October 2.

The Ballet for America came to the Academy of Music on October 3. The music was provided by pianists Tadeusz Sadlowski and Paul Berlin. Lead dancers were Nana Gollner, Kathryn Lee, and Tatiana Grantzeva.

WSLS Radio was given a temporary permit to operate an FM station, being Roanoke's third such station after WDBJ and WROV had been given permits.

Mrs. Paul Wade of Roanoke returned from a whirlwind trip to Britain, having won the trip through a national radio program on the ABC network.

Granby High School, Norfolk, beat Jefferson High School 46–0 in football at Victory Stadium on October 3. Granby won the state football championship in 1945.

The Roanoke City Council concluded its study of new revenue sources by adopting a new tax on wine, beer, and tobacco. The tax was estimated to generate $100,000 annually.

The Roanoke Raiders, a semipro black football team, began their six-game season in Springwood Park on October 6. The Raiders' opponents were teams from Bristol, Petersburg, Washington, Norfolk, Portsmouth, and Lexington.

Virginia Tech and the University of Virginia played to a 21–21 tie in football before twenty thousand fans at Victory Stadium on October 5.

Thompson Grove Primitive Baptist Church at Bent Mountain held a dedication service for their building on October 6, having purchased it from the Methodists, who were erecting a new church.

William P. Swartz, Jr., and Company moved to its new quarters at 421 Luck Avenue, SW, in early October. The company was founded in 1936.

The Rev. William Simmons of the Fifth Avenue Presbyterian Church, Roanoke, announced he and others were exploring the opportunity to establish a black college in the Roanoke region as there was no black college within a hundred-mile radius of Roanoke. Simmons indicated there was strong interest among black veterans.

James Carper, prominent businessman in Salem, died at Fincastle on October 7 at age sixty. Carper was in the plumbing and heating business and had spearheaded efforts in Salem for fire and rescue departments and for the acquisition of the town's first iron lung.

Henry Hill, seventy, was awarded Roanoke College's Certificate of Merit on October 9 on the occasion of his seventieth birthday. Hill had rung the college bell at the stroke of every hour for thirty-five years.

The annual convention of the Women's Christian Temperance Union of Virginia was held at Greene Memorial Methodist Church. The women adopted resolutions opposing advertisements for liquor in magazines, in newspapers, and on the radio. They also declared their opposition to "amusements," such as movie theatres and baseball games, on Sunday, the Christian Sabbath.

Lawrence Hogan, twenty-three, who had grown up in Roanoke County and attended schools in Salem, was the victim of a double murder at Dania, Florida. He and his girl-friend had been killed, and police had no clues as to a suspect.

The first families moved into the veterans' housing project on the Roanoke City farm in mid-October.

Lowell White, disabled from the waist down due to a baseball accident in childhood, flew his first solo flight at Woodrum Field in a specially outfitted plane. The Ercoupe was equipped to allow all controls, including the pedals, to be operated by hand. White's instructor was Wes Hillman.

The Rev. Arthur James of First Baptist Church, Gainsboro, was honored on the occasion of his anniversary as pastor. He came to Roanoke in 1919 from Florida and was the first black minister to have a local radio program.

A 350-gallon distillery was seized and broken up in the Bottom Creek section by federal agents in mid-October. The dawn raid destroyed the distillery and 2,800 gallons of corn mash. Agents seized a truck and arrested Otis Martin.

Cupid Davis and his All-American Hillbilly Barn Dance performed on the stage of the Roanoke Theatre on October 16.

Rabbi Bernard Zeiger announced his resignation from Temple Emanuel, having accepted a call from a synagogue in Riverside, California. Zeiger had served Temple Emanuel for two years.

The Twilight Tea Room on Route 11 across from Hollins College changed its name to the College Inn. The reservations-only restaurant was managed by Blanche Poole and Kate Beckner.

William and Mary defeated Washington and Lee in football, 34–18, before an estimated ten thousand spectators at Victory Stadium on October 19.

W. E. Parsons, an educator and school leader in Roanoke for forty-two years, announced his intended retirement, effective December 31. Parsons first came to Roanoke as a chemistry teacher at Roanoke High School in 1905 for a salary of ninety dollars per month. In 1909, he married Lillie Cutchin, daughter of Roanoke mayor Joel Cutchin. Parsons rose to become principal of Roanoke High School and later of Jefferson High School, which opened in 1923.

Dr. Andrews Bass was appointed resident physician at Burrell Memorial Hospital, succeeding Dr. Justin Plummer. Bass came to Roanoke from the Freedman's Hospital in Washington, DC.

Robert C. Royer, "Mr. Roanoke," died unexpectedly at his home in Raleigh Court on October 21. He was sixty-three. Royer was a native of Bedford County and dedicated his career to bringing entertainment and athletic events to Roanoke. Royer directed the operations of the Academy of Music, oversaw the Thanksgiving Day football games at Maher

Field and then Victory Stadium, organized a local troupe of entertainers to perform at Virginia military camps and hospitals during the Second World War, and organized the VPI-VMI freshmen tilt on Armistice Day beginning in 1933.

Drawings of the new Monroe Junior High School for northwest Roanoke were inspected by the Roanoke School Board. The architectural firm Stone and Thompson had been engaged for the project.

Dr. William Burton, forty-eight; Dr. Gilbert Burton, thirty-nine; and pilot Carlile Hippert were killed in a plane crash on Christiansburg Mountain minutes after flying out of Woodrum Field on October 20 for a hunting trip to South Dakota. The Burton brothers were well-known physicians in the Roanoke region. The pilot was from Lynchburg.

Carl Mason's touring show of variety acts, *Festival of Fun*, came to the stage of the Roanoke Theatre on October 23. Performers included Long and Mason, Betty La Rue, Dick Wilson, Bess Carson, and "the famous sextette of scintillating sirens."

The first helicopter to appear at Woodrum Field arrived on October 22 when a navy Sikorsky R-6A made a flight from Washington, DC. The helicopter flew at seventy miles per hour and was en route to a naval show in Memphis, Tennessee.

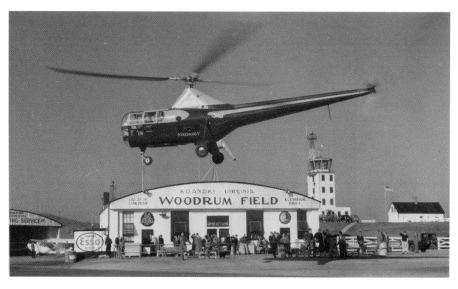

A navy Sikorksy helicopter landed at Woodrum Field on October 22, 1946. Being the first helicopter into Roanoke, it drew a crowd. *Virginia Room, Roanoke Public Libraries.*

Miss Katherine Lawson escaped serious injury when her plane crash-landed a few miles northeast of Woodrum Field on October 24. Her plane clipped an apple tree on the farm of J. M. Petty.

Three Mobil gas stations opened the weekend of October 25. They were the stations managed by R. B. Tate at 206 Grandin Road, L. O Lemon at 1911 Franklin Road (at Roanoke River bridge), and L. D. Garrett at Williamson Road and Lynchburg Avenue.

The Lawson Oil Company opened on October 26 at Williamson Road and Lynchburg Avenue. George B. Lawson Jr. was proprietor.

The Broadway comedy *Dear Ruth* came to the Academy of Music on October 26. The touring production starred Lois Wheeler, Sidney Blackmer, Leona Powers, and Joan Winninger.

Over ten thousand fans watched Jefferson and Andrew Lewis High Schools battle to a 0–0 tie at Victory Stadium on October 26. It was believed to be the largest attendance at a high school football game ever in the Roanoke Valley for local schools.

A special cachet for the observance of National Air Mail Week was revealed for use by the Roanoke, Salem, and Vinton post offices. The local cachet was designed by Mrs. L. C. Schrader of Roanoke, an illustrator, for the advertising of a local department store.

Savory Foods, Inc., opened on October 29 at 208 Nelson Street, SE.

Jimmy Gibson, twenty-eight, of Roanoke was featured as being one of the nation's top freelance cartoonists in an article in the *Roanoke Times* on October 27. Gibson's work had appeared in numerous national publications such as *Collier's*, *Saturday Evening Post*, *American*, *This Week*, *Parade*, *True*, *Esquire*, and major American newspapers.

"Big Dan" Cunningham, a native of Roanoke and subject of a best-selling biography, *Big Dan*, returned to Roanoke for a brief visit with his brother and was welcomed by the N&W Railway. He had begun his storied railroad career in the N&W Shops as a machinist. He left Roanoke in 1899 with thirty-five dollars, headed west, and became famous as a railroad man.

Four large circus trains rolled into Roanoke for the Ringling Brothers and Barnum & Bailey Circus at Maher Field. Two performances were held under the big top on October 28. Performers included the great Wallendas on the high wire, Giusting Loyal (bareback rider), Gargantua and Toto (guerillas), Truzzi (Russian juggler), the Flying Behees, Con Colleano, plus horses, elephants, sea lions, a rhino, and a hundred clowns. Some seventeen thousand spectators attended.

The Shenandoah Life Insurance Company announced plans to build a new home office structure on Brambleton Avenue across from Fishburn Park. The company stated that the building would be erected in 1949. Paul Buford, company president, asked the Roanoke City Council to make plans to provide water and sewer to the property.

Pianist-humorist Victor Borge performed his comedy act at the Academy of Music on November 1. He was accompanied by his twenty-eight-piece orchestra.

For Halloween, a number of dances and musical shows were held throughout the Roanoke Valley. Happy Bobbitt and the Blue Mountain Boys were at the Salem Theatre; Wanderers of the Wasteland played at Blue Ridge Hall on Campbell Avenue; Jack Saunders's Orchestra was at Apartment Camp on Veterans Road, Salem; the Hall Brothers entertained at Victory Hall on Commerce Street; and several civic and school organizations held supervised events for children and youth.

Over 7,000 youth and adults participated in Roanoke city Halloween events in city parks. The largest was held at Eureka Park, where Monroe Junior High band performed before some 2,000 people. Jackson Park's celebration had 1,500, while at the Gainsboro Branch Library grounds, a party for black citizens drew around 1,200. An estimated 1,200 attended the Halloween party in Raleigh Court Park. In Salem, the largest Halloween crowd ever thronged municipal field. The crowd was reported to be 3,000.

The First National Exchange Bank opened their new fireproof records depository in early November. The depository was on Albemarle Avenue, SE, directly across from the Jefferson Street Baptist Church. Bank records dating back to 1926 had previously been

stored in the bank's basement. B. F. Parrott and Company was the contractor for the new depository.

D. R. Taylor became Roanoke's first assistant city manager on November 1. Taylor was head of the water department, and the move was done in anticipation of Taylor becoming the city manager upon the retirement of W. P. Hunter.

A soldier, Ray Elkins, nineteen, who had been AWOL for four months, was captured by Roanoke police in the 500 block of Day Avenue on the night of November 1. Elkins had pointed a double-barreled shotgun at officers at one point during the manhunt, and he was finally caught after being shot in the ankle by police. Police became involved earlier in the evening when Elkins's wife called to make a domestic violence accusation and told officers her husband had fled the home and procured a shotgun.

The touring production of the Broadway play *Voice of the Turtle* came to the Academy of Music on November 2. The play starred Harvey Stephens, Louisa Horton, and Frances Tannehill.

The OPA's price-rationing board in Roanoke closed its office permanently on November 3. The board was involved in rationing and price stabilization during the war and was deemed unnecessary by federal authorities. OPA boards were closed across the nation effective November 4.

North Carolina State defeated VMI in football 49–7 in front of 5,500 fans at Victory Stadium on November 2.

Piped music, a popular phenomenon in some cities, was established in Roanoke by Paul Nash, formerly of Grand Piano Company. Piped music emanated from automatic record machines and was transmitted over phone wires. Nash indicated that his company could serve up to one thousand subscribers. The main clients were to be restaurants, where special boxes would be installed at booths, and for five cents customers could listen for up to six minutes of music while they dined. The piped music studio for Advance Music, Inc., was located at 34 W. Kirk Avenue.

Work was completed on the radio tower for WROV. The 190-foot tower was located near the station on Cleveland Avenue, SW. WROV anticipated going on the air December 1.

The Roanoke Antique Clock Shop opened at 916 Salem Avenue, SW.

Dr. Wade Bryant, pastor of the First Baptist Church, Roanoke, was elected president of the Roanoke Ministers' Conference.

Henry Wolfe delivered a lecture at the Academy of Music on the topic of "Russia and the West." Wolfe was a nationally known war correspondent whose appearance was sponsored by the City-County Public Forum organization. Some eight hundred persons attended.

The Roanoke County bookmobile made its initial run through the county in early November. The bookmobile had a three-person staff, and stops on its first day were at Broad Street School, Fort Lewis School, South Salem, Cain's Store, and the Glenvar filling station.

Congressman Lindsay Almond Jr. was reelected to his House seat for the Sixth District in the November 5 election. Almond, a Democrat, defeated Republican Frank Angell of Roanoke. Virginians reelected Senator Harry F. Byrd and elected Congressman Willis Robertson of Lexington to serve the unexpired Senate term of Carter Glass. In the

congressional election, Roanoke city voters gave 6,038 votes to Almond to Angell's 2,814; while in Roanoke County the vote total was Almond, 2,530, and Angell, 1,982.

Irvin C. Miller's touring show *The Brownskin Models* came to the Academy of Music on November 7. Miller's all-black production was celebrating a half century of shows around the nation. The thirty-five-model show also featured the Barney Johnson Band, comedian William Earl, and vocalist Margaret Simms. The first balcony was reserved for white spectators.

The Roanoke City Council approved further work on developing maps and compiling data pertaining to its desire to annex portions of Roanoke County in 1947. No boundaries were identified.

The Hotel Ponce de Leon Coffee Shop reopened under new management. The new manager was George Likenhoker Sr., a native of Roanoke, who had been managing food service at the Hotel Seminole in Jacksonville, Florida, for the past thirty years.

Capt. Clay Ferguson, head of the Roanoke Police Department, announced on November 8 the appointment of two additional black police officers, Harry Stovall and Leon Fields. This gave the department a total of four black officers.

Members of Company F, 116th (2nd Virginia) Infantry Veterans Association held a reunion at the Patrick Henry Hotel. About forty-five veterans attended the event.

Roanoke held its first regular airline night operation on November 8 when two scheduled Eastern Airlines planes landed and departed. Marker beacons had been completed on seven points around the valley.

Roy Allen, fifty-three, manager of the Cavalier Hotel, was severely beaten near the hotel and died as a result of the attack on November 9. Aubrey Thompson, twenty-two, of Blue Ridge was charged with killing Allen.

The Magic City Travel Agency opened in offices in the Patrick Henry Hotel on November 9. W. J. Meek was president of the agency.

Dr. Kiusic Kimm of Korea and a graduate of Roanoke College, Class of 1903, made a $1,000 donation to the college and donated some books to the library. The four books were written by Kimm and described as "badly printed" due to wartime printing in China. Following his graduation from Roanoke College, Kimm had a distinguished career in his native Korea, serving as a delegate to the Versailles Peace Conference, the president of a college, and a former military officer.

The new Roanoke Dressed Poultry Plant opened at 1027 E. Campbell Avenue, Roanoke. The plant was operated by J. Brumberg and Sons.

Roanoke celebrated Armistice Day with a football game, parade, and memorial service. The football game was between the junior varsity squads of Virginia Tech and VMI at Victory Stadium. A downtown parade, lasting about ten minutes, involved veterans' groups, four school bands, and local dignitaries. Mayor Richard Edwards delivered a memorial service address in Elmwood Park. A drizzling rain kept most away from the football game, and it was attended by slightly more than one thousand. VMI won, 14–13.

From Slave Cabin to Hall of Fame, a play about the life of Booker T. Washington, was presented at the Academy of Music on November 13. The play was narrated by Washington's grandson, Booker T. Washington III of New York. The great educator had visited Roanoke on September 26, 1908, to deliver an address at the Roanoke fair grounds.

Southern Railway trains Nos. 41 and 42 that traveled along the tracks of the N&W Railway between Lynchburg and Bristol officially became known as The Pelican on

November 15. The announcement was made by N&W officials. The name was based on the train operating out of Louisiana, "the Pelican state."

Gilbert Studio opened on November 19 at 124 Church Avenue, SW. Warren Gilbert was the proprietor. The studio, successor to the Kidd Studio, advertised portrait, commercial, and aerial photography services.

The cornerstone for the Vinton War Memorial building was laid on November 16. The principal speaker for the occasion was Dr. James Hillman, grand secretary, grand lodge of Virginia Masons. A scroll bearing the names of twenty-seven young men who lost their lives in World War II was sealed inside the cornerstone.

On November 17, the price of a week's subscription to the *Roanoke Times* increased from twenty-five to thirty cents.

Heironimus began its weekday broadcasts of *Santa in Toyland* from the fifth floor of its store. The 4:45 p.m. show was broadcast live over WSLS as children told Santa what they wanted for Christmas. The fifteen-minute broadcast began the week of November 17 and ended on Christmas Eve.

The touring production of *Blossom Time* came to the Academy of Music on November 18. The fifty-member cast included Earl Covert, Anthony Blair, Vicky Sherry, Edith Herlick, and Dennis Carroll. The production was an operetta of the music of Franz Schubert.

"The South's Finest Blackface Comedian" performed on the stage of the Roanoke Theatre on November 20. Emmett Miller was part of the *Stardust Revue* minstrel show.

The Shamrock, formerly Uncle Tom's Barbeque, opened on Route 220 at Starkey Road on November 20.

Pianist Abbey Simon performed at the Academy of Music on November 20. Simon had performed with many of the nation's leading orchestras. His appearance was part of the Roanoke Community Concert Association's music series.

Stan Radke, president of the Roanoke-Salem Baseball Corporation, announced the purchase of twenty-three acres along the Lynchburg-Salem Turnpike for the site of the corporation's own baseball park. The property was formerly part of the Trout farm and had been used as an early airfield, Trout Field.

After a spirited campaign from both sides, the sale of wine and beer in Botetourt County was defeated by voters 1,216 to 788.

Graves-Humphreys Hardware Company purchased the former Colonial Ice Company's four-story apple-storage warehouse at the corner of Franklin Road and Brandon Avenue, SW. The price was $84,000. The Colonial Ice Company officials stated they planned to expand their ice-storage plant in Wasena to make up for the lost warehouse space.

Fallon Florist held its grand opening at its new location at 23 W. Church Avenue on November 22.

The call letters WROV-FM were officially assigned to Roanoke's newest radio station by the FCC. Call letters originally assigned to the station had been WRFG. The station planned its initial broadcast for early December.

Due to a nationwide coal miners' strike, all counties and cities in Virginia were placed under a "brown out," meaning advertising signs, store window lights, and other lighting had to be turned off at 6:00 p.m. Also, the N&W Railway and Virginian Railway announced cutbacks in passenger train service.

The Roanoke-Botetourt Fruit Growers Association announced that a total of 156,772 bushels of peaches and apples had been harvested in 1946. The group also stated that their labor camp at the foot of Catawba Mountain housed some fifty itinerant laborers for the harvests.

The Yellow Mountain Garden Club was organized in late November at a meeting held at Gladys Layman's tea room in Garden City.

Turner's Auto Service opened at 109 W. Church Avenue, formerly the site of Hoffman Tire Service.

Raymond Etter, fifty, was killed when his home caught fire on November 23. The home was in the Tinker Creek section, near Hollins. His wife was badly burned.

The first of four Quonset huts began being constructed in late November at Woodrum Field. Each hut could house twelve light planes. Frantz Flying Service occupied the first hut erected.

The Religious Education Committee of the Roanoke Council of Church Women reported that 2,832 pupils in the fourth, fifth, and sixth grades in Roanoke city public schools were receiving religious education. Only 59 children in the three grades had elected not to receive it. The organization reported that thirty-eight churches had contributed to underwrite the instruction.

A "Committee of 100" was organized by local clergy from Roanoke city and the Williamson Road section for the purpose of "improving the moral and spiritual welfare of the community." The Rev. Clyde Forney, pastor of Central Church of the Brethren, was elected chairman. The group's aims included a focus on juvenile delinquency, roadhouse eradication, temperance education, abolishment of liquor advertising, and movie ratings.

The 20th Century Studio, billed as "Roanoke's Only Colored Studio," opened on November 27 at 98 N. Henry Street. Flowers were given to ladies on opening day.

A committee of the Roanoke Chamber of Commerce reported that the restoration of the historic Raleigh Tavern on Lynchburg Road was beyond possibility due to its dilapidated condition. The committee had been considering repairs to the structure.

Directors of the Colonial-American National Bank and Liberty Trust Bank, voting in separate meetings, moved forward plans to consolidate the two banks, effective at the close of business on December 31. The recommended plan, approved November 26, was placed before upcoming meetings of the banks' stockholders scheduled for December 27. The new institution was to be called Roanoke National Bank.

Virginia Tech beat VMI 20–7 in the Thanksgiving Day football game at Victory Stadium. Over twenty-eight thousand spectators set a record for the largest college football game attendance in Virginia's history. The "Military Classic of the South" was attended by Virginia's governor, William Tuck.

The Mt. Regis Sanatorium, Salem, was slated to reopen as a treatment hospital for alcoholics, according to Dr. Henry Alford. The facility had previously been used as a treatment center for pulmonary diseases and, during World War II, as a WPA training center for women.

The N&W Railway began converting some of its coal-burning locomotives to oil-burning in an effort to conserve a rapidly diminishing supply of its coal reserves impacted by the national coal miners' strike. The conversion was being done in the Roanoke shops, with the first engines going to oil being the Mountain Type Class K-1.

George Bott, twenty-three, of the Dry Hollow community near Glenvar, died on December 1 at the Veterans Hospital, the victim of a hit-and-run driver while he walked along Route 11.

Turner's News Stand at 17 E. Main Street, Salem, announced the opening of their soda fountain on December 1.

The All City-County high school football team selected by area coaches consisted of the following players: Dick Bunting, Andrew Lewis; Albert Wilson, Fleming; Curtis Cooper, Byrd; Mont Linkenauger, Fleming; Frank Shelor, Lewis; Louis McLelland, Jefferson; George Graybill, Lewis; Henry Quisenberry, Fleming; Tommy Martin, Jefferson; William Comer, Byrd; and Bill Diehl, Fleming. Players from Addison and Carver High Schools were not eligible.

A crowd of 1,200 watched the sandlot football championships at Victory Stadium on November 30. South Roanoke defeated Villa Heights 8–6 for the 110-pound title, while Fallon Park beat the Boys Club 12–0 to win the 135-pound championship.

The Roanoke Christmas Parade wound its way along twenty-seven blocks of downtown Roanoke on Tuesday afternoon, December 3. The parade, sponsored by the Roanoke Chamber of Commerce and the Roanoke Merchants Association, featured fifty-two giant balloon figures, eight military bands, and Santa Claus. The parade stretched a mile in length. A reviewing stand was staged on the front steps of the municipal building. The parade committee was chaired by N. W. Pugh. An estimated fifty thousand watched the event.

A balloon float moves along the route of Roanoke's Christmas Parade in 1946. There were fifty-two such giant balloons in the parade that year. *Bob Stauffer.*

Nadine Conner, leading soprano at the Metropolitan Opera, performed at the Academy of Music on December 5 as part of the Roanoke Community Concert Association's season.

The Poole-Miller Company, a household appliances store operated by William Poole and Hayne Miller, opened on December 2 at 106 Luck Avenue, SW.

The Roanoke City Council voted 3–2 to abolish the board of real estate assessors and by the same vote then increased the real estate and personal property tax to three dollars per one hundred dollars of assessed value, with fifty cents of that figure to be set aside in

a reserve to avoid a financial crisis predicted by city officials to happen in 1952 due to debt service.

Virginia Wrecking Company, Roanoke, changed its company name to the Virginia Building Supply Company in early December, stating that they were no longer in the demolition business.

Tragedy struck on December 3 when a streetcar collided with a bus, shoving it into a crowd waiting on the southwest corner of Campbell Avenue and Henry Street to see the Christmas parade. Jeanette Robertson of Salem was killed and eighteen others, including Robertson's daughter, were injured. Most of the injured were children. It was Robertson's fifty-fifth birthday. The cause of the crash was attributed to failed air brakes on the streetcar.

Stanley Radke, president of the Roanoke Red Sox, announced that Mike "Pinky" Higgins, a former veteran third baseman of the Boston Red Sox, would be the manager of the Roanoke team for the 1947 season.

The first oil-burning locomotive for the N&W Railway, converted due to the coal shortage, pulled out of Roanoke on December 4. Locomotive No. 103 pulled train No. 63. The following day, locomotive No. 107 was converted and put into operation.

Rev. William Simmons of Roanoke sued the Atlantic Greyhound Corporation in US District Court on December 5 for $20,000. He had been asked by the driver to move to the rear of the bus because he was black before it pulled out of Roanoke. Simmons asserted he was embarrassed, harassed, and assaulted. He got off the bus rather than comply and took a train later that day (October 16) to the synod meeting of the Presbyterian Church, USA.

The Rev. William Simmons of the Fifth Avenue Presbyterian Church sued Greyhound Bus Lines in 1946 for having segregated seating. *Fifth Avenue Presbyterian Church.*

Soprano Aminee Hudson, a Roanoke native, gave a concert at the First Baptist Church in Gainsboro on December 5. Her appearance was sponsored by the Hunton Branch, YMCA. Hudson grew up singing at the Hill Street Baptist Church and left Roanoke for New York City, where she had been singing at Carnegie Hall.

Some five hundred sandlot football players enjoyed a banquet in their honor at Jefferson High School on December 6. Speakers included Roanoke mayor Richard Edwards, humorist Joe Hardy, Paul Coffey, and Rex Mitchell.

US 220 south of Roanoke in the Red Hill and Clearbook sections was improved in early December with new routing that eliminated curves, widened the road bed, and improved bridges.

Hundreds turned out to greet Santa in Vinton on December 7. Saint Nick arrived by train, the Tennessean, and then rode on a float through the town.

Felton Cleaning Service opened at 323 Fourth Street, SE, on December 9.

Hundreds of automobiles jammed downtown Roanoke streets on December 8 when the city turned on its Christmas lights. The lights were scheduled to go on Thanksgiving Eve, but the threat of a coal strike delayed the event. Store windows were also lighted for the first time in two weeks. On December 11 Salem turned on its Christmas lights on Main Street and College Avenue.

The *Esso Roanoke*, a fuel tanker named in honor of Roanoke by the Standard Oil Company, was very active in World War II. According to company records, the tanker made fourteen voyages in fourteen months between July 14, 1944, her maiden voyage, and the close of the war in 1945. The tanker also carried aircraft on her spar deck during one trip from New York to London. Her cargo capacity was 138,336 barrels.

The N&W Railway chose not to reconvert its oil-burning locomotives for the near future. The conversions had been made in response to a seventeen-day, nationwide coal miners' strike.

The Roanoke City Council began formalizing plans for a large annexation of Roanoke County for 1947. The council met with city administrators, surveyors, and consultants on December 13. The preliminary annexation maps viewed by the council, if adopted and successful, would double the city's size.

Radio station WROV went on the air on December 15. The station added a third option for those in the Roanoke Valley, in addition to WDBJ and WSLS. The station's ownership group and management offered prizes for news tips, promoted a "Name It-Claim It" treasure hunt show that originated from local grocery stores, purchased a Cessna plane and van for news coverage, and equipped a studio atop the Mountain Trust Bank Building. Transmission facilities were at Cleveland Avenue and Fifteenth Street, SW. WROV was affiliated with the Mutual Broadcasting System. The station went live at 8:00 a.m. and began with an invocation by the Rev. Ramon Redford, pastor of Belmont Christian Church.

The directors of the minor pro football Dixie League met in Richmond on December 15 and decided to admit Roanoke into the league for the 1947 season. Roanoke became the seventh team with directors, anticipating the later admission of an eighth team. John Godwin represented Roanoke at the meeting.

A Hustings Court jury found Levi Stott guilty of the assault on two police officers during an escapade at the Patrick Henry Hotel in February. He was fined $500 and given one year in jail.

The Blue Ridge Entertainers consisted of (*l–r, back*) Rufus Hall, Hank Angle, Jay Hall, (*l–r, front*) Steve Ledford, Bill Brown, and Carl Decker, 1946. *John Ewald.*

The Roanoke County Board of Supervisors voted to employ Furman Whitescarver, a Salem attorney, to assist in defending the county against annexation by Roanoke city. The board gave Whitescarver permission to hire clerks, engineers, and any other experts necessary for his work.

Roanoke's two black football teams, the Raiders and Cardinals, announced they would play a Mud Bowl on New Year's Day in Springwood Park.

Vinton's Planning Commission approved plans for the construction of a 552-seat theatre to be erected on Pollard Street by Roth Enterprises, Inc.

The Beacon Field Dairy, also known as the Old Martin Home, was auctioned off on December 18. The land consisted of fifteen home sites and was located on Mt. Regis Road, just outside Salem.

Dr. Charles Smith, president of Roanoke College, penned an article in the December issue of the *Roanoke Collegian* stating that the decision to not field a college football team was the correct one. Smith asserted that college football had become too commercial and was a distraction to good education. He did not, therefore, plan to propose reinstating football at the college in the foreseeable future.

Frank Spence, nineteen, was sentenced to eight years in prison for the malicious wounding of Det. Sgt. Joseph Jennings of the Roanoke police department on September 26, 1945. Jennings was paralyzed from the waist down and had been a resident of Lewis-Gale Hospital since the shooting.

The Salem Terminal Appliance Company, at 306 E. Main Street, Salem, changed their name to the Salem Electric Company in mid-December.

The Hourglass Restaurant opened at 117 W. Church Avenue, Roanoke, on December 22. The proprietor was W. A. Ingram. The restaurant had three private dining rooms and an adjoining snack bar. Total seating capacity was around two hundred.

Thornton-Creasy Pharmacists began providing motorcycle delivery service throughout Roanoke of prescriptions, drugs, sundries, and toiletries.

The Chesapeake and Potomac Telephone Company sought permission for rate hikes of residential and commercial phone service. Residential private lines would go from $3.50 to $3.75 per month, and two-party line from $3 to $3.25. Business private lines would go from $6 to $8 per month.

A manslaughter charge against Vernon McCarty, streetcar operator involved in a December 8 accident with a city bus that resulted in the death of a pedestrian, was dismissed in court. A reckless-driving charge filed against the bus driver, A. L. Robertson, was also dismissed by Judge Richard Pence.

Joanne Friend was crowned as Jefferson High's first annual Snow Queen at the school's Christmas Dance in 1946. *Virginia Room, Roanoke Public Libraries.*

Warren's Chicken House advertised its opening on December 21. The restaurant, which was also a steak house, was located on Williamson Road.

Russ Peters of Roanoke, a player in the major leagues of baseball, was sold to the St. Louis Browns by the Cleveland Indians. He had also played with the Philadelphia Athletics.

A new form of Christmas decoration was on view in downtown Roanoke three days before the holiday when the lights in the windows of the Colonial-American National Bank building were patterned to form a Christmas tree.

In the December 22 edition of the *Roanoke Times* appeared an architectural rendering by Paul Hayes of the new theatre being planned for Vinton. The caption read, "The new movie house will be air-conditioned and will be equipped to handle television, a new development in theatre entertainment."

Capt. Purnell Bailey, the army chaplain who accompanied the Japanese Premier Tojo to the hospital after the premier had attempted suicide, preached his first sermon since returning to the United States after fifteen months in Japan, at Trinity Methodist Church, Roanoke, on December 29.

Stockholders of the Colonial-American National Bank and the Liberty Trust Bank approved the merger of the two banks in separate meetings. The effective date was set as December 31. The new institution would be known as the Colonial-American National Bank. This was a change from an original proposal that the name be Roanoke National Bank.

The Roanoke chapter of VPI alumni hosted a send-off for the Virginia Tech football team at Woodrum Field on December 28 as they flew to El Paso, TX, for the Sun Bowl, their opponent being Cincinnati.

The last known Civil War slave in Floyd County died on December 28. Wise Hayden's father had been brought to the county in the 1840s. One story Hayden often told about the Civil War period was his selling pies to Stoneman's Brigade, a Union outfit, when they came through the county on their way to Salem.

Plans to enlarge the plant of the *Roanoke Times* and the *Roanoke World-News* were announced in late December, with an architectural rendering of the new building appearing in the December 29 edition of the *Times*. The expansion was largely due to the construction of a mechanical wing at an estimated cost of $390,000. The three-story structure would be built on the southwest corner of Salem Avenue and Second Street, SW, with anticipated completion in 1948. B. F. Parrott and Company was the general contractor, and the firm of Stone & Thompson was the architect. Both were Roanoke companies.

The Roanoke Christmas Basket Bureau reported that 933 families received food goods during the Christmas season. The bureau's work for needy families was assisted by schools, churches, civic groups, and social welfare agencies.

The Virginian Railway announced details of the new mountain-type electric locomotives to be put in use between Roanoke and Mullens, West Virginia, in 1947. The electric locomotives, the largest ever built, would have speeds up to fifty miles per hour. General Electric was the designer for the eight-thousand-horsepower locomotives.

For those looking to celebrate New Year's Eve, there were many options. The Lee Theatre had a midnight stage show with Woody and His Wanderers. A cabaret dance was held with Eddie Wiggins and his orchestra at the Market Auditorium, sponsored by the Golden Leaf Club. The Dixie Playboys entertained at the Blue Ridge Hall dusk to dawn, while the Wanderers of the Wasteland played for a dance at Victory Hall.

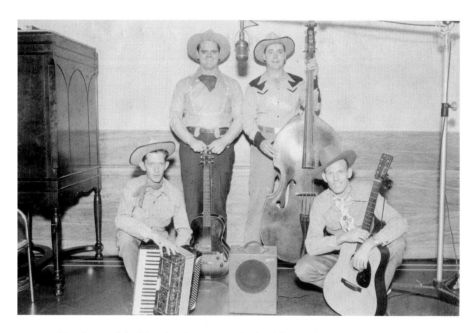

Wanderers of the Wasteland was a popular local band; (*l–r*) Roy Lemmon, Bob Pauley, Glenwood Howell, and Woody Mashburn, circa 1946. *Mattie Forbes.*

1947

A contract was awarded to C. W. Francis and Son for a new post office substation in Virginia Heights at 210 Grandin Road that served all of Roanoke west of the river. Completion of construction was expected by end of the month.

The First National Exchange Bank of Roanoke reported assets and liabilities for the end of 1946 at $63.5 million. Colonial-American Bank reported $24.0 million.

Ben Patterson, seventy-one, retired as the elevator operator in the Roanoke municipal building. He had worked in the city for twenty-eight years, wearing a white coat as a uniform for his elevator duties. Patterson was widely known for his smile and well-chewed cigar.

Roanoke's first baby for 1947 was a boy born at Lewis-Gale Hospital to Mr. and Mrs. Walter Sarver of Elm Avenue.

Dr. John Preston, physician, died at his home on Walnut Avenue, Roanoke, on January 1 at the age of seventy-nine. He began his medical practice in Roanoke in 1909 and served as president of the Virginia Medical Society in 1928.

The systematic renumbering of houses in Roanoke began the first week in January. The effort was overseen by John Wentworth, city engineer, and involved almost sixteen thousand residences.

Roanoke's stadium committee considered a proposal by Stanley Radke for midget auto racing at Victory Stadium. The proposal called for an asphalt track to be inside the stadium but to not interfere with the football field. A syndicate from New York wanted to include Roanoke on its auto-racing circuit. Abney Boxley, chair of the committee, appointed a group to study the idea.

Mrs. Elizabeth Gresham of Salem had her second novel, *Puzzle in Pewter*, published by Duell, Sloan and Pearce, Inc., of New York City. The mystery novel was set in Fincastle. Her first novel was *Puzzle in Porcelain* under her pen name Robin Grey. The Book Nook, 20 W. Kirk Avenue, Roanoke, held a book-signing event for her there on January 10.

The Seventh-Day Adventist Church at 727 Jamison Avenue, SE, was put up for sale.

The Air Force Reserve program got underway at Woodrum Field during the first week of January.

Frank Wiley, prominent Salem businessman, died January 5 aboard a train as he traveled to Tucson, Arizona. He was sixty-eight. He owned Wiley Feed and Fuel Company and was later engaged in the construction business with R. D. Martin. He was instrumental in the development of Langhorne Place.

Cecil Campbell and his Tennessee Ramblers performed on the stage of the Roanoke Theatre on January 8.

A portion of the Arcade Market property was purchased by the Business Realty Corporation for $31,000 on January 8. The property extended from Kirk Avenue to Church Avenue and was acquired from the Mountain Trust Bank. Sol Rosenberg of the BRC said plans for the property had not been made.

C. R. McCraw and M. S. Bowyer purchased the former Eagle Cleaners and Dyers, 1303 Ninth Street, SE, for $32,000 on January 8.

Buildings located on property purchased for the expansion of the *Roanoke Times* and the *Roanoke World News* were razed the week of January 10. Two structures, near the southwest corner of Second Street and Salem Avenue, were torn down. These were identified as one having once housed the George E. Markley Tin and Stove Store and the other a shoemaker's supply store. Adjacent to the buildings was a vacant lot that was the former site of an early saloon in Roanoke operated by John H. Davis. The saloon was razed and replaced by a four-story hotel called The Lee. For several years the ground floor of the hotel was a saloon operated by S. K. Bitterman. Eventually, the hotel was taken over by the Salvation Army and used until it was condemned and taken down in the 1930s. At the time of the newspapers' expansion, the vacant lot was used for parking.

Reuben Kidd purchased the Huggins Nut Company, 1511 Williamson Road, in early January.

Norman-Shepherd, a men's clothier at 505 S. Jefferson Street, became John Norman in early January, as noted in advertisements.

The Roanoke County School Board asked architects to draft estimated costs for an aggressive school building program. The board was interested in making additions to Lewis, Fleming, and Byrd High Schools, a new high school for Cave Spring, and new schools in Garden City, Tinker Creek, and West Salem sections.

Mrs. Ola Boling opened the Vogue Beauty Salon at 404 Henry Street, formerly the Sharlimar Beauty Salon, on January 16. Agnes Hodges and Olga Shank were the beauticians.

About a hundred individuals representing groups and agencies formed the Roanoke chapter of the Virginia Mental Hygiene Society in a meeting at the YWCA on January 14. Rev. J. E. Stockman was elected temporary chairman.

Roanoke's first unit in the army's organized reserves, the headquarters and headquarters battery of the 780th Field Artillery Battalion, was formally recognized in a ceremony in the federal building on January 17. Lt. Col. J. Minor Kulp was the commanding officer of the new unit.

The F. W. Woolworth Company renewed its leases for its Campbell Avenue store for a thirty-five-year period. The new leases took effect on May 1, 1949, and expired on April 30, 1984. Total rental for the thirty-five-year period was estimated at $456,000.

A Roanoke Junior Rifle Club was formed in mid-January by Arthur Walker, a gun hobbyist. The club was under the auspices of the National Rifle Association and was for the purpose of gun safety and marksmanship training.

The new Sunnyside Awning and Tent Company building was completed in mid-January, located at 621 First Street, SW. The building cost $105,000. In addition to the awning company, the building also housed the National Park Service office and Houck Advertising. Martin Brothers was the contractor.

Robert Daniel Routt, age five, son of Mr. and Mrs. A. E. Routt of Roanoke, was struck and killed by an auto on Jamison Avenue, SE, on January 21. On the same day,

Bedford County resident Lewis Thurman, twenty-nine, was killed in a head-on auto collision on Lynchburg Road outside of Roanoke.

The Vinton Town Council voted on January 21 to withhold statistical information from Roanoke city officials that the council felt might be used by Roanoke in its annexation suit against Roanoke County. The town council prohibited any town employee from relaying maps, finances, capital improvements, or charts without approval from the town's attorney.

Mrs. Anna Curville, eighty-eight, cousin of Lady Nancy Astor, died in a house fire at a convalescent home on Oxford Avenue in Roanoke on January 22.

Over a hundred friends of the D. E. Underwood family gave them a "pounding" following a loss of all they owned in a house fire in the Westchester Heights section. The Underwoods were given food, clothing, furniture, and other items to help them recover.

Rudolph Zerkin, a renowned pianist, performed at the Academy of Music on January 25, sponsored by the Roanoke Community Concert Association.

A contract to allow midget auto racing at Victory Stadium was approved by the Roanoke City Council on January 23. The council authorized a contract with S. L. Franco and Stan Radke, representatives of the National Sport Syndicate. According to Radke, the Roanoke track would be part of the Dixie Circuit.

Lawrence Transfer and Storage moved their warehouse and offices from 109 E. Church Avenue to Gillespie Road in the Williamson Road section.

Theodore Young, designer of the Jefferson Memorial in Washington, DC, visited Roanoke in mid-January to examine the proposed site on Mill Mountain for Roanoke's war memorial. Once Young submitted his design, then the War Memorial Committee would draft recommendations on financing and submit the design and costs to the Roanoke City Council, according to Dr. Hugh Trout, committee chairman.

The C&P Telephone Company eliminated toll charges on Salem calls made from Roanoke telephones but increased from five to ten cents the toll for Roanoke calls made from Salem. The reason given was the Salem switchboard was overloaded, so an increased toll would discourage callers.

Alvin Stewart, thirty-six, of Stewartsville was struck by an automobile near Fort Lewis on January 24 and died on the way to the hospital.

American Airlines announced it was increasing service to Woodrum Field beginning March 1. The airline stated the Roanoke airport would receive an additional northbound and southbound flight.

Elmwood Cleaners and Dyers opened at 822 Third Street, SE, at the site formerly occupied by Stewart's Cleaners. Proprietors were E. M. Pendleton and Beck Meador.

Guy Fisher opened Fisher Optical Company at 117 Franklin Road on January 27.

The Hotel Roanoke's main dining room reopened on January 27 after being expanded and renovated.

The Jubalaires, a quartet that performed regularly over the CBS radio network, performed at the Academy of Music on January 28.

Billy Eckstine and his orchestra performed for a blacks-only dance at the City Market Auditorium on January 30. Eckstine was named best male vocalist by *Esquire* magazine in 1944. He was joined by Ann Baker. White spectators were admitted.

Skyline Crafts, a school to teach handicrafts and a hobby shop, opened at 506 S. Jefferson Street, Roanoke.

Camilla Williams, one of the stars of New York opera, performed at the Academy of Music on February 3. Williams was a two-time winner of the Marian Anderson Award and a native of Danville, Virginia. Her appearance was sponsored by St. Paul's Methodist Church.

Mrs. S. S. Jett opened the Post House Tea Room at 40 E. Main Street, Salem, at the end of January.

Ernestine Washington, nationally known gospel singer, performed at Second Baptist Church, Roanoke, on January 28.

Roanoke mayor Richard Edwards was presented the Roanoke Junior Chamber of Commerce's "Man of the Year" Award. It was the first time the award was given. President Ralph Long said the award would be given every year going forward.

Martin and Wetzel Optical Company opened in early February on West Campbell Avenue near the Ponce de Leon Hotel. The new firm was owned by Dr. Harry Martin and his grandson, Fritz Wetzel.

The congregation of Virginia Heights Lutheran Church approved the construction of a new church and education building during a meeting on January 29. The site for the new church was the corner of Grandin Road and Auburn Avenue, which was already owned by the congregation. The church was organized in 1916 and was the second Lutheran congregation in Roanoke.

Leonard Warren, a leading baritone with the Metropolitan Opera, gave a concert at the Academy of Music on February 1 under the auspices of the Roanoke Community Concert Association.

Dews Café, formerly The Haven, opened at 309 S. Henry Street, Roanoke.

The Wasena Civic League presented a petition to the Roanoke City Council protesting the construction of smaller, postwar houses in the neighborhood. The league claimed the houses were inferior to the prewar homes and were built under the guise of helping veterans.

A fifty-five-year-old "corn doctor" promised Justice Richard Pence that he would not peddle his "medicines" in Roanoke in exchange for charges against him being dismissed. Police officers testified the traveling "doctor" was arrested at the Greyhound bus terminal while drunk at a homemade stand selling his medicines.

The Sunny Brook Tea Room opened on January 31 on Route 11 just north of Roanoke. Mrs. Helen Couch was the proprietor.

The Razor's Edge, starring Roanoke native John Payne, opened at the Grandin and Lee Theatres on February 2.

Four units of the army's Organized Reserves were formally activated in a ceremony at the American Legion on West Church Avenue on January 31. Commanding officers were Lt. Col. Walter Damewood, headquarters and headquarters service company of 349th Engineer Construction Battalion; Capt. William Becker Jr., Battery C, 466th AAA AW battalion; Capt. Edmund Potter, Company F, 317th Mechanized Cavalry Reconnaissance Squadron; and Capt. Robert Graves, Company B, 349th Engineer Construction Battalion.

The Roanoke County Board of Agriculture was organized in Salem with Virgil Frantz as chairman.

The US Navy set up a three-day exhibit of naval technology and military life in the southeast corner of Elmwood Park in early February. The traveling exhibit demonstrated new advances in radar and electronics.

The Barter Theater Players began selling block tickets to four plays planned for Roanoke: *Blithe Spirit* (February 26), *Our Town* (March 5), *Arms and the Man* (March 19), and *Much Ado About Nothing* (March 26). All performances were at the Academy of Music.

"Harmony Hangout" was the name selected for the teenage recreation center established in the auditorium at Highland Park School. The center was open on Friday nights for those ages fourteen to nineteen.

Properties in the Fairland subdivision were advertised for sale in early February. Fairland was the site of the former Joseph C. Moomaw farm on Cove Road adjoining the Villa Heights section. The subdivision was advertised as having a large lake. Henry Giles was the owner and realtor.

Hobbie Brothers, Inc., opened their radio-phonograph salon adjoining their location on Church Avenue. The space was previously occupied by the Goodyear Shoeshop, which relocated to Second Street next to the YMCA.

Mick-or-Mack opened a new grocery at 117 W. Church Avenue on February 2. Neilson Henry was store manager, and W. C. Nash was head of the meat department.

Roanoke city manager W. P. Hunter announced that Carvins Cove would be open for recreational use such as picnicking, boating, and fishing effective April 1.

A new postal substation opened on the city farm to serve the families living in the veterans' housing units there. Miss Margaret Morgan was the postmistress at substation No. 4.

The Roanoke Symphony Orchestra, which was discontinued during the war, was reorganized, and a first rehearsal was held on February 10. C. F. Keeley was president of the symphony, and Donald McKibben was conductor.

The *Show of Shows* came to the stage of the Roanoke Theatre on February 5. The acts included Madeline, curvaceous model; the music duo of Harris and Allen; the one-legged dancer Jack Joyce; Krick and Bobo, trampoline artists; and Ned Haverly, comedian.

The New York Civic Opera Company presented *Carmen* at the Academy of Music on February 8. Marilyn O'Conner and Gerta Koblitz had the lead roles.

Dr. John Hutcheson, one of the leading scientists with the Manhattan atomic bomb project, lectured at the Academy of Music on February 15 as part of the Roanoke City-County Public Forum Lecture Series.

Arthur Clay, prominent Roanoke businessman and civic leader, died in a local hospital on February 8. Clay was one of the founders of the Hancock-Clay Company, one of the leading department stores in Roanoke. The store was located at the corner of Campbell Avenue and Henry Street and then moved to Jefferson Street.

Dr. Julian Gilliam of Roanoke was the first black physician to be granted a fellowship by the Virginia Cancer Society. He was given a year of postgraduate study at New York University. Upon completion of the fellowship, Gilliam planned to return to the tumor clinic at Burrell Memorial Hospital.

The six-team Dixie Professional Football League, of which Roanoke was a member, was open to expansion to eight or even ten teams. In addition to Roanoke, the other cities with teams included Charlotte, Richmond, Portsmouth, Norfolk, and Newport News. Cities under consideration for expansion for the 1947 season were Atlanta, Greensboro, Jacksonville, and Winston-Salem.

Roanoker W. Pugh won the tenth annual Virginia State Open Duckpin Bowling Tournament that was held in Lynchburg on February 9. Pugh had a seven-game total of 922.

Rev. Ewell Hess, founder of the First Union Gospel Mission, died at his home on Elm Avenue on February 10 at the age of seventy-nine. He founded the mission in Roanoke in 1907 at 108 W. Salem Avenue. During the mission's first two years, some 1,200 persons joined the congregation. The mission later moved to 109 E. Salem Avenue.

Bernard Dunn was awarded a one-year lease of the Rockledge Inn on Mill Mountain by the Roanoke City Council.

Grace Baptist Temple opened on February 16 at 729 Jamison Avenue, SE.

Salem's first set of chimes rang out on Sunday morning, February 16, at the Salem Baptist Church, where installation of the memorial bells in honor of those of the Baptist Orphanage who served in WW II had been completed.

Fink's Jewelers opened at their new location at 308 S. Jefferson Street on February 18, just six doors south from their previous address.

Milliken Reo Company, 1604 Williamson Road, was announced as the distributor for Reo Trucks in mid-February. Reo Motors, Inc., was headquartered in Lansing, Michigan, and had been producing the Reo brand of trucks and tractors since 1904. George Milliken, operator of the Milliken Reo Company, announced that he would begin construction of a new super truck service center in the spring at the intersection of Williamson Road and Liberty Road. Howard Ferguson would be the sales manager for the company.

Frances Ramser held a distinction in the nation in college athletics. Being a female coach of the Roanoke College boys' swim team, she was the only woman in the nation, as could best be determined, that coached a men's collegiate swim team.

Admiration Beauty Shoppe opened at 3 Grace Street in the Williamson Road section on February 17.

E. R. Sweeney advertised immediate delivery of one- or two-bedroom prefabricated homes. A model home located at 309 Clover Street, Williamson Road, was open for tours to prospective customers.

Construction of a five-story ultramodern Smartwear-Irving Saks store at 210–212 South Jefferson Street was announced by Irving Saks, president and general manager of the corporation. The new building was estimated to cost $350,000, and a planned opening was set for the spring of 1948. Razing of the old building at the new store site began in mid-February. The store at 204 S. Jefferson was formerly occupied by Fallon's Florist. Interior design had been contracted with E. Paul Behles of New York City, and the exterior design was done by Joseph Silbert, also of New York. The local building contractor was Martin Brothers.

Nelson Bond of Roanoke was awarded $2,000 for his script "The Ring" on the Dr. Christian radio writing competition. The script aired nationally on CBS's *Dr. Christian* program on February 26 and starred Jean Hersholt. Bond had written more than 250 short stories, scripts, and articles.

Herman Stone opened his upholstery and furniture repair shop at 1601 Rorer Avenue, SW, in mid-February.

A Yellow Cab from Roanoke that had been missing for four days was recovered in New Orleans, Louisiana. The cab had been painted black and driven one thousand miles by a cab driver, Edward Oyler. Oyler was charged with grand larceny.

The Roanoke City Council adopted an ordinance on February 17 that placed all city hall offices under the supervision of the city manager on uniform hours and reduced the working hours per week from forty-five to forty-one.

The Roanoke Civic Ballet gave a performance of *Aurora's Wedding* and *Strauss Suite* at the Academy of Music on March 7.

A snowfall measuring fifteen inches deep occurred over the Roanoke Valley on February 20. It was the heaviest snowfall in four decades, according to O. F. Estes, volunteer weather observer.

Virginia Trailways advertised bus service from its terminal at 16 W. Church Avenue. The schedules included five round trips daily for Floyd, Galax, and Hillsville, and two round trips daily for Stuart and Mt. Airy.

Lucky Millinder and his orchestra played at the City Market Auditorium on February 25. White spectators were admitted for half price.

Albert Witcher of Roanoke was appointed vice consul at Monrovia, Liberia, in late February. He was a graduate of Addison High School and Lincoln University in Missouri.

C. B. Houck, president of the Houck Advertising firm in Roanoke, announced the company was opening an office in Miami, Florida, and would be known as Houck and Company of Florida.

The Fair-Acre Farm Store opened at 407 Nelson Street, Roanoke, on February 28. The store was owned and operated by Lindsey-Robinson and Company.

Lee's Beauty Shop opened at 1110 South Jefferson Street at the end of February. Lillian Compton was owner and manager.

WSLS began broadcasting a live music program from 6:30 to 6:45 p.m. each weeknight that featured the local Dixie Playboys. The program was sponsored by Kane Furniture.

Thomas Surratt, carpenter's mate second class, US Navy, was believed to be Roanoke's only sailor on Admiral Byrd's Antarctic expedition. In a letter received by his parents, Mr. and Mrs. O. A. Surratt of Rorer Avenue, and dated January 16, Surratt wrote that the ship was at that time anchored in Roosevelt Bay awaiting orders to sail closer to the Little America settlement.

Congressman Lindsay Almond announced that the weather station at Woodrum Field would start operating on a twenty-four-hour basis in March.

A petition began circulating at Roanoke College calling for the reinstatement of organized football "of some size or shape, subsidized, semi-subsidized, or amateur—it makes no difference to us so long as it's a football team." Roanoke College had not fielded a team since 1941.

American Airlines inaugurated its first night flights from Woodrum Field on March 5. The flight was part of its New York-to-Nashville route.

Over one hundred members of St. Paul's Methodist Church appeared at an ABC hearing to oppose the issuance of a permit to sell beer and wine at the Park Street Grocery, located at 431 Gilmer Avenue, NW.

Mr. and Mrs. J. B. Doss, who served for twenty-two years as the superintendent and matron of the city almshouse, retired on February 28. Elbert Brown succeeded Doss.

The Roanoke Railway and Electric Company inaugurated bus service from Roanoke to Moneta on February 28. The bus terminals were the Greyhound station in Roanoke and Peter's Store in Moneta with between stops at Bayse Store and Davis' Mill. There were two runs, morning and late afternoon.

Bibee's Supermarket opened their fourth store in late February at 313 Nelson Street. Their other stores were located at 418 Luck Avenue, SW; 126 Grandin Road; and 2106 Williamson Road.

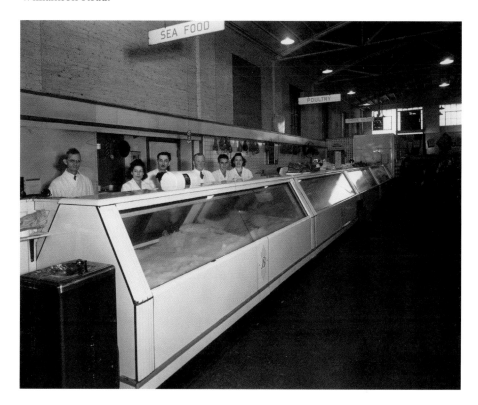

This is the interior of Bibee's Supermarket on Luck Avenue, SW, in 1946. The supermarket chain had four stores in Roanoke. *Historical Society of Western Virginia.*

Hotel Roanoke's associate managers, Kenneth Hyde and George Dennison, announced that sixty-five modernized rooms on the hotel's east wing were open for guests and that the new 125-room wing would open April 1.

The Roanoke and Vinton Lions Clubs held a joint dinner-dance at Hotel Roanoke on March 1. Some three hundred attended, and the keynote address was given by Lions International President Clifford Pierce.

Conductor Hans Kindler and the National Symphony Orchestra presented a concert at the Academy of Music on March 3. The concert was the final one of the season presented by the Roanoke Community Concert Association.

Kroger remodeled its grocery at 119 Grandin Road and had a reopening day on March 3.

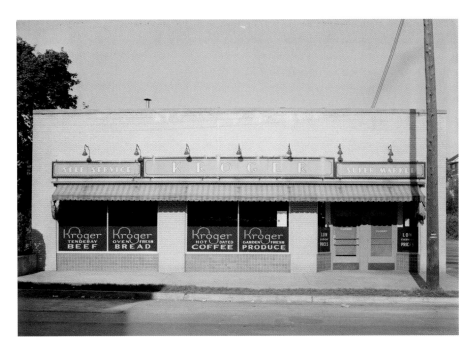

Kroger on Grandin Road, shown here in 1949, reopened in that location in 1946 following a complete remodel. *Virginia Room, Roanoke Public Libraries.*

Delmas Seagle, thirty-four, shot and killed his estranged wife, Katherine, at her parents' home in Salem on March 3 and then killed himself. The couple had been living in New York, before the wife moved to her parents' home in South Salem.

Andrew Lewis High School captured the Western District Class I basketball championship by defeating E. C. Glass 37–34 at Washington and Lee in Lexington on March 3. Leading scorer for Lewis was Dicky Bunting.

The famous all-female orchestra Sweethearts of Rhythm performed for a blacks-only dance at the City Market Auditorium on March 6. White spectators were admitted for half price.

E. L. Craighead Jr. opened his dry-cleaning service on March 4.

William Lee, twenty-four, of Roanoke and a brakeman for the N&W Railway, died shortly after falling beneath the wheels of a string of moving cars in the West End Yards on March 6. He was transported to a hospital but died a few hours after his arrival.

Butner Plumbing & Heating Appliance Store opened at 209 College Avenue in Salem on March 7. It also had a Roanoke store at 1610 Williamson Road. C. E. Butner and J. C. Butner were the proprietors.

The Roanoke Hobby Shop opened in early March at 117 Franklin Road, Roanoke.

Directors of the Greenvale Nursery School took an option on a ten-room house at 1206 Patterson Avenue, SW, for the nursery's new permanent quarters. The school had been in various locations during its thirteen-year existence, but it took its name from once being housed in the Andrews home, "Greenvale," on Campbell Avenue.

The Roanoke Royals, a local black baseball team, began practicing for the season in Washington Park in mid-March. The team was managed by Sparky Robertson.

Andrew Lewis High School lost to Granby High School, 46–24, in the high school basketballs semifinals held in Norfolk on March 8.

Roanoke's Old Dominion Rebels AAU basketball team won the state championship in tournament play at Roanoke College on March 8. They defeated the Langley Field Flyers, 58–45. The Rebels' coach, Joe Daher, announced plans to take the team to the national AAU tournament in Denver in mid-March.

Roanoke's new Carvins Cove water system was in place the second week of March. The filtration plant was near completion and connected the four pipe systems to the main leading to the city. The valves releasing the filtered water opened on March 17.

The Salem Lions Club held its three-day-long twelfth annual minstrel show fund-raiser at the Andrew Lewis High School auditorium on March 13. The club's first minstrel show was in 1936, and in the twelve years since, the club had raised some $5,200 through the events.

Concrete Readymix officials announced they would be operational before April 1 at 611 Norfolk Avenue, SW. Earl Simms was president of the new firm.

A contract for operating concessions at Maher Field and Victory Stadium was awarded by the Roanoke City Council to Roanoke Fair, Inc., an entity owned by American Legion Post. No. 3.

WDBJ advertised the formation of the *Orange Blossom Boys*, a local radio program featuring Tommy Magness, Slim Idaho, Saford and Clayton Hall, and Warren Poindexter. The show aired Monday through Saturday at 6:05 a.m., Monday through Friday at 12:15 p.m., and Saturdays at 5 p.m. and began the second week in March.

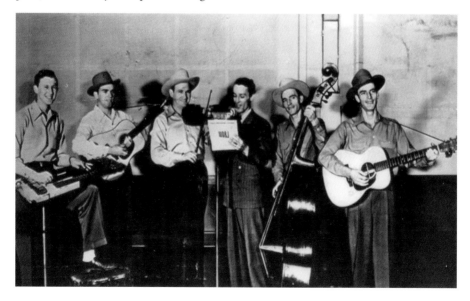

The Orange Blossom Boys in the WDBJ studio; (*l–r*) Slim Idaho, Warren Poindexter, Tommy Magness, Dexter Mills, Clayton Hall, Saford Hall, 1947. *Mitch Drumm.*

WSLS was granted authority by the FCC to operate an FM station. Land was cleared at the top of Poor Mountain for the station's transmitter.

The Rt. Rev. Monsignor John Kelliher, sixty-six, died in Richmond on March 12. He had served as pastor of the St. Andrews Catholic Church in Roanoke from 1921 until 1930, when he was returned to Richmond's St. Peter's Church. He was named as a domestic prelate by Pope Pious XXII in 1940.

T. S. Deyerle, vice president of Thurman & Boone Company, was elected president of the seven-hundred-member Roanoke Merchants Association on March 12, succeeding Frank L. Moose.

Glenn-Minnich Clothing Company completed a $100,000 remodel of its store at 108 W. Campbell Avenue and reopened for business on March 19. The four-story building had three floors of merchandise of men's clothing and accessories, a boys' department, a college shop featuring "California type apparel for men and women," and a department for mannish tailored clothes for women. The fourth floor was used for stock and alterations.

Several persons were fined in Roanoke police court following a gambling raid on the Mount Lebanon Club, 633 S. Jefferson Street.

Salem entered the Skyline Baseball League for the 1947 season. Charley Clark served as the team's representative to league officials, who voted to include Salem.

Dr. William Neff, magician, presented his *Madhouse of Mystery* on the stage of the Roanoke Theatre on March 19. His show was on a coast-to-coast tour.

Four stone cutters using handheld chisels worked daily shaping stones for the construction of the new Seventh-Day Adventist Church on the corner of Oxford Avenue and Virginia (Memorial) Avenue.

The new Bethany Christian Church on Fleming Drive, Williamson Road section, was completed in mid-March and dedicated on March 23. The Catawba stone building cost $50,000. The congregation was organized in 1944 and had been meeting in the auditorium of William Fleming High School.

St. Gerard's Catholic Chapel was established on Moorman Road, NW, in March. Two priests were appointed to serve the mission congregation.

Officials with Reid and Cutshall, Inc., one of Roanoke's oldest furniture stores, announced they had leased the building at 309 W. Campbell Avenue and planned to reopen for business as soon as remodeling was complete. The company had suspended business for several months when they leased their former location, 209 W. Campbell Avenue. The business was started in 1924 by Robert Cutshall and C. S. Reid.

Roanoke's Old Dominion Rebels advanced in the AAU national basketball tournament in Denver by defeating Highland University, 78–46.

Charles King of Roanoke County was rescued after drifting for eleven days in the Gulf of Mexico without food or water. King was in a twenty-two-foot launch that had been sent out by a yacht that had sprung a leak and needed assistance. He and another man were eventually spotted by an army plane.

New state police headquarters for the Roanoke region opened at 217 Williamson Road in mid-March.

Commonwealth Natural Gas Corporation was chartered on March 18 by the SCC to build and operate a seven-hundred-mile natural gas pipeline across Virginia through Roanoke in a plan by Roanoke Gas Company to bring natural gas to Roanoke.

Final tests on the water from Carvin's Cove were performed on March 20 prior to tripping the valves at the main reservoir for the city's water system.

Gilbert's Grill at the corner of Franklin Road and Roanoke Street, Roanoke, advertised their being open twenty-four hours in late March.

Jennings-Shepherd Company opened on March 22 at 411 First Street, SW. The company carried sporting goods and toys.

The interior of Jennings-Shepherd Company on First Street, SW,
which opened in 1946. The image is dated 1947. *Nelson Harris.*

Samuel Hoge, former Roanoke postmaster and a retired attorney, died on March 21 in a Roanoke hospital. Hoge came to Roanoke in 1895. was appointed postmaster in 1898, and served until 1906. He served as postmaster again in 1929 through the early '30s. He was also the Republican nominee for Congress for the Sixth District.

L. E. Lookabill, pioneer Roanoker, died at Mercy House on March 21. He was seventy-six. He moved to Big Lick when he was twelve in 1882 when his father took a job with the railroad. His first job was clerking in a cigar store that was located where the N&W Railway freight station was located (current site of the Transportation Museum). Lookabill's father purchased the business for his son, but the business came to end when the store collapsed in the big snow of 1890. Lookabill then established a print shop at the corner of Salem Avenue and Jefferson Street, which he operated for fifty-five years. He was also known for his knowledge of local history.

The Roanoke County Conservation Association was organized at the courthouse in Salem on March 22 for the purpose of promoting wildlife conservation. Howard Beasley of Cave Spring was elected president.

The 8th Battalion, Virginia State Guard, was formally disbanded in proceedings held at Hotel Roanoke on March 22. The guard had been organized six years prior. Four companies comprised the battalion: the 81st, 82nd, and 83rd in Roanoke and the 123rd at Blacksburg. Lt. Col LeRoy Smith was battalion commander.

Parkdale, a Roanoke County subdivision located between Roanoke and Salem, near Lakeside, was put up for auction in late March. Forty home and business sites were auctioned by J. G. Sheets & Son.

A new four-lane highway was under construction on Route 220 between Clearbrook School and Red Hill Baptist Church. The new road bed eliminated dangerous curves and cost $400,000.

A public music library, the first of its kind in Roanoke, was opened on March 23 at the McAvoy Music House, 817 S. Jefferson St., under the auspices of the Thursday Morning Music Club. The music library operated the same way as a public book library.

A new professional building opened in late March in Salem on College Avenue. The Colonial-style, four-story structure housed the offices of Dr. R. J. Russo and Dr. Esther Brown. Charles Burris was the general contractor.

Dewey Wynn, president-owner of the George T. Horne Company, 410 S. Jefferson Street, announced that construction would begin April 10 on a $100,000 two-story structure that would become the new home of the company. The women's clothing store would be constructed in such a way as to have an additional entrance at 9 E. Church Avenue. The store first opened in 1933 and was enlarged in 1940. The company manufactured about 75 percent of the goods sold in the store and through its mail-order business.

Mike "Pinky" Higgins arrived in Roanoke on March 25 from Dallas, Texas, to begin his duties as manager of the Roanoke Red Sox. Higgins played in the 1946 World Series for the Boston Red Sox, and managing Roanoke's baseball team was his first managing assignment. A banquet was held the following evening at the Hotel Roanoke to introduce Higgins to area baseball fans.

Roanoke Artificial Limb Company was sold to the C. H. Davies Company of Philadelphia.

Roanoke mayor Richard Edwards threw a ceremonial lever at 10:00 p.m. on March 25 and officially turned on Carvin's Cove water into the city's new $2 million water system. When the valve was opened, it began providing the city two million gallons of water daily, marking the end of a thirty-year effort to provide the city a sufficient water supply. The city's water department manager, Charles Moore, was given much of the credit for the new system.

Mrs. Robert Jennings, seventy-four, of Roanoke was named as Virginia Mother of the Year for 1947 by the Golden Rule Foundation in an announcement made in Richmond. Jennings, mother of two daughters, had been active in civic and religious affairs in Roanoke for over three decades, notably helping to organize the Roanoke YWCA.

The first worship service in the newly completed Woodlawn Methodist Church was held on Sunday, March 30. The pastor was Rev. Raymond Musser of Roanoke.

Prominent Baptist leader Rev. Robert G. Lee of Bellevue Baptist Church in Memphis, Tennessee, spoke for a series of sermons at First Baptist Church, Roanoke, in late March. He also addressed several civic and fraternal organizations in Roanoke during his stay.

The "new" Harris & Huddleston grocery store opened on March 27 at 119 S. Pollard Street in Vinton. The new store was located adjacent to the former store.

Randolph Whittle was elected president of the Roanoke Bar Association.

The Roanoke Aviation Club was formed in late March. Officers were Al Lipes, president; Charles Glover, vice president, and Dot Patterson, secretary-treasurer.

Joe Long opened Long's Antiques at 352 Marshall Avenue, SW, on April 1. Long had been associated with The Old Book Shop on Kirk Avenue.

Some 2,500 boys and girls began practicing in early April for the annual Roanoke city-county marbles tournament. All school tournaments had to be completed by April 25.

The three draft boards for the Roanoke area that functioned during World War II and ultimately drafted some twelve thousand valley men into service held their last official meetings on March 31. Men in the Roanoke region first registered for the Selective Service on October 16, 1940.

The personal effects of Herman Goering, German Luftwaffe commander, were displayed in early April for four days by the Marine Corps League in a large Trailmobile at Jefferson Street and Campbell Avenue.

Dr. E. G. Gill announced that some 350 eye, ear, nose, and throat specialists had registered for his twentieth annual Gill Memorial Eye, Ear and Throat Hospital spring course held April 7–11. Eighteen specialists were serving as faculty.

Sunnyside Awning and Tent Company moved into their new building at 621 First Street, SW, in early April.

Howard Lucas and George Lucas assumed the management of the Roanoke Garage, an auto body shop, at 129 West Salem Avenue, in early April.

WSLS launched *This Is Roanoke*, a program about news, regional history, and local persons of interest that aired Mondays and Wednesdays at 9:00 p.m.

Former Roanoker Lynn Bari starred in the film *Nocturne*, which played at the Grandin and Lee Theatres in early April. Her costar was George Raft.

Judge Dirk Kuyk took under advisement on April 1 the case of Richard Ratcliff of Vinton, who was charged with malicious destruction of property in connection with a fireworks display explosion at the Junior Grocery on Franklin Road in June 1946. Ratcliff had been accused of sticking a lighted match through a crack in the window and setting off the fireworks that leveled the grocery and injured several persons. Ratcliff strongly denied the claim against him.

Charles Taft, president of the Federal Council of Churches in America, was the final speaker for the Roanoke City-County Public Forum lecture series of 1946–47. His address on April 4 at the Academy of Music was on America's approach to Russia. Taft had served as wartime director of economic affairs for the State Department.

Mrs. Kate Oakey Dillard of Salem died on April 4 at the age of seventy-eight at her home. Dillard was the widow of W. D. Dillard, pioneer Salem druggist. She served as president of the Salem Community Nursing Association for twenty years.

The Roanoke Royals baseball team opened their season with a home game against the Bedford Athletics at Springwood Park on April 6.

The Roanoke Gun Club held its first shoot of the season on April 5.

A downtown parade and other activities were held in Roanoke on April 7, Army Day, to celebrate and honor the military. The parade began at 4:00 p.m., and some one thousand veterans participated along with five bands. Congressman Lindsay Almond and VMI Superintendent Maj. Gen. Richard Marshall addressed the crowd from the steps of the Municipal Building. Army planes based at Woodrum Field flew in formation over the parade route. The parade began and ended at Elmwood Park, having snaked through downtown.

Thomas Engleby, retired vice president of First National Exchange Bank, died on April 5, in a Roanoke hospital. He had served with the bank forty-four years. He was a veteran of the Spanish-American War and vice president of the Fairview Cemetery Corporation.

Rabbi Charles Lesser conducted his first service at Temple Emanuel on April 11. Lesser came from a synagogue in Wheeling, West Virginia, and had succeeded Rabbi Bernard Zeiger.

Charles Kepley, president of the Success Education Association, opened new headquarters at 1224 Maple Avenue, SW. The association sold reference books across five states and employed fifty people.

Thomas Surratt, twenty, carpenter's mate third class, US Navy, drowned on April 5 en route home with the Byrd Antarctic expedition at Balboa, Canal Zone. Surratt was a native of Roanoke.

The Roanoke City Council was presented a large map detailing the proposed areas to be annexed during its meeting on April 7. If successful, the city would increase by 150 percent. The city manager recommended that an auditing firm be retained to calculate land values and improvements before the council took any further actions.

The Boston Red Sox and the Cincinnati Reds played a major league baseball exhibition game at Maher Field on April 10. Among those that played were Tex Hughson, Hal Wagner, John Pesky, Dom DiMaggio, Ted Williams, Bob Ferriss, and Bobby Doerr of the Red Sox, who won the 1946 World Series. For the Reds, players included Virgil Stallcup and Everet Lively, both of whom had played in the minor leagues for Roanoke and Salem respectively. Other Reds in the lineup included John Vander Meer, Bucky Walters, Linus Frey, and Augie Galan. A crowd of 6,332 fans watched the Thursday afternoon game as the Reds defeated the Red Sox 5–0.

Pvt. Robert Stump of Roanoke was killed in a truck accident near Honshu, Japan, on April 4. He was serving with the 408th quartermaster company, 11th Airborne Division.

Carlton Sutphin, three, of Salem was killed when he was struck by a truck near his home at 219 Wilson Street.

Mary Craft, eighty-seven, of southeast Roanoke died from burns she received when her clothing caught fire while burning paper in her yard at 1000 Fourteenth Street.

Ghent Brethren Church in Roanoke and the Bonsack Methodist Church both held organ dedication services at their respective churches on Sunday, April 13.

A homicide charge against Aubrey Thompson in the death of R. R. Allen, manager of the Cavalier Hotel, was dismissed, and a conviction for assault was entered by Judge Dirk Kuyk in hustings court on April 11. The judge did not believe there had been sufficient evidence establishing that Allen had died from injuries inflicted upon him by Thompson.

The Cetlin & Wilson Circus came to Roanoke April 14 for the week. The circus was held on the show grounds at Big Oak Avenue off Williamson Road. The midway had

twenty rides and sixteen shows. Among the attractions advertised were the world's tallest man (eight and a half feet), the "world's only living half girl," and "the world's smallest woman, 'Margie,' age 19 years, 24 pounds, height 20 inches."

The Roanoke Black Cardinals semipro baseball team opened their 1947 season on April 13 at Springwood Park against the Zula Giants from Miami, Florida. The lineup included some returning from the previous year, S. Robinson, G. Brown, and C. Brown.

Roanoke's annexation suit was postponed as the completion date necessary to have annexed territory included in the city on January 1, 1948, was no longer possible. City officials stated they would not seek to bring new areas into the city until 1949. Nonetheless, the Roanoke City Council moved forward with the process to annex twenty-one square miles by passing unanimously the annexation ordinance on first reading at their April 14 meeting. At the same meeting, the council authorized the city manager to acquire the Andrews farm, upon which the Roanoke Orchard Company had operations, for expansion of the airport.

Joseph Adams, nineteen, died on April 12 from injuries he sustained while working at Roanoke City Mills a week earlier. He had both legs amputated a few days prior to his death after his feet became caught in a conveyer belt.

Appalachian Electric Power Company began extending electric lines up "Bull Run Knob" in the Bent Mountain section in mid-April.

The Roanoke Racing Homer Club held its first race of the year. Homing pigeons were released in Marion. Some 161 birds from eleven lofts competed.

The garden theatre used by the Patchwork Players was remodeled in mid-April. The theatre was located at 1240 White Oak Road in the Prospect Hills section and mostly consisted of a raised, grass-carpeted stage. The stage was expanded, and a lightly graveled area was included for an audience capacity of up to three hundred persons.

Gen. Dwight Eisenhower and his wife, accompanied by two officers, spent the night at the Hotel Roanoke on April 15 as part of a trip from Fort Benning, Georgia, to Washington, DC. The five-star general and his wife caught hotel guests by surprise when they entered the lobby with a state police escort. They dined in one of the hotel's private dining rooms.

International Business Machines (IBM) opened a sales and service branch office at 141 W. Campbell Avenue on April 18.

A wing of the former Roanoke Ice and Cold Storage facility caught fire on April 16. The property had recently been purchased by Graves-Humphreys Hardware Company. The structure, located at Franklin Road and Brandon, caught fire due to a cutting torch used by workmen.

Jefferson High School presented *Escapades of 1947* in mid-April that included a minstrel chorus, variety acts, and the school choir.

The Shenandoah Life Insurance Company officials announced plans to use a portion of the property the company had acquired across from Fishburn Park on Brambleton Avenue for its new home office building. Plans called for construction to begin in either late 1947 or early 1948. The company had engaged the firm of Smithey and Boynton Architects to supervise construction.

Judge Dirk Kuyk freed Richard Ratliff of Vinton of a charge of malicious destruction in connection with the June 1946 explosion at the Junior Grocery in Roanoke. The judge ruled there was no evidence of malice.

The Martinsville Athletics of the Carolina League beat the Roanoke Red Sox of the Piedmont League in the Sox's first home exhibition game for the season at Maher Field on April 20. The score was 4–2.

Officials with the Dixie Professional Basketball League announced from Charlotte the formation of the league. All participating cities also had football teams in the Dixie League, and those were Roanoke, Portsmouth, Norfolk, Richmond, Newport News, and Charlotte, North Carolina. The Dixie basketball league would be composed of sixteen teams equally divided between Virginia and North Carolina for the 1947–48 Season.

The Roanoke City Council at its April 21 meeting agreed to exchange for a one-hundred-acre site at Shrine Hill in Raleigh Court a five-acre tract on the southeast corner of Campbell Avenue and Seventh Street with the Kazim Temple. The city would also include an additional $125,000 for the exchange. The council intended to use the Shrine Hill site for a future high school (the present-day Patrick Henry High School). The site was in keeping with the city's plans should it prevail in an annexation suit. Further plans per annexation included acquisition of William Fleming High School on Williamson Road and the William Byrd High School in Vinton. The Campbell Avenue tract, known as the Andrews property, had been acquired by the city prior to World War II for a possible site of a vocational building for Jefferson High School, but that plan had been abandoned.

The second reading of the annexation ordinance was adopted by the Roanoke City Council on April 22 and included the town of Vinton. The council had been encouraged to drop Vinton from the ordinance as it would effectively eliminate the town as a political entity, but the council proceeded with the ordinance as written.

Controversy continued to swirl around the recommendation of Roanoke's War Memorial Committee that a large monument be erected atop Mill Mountain. Veterans groups and others made attempts to persuade city officials and the public of giving attention to other memorial recommendations. The War Memorial Committee presented a revised report to the Roanoke City Council on April 22 that the Hall of Records Monument recommended for Mill Mountain be placed instead in Elmwood Park and that the monument be constructed in conjunction with the proposed new city library for the park. Veterans organizations advocated that the planned city armory be the war memorial.

The Mason and Dixon Airlines announced it would cease operations at Woodrum Field within sixty days after April 15 due to competition from other airlines.

W. C. "Smokey" Joe Woods was elected president of the newly formed Virginia Amateur Baseball League. The league consisted of six teams: Blacksburg Independents, Rayon Premiers of Covington, New Castle, National Business College, Royal Billiard Aces, and Valleydoah.

Roanoke mayor Richard Edwards threw out the opening ball at the first regular-season home game for the Roanoke Red Sox on April 24 at Maher Field against the Lynchburg Cardinals. The starting lineup for the Red Sox was Harold Brown, pitcher; Bob Scherbarth, catcher; Frank King, third base; William Burke, shortstop; Ray Allen, second base; Bill Spaeter, first base; Marvin Rasch, center field; Ted Del Guercio, left field; and George Wilson, right field.

Roanoke Dressed Poultry Plant, a newly established operation of the Southern States Marketing Cooperative, opened on April 25 at 316 Mountain Avenue, SE. The new plant could handle 2,500 birds daily.

This is a Mason and Dixon Airlines passenger plane at Woodrum
Field on March 30, 1947. The airline ceased operations there a
few weeks later. *Virginia Room, Roanoke Public Libraries.*

The Roanoke Dressed Poultry Company opened on April 25, 1947, on
Mountain Avenue, SE. *Virginia Room, Roanoke Public Libraries.*

Fleet Adm. William Leahy and members of his family spent the weekend at the Hotel Roanoke in late April. Leahy was chief of staff at the time to President Harry S. Truman. The Leahys were visiting their daughter, who was a student at Hollins College.

William Austin, chief engineer for the Blue Ridge Parkway from the time of its inception until the beginning of World War II, died at his home in Charlottesville on April 27 at age sixty. Austin had grown up in Roanoke.

The Roanoke City Council delayed action on an amended report from the War Memorial Committee at its meeting on April 28. The council was made aware that the committee was not unanimous in its recommendation and that the committee may have been unfairly influenced by perceived expressions of city council members on the matter.

James Lewis, former superintendent of Community Hospital in Newark, New Jersey, was appointed as the new superintendent for Burrell Memorial Hospital, succeeding Dr. L. C. Downing. Downing had served as superintendent since the hospital's founding in 1915. Lewis was a native of Lexington, Virginia, and had worked previously at Burrell from 1935 to 1939 as the cashier and bookkeeper.

An early-morning fire swept through the Jeffreys Laboratories at Salem on April 28, causing $100,000 in damage. The cause of the blaze was not immediately determined.

The Patchwork Players announced that their summer schedule would include six performances in city parks and two at Victory Stadium. The players would perform on successive Monday nights at Jackson, Washington, Norwich, Sherwood, and Highland.

Wilhelm Cleaners opened their Williamson Road branch at 101 Williamson Road on April 30.

The Book Nook hosted a book signing for Roanoke author Miss Alfreda Peel's work *Witch in the Mill* on May 3.

The Roanoke Branch of the NAACP became the first branch in the United States to become a life member (as a branch) of the national organization. Madison Jones Jr., national assistant administrator of branches for the NAACP, presented a medal and life membership certificate to Miss Justina Spencer, chairman of the Roanoke Branch's membership committee during a mass meeting of the local branch.

The first professional boxing fights of the year were held at the City Market Auditorium on May 1. The headliner was an eight-round bout between Billy "Anderson Express" Thompson and Wild Bill Rheinhardt. Local boxers participating were Johnny Hodges and Dick Elliatt. The event was sponsored by the Magic City Athletic Club.

Officials with First National Exchange Bank in Roanoke announced that a branch of the bank was planned for the Williamson Road section at 1217 Williamson Road to open in mid-June. The branch was being located in what formerly was the Lawson Oil Company office.

The Maytag Appliance Company opened a new store at 29 E. Main Street, Salem, on May 5.

Dr. Hugh Trout resigned his position as chairman of Roanoke's War Memorial Committee, having served as chairman of the group since its inception two years ago. Trout stated in his letter of resignation that the committee had submitted its report to the Roanoke City Council with a compromise proposal that Elmwood Park, along with a proposed new library in that location with an accompanying monument, be the war memorial.

H. L. Roberts advertised that Lakeside and Lee Hy Pool would open for the season on May 7.

The Pollard Taxicab Corporation and its fleet of thirty cabs were sold to Paul Keenan, former assistant manager of Yellow Cab.

Tex Ritter and his horse, White Flash, appeared on the stage of the Roanoke Theatre in a show billed as *Western Hillbilly Jamboree* on May 7.

The new asphalt track inside Victory Stadium was completed by early May in preparation for midget auto racing on May 15. The oval track around the football field was twenty-eight feet wide on the straightaway and forty feet on the curves. The track's starting line was the fifty-yard line on the west side, and pits for the racers were at the north end of the field.

An expansion program of $1.5 million was launched by the Roanoke Hospital Association that would provide for an eight-story brick building connecting with and extending northwestward from the main building of Roanoke Hospital. The plan also included the enlargement of the nurses' home to accommodate one hundred additional young women.

A Japanese suicide sub was on display in Roanoke May 5 and 6. The one-man subs became famous in World War II for ramming Allied ships. The subs contained 1,800 pounds of high explosives.

Construction was started on a $65,000 addition to Miller Hall, the physics building at Roanoke College in early May. Architectural work was done by the Roanoke firm Eubank and Caldwell, and the contractor was J. F. Barbour and Sons of Roanoke. The original portion of Miller Hall had been constructed in 1857. The building was named for Michael Miller of Roanoke County, who donated much of the original building's cost.

The Kenosha Comets played the South Bend Blue Sox in the All-American Girls Baseball League games on May 11 and 12 at Maher Field. The games were sponsored by the Roanoke Optimist Club. Attendance at the game was estimated at two thousand.

Three teenagers were arrested for overturning twenty-five headstones at the City Cemetery on Tazewell Avenue. Some dated back to 1866. Some headstones were uprooted, others broken, and others completely shattered.

The Roanoke Kiwanis Club purchased a twenty-five-acre tract of land adjoining the Roanoke Girls' Camp near Shawsville in an effort to expand the already-existing 225-acre camp.

Kann's held its summer fashion show at the Grandin Theatre on May 8. The evening event featured local models showcasing beachwear, playwear, and afternoon wear. A previous fashion show had been held at the Lee Theatre.

William Lotz, owner of Lotz Funeral Home, purchased the Lewis residence on Jefferson Street at the intersection of Walnut and Clark Avenues for a new funeral home. Lotz announced his intent to occupy the site by September 1. Lotz Funeral Home was located on the Andrews property in the 600 block of Campbell Avenue, but the property had been recently acquired by the Kazim Temple as part of a land-swap deal with the City of Roanoke.

Arthur Moody retired as the manager of the Patrick Henry Hotel after nineteen years in that capacity. Moody opened the hotel in 1925.

Fink's Jewelers exhibited in their store in mid-May the $500,000 212-carat brooch "Spellbound." The brooch was originally made to be worn in the motion picture *Spellbound*

and was owned by Harry Winston of Harry Winston, Inc., in New York City. The display was in connection with the opening of Fink's new store at 308 S. Jefferson Street.

Over one thousand persons attended the annual 4-H Club baby beef show at Neuhoff Packing Company pens in Salem on May 10.

Fifteen young black men established the first Negro junior chamber of commerce in Roanoke in early May, known as the Big Lick Junior Chamber of Commerce. Officers elected were G. P. Lawrence, president; W. L. Jones, vice president; R. E. Lawson, secretary; and Ralph Coleman, treasurer. It was the second black junior chamber of commerce to be organized in Virginia.

Apple and peach orchards at Bent Mountain and Bonsack were reported as completely lost due to two successive days of frost.

The Fountain Room at the Hotel Roanoke was completed and opened for business on May 12.

"Dwight Hills" was auctioned on May 17, with 115 home sites located on Peters Creek Road near the intersection with Route 11.

The twelfth annual Roanoke dog show was held on May 11 at Lakeside Park, with over two hundred canine entries representing thirty-seven breeds. The winner was a Boston terrier owned by Claude Fitzgerald of Michigan.

The Fountain Room at the Hotel Roanoke, shown here in March 1948, opened in May 1947 as part of the hotel's remodeling.
Norfolk & Western Railway Historical Society.

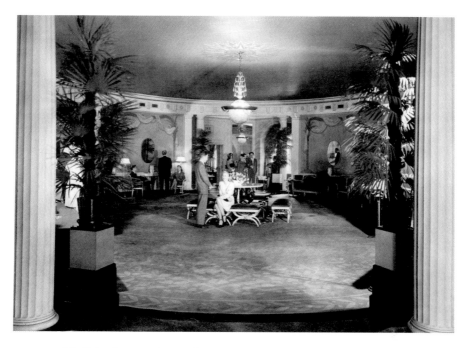

The Palm Court at the Hotel Roanoke in 1947 was another element of the hotel's postwar renovation. *Norfolk & Western Railway Historical Society.*

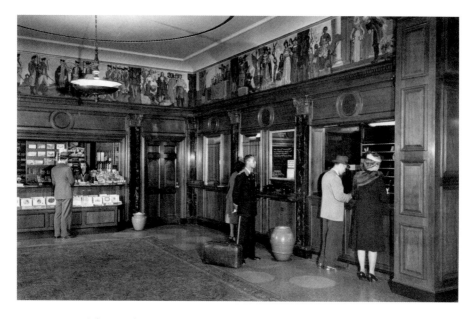

The Hotel Roanoke's front desk and lobby retained its traditional look during the postwar renovation. Cigar stand is in left background. *Norfolk & Western Railway Historical Society.*

Fink's held a formal opening of its new store on May 13 at 306 S. Jefferson Street. Nearly twelve thousand persons visited the store that day to view the famed "Spellbound" brooch and other jewelry from the personal collection of Harry Winston.

The Roanoke City Council adopted an ordinance at its May 12 meeting that smoking be prohibited on buses and streetcars. At the same meeting, council directed that ordinances be prepared to change the name of Otterview Avenue, Ghent, to Maiden Lane and that Northumberland Avenue be changed to Westover Avenue per the requests of citizens living on those streets. This allowed the street names to coordinate with the names of the streets on the west side of Grandin Road.

Zane Williams defeated Charley Turner in the city-county ranking tennis tournament championship. The other ranked players were Turner, second; Landon Buchanan, third; and Paul Rice, fourth.

Russell Seay of Roanoke was appointed manager of the Patrick Henry Hotel, succeeding Arthur Moody. He assumed his post on May 19.

Maurice Bell, principal of Andrew Lewis High School in Salem, was named as the new superintendent of schools for Harrisonburg, Virginia. Bell would take office there on July 1. He became principal at Lewis in 1946.

The Roanoke Civic Chorus gave its second annual concert at the Hotel Roanoke on May 16. The chorus presented *Hiawatha's Wedding Feast*. Guest vocalist was a tenor, John Jameson, of New York. Fred Willman was president of the chorus.

Roanoke police officials traveled to Pittsburgh to question three inmates there about the murders of William Ralph Chattin and Roy Rice, both of whom were killed two weeks apart in January 1946. The inmates were also questioned about an armed robbery during that same period. While none of the inmates confessed to the killings, one did state he had participated in an armed robbery of the Robert E. Lee Hotel in Lexington during that time.

The entire stock of Burn's Loan Office, 11 S. Jefferson Street, was liquidated at a public auction on May 17.

A groundbreaking ceremony was held for the new First Church of the Brethren at Carroll Avenue and Twentieth Street, NW, on May 18.

Some 650 patients and staff at the Veterans Administration Hospital were reportedly stricken with a flu virus in mid-May, the source of which was undetermined.

Ray Robinson, the reigning world welterweight champion, was awarded a controversial split ten-round decision over Roanoke native and Brooklyn resident Georgie Abrams in a nontitle boxing match before sixteen thousand fans at Madison Square Garden on May 16. The crowd booed loudly when the judges awarded the match to Robinson.

Members of the Kazim Temple, AAONMS, formally approved the transfer to the city of Roanoke their Shrine Hill property at a meeting on May 17. In addition to receiving city-owned property at Campbell Avenue and Seventh Street, SW, the Kazim Temple received an initial payment from the city of $15,000 and then $10,000 annually for a period of eleven years.

Manchester Court containing twenty-eight home sites went up for auction on May 24. The subdivision was located on Route 11 between Salem and Roanoke. Several of the lots fronted Yorkshire Street.

The Monroe Junior High School Band is the subject of this 1947 image that appeared in the *N&W Railway Magazine. Norfolk-Southern Foundation.*

Western radio and movie personality Ray Whitley and his "Western Jamboree" performed on the stage of the Roanoke Theatre on May 21.

Midget auto racing made its debut in Roanoke on May 22 (postponed from May 15) at a track inside Victory Stadium created for the Dixie Circuit of midget racing. The opening event included an eight-race card with twenty-five veteran drivers of the "doodlebugs." Roanoke was one of six cities that made up the Dixie Circuit. The race drew an estimated twelve thousand spectators.

Charley Turner and Landon Buchanan captured the men's doubles title in the city-county ranking tennis tournament in mid-May. They defeated Paul Rice and Zane Williams.

The Huntington Court Methodist Church held groundbreaking services on May 18 for their new $100,000 church building on the southeast corner of Williamson Road and Huntington Boulevard. The new structure was adjacent to a frame building that the congregation occupied for many years. The congregation began by meeting in a garage on Williamson Road. The church's membership exceeded one thousand. The Roanoke firm of Smithey and Boynton was the architect.

Congressman Tom Pickett of Texas was the keynote speaker for the Americanization Association's "I Am an American Day" celebration held in the auditorium of Jefferson High School on May 18. Later that day, Congressman Lindsay Almond addressed the association at a banquet at Hotel Roanoke. Norred Trinkle was honorary chairman of the Roanoke chapter of the association and presided at both events.

Rev. John Coburn, pastor of Jefferson Street Baptist Church in Roanoke since 1933, resigned to accept the pastorate of the First Baptist Church, Washington, DC, effective September 1.

The Dailey Brothers 5-Ring Circus came to Maher Field on May 24. The circus featured aerialists, an elephant herd, and a stampede of fifty wild horses.

The Roanoke Black Cardinals played the Atlanta All-Stars at Springwood Park on May 25.

Home sites in Spring Garden were sold at auction on May 31. The forty home lots were located near Lakeside Park.

Hidden Valley, a one-hundred-acre tract, was subdivided, and lots were auctioned on May 28. The land was located on Route 675 (Indian Grave Road) between Roanoke and Clearbrook.

The Community Children's Theatre of Roanoke dissolved on May 23 as demand for the organization no longer existed, according to its board. The organization was launched in 1940 and funded by the Junior League. Francis Ballard was the theatre director. Prior directors were Clara Black and Mac Johnson. An estimated one hundred children had participated in the theatre's school and productions during the seven years of its existence.

The Rowe-Jordan Furniture Corporation moved into its new plant the third week of May. The new facility was located just south of Salem. The company had been in temporary quarters at 1228 Indiana Avenue, Salem.

Three elephants and a camel participated in the Shrine Parade to the Academy of Music on May 24 in the spring ceremonial of the Kazim Temple. L. A. Ballard rode the camel.

Frances Hill, ten, died from injuries she sustained when struck and dragged by an auto on May 24 near her home in Pinkard Court. She died at Burrell Memorial Hospital.

Dean Hudson and his orchestra gave a performance on the stage of the Lee Theatre on May 27.

Tragedy struck on the small lake of Cave Springs in Botetourt County on May 26 when three persons drowned in a boating accident. The victims were Berlin Fisher, twenty-five; Jeanette Anderson, fifteen; and Carol Seay, fourteen. All were from Springwood. The Williamson Road Life Saving Crew was the first to respond to the scene.

The Roanoke City Council adopted further name changes to streets at its May 27 meeting. Those changes were Kensington Avenue to Bluemont Avenue (Raleigh Court), Wellington Avenue to Jefferson Street (South Roanoke), Virginia Avenue to Memorial Avenue (Virginia Heights), and Virginia Avenue to Crystal Spring Avenue (South Roanoke).

Garwood Trenor of Roanoke was sentenced to ten years in prison after he plead guilty to second-degree murder in the death of Clarence Hubbard, twenty-two, a guard at the Virginia Industrial School for Boys in Powhatan County.

Bill Mumpower (a.k.a. Bob Power), a member of the Sky Writers quartet, won as part of the quartet the talent prize on the nationally broadcast Arthur Godfrey show on CBS.

Vinton opened its new $10,000 swimming pool at Memorial Park on May 30 with a formal dedication ceremony. The pool project was launched with an initial $3,500 gift from the Vinton Lions Club. Several hundred people attended the ceremony. Under development at the park was the Colonial-style war memorial community center.

Midget auto racing returned to the track at Victory Stadium on May 30.

Tinker Bell Pool on Route 1 at Hollins opened at the end of the May for the summer season.

The Dixie Playboys performed every Friday night at Harvey Howell's at Bent Mountain. The music group was composed of Glenn Howell, Roy Lemon, Gordon Reed, Bill Williams, and Bob Pauley.

Seventy-five home sites in the Dorchester Court subdivision off Williamson Road were auctioned off on May 31.

Respects were paid to fallen servicemen in ceremonies around the Roanoke Valley on Memorial Day. All events had one common element: the dropping of flowers over soldiers' graves by low-flying planes at almost all cemeteries. The pilots who provided the service were Don Cross, T. E. Frantz Jr., Martha Ann Woodrum, Paul Turner, Clayton Lemon, Al Lipes, and Lawrence Bohon.

Rev. L. L. White, pastor of St. Paul's Methodist Church in Roanoke, accepted the call to become pastor of Holman's Methodist Church in Los Angeles, California. White had been a leader in Roanoke's black community since coming to St. Paul's in 1941.

Nelson Hardware, 19 E. Campbell Avenue, held a formal opening for its new sporting goods department on June 2.

Reid and Cutshall reopened for business in their new quarters at 309 W. Campbell Avenue, a location that featured four floors of furniture, on June 5.

The Emmanuel Lutheran Parish formally divided into two churches in early June, the Emmanuel Lutheran Church in the Villa Heights section of Roanoke and the Glade Creek Lutheran Church at Blue Ridge.

The Vinton Flour and Feed Mill reopened for business after completely rebuilding from a devastating fire in 1940. The roller mill could produce one hundred barrels of flour each day. Corn meal and feed were also produced. John Cooper was the owner.

A five-man committee of World War II veterans, who claimed they had surveyed over two thousand veterans in Roanoke, presented to the Roanoke City Council a proposed memorial hall idea as a proper monument to the city's war casualties. The council appointed the five men to their War Memorial Committee and tasked the committee with considering the proposal. The committee had suggested that Elmwood Park and its new library be encompassed in the war memorial.

Larry Vinson, ten, became the youngest champion in the history of the Roanoke city-county marbles tournament when he won the eighteenth annual tournament in Elmwood Park on June 2. Vinson was a student at West End School and became eligible to compete in the national marbles tournament in Wildwood, New Jersey. He beat Russell Hurst of Bent Mountain.

Charley Turner, well known for tennis, captured the championship of the Roanoke city badminton tournament held the first weekend in June at the city market. He defeated Rudy Rohrdanz.

A. S. Pfleuger announced on June 4 his retirement from the jewelry business and the sale of his store at 118 W. Campbell Avenue to George Hitch of Pulaski. Pfleuger came to Roanoke in May 1912 and took over the business of the Rankin Company (jewelers). In 1924, Pfleuger then went into business for himself.

Sixty home sites in the Westchester subdivision went up for auction on June 4. Westchester was located in the Mudlick-Deyerle Road section.

Marble tournament champion Larry
Vinson, shown with his parents,
became the youngest city-county
champion in 1947 at the age of ten.
Norfolk-Southern Foundation.

George Dickinson died at age seventy-one at his home in South Roanoke on June 4. Dickinson was the retired president of the Colonial-American National Bank. His career in banking began when he was named secretary of the Colonial Bank and Trust Company when it opened in Roanoke on August 1, 1910. He was elected president of the Colonial-American National Bank in 1933 and served in that capacity through 1946.

Sunnybrook subdivisions Nos. 1 and 2 came up for auction on June 7. The tracts contained twenty-five home sites and two business tracts. The subdivision was located on Route 11 and Route 601, one mile west of Hollins College.

The Checker Cab Company, formerly Pollard Taxicab Corporation, inaugurated service in the Roanoke Valley on June 6.

Digging started on June 9 for the foundation of the new Appalachian Electric Power Company's new $150,000 general office building at the corner of Franklin Road and Henry Street, SW. It was adjacent to the Medical Arts Building. Appalachian established its headquarters, using various buildings, in Roanoke in 1943.

Aaron DeHart, ninety-nine, one of Virginia's last surviving Confederate soldiers, died at the home of his son in Salem. DeHart was a native of Floyd County and was buried in Patrick County. According to state officials, he was one of thirteen surviving Confederates at the time of his death.

Roanoke Steel and Supply Company opened at its new location at 202 E. Campbell Avenue on June 8.

The Morgan School of Dancing opened at 218 E. Main Street, Salem, the second week of June. The school offered courses in ballroom dancing.

Midget auto racing became so popular that races were held every Thursday night during the summer months on the track inside Victory Stadium.

More than five hundred Boy Scouts from around the Roanoke Valley participated in the annual spring camporee on the grounds of the Veterans Administration Hospital during the second weekend in June.

E. B. Broadwater, principal of Jefferson High School, resigned to accept the same position at Andrew Lewis High School in Salem. Broadwater had been principal at Jefferson for two years and had come to Jefferson from Roanoke College, where he had been a dean.

The Roanoke County School Trustee Electoral Board reappointed two incumbent members, Mrs. Frank Thomas (Central District) and Eugene Kirkwood (Cave Spring District). Both took office in 1941.

The Virginia Doughnut Company opened on June 11 at 2319 Melrose Avenue, NW.

Margaret Gill, daughter of Mr. and Mrs. H. T. Gill of 901 Tenth Street, NW, became the first black female attorney from Roanoke. She graduated from Howard University School of Law in Washington, DC. Gill was a graduate of Addison High School and completed her prelaw work at Howard University and Wayne University in Michigan. She became a member of the Washington, DC, bar.

Vinton town leaders launched a campaign to raise $25,000 in mid-June to complete the town's war memorial building. Worked had stopped on the Vinton War Memorial building in May due to lack of funds. R. W. Corbin was chairman of the project's finance committee.

The Crystal Hat Cleaners, formerly of 110 S. Jefferson Street, consolidated with Modern Shoe Repair, 36 W. Church Avenue, in mid-June. "We have 35 years experience in the hat cleaning business. Also shoe repairing, dry cleaning."

The new branch bank of the First National Exchange Bank opened at 1217 Williamson Road on June 16. Frank Duffy was appointed manager.

The dangerous Murray's Curve on Route 11 at Hollins was straightened. Over the past forty years, a dozen motorists had lost their lives in wrecks at the curve. It was named for G. P. Murray, who lived nearby and ran Murray's Store near the road.

The junior chamber of commerce presented its annual hippodrome circus at Victory Stadium the third week of June. The circus included twenty acts, including the Sky Rockets (aerialists), acrobats, jugglers, horses, and clowns.

The new light cruiser USS *Roanoke* was launched at 11:17 a.m. on June 17 into the Delaware River at Camden, New Jersey, by the New York Shipbuilding Company. The cruiser displaced 14,700 tons and could travel up to thirty-two knots or better. The official launching party included the sponsor of the ship, Miss Julia Henebry, daughter of former Roanoke mayor Leo Henebry, who attended. The maid of honor was Miss Margaret Smith, daughter of N&W Railway president R. H. Smith. Others present were Mayor and Mrs. Richard Edwards, Councilman and Mrs. W. B. Carter, and city manager W. P. Hunter.

The Roanoke chapter of Alcoholics Anonymous that was started with two people in February 1946 had grown to thirty-five members, according to a report from the YMCA.

Roanoke Sweeper Company opened on June 19 at 418 Thirteenth Street, SW.

Yellow Cab Company placed a Desoto limousine in operation at Woodrum Field on June 20. The cab service was in cooperation with American and Eastern Airlines as a service to their passengers.

Miracle on 34th Street opened at the Grandin Theatre and Lee Theatre on June 22 and starred Roanoke native John Payne.

The Patchwork Players opened their third summer season the week of June 22 with a production of Noel Coward's *Hay Fever*. The Players offered plays in city parks and at their terraced garden theatre at 1240 White Oak Road in South Roanoke.

Four large apartment complexes were under construction in June in Roanoke, providing a total of 145 units, bringing housing relief to veterans. The complexes were on Longview Avenue (South Roanoke), Grandin Road, and Virginia Avenue (Virginia Heights).

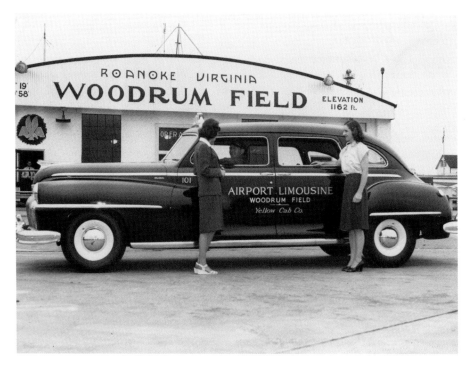

Yellow Cab began offering limo service at Woodrum Field in 1947. Pictured are Mae Williams (*left*) and Margaret Franklin (*right*). *Virginia Room, Roanoke Public Libraries.*

Peoples' Perpetual Loan and Building Association formally changed its name in mid-June to Peoples Federal Savings and Loan Association. The association was started on May 11, 1887. The company was located at 130 W. Campbell Avenue.

The Department of the Navy awarded a $143,000 contract to Turner Construction Company of Roanoke to build the new Naval Reserve armory at the intersection of Franklin Road and Pleasant Avenue, SW, adjacent to the Maher Field baseball park.

Roanoke police began using FM radio equipment on June 26, and the city's fire department was connected to the system by virtue of a phone land line between the police dispatch and the No. 1 Fire Station.

Larry Vinson, Roanoke's marbles champion, lost in the national marbles tournament in Inglewood, New Jersey, but made it to the semifinals before being defeated.

Mrs. J. B. Cralle II placed second in the Virginia state women's golf championship held at Staunton on June 27. Mrs. Cralle's home course was Monterey Country Club.

The Bank of Virginia held a formal opening of its new quarters at First Street and Church Avenue on June 30. As part of the opening, the bank displayed ten $10,000 bills, the largest denomination in circulation. The bank's former location was the first floor of the State and City Building. The bank's display also included various other bills and coins totaling exactly $1 million. Plainclothes policemen and uniformed guards circled the building.

The Bank of Virginia is under construction on Church Avenue, SW, at First Street. It opened on June 30, 1947. *Virginia Room, Roanoke Public Libraries.*

The Vinton Lions Club staged its annual horse show at Leggett Field in Vinton on the Fourth of July. Some fifty horses from Virginia and the Carolinas were entered. R. A. Covington was chairman of the Show Committee. Virginia's lieutenant governor, L. P. Collins, spoke at the horse show's evening event. Attendance was estimated at two thousand. "Little Greyhound," owned by R. A. Covington of Roanoke, took top honors in the roadster stake.

Some five thousand spectators went to Victory Stadium to watch entrants in the Roanoke Gas Modelers control line airplane contest. Harold Gettle of Roanoke won first place for his plane's stunt work.

The Roanoke City Council appointed two new members to the school board for three-year terms: Mrs. Kirk Ring and Arnold Schlossberg. They succeeded M. A. Smythe and Mrs. Lewis Campbell.

The Lafayette Beauty Salon opened at 1001 Lafayette Boulevard, NW, on July 3. Mrs. Pauline Giles was the operator, and Mrs. Arleen Collins was the owner.

Frederick Temple, owner of Sunnyside Awning and Tent Company, died at his home in South Roanoke on July 2 at the age of seventy.

Salem held its first Fourth of July parade since 1932 with the theme "Welcome Home GI Day." Parade entrants included Roanoke American Legion Post No. 3 drum and bugle corps, Virginia lieutenant governor Preston Collins, Salem Legion Post No. 19, as well as various civic organizations. The parade began at Lake Spring Park.

Dr. Peter Peffer, manager of the Veterans Administration Hospital, announced that the hospital would begin admitting female patients for the first time in its history. The women's ward would consist of twelve private rooms, a day room, and a visitors' lounge on the second floor of the north wing of Building No. 6. Dr. Rose Herman was appointed head of the ward.

Tennis courts were erected in Wasena Park in early July. The new courts' surface consisted of a mixture of sand and asphalt.

Stanford, Inc., announced their new location at Salem Avenue and Eleventh Street. The company specialized in outdoor advertising, commercial signs, and neon signs.

Dr. Esther Brown opened her general practice in an office at the Professional Building in Salem in early July. She became the first woman to have a general medical practice in Salem or Roanoke County. She was a graduate of the Medical College of Virginia, Class of 1945.

The Mount Olive Baptist Church was organized, and the selection of a site for its location at Woodlawn Avenue and Red Rock Road in the Grandin Court section was announced on July 5. Elder J. S. Harris was elected moderator of the Primitive Baptist congregation.

The Seventh-Day Adventist Church held their first service in their new church on Memorial Avenue at Oxford Avenue in the Virginia Heights section on July 12. Rev. L. H. King was pastor.

Roanoke city manager W. P. Hunter officially changed the name of the city's largest reservoir from "Carvin's Cove" to "Carvins Cove." The name issue had been raised by the city's water department staff, and Roanoke City Council adopted Hunter's recommendation at its meeting on July 7. The name Carvin came from William Carvin, who owned most of the land above and below the dam.

A flag in the shape of a shield taken from the cruiser USS *Roanoke* was presented to the Roanoke City Council on July 7. Other items pertaining to the cruiser, such as photographs and bulletins, were also given to the city.

The first-ever reports of flying saucers being seen over Roanoke occurred on July 7. The eyewitness was Mrs. M. A. Burtin of Rorer Avenue, who spotted the object in the afternoon. Later that same day, a flying saucer was reported by Dorothy Douglas near Boones Mill. A third person spotted two round, shiny objects over Tinker Mountain the same day. All three witnesses said the objects moved at quick speed and were circular like a large dinner plate.

Groundbreaking ceremonies for the new navy armory at the western end of Maher Field were held on July 8. Participants included Roanoke mayor Richard Edwards, Lt. Commander Edward Harmon, and W. P. Hunter.

Trinity Evangelical Lutheran Church was officially organized on Sunday, July 13 with sixty-two charter members. The congregation was meeting at the Lee Theatre on Williamson Road. Rev. C. M. Huddle, a former navy chaplain, was the minister.

William Payne, principal of the high school in Lexington, North Carolina, was appointed principal of Jefferson High School by the Roanoke School Board on July 8.

On July 10 D. W. DeBusk of Roanoke was standing on the roof of the Viscose, where he was employed, watching an airplane, when he claimed to see a flying saucer moving at high speed. The object appeared to be a shiny, metal ball.

The Grandin Court School, shown here in 1949, was also used as a church and eventually became a recreation center. *Virginia Room, Roanoke Public Libraries.*

Vandals broke out windows in the Grandin Court School building that was also being used twice weekly by a Church of Christ congregation. Destruction to the school had apparently occurred repeatedly.

A building permit for the three-story Stonewall Jackson Apartments to be built at 1720 Grandin Road by the Wood Apartment Corporation was issued by Roanoke officials on July 10. The apartment building was estimated to have a cost of $400,000 and contain sixty units.

Owen's Seat Cover Shop opened in mid-July at 308 Seventh Street, SW.

The Shenandoah School of Business opened at 118 E. Main Street, Salem, in mid-July, with classes to begin September 1. The business school was founded by Bernard Dunn and E. K. Walker.

Charles Hall, twenty-five, of Copper Hill was killed in an automobile accident on Bent Mountain on July 13. The accident happened on Route 221 about a half mile from Harvey Howell's store. Three others were injured: James Wimmer, Joseph Wimmer, and Dennis Beckner. Beckner, thirty-seven, and Joseph Wimmer, twenty-four, both died a few days later of their injuries.

Thirty-three new buses arrived in Roanoke over the course of several days for the Roanoke Railway and Electric Company and the Safety Motor Transit Company, meaning more streetcars would be eliminated. The buses were manufactured by the ACF-Brill Motors Company of Philadelphia, Pennsylvania.

The Crescent Amusement Company opened its weeklong amusement expo at Vineyard Field in Vinton on July 14. The expo featured a dozen rides, nightly shows, and a Ferris wheel. The event was under the auspices of the Vinton Fire Department.

Roanoke's reorganized War Memorial Committee met in mid-July and submitted a progress report to the Roanoke City Council. After several resignations from the committee, new members had been added. The committee recommended that a war memorial be developed for Elmwood Park along with the new library and that neither be subordinated to the other.

Nearly one thousand persons watched the Patchwork Players production of the Greek tragedy *Antigone* in Washington Park on July 14.

L. H. Flick of Roanoke reported seeing a group of four flying saucers while working his run as a freight conductor on the N&W Railway on the night of July 13. He spotted the objects near the "Low Tunnel" in Pulaski County. Flick said they looked like marbles and were moving much too fast to be airplanes.

The Roanoke All-Stars was a semipro black baseball team. The team's manager was Edward Jones (*front, right*), July 1947. *Norfolk-Southern Foundation.*

Roanoke's Soap Box Derby was held July 16, with fifty-five teenage boy entrants. The derby was run on a three-lane, 975-foot course laid out on Virginia Avenue (Crystal Spring Avenue) in South Roanoke. The day began with a midmorning parade in downtown and a luncheon. An estimated ten thousand persons watched the event. Snow fencing had been erected along the curbing to protect drivers and spectators, as the derby cars had potential speeds of thirty miles per hour. The derby was sponsored by the Roanoke Optimist Club and the Johnson-McReynolds Chevrolet Corporation. The winner was Ray Kane, and the runner-up was Jimmy Brugh. Kane earned a trip to compete in the National Soap Box Derby on August 17 in Akron, Ohio.

Roanoke City officially filed notice to Roanoke County of its intention to annex twenty-one square miles when Roanoke County Sheriff E. E. Waldron served notices of intention to the members of the county board of supervisors on July 16. Notices were also served to the town of Vinton.

The Roanoke chapter of the Izaak Walton League was presented a charter at its meeting in the circuit courtroom in Salem on July 18.

Roanoke's first launderette, equipped with twenty-one coin-operated washing machines, opened the third week of July at 823 Tazewell Avenue, SE. It was the only such launderette in Virginia west of Richmond and was owned and operated by Billy Kellner and Franklin Hough, both of Salem.

The new home of the Rainbo Bread Company was halfway completed by mid-July on Gillespie Road at Liberty Road in the Williamson Road section. The company was

moving from its location on Centre Avenue. F. J. Welch, manager, indicated the new bakery plant would be open by the first of the year.

Oliver "Bo" Roddy captured the Roanoke Exchange Club's singles tennis tournament held at Roanoke Country Club. Roddy, eighteen, from Charlotte, North Carolina, defeated Don Leavens, thirty, from Washington, DC.

The Roanoke School Board authorized a $150,000 contract with English Construction to begin building the new Monroe Junior High School in northwest Roanoke. This followed the appropriation of that amount from the Roanoke City Council.

Roanoke's newest all-night restaurant, Java House, opened on July 22 at 136 W. Campbell Avenue. The owner was W. A. Ingram, who also owned the Hourglass Restaurant on Campbell Avenue.

American Legion Post No. 3 negotiated the purchase of the Roanoke Auditorium from the N&W Railway. The railway had closed the auditorium for public use during a renovation and reconstruction of the Hotel Roanoke, using the building for storage. Legion membership approved the purchase at a meeting on July 22 for a price of $55,000, with the deal expected to be completed in the coming weeks. Post No. 3 had over one thousand members and was the largest post in Virginia.

An impromptu contest as to who owned the oldest working light bulb in Roanoke unfolded during the summer. After several residents demonstrated their working bulbs, the winner of the contest was G. V. Kromer, who had been using the same bulb for fifty-one years. Kromer purchased an old carbon filament bulb when he was twenty-one and living in New York. Now seventy-two, he still used the bulb in his shop at 105 First Street, NW.

Dr. Charles Smith, president of Roanoke College, informed the college's governing board that he was ready to retire and encouraged the board to begin the process of seeking his successor.

The Roanoke Black Cardinals played the Pittsburgh Monarchs at Springwood Park on July 27.

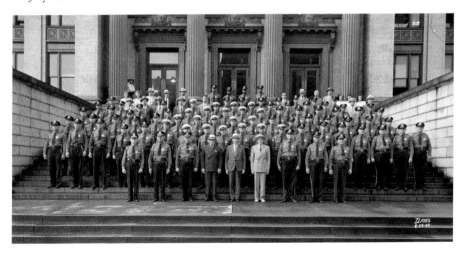

The Roanoke City Police Department posed on the front steps of the Municipal Building, August 1947. *Virginia Room, Roanoke Public Libraries.*

The Virginia Entertainment Corporation of Williamsburg announced on July 26 that it was beginning construction of the Roanoke Valley's first outdoor movie theatre on Lee Highway between Roanoke and Salem. The $100,000 venue would accommodate five hundred vehicles.

Drs. John and Marie Stokes, pioneer Roanoke chiropractors, opened their new offices at 21 East Highland Avenue in late July.

Roanoke's new twenty-four-hour weather station went into operation in late July, having moved from the Cannaday home at Woodrum Field to the control tower.

Construction on one of the first continuous car tunnel brick kilns to be built in Virginia was started by the Salem Brick Company, manufacturers of the Old Virginia brick. The plant was located west of Salem on Route 11 and was expected to be completed by December 1. Henry Garden was company president.

Roscoe Sinclair, twenty-three, of Blue Ridge drowned on July 27 while swimming with five friends at Mundy's quarry north of Route 460 near Tinker Creek Bridge.

The Roanoke City Council became embroiled in a debacle surrounding the appointment of the new city manager. Mayor Richard Edwards had announced that W. P. Hunter would retire at the end of the year, as expected. Edwards also announced, however, that council was prepared to appoint Lt. Commander Edward Harmon of the Naval Reserve as Hunter's successor. The council convened in a special session only to be instructed by the city attorney that the meeting was in violation of the city charter. Thus, the council postponed the matter until its regular meeting on Monday, July 28. At that meeting the council's coherence fell apart when confronted by citizens who complained that the decision to appoint Harmon was too hasty and a surprise move. The council decided to again postpone action on Hunter's resignation and the appointment of his successor until August 25. Citizens and newspapers decried the mayor and council for making the decision about Hunter's successor in private meetings.

A federal jury, with reluctance, awarded Rev. William Simmons of Roanoke $25 in a judgment against Atlantic Greyhound Bus Company for violating Simmons's rights when the bus driver asked the minister to give up his seat to a white patron and move to the back of the bus. Simmons refused, got off the bus, and took a train from Roanoke to Salisbury, North Carolina, later that night. Simmons had asked for $20,000 in damages.

The Roanoke City Council adopted an ordinance changing numerous street names, mirroring actions taken previously in regard to other streets. Most of the name changes involved streets in the northwest and southwest quadrants.

Lakeside Swimming Pool was sued in Law and Chancery Court on July 29 by two chemical engineers from Narrows for $20,000. In their suit, Hector Ayala and Fernando Santin claimed they were humiliated by being asked to leave the premises after they had purchased tickets and gained admission to the pool. The men asserted they were white men of Spanish descent who were asked to leave by pool owner H. L. Roberts. According to the suit, the men claimed Roberts told them, "The premises were intended for white American Christians," and thus they were not "fit and proper" persons to be there.

The Grandin Road branch post office officially opened for business on August 1, replacing the mailing station at Garland's Drug Store. The branch was located in the 200 block of Grandin Road.

Bill Monroe and his Bluegrass Boys performed on the stage of the Roanoke Theatre on July 30.

A groundbreaking ceremony was held on August 1 for the new Monroe Junior High School at Nineteenth Street and Carroll Avenue, NW. It was the first public school built in Roanoke in twenty years.

Members of the Roanoke Bar Association, with the help of local inmates, began assembling the law library in new quarters on the second floor of the municipal building in early August.

The Roanoke Junior Chamber of Commerce illuminated a large "V" on Mill Mountain using neon tubing on the night of Monday, August 4, as part of a get-out-the-vote effort for the Democratic primary being held the following day. The V could be seen in almost all sections of the city.

Frank Craig of Roanoke died in a local hospital at the age of ninety on August 4. Craig came to the city in 1889 with ten dollars in his pocket and became one of the leading real estate developers in the area. He was involved in developing the Virginia Heights, Raleigh Court, and Williamson Road sections when they were, as he described them, "wheat fields."

In a large-turnout Democratic primary election in Roanoke city, Earl Fitzpatrick defeated Walter Scott for the Senate seat vacated by Leonard Muse by a vote of 4,854 to 3,104. Scott had defeated Fitzpatrick two years earlier for the House of Delegates seat. In the race for the House of Delegates nominations, the victors were Griffith Dodson Jr. and Julian Rutherfoord Jr., with votes of 3,714 and 3,580 respectively. Incumbent James Bear received 3,158 votes. Other candidates finished as follows: William Martin, 2,471; Mosby Williams, 1,861; and Murray Stoller, 683. The nominations of Fitzpatrick, Dodson, and Rutherfoord were seen as a repudiation of what had been termed during the campaign the "Scott-Martin political machine."

In Roanoke County, incumbent Furman Whitescarver was defeated by Ernest Robertson, 3,009 to 2,561, for the House of Delegates nomination. Sheriff Emmet Waldron was defeated by H. B. McManaway, 2,728 to 1,819, in his bid for reelection.

In the Twenty-First Senatorial District, Benjamin Chapman of Salem defeated Carter Lee of Franklin County, 3,917 to 1,787. For Roanoke County commonwealth's attorney, Eugene Chelf was decisively renominated, defeating two challengers. For the county's commissioner of revenue, W. C. Muse was renominated, defeating Ran Francis 2,821 to 2,778.

For the Roanoke County Board of Supervisors, all three incumbents were renominated: Howard Starkey (Salem district, unopposed); Mason Cook (Big Lick district) defeated Glenn Culbertson; and Herbert Tayloe (Cave Spring district) defeated J. T. Burch.

Fred Kirby and his Carolina Play Boys performed on the stage of the Roanoke Theatre on August 6.

Cab Calloway and his orchestra performed for a show and dance at the City Market Auditorium on August 6. White spectators were admitted for half price.

The Windsor Hills-Lee Hy Park Civic League was organized on August 7 in a meeting at Oak Grove Church of the Brethren. Frank Angell was elected president. The stated purpose of the league was to advocate for improvements to the neighborhoods in those sections.

Associate US Supreme Court Justice Robert Jackson addressed the Virginia Bar Association at the Hotel Roanoke on August 8. Jackson had also been the country's lead prosecutor at the Nuremberg trials of Nazi war criminals. In speaking about Nuremberg,

Jackson said four things were accomplished. It gave a documentary history of the war, provided a global example of a just trial, showed that four nations could cooperate in the cause of justice, and set an example for Europe for civil discourse and politics. Jackson received a standing ovation for his speech entitled "A Country Lawyer in an International Courtroom."

The Roanoke Black Cardinals played the Atlanta Crackers in baseball at Springwood Park on August 10.

American Legion Post No. 3 sponsored the Roanoke Fair that ran from August 11–18 at Maher Field. According to advertisements, the fair had livestock and agricultural displays, fireworks nightly, and performances by the Frank Melville Entertainers twice daily. John Marks' Mile-Long Pleasure Trail was on the midway. There was a husband-calling contest Wednesday night, Miss Roanoke contest Thursday night, and amateur night on Friday. Another feature was Brooklyn Supreme, billed as the world's largest horse.

John Walker of Roanoke was elected president of the Virginia Bar Association at meeting held at the Hotel Roanoke on August 9. Walker had practiced law in Roanoke since 1930, and was a member of the Woods, Rogers, Muse, and Walker law firm.

Over a hundred Bahamians helped to harvest peaches from orchards in Roanoke and Botetourt Counties in August. The workers were housed at the former CCC camp at Catawba.

Landon Buchanan won the men's singles tennis title in the annual city-county tennis tournament on August 10. Buchanan defeated Paul Rice. Juanita Reed won the girls singles title, defeating Betty Campbell. In double play, Paul Rice and Zane Williams defeated Landon Buchanan and Charley Turner for the title. The matches were held at Wasena Park.

Jordan Funeral Home opened at 601 W. Loudon Avenue in Roanoke on August 12. The director was James Jordan Jr.

W. J. Lotz purchased the American Legion post home at 430 Church Avenue for the new location of Lotz Funeral Home. The purchase price was $38,500.

Williamson Road Photo Shop opened at their new location, 1513 Williamson Road, on August 15.

Tennis pros Frank Kovacs and Jack March held an exhibition match in Wasena Park on August 16. The two were on a nationwide tour conducting tennis clinics and exhibitions.

Floyd County's last living Confederate veteran turned ninety-nine on August 14. James Cannaday served with the 14th Virginia Cavalry. Asked what he'd do if another war came, Cannaday replied, "I'd shoulder my gun and do what I could."

An Air Show was held at Montvale on August 17.

Roy Casey, thirty, of Wright's Siding was killed near Connecticut Avenue, NE, when he was struck by an N&W Railway southbound freight train.

The Roanoke chapter of the National Negro Business League was chartered at a meeting at the William Hunton Branch YMCA on August 21. The local chapter president was D. H. Woodbury.

Roanoke's Soap Box Derby champion, Ray Kane, was eliminated in the second round of the national derby championship held in Akron, Ohio, on August 17.

Crystal Exposition Shows opened for a week's run in Salem the third week in August under the auspices of the American Legion. There were shows, rides, and nightly fireworks.

State Senator Leonard Muse, Dr. E. G. Gill, and Eugene Harris presented a petition from sixty-four civic and business leaders to the Roanoke City Council asking that the city manager, W. P. Hunter, be kept in his position until October 1, 1948. That would mark the completion of thirty years of "efficient and faithful" service. The petitioners felt there were too many significant matters before the city for an inexperienced manager to handle.

The Hatcher Gospel Singers of New York and Chicago performed on August 21 at Second Baptist Church, Roanoke.

Roanoke's Johnny Hodges fought Tommy Larner of Washington, DC, in an outdoor boxing match at Salem Municipal Field on August 20. The six-round match was sponsored by the Magic City Athletic Club and the Salem Community Baseball Association. Besides the main event, other matches featured Roanoke boxers Jesse Baker, Lew Yonkers, Roy Wirt, and Gene Leggee.

The Southerner Restaurant opened on August 21 at 1508 Williamson Road. A private dining room, The Palm Room, was also available.

The Buck Mountain Ramblers performed a midnight show on the stage of the Lee Theatre on August 23. Other local entertainers that performed were Pat Fisher, Jack Winston, Paul Ramo, Helen Hickman, Stacy Remaine, Ray Bentley, Mildred Harlow, and Thelma Altizer. Coleman Austin was the emcee. The show was a benefit for the Williamson Road Life Saving Crew.

The Roanoke Black Cardinals played the Baltimore Panthers on August 24 and 25 at Maher Field.

Parsell's Pie Shop and drive-in opened at 1414 Williamson Road on August 24.

Charles Jones of Richmond won the Virginia AAU horseshoe championship held at Elmwood Park on August 23. G. B. Darnell of Roanoke placed third. The round-robin tournament was played throughout the afternoon and under the lights that evening.

A newborn baby girl was found dead in a hat box in an alley east of Eighth Street, between Sixth and Seventh Avenues, NW, on August 24. The parents were unknown, and the city coroner believed the infant had been dead a day or two when found by Nathan Moore.

The Roanoke City Council formally accepted the resignation of the city manager, W. P. Hunter, effective December 31 at its meeting on August 25. The council stated that the position would be advertised and a decision on Hunter's successor would not be made until October. The council voted 3–2 to accept the resignation, after two members tried to defer the effective date until later. Hunter had served in the city manager post for twenty-nine years. Hunter's salary was $7,200 per year, and the council took action to increase his pension. The *Roanoke Times* editorial board wrote about Hunter: "Mr. Hunter's record of service is exemplary. Only one other municipal executive officer in the entire United States has served a city in such a capacity for a longer period…He has served Roanoke long, faithfully and well. He is deserving of the gratitude of every citizen." The editorial board was not so kind to the council that had bungled the handling of Hunter and his successor. "Council has displayed an extraordinary clumsiness in the manner in which the whole city manager affair has been handled." The newspaper pointed out that the council had chosen to pressure Hunter for his retirement on the eve of the Democratic primary; engaged in numerous secret meetings in which decisions were made; offered no real reasons for wanting to make a change; and failed to exhibit an interest in a robust search and hiring process. The editorial board continued, "Either through a misguided

Williams P. Hunter served as Roanoke's city manager for almost three decades and later as mayor. *Historical Society of Western Virginia.*

desire to deliver a master political stroke… or through sheer ignorance of mass human psychology, the result was an immediate and generally adverse public reaction."

The James M. Cole Circus came to Maher Field on August 26. The three-ring circus included seven-year-old Jimmy Cole, billed as the world's youngest animal trainer; riding groups; trained dogs; aerialists; acrobats; and Frieda, the largest trained elephant in the world.

Bobby Blake, who portrayed Little Beaver in the movie *Red Ryder* appeared in person on the stage of the Roanoke Theatre on August 27.

A proposal that Roanoke City Council enclose the west stands of Victory Stadium to provide quarters for the Organized Reserve Officers was turned down due to cost.

Kraft Foods Company of Chicago announced plans to build an office, storage, and distribution facility at 1340 W. Main Street in Salem. The cost was estimated at $103,000.

Denny Boyd won the boys' division of the singles city-county tennis tournament held in late August. He defeated Junior Boyd. The boys' doubles division was won by Hap Pate and Carl Trippeer.

The Roanoke School Board agreed to try, for the first time, the federal free lunch program beginning in the fall. School board members openly expressed doubts as to its success, but members of the Roanoke City Council strongly encouraged the board to do a trial run of the program in response to community welfare advocates who argued that indigent children were not getting nutritious lunches at city schools.

Harvey Apperson of Roanoke was appointed by Virginia's governor to the position of the state's attorney general when Abram Staples, who held the position, was appointed to the Virginia Court of Appeals. Apperson was a former state senator and had been a member of the State Corporation Commission since 1944.

Frank Fitch Sr. died at his home in Roanoke on August 29 at the age of seventy-five. Fitch had sold produce on the city market since June 1, 1892. His most outstanding accomplishment was arranging for overstocked produce brought in by farmers to be shipped by rail to other communities, thereby eliminating the need for farmers to accept lower prices for their goods.

The Roanoke City Council's Stadium and Parks Committee turned down a proposal by local baseball promoter Stan Radke to build a baseball stadium at Shrine Hill Park near the Raleigh Court neighborhood. Radke believed Shrine Hill Park was the most logical location for a professional baseball complex, with Maher Field being his second choice. Abney Boxley was chairman of the committee.

George's Drive-In opened at 11 Walnut Avenue, SW, on August 30.

CBS stations nationwide that carried the *Church of the Air* radio program heard Roanoke pastor Dr. A. H. Hollingsworth Jr. deliver the Sunday-morning message on August 30. He was pastor of Roanoke's Second Presbyterian Church. His sermon title was "Finding Help in Our Failures" and was heard on over 150 stations coast to coast.

One of the features of the Roanoke Aviation Club was the breakfast flight. Members would fly out early in the morning and eat breakfast at a destination airport. On August 30, the club flew out of Woodrum Field in twenty-five planes and breakfasted at the airport in Winston-Salem, North Carolina.

The Roanoke Auditorium was reopened to the public for the first time in over a year as a result of its purchase by American Legion Post No. 3. The first use of the building was on Monday, September 1, by the Lott Carey Baptist Foreign Mission Association convention. The auditorium had been closed by the N&W Railway, its prior owner, during renovations to the Hotel Roanoke. The Legion painted the interior and refinished the floors.

A mobile Catholic chapel, "St. Mary's of the Highway," came to Salem in early September for two weeks. The purpose of the mobile chapel was to provide communities across Virginia without Catholic churches the opportunity to learn about Catholicism.

The formal opening of Lawrence Memorial Methodist Church, Bent Mountain, and the laying of the cornerstone occurred on September 7.

Don Pollard of Roanoke was awarded the northeastern states soaring championship on September 1 in Elmira, New York. Pollard, twenty-three, built gliders and amassed his most points in the contest during a two-hundred-mile motorless flight from Harris Hill to Asbury Park, New Jersey. Over forty pilots competed in the four-day soaring event.

The Little Mending Shop opened in the American Theatre building, 213 S. Jefferson Street, on September 4.

Fox-Hunt-Loyd reopened its store following an extensive remodeling on September 3. The men's clothing store was located at the corner of First and Kirk, SW.

Over eighty home sites went up for auction in the Southern Hills section, just off Route 220 near Craighead's Store on September 10.

Bobby Riggs and Frank Kovacs, both top-ranked professional tennis players, held an exhibition match at Roanoke Country Club on September 4. The match was arranged by Jack March of the Roanoke Tennis Association.

Jacob Frantz Sr., seventy-eight, died at his home in Roanoke on September 3. Frantz had served as city treasurer in Roanoke from 1925 to 1933.

Maison Kes' Be opened on September 4 at 506 S. Jefferson Street. The high-end clothing store was operated by Marie Beheler and Clara Kessler.

Roanoke women united to form a local chapter of the Little below the Knee Club (LBK) as part of a nationwide protest by women against longer skirt lengths being advocated by certain fashion houses and employers. The LBK movement originated in Dallas, Texas. Mrs. P. M. Dillon organized the local chapter. The LBKers organized an all-women's parade through Roanoke that marched on Saturday, September 6, from the municipal building to Elmwood Park. Music for the march was provided by Tommy Magness and his band. Some women marched in bathing suits to counter what they considered the prudish styles being enforced by certain employers. An estimated seven thousand spectators turned out to see the one hundred marchers. To make their point, many of the women wore fashions from twenty-five to fifty years ago, proving that "just below the knee" had been an accepted skirt length for generations. In addition to the parade, the LBK

Club had also gathered petitions from women employed at Viscose, Bassett Furniture, and several small businesses.

Officials with the N&W Railway announced a renovation of the Roanoke passenger station on September 6, stating the project would take at least a year to complete. The railway had contracted with John Pettyjohn and Company of Lynchburg for the work. The railway had sought approval from the federal government for a renovation last year, but their application was denied. Unofficial estimates for the new plans were $1 million. Raymond Loewy Associates of New York, New York, designed the new station set to reconstruct the station that had been built in 1904.

In light of Roanoke's annexation suit against Roanoke County and Vinton and that Baton Rouge in Louisiana had merged with the surrounding parish (county) there, the editorial board of the *Roanoke Times* opined the following in its September 7 edition: "We believe that more serious thought should be given to City-County consolidation looking to one government…the objective of one community, engaged in the purpose of achieving better living and better employment conditions, and better educational opportunities for the rising generation, seems well worth the effort."

The Lott Carey Baptist Foreign Mission Convention held its Golden Jubilee September 2–5 in Roanoke. Delegates from across the United States and missionaries from foreign countries attended the event. It was the only all-black missionary convention in the United States. Among the delegates was Dr. E. G. Lampkins, a native of Roanoke County, who founded twenty-three churches in the Washington, DC, region and was instrumental in starting Roosevelt University in that city.

Robert Porterfield of the Barter Theatre presented Broadway actor and producer Brock Pemberton with the Barter Players in a production of *Harvey* at the Academy of Music on September 13. The comedy had held for 1,200 performances on Broadway.

Construction began on the new First Church of the Brethren, Roanoke, during the first week in September. The new building would face Carroll Avenue, NW, at Twentieth Street. Ralph White was the pastor. The Colonial-design church would seat three hundred. First Church had been located for over fifty years on Loudon Avenue, NW. They had sold the present building to the Ninth Avenue Christian Church for future occupancy.

A temporary organization to establish another bar organization for black attorneys was held on September 6, headed by Willmer Dillard. One already in existence was the Old Dominion Bar Association. From that meeting emerged a new organization, the Magic City Bar Association, with Dillard as president. Other attorneys that participated were Reuben Lawson, Jacob Reid, and George Lawrence.

Pearl Deering, seventeen, of Roanoke was struck and killed by a taxi cab on September 7 on Walnut Hill in Roanoke.

Harry Sheeler offered midget auto-racing driver's school at Victory Stadium in mid-September.

The Roanoke Red Sox finished first in the regular season of the Piedmont League. The baseball team ended the season with a 90–49 record. For the Shaughnesy Playoff Series, the Red Sox played Richmond, and Norfolk played Portsmouth. Bob Scherbarth received the most popular player award from the Red Sox. The catcher, a resident of Milwaukee, received a watch and a Victory bond.

The Hal Sands Dancers brought their Atlantic City show *Spices of Broadway* to the stage of the Roanoke Theatre on September 10. The exotic dancers were accompanied by Paul Whiteman Jr. and his orchestra.

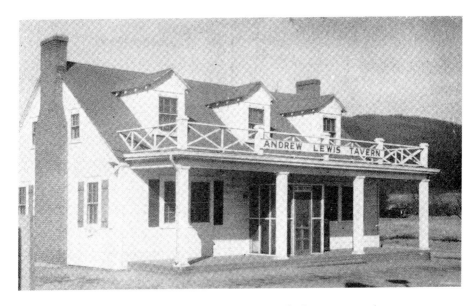

Andrew Lewis Tavern on Route 11 west of Salem was a popular
restaurant and meeting place. *Salem Historical Society.*

Roy Willett, a Roanoke business leader, was killed on Main Street, Wasena, on
September 8 when his car struck a tree. Police believed Willett may have suffered a heart
attack prior to the accident. Willett, along with his brother, owned and operated Willett
Brothers Transportation on Lincoln Avenue, NE.

About 150,000 bushels of peaches were picked in the Roanoke area during late
August and early September. Eighty of the nearly one hundred itinerant workers from the
Bahamas had left the area to harvest peaches in the Shenandoah Valley.

S. H. Heironimus Company held its annual fall fashion show on September 10 at the
Hotel Roanoke. Patrons in attendance were keenly interested in the hem length on dresses
given the popular longer length appearing in fashion magazines.

Larry Dow Pontiac opened in their new location at 415 Marshall Avenue on
September 12. The location featured a new $100,000 shop and showroom.

Allen Casey, sixty-one, an employee of the N&W Railway was killed on September
11 when a railway motor car on which he was riding rammed the rear of a standing freight
train at Blue Ridge.

H. L. Carpel Company officials announced plans for erecting a $200,000 office and
warehouse building as a general expansion of its Roanoke branch. The company's branch
had been at 713 Centre Avenue, NW, for about twenty years, but the new facility would
be located on a four-acre tract at the end of King George Avenue, SW, with a rail siding for
the Virginian Railway. The company specialized in wholesale groceries and cold storage.

The Colonial Hills Club on Colonial Avenue opened on Saturday, September 20,
and scheduled public dances there every Saturday night with the Freddy Lee Orchestra
and Jimmy St. Clair on the piano. It boasted a seating capacity of five hundred.

The Piedmont Woolen Mills building at Callaway was razed in mid-September.
The mill was established by James Martin in 1880 and manufactured clothing, rugs, and

blankets for residents across nine counties. The mill was housed in a barnlike structure from 1880 until 1907 before being sold by Martin. The mill was powered originally by water running over an overshoot wheel eighteen feet in diameter. Water came from a creek known as Daniel's Run, supposedly named for a runaway slave who was killed near the stream.

The Broadway play *Voice of the Turtle* came to the stage of the Academy of Music on September 18. The touring production included well-known actors Haila Stoddard, Sheila Bromley, and Philip Faversham.

A suit was filed in the US District Court for Western Virginia on behalf of Dorothy Jones against three precinct judges at Roanoke's Melrose Precinct for not allowing her to vote in 1946 due to her unpaid poll tax. The suit sought to have Virginia's poll tax declared unconstitutional. The plaintiff, who was black, asserted in the filing that the poll tax discouraged blacks from voting. Moss Plunkett represented Jones.

The all-female band Sweethearts of Rhythm performed at the City Market Auditorium on September 19. "Beautiful girls of all nations, Negro, Indian, Mexican, and Chinese" read the ads. White spectators were admitted for half price.

Dobbs Radio Service opened at 1513 Williamson Road on September 17.

The Roanoke School Board decided to transfer students between schools based on race as overcrowding at black schools created a situation whereby five hundred black students were only receiving half-day school. All white students were transferred out of Melrose School, and fifteen black classrooms were moved into that school. The white students at Melrose were transferred to Monroe, West End, and Forest Park Schools. Fifteen black classes were transferred to Harrison School from Gainsboro School.

The Richmond Rebels played the Norfolk Shamrocks in a professional football exhibition game at Victory Stadium on September 20. The game was sponsored by the Roanoke Junior Chamber of Commerce. Ads stated, "Reserved section for colored spectators." Both teams were part of the Dixie League. It was also the first nighttime pro game at the stadium. Attendance was four thousand.

A dedication service was held at Second Baptist Church on September 21, at which time the church formally changed its name to High Street Baptist Church, its original name. The cornerstone was unveiled by the Dunbar League of Masons.

A murder-suicide occurred in the Washington Heights section of Roanoke County on September 19 when Leslie Cole, thirty-three, shot and killed his wife, Virginia Thomas Cole, thirty-two, and then turned the gun on himself.

Groundbreaking ceremonies were held on September 20 for the new Mount Pleasant Methodist Church parsonage that was going to be erected across the road from the church.

The nation of France awarded the 116th Infantry, Virginia National Guard, the Croix de Guerre with Palm for the regiment's part in the invasion of Normandy. The award ceremony was held at regimental headquarters in Roanoke.

Louis Szanto and Andrew Karoly completed four murals in the Palm Room of the Hotel Roanoke. Each mural was painted on canvas and attached to the walls; and each mural depicted a dance scene common in Virginia during the nineteenth century.

N&W Railway officials announced that materials were on order for the construction of ten new heavy-duty freight locomotives to be built in the Roanoke Shops. The locomotives would be of the Y6a Class, similar to the sixteen built in Roanoke between 1942 and 1943. The estimated cost for the ten engines was $2 million.

Edward Dudley, formerly of Roanoke and legal advisor to the governor of the Virgin Islands, addressed the William Hunton branch YMCA on September 25. Dudley was also on the legal staff of the NAACP and was residing in New York. He was the son of Dr. E. R. Dudley of Roanoke.

The Dudley Store Equipment Company announced it was changing locations, moving from 126 E. Salem Avenue to Williamson Road. The company began in 1937.

The former Daleville College was put up for auction on September 25. The five tracts included the boys' dormitory, administration building, houses, baseball diamond, and acreage.

Forty home sites were auctioned for the Dorchester Court subdivision (No. 2) on September 27. Dorchester Court was in the Williamson Road section.

Western movie star Tex Ritter performed on the stage of the Roanoke Theatre on September 24.

L. D. James, city clerk for Roanoke, tendered his resignation to the city council on September 22 after serving thirteen years in that capacity. James became city clerk on October 1, 1934, having been associated with Stone Printing. The next week James was appointed the city manager of Hampton, Virginia.

The Roanoke City Council authorized the start of the Melrose Branch Library at its meeting on September 22. The cost was estimated to be $17,500.

The Roanoke Red Sox won the championship series of the Piedmont League, defeating the Norfolk Tars four games to three. About three thousand fans watched the final game in Roanoke on a rainy night.

The Roanoke city manager, W. P. Hunter, appointed Joseph Wilkerson as the city's first personnel director. The position had been created at the request of the city council.

WSLS Radio purchased a thirty-seven-acre site near Lakeside Park as the new site for its 610 FM transmitter.

Dodson Brothers Exterminating Company opened in Roanoke on September 29. Bill Dillard was the local manager.

Marvin Pace, well-known realtor and former member of the Roanoke City Council, died on September 29 at age seventy-two. Pace came to Roanoke in 1888 and started in the real estate business in 1904, forming the firm Pace Brothers with his brother, E. C. Pace, in 1908.

Roanoke officials announced that photographs would be used to enforce the city's new smoke control ordinance. A photograph taken by an inspector along with a copy of the complaint to the violator would be sent to notify that the violator's chimney was producing too much smoke.

Carlin's Amoco Service Station opened on October 1 at Williamson Road and Locust Avenue.

Signalman Third Class Charles Charlton, twenty-one, of Roanoke was one of three navy men killed when a mine damaged the destroyer *Fox* near Trieste in the Adriatic Sea on September 29. Charlton attended Jefferson High School and served in World War II.

Black veterans who served overseas gathered at the American Legion Hall on Park Street, NW, on October 3 to form a new post of the Veterans of Foreign Wars.

Roanoke native William Wolfe, thirty, was killed on October 2 when a plane he was piloting crashed near Carrsville, Virginia.

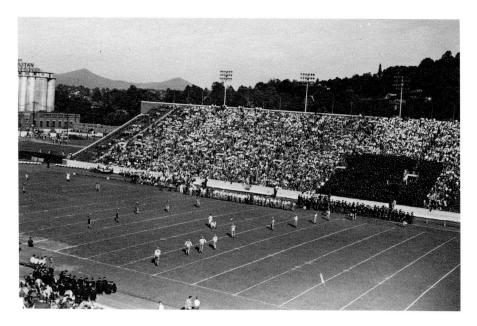

The University of Virginia played Virginia Tech in football at Victory Stadium on October 4, 1947. UVA won, 41–7. *Digital Collection, Special Collections, VPI&SU Libraries.*

The University of Virginia defeated Virginia Tech in football 41–7 in a game at Victory Stadium on October 4. Attendance was estimated at twenty-two thousand.

Temple Emanuel held an installation service for its new rabbi, Charles Lesser, on October 10. The principal speaker for the occasion was Rabbi Dr. Solomon Freehof of Pittsburgh.

Approximately 1,300 patients of the Veterans Administration Hospital assembled on the facility's baseball field on October 4 to hear retired Fleet Adm. William "Bull" Halsey express his personal greetings and admiration for their service. Dr. Hugh Trout introduced Halsey to thunderous applause.

Roanoke Business Service, a bookkeeping business, opened in early October at 506 S. Jefferson Street.

Maston Moorman was appointed by the Roanoke City Council to serve as city clerk on October 6. Moorman was previously the assistant civil and police justice.

Dr. Charles Irvin was elected president of the Roanoke Academy of Medicine.

The Roanoke Ministers' Conference agreed to appoint a committee to explore the possibility of the formation of an interracial minister's conference in the city at their meeting on October 6.

Graves-Humphreys Hardware Company received a permit to expand its existing building at 1942 Franklin Road. Company officials estimated the expansion to cost $195,000.

William Casey, chairman of the board of editors of the Research Institute of America, addressed the Roanoke Bar Association on October 14 at the group's monthly luncheon

at Hotel Roanoke. Casey later served as director of the Central Intelligence Agency from 1981 to 1987 under President Ronald Reagan.

Roanoke Storm Sash and Screen Company changed its name to Rusco Window Company in early October.

The Roanoke Raiders, a semipro black football team, inaugurated its 1947 season on October 12 against the Richmond Rams in a game at Victory Stadium. The Raiders were 8–1 in 1946.

Film comedians the Three Stooges performed in person on the stage of the Roanoke Theatre on October 8 with their show *Hollywood Fun Revue.*

Roanoke's assistant city manager, D. R. Taylor, submitted his resignation on October 8 to take effect October 28. Taylor had accepted a position with a private-sector water company. The Roanoke City Council offered Taylor the city manager's post to entice him to remain with the city, but Taylor expressed dissatisfaction with the council's interest in other candidates and the salary offered.

The congregation of Ghent Brethren Church celebrated the payment of its last note on the church's debt on October 12. The church, at the corner of Wasena Avenue and Maiden Lane, moved to that location in 1930 from northwest Roanoke.

Louis Jordan and his Tympany Five performed at the City Market Auditorium on October 10. White spectators were admitted for half price.

Dr. A. Clayton Powell spoke at First Baptist Church, Gainsboro, on October 12. Powell's son was a congressman, and Powell was the minister and founder of the Abyssinian Baptist Church in New York, the largest black congregation in the world. His sermon was entitled, "Is the Negro Race Being Mis-educated?" Powell's appearance was in connection with the church's celebration of its eightieth anniversary.

Officials with the Dixie Professional Football League announced there would be no season for 1947 but expressed hope for one in 1948. Roanoke had fielded a team in the semipro league previously.

Robert Peters, five, of Roanoke County died on October 10 from a head wound he received when playing with a revolver at his grandfather's house in Lynchburg. The child apparently found the revolver on a dresser.

Selection of a new name for the Roanoke Auditorium that was acquired by the American Legion Post No. 3 was under consideration by a select committee. H. H. Baber was chairman of the committee.

Noland Company officials announced plans to erect a new building on Shenandoah Avenue west of Twelfth Street, NW.

Sixteen Roanoke city schools began operating under the federal free lunch program on October 13.

Due to the Patrick Henry Hotel and Hotel Roanoke policies against booking rooms and events to blacks or attended by blacks, some twenty blacks had to withdraw from attending the meeting of the Roanoke Tuberculosis Association meeting at the Patrick Henry Hotel. All were city and county TB workers and represented about one-third of the association's attendees. A few days later, the association moved its meeting venue for early November to the YWCA.

An estimated 350 black veterans of twenty or more years of service to the N&W Railway convened for their eleventh annual meeting at the Virginia Theatre on October 18. N&W President R. H. Smith presented a fifty-year pin to William Wise of Bristol.

The Colored Division of the N&W Veterans Association met at the
Virginia Theatre in October 1947. *Norfolk-Southern Foundation.*

Ebbie's Beauty Shop at 1408 Wise Avenue, SE, opened on October 15, owned and
operated by Evelyn Byrd.

Paul Howard and his Grand Ole' Opry Gang performed at the Roanoke Theatre on
October 15.

Hollins College presented a ninety-minute equestrian show for the patients and their
family members on the grounds of the Veterans Administration Hospital on October 16.
An estimated two thousand spectators attended.

Local musicians Herndon Slicer and The Dixie Playboys began playing regularly
for a full hour, 6:00–7:00 a.m., on WSLS Mondays through Saturdays beginning in
mid-October.

Jesse James Studio opened in the Rosenberg Building the third week of October.

The Cole Brothers Circus came to Maher Field for two shows on October 23. The
circus had three rings and two stages under the big top. Headliners included the Cristiani
family (bareback horse riders) and Hubert Castle on the high wire. Forty clowns were
headed by Otto Greibling, and there were numerous animal acts, including elephants.
Philippe Manzio, billed as the world's tallest man at eight feet six inches, and Margarieta
Leyton, a twenty-one-inch pygmy from Mexico, were also part of the show.

John M. Oakey Funeral Service purchased a new 1948 Packard ambulance in late
October that was equipped with a breathing resuscitator and first-aid equipment and
windows that provided patient privacy during transport.

Moore Milling Company in Salem was completely destroyed by an early-morning
fire on October 19. The mill, which produced flour and mixed feeds, sustained a loss esti-
mated at $800,000. Mill officials announced they planned to rebuild. Six fire companies
responded to the blaze.

Arthur Owens, city manager of Portsmouth, was announced as the new city manager for Roanoke on October 20, succeeding W. P. Hunter. Owens would begin his service on January 1 at an annual salary of $10,000. The Roanoke City Council elected Owens by a unanimous vote. At the same meeting, the council abolished the position of assistant city manager that had been created a year ago. Some forty persons applied for the position, and the council interviewed five. Owens, forty-four, had been manager at Portsmouth for the past five years and was a native of Chesterfield County.

The Economy Wallpaper Company, at 204 Second Street, SW, sustained damage from a fire on October 20. Fire officials said it was the worst fumes they had encountered in twenty years due to the amount of paint and turpentine in the building. J. R. Alvis was owner of the company.

The Durham Life Insurance Company of North Carolina opened a district office at 25 W. Church Avenue in mid-October. Theodore Jones was district manager.

A fire badly damaged a two-story structure at 106 Second Street on October 21. The building housed Leonard Electronics Supply, Friendly Lunch, Roanoke Sanitary Supply, and Maco Venetian Blind Manufacturing Company.

The town of Vinton began taxing women in late October. The town adopted a capitation tax in March 1936 of "one dollar per annum upon all residents of the town who have obtained the age of 21 years." Town council, however, had only applied it to men as a courtesy to females, but officials changed their opinions. The capitation tax for both genders was set at fifty cents.

Leeds Lingerie opened in the State and City Building on Henry Street on October 23. The new women's store offered hosiery, negligees, bras, girdles, robes, blouses, sweaters and handbags.

The Merle Norman Cosmetics Studio opened on October 27 in the Patrick Henry Hotel.

St. John African Methodist Episcopal Church at Ballyhack held a mortgage-burning ceremony on October 26. The church building was erected in 1924.

Reuben Lawson, Roanoke attorney, was announced as the keynote speaker for the annual Virginia state conference of the NAACP held in Roanoke on November 1 and 2.

The old drinking fountain that served horses and dogs that once stood near the N&W Railway freight station at Second Street was set up in late October at the northeast entrance to Highland Park. The fountain had originally been donated to the city by a humane society.

Donald Keesey, a student at William Fleming High School, came in first place in a statewide competition for gasoline-powered model airplanes held in Wasena Park on October 25.

Col. William Battle Jr., retired vice president of the N&W Railway died at his home in Roanoke on October 25 at seventy-seven. Battle was deeply involved in Roanoke's business and civic affairs.

The reward fund established by the Salem Chamber of Commerce of $2,570 for information leading to the arrest and conviction of the killer of Roby Daugherty in Salem in 1945 was split among six claimants by Judge T. L. Keister in Roanoke County Circuit Court on October 27.

Negotiations were successfully concluded between Stan Radke, president of the Roanoke Red Sox, and the city manager for lease of Maher Field for one and possibly two

seasons of professional minor league baseball. The point of contention was the condition of the wooden bleachers and who should pay for their improvement.

Richardson-Wayland Electrical Corporation held a grand reopening on October 29 after extensive alterations to their store at 122 W. Church Avenue, giving away over $1,000 prizes and favors to customers.

The first of Roanoke's World War II dead came home by train on October 29. An audience packed the American Legion Auditorium for a memorial service that included an address by Mayor Richard Edwards. Four flag-draped bronze caskets contained the remains of Capt. Gordon Brooks, Preston Johnson, Benjamin Brown, and Ralph Huddleston. An estimated four thousand persons attended to pay their respects. Thousands more lined the streets of downtown Roanoke as the caskets were escorted by the military to Oakey's Funeral Home.

The remains of local servicemen from World War II continued to arrive by train for burial more than two years after the war, 1947. *Norfolk-Southern Foundation.*

Several human bones were unearthed during excavation work at the site of the Yale and Towne Lock Plant at 1242 Colorado Street in Salem. M. D. Webber, a Salem druggist, stated they were bones of Native Americans as the site was long-rumored to be an Indian burial ground.

John Leonard Shank, seventy-seven, former mayor of Salem, died at his home on October 30. A native of Floyd County, Shank came to Salem in 1890, where he later became connected with the Salem Foundry and Machine Works. Shank was Salem's mayor from 1931 to 1934.

Organized Halloween activities drew large crowds. Sherwood Burial Park drew an estimated 1,000 children and adults for their contests and costume party. Five hundred were on hand for the party in Norwich Park, and the Jackson Park celebration drew 2,000.

A party in Eureka Park brought out an estimated 1,300 children and adults, and a party for black children at the Gainsboro Branch Library grounds drew 1,500.

The new bar association in Roanoke for black attorneys formally adopted the name of the Magic City Bar Association and elected Willmer Dillard as its first president. Other officers included Reuben Lawson, George Lawrence, and Jacob Reid.

Brothers Fred and John Sykes organized Boxing Incorporated to promote boxing matches. This provided fans with two boxing outfits in Roanoke, the other being Magic City Athletic Club operated by brothers E. R. and "Bunk" Sweeney.

Ronald Frier, Salem's police chief, resigned on October 31. Frier had served as police chief since 1937, having joined the department as a patrolman in 1924. George Eades took over as the interim chief.

Movie star Paule Croset came to Roanoke on November 2 as part of the Kroger Grocery chain's sixty-fifth anniversary celebration. She was interviewed by WDBJ and was the guest for a sorority tea at Roanoke College.

George Yeager opened Yeager Motor Company at 507 Second Street, SW, on November 2. The company offered the sale of used cars and auto maintenance.

Two officials with the NAACP held a press conference in Roanoke on the eve of the Virginia chapter's convention to announce that two lawsuits would be filed soon to overturn Virginia's school segregation laws. The suits would be filed against the University of Virginia and a county-by-county campaign across the Commonwealth. The two officials holding the press conference on November 1 were Dr. J. M. Tinsley of Richmond and Thurgood Marshall of New York. Marshall stated, "There can be no equality where there is segregation." The state convention was being held at the Ebenezer African Methodist Episcopal Church in Roanoke.

Metropolitan Opera baritone Walter Cassel performed at the Academy of Music on November 3 under the auspices of the Roanoke Community Concert Association.

Sylvester Hill Jr. died from injuries on November 2 he sustained after being shot by Roanoke city policeman W. W. Gaitor in an effort to break up a fight Halloween night on North Henry Street.

Kenneth Whitlock of Addison High School won first honors in the valley-wide "I Speak for Democracy" contest held at Jefferson High School. The event was sponsored by the junior chamber of commerce.

Senator Ted Dalton defeated his Democratic opponent Benjamin Chapman of Salem in the November 4 election for the Twenty-First Senatorial District seat in the Virginia General Assembly. Other election results were as follows: Earl Fitzpatrick, state senate, unopposed; Griffith Dodson Jr. and Julian Rutherfoord Jr., Roanoke seats in the House of Delegates, both unopposed. H. B. McManaway defeated R. Q. Hite for Roanoke County sheriff. Eugene Chelf was reelected Roanoke County commonwealth's attorney over Joseph Engleby Jr. Mrs. Janie McNeal defeated E. D. Hilten for county treasurer. William Muse was elected county treasurer over C. C. Burdette. All county officers elected were Democrats. In the county board of supervisors races, Minor Keffer defeated T. O. Richardson for the Catawba district seat; Mason Cook won over R. W. Dalton for the Big Lick seat; H. A. Taylor defeated B. F. Garner in the Cave Spring district; and Howard Starkey won over G. E. McDaniel in the Salem district.

With the result of the election official, Mrs. Janie McNeal became the first woman to seek political office in Roanoke County and to be elected to office. She would assume

her duties as county treasurer on January 1. She had worked in the treasurer's office for over twenty years.

Mr. and Mrs. Adger Smyth announced the opening of their Post-House Tea Room in Salem on November 5.

Grand Ole Opry stars Annie and Danny, along with western film actor Salty Holmes, performed on the stage of the Roanoke Theatre on November 5.

Hencil Ring, forty-five, treasurer of Roanoke City Mills, died at his summer home at Irvington on November 7.

Some two thousand Shriners from across Virginia marched in a parade through downtown Roanoke on November 8 in conjunction with a state convention being held. The parade route went from Elmwood Park to the American Legion Auditorium.

Ninth Avenue Christian Church moved into the former First Church of the Brethren building on November 16. The building was located on Loudon Avenue.

American Legion Post No. 3 voted November 10 to adopt the name "American Legion Auditorium" for the former Roanoke Auditorium it had purchased from the N&W Railway.

The Roanoke City Council voted on November 10 to make the city attorney post full time and elected Randolph Whittle to the position.

Harold Engle, a Vinton native, was killed in a plane crash in Orange County on November 10. He was twenty-two. He was interred at Mountain View Cemetery.

Roy Milton and his orchestra, The Solid Senders, performed at the City Market Auditorium on November 14. They were accompanied by vocalist Camille Howard. White spectators were admitted.

Edwin Strawbridge and his New York Ballet Company presented the dance play *Simple Simon* at the Academy of Music on November 14.

Former Georgia governor Ellis Arnall delivered a speech on "The New South" at the Little Theatre at Hollins College as part of the Roanoke City-County Public Forum's lecture series. Arnall's thesis was that the South was in "relative poverty" due to the lack of industrialization and education.

The Concord Men's Clothing Factory Showroom opened on November 14 at 509 Second Street, SW.

Denny and Brammer Cleaners opened in mid-November at 914 Lynchburg Road.

McFarland's Self-Service Grocery Store opened on November 15 on Route 11 at Cloverdale. The proprietor was D. W. McFarland.

Plans for a new modern theatre on the northwest corner of South Jefferson Street and Day Avenue were announced in mid-November by C. A. Posey, manager of the Jefferson Theatre. The $300,000 structure would seat 1,500 and would be owned and operated by the Jefferson Theatre Corporation that also owned the Grandin Theatre and Lee Theatre. The new motion picture house was to be called the Pix Theatre.

Choirs from seventeen local churches participated in the annual Church Choir and Music Festival in mid-November, presenting a 450-voice choir concert at the Academy of Music under the direction of Dr. Augustine Smith of Boston University.

Kenneth Whitlock, seventeen, of Addison High School placed first in the Virginia Junior Chamber of Commerce "I Speak for Democracy" contest, having previously won the contest in Roanoke. He would represent Virginia in the national contest to be in

Washington, DC. Runner-up for the state contest was Betty Moore of William Fleming High School.

Samuel Huff, seventy-three, died on November 15 from injuries he sustained a week prior when he was struck by a car while crossing the highway near the Bent Mountain post office.

Two semipro black football teams played for an unofficial Roanoke title when the Roanoke Cardinals squared off against the Roanoke Raiders at Springwood Park on November 16. The Cardinals won 12–6 and remained unbeaten.

The Rainbow Room restaurant at Scottie's Normandie Inn at 1226 Patterson Avenue, SW, opened on November 17.

The Barter Theatre Players presented *The Importance of Being Earnest* at the Academy of Music on November 19.

The Pelican Club sponsored a dance at the Colonial Hills Club on November 18 that featured Bob Chester and his orchestra from New Orleans.

John Penn, eighty, died in Kingsport, Tennessee, on November 17. Penn had helped to organize two Roanoke banks: Bank of Commerce and Liberty National Bank.

Dr. Roland Riddick was elected president of the Roanoke Ministers' Conference for 1948. He was the district superintendent for the Methodist church.

The Roanoke City Council heard complaints about hazardous conditions and other concerns from residents of the black veterans' housing project at Jackson Avenue and Sixteen Street, SW. The city manager and council members agreed to make a personal inspection of the housing units.

The freshman football squads of VMI and Virginia Tech played under the lights at Victory Stadium on November 18. VMI won 20–19 in front of a small crowd.

Twenty-two documents and historic artifacts were sealed in a copper box for the laying of the cornerstone at the new Monroe Junior High School in northwest Roanoke that occurred on November 20. Mayor Richard Edwards spoke during the ceremony, which was attended by hundreds of schoolchildren. The cornerstone was laid during a Masonic ceremony. Rev. W. B. Denson, a member of the school board, also spoke.

Some 150 Jefferson High School students participated in the school's annual minstrel variety show *Escapades of 1948* in the school's auditorium on November 20 and 22.

The Church of Jesus Christ of Latter-Day Saints purchased a residence at 125 Lincoln Avenue, SW, for use as an office and mission home. The LDS chapel was located at 1529 Patterson Avenue.

Roanoke native and film star John Payne, along with his actress wife, Gloria de Haven, and daughter Kathleen, visited Payne's mother in Roanoke, staying at her home on Creston Avenue in Grandin Court.

Russ Peters, a Roanoke native, was sent to the minor leagues in baseball by the St. Louis Browns. He played for the Browns' farm team in Toledo, Ohio.

The state boxing commission branded a headline bout in Roanoke a "fake." The boxing match had been held in the American Legion Auditorium on November 10 by the Magic City Athletic Club, and the commission believed the outcome had been arranged in advance and the entire bout staged.

"The Chapel with Chimes" opened on November 23, the newest chapel for Lotz Funeral Home. The chapel was located on Church Avenue at Park Street, SW.

Warner Brothers' picture *Soap Box Derby* played at the American Theatre. The film contained shots of Roanoke's 1946 champion David Poage at Akron, Ohio, plus footage of the derby in Roanoke that year.

Roanoke, Salem, and Vinton residents and businesses contributed over twenty-five thousand pounds of food to the "Friendship Train" to assist starving Europeans. The train was on a siding at the N&W Railway salvage warehouse and was going across the state.

The Barter Theatre Players performed *The Barretts of Wimpole Street* at the Academy of Music on November 26.

The Lee Restaurant opened at 1905 Williamson Road across the street from the Lee Theatre on November 25. The restaurant was managed by George Linkenhoker.

William Richardson, twelve, a newspaper carrier, was struck and killed by an automobile on the Veterans Administration Hospital road on November 25. He was riding his bike home after finishing his route.

The Norwich Church of God held a mortgage-burning and dedication service for its new sanctuary on Thanksgiving Day. The building was begun in 1941 and completed in 1943.

VMI defeated Virginia Tech 28–14 in the traditional Thanksgiving Day football game at Victory Stadium. The attendance set a new state college football attendance record at 27,836.

The sword of Col. William Fleming was put on display in the First National Exchange Bank for Thanksgiving weekend. The display was part of the city's observance of "Rededication Week," sponsored by area women's clubs. The sword, used by Fleming in the French and Indian War and the American Revolution, was owned by the Nancy Christian Fleming Chapter of the Daughters of the American Revolution and kept in a vault at the bank.

Neville's Salon of Pictorial Photography opened at 2100 Williamson Road on November 30.

Over three hundred photographs from the White House Press Photographers Association were exhibited in the Crystal Ballroom of the Hotel Roanoke in late November. The event was sponsored by the *Roanoke Times*.

The Dialect Records Company, at 18 W. Kirk Avenue, produced *The Psaltree*. The record was advertised as a rare bit of Americana, capturing "the true Negro dialect in the time of Uncle Remus."

The new WSLS FM radio station began operating on December 1 from a transmitter on Poor Mountain. The station's broadcasts were heard daily from 10 a.m. to 10 p.m. on 99.1 on the FM dial.

John Garlick, thirty-five, was shot and killed at the Cavalier Hotel, 106 E. Salem Avenue, on November 29 by the manager of the hotel. Garlick was an employee of the hotel, and according to witnesses, he obtained two guns from the hotel's office and began threatening coworkers.

James Cannaday, ninety-nine, died at the home of his son in Roanoke on November 29. Cannaday was believed to have been the last surviving Confederate veteran from Floyd County.

The "Freedom Train" stopped in Roanoke on December 2. The special "Spirit of 1776" train was operated by several railroads throughout the United States and carried an exhibit of historic American artifacts and documents. The train was sponsored by

the American Heritage Foundation. Among the items were a copy of the Declaration of Independence attested by Benjamin Franklin, Christopher Columbus's letter describing his voyage to America printed in Rome in 1493, the original manuscript of the Pennsylvania Charter of Privileges by William Penn, George Washington's copy of the US Constitution, a copy of the Bill of Rights dated 1789, and the copy of the Gettysburg Address held by President Lincoln when delivering that speech. There were numerous other documents, manuscripts, and materials loaned from universities, the Library of Congress, and the National Archives. An estimated nine thousand persons went through the train during its Roanoke stop.

The Freedom Train carrying historic American artifacts and documents came to Roanoke in December 1947. *Norfolk-Southern Foundation.*

The Roanoke chapter of the Military Order of World Wars was reorganized and presented a charter in a meeting and ceremony at the Hotel Roanoke on December 3. Rear Adm. Harold Train was the principal speaker for the occasion. Dr. M. A. Johnson Jr., was the local chapter commander.

Fine's Men's Shop at the corner of Campbell Avenue and Henry Street reopened on December 4 following its relocation to the ground floor of the State and City Building. The store had been previously located at 3 W. Campbell Avenue. Lou Rubenstein was the manager.

The De Luxe Studio opened at 140 W. Campbell Avenue on December 4, offering same-day Kodak photo print service.

A large crowd filled the American Legion Auditorium on December 4 and watched Bulldog Rutherford win a technical knockout victory over Tommy Larner in the top card of boxing matches sponsored by the Magic City Athletic Club.

Roanoke College presented *Night Must Fall* at the Academy of Music on December 5. While the cast of the play consisted of college students, they were joined by professional actor Francis Ballard, who played the lead.

Dudley Jewelry Store opened at 1519 Williamson Road on December 6.

The old Railroad YMCA at Twelfth Street and Shenandoah Avenue, NW, was sold by the N&W Railway to Noland Company for $16,000.

The old Railroad YMCA was sold by the N&W Railway to the Noland Company in late 1947. It was razed soon thereafter. *Virginia Room, Roanoke Public Libraries.*

Virginia Tech defeated Roanoke's Old Dominion Rebels in basketball in a game at the American Legion Auditorium on December 5 by a score of 58–46.

A new wholesale electrical appliance firm was announced in early December. Marshall and Deyerle Inc. would open January 1 and operate at the corner of Park Street and Salem Avenue, SW. The new firm was organized by T. S. Deyerle and D. H. Marshall.

Santa arrived by rail in Vinton on December 6. Parents and children greeted Santa as he stepped off the Tennessean when it pulled into the Vinton station.

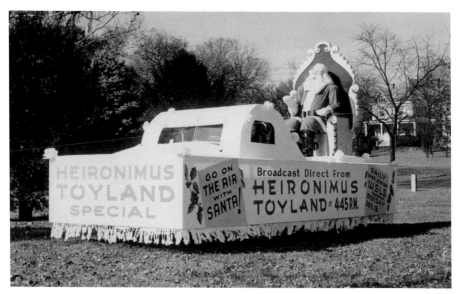

A Heironimus Christmas parade float promoted the store's "Go on the air with Santa" broadcasts on WSLS. *Virginia Room, Roanoke Public Libraries.*

The Roanoke City-County Public Forum sponsored an address by Austria's ex-chancellor Kurt von Schuschnigg at the Academy of Music on December 11. His speech was entitled "The Problems of Central Europe." He was chancellor of Austria from 1934 until 1938, when the country was overrun by Germany.

Some 150 persons from nine Protestant churches in the Roanoke area formed the Roanoke Area Christian Layman's League at a meeting held at Belmont Christian Church on December 9. Fred Moore was elected as president of the group.

Miller and McBee, "the South's funniest blackface comedians," performed on stage at the Roanoke Theatre on December 10.

W. E. Cundiff and F. W. Overstreet opened Northwest Hardware Company at 611 Eleventh Street, NW, on December 11. Cundiff was also proprietor of Vinton Hardware Company.

Pugh's Radio Service opened at 207 Williamson Road on December 12.

The Roanoke Civic Chorus presented a Christmas concert at the Academy of Music on December 11 under the direction of Franklyn Glynn. Special guest Virginia Hover, a mezzo-soprano, accompanied the choir.

A dead newborn baby was found wrapped in newspaper in a storm drain at Morton Avenue and Thirteenth Street, SE, on December 11. The city coroner stated the child had probably been dead two days. Police had no leads in the case.

Tazewell Avenue Methodist Church was dedicated on December 21. The church was built in 1926 and paid off its last mortgage payment in early December following a successful capital campaign. The church was planted by Lee Street Methodist Episcopal Church, Roanoke. The Lee Street Church was begun in 1883 and in 1910 became the First Methodist Episcopal Church and then later First Methodist Church.

Robert Hurt of Salem was killed instantly when the car he was driving was struck by a Virginian Railway train at "Hurt's Crossing," just east of Salem on December 13. Hurt, seventy-three, was a former Salem businessman and former member of the Roanoke County board of supervisors, serving for sixteen years from 1919 to 1935.

Arthur Smith and the Cracker Jacks of the nationally broadcast *Carolina Hayride* show performed on the stage of the Roanoke Theatre on December 17.

Virginia Union University played Virginia State College in a basketball game at the City Market Auditorium on December 17; the game was followed by a dance. The event was a benefit for Burrell Memorial Hospital.

Dr. Harry Penn was elected president of the Virginia Civil Rights Organization, which was constituted in Richmond in mid-December. The group consisted of about a hundred black Virginians representing themselves or organizations that united for the purpose of repealing Virginia's segregation statutes.

Theron Williams, fifty-four, former principal of Carver School in Salem, died on December 14. Williams served as principal of Carver for twenty-two years from 1925 until 1947, when illness forced his retirement. He was also a veteran of World War I and a former dean at Shaw University.

The congregation of St. Mark's Lutheran Church in Roanoke voted to sell its parsonage at 352 Church Avenue, SW, to the local chapter of the Red Cross for use as their headquarters.

Glen Gray and his Casa Loma Orchestra performed at the American Legion Auditorium on December 19.

Federal agents from Roanoke destroyed eight stills in the Endicott section of Franklin County and one near Callaway in an effort to curtail illicit Christmas whiskey. The raids destroyed 6,650 gallons of mash and 197 gallons of whiskey.

Officials with the N&W Railway announced that the construction on the new $1 million renovation of the Roanoke passenger station would begin the first of January, having been assured that steel will be on hand at that time. John J. Pettyjohn and Company of Lynchburg was the general contractor, and Raymond Loewy of New York was the architect.

The former site of the Roanoker Restaurant at 12 S. Jefferson Street was purchased by Thomas Castros, operator of the Presto Café, on December 18.

Roanoke Photo Finishing Company offered 8 mm and 16 mm film of the Royal Wedding of Elizabeth and Philip for sale in their store, advertising it as "the most romantic spectacle of the century!"

The Williamson Road Grill opened on December 20 at 1602 Williamson Road.

Construction of the new Graves-Humphreys Hardware Company building began the third week in December. The new building utilized two sections of the former Roanoke Ice and Cold Storage Company plant that had previously been occupied by Griggs Packing Company. The site was located at the intersection of Franklin Road and Brandon Avenue.

Eddie "Mr. Cleanhead" Vinson and his orchestra performed for a Christmas dance at the American Legion Auditorium on December 26. White spectators were admitted for a reduced price.

Fifteen cars of an N&W Railway freight train derailed east of the passenger station in Salem on December 24. The accident tore up about three hundred yards of track, but there were no injuries.

Retiring Roanoke city manager W. P. Hunter was showered with gifts and accolades at a Christmas party thrown in his honor by city employees. Over a hundred city employees gathered to take part. The gifts included a double-barreled shotgun, a Hamilton watch, hunting equipment, a spun-glass fly rod, and a chair. The ceremony was broadcast live over local radio. The event was hosted by Congressman Lindsay Almond, and no city council members were present. Hunter came to Roanoke as its first city manager on October 1, 1918, having been a resident engineer with the C&O Railroad at White Sulphur Springs, West Virginia. The late Capt. W. W. Boxley was credited with bringing Hunter to Roanoke as they had been longtime friends and Boxley wired Hunter about the position. Hunter steered Roanoke's progress, including the construction of several bridges (Wasena, Walnut Avenue, Franklin Road, and Jefferson Street), a road-paving program, and the building of the city almshouse, tuberculosis sanatorium, juvenile detention home, and garbage incinerator. He also oversaw the expansion of Woodrum Field and the water and sewer systems.

The Roanoke Cardinals and the Roanoke Raiders faced off again in football. The two black semipro teams gave Roanokers their last opportunity of the season to see the game played. The game was on Christmas afternoon. The Cardinals were undefeated in 1947.

The Roanoke Valley experienced a white Christmas when an inch of snow dusted the region.

Members of the Roanoke police department donated $1,650 to Detective Sgt. Joe Jennings for Christmas. Jennings was wounded by a prisoner on September 26, 1945, and had lain paralyzed in Lewis-Gale Hospital since then.

Oliver Hill, chairman of the legal committee of the Virginia NAACP and vice president of the newly formed Virginia Civil Rights Organization, was announced as the keynote speaker at a civil rights mass meeting at Ninth Avenue Christian Church scheduled for January 4, 1948. Hill was a former Roanoker and the first president of the Old Dominion Bar Association.

Roanoke's War Memorial Committee released details of their master plan for the development of Elmwood Park into a War Memorial Center. The plan included a memorial to the casualties of World War II on the knoll where the library was located, a new library at the northwest corner of the park, and an arts center on the southwest corner. The plans were endorsed by Theodore Young, an architect from New York who was advising the committee.

The Book Nook at 20 Kirk Avenue was purchased by Mr. and Mrs. Saxton Kitchel from Mrs. William Hobbie.

The Roanoke Junior Chamber of Commerce embarked upon a new fundraising method by setting a goal to install five hundred gumball machines in businesses and civic venues throughout the Roanoke Valley. The group had obtained a franchise from a nationally known chewing-gum-machine company.

A number of New Year's Eve concerts and dance parties were held. Jimmy St. Clair and his orchestra were at the Lee Theatre; Wanderers of the Wasteland were at the City Market Auditorium; Dixie Playboys were at Blue Ridge Hall; and Comedy's Rhythm Boys were at Riverjack.

Al Cassidy landed his Goodyear Amphibian on Carvins Cove on December 30. It was the first time a plane had landed on the cove.

1948

Prominent Bent Mountain orchardist Jordan L. Woodrum, eighty-two, died in Hot Springs, Arkansas, on December 30, 1947, where he was visiting relatives. Woodrum was the son of Jordan Woodrum, a pioneer orchardist in Roanoke County.

Arthur Owens was formally sworn in as Roanoke's city manager and assumed duties at 12:01 a.m. on January 1. Randolph Whittle was sworn in as the city attorney on January 2.

Over the New Year's holiday, S. H. Heironimus Company had an unusual window display in downtown Roanoke: caged monkeys.

Houck Advertising announced their new location on the top floor of the Temple Building in downtown Roanoke on January 1.

Federal Judge John Paul ruled in favor of bus companies' right to segregate passengers by race in a case that was brought by Roanoke minister Rev. William Simmons. Simmons had sued Atlantic Greyhound for a driver telling Simmons to move to the back of a bus that was leaving Roanoke on October 16, 1946. Simmons refused and later took a train to his destination. Paul ruled that the bus company's policy was not "unreasonable."

Rusco Window Company reopened at its new location, 1511 Williamson Road, on January 2.

Roy Wirt and Chief Mark Reed, a full-blooded Cherokee, had an eight-round bout that headlined the boxing card at the American Legion Auditorium on January 4.

Approximately five hundred persons registered for the Emancipation Day program and civil rights rally to be held on January 4. The program was sponsored by the Youth Council of the Roanoke Branch NAACP. The principal speaker was Oliver W. Hill from Richmond, who was calling for the end of segregation in Virginia in all its forms.

Roanoke's Old Dominion Rebels basketball team left the AAU ranks, even though the team was the defending state champion, due to certain players being classified as professionals under AAU guidelines. The announcement was made by Paul Compton, the team's business manager.

The Virginia Museum of Fine Arts brought an exhibit of their collection to the Hotel Roanoke in early January. The weeklong exhibit was held in the hotel's Pine Room and Writing Room. Over five hundred persons went through the exhibit on opening day.

General Electric brought its science show *House of Magic* to the Hotel Roanoke ballroom on January 9. The show demonstrated the "wonders of electricity." It had made its debut at the 1933 World's Fair and had been touring ever since around the world. Almost all of the eight hundred tickets had been distributed several days in advance.

Stage and film actress Diana Barrymore, of the famed Barrymore theater family, performed the lead role in *Joan Of Lorraine* at the Academy of Music on January 10.

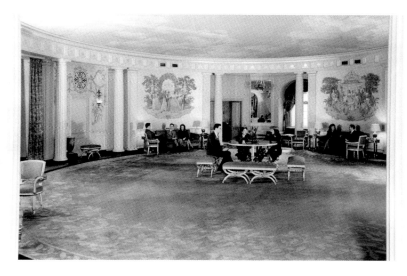

The Colonial Room of the Hotel Roanoke in March 1948.
Norfolk & Western Railway Historical Society.

The "immediate end of segregation" was called for at a civil rights mass meeting held on January 4 at the Ninth Avenue Christian Church. The event was sponsored by the Roanoke Youth Council, NAACP. Keynote speaker was Oliver Hill, an attorney, who stated "to abolish segregation solely on the basis of race would not create disharmony." Hill pointed out that thirty-four of the forty-eight states had abolished the practice.

The Roanoke Ministers' Conference voted to approve a recommendation from a committee composed of both white and black clergymen that it sponsor the formation of an Interracial Ministers Alliance that would meet at least three times per year.

Western movie actor Lash Larue brought his *Western Revue* show to the stage of the Roanoke Theatre on January 7.

C. D. M. Showalter died at his home in South Roanoke on January 7. Showalter came to Roanoke in 1903 and was one of the organizers of the Liberty Trust Company and of the Old Dominion Fire Insurance Company. He also operated a large dairy farm in north Roanoke County.

American Airlines began an intrastate flight serving Bristol, Lynchburg, Roanoke, and Richmond in mid-January.

The Quota Club of Roanoke celebrated its first anniversary with a dinner at the Hotel Roanoke on January 8. The woman's group was a service club that had adopted the Juvenile Detention Home as its initial focus. Miss Wilda Coleman was president.

The first meeting of Alcoholics Anonymous in Salem was held on January 10 at First Methodist Church.

St. Paul's Chapel opened on January 11 on Peters Creek Road. Rev. C. R. McCraw was pastor.

Lillie Honeycutt opened her Southeast Beauty Shop at 909 Ninth Street, SE, on January 11.

The William Hunton Branch YMCA celebrated its twentieth anniversary the week of January 19. Among those participating in various dinners and events was Dr. Mordecai Johnson, president of Howard University. L. A. Lee had served as the branch's executive secretary for twenty years, and Dr. E. D. Downing had served as board chairman for the same period.

Gene Autry, famous screen and radio cowboy, along with his horse, Champion, gave a performance at the American Legion Auditorium on January 16. Autry was joined by a large cast of other western film and radio personalities and singers.

Daniel and Weddle Auto Electric Service opened at 6 Locust Avenue off Williamson Road on January 12. Proprietors were C. L. Daniel and F. C. Weddle.

Douglas Nininger, superintendent of Roanoke County schools, reported to the school board in mid-January that two black schools, Mountain Top and Catawba, had been recently wired for electric lights.

A. M. Bowman Jr. was named president of the Bank of Salem, succeeding C. A. Albert.

A match between Primo Carnera and Laverne Baxter headlined the Roanoke Wrestling Association's show at the American Legion Auditorium on January 14.

Becker's Millinery at 313 S. Jefferson Street closed and consolidated with Becker Apparel at 125 W. Campbell Avenue in mid-January.

A dead newborn was found in a small piece of luggage on the banks of the Roanoke River near Riverland Road on January 17. The bag and body were found by men looking to set muskrat traps. The county sheriff hypothesized that the bag had been thrown from a moving car in the hopes that it would land in the river and be carried downstream. The coroner stated that the white male child had been born alive and probably died in the bag from exposure.

The Suzara Marionettes from New York gave two performances of *Aladdin and His Wonderful Lamp* in the Jefferson High School Auditorium on January 17 to a packed house of children and parents.

Filatex, a new American Viscose Corporation product used in such clothing as men's socks, was being manufactured exclusively at the Roanoke plant in a special department.

A new Kroger Grocery opened at Franklin Road and Maple Avenue on January 22. It was the largest Kroger store in the South according to company officials. New store features included on on-site coffee grinder that allowed customers to grind coffee beans before purchase; a three-tier self-service dairy section; frozen foods; and five check-out lanes. The store manager was C. H. Moore. An estimated fifteen thousand persons shopped at the store on opening day, and the first customer, Mrs. J. L. Harmon, was checked out by Roanoke's mayor, Richard Edwards, at the itemized cash register.

Roanoke's 1948 March of Dimes campaign launched in mid-January to raise funds for infantile paralysis patients. In 1947, twenty-six cases of polio were reported to Roanoke Hospital.

The inaugural flight of American Airlines passenger and mail service between Roanoke and Richmond occurred on January 18. Many Roanokers were on hand at Woodrum Field to welcome the flight, which arrived at 5:08 p.m. The flight was part of American's Nashville-Washington, DC, service.

The Virginia governor's proposed budget included more than $1 million in operating expenses and $2 million for outlays at the Catawba Tuberculosis Sanatorium. The budget

plan called for patients to pay $1.50 per day for expenses, which covered a portion of the $3.50 per day incurred for patient care.

Citizens of South Salem organized to review the benefits of annexing themselves into the Town of Salem for purposes of receiving town services such as garbage collection and improved facilities.

A twenty-six-year-old unwed mother confessed on January 19 to abandoning her newborn in a small luggage bag near the Roanoke River days prior. The county sheriff had received a tip from a taxi driver who reported a passenger asking him to stop near the Viscose plant. When he did the woman took her bag, claiming it had old letters she wanted to dispose of, and tossed it toward the Roanoke River. The following day the young woman, Beulah Murphy, was charged with murder.

Herbert Tayloe of the Cave Spring district was elected chairman of the Roanoke County board of supervisors for the next four years, succeeding Howard Starkey of the Salem district.

The Melrose Sweet Shop and Grocery opened at 2304 Melrose Avenue on January 21. The proprietors were Mr. and Mrs. Karl Thompson. Their ads read, "All groceries will be marked at cost plus 15 cents for handling."

Grandin Self-Service Laundry opened at 1908 Memorial Avenue, SW, on January 21.

Allan Luke, sixty-six, died at his home near Salem on January 21. Luke, a retired bulk paper company executive, owned and resided at "Fort Lewis," which he purchased from the Payne family in 1936.

Citizen's Undertaking Establishment at 520 Commonwealth Avenue, NE, advertised the addition of a 1948 Cadillac ambulance to its fleet. R. W. Clark was president and treasurer.

Miss Mary Lewis Shanks, retired executive of General Motors and the nation's first female distributor of automobiles, died at the home of her sister in Salem on January 22. Shanks was a native of Salem and began her career as the first woman distributor of automobiles in 1911. Later she was secretary-treasurer of both the Monarch Motor Car Company and Emerson Motor Car Company. She joined General Motors in 1917, where she served in several executive positions before retiring in 1944.

Roanoke City's annexation suit to acquire twenty-one square miles of Roanoke County, including the town of Vinton, was set to be heard on April 20. The schedule was set by a three-judge panel of the circuit court that also dismissed four objections to the suit from the county that they deemed to be "without merit."

Loch Haven, formerly Greenridge Park, advertised nighttime ice skating under flood lights, with music and bonfires. "Five acres of the best ice in this vicinity," read the ads.

Ace drummer Gene Krupa and his orchestra performed at a dance at the American Legion Auditorium on January 28. Black spectators were admitted at half price. Earlier that day, Krupa made a personal appearance at Grand Piano Company, where he autographed photos.

The new Chesapeake and Potomac Telephone building was under construction by mid-January at Calhoun and Alabama Streets in Salem. The $163,000 structure, slated to be completed by fall, would allow for a rotary dial system for customers.

Elmwood Cleaners and Dyers opened a branch office on Ninth Street across from Jackson Junior High School on January 25. The main plant was located at 820 Third Street. E. M. Pendleton and R. B. Meador were proprietors.

The Hunton Branch YMCA held a twentieth anniversary celebration at First Baptist Church, Gainsboro, on January 25. An overflow crowd was present to hear the event's main speaker, Dr. Mordecai Johnson, president of Howard University.

Film comedian Fuzzy Knight and his *Hollywood Revue* show performed at the Roanoke Theatre on January 28.

Dr. Fred Hamlin was elected president of the Roanoke Chamber of Commerce. Ben Moomaw was named as executive director. Frank Wright was elected president of the Salem Chamber of Commerce.

The Roanoke School Board authorized retaining the architectural firm of Eubank and Caldwell to develop plans for a new elementary school in the Grandin Court section at their meeting on January 29.

The first of four giant electric locomotives acquired by the Virginian Railway from General Electric made its debut appearance in Roanoke on January 29. No. 125 arrived as part of a test run over the mountains from Mullens, West Virginia.

Mayor Oscar Lewis, eighty, of Salem announced in late January that he would not seek reelection in June to the town council. Lewis had been a member of the governing body for twenty consecutive years. Lewis was the first Ford dealer in Roanoke County.

Helen MacKellar played the lead in the touring production of Tennessee Williams' *The Glass Menagerie* at the Academy of Music on February 3. MacKellar had appeared in numerous plays on Broadway as well as films.

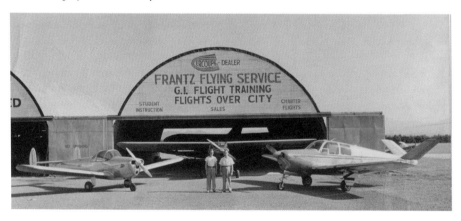

Frantz Flying Service opened in 1948 at Woodrum Field, operated by "Boots" Frantz (*right*). Wes Hillman (*left*) was an employee. *Virginia Room, Roanoke Public Libraries.*

Lt. Col. Howard Hammersley Jr. was named commanding officer of the 511th Composite Squadron of the Air Reserve at Woodrum Field. The squadron was one of three new units being formed in Virginia.

A new sixteen-unit apartment complex at 445 Walnut Hill, SE, caught fire on January 31, forcing all the tenants to evacuate. There were no injuries, but the roof and attic were destroyed.

Vernon Robinson, forty-one, was shot to death in his home at 328 Tazewell Avenue, SE, on February 1 in what police called "questionable circumstances." Police charged the victim's daughter the next day for the killing.

Harvey Apperson, former state senator and Virginia's attorney general, died in Richmond on February 2 at the age of fifty-seven. Apperson's funeral was held at St. Paul's Episcopal Church in Salem with burial at East Hill Cemetery two days later. Apperson was a native of Marion who began practicing law in Roanoke in 1913. He entered the Virginia Senate in 1933. Apperson was appointed as Virginia's attorney general by the governor in 1947 when the sitting attorney general was appointed to the state's supreme court of appeals.

William Straightiff, thirty-one, blew himself apart in a suicide near his home at 519 Arbutus Avenue, SE, on February 2. Straightiff lit a stick of dynamite stuffed in his belt, as his girlfriend tried to dissuade him. The woman was injured from the blast. The force of the blast shook houses in the neighborhood. The incident happened in an alley between Walnut Hill and Riverland Road. Straightiff was a veteran of World War II.

A Hustings Court grand jury did not indict Beulah Murphy with the charge of murdering her baby, as there was no evidence the child was alive at birth.

The congregation of Twelfth Street Holiness Church announced plans to build a new chapel at 1823 Loudon Avenue, NW. The congregation had sold its building at the corner of Twelfth Street and Centre Avenue, NW, to the Noland Company.

Dr. Howard Odum of the University of North Carolina stated that the American South must come to terms with "delayed social justice, fair practices and unfilled hopes" in the matter of racial reconciliation. Odum addressed the annual meeting of the Roanoke Commission on Interracial Cooperation held at St. John's Episcopal Church. The commission had been formed in 1922.

The huge fifteen-foot columns that were removed from the N&W Railway passenger station in Roanoke due to a major renovation were taken to a 182-year-old sandstone home in Botetourt County belonging to Mrs. Eva Henderson. Each of the limestone columns weighed 4,400 pounds.

The Salem Town Council met with a three-member committee representing the unincorporated South Salem and shared that if a petition were presented to the town council showing an overwhelming number of South Salem residents wanted to be annexed into Salem, the town council would formally consider the matter. The three members of the South Salem committee were William Wertz, A. W. Clinevell, and Paul Ames.

The Virginia General Assembly Democrats voted to nominate Roanoke's J. Lindsay Almond as Virginia's attorney general by a vote of ninety to thirty-four. Almond, forty-nine, was serving in Congress representing the Sixth District at the time of his nomination to fill the unexpired term of Harvey Apperson.

Lucky Millinder and his recording orchestra performed for a dance at the American Legion Auditorium on February 12. Joining Millinder's band were vocalists Bull Moose Jackson, Annisteen Allen, and Paul Breckenridge. White spectators were admitted for half price.

Gen. George Kenney, commanding general of the air force's strategic air command, addressed the annual "Bosses Night" dinner of the Roanoke Junior Chamber of Commerce at the Hotel Roanoke on February 10. The four-star general told the audience that having the globe's mightiest air force was an absolute necessity to thwart war.

Roanoke College defeated Virginia Tech in basketball, 42–35, before 2,300 spectators in the American Legion Auditorium on February 10.

The Philadelphia Athletics' star pitcher Bob Savage spent a few days in Roanoke in mid-February and offered comments on major league baseball and the A's prospects. Savage's wife, Dorothy Gay White, was from Roanoke, and the couple often visited her parents on Wycliffe Avenue.

Final payment of $3,500 on the mortgage of the Central YMCA was presented by Lucian Cocke Jr., treasurer, to J. B. Fishburn of First National Exchange Bank. The Central YMCA had been erected in 1914.

A group of black businessmen from Roanoke purchased a 125-acre tract near the Booker T. Washington Memorial in Franklin County for the purpose of building a blacks-only resort complete with a swimming pool and auditorium. Jeremiah Holland was president of Washington Resort, Inc.

Tommy Dorsey and his orchestra performed for a show and dance at the American Legion Auditorium on February 19. Vocalists included Stuart Foster, The Town Criers, and Gordon Polk. Charlie Shavers, a former Roanoker, also appeared with the band. Black spectators were admitted for half price.

Alicia Markova and Anton Dolin, ballet dancers, performed at the American Legion Auditorium on February 17.

The Elks gave their annual musical and minstrel revue at the Academy of Music for three nights beginning February 17. *Tune Time* featured local talent.

Louis Hunt, head waiter at Hollins College, was presented an engraved gold watch from the student body on the occasion of his sixty-third birthday and fifty years of service to the college.

The first edition of the *Roanoke Record*, published by the Roanoke Chamber of Commerce, was sent to members in mid-February. The publication highlighted the chamber's work.

The Hourglass Restaurant at 117 W. Church Avenue closed on February 18. The eatery had been purchased, and the new owners announced it would reopen as Woodson Cafeteria the next month. Officers for Woodson Cafeterias were W. A. Ingram and Jack Woodson.

Western film star Johnny Mack Brown came to the Roanoke Theatre stage with his *Western Show* on February 18.

Bill Monroe and his Blue Grass Boys performed at the Roanoke Market Auditorium on February 22. Monroe was joined by the Blue Grass Quartet that consisted of Chubby Wise, Lester Flatt, Earl Scruggs, and Cedric Rainwater.

Byron Woodrum, fifty-two, prominent Bent Mountain orchardist died on February 19.

Stanley Radke, president of the Roanoke Red Sox, proposed to the Roanoke City Council a facelift for Maher Field. Radke had purchased steel bleachers, a grandstand, and a complete lighting outfit from a Philadelphia railroad and wanted to install the equipment in Roanoke.

Roanoke College defeated VMI in basketball, 49–37, in a game at the American Legion Auditorium. The Maroons finished their regular season with a 16–1 record, giving them the state title.

The Virginia House of Delegates defeated a bill to prevent Roanoke city from annexing the Town of Vinton by a vote of forty-five in favor and forty-eight against. The bill had been introduced by Delegate Ernest Robertson of Roanoke County and was adamantly opposed by the city's delegation.

James Randall, twenty-one, of Roanoke, son of Mrs. Ora Randall and the late Samuel Randall, became the first black man to be accepted for training under the army's new aviation cadet program at Langley Field. Randall was a graduate of Addison High School and was attending Hampton Institute.

Cora Teasley, sixty-five, of Wells Avenue, NW, was fatally burned on February 21 when her clothing caught fire while she was starting a small heater at home. She succumbed to her burns at Burrell Memorial Hospital.

The Harlem Globetrotters came to the American Legion Auditorium on February 26. Accompanying the famous court jesters were Olympian Jesse Owens, Hawaiian hula dancers, Philly Sphas, Hawaii All-Stars, and the Kansas City Stars. The ads read, "House equally divided for white and colored."

Robert Cacadesus, renowned French pianist, performed a concert at the Academy of Music on February 28. His appearance was part of the Community Concert Association's season. He had played with almost every major symphony around the world.

Leaders with the Salvation Army held a mortgage-burning ceremony on February 22. The army's citadel at 821 Salem Avenue was debt free. The citadel had been formally dedicated on October 12, 1941.

Dr. Ellwood D. Downing was prominent in Roanoke's black community and a nationally ranked tennis player. *Virginia Room, Roanoke Public Libraries.*

Eastern Packing and Storage opened its new warehouse for general and wholesale use in Norwich in late February. The company used the former dehydration plant.

The Roanoke City Council authorized that a ten-month lease of the Rockledge Inn on Mill Mountain be granted to Fred Ellis and Aubrey Kelly.

The Crane Company was named as the lessee of the Rainbo Bread Company building on Centre Avenue, NW. The bread company was in the process of moving to a new building on Williamson Road. Rainbo had been at the Centre Avenue location for thirteen years.

The Rev. Wirt Davis, former pastor of Virginia Heights Baptist Church from 1921 to 1926, died at his home near Accomac on February 23.

Citizens of the unincorporated South Salem voted 31–6 at a mass meeting to begin circulating petitions to determine whether a majority favored (1) annexation into Salem, (2) forming a sanitary district, or (3) remaining in their present status.

Roanoke's city manager, Arthur Owens, negotiated a lease of Maher Field with Stanley Radke, president of the Roanoke Red Sox, that would use the bleachers and other equipment Radke had recently acquired and be for a period of five years.

A fire in a defective flue forced some five hundred students and faculty to evacuate Gilmer School on February 24. All remained home for one additional day so repairs could be completed. The school was one of the oldest in the city still in use, having been erected before 1900.

WSLS radio station was granted permission by the FCC to increase its power from 250 to 1,000 watts and to change its frequency from 1240 to 610 kilocycles.

Carson Mays, forty-five, was killed in a house fire at 2507 Laburnum Avenue, SW, on February 25. Mays was an insurance executive in Roanoke.

Maurice Tillett, better known as "The Angel," brought his pro wrestling skills to the American Legion Auditorium on March 2. The Angel squared off against Johnny Long in the main event. Tillett drew full houses around the country, and Roanoke was no exception.

Rutrough-Mack Incorporated, a newly formed partnership in handling the sales of Mack trucks in southwest Virginia, opened its headquarters at 216 Centre Avenue, NW. The Mack line was previously handled by Rutrough Motors, Packard dealers, at 327 W. Luck Avenue. Rutrough-Mack occupied a building formerly used by Mundy Motor Lines. Henry Rutrough was president of the newly formed entity.

Operators of the Crystal Spring Laundry and Dry Cleaners, located at 720 Franklin Road, SW, announced they had acquired a residence at 315 Elm Avenue that they intended to raze in order to expand their plant.

Self-Service Laundry opened on March 1 at 1706 Williamson Road.

Buddy Johnson and his recording orchestra played for a dance at the American Legion Auditorium on March 3. Joining the band were vocalists Arthur Prysock and Ella Johnson. As part of the show, Johnson sponsored for all women within a seventy-five-mile radius of Roanoke, a "fine brown frame" contest, with the winner eligible to compete in a national competition later in Chicago. White spectators were admitted for half price.

The Roanoke City Council authorized the purchase of nearly two acres of land for the extension of the south end of the north-south runway at Woodrum Field at their meeting on February 29. The land was purchased from T. J. Andrews representing the Roanoke Orchard Company.

More than 150 persons attended the twenty-fifth anniversary dinner of the Israel Friedlander Lodge No. 877, B'nai B'rith, at Hotel Roanoke on March 3. The meeting honored twenty-five charter members still residing in the Roanoke area.

A mortgage-burning ceremony was held by the Central YMCA on March 3 during a dinner at the Hotel Roanoke. The Y was debt free for the first time since its beginning in 1884. The debt-elimination campaign was begun in 1945 by local attorney W. P. Hazlegrove with the assistance of Charles Lunsford and J. W. Davis. The Central Y existed at various locations in the city until 1901, when a facility was erected at Kirk Avenue and Jefferson Street. Then in 1914 the Central Y opened at their new building on Church Avenue at Second Street, SW.

Leaders of the local AFL-Carpenters Union announced plans to build a $30,000 union hall at 24 Wells Avenue, NE, near the Hotel Roanoke. A frame dwelling on the lot was razed before construction began.

The State Corporation Commission granted a charter in early March to the Roanoke Valley Horse Show Association for the purposes of promoting horse shows and

equestrian skills. The president of the association was R. A. Covington. Hubert Wright was secretary-treasurer.

The Charlotte Doyle Shop, a women's hat store, opened on March 5 at 133 W. Kirk Avenue. Proprietors were Charlotte Doyle and Louise Spigle.

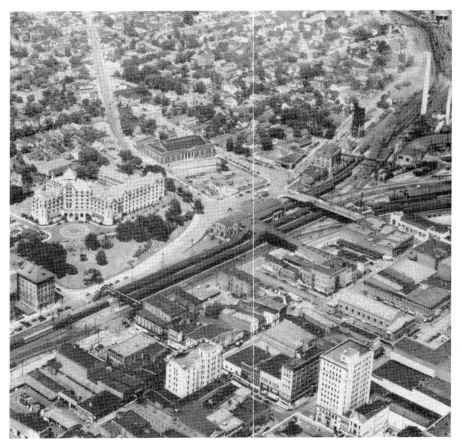

This aerial of downtown Roanoke in the 1940s appeared in many promotional brochures produced during the decade. *Steve Nelson.*

Governor "Big Jim" Folsom of Alabama stayed overnight in a local hotel in Roanoke on March 4. Folsom was viewed as a potential Democratic rival to President Harry Truman for that party's nomination due to Truman's pro–civil rights platform. Folsom had come north to avoid a paternity suit but had ducked media on his way back to Alabama.

Twenty-two blacks were listed among six hundred names drawn for inclusion on the jury list for Hustings Court for 1948. Judge Dirk Kuyk had begun advocating for black jurists in 1947.

The Williamson Road Kiwanis Club was organized on March 4 in a meeting at the Williamson Road Fire Station. Walter Nelson was elected president.

Spring Garden Development Company of Martinsville obtained twenty-nine home building permits for construction in the Edgewood section of Roanoke County.

The world's wonder horse, Bob White, came to the stage of the Salem Theatre on March 5 with trainer and western film actor Johnny Wise. They were joined by a company of five cowgirls.

Dean Hudson and his orchestra performed for a cabaret dance at the American Legion Auditorium on March 10.

Newell Banks of Detroit, known as the world's blindfolded checker champion and as one of America's master chess players, came to Roanoke on March 8 and held exhibition matches at the Community Fund headquarters. His opponents included writer Nelson Bond and fifteen-year-old Jack Godfrey.

Old-timers in Fincastle reminisced about the two stagecoach lines that served Fincastle. The last stagecoach pulled out of the town in the early 1880s, but according to elderly residents, the coaches arrived at the livery of Zimmerman and Dull on the west side of the town. One line connected Fincastle with Bonsack and points east and ran west over the Sweet Springs Road to Lewisburg, West Virginia. The other line went north to Lexington and Staunton. Four horses pulled the coaches, but six were required in bad weather, and they carried no freight, only passengers and the mail. The residents interviewed even recalled the names of the drivers: Isom Baker, Alec Johnson, and Bill Crush, among others.

William Fleming High School beat Martinsville 46–40 to win the District Six basketball championship on March 6. The game was played at Memorial Gym on the campus of Virginia Tech.

The Salem Lions Club held their thirteenth annual minstrel show fundraiser the second weekend in March at the Andrew Lewis High School auditorium. Proceeds benefited Lions' sight programs, sandlot football, and club activities.

St. Paul's Lutheran Church reopened on Peters Creek Road on March 7 after having been closed for several years. The Lutheran Synod of Virginia spearheaded the effort to have the church relaunched. Dr. William McCauley of Salem headed the reorganization effort.

Tony Pastor and his orchestra performed at the Roanoke Theatre on March 10.

The Virginia state senate passed a joint resolution naming Roanoker Leigh Hanes as Virginia's poet laureate. Hanes, an attorney, was editor of the *Lyric*, a national poetry journal.

Roanoke County and City school officials decided to review the US Supreme Court ruling in early March that held that teaching religion in public schools, even if voluntary, was unconstitutional. Bible courses were and had been taught at the elementary grade levels by teachers paid out of funds from local churches. Students took the courses voluntarily and with the consent of their parents. Local officials agreed that their setup closely resembled the situation in Champaign, Illinois, that went before the court.

Frank VanZandt, listed as residing in Roanoke, was killed aboard an airliner that crashed in Alaska on March 13. The Northwest Airlines plane hit Mount Sanford, killing thirty passengers and crew. Because of the location of the crash site, there was no effort to recover the bodies.

Cab Calloway and his orchestra performed for a "white patrons dance" at the American Legion Auditorium on March 17. Black spectators were admitted for half price.

The Vinton Lions Club held its annual minstrel show the third weekend in March as a fundraiser for its various projects. The program was held in the auditorium of William

Byrd Junior High School. Herman Horn directed the show with assistance from Paul Ahalt and Mary Silver. A fifty-voice chorus from William Byrd High School also participated by singing minstrel songs.

Officials with Sherwood Burial Park revealed plans for a one-thousand-crypt mausoleum that would be directly in front of a two-thousand-seat outdoor chapel. The master plan also included a reflecting pool at the main entrance. J. R. Goodwin Jr., secretary-treasurer of the burial park, stated that the various elements of the plan would cost a combined $300,000. The mausoleum was modeled after the Campo Santo of Genoa, Italy.

Junior Shoeland, a children's shoe store, opened on March 16 at 205 First Street, SW.

The Jefferson Street Food Market opened on March 18 at 1003 S. Jefferson Street. T. O. Massey was secretary-treasurer for the business, and J. O. Carter was president. The market was a full-service grocery store.

The Rochester Philharmonic Orchestra performed at the Academy of Music on March 19 and was the final concert of the 1947–48 season, sponsored by the Roanoke Community Concert Association. The orchestra was conducted by Erich Leinsdorf. Broaddus Chewning was president of the concert association.

Radio humorist John Henry Faulk, host of the popular CBS program *Johnny's Front Porch*, spoke at a meeting of the Roanoke Executives Club on March 19 at Hotel Roanoke.

Rita Ridenhour, nine, succumbed to injuries she received on March 14 when she ran into a moving car while riding her bicycle near her home on Orange Avenue, NW.

Four women from Roanoke were killed in a single-car accident near Danville while they were on a shopping trip there. The accident that occurred March 16 on Route 29 took the lives of Mrs. L. A. Perdue, fifty-two; Mrs. Dalton France, twenty-three; Mrs. Christie Perdue, twenty-six; and Mrs. Clara Linkenhoker, thirty-seven. Two other passengers were injured. Three of the women were related: a mother, daughter, and daughter-in-law.

Ron Randell, an Australian actor who had starred in six American films, stopped in Roanoke overnight on March 16 during a visit to Natural Bridge.

Woodson Cafeteria formally opened at 117 W. Church Avenue on March 18.

Film comedian Roscoe Ates came to the Roanoke Theatre with his *Star Revue* on March 17. Joining him for the stage show were Art Gibson, JeanSelb, and Lilly Belle.

Julian Wise, founder of the Roanoke Life Saving and First Aid Crew, addressed the Washington, DC, Kiwanis Club in mid-March and advocated for a nationwide organization of rescue squads affiliated with and supported by the National Safety Council. Wise cited several recent disasters across the United States where a lack of coordination and training by rescue squads resulted in unnecessary deaths.

Charles I. Lunsford, senior partner in Charles L. Lunsford and Sons insurance, died at his home on March 19. He came to Roanoke with his parents in 1867.

Gilbert Seay Incorporated opened at 15 W. Church Avenue on March 22. The electrical appliance store specialized in the sale and service of General Electric products.

The Detroit Symphony Orchestra performed at the Academy of Music on March 27 with Karl Krueger conducting. Ida Krehm was featured pianist. The symphony's appearance was sponsored by the Thursday Morning Music Club.

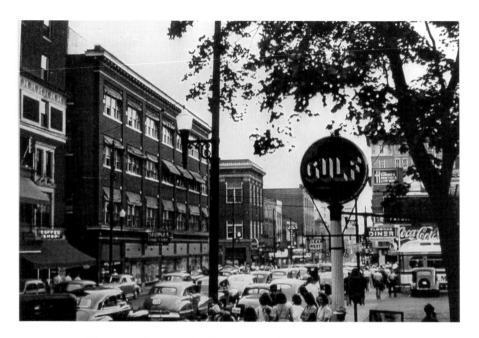

This image shows South Jefferson Street, looking north, in the late 1940s. The Elmwood Diner is in the lower right. *Tommy Firebaugh.*

Erection of a health center building at the northeast corner of Elmwood Park was proposed by Roanoke's Board of Health. The proposal was conveyed to city officials by Dr. E. G. Gill, president of the board, who stated that federal funds could be used to construct the center.

Plans for a new $10,000 church were approved by the congregation of Grandin Court Baptist Church. The Colonial-style building would be constructed at the intersection of Spring Road and Brambleton Avenue and would hold 650 people.

Sixth District congressman and newly appointed attorney general for Virginia Lindsay Almond was a leading opponent to President Harry Truman's civil rights program. Almond opposed abolishing the poll tax and agreed with other Virginia Democrats in what ultimately became an aborted effort to prevent Truman's name from appearing on the future presidential election ballot in Virginia.

First prize in the Virginia State dramatics tournament at Virginia State College in Petersburg went to Addison High School students under the direction of Mrs. Pearl Fears. The students performed *Which Is the Way to Boston.*

Ches Davis and his *Swanee River Barn Dance* came to the stage of the Roanoke Theatre on March 24.

A note-burning and dedicatory service was held at Central Baptist Church at Starkey on March 30. The church was organized in 1905. Dr. E. D. Poe delivered the dedicatory sermon.

Homer Reed purchased the home of the late Jordan Woodrum near Air Point. The home and tract, known as "The Rocks," were purchased from Mrs. Robertson Wood.

Patsy Lee Robinson, seventeen, was convicted by a Hustings Court jury on March 25 of involuntary manslaughter in the gunshot death of her father, Vernon Robinson, on February 1. The jury recommended twelve months in jail but with the sentence suspended.

The FCC granted WROV radio station permission to change its frequency from 1490 to 1240 kilocycles when WSLS changes its frequency.

N&W Railway officials announced plans to install air conditioning in its General Office building, with completion set before the summer of 1949. The installation was estimated to cost $650,000.

Mick-or-Mack Stores Company officials announced plans in late March for the construction of a new $100,000 warehouse and office building at the corner of Union Street and Seventh Street in Salem. Norman McVeigh was company president.

Dr. Robert Lapsley Jr., pastor of Roanoke's First Presbyterian Church, delivered the sermon for the Easter sunrise service held at Natural Bridge. Some six thousand persons were in attendance. Music was provided by the VMI Glee Club.

John Walker was elected president of the Roanoke Bar Association. He was also completing his service as president of the Virginia Bar Association.

An Easter show and dance was held at the American Legion Auditorium on March 29 that featured Savannah Churchill, Tab Smith and his band, and The Four Tunes. White spectators were admitted for half price.

Congressman Lindsay Almond announced on March 27 that he would leave Congress and assume his post as the attorney general of Virginia on April 17.

A *Hillbilly Jamboree* starring Eddy Arnold came to the American Legion Auditorium on April 1. Other performers included the Oklahoma Wranglers, guitarist Roy Wiggins, Annie, Lou, and Danny Dill, and minstrel comedian Slim Williams.

Wings Over Jordan performed for two nights, March 31 and April 1, at the Virginia Theatre in Gainsboro.

Turner Coffman won the Easter contest held by the boys' department of John Norman. First prize was a new bike. Other prizes were clothes, baseballs, and baseball gloves.

Roanoke city manager Arthur Owens reported to city leaders that the Academy of Music would not be permitted to open for a fall season unless the upper balcony was removed and other steps taken to enhance public safety. The unsafe conditions of the academy had become a topic in the city council election. Owens had met with the fire chief, and both deemed the academy a fire trap. The building lacked adequate fire escapes, fire alarms, lighting, and other features.

Camilla Williams, nationally known soprano, performed at the Academy of Music on March 31. It was her second appearance in Roanoke. Williams's performance was sponsored by St. Paul's Methodist Church.

Lacy Simpson, sixty-six, of Cave Spring died on March 28 from injuries he had sustained a few days earlier when he was struck by an automobile while crossing Route 11 near Mercy House where he was a patient.

Roanoke's War Memorial Committee continued its work of finalizing a recommendation to the Roanoke City Council. The memorial as envisioned by the committee would be similar to the Jefferson Memorial in Washington, DC, and would sit on the knoll in Elmwood Park. A new library would be located in the northwest corner of the park, and a combined museum and assembly hall would be erected on the south side.

This late 1940s image shows Victory Stadium, Reserve Avenue, and the local operations of the Virginian Railway. *Roanoke City Police Department.*

Inside the memorial building would be a globe forty-two feet in diameter, and around the base would be space for trophies and plaques. The front entrance would be set off by twenty-seven-foot columns of marble or limestone. The master plan for the memorial and Elmwood Park was developed by the Eubank and Caldwell architectural firm.

Roanoke police investigated the death of Sam Austin, who was fatally hurt while at work for the N&W Railway on March 25. He was found near the First Street Bridge with a severe wound behind his right ear.

A large auction of the personal property of Byron Woodrum and Jordan Woodrum was held at the Woodrum farm near Air Point on March 30. Those purchasing various tracts included Homer Reed, B. W. Angle, Joseph Wimmer Jr., and Dalton Sink.

Harry Weinsaft, who helped thousands of Jewish refugees reach Palestine, addressed local leaders of the United Jewish Appeal on April 1 at Hotel Roanoke. Arthur Taubman presided at the dinner event.

Gen. A. A. Vandergrift, retired commandant of the US Marine Corps, formally opened the Virginia Cancer Control Campaign at a dinner at the Patrick Henry Hotel on April 1.

The US Navy Band gave a concert at the American Legion Auditorium on April 1.

The Roanoke Black Cardinals opened their baseball season in a game against the Atlantic Hi-Acres of Danville on April 4 in Springwood Park.

Smokey Graves and his Blue Star Boys performed at the City Market Auditorium on April 4. They were joined by guitarist Herman Yarbrough, Chuck Johnson, comedian Roscoe Swerps, and Cub McGee.

Roanoke County authorities closed a dog pound near Glenvar on April 3 after nearby residents complained. County officials investigated and found the pound to be in an

unacceptable condition. Upon learning of the investigation, someone unlocked the gate to the pound and set eighty dogs free. The following day, county officers recovered thirty of the dogs and shot them.

The Barter Players of the Barter Theatre in Abingdon presented *The Hasty Heart* at the Academy of Music on April 7. The cast was led by Fern Bennett and Frederic Warriner.

The N&W Railway reported that total operating revenues for 1947 were $165,862,000, the highest in the company's history. Total net earnings were $35,332,000.

Ace Hardware opened at 14 E. Salem Avenue in mid-April.

James Caird of Troy, New York, consulting chemist to the Roanoke Water Department, told city leaders that the "red" water from Carvins Cove was due to the failure of the reservoir to "age" before it was put into use and the repeated turnover of the water, which brought organic materials to the surface. The city had received numerous complaints about the water's discoloration.

Roanoke celebrated Army Day on April 6 with a formation of AT-6 planes flying in formation over the city. The aircraft were from the 66 Troop Carrier Squad at Woodrum Field.

Plans for a war memorial in Elmwood Park were laid before Roanoke City Council on April 5 by the War Memorial Committee. The plan drew immediate opposition from the Roanoke Recreation Association, headed by Blair Fishburn, who argued for preservation of the park. The war memorial plan was presented by leaders of the War Memorial Committee, John Falwell and Arthur Taubman. Council decided to hold a public hearing on the matter on May 31.

The Roanoke City Council voted to change the name of Pleasant Avenue, SW, to Naval Reserve Avenue in honor of the local Naval Reserve unit.

W. P. Hunter, retired Roanoke city manager, and Dan Cronin won the five-way race in the Democratic primary for Roanoke City Council on April 6. The election results were as follows: Cronin, 3,064; Hunter, 2,663; John Thompson, 2,624; L. D. Booth, 2,568; and Virgil Grow Jr., 2,403. A total of 6,850 votes were cast.

Dr. Gordon Simmons, eighty-three, died at his home on April 6. Simmons was the first commander of the George H. Bentley Camp, Spanish-American War Veterans. He came to Roanoke in 1883 and was a charter member of the Roanoke Light Infantry. He was appointed city coroner in1910.

A two-minute "auto laundry" opened in mid-April, operated by Paul Hunter. This was the first car wash in Roanoke, and it was located in a building between the Elks Club and the Elmwood Diner on S. Jefferson Street. The Elmwood Minit Car Wash had cars pass through on a conveyor chain to be vacuumed, washed, and dried in two minutes.

Bob Porterfield of the Barter Theatre defended the Academy of Music while in Roanoke. "The acoustics of the Academy are by far the finest of any theatre I have seen, and I wonder if the people of Roanoke realize the really great asset they have in this magnificent theatre." Porterfield was passing through Roanoke on a return trip from New York City, where he had received a Tony. It was the first time the award had been presented to anyone in the theatrical profession outside of New York City.

Fred Kirby, Claude Casey, and the Briarhoppers performed on the stage of the Roanoke Theatre on April 7. All were well-known country-music radio personalities.

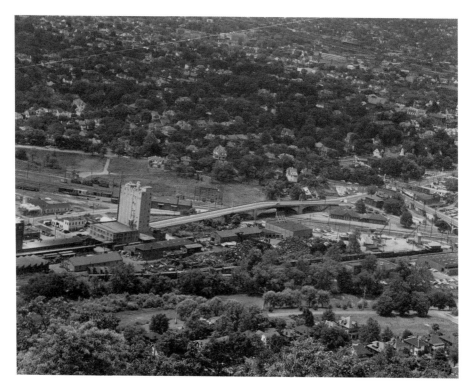

This aerial view shows the Roanoke City Mills at 1750 South Jefferson Street in 1948. *Virginia Room, Roanoke Public Libraries.*

Roy Milton and his orchestra, along with pianist Camille Howard, performed at the American Legion Auditorium on April 9. White spectators were admitted for half price.

The Boston Red Sox and the Cincinnati Reds were slated to play an exhibition baseball game at Maher Field on April 14, but rain canceled the game.

Esso Standard Oil Company received authorization to build a warehouse and gas bottling plant at 711 Water Street in Salem.

Roanoke Superintendent of Police H. C. Ferguson announced that he would retire on May 1. Ferguson had been with the city police department for over twenty-five years. He first joined the force as a police chauffeur on October 2, 1922, and was promoted numerous times thereafter.

Piedmont Airlines announced that service to Roanoke would begin on April 15. The airline had been certified to inaugurate flights from Roanoke to Wilmington, North Carolina, via Danville, Greensboro, and Raleigh-Durham.

The Roanoke Stamp and Coin Club was organized at a meeting in the Patrick Henry Hotel on April 9. R. O. Johnson was elected president.

The Chattanooga Choo Choos played the Roanoke Black Cardinals in baseball at Salem Municipal Stadium on April 11.

An extensive expansion of the Johnson-Carper Furniture Company plant near Salem was underway by mid-April. The expansion was for the addition of seven dry kilns.

Gerhart Seger, a former member of the German Reichstag and a former prisoner of a Nazi concentration camp, addressed the Roanoke Executives Club on April 16. He was also a key prosecution witness at the Nuremberg trials.

Rutrough's, a men's clothing store, opened in mid-April in the Ponce de Leon Hotel building. Herbert Gilliam was president of the company, and Rex Wright was secretary-treasurer.

John Lewis, thirty-two, was killed while on the job at the N&W Railway on April 12. He fell between two cars while they were shifting in the West End Yard. A brakeman, Lewis died of his injuries a few hours later en route to the hospital.

The Roanoke Safety Council held its first meeting on April 12 at the Hotel Roanoke. The council was endorsed by the chamber of commerce and the Roanoke City Council for the purpose of promoting safety among citizens and improving hazardous conditions in Roanoke. Paxton Judge was elected temporary chairman.

The erection of apartment buildings containing two to three hundred units was proposed for the south side of the 1500 block of Maiden Lane, SW, in mid-April. The announcement by contractor Paul Wood came during a petition to rezone over ten acres for the project.

The Barter Theatre Players presented *John Loves Mary* at the Academy of Music on April 14.

Representatives of some sixty civic and cultural organizations met on April 14 to discuss the future of the Academy of Music. A nine-member committee was selected by the group to meet with the Roanoke city manager and elected officials to plan for the upgrade and preservation of the Academy. A. S. Pflueger was chairman of the committee. The group had been convened by the Junior League.

A 1948 Desoto is parked in front of an Eastern Airlines DC-3, part of the "Great Silver Fleet," at Woodrum Field in 1948. *Virginia Room, Roanoke Public Libraries.*

This was the façade of the new Smartwear-Irving Saks store in downtown Roanoke, which held a grand opening in April 1948. *Historical Society of Western Virginia.*

Eastern Airlines officials announced in mid-April that the company would inaugurate the first direct, one-carrier service connecting Roanoke to Chicago on April 25.

N. W. Kelley of Roanoke was elected president of the Virginia Chamber of Commerce on April 15 during the group's annual meeting in Norfolk. Kelley was president of the Southern Varnish Company.

Roanoke Superintendent of Police H. C. Ferguson rescinded his announced retirement and agreed to stay on indefinitely. Ferguson had been lobbied heavily by his police officers and the city manager to reconsider his retirement plans.

A charter was issued for the Staple Coal Company of Salem by the SCC in mid-April.

Piedmont Airlines inaugurated its first Roanoke flight on April 16. The Roanoke-Wilmington, North Carolina, connection was praised by the mayors of both cities. A welcoming committee was on hand when the DC-3 landed at 8:00 p.m. at Woodrum Field. Aboard the plane was Piedmont's president, Thomas Davis. Davis used the occasion to announce that additional daily connections for Roanoke to other cities would begin May 1.

The Roanoke Black Cardinals played the Raleigh Tigers in Springwood Park on April 18.

William Robinson, thirty-four, died on April 17 at Burrell Memorial Hospital from injuries he sustained when struck over the head with a piece of steel. Police charged B. J. Moorman with the attack.

Smartwear-Irving Saks opened its new half-million-dollar modern ladies specialty salon on April 19. Flood lights provided by the local Marine Corps Reserve illuminated the exterior of the building for the evening grand opening. Chandeliers lit the second-floor area, which also had curved, mirrored walls. The main first-floor entrance included a public lounge and a street façade of Indiana limestone and Levanto marble of mottled burgundy. The storefront windows allowed for views of both the first floor and mezzanine. Police estimated a crowd of ten thousand attended the opening.

The grand opening of Smartwear-Irving Saks on April 19, 1948, attracted a crowd of ten thousand according to city police. *Historical Society of Western Virginia.*

An interior image from the Smartwear-Irving Saks grand opening shows the sleek, modern look of the displays. *Historical Society of Western Virginia.*

Smartwear-Irving Saks interior contained curved mirrored walls, a mezzanine, lounges, and chandeliers. *Historical Society of Western Virginia.*

John Reed King, host of the popular CBS program *Give and Take* brought his national broadcast to the American Legion Auditorium on April 23 and 24. King's appearance was sponsored by the Roanoke Kiwanis Club.

The Williamson Road Kiwanis Club held its charter-night banquet on April 19 at Hotel Roanoke. The official club charter was presented to the club's president, Walter Nelson.

The new Melrose Branch Library held its formal opening on April 22. The library was located between Twenty-Third and Twenty-Fourth Streets, NW, on the south side of Melrose Avenue. Its former quarters were at 1801 Melrose Avenue. The new location was the first permanent home of the branch, which first opened in 1929 at 1502 Melrose Avenue after being a book station the prior two years. Miss Christian Blackard was the branch librarian and had been since 1929.

Roanoker Lindsay Almond officially took of the oath of office on April 20 to become Virginia's attorney general.

The Roanoke County Board of Supervisors authorized the immediate construction of a new dog pound to be located on county-owned property north of Mercy House and west of Salem.

A total of 210 dogs of forty-five breeds participated in the thirteenth annual Roanoke Kennel Club dog show that was held in the American Legion Auditorium. Best in show went to Champion Merry Monarch, a boxer, owned by Claredda Kennels of Long Island, New York.

Roanoke's library director, Pearl Hinesley, stands in front of the new Melrose Branch Library at its opening in April 1948. *Virginia Room, Roanoke Public Libraries.*

Ernest Williams, thirty-eight, partner in the Moore and Williams Clothing Company, died at his home in Roanoke on April 21.

Psychiatrist Dr. Paul Hock of the New York State Psychiatric Institute addressed Roanoke-area physicians on April 23. He spoke at the Veterans Administration Hospital on the topic "The Place of Shock Therapies in Psychiatric Treatment."

Thirteen persons were injured when a school bus en route to Fort Lewis School and a tractor trailer crashed into one another.

Air mail service between Roanoke and Wilmington, North Carolina, and intermediate points was inaugurated by Piedmont Airlines on April 23. Included in the mail were 1,548 first-flight covers prepared by collectors.

The Salem Community Players presented *Murder for Two* at Andrew Lewis High School on April 30. The play was written by Salem resident Elizabeth Gresham and was first performed in 1933 at the University of Virginia. The theatre group met the first Monday of every month at North Cross School in Salem.

William McClanahan, a pioneer Roanoke businessman, died on April 24 in a Roanoke hospital at the age of seventy-nine. McClanahan had been born at his ancestral home on the site of First Presbyterian Church. He established the W. S. McClanahan insurance firm and was active in civic and business affairs.

Irving Sharp launched a new radio program on WDBJ in late April. *Sharp's Daily Dozen* played twelve popular songs each weekday at 10:00 a.m. as requested by listeners.

Bill Thomas defeated Sam Riley in the annual city-county Ping-Pong tournament. The two teamed together to win the doubles tournament, defeating Billy Gravett and Ed Pettigrew.

Three women associated with the Roanoke Welcome Wagon were profiled in the April 25 edition of the *Roanoke Times*. Mrs. Rose Cawthorne called on new mothers, and Mrs. Eleanor Messick greeted newly married couples. Mrs. Margie Williams called on new residents of Roanoke. The members of the Welcome Wagon presented gifts and information from participating merchants.

The Williams Branch YWCA held its twenty-fifth anniversary program at First Baptist Church, Gainsboro, on April 25. The keynote speaker was Miss Dorothy Height of the national board YWCA.

The famous English historian Dr. Arnold Toynbee visited Roanoke College in late April. He spent time with faculty and attended a dinner in his honor at the Hotel Roanoke.

The Patchwork Players launched a campaign to seek five hundred patrons for their 1948 season in an effort to hold multiple theatrical performances for a cumulative audience of one hundred thousand persons.

The Junior Chamber of Commerce launched a "Pay Your Poll Tax" campaign with a parade through downtown Roanoke on April 24. Their goal was to get twenty thousand registered voters to pay their poll tax. The effort was also joined by the Junior Woman's Club.

Cliff "Ukulele Ike" Edwards and his Hollywood Caravan performed for veterans at the Veterans Administration Hospital and at the American Legion Auditorium on April 28. He and the group were welcomed to Roanoke with a parade thrown in his honor that started at Elmwood Park and ended at the municipal building.

Dr. G. M. Gilbert, a psychiatrist from New York, gave a public address in the auditorium of the Veterans Administration Hospital on April 30. Gilbert was the only German-speaking American officer allowed access to the Nazi war criminals at Nuremberg. He discussed his interactions with and observations of top Nazis at the trial, including Goering, Hess, Ribbentrop, and Streicher.

The powerful new N&W Railway freight locomotive No. 2171 rolled out of the Roanoke Shops on April 29, becoming the first to be built by the railway since June 1944. The new Y6b locomotive, the most powerful built by the N&W, was the first of twenty-two slated to be built at the Roanoke Shops.

Hollywood on Ice opened for a week's run on May 1 at the American Legion Auditorium. The ice show was billed as Roanoke's "first big time ice revue." The show had performances by fifty ice skating stars doing precision ballet, comedy, and figure skating.

Professional All-American Girls Baseball came to Maher Field on May 1 and 2 when the Chicago Colleens and the Grand Rapids Chicks played a two-night series. The event was sponsored by the Roanoke Optimist Club.

Robert Ripley's Animal Oddities opened for a four-night run at 1300 Williamson Road at Liberty Road on May 3. The show featured Belgian Bob (the world's largest horse), llamas, Lone Star (world's largest steer), and Professor Joseph Cogozzo with his trained monkeys. The attraction was sponsored by the Roanoke Optimist Club.

Roanoke's first open-air, drive-in theatre was under construction in early May on Lee Highway between Roanoke and Salem. The $200,000 theatre had a capacity for six hundred cars and seats for about one hundred persons. The theatre was being constructed by Public Entertainment, Inc. A sixty-four-foot steel tower was under construction to support the screen. Company officials hoped for an opening date of June 1.

Professional golfers held an exhibition match on May 5 at the Roanoke Country Club. Sam Snead, Jimmy Thompson, and Joe Kirkwood were joined by local amateur George Fulton Jr., who also participated in a driving contest. The golf event was sponsored by the Roanoke Chamber of Commerce.

Midget auto racing opened for the season at Victory Stadium on May 6, with races being held throughout the summer on most Thursday nights.

Roanoke's city attorney opined that the city's religious education program was legal. Randolph Whittle provided his opinion to the Roanoke School Board, stating that religious education established no religion and did not prohibit the free exercise of religion.

Crane Company of Chicago, a plumbing manufacturer, held a formal opening of its new branch warehouse in the former Rainbo Bakery Building on the corner of Salem Avenue and Fifth Street on May 3.

Dr. Amiya Chackravarty, a close associate of Mahatma Gandhi, gave several talks while in Roanoke on May 5. His appearances were sponsored by the Roanoke Ministers' Conference. The Indian scholar spoke to the general public at the Roanoke Kiwanis Club, the Dumas Hotel, and at Roanoke's First Christian Church.

Roanoke attorney James Hart Jr. announced in early May that he would oppose US senator Willis Robertson in the Democratic primary, stating, "The Byrd machine must never go unchallenged in any election."

Baptist churches withdrew from participating in the religious education program in Roanoke city, citing the recent US Supreme Court ruling, even though the city attorney of Roanoke had stated that the program was legal as carried out in Roanoke.

Bradford's Seafood Restaurant opened on May 5 at 2523 Franklin Road.

Rev. Ethridge Ricks, pastor of Mt. Zion Baptist Church in northwest Roanoke, died on May 5 in Washington, DC, following a lengthy illness. Ricks had been pastor of Mt. Zion since 1935.

Julian Wise was the guest speaker at a service to dedicate a new truck recently purchased by the Hunton Life Saving and First Aid Crew. The service was held at First Baptist Church, Gainsboro, on May 9. The Hunton squad was composed of sixteen men.

Roanoke's US Naval Reserve Training Center at Maher Field was dedicated on May 8. Principal speakers for the occasion were Secretary of the Navy John Sullivan and Virginia governor William Tuck. An estimated six thousand attended the ceremony held in Victory Stadium.

Clarence Spickard, a brakeman for the N&W Railway, was killed instantly when he was run over by a string of rail cars on May 7 in the West End Yards near 16 Street. He was thirty.

Dick Haymes, radio and screen star, made a brief stop at Woodrum Field on May 8 when he refueled his Navion. He arrived around the same time Virginia's governor did and so went largely unnoticed except by airport employees, who got his autograph.

Work began on the Diocesan House for the Episcopal Diocese of Southwestern Virginia at the corner of First Street and Highland Avenue, SW. It would be known as the Evans House in honor of its benefactor, Mrs. Arthur Evans.

A new A&P Supermarket opened at Salem Avenue and First Street, SE, on May 13. The 12,500-square-foot store had eighty employees under the management of Charles Joseph. A dinner for store employees was held at Greene Memorial Methodist Church the night before the opening. The opening also marked the closing of two A&P Supermarkets,

one at Market Square and the other at 707 Franklin Road, SW. Waldrop-Price Hardware took over the old A&P store at 205 Market Square.

A local women's apparel association was organized in Roanoke in early May. Samuel Spigel was president.

Carnival Harrison Shows came to the Roanoke Valley on May 10 with rides, acts, bands, and clowns. The carnival was held at the skating rink lot on Salem Road in Roanoke. The event was sponsored by the American Legion Post 202.

The Town Council of Salem decided not to annex the unincorporated South Salem per a request presented by petitioners.

Western screen actor Donald Red Barry performed on the stage of the Roanoke Theatre on May 12.

The inaugural flight of Piedmont Airlines new Norfolk-Cincinnati run was on May 13. Roanoke civic officials were guest passengers in celebration of the occasion.

Film stars Jackie Moran, Wesley Tuttle, the Milo Twins, and the Texas Stars brought their *Hollywood Hayride* show to the American Legion Auditorium on May 15. Local performers included Wanderers of the Wasteland.

Rev. Christian Eller, founder of the Oak Grove Church of the Brethren, died on May 13 at his home near Salem. He was seventy-eight. Eller had been very active in Brethren ministry and churches for over fifty years.

The Roanoke Black Cardinals played the Baltimore Giants on May 16 at Maher Field. On the same day, the Roanoke Royals played the Washington Athletics at Springwood Park. Lefty Smoot, former pitcher in the Negro National League, pitched for the Athletics.

The Poages Mill Church of the Brethren, located on Route 221, was dedicated during all-day services on May 23. The dedication sermon was delivered by Rev. Lawrence Rice.

George Arthur, twenty-eight, died on May 16 from injuries he had sustained a few days earlier when his car was hit by an N&W Railway passenger train at a grade crossing near his home in Glenvar.

The local chapter of the Civitan Club was organized in Roanoke on May 17 at a meeting held at the Patrick Henry Hotel with twenty persons in attendance. Wallace Parham was elected temporary chairman.

The C. W. Nuckels Grocery, also known as The Corner Market, at 1734 Memorial Avenue, SW, was acquired by and became the Hoover Brothers Grocery on May 18. Ralph Hoover and Arthur Hoover Jr. were proprietors.

Surplus Supply Company opened in mid-May at 114 E. Campbell Avenue specializing in the sale of government surplus.

The Roanoke City School Board voted 4–1 to allow religious education to be continued to be taught in grade schools. The issue had been raised due to a recent Supreme Court ruling. The dissenting vote was cast by Arnold Schlossberg, who stated that the religious component was Protestantism and that parents and children often felt pressured to participate. The religious education was sponsored by the Council of Church Women.

An estimated two hundred parents and teachers attended a meeting at Jefferson High School on May 19 and voted to organize the high school's first parent-teacher association.

The Roanoke County sheriff and deputies destroyed a one-hundred-gallon still on the top of Catawba Mountain on May 20. They also confiscated large quantities of mash

and new whiskey. No one was arrested, though two men fled the area when the officers approached the site.

A cornerstone was laid on May 22 for the house of Mrs. Marie Dillon and her five children, who lost their house in a fire a few weeks prior. The widow and her children were made homeless and lost everything, so neighbors and local businesses came to their aid. They lived in the Southview section of Roanoke County.

Screen actor John Calvert came to the stage of the Roanoke Theatre on May 26. He was joined by his Musical Maids of Magic.

Red Crise announced that midget auto racing would be discontinued at Victory Stadium. City officials and others wondered about what to do with the oval asphalt track that had been built within the stadium to accommodate the auto racing.

This is Jefferson Street looking north from the Patrick Henry Hotel in August 1948. *Digital Collection, Special Collections, VPI&SU Libraries.*

The Roanoke Life Saving and First Aid Crew celebrated its twentieth anniversary in mid-May. The crew was formally organized on May 25, 1928, with ten men. The squad celebrated its anniversary with an open house on May 25 at its headquarters at 323 Luck Avenue, SW. The open house included early equipment, and a dinner dance was held at the Hotel Roanoke that evening. Principal speakers included Julian Wise and Dr. Marcellus Johnson Jr., assistant chief surgeon of the N&W Railway. According to crew records, during the first two decades, 453 lives were saved, 18,254 minor first-aid cases were treated, and 2,847 calls were responded to. The original crew consisted of employees of the N&W Railway who dedicated themselves to saving persons from drowning. With the donation and acquisition of equipment, the crew expanded its mission. During its first

year, John M. Oakey Funeral Service donated a Cadillac ambulance. By 1930, the crew had received recognition from the Roanoke Academy of Medicine and a charter from the American Red Cross. Crew members began working with other communities throughout Virginia such that the Virginia Association of Rescue Squads was formed. The crew was instrumental in acquiring iron lungs during the polio epidemic. Original crew members were F. P. Grimes, Allen Grasty, Julian Wise (founder), O. P. Britts, Herman Moorman, E. A. Wolfenden, G. C. Lankford, C. F. Britts, Harry Martin, and Harry Avis.

Groundbreaking services for the new $154,000 Virginia Heights Lutheran Church were held on May 30 at the corner of Grandin Road and Brandon Avenue. The church was organized on May 10, 1916, by Dr. William McCauley with twenty-nine charter members.

The Williamson Road Chapter of the Order of the Eastern Star received its charter on May 25 at a meeting held at Bethany Christian Church.

A National Exchange Club charter was presented to the newly formed Williamson Road Exchange Club on May 27 in ceremonies held at the Canary Cottage. Winston Coleman was president of the local club.

C. W. Francis Jr. purchased from the Chesapeake and Western Railroad the unused rights-of-way in Rockbridge, Botetourt, and Roanoke Counties. The railroad was to have been built from Lexington to Salem. The Valley Railroad was organized in 1866 and acquired land with the idea of connecting the B&O Railroad with the N&W Railway. The connection between Harrisonburg and Staunton was completed by 1874 but never came further south.

The Rainbo Bread Company held an open house on May 24 and 25 at its new headquarters and bakery at Liberty Road and Gillespie Street.

Culligan Soft Water Service held an open house on the same dates as Rainbo Bread as they were located across the street on Gillespie Street. Culligan had opened in Roanoke a few months prior.

The idea for a civic improvement Roanoke Foundation Fund gained initial support from citizens who gathered at a meeting convened at the Hotel Roanoke by Roanoke city manager Arthur Owens. Mayor Richard Edwards appointed Dr. E. G. Gill as temporary chairman of a citizens committee to further develop the idea.

Eugene Bush died at his home on May 24. Bush was cofounder of Bush-Flora Shoe Company in Roanoke and had been a merchant for over fifty years.

The Wasena Civic League and the Virginia Heights-Raleigh Court Civic League were consolidated to form the Raleigh Court Civic League during a meeting at Virginia Heights Baptist Church on May 24. Lucian Crockett was elected chair of the new league.

Two members of the Air Force Reserve Unit were killed in a plane crash near Dixie Caverns on May 26. Capt. Jack Dunn and Lt. John Petticrew were both flying separate planes when they collided midair, according to eyewitnesses. They were both members of the 66 Troop Carrier Squadron. Both men were residents of the Roanoke area.

Friends of the Roanoke Library was organized on May 27 for the purpose of promoting the use and needs of Roanoke's library and branches. Frank Rogers was elected president.

Professional golfer Mildred "Babe" Zaharias and her husband, George, stopped in Roanoke on May 27, catching the attention of some Roanokers. The couple was en route to their home in Ferndale, New York.

Main Street in Salem in the 1940s was bustling with activity
when this photograph was taken. *Salem Historical Society.*

The Bank of Salem underwent extensive renovations and expansion beginning in late May. The Alabama Street entrance was closed, and doors were placed at the Main Street entrance. Martin Brothers of Roanoke was the general contractor.

Western film comedian George "Gabby" Hayes brought his show to the stage of the Roanoke Theatre on June 2.

Kainey Agee defeated his Bent Mountain schoolmate Hylton King by one game to claim the 1948 city-county marbles tournament championship held in Elmwood Park on May 29. Agee, thirteen, qualified to represent Roanoke in the national tournament in New Jersey.

Waldrop-Price Hardware opened for business on May 31 at 205 Market Square in the McGuire Building. Proprietors were W. P. Price and J. B. Waldrop.

Daniel Horgan, ninety-five, died at his home on May 30. An Irish immigrant, he came to Roanoke in 1890, where he established a shoe and harness shop. He later worked for the city health department.

Three Memorial Day services were held in the Roanoke Valley—at Sherwood Burial Park, Mountain View Cemetery, and the Hotel Roanoke—sponsored by the local DAV chapter.

The Roanoke City Council unanimously approved the full recommendation of its War Memorial Committee to erect a memorial in Elmwood Park as outlined by the committee. The decision followed a two-hour public hearing where both proponents and opponents spoke on the matter. The proposal adopted included four components: (1) that money be raised for the memorial by public solicitation, (2) that a council-appointed committee would oversee the solicitation campaign, (3) that pledges could be spread over a period of three years, and (4) that a paid secretary be provided to the committee for the duration of the solicitation campaign.

The Roanoke Civitan Club held its charter-night banquet at the Hotel Roanoke on May 31, at which the club was formally presented its charter.

Al Hayse and his All-Star Orchestra performed for a benefit dance at the American Legion Auditorium on June 1. The event was sponsored by the Atomic Club, and white spectators were admitted for half price.

Illinois Jacquet and his orchestra, along with the Jumping Jacquettes, performed at the American Legion Auditorium on June 2. Jacquet was an up-and-coming jazz musician. White spectators were admitted for half price.

Woodrow Turner became town clerk of Salem on June 1. He succeeded Frank Chapman, who had been appointed town manager in 1943. The position had been vacant during the five-year period between Chapman and Turner.

A branch of Stanley Home Products opened on June 2 at 1316 Grandin Road, SW.

The first outdoor boxing match of the season was held on June 4 at Salem Municipal Field. The three main bouts were Willard Coffey versus Roy Wirt, Ronnie Harper versus Dutchy Schnappauf, and Jessie Barker versus Johnny Clemens.

The Roanoke Lions Club launched a movement with hopes to raise millions of dollars nationally from club members throughout the United States to clean up and landscape Bedloe's Island in New York harbor on which stood the Statue of Liberty. The idea was put forward by Leroy Smith, manager of Roanoke's Viscose plant. Smith had made a visit to the site and was appalled by its derelict condition. The Roanoke Lions intended to present their proposal to the Virginia State Lions Club convention and ultimately to the Lions International convention.

The Roanoke County Woman's Club celebrated their twenty-fifth anniversary at a luncheon at their clubhouse on June 3.

The congregation of Virginia Heights Lutheran Church voted on June 4 to change their name to Christ Evangelical Lutheran Church.

Sixty-six boys attended a two-day tryout baseball camp in early June held by the Boston Red Sox organization. The camp was held at Maher Field, and three young men (none from the Roanoke area) were given contracts to play for Red Sox farm teams.

Dr. Charles Smith announced he would retire as president of Roanoke College on January 1, 1949. Smith had been at the college since 1920. Smith cited health reasons for his decision.

The Lee-Hi Drive-In Theatre opened on June 7 on Lee Highway between Roanoke and Salem. The opening night movie was *Margie*. Ads boasted that the drive-in could accommodate six hundred cars, with admission being fifty cents for adults and twenty cents for children. The film starred Jeanne Crain, Glen Horgan, Lynn Bari, and Alan Young.

Five area high schools held baccalaureate services the week of June 6. Rev. Harry Gamble of Calvary Baptist Church in Roanoke spoke at the American Theatre to graduates of Jefferson High School. St. Andrew's High School held its service at Our Lady of Nazareth Catholic Church. Rev. Robert Smith of High Street Baptist Church spoke to the graduates of Lucy Addison High School at the American Legion Auditorium. Rev. John Elliot of Salem Presbyterian Church gave the baccalaureate sermon to graduates of Andrew Lewis High School in the school's auditorium. Rev. Gamble also delivered the sermon for William Fleming High School at Oakland Baptist Church.

The Kraft Food Company completed its branch distributing plant in Salem in early June. The $103,000 facility was located on West Main Street and employed thirty-five persons.

Professor Cleo Blackburn of Indianapolis, Indiana, delivered the sermon at the Ninth Avenue Christian Church on June 13, and later that afternoon the church's cornerstone was unveiled and the name of the congregation officially changed to the Loudon Avenue Christian Church. The church was located at 730 Loudon Avenue, NW.

A fire swept through the second floor of the Gilmer School on June 6, bringing to an end the school year for its students. The principal directed students to a nearby Methodist church to receive their report cards while teachers finished their work in the undamaged parts of the building.

Dr. Henry Sloane Coffin of the Riverside Church in New York City delivered the baccalaureate address to the graduates of Hollins College on June 6.

The Castle Hill development went up for auction on June 9. The section was located in the Cave Spring area on Bent Mountain Road, consisted of ninety acres, and had been subdivided into home sites.

Count Basie and his orchestra performed for a show and dance at the American Legion Auditorium on June 9. It was Basie's first appearance in Roanoke. The event included a musical quiz contest. White spectators were admitted for half price.

In the June 8 local elections, former Roanoke city manager W. P. Hunter and Dan Cronin were elected without opposition to the Roanoke City Council. In Salem, Leonard Shank defeated Maynard Dooley 517 to 240 for the town council seat, and in Vinton mayor Ross McGee and incumbent Nelson Thurman were reelected to the two open seats, defeating challenger Paul Foutz.

For the first time in the history of Roanoke city, blacks were allowed to serve as election judges and clerks, five in the Melrose Ward and five in the Kimball Ward, for the June 8 city council elections.

In Richmond, former Roanoker Oliver W. Hill was elected to the city council on June 8, becoming the first black to win public office in Virginia since Reconstruction.

Hylton King, fourteen, of Bent Mountain won the Southern Marbles Tournament in Greensboro, North Carolina, and earned a trip to compete in the national marbles tournament in New Jersey.

Two teenage boys from Roanoke County were killed instantly on June 11 when the motorcycle they were riding collided with a truck on Route 220 near Rocky Mount. Don Lawrence, nineteen, of Bent Mountain and Melvin Henry, eighteen, were cousins.

The stock and equipment of the Dudley Store Equipment and Manufacturing Company located on Forest Hill Road in the Williamson Road section went up for auction on June 14. The company's assets and plant were purchased by the R. G. W. Distributors Corporation of Rocky Mount.

Fowlkes & Kefauver began advertising homes in their newest development, Manchester Court, in mid-June. Manchester Court was located just off Route 11 past the Riverjack, between Roanoke and Salem.

WROV radio's *Tots n' Teens Time* celebrated its one-year anniversary in mid-June. The local broadcast heard weekly at 10:00 a.m. was hosted by Mary Daily from various department stores in Roanoke. The show featured live interviews with children and various contests.

Officials with Tri-State Enterprise announced in mid-June that they would bring their midget auto racing circuit to Victory Stadium on June 22. Prior racing promoters had withdrawn from the stadium after suffering financial losses.

Several hundred persons attended a savings bond drive held at First National Exchange Bank. Rear Adm. W. L. Ainsworth addressed the rally. The Patchwork Players entertained the crowd with a skit.

Herndon Slicer, popular Roanoke entertainer and local radio personality, died on June 13 in Jefferson Hospital. Slicer started playing on WDBJ in 1924 when radio was a novelty. A native of Fincastle, he wrote the score for "Fincastle Rag," a popular local musical piece.

Mrs. Viola Clark, RN, was presented a silver pitcher for twenty years of service at Burrell Memorial Hospital. Dr. J. B. Claytor Sr. made the presentation.

The name of the Lutheran orphanage in Salem was changed to The Lutheran Children's Home of the South when the board of trustees for the home met on June 15.

The Lutheran Children's Home of the South in Salem had a working farm as seen in this 1949 image. *Digital Collection, Special Collections, VPI&SU Libraries.*

The name of the Big Lick Hotel at the corner of Salem Avenue and Randolph Street was changed to the Lee Hotel. The 105-room hotel was owned by the Dayton-Chambers hotel chain. The name change coordinated with a renovation of the rooms and other improvements.

Roanoke city officials purchased five hundred bronze safety markers and had them installed on city sidewalks in downtown. The "Walk Safely / City of Roanoke" medallions were four inches in diameter and placed at all pedestrian crossovers.

The Vinton Motor Company held its formal opening on June 19. The company sold Ford automobiles.

The Adams and Tate Construction Company of Roanoke was awarded the paving contract for the thirty-mile section of the Blue Ridge Parkway that stretched from Adney's Gap at Bent Mountain to Tuggles Gap near the Stuart-Floyd County line.

The Big Lick Hotel on Salem Avenue in Roanoke became the Lee Hotel in 1948, the year this photo is dated. *Historical Society of Western Virginia.*

Lorenz Neuhoff Jr., president of Neuhoff, a Salem meat-packing firm, announced on June 18 that the firm would be known as Valleydale Packers, Inc.

Charles Lunsford & Sons became Charles Lunsford Sons and Izard on June 19. The insurance firm was located in the Colonial-American National Bank building. The name change was due to the sole surviving partners being Charles P. Lunsford and James Izard.

WDBJ radio station honored its twenty-fourth anniversary on June 20. It first went on the air on June 20, 1924, and was the first radio station to broadcast in southwest Virginia.

Julian Wise, H. W. Popper, and Dan Veasey, all with the Roanoke Life Saving and First Aid Crew, sought to help organize an International Association of Rescue and First Aid Squads. To that end, the trio flew to New York to meet with representatives of squads from several states. The Roanoke squad was instrumental in developing Virginia's association.

The Magic City Athletic Club had its license to promote boxing suspended by Commissioner Rex Mitchell following a bout at the American Legion Auditorium on June 21. Mitchell claimed the promoters failed to comply with commission regulations.

Original Currier and Ives prints were on display at the Hotel Roanoke in mid-June. The prints were a collection owned by the Travelers Insurance Company, and the local exhibit was under the auspices of Davis & Stephenson, Inc.

Bobby Blake, film star of the *Red Ryder* series, performed at the Roanoke Theatre on June 23.

A mural located on the first floor of the N. W. Pugh Company building on West Campbell Avenue was unveiled in a ceremony on June 26. The mural was painted by Roanoke artist William Hutchinson and depicted the first train to roll across the tracks of the N&W Railway in 1838. Railroad officials assisted the artist in historic research.

The Roanoke Weaving Company of Burlington Mills at Vinton held an open house the third week of June to celebrate the plant's new weave room and the twenty-fifth anniversary of the company. More than 1,300 persons attended the four-day event.

EEE's Beauty Shop opened on June 27 at 1322 Jamison Avenue, SE. Proprietors were Edna Creasy, Edith Campbell, and Mrs. B. L. Campbell.

Dr. Harry Penn, a dentist, and Barclay Andrews were appointed to the Roanoke School Board by members of the Roanoke City Council on June 28. They both replaced incumbent board members who did not seek reappointment. Andrews was elected by unanimous vote, but two council members, Edwin West and W. B. Carter, asked that they be recorded as "not voting" during the roll call for Penn. It was generally believed the two members' motive was that Penn was black. With the appointment of Penn, the city council had elected the first black person to the city school board. Penn and Andrews assumed office on July 1.

Clarence Stone and W. G. Simpson opened their realty firm, Stone & Simpson Realty Company, on June 29 at 1914 Williamson Road.

Robert Swortzel, thirteen, and Clinton McClure, twelve, drowned while swimming in an abandoned iron ore pit at Blue Ridge on June 30. The bodies were recovered by the Roanoke Life Saving and First Aid Crew.

Louis Jordan and his orchestra performed for a dance at the American Legion Auditorium on July 2. White spectators were admitted.

Alford's Quality Market opened on July 1 at their new location at 821 Franklin Road, SW.

The Minnie Tour Golf Course opened opposite Lakeside on July 1.

Art Mooney and his orchestra played for a holiday dance at the American Legion Auditorium on July 5. Mooney made famous "I'm Looking over a Four-leaf Clover."

N. W. Pugh Company opened its Fountain Room in early July, which served lunches and specialty dishes.

Randy Vaughan of Vinton won Roanoke's All-American Soap Box Derby on July 3. The derby was held on Crystal Spring Avenue in South Roanoke. More than four thousand spectators watched the thirty-nine heats involving over seventy-five racers.

The new Martinsville Speedway opened on July 4 with a stock car race sponsored by Bill France of Daytona Beach, Florida. The race track was constructed by two Martinsville sports enthusiasts, Clay Earls and Sam Rice. The race was won by Fonty Flock of Atlanta.

The Roanoke chapter of the American Gold Star Mothers' Club was organized on July 8 in a meeting held at the YWCA. The organization was open to any mother who lost a son in either World War. The effort to organize a local chapter was spearheaded by Mrs. Luther Price.

The first outdoor boxing event held in Victory Stadium occurred on July 6. Eddie Miller defeated Teet Montooth, and Dutchy Schnappauf defeated Ronnie Harper. The crowd was estimated at 2,500.

Johnny Hand and his Hell Drivers came to Victory Stadium on July 10 and performed various auto stunts. Some nine thousand spectators watched the two-hour program. At

the end, however, "Dusty" Hand was critically injured in a stunt when he drove a car off a ramp, soaring eighty-five feet in the air, and flipped the car upside down onto a row of old autos that were to act as a cushion. Hand, nineteen, was rushed to Jefferson Hospital with back and neck injuries where he underwent emergency surgery.

Col. James Woods, former Sixth District congressman and pioneer Roanoke businessman, died at his home at the age of eighty on July 7. Woods was born in the Catawba Valley section of Roanoke County in 1868 and was a graduate of Roanoke College and the University of Virginia law school. At the time of his death, he was a partner in the Woods, Rogers, Muse and Walker law firm in Roanoke. He was a member of several early Roanoke City Councils and served as the city's mayor from 1897 to 1899. He served in Congress from 1918 until 1923. He served on numerous boards and was active in educational and business endeavors.

The Magic City Athletic Club, a local boxing promoter, had its license reinstated by the State Boxing and Wrestling Commission after being suspended for three weeks.

Haskell Deaton and his All-Star Air Circus came to the Montvale Airport on July 11. The famous Thrasher Brothers did their world's smallest airfield act, which included landing a small plane on a moving automobile. The air show featured parachute jumps, aerobatic planes, and picking a man up from a moving auto using a ladder suspended from a plane. An estimated crowd of ten thousand was in attendance.

Some 120 house lots in the subdivision known as "Andrew Lewis Place" went up for auction on July 10. The subdivision was located along Route 11, three miles west of Salem.

Roanoke's newest radio station, WDBJ-FM, went on the air at 11:00 a.m. on July 11 and was the most powerful FM radio station in southwest Virginia, with 11,800 watts of radiated power. The radio station's AM and FM studios were located at 124 W. Kirk Avenue. Transmitters for the FM station were located on Bent Mountain at Bull Run Knob.

Ground was broken for the new Johnson-McReynolds Chevrolet building on Williamson Road at Laurel Avenue in mid-July. The $100,000 structure was to be a service center and for truck sales.

Don Pollard of Roanoke placed third in the National Soaring Contest held in mid-July at Elmira, New York. The contest was for pilots of gliders.

The Roanoke City Council adopted a resolution by unanimous vote at its July 12 meeting to end streetcars in Roanoke. The council and city administration had worked with the Safety Motor Transit Corporation and the Roanoke Railway and Electric Company for an agreement on bus service, transit fares, and the phasing out of streetcars. At the same meeting, city council agreed to bar the use of the third floor of the Academy of Music as it was deemed a fire hazard.

The Roanoke Booster Club reported that three hundred business and professional men went on their one-day trip to the Homestead at Hot Springs. The Booster Club trip was for fellowship and recreation, and a special train was provided by the N&W Railway for the affair.

The Hitching Post Motel opened at Hollins in July.

The Hitching Post opened in the summer of 1948 on Williamson Road. This photo was taken the following year. *Virginia Room, Roanoke Public Libraries.*

Roanoke's Bulldog Rutherford squared off against Eddie Miller from Dayton, Ohio, in a ten-round main boxing event at the Red Sox baseball field at Maher Field on July 13. Other contests included Joe Lassiter versus Dick Vess, and Ernest Cabbler against Frankie Woods.

Joe Shaver, sixty-three, of Salem was killed instantly on July 13 when he was struck by the eastbound N&W Railway passenger train No. 24 near the South Bruffey Street crossing in Salem.

Lew Childre, String Bean, and the Alabama Boys came to the stage of the Roanoke Theatre on July 14 with their *Grand Ole Opry Show.*

A three-judge panel concluded the protracted annexation suit by Roanoke City on July 14 when they awarded the city enough area to effectively double the size of Roanoke. Among the areas brought into the city were the American Viscose plant, Williamson Road, Garden City and East Gate. The city had originally sought to annex twenty-one square miles, but the panel awarded twelve square miles. In terms of population, sixteen thousand county residents lived in the annexed areas. As part of the ruling, the judges determined the city would have to pay the county $688,780 for the six schools, including William Fleming High School, and the Williamson Road Fire Station. The judges were T. L. Keister of Roanoke County Circuit Court, V. L. Sexton, and Floyd Kellam. Unless appealed, the annexation would take effect January 1, 1949. Among sections not annexed was the town of Vinton.

The West End and Ninth Street streetcar lines made last runs on July 15. The streetcar operators for those lines were transferred to the South Roanoke and Raleigh Court lines or to city buses. The overhead electric lines for the closed lines were removed within the next two days by the streetcar company.

This is Car No. 46 en route to Ninth Street, SE; it is passing a 1945 Ford bus that is turning north on Jefferson Street, late 1940s. *Historical Society of Western Virginia.*

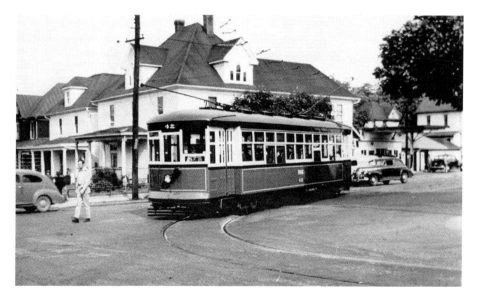

This streetcar is running from the Viscose plant and is turning left on Jamison Avenue from Ninth Street, SE, 1948. *Gordon Hamilton.*

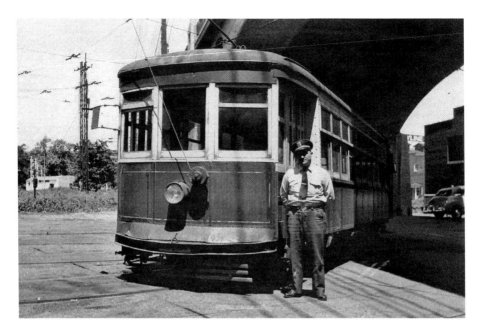

Motorman Homer Turner poses with Car No. 45 under the Walnut Avenue Bridge.
The car served the West End Line that ceased in July 1948. *Gordon Hamilton.*

The Triangle Food Market opened on July 16 at the corner of Brandon and Carter Roads, next to the Dairy Fountain.

The Anderson and Weeks Service Station opened at 1828 Memorial Avenue, SW, on July 17. The gas station had formerly been Whiting Service Station. Proprietors Billy Anderson and John Weeks sold Conoco products.

Magic City Tile Company began operating from its new location at 1513 Williamson Road in July.

The Neu-On Electric Advertising Corporation, specializing in neon signage, opened its general office at 416 Salem Avenue, SW, in mid-July.

The historic Fort Lewis estate was listed for sale with D. E. Nelson serving as broker. The Colonial-era home had been owned most recently at the time by Frank Gordon who purchased it in 1910. The home was originally constructed around 1755 by Andrew Lewis.

The N&W Railway Band resumed playing following a hiatus during World War II. Their first postwar concert was on July 22 in Highland Park. The band was originally organized in the early 1880s at what was then the Roanoke Machine Works before it was acquired by the N&W. The band's originator was G. F. Fraser of Canada, who had come to the works as chief clerk.

The local chapter of the Wallace-Taylor Club had a first meeting at Ebenezer African Methodist Episcopal Church, corner of Wells Avenue and N. Jefferson Street, on July 19. The group backed Henry Wallace and the Progressive Ticket in the upcoming presidential election. Clara Saba and Joseph Tyree were cochairs of the club.

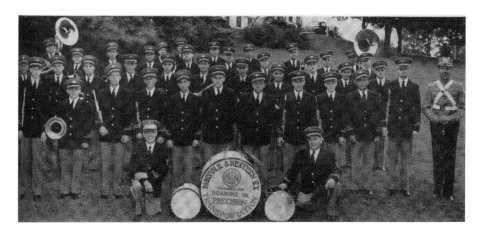

The N&W Railway Band posed in their new uniforms for the June 1948 image.
L. Christensen was the director (*kneeling, left*). *Norfolk-Southern Foundation.*

Don Leavens of Washington, DC, defeated Maurice Fincher of Charlotte, North Carolina, to win the singles title in the annual Exchange Club Invitational Tennis Tournament, which was held at Roanoke Country Club the third weekend in July.

Edward Abbuehl came to Roanoke in mid-July as the Resident Landscape Architect for the Blue Ridge Parkway headquartered in the city. He succeeded Stanley Abbott, who had moved to Richmond when he was promoted to the position of Regional Landscape Architect with the National Park Service.

The Roanoke Junior Chamber of Commerce presented E. F. Kindlan's Circle K Ranch All-Star Rodeo at Victory Stadium in late July.

The Palm Room opened at The Southern on Williamson Road on July 23. The restaurant also had dance bands on the weekend.

A display of weapons developed during World War II was sponsored by the Navy Club. The weeklong exhibit was held at the corner of Campbell Avenue and Jefferson Street and featured a German buzz bomb and a diving torpedo.

The new Union Hall built by the AFL Carpenters' Union on Wells Avenue, NE, at the rear of the Hotel Roanoke opened on July 25. The meeting room could accommodate two hundred.

Children at the Baptist Orphanage in Salem were placed under quarantine in late July to protect them against an outbreak of infantile paralysis (polio).

Noland Company was given a permit to construct a new office and warehouse at 1226 Center Avenue, NW.

The Roanoke Blood Bank was granted a charter by the SCC on July 24. The purpose of the organization was to provide blood and blood products to hospitals and physicians. The Blood Bank was headed by Dr. Ira Hurt.

The Roanoke Black Cardinals played the Baltimore Panthers in Springwood Park on July 25.

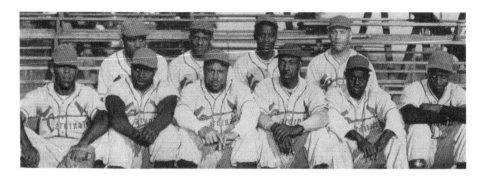

The Roanoke Black Cardinals was a semipro baseball team. The team regularly played touring pro teams from the national Negro Leagues. *Norfolk-Southern Foundation.*

The Moon Light Inn and Service Station, located on Route 220 south of Roanoke city, was put up for auction by its owners, the Schaffer family.

House lots in the Plymouth Colony subdivision went up for auction on July 31. The development included lots on or near Route 623 and Route 11. The land was formerly known as the Harvey Hall Estate.

Professional tennis players Frank Kovacs and Welby Van Horn played an exhibition match on the clay courts at Roanoke Country Club on July 30. The event was sponsored by the Roanoke Tennis Association. Kovacs and Horn were ranked Nos. 3 and 5, respectively, in the world tennis rankings.

Roanoke city officials launched an intensive DDT spray campaign as a precautionary measure against infantile paralysis and appealed for public cooperation. While there were no reported cases in the city, there were five children from surrounding areas in the polio ward at Roanoke Hospital. The spray was to kill flies, rodents, and mosquitoes. Of particular attention were areas along the Roanoke River where the city's raw sewage was emptied.

Hundreds drove by Elmwood Park in late July to see the new fountain in the center of the park's pond. Multicolored lights lit the fountain, so nighttime observations were best.

The Dudley Store Equipment Company reopened at its new location at 128 E. Campbell Avenue in late July.

Former Salem newspaper publisher and editor J. A. Osborne, eighty-seven, died at his home in Newport News on July 25. Osborne came to Salem in 1927 and purchased the *Salem Times-Register and Sentinel*, which he published until 1933. He was associated with numerous newspapers in Virginia.

Roanoke's police switchboard received an overwhelming number of calls on the night of July 26 from persons seeing odd objects in the sky. The flying saucers were reported as either reddish or bluish, ten to twelve feet in length, with tails, and hovering over various parts of the city. Two Eastern Airlines pilots reported the sighting of a meteor on the same night. Lynchburg residents also reported similar sightings in the area to local police. Roanoke officials believed the lights were produced by Very pistol flares dropped from a plane.

Bruce "Bubbles" Becker along with the Five Dimple Darlings gave a floor show and cabaret dance at the American Legion Auditorium on July 31. Becker got the nickname "Bubbles" because he was the first person "to blow smoke filled bubbles and bounce them on his knee."

A. L. Nelson Motor Company at 31 Shenandoah Avenue, NW, became a distributor for the new Tucker Car and began issuing sequence numbers for the car in late July. Hundreds swarmed the showroom on the first day as it was the first time a Tucker-brand automobile had appeared in southwest Virginia. The model on display was the fifth car built by the Tucker Company. Of interest was the "Cyclops light," which had a forward luggage compartment, a rear engine, and an overall sleek design.

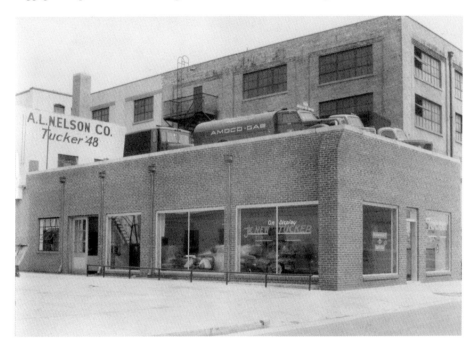

The A. L. Nelson Tucker Showroom was on Shenandoah Avenue. The $40,000 showroom housed one Tucker-model car, 1948. *Steve Nelson.*

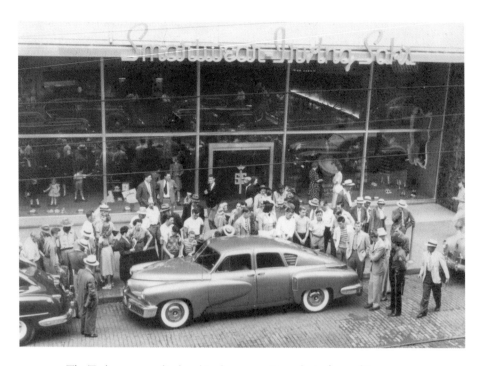

The Tucker car was displayed in downtown Roanoke in front of Smartwear-Irving Saks by local dealer A. L. Nelson in 1948. *Steve Nelson.*

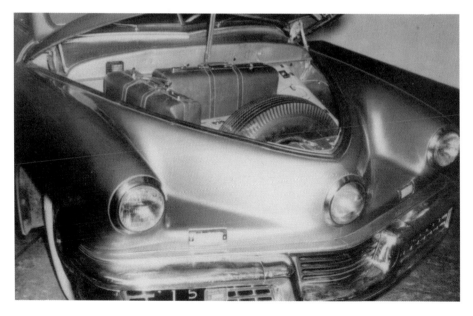

Tucker car No. 15 in the A. L. Nelson showroom on
Shenandoah Avenue, 1948. *Steve Nelson.*

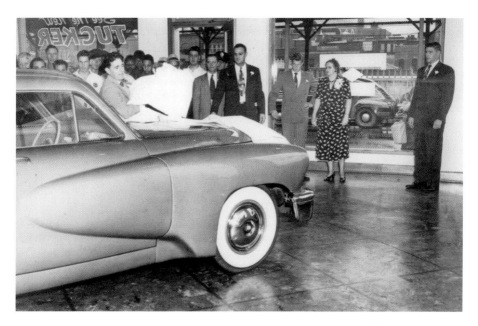

Roanoke mayor Richard Edwards pulls off the covering to reveal the Tucker car; *far right to left*, Bob Nelson, Dorothy Nelson, Richard Nelson. *Steve Nelson.*

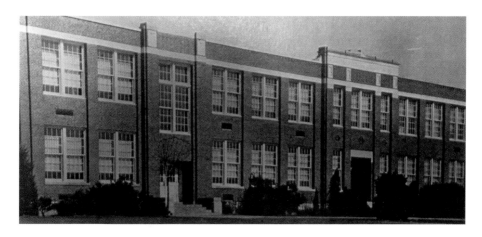

This 1947 photograph shows William Fleming High School, which faced Williamson Road. Today, it is Breckenridge Middle School. *Virginia Room, Roanoke Public Libraries.*

The Roanoke City School Board approved a plan for the Roanoke County School Board to operate county schools in the annexed sections through June 30, 1949. The county board rejected the plan. The schools affected were William Fleming High School, Garden City Elementary School, Tinker Creek Elementary School, Oakland Elementary School, Washington Heights School, and Riverdale School.

Edward R. Dudley, who grew up on Gilmer Avenue, NW, in Roanoke, was nominated by President Truman to be minister to Liberia in 1948. *Nelson Harris.*

The Lee Sports Center, located in the basement of the Lee Theatre, opened on July 30 and was operated by Walter Nelson.

President Harry S. Truman nominated former Roanoker Edward Dudley for minister to Liberia on July 29. His nomination was forwarded by Truman to the US Senate for confirmation. Dudley was the son of Dr. and Mrs. E. R. Dudley of Roanoke, and his childhood home was 405 Gilmer Avenue, NW. From 1945 until 1947 he served as general consul to the Virgin Islands. Dudley graduated from Lucy Addison High School and left Roanoke in 1928 to pursue higher education. He was residing in New York City at the time of his nomination.

Salem officials alerted residents that the town would be sprayed with DDT to prevent infantile paralysis. Fly-breeding areas were the main targets.

Charlwynn House, a seafood restaurant, opened on July 30 on Route 11 west of Salem.

Howard Gilmer of Pulaski was sworn in as the US Attorney for the Western District of Virginia on July 30.

Dr. J. N. Dudley, Roanoke's health commissioner, announced the appointment of a Polio Advisory Committee in late July. The advisors were Dr. H. W. Wescott, Dr. Berkley Neal, and Dr. Charles Irvin.

The Roanoke Archery Club laid out an archery course on a ten-acre tract at the foot of Mason's Knob on the Bent Mountain Road. The fourteen-target course had targets ranging from fifteen to fifty feet and was known as the Sherwood Forest Range.

The last streetcar run in Roanoke occurred on July 31, ending service that began in 1887. Operators on the cars for their final midnight runs were L. G. Kessler and L. C. Kessler. O. D. Smith, an employee of Appalachian Power Company, flipped the streetcar system switch to off at the power station on Walnut Avenue, SE. The final runs were on the South Roanoke-Raleigh Court lines. On one of the final runs, city dignitaries and other guests were passengers. Buses began operating on the South Roanoke and Raleigh Court routes the next day.

The town of Vinton and Roanoke County joined other localities in spraying certain sections with DDT to eliminate flies and mosquitoes in an effort by public health officials to curb the spread of infantile paralysis.

De Luxe Shoe Repair opened on August 2 at 1845 Williamson Road, operated by Layman Garst.

Bohon Aviation launched the Roanoke region's first aerial sign service in late July. One of the first banners towed by Lawrence Bohon's Stearman read "Read the *Roanoke Times*" in seven-foot letters.

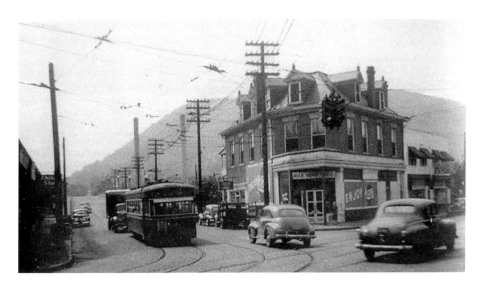

This 1948 photo shows the intersection of Walnut Avenue and Jefferson Street, SW. Walnut Avenue Bridge is in the background. *Historical Society of Western Virginia.*

Charley Turner defeated Landon Buchanan to win the 1948 City-County tennis title at South Roanoke Park on August 1. Turner had dominated city tennis for years. Turner and Buchanan teamed up to win the men's doubles title, defeating Doug Craig and Paul Rice a week later.

Roanoke streets were flooded especially in downtown and in the Williamson Road sections when three inches of rain poured on the city in a short period of time. The flooding was blamed for one death, that of Claude Martin, fifty, of Roanoke County, who was electrocuted when pumping water out of his basement.

The first infantile paralysis (polio) case in Roanoke for 1948 was reported on August 4. The patient was a twenty-two-year-old man, and his wife and children were quarantined. The Roanoke Hospital polio ward had treated eighteen cases, but all were from outside the city.

Wiley-Hall Motors at 1337 W. Main Street, Salem, was purchased by Walker Motors. C. G. "Honey" Walker of Virginia Beach was president of Walker Motors. The motor companies sold Ford-brand automobiles.

Radio evangelist Rev. M. F. Ham held a revival service at the American Legion Auditorium on August 8. His message was entitled "The Doom of Russia." Ham's radio program was *My Old Kentucky Home Revival Hour.*

The Kellers Motor Corporation held a special showing of its 1948 model of the Keller Super Chief convertible and Super Chief station wagon at the Hotel Roanoke on August 9 and 10. The corporation invited dealerships to visit as the Huntsville, Alabama, company was looking for a local dealer.

The Roanoke Civic League held its annual organizational meeting at the Hunton Branch YMCA and elected S. E. Brown as president and Reuben Lawson, vice president.

Juanita Stanley defeated Nell Boyd for the women's title in the annual City-County tennis tournament held at South Roanoke Park in early August. The doubles championship was won by Kitty Coxe and Nell Boyd.

Mayor Oscar Lewis presided over his final Salem Town Council meeting on August 9. He had served on the body for twenty consecutive years, being first elected as a councilman in 1928. Lewis, eighty, had never been opposed in his bids for reelection.

Monticello Craftsmen opened on Route 221 near Cave Spring for the manufacture of authentic reproduction furniture.

Various local insurance representatives began advertising polio protection policies usually with coverage of up to $5,000 for $5 per year.

George Fulton won the Roanoke Country Club golf championship. It was the third year in a row Fulton claimed the title.

The Roanoke City Council authorized an additional $2,000 for precautions against a polio outbreak in the city. The monies were to be used for more spraying of DDT along the Roanoke River and in garbage cans.

A fire completely destroyed the home of Preston Hylton in the Mount Pleasant section on August 10. Neighbors helped the widower and his three children recover from their losses.

The first death from infantile paralysis in Roanoke city for 1948 occurred on August 10 when D. G. Robertson, twenty-two, died at Roanoke Hospital.

Residents of northwest Roanoke had complained for weeks about "red water." City officials addressed the issue by offering water softeners to those impacted.

Dr. Manning Potts, formerly of Roanoke, became the editor of the *Upper Room* devotional magazine in mid-August. The magazine had a circulation of two million and was published in numerous languages by the Methodist General Board of Evangelism.

Johnny Peek defeated Denny Merchant to win the City-County junior tennis championship held in South Roanoke Park on August 11.

The state board of elections concluded its official canvas of the results of the statewide August 3 Democratic primary for US Senate. The board reported that incumbent Senator Willis Robertson defeated James Hart Jr. of Roanoke 80,340 to 33,928.

The body of Eugene Sayers, thirty-four, of Tazewell was found in an N&W Railway car in Roanoke on August 12. The body had been crushed by a load of iron pipe. The victim was identified as an escaped inmate from Southwestern State Hospital at Marion.

The Roanoke Blood Bank began operations on August 13. A group of fifteen N&W Railway employees made the first contributions. The bank's headquarters were at Room 205 in the Jefferson Apartments, 818 S. Jefferson Street.

An estimated crowd of seven thousand in Salem watched a thousand visiting firemen from around the state parade down Main Street on August 13. The parade was the conclusion to the annual convention of the Virginia Fireman's Association. The parade consisted of six bands and twenty-five pieces of fire apparatus. According to town officials, it was the biggest parade in Salem since Roanoke County's centennial parade in 1938.

A new chest respirator was flown in to Roanoke from the New York Polio Foundation headquarters on August 13. The respirator was taken to Roanoke Hospital.

Mrs. James Reynolds of Richmond won the Ladies' Virginia State Golf Championship held at Roanoke Country Club in mid-August.

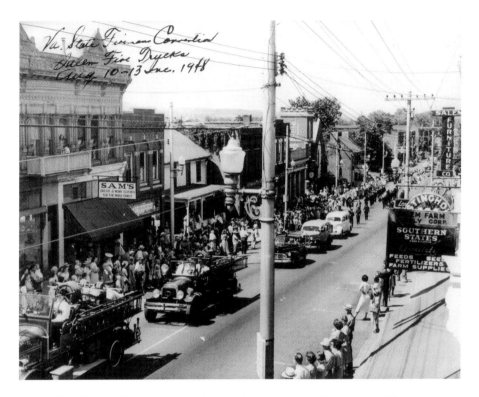

The Virginia Fireman's Association Parade moves along Main Street in Salem in
August 1948. It was the biggest parade in Salem in a decade. *Salem Historical Society.*

J. W. Haddad opened a store selling Oriental and American rugs at 2319 Melrose
Avenue, NW, in mid-August.

A sixty-acre peach-and-apple orchard known as Jamison or Wright Siding Orchard
came up for auction on August 24. The orchard was located three miles south of Starkey
on Route 615.

The Used Car Corporation opened a new used car lot at 328 W. Campbell Avenue
on August 16. The lot was operated by Dave Fitzhugh and Bud Payne.

A musical battle of two great bands was held at the American Legion Auditorium on
August 18. The double attraction dance event featured "Bull Moose" Jackson with the
Lucky Millinder Recording Orchestra and Paul Williams and his orchestra. White specta-
tors were admitted.

Western film comedian Dub Taylor, along with the Wabash Cannonballs, came to
the stage of the Roanoke Theatre on August 18.

The *Roanoke Times* expanded its Sunday comics section from twelve to sixteen pages
on August 22. The new comic strips were *Steve Canyon, Rusty Riley, Buz Sawyer, Donald
Duck, Ozark Ike, Barney Google and Snuffy Smith, Smitty, Tim Tyler's Luck,* and *Elmer.*

The Bent Mountain Game Protective Association held its annual fish fry at Wimmer
Park on Bent Mountain. As part of the fun, the association conducted a mock trial of
a member for killing a squirrel out of season. There was also a skeet shoot, horse shoe

pitching, and a husband-calling contest. Officers were C. F. Holt, W. E. Kefauver, Walter Overfelt, and E. V. Baldwin.

The Vinton War Memorial building opened to the public on August 20. The war memorial consisted of a community building, swimming pool, and fifteen-acre park and was dedicated to the town's twenty-eight World War II dead. The total cost for the memorial was $93,000. According to town officials, it was the first memorial of its scope in Virginia. The dedicatory speech was given by P. E. Ahalt, principal of William Byrd High School.

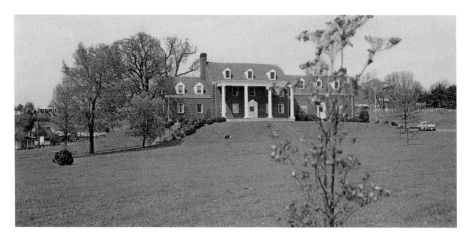

This 1950s postcard shows the Vinton War Memorial that was dedicated in 1948 to the town's twenty-eight casualties in World War II. *Virginia Room, Roanoke Public Libraries.*

Roanoke's Piedmont League baseball team, the Roanoke Red Sox, was purchased by a group of local businessmen operating as Roanoke Baseball, Inc. The sale was transacted on August 16, with the team being sold by the Roanoke-Salem Baseball Corporation, headed by Stanley Radke. Clarke Wray headed the new ownership group.

Administrators of four Roanoke hospitals reported that they were prepared to assist in the event of a polio outbreak. Roanoke Hospital was the center for polio cases, but officials with Jefferson Hospital, Lewis-Gale Hospital, Shenandoah Hospital, and Burrell Memorial Hospital assured health officials they would prepare rooms to take in polio victims should the need arise.

The Roanoke Firemen's Annual Ball was held at the American Legion Auditorium on August 20. Russ Carlton and his orchestra played for the event and were joined by vocalist Audrey Roach.

Over five hundred Roanoke youngsters attended the final Play Day of the City Recreation Department at Wasena Park on August 18. The event included bicycle races, a parade, boxing bouts, and exhibitions.

The Vinton Lions Club sponsored the annual Vinton Horse Show on August 21. The event was held at the William Byrd High School athletic field.

The Hicks-Kesler Flying School was granted a charter by the SCC on August 20. The school operated at Woodrum Field, and the officers were Jackson Hicks and Paul Kesler.

Hill House was the living quarters for student nurses working
at Roanoke Hospital, 1948. *Carilion Clinic.*

Sidney Pace, eighty, died on August 21 in a Roanoke hospital. Pace was in real estate and developed many of the early neighborhoods and subdivisions in Roanoke city and county.

A ceilometer was put in operation at Woodrum Field on August 21. The meteorological instrument measured the heights of clouds. Prior to the new instrument, airport officials used balloons to estimate cloud height over the airport.

The Roanoke City health department advised parents to keep their children away from unnecessary gatherings as a means of polio prevention.

Six of the sixteen trolleys that were removed from streetcar lines were sold to locals who planned to convert them for use as summer cabins, homes, and hamburger stands. The remaining cars were sold to a dealer who intended to resell them to other cities still using streetcar lines.

Cushman Motor Scooter opened in August at 207 Williamson Road.

The American Legion held a parade in downtown Roanoke on August 24 in connection with a state convention that occurred that same weekend. The convention met at the American Legion Auditorium.

H. S. Tolchard of Roanoke announced in late August that he had developed a new dog cleaner that killed tics, fleas, lice, and odors. Tolchard's Dog Lotion was to be sold nationwide via a contract with a national dime store chain, and a local plant would be erected to handle demand.

The Salem Catholic Mission launched a plan to raise funds for reerecting an army chapel that was purchased from the War Assets Administration. The chapel was at Camp Butner near Durham, North Carolina, and was to be dismantled and moved to Salem. Its planned location in Salem was at the corner of West Main and Green Streets and would be called Our Lady of Perpetual Help. The Redemptive Fathers of St. Gerard's in

This was the very first chapel of Our Lady of Perpetual Help in Salem. The chapel had been moved from an army base in North Carolina, 1948. *Nelson Harris.*

Roanoke were in charge of the Salem parish. Frank Svoboda was chairman of the fundraising campaign.

Blue Ridge Parkway officials continued acquiring rights-of-way through the Bent Mountain section in late August. The home of the late Joseph Lancaster had been purchased for the route and was to be razed.

Four new business offices opened at 101 Williamson Road, formerly occupied by Two J's Restaurant, in late August. They were C & B Insurance Agency, Neal and Ferguson Company, Yeatts Machine Company, and Standard Duplicating Machine Company.

Goode's Department Store at 1912 Williamson Road held its formal opening on August 27.

The Ninth Annual Roanoke Fair opened on August 30 at Maher Field. The fair and expo included grandstand shows that featured Werner Amaros, Georgiana Dictcr, the Musical Johnstons, Tiebor's Sealions, aerialist Ullaine Malloy, and acrobats Sorelle Salton's Company. There were agricultural and livestock displays, handicraft judging, and the John H. Mark's Shows, billed as a "Mile Long Pleasure Trail," on the midway. Fireworks were nightly, and music was provided by the Jimmy St. Clair Circus Band. An estimated twelve thousand persons attended the fair on its closing day.

Taylor-Rutrough, a men's clothing store, opened at 30 Church Avenue, SW, on September 2. The two main proprietors were E. A. Rutrough and T. M. "Mac" Taylor.

Williams P. Hunter was elected by his Roanoke City Council colleagues to serve as the city's mayor at their organizational meeting on September 1. Benton Dillard was named as vice mayor. Hunter succeeded Richard Edwards in the mayor post. Mayor W. R. McGee of Vinton was reelected by the town council to a two-year term as mayor. In Salem, James Moyer was elected mayor by the town council.

A contract was awarded to Adams and Tate Construction Company by Roanoke city officials for the removal of streetcar rails throughout the city. The contract was for $20,000.

John Simpkins of Loudon Avenue, NW, in Roanoke was found dead in the middle of Route 460 on September 1. Police believe Simpkins was the victim of a hit-and-run. His body had been carried about eighteen feet from the point of impact.

At 6:10 p.m. on September 4, WSLS radio invited listeners to tune their radio dials from 1240 to 610 for the dedication program of what was billed as "the greater WSLS." The station moved from 250 watts to a 1,000-watt transmission that could reach sixty-seven counties in three states. The transmission towers were located on a forty-acre tract near Lakeside Park.

McAvoy Music House opened at its new location at 106 W. Church Avenue on September 7.

For the first time in Roanoke's history, the Retail Merchants Association organized a mass fashion show involving all clothiers in the downtown area on September 9. Stores held open houses with live models and window displays. The Fall Fashion Futurama began promptly at 7:30 p.m. when the whistle signal at the N&W Railway yards sounded. Campbell Avenue and Jefferson Street were flooded with light provided by the 16th Engineer Company of the US Marine Corps Reserve and gave a carnival-like feel to the event. Kirk Lunsford Jr. was publicity chairman for the event. An estimated twenty-five thousand persons came downtown for the fashion night.

This was the Children's Department at Heironimus in downtown Roanoke. The photo is from the late 1940s. *Virginia Room, Roanoke Public Libraries.*

These were the floor displays for the Calexico Colorama clothing
line inside the Heironimus store in downtown Roanoke, late
1940s. *Virginia Room, Roanoke Public Libraries.*

The coal yard and facilities of Howard Coal Company at 610 Warwick Street, SW,
were purchased in early September by Catawba Coal Company. The company offered
Pocahontas, Keen Mountain, Red Ash, Clinchfield, Iroquois, Tom's Creek, and New
River coals.

Earl Bostic and his orchestra played for a show and dance at the American Legion
Auditorium on September 6. White spectators were admitted.

Johnny Long and his orchestra played for a show and dance at the American Legion
Auditorium on September 9. The stage show also featured the singing group the Beach
Combers. Black spectators were admitted for half price.

Clarence Smiley, inventor and manufacturer of a knife widely used by tomato can-
neries, died at his home in Bonsack on September 7. He was sixty-four.

The N&W Railway received the Edward H. Harriman Memorial Gold Medal for
outstanding safety record among the nation's large Class 1 railroads for 1948. The railway
earned the medal in 1926, 1938, and 1940.

Fifty home sites and one apartment building went up for auction on September 8,
all known as the Fairland subdivision. The tract was located on Cove Road at the end of
Lafayette Boulevard in the Villa Heights section.

Roanoke native and film star John Payne was sued for divorce by his actress wife
Gloria DeHaven in early September in Los Angeles, California. The couple had wed in
December 1944. It was Payne's second marriage.

The Acme Super Market opened on September 16 at 709 Franklin Road, SW. The
location was formerly occupied by A&P Super Market. Thomas Roman Jr. was the
manager.

Mrs. Georgia Whiticar, well-known resident of Salem, was shot and killed by her nephew Donald Sigman, twenty-six, of the Riverdale section on September 12. Whiticar, fifty-two, was killed in her apartment on Main Street.

Black civic leaders throughout Virginia gathered in Richmond and announced a consolidated effort to support the reelection of President Harry Truman. The Virginia Committee to Re-Elect Truman was chaired by Dr. Harry Penn of Roanoke.

Blackface comedian "Slim" Williams brought his *The Darktown Deacon* act to the stage of the Roanoke Theatre on September 15.

Creed Atkins of Coopers Cove died on September 12, one day after celebrating his one hundredth birthday. Relatives from several states had gathered to honor Atkins on his century mark and during the party he said, "I want to turn 100 and then go home." Atkins was survived by five of his ten children, thirty-three grandchildren, fifty-one great-grandchildren, and ten great-great-grandchildren.

WDBJ celebrated the tenth anniversary of the nationally broadcast *The Lone Ranger* on September 13 with a special all-evening selection of favorite episodes of the program. Listeners learned how the Lone Ranger got his name, how he captured his horse, Silver, and how he and Tonto became companions.

Kohen's Lingerie opened at 3 W. Campbell Avenue on September 16. The store was under the auspices of the David Kohen Company, of which Josef Cohn was president. Edith Gregory was the manager of the new store.

The first efforts to place power lines underground in downtown Roanoke began on September 14 when a trench was dug along the block between Bullitt and Elm Avenues on Jefferson Street.

Roanoke's War Memorial Committee scaled back the budget for the planned war memorial in Elmwood Park from $900,000 to $600,000 after leaders became concerned that the original figure could not be raised. The new version still called for a large rotunda to be placed as a centerpiece in Elmwood Park. The committee felt certain the other elements could be accomplished over time but not as part of the original phase. Committee chairmen J. H. Fallwell and Arthur Taubman were asked to carry the plan forward to city leaders and solicit public funds as well.

Thirty-four cars of an eastbound N&W Railway coal train derailed in Salem on September 15. The wreck was just off Fourth Street and west of Union Street and blocked a main line of the railway for a day before the wreckage could be cleared. Some 2,200 tons of coal were spilled, and hundreds flocked to see the derailed cars. The accident was at almost the exact same location as the derailment that happened on December 24, 1947. There were no injuries, and a broken wheel was determined to be the cause.

Representatives of various civic organizations organized the Roanoke Foundation at a meeting at the Hotel Roanoke on September 16. They elected M. C. Townsend as temporary chairman. The idea of a foundation to raise monies for civic projects in the city was the idea of Roanoke's city manager Arthur Owens.

Members of the Roanoke Junior Chamber of Commerce painted air markers around the Roanoke Valley in mid-September. The first was "Salem" in large white letters on the roof of the Roanoke College gymnasium with an arrow pointing to Woodrum Field. Another was "Vinton" on the roof of the weaving mill, and "Roanoke" on the Market Building was repainted.

Business offices for C&P Telephone Company moved to 10 Alabama Street in Salem in mid-September. All equipment would not be moved to the new location from Farmers National Bank until the rotary dial system was implemented by February 1, 1949.

The Fort Lewis estate near Salem was auctioned for subdivision purposes on September 18. The forty-seven-acre site had been subdivided into house lots. The Fort Lewis mansion and nine adjoining acres were sold separately.

Miss Sadie Lawson, a teacher for thirty-two years in Roanoke public schools, was named dean of women at Cheney State Teachers College in Cheney, Pennsylvania. Lawson had been head of the English department and assistant principal at Lucy Addison High School for twenty years.

Removal of abandoned streetcar trolley wires began in mid-September. W. H. Horn, general manager of Safety Motor Transit Corporation also stated that the firm had sold all streetcar equipment to a firm in Pittsburgh, Pennsylvania, including trolley wire, streetcars, machinery, and stores. The streetcar barn was to be transferred to Appalachian Electric Power Company.

Streetcar ties and rails are being removed in 1948 near Hamilton Terrace. Streetcars had been replaced by buses by late 1948. *Historical Society of Western Virginia.*

John W. Hancock, Jr., Inc., announced the first model Gunnison Home, a subsidiary of US Steel. The model home was located at 2509 Wycliffe Avenue, SW, and was open to the public the last two weeks of September. Hancock was the local authorized dealer.

Renick Motor Company held its formal opening on September 20 at 2239 Franklin Road, SW. The company sold and serviced Kaiser-Frazer brand automobiles.

The Williamson Road Health Center opened on September 20 in the 2400 block of Williamson Road. The main feature of the sports complex was twelve duckpin bowling alleys. The center was owned and operated by O. W. Shepherd and H. H. Peters.

An organizational meeting for States Rights Democrats, known as "Dixiecrats," was held in Salem on September 20 at the courthouse. The group, like others around the

This shows the front entrance of Andrew Lewis High School in 1948. David McClung II is driving the jeep from Renick Motors. *David McClung.*

nation, was organized to support the presidential campaign of South Carolina's Governor Strom Thurmond. J. J. Bower was the local organizer.

Lucius Johnson, president of the Johnson-McReynolds Chevrolet Corporation, died at his home on September 19 of a self-inflicted gunshot. He was forty-three. Family members stated Johnson had been in declining health for years. He had been in the automobile business in Roanoke for fifteen years.

The Roanoke City Council appointed K. A. Pate as a judge of the Juvenile and Domestic Relations Court for a six-year term. He was appointed on a 3–2 vote to replace the sitting judge, Odessa Bailey.

Dr. Marcellus Johnson Jr. of Roanoke was elected the first president of the newly formed International Association of Rescue Squads at an organizational meeting in Atlantic City, New Jersey, on September 20. Julian Wise was elected eastern director of the organization.

Buddy Johnson and his orchestra played for a dance at the American Legion Auditorium on September 23. Vocalists were Ella Johnson, Arthur Prysock, and the Four Buddies. Johnson was known for his hits "Baby Don't You Cry," "Since I Fell for You," "Fine Brown Frame," and "Li'l Dog." White spectators were admitted.

Screen actress and Roanoke native Lynn Bari (real name Marjorie Fisher) celebrated the birth of a son, John, in Hollywood on September 20. Bari was married to Hollywood producer Sid Luft.

The Walnut Avenue Bridge was closed the third week in September for removal of streetcar track and resurfacing.

Roanoke County issued a building permit to the Starkey Speedway and Amusement Company on September 21 for the construction of a $50,000 amusement park. The park plan featured an auto racing track to be built opposite the Starkey railway station. The thirty acres for the park had been sold to the company by William Smith for $4,800. The contractor for the park's development was Homer Shropshire of City Auto Supply Company.

Mundy's at 15 W. Church Avenue became Riggle's in mid-September. Riggle's offered bowling and billiards.

The Mills Brothers Circus came to Roanoke on September 24. The circus set up at Radke Field on the Salem Turnpike and featured three rings of animal and clown acts under the big top.

Poole-Miller Company opened at their new location at 213 Franklin Road, SW, on September 24. The company was a home appliance retailer.

The Roanoke branch of the Booker T. Washington Memorial Trade School received nearly three hundred applicants for enrollment. The new training school offered classes in construction trades, electronics, barbering, and other vocational skills. The branch for men was located at 20 Loudon Avenue, NW, and the branch for women at 1401 Salem Avenue. A committee of black civic leaders and clergy oversaw the branch's operation.

Controversy followed the Roanoke City Council decision to appoint K. A. Pate as judge of the Juvenile and Domestic Relations Court over the incumbent judge, Odessa Bailey. The 3–2 decision was protested by several women's organizations throughout the city that supported the female jurist. A. R. Minton, who had voted for Pate, moved to reconsider the decision, and a spirited discussion occurred. Roanoke's city attorney, Ran Whittle, ultimately opined that Minton's motion was out of order. The Roanoke Ministers' Conference also formally criticized the council's action in not reappointing Bailey.

Police Justice Richard Pence announced his anticipated resignation from the Police Court effective November 1. His resignation was submitted to the Roanoke City Council and cited his desire to return to private law practice.

Several hundred persons attended the laying of the cornerstone for Christ Evangelical Lutheran Church on September 26 at Brandon Avenue and Grandin Road. The congregation was established in 1916 as Virginia Heights Lutheran Church.

A mother and her two children were killed on their way to church on September 28 as they walked along Route 11 near Troutville. The three family members were struck and killed by a truck. The victims were Edna Basham, forty-five; Donald Basham, fourteen; and Margaret Basham, twelve.

Twenty-eight students from four high schools met at WDBJ radio station on September 29 and formed the first Junior Achievement Corporation in Virginia. The group was under the direction of Clifford Huffman of WDBJ. Officers elected were Steve Lichenstein, president; Bobby Bohon, vice president; Janet Gibson, secretary; and Bobby Hartman, treasurer.

The Sounding Summer, a collection of poems written by Carleton Drewery of Hollins, was published by a New York firm. Drewery worked in the accounting department of the N&W Railway.

Renee Martz, an eight-year-old evangelist, preached for two services at the American Legion Auditorium on October 3. She began her preaching career in Oklahoma City, Oklahoma, at the age of six.

This image is of the foundation for Christ Evangelical Lutheran Church at the corner of Grandin Road and Brandon Avenue, SW, December 23, 1948. *Christ Evangelical Lutheran Church.*

The cornerstone for Christ Evangelical Lutheran Church was laid during a ceremony on September 26, 1948. *Christ Evangelical Lutheran Church.*

South Carolina Governor Strom Thurmond, the States Rights Democrats' presidential candidate, brought his campaign to Roanoke on October 6. J. J. Bower of Roanoke County was the campaign's local advance man. About one thousand persons heard the governor declare, "If Virginia can solve her problems by separating the races that is the privilege of Virginia."

The Club Morocco opened under new management on October 1. Lunch service began at 11:00 a.m. and high school hour each day from 3:00 to 5:00 p.m. A floor and dance show kicked off the new management's program and featured the Aristocrats of Swing. The club was located at 109 N. Henry Street and advertised a reserved section for white spectators.

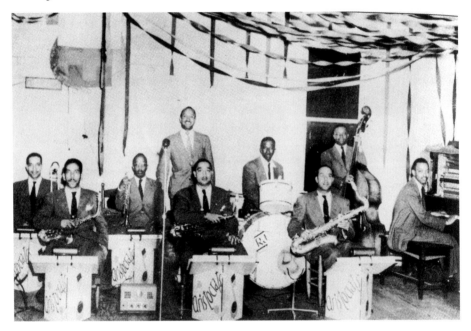

The Aristocrats of Swing was a popular dance band. In this photo, they are playing at the Morocco Club on Henry Street, 1940s. *Harrison Museum.*

A doubleheader football contest was held at Victory Stadium on October 2. Washington and Lee defeated Ohio University 13–0, and it was the first college game held under the lights at the stadium. In the second game, the University of Virginia defeated Virginia Tech 28–0. An estimated seventeen thousand fans watched the games in ideal weather.

Fifty home sites in the Fairland subdivision went up for auction on October 5. The sites were on Aspen Road, Kirkland Drive, and Meadow View Drive.

Lansing Hatfield, baritone formerly with the Metropolitan Opera, performed at the American Legion Auditorium on October 5.

The Huntington Court Methodist Church on Williamson Road was dedicated with an 8:00 a.m. Holy Communion service on Sunday, October 10. Dr. J. Manning Potts was the guest preacher.

This photo was taken in 1948, the year Huntington Court Methodist Church
on Williamson Road was dedicated. *Huntington Court Methodist Church.*

The new First Church of the Brethren was dedicated on October 10. Located at 20
Street and Carroll Avenue, NW, the building was constructed for $115,000 by a member-
ship of three hundred.

Merritt Powell sold his store at Bent Mountain to C. Stewart in mid-October.
Clinton Craighead and Edgar Baldwin of Bent Mountain purchased large orchard tracts
at Big Bend.

The Hotel Roanoke opened its new one-day laundry on October 3. The laundry oc-
cupied a second story of a new building on Wells Avenue.

A new drive-in theatre for Roanoke County was announced, with the location be-
ing one mile east of Vinton on the Stewartsville Road. The drive-in's operators listed on
the building permit were W. A. Bohon and E. C. Creasy of Roanoke. The name for the
$60,000 project was to be the Dixie Drive-In Theatre.

Roanoke's streetcar repair shop officially closed its doors in early October when Alan
Crantz, foreman, dropped the doors and locked them. The shop was located beneath the
Walnut Avenue Bridge. Crantz retired the next day after fifty-six years of service.

The long-planned AAA high school driver training program became a reality when
Larry Dow Pontiac presented Jefferson High School with a 1948 Pontiac equipped with
dual controls.

Buster Bennett and his orchestra performed at Club Morocco on October 8 along with the Aristocrats of Swing.

John Kanode, a plasterer, fell three stories from the Appalachian Electric Power Company building on Franklin Road and lived. Kanode, twenty-three, fell into a pile of sand on the sidewalk and managed to suffer only fractures on two bones and abrasions. The construction foreman said Kanode had been knocked from his position near a construction hoist.

The new American Electric Power Company building is under construction on Franklin Road in this 1948 image. *Virginia Room, Roanoke Public Libraries.*

Eighty homes sites came up for auction in the Oakdale subdivision on October 16. Oakdale was located on the former Hicks family farm along Hershberger Road.

Louis Jordan and his orchestra came to the American Legion Auditorium on October 14. White spectators were admitted to the dance and stage show.

A fire swept through the City Auto Supply Company on Tenth Street, NE, on October 9. The fire damage was estimated at $200,000. Business owner Homer Shropshire stated the business was uninsured.

The first heat pump ever installed in a home in Roanoke was put in the new home of E. B. Setzler on Yellow Mountain Road in mid-October by Appalachian Electric Power Company. The power company called it an "experiment." The unit was manufactured by York.

A unit of the "Wallace Caravan" came to Roanoke for a three-day stand on October 10. The caravan was part of the presidential campaign of Henry Wallace, an independent running on the Progressive Party ticket.

A. J. Oliver, the first black attorney to practice in Roanoke, died at Burrell Memorial Hospital on October 8 at the age of eighty. He passed the West Virginia Bar exam in 1885 and became the first black attorney in that state. He moved to Roanoke in 1889. He was also a columnist for the *Roanoke Tribune*.

Samuel Price was unanimously elected by the Roanoke City Council to replace retiring Judge Richard Pence as Civil and Police Justice.

Both the *Roanoke Times* and the *Roanoke World-News* endorsed Republican Thomas Dewey in their editorials over incumbent President Harry Truman. Both papers argued that Truman had violated states' rights through various Federal controls, namely civil rights, and had not been an able administrator of the nation's government.

Johnny Hand's Hell Drivers came to the Roanoke Red Sox ballpark on October 16. The auto daredevil show featured fifteen stunts, five drivers, and two clowns. Some 1,500 people attended the event, which culminated in former Roanoke taxicab driver "Wild Bill" Collins jumping an auto over a tractor trailer and into junk cars.

Bubbles Becker and his orchestra played for a cabaret dance and floor show at the American Legion Auditorium on October 16.

The new fine arts building at Hollins College was dedicated and opened on October 15. Guest speaker for the occasion was William Constable of the Boston Museum of Fine Arts.

Robert Funk of Roanoke was struck and killed while walking along Route 11 near Fort Lewis Elementary School on October 15. His female companion, Mary Hoal, was critically injured and died a few days later. The driver of the auto that struck them was Herman Ashby of Roanoke.

Furman Whitescarver, former member of the House of Delegates and the chief legal counsel for Roanoke County in the annexation suit by Roanoke City, delivered an address to the Salem Kiwanis Club, where he advocated consolidation of the two governments. "We in the Roanoke Valley are the same people and should consolidate our efforts for the entire area." Consolidation would end duplication of services and save taxpayer money, he argued.

An initial meeting and rehearsal of the season of the Roanoke Civic Orchestra was held at the Our Lady of Nazareth School on October 17. It was a successor to the Roanoke Symphony Orchestra and was under the direction of Franklin Glynn, organist at St. John's Episcopal Church.

Five authors, four of them Pulitzer prize winners, were announced as the lineup of speakers for the 1948–49 City-County Public Forum lecture series. The guest lecturers were Walter Duranty, H. R. Knickerbocker, Stuart Chase, John Brown, and Hanson Baldwin. Griffith Dodson Jr. was chairman of the forum, and lectures were held at the Academy of Music.

Hazel Harrison, a concert pianist, performed at High Street Baptist Church on October 24. Her performance was sponsored by the Lula Williams Branch of the YWCA.

Jennie Tourel, mezzo-soprano with the Metropolitan Opera, presented a concert at the Academy of Music on October 20 under the auspices of the Thursday Morning Music Club.

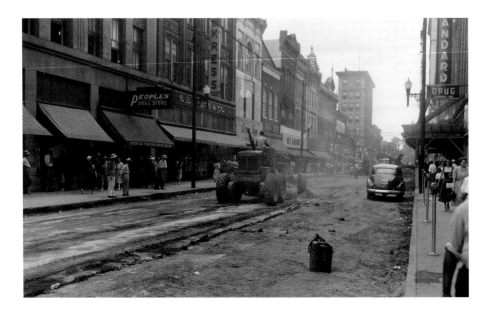

Campbell Avenue in downtown Roanoke is being repaved in 1948. The city had a backlog of street projects following the war. *Historical Society of Western Virginia.*

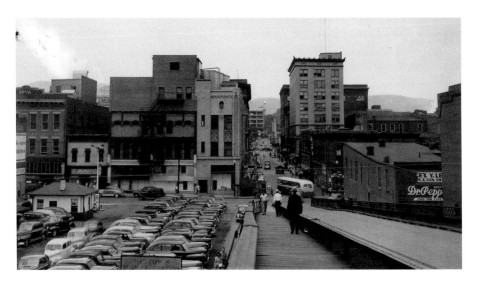

This is Henry Street (First Street) at Salem Avenue in 1948. The small building and car lot in lower left was the Midtown Service Station. *Historical Society of Western Virginia.*

Roanoke's Army Organized Reserves moved into its new armory at 807 Norfolk Avenue, SW, on October 16.

Osceolo Lodge, forty-seven, Knights of Pythias, formally opened their new club room at the Pythian Hall on October 21. The room contained a library, lounge chairs, radio, and game tables.

The initial public meeting of a new civic organization, the Roanoke Citizens Association, was held at the American Legion Auditorium on October 17. About 250 people attended. The stated purpose of the organization was to make Roanoke a better place to live.

A contract to construct a new addition to the northeast side of the Roanoke County courthouse in Salem was awarded to Martin Brothers for $186,675. H. M. Miller of Roanoke was the architect.

Mrs. Nettie Oliver, thirty-four, was gunned down on the steps of her northwest Roanoke home on October 20. The victim suffered four bullets to the chest. Her estranged husband, Thomas Oliver, was arrested for the crime.

Two freeholder bond referendums passed in Roanoke city in a special election held on October 19. The two referendums approved a total of $1.1 million, with most of the money used to address properties and promises the city made in its successful annexation suit against Roanoke County. The vote was roughly 2,000 in favor and 1,200 opposed for each bond.

Airlee Court Baptist Church at the corner of Hershberger Road and James Street was dedicated on Sunday, October 24. The congregation was formally organized in March 1948.

The biggest single project in streetcar rail removal in Roanoke happened at midnight on October 23 when the switching system at Jefferson Street and Campbell Avenue was removed. The intersection was closed for over a day. The network of switches, known as "Grand Union," was installed in 1926 at the intersection.

Louis Randolph's Smarties from Philadelphia performed at the Club Morocco on October 23 and 24.

The Barter Theatre brought its production of *Papa Is All* to the Academy of Music on October 28. Gordon Summers and Elizabeth Wilson played the leads.

Duke University defeated Virginia Tech 7–0 in football at Victory Stadium on October 23. An estimated ten thousand fans attended the game.

Several hundred navy veterans, reservists, and active personnel attended the inaugural Navy Memorial Sunday in services at Greene Memorial Methodist Church on October 24.

Roger Kelley, age twenty months, was struck and killed on October 23 by an N&W Railway freight train near his home in Vinton.

Leslie Mincey of Raleigh, North Carolina, had a six-game total of 815 points to win the annual Luckland Alleys duckpin bowling tournament in late October. A field of 66 competed in the event.

The Roanoke City Council agreed at their meeting on October 25 to begin opening their session with a prayer delivered by a local member of the clergy. The recommendation for such a practice came from the McClanahan Bible Class of First Presbyterian Church. Vice Mayor Benton Dillard supported the measure after he was assured by his colleagues that all sects would be invited, including Protestant, Catholic, Jewish, Muslim, and Buddhists.

One of Salem's oldest structures, the McClung Building, was razed the week of October 25 to make room for the northeast addition to the courthouse.

James Trussler, seven, died from injuries he sustained when he fell off a truck driven by his father at the Crumpacker Orchards near Bonsack on October 26.

"Can Russia Be Part of One World?" was the question put before the first of the City-County Public Forum lectures at the Academy of Music on October 25. Two Pulitzer-prize-winning journalists responded to the issue in a debate-style format. Arthur Duranty argued that Russia operated out of fear and not aggression, while H. R. Knickerbocker asserted Russia was innately aggressive and only the full weight of America and its allies could stop her. Dr. E. D. Myers of Roanoke College was moderator.

John Marion was named as the manager for the Roanoke Red Sox for the 1949 season. He had managed a Class C team in the Canadian-American League for the past three seasons. Marion succeeded Mike Higgins. The announcement was made in late October by Clarke Wray.

Cotton Watts All-Star Revue came to the stage of the Roanoke Theatre on October 27. According to the ad, the show featured "six big Blackface acts."

Carson's, a self-service ladies apparel shop, opened on October 29 at 140 W. Campbell Avenue.

The Pan-Hellenic Council elected officers at its inaugural meeting. Dr. Harry Penn was elected president, and other officers included Mrs. Almond Crockett, Miss Alice Moore, Mrs. Letitia Penn, Douglas Sorrell, and Rev. W. J. Simmons.

Dr. Pepper salesman Bill Davis is in front of a display in 1948.
Davis was a well-known personality and spokesperson for the
soft drink. *Historical Society of Western Virginia.*

A watercolor by Allen Palmer of Roanoke County was selected for display in the Chicago Art Institute's fifty-ninth annual American exhibition. The title of Palmer's painting was *The Dunkards*.

A building permit for a twenty-four-unit apartment house was granted by Salem to Bowles Construction Company in late October. The apartment complex was planned for the north side of Elizabeth Avenue, west of Idaho Street.

Sewanee defeated Hampden-Sydney 20–13 in football at Victory Stadium on October 30 in front of 2,500 spectators.

Over one thousand white children participated in the Roanoke recreation department's Halloween Party at Eureka Park. A party attended by five hundred black children was held near the Gainsboro Library.

Heavyweight boxing champion Joe Louis fought a four-round, nontitle exhibition match against Bob Garner of Louisville, Kentucky, on November 1 at the American Legion Auditorium. Ringside seats cost five dollars. Other bouts were Bulldog Rutherford versus Lou Atterbury, and Lou Yonkers against Harry Harvey. Attendance was 2,500.

Dr. Joe Hankins of Little Rock, Arkansas, began a three-week evangelistic crusade in Roanoke, with most of the services held at the American Legion Auditorium. Hankins's crusade was sponsored by the Roanoke Ministers' Conference and some twenty religious and church organizations. Some three thousand attended the opening night service. School passes were honored as tickets by city bus drivers so children could attend the nightly services. The crusade was aimed at youth and children.

The Roanoke City Council named the "Committee of 100 for Progress" to develop ideas and suggestions for the progress of the city. The committee was composed of one hundred citizens.

Rev. Frank Efird of Christ Lutheran Church was elected president of the Roanoke Ministers' Conference for 1949, succeeding Rev. J. E. Adkins of Melrose Presbyterian Church.

Although President Harry Truman won reelection on November 2, he was not helped by voters in Roanoke city or county. The vote in the city was Truman, 5,236; Thomas Dewey, 6,548; Strom Thurmond, 1,245; and Henry Wallace, 60. In the county, the vote was Truman, 2,876; Dewey, 3,987; Thurmond, 568; and Wallace, 16. Lynchburg mayor Clarence Burton, Democrat, won the Sixth District congressional seat, succeeding J. Lindsay Almond.

Dr. L. E. Paxton was elected president of the Magic City Medical Society for 1949 at a meeting at Burrell Memorial Hospital.

Trumpeter Harry James and his Music Makers played for a floor show and dance at the American Legion Auditorium on November 9. Black spectators were admitted for half price.

WDBJ began a new local program *The Homemakers Corner* that featured Jane Frost and Hal Grant offering cooking tips and popular music. The show debuted on November 9 and was heard three times per week.

The Dixie Minstrels, sponsored by United Commercial Travelers, performed at the Jefferson High School Auditorium on November 12, 13, and 15. The show was advertised as featuring six blackfaced Men of Fun, the UCT quartet, and a fifty-voice chorus.

Martin and Olga Stevens, puppeteers, presented *Macbeth* and *Taming of the Shrew* using their puppet-actors at the Academy of Music on November 8. The program was

sponsored by the Roanoke Woman's Club. The puppets were not on strings, but rods from below were used to maneuver the figures.

An estimated four hundred members of the N&W Railway Veterans Association, Colored Division, met for their twelfth annual meeting at Addison High School on November 13. The group was addressed by R. H. Smith, N&W president. A vaudeville show was held that afternoon in the school's auditorium.

Perdue Cinema Service, a photo finishing and movie studio, opened in mid-November at 36 Kirk Avenue, SW.

The Mighty Kara-Kum brought his mystery show to the Academy of Music on November 17. Advertisements read, "Head of any volunteer will be cut off and thrown into the audience."

Dr. Charles Smith of Roanoke College was the main speaker at dedication services for a plaque in honor and memory of Darden Harmon, for whom Salem's VFW Post No. 4318 was named. The November 14 service was held at Sherwood Memorial Park. Harmon, a native of Salem, was a marine who was killed October 8, 1944, on the Island of Saipan.

Ross Shoppe opened on November 15 at the corner of Big Oak and Williamson Road. The store offered baby items and infants' and children's clothing.

The Roanoke Raiders, a semipro black football team, played the Washington Indians, DC city champs, in Springwood Park on November 14.

Roanoke school officials announced that the new Monroe Junior High School would be ready by January 1. The new school was the first new school built in the city in twenty years and the first building in a five-million-dollar bond issue approved by freeholders. The building cost $700,000.

Bartin-Deyerle Studios opened in their new location at 16 W. Kirk Avenue in mid-November.

Holdren Maytag Appliances held a formal reopening of its store at 209 Franklin Road on November 15.

The Roanoke Ministers' Conference held a Temperance Rally at First Baptist Church on November 15. The guest speaker was a bishop of the Methodist denomination. Earlier that same day, the ministers adopted a resolution adamantly opposing the sale of beer and wine in grocery stores. Kroger Grocery on Franklin Road had applied for an ABC license prompting the ministers' conference to take a position on the matter. A&P grocery stores had been selling beer and wine for two years in the city.

The General Finance and Small Loan Corporation moved to its new location at 18-A Kirk Avenue, SW, on November 20.

Harry Lawson, seventy-one, died at his home in Roanoke on November 16. Lawson was prominent in the city's business and civic affairs. He served as a director of the Colonial-American National Bank and was one of the founders of the Old Dominion Fire Insurance Company.

Dr. W. E. B. DuBois, director of special research for the NAACP, spoke at a meeting at First Baptist Church, Gainsboro, on November 18. He was one of the founders of the NAACP and was the editor of its magazine, *Crisis*.

A building permit was granted by the town of Salem to Younger Park Building Inc. for the erection of a $10,000 office building to be located at 36 E. Main Street, just west of the Post House Tea Room.

The Virginia Air National Guard and the Civil Air Patrol performed an all-state air show at Woodrum Field on November 21 as an effort to raise funds for the forty-second annual sale of Christmas Seals. The show involved eleven F-47 Thunderbolts piloted by veterans associated with the 149th Fighter Squadron. The planes flew over Roanoke at 1:35 p.m. in a double-barred cross formation signaling the official start of the Christmas Seal sale campaign.

Virginia Tech defeated VMI 6–0 in what was billed as the Junior Military Classic at Victory Stadium on November 20. The two freshmen squads had as their guests some eight hundred local sandlot football players who paraded into the stadium in advance of the game.

Jefferson High School lost to E. C. Glass High School 20–7 in what most considered an upset at Victory Stadium. The Lynchburg team stopped the Magicians' hopes of winning their first state football championship in twenty years. An estimated eleven thousand fans attended the game.

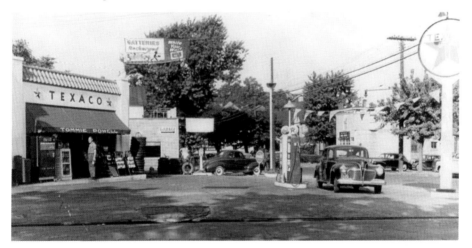

Tommy Powell's Texaco station was on the corner of Ninth Street and Tazewell Avenue, SE, in the 1940s. *Southeast Roanoke History Group.*

The N&W Railway main line at Montvale was disrupted for fourteen hours on November 20 due to the derailment of twenty cars on an eastbound coal train.

The installation of six new Goss high-speed printing presses was begun in mid-November inside the new mechanical building of the Times-World Corporation. The presses had forty-horsepower motors, and the presses had a combined weight of 284 tons. The presses could print a forty-eight-page edition at a rate of fifty-two thousand copies per hour. The installation process took four months.

A new weekly feature column began in the *Roanoke Times* on November 21. The column was a Sunday school lesson commentary provided by Dr. Roy Smith, a nationally prominent Methodist. The lessons were coordinated with forty Protestant denominations.

A corps of architectural craftsmen from a firm in Yonkers, New York, completed interior renovations to St. Andrews Catholic Church after several months of work. The crew

constructed two new marble side altars, a new marble altar railing enclosing the sanctuary, new lighting effects, new pews, and new frescoing on the walls and ceiling.

Edward Victorine and Sons, piano technicians, opened for service calls from their home at 1133 Howbert Avenue. The family had previously worked for Grand Piano Company.

Martha Ann Woodrum won the Roanoke Aviation Club's first annual spot landing contest that was held at Woodrum Field on November 21. She topped a field of thirty-four pilots.

The Roanoke Junior Chamber of Commerce completed the painting of air markers on the roof of the Roanoke College gym in mid-November. The bold white letters read "Roanoke College" with a white arrow indicating the direction of Salem as well as the numerical geographic coordinates of the town.

Woody Herman and his orchestra performed at the American Legion Auditorium on November 24. The floor show and dance admitted black spectators for half price.

Horace Smith, eighty-two, a pioneer druggist in Roanoke died at his home on November 22. From 1905 until 1922 he owned four drug stores in Roanoke.

Porterfield Distributing Company began work on a new warehouse at Eighth Street and Kerns Avenue, SW, at an estimated cost of $30,000.

Schneider Oil Company opened on November 25 at 2001 Franklin Road. The company was the local distributor for Sunoco and was owned by Leroy Schneider.

Nelson Bond addressed a creative writing class at Roanoke College and told the students that writing stories for popular magazines was difficult work. There is "no easy way" to write, he said. Bond was the author of several books and 250 short stories. He was first published in 1928.

Dizzy Gillespie and his orchestra performed for a floor show and dance at the American Legion Auditorium on November 26. White spectators were admitted.

VMI defeated Virginia Tech 33–7 in a Thanksgiving Day football game at Victory Stadium. The midafternoon match was attended by Governor William Tuck of Virginia and Secretary of State Gen. George C. Marshall. It was the 44th Military Classic of the South. A crowd of 27,984 watched the game, which had been preceded that day by the cadets of both schools marching through Roanoke from the train station and into the stadium. The city's entire police force was brought out to manage traffic. The crowd was the largest ever to see a football game in the history of Virginia.

Santa flew in from the North Pole to Woodrum Field on November 27. The 11:00 a.m. arrival was a huge event for children. From the airport, Santa traveled to Sears Roebuck and Company's Toyland at 12 E. Church Avenue.

The management of the Lee-Hi Drive-In announced that the theatre would close after November 28 for the winter and reopen in the spring.

El Geib of Washington, DC, won the Virginia State Open Duckpin bowling tournament at Luckland Alleys on November 27. Forty-three bowlers were entered in the contest.

The Roanoke Rebels, formerly the Old Dominion Rebels, opened their 1948–49 basketball season on November 31 in a game against Virginia Tech at the American Legion Auditorium. The Rebels were reorganized by Paul Compton and Sam Berry and were player-coached by Paul Rice, one of the Five Smart Boys of Roanoke College who gained fame between 1936 and 1940. The Rebels won, 55–40.

Officials of the N&W Railway announced in late November the expansion of the Motive Power Building in Roanoke. The expansion was estimated at $275,000. The building was located on Shenandoah Avenue, NE, just east of the Second Street Bridge.

Stuart Chase, author and lecturer, spoke for the Roanoke City-County Public Forum series on November 30 at the Academy of Music. His speech was titled "Inflation or Deflation? How to Get Rid of Both."

Property that housed German prisoners of war in Salem, known as the Salem Repair Shop, was to be sold in mid-December, according to officials with the War Assets Administration.

Members of the Roanoke City Council were lobbied heavily in late November to support a branch library in the Williamson Road section when the annexation program took effect. The council referred the matter to the library board chaired by F. M. Rivinus.

The Southerner Restaurant, located at 1508 Williamson Road, closed, and the contents of the restaurant were liquidated at auction on December 2.

Lionel Hampton and his twenty-one-piece recording orchestra performed for a floor show and dance at the American Legion Auditorium on December 2. He was joined by the comedy act Red and Curly. White spectators were admitted.

Roanoke city filed suit to terminate a water agreement with the town of Vinton that had been in place for thirty-four years, an agreement originally made under the auspices of the old Vinton-Roanoke Water Company. Officials in both localities could not come to agreement on terms of a new contract.

A sleek red Pullman car rolled into Roanoke on December 1 from New York. It was one of twenty-three new bedroom sleeping cars ordered by the N&W Railway and was declared a milestone in passenger comfort by railway officials.

Black and white clergy held their fifth annual joint meeting and worship at First Baptist Church, Gainsboro, on December 6. The message was preached by Rev. William Simmons of Fifth Avenue Presbyterian Church. The event was sponsored by the Roanoke Ministers' Conference and the Interdenominational Alliance.

Santa made his annual pre-Christmas visit to Vinton on December 4. He arrived by train, the southbound Tennessean, and participated in a Christmas parade led by the American Legion Drum and Bugle Corps from the train station to a vacant lot on Pollard Street, where a large Christmas tree had been erected.

The Claytor Memorial Clinic opened in the Gainsboro section and was dedicated on December 5. The clinic was dedicated to the late Mrs. Roberta Claytor, wife of Dr. J. B. Claytor Sr. In addition to members of the Claytor family, the invitees for the ceremony included the Magic City Medical Society, clergy, and close friends of the Claytor family. The medical clinic housed the offices of Dr. Claytor and three of his sons. The clinic included a physical therapy department, X-ray room, and laboratory. A public open house was held a few weeks later.

The Bank of Salem held an open house on December 7 as a formal end to a major renovation of the bank building that had begun in August. The Main Street entrance had been redesigned and the Alabama Street entrance eliminated, among other changes in interior upgrades.

A $1,700 chest-type iron lung was donated to the city of Roanoke by VFW Post 484 in early December. The iron lung was placed in the police department for use in emergencies.

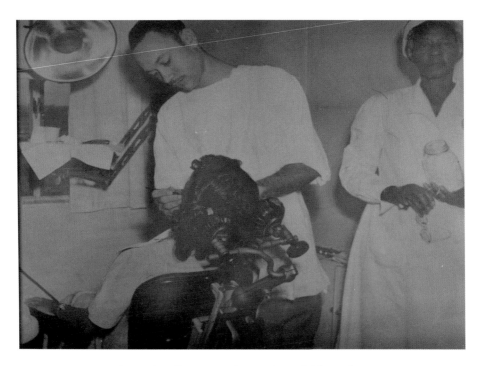

Dr. Walter Claytor is with nurse Daisy Schley as they
tend to a patient, 1940s. *Harrison Museum.*

Emmett Miller, blackface comedian, performed on the stage of the Roanoke Theatre
on December 8.

John Farmer, forty-eight, was struck and killed by an N&W Railway passenger train
in Salem on December 6. Farmer's partial deafness was blamed for his not hearing the ap-
proaching Powhatan Arrow. Farmer was using a compressor drill between the tracks as a
carpenter foreman and had his back to the westbound train.

The Roanoke City Council authorized city auditor Harry Yates to become acting
city manager should a need ever arise. The move basically eliminated the position of an
assistant city manager.

Trent Motors at 1602 Williamson Road became a new dealer for the Kaiser-Frazer
Motor Company in early December. The other local dealer was Renick Motor Company
at 2239 Franklin Road.

Charles Sherrill of Roanoke received a mail order for his patented invention, a heated
foot warmer. The order was placed by Hollywood actress Ginger Rogers as a gift for her
father.

On Wednesday evening, December 8, almost all downtown department stores ob-
served Stag Night, a men's only evening for Christmas shopping. At some stores, female
models paraded down aisles displaying jewelry and clothing for the men to consider for
their wives. Some stores, such as Pugh's, offered complimentary sodas and a buffet.

The Roanoke Touchdown Club presented its Outstanding Player in Virginia for 1948
trophy to Jack Cloud of William and Mary College during the club's annual banquet at

the Hotel Roanoke. Ed Danforth, sports editor of the *Atlanta Journal*, was the guest speaker.

Mrs. Eva Price was installed as the first president of the Roanoke chapter of American Gold Star Mothers in a December 7 ceremony at the Hotel Roanoke. Uniformed members of every branch of the armed services were present.

Airport officials announced on December 7 that American Airlines would inaugurate its new Convair Liner service to Roanoke on Christmas Day. The forty-passenger planes would make two stops daily at Woodrum Field.

Claude Rains, Hollywood actor, spent the night at the Patrick Henry Hotel on December 8. He was traveling to his family's home in Pennsylvania by auto from the West Coast.

To Hear My Banjo Play, a twenty-minute documentary film on folk music, included two persons from the Back Creek section of Roanoke County, Mrs. Fannie Grubb and Minter Grubb. The film was shot in 1941 and also included Mrs. Texas Gladden. The film was being considered for purchase by the State Film Library for showings in schools.

The National Shirt and Hat Shop at 214 S. Jefferson Street lost its lease and began advertising a going-out-of-business sale in mid-December.

Roanoke city manager Arthur Owens included no funding in his proposed 1949 budget for improvements to the Academy of Music that was owned by the city. The "Save the Academy of Music Committee" responded by sending letters to seventy-five organizations asking them to lobby city officials.

The Zetty Chinchilla Ranch opened in mid-December at 308 Princeton Circle in the Williamson Road section. The animals were advertised as "clean, hardy, odorless, easy to raise, inexpensive to feed."

Montgomery Ward on Campbell Avenue advertised a store-closing sale in mid-December. Store officials stated their lease had not been renewed and they would relocate.

Graves-Humphreys Hardware Company officials announced they would move into their new wholesale store at 1948 Franklin Road, SW, on January 3. They were formerly at 20 E. Church Avenue that had been taken over by Phelps and Armistead.

What's the Answer?, a quiz show for local listeners of WROV, began a new format in mid-December to appeal to more listeners. The show first aired on December 15, 1946.

A local cast of sixty-eight presented *A Christmas Carol* for three nights at the Academy of Music in mid-December. The play was directed by Francis Ballard and sponsored by the Junior League of Roanoke. Ballard played the role of Scrooge.

The N&W Railway announced it would begin work in the spring of 1949 on a new four-story general warehouse in its Roanoke shops at a cost of $1.8 million. It would be located immediately east of the blacksmith shop.

The Barter Theatre presented *Hamlet* at the Academy of Music on December 15. The cast included Robert Breen and Jacqueline Logan. Logan had starred in many Hollywood films. The cast also featured Broadway actor Leo Chalzel.

The Jack Horner Shop held a going-out-of-business sale beginning in mid-December as its lease had expired at its location, 209 S. First Street.

The residents of Bent Mountain learned that a favored couple new to their area would be returning there in March. Mr. and Mrs. Stanley Maxted bought the Anna Payne home in December 1947. What made them endearing was that they were British, and the husband was a famous war correspondent for the BBC and a radio actor in England. The

couple had been called back to London for Maxted to act. The WSLS station manager arranged for Maxted to continue doing a five-minute weekly broadcast for the BBC from his Bent Mountain home.

J. P. Boland, sixty-two, secretary and director of Roanoke Mills, died on December 11 at Columbia Presbyterian Hospital in New York City. Boland began his career in Roanoke in 1918 as sales manager for Carolina Cotton and Woolen Mills. In 1937 that unit became Roanoke Mills.

The Roanoke City Council decided to not renew the contract with the Civic Academy Association for the operation of the Academy of Music. The contract expired on December 14, and the operation of the academy was placed in the hands of the city manager.

Dr. T. Allen Kirk of Roanoke was awarded the top honor by the American Rose Society during its annual meeting in Pasadena, California. Kirk was made aware of the honor during a meeting of the Roanoke Rose Society in mid-December. Kirk had grown roses for thirty years and helped establish national judging guidelines for rose shows.

Charles Wiley Jr., twenty-two, of Salem was struck and killed by an N&W Railway locomotive on December 14. Wiley was driving a small truck that was broadsided by a shifter locomotive in the East End Yards. According to witnesses, Wiley was crossing the tracks while watching the approach of the Tennessean.

Scott Mattress Company opened on December 17 at 3056 Lynchburg Avenue, NW.

Grandin Court Baptist Church held a cornerstone-laying service on December 19 for their new brick Sunday School building. Rev. Harry Gamble was guest speaker.

This is the 1948 groundbreaking for Grandin Court Baptist Church's first permanent building on Brambleton Avenue, SW. *Grandin Court Baptist Church.*

The Town of Salem was the high bidder and acquired the former five-acre prisoner-of-war camp on Indiana Street from the War Assets Administration. The property was originally built as a CCC camp, then taken over by the US Forestry Service, and was last used to house German prisoners. Salem's bid was $29,860.

Thomas Oliver was found guilty of first-degree murder in the slaying of his estranged wife, Nettie Oliver, on the night of October 19. A jury imposed a sentence of twenty years.

Dr. Charles Smith, president of Roanoke College, announced he would not retire on January 1 as he had previously indicated. Smith agreed to serve as president through the end of the academic year or until a successor was found.

Roanoke City's recreation department placed several kinds of Christmas decorations throughout the city. Two trees were decked out in colored lights in Elmwood Park, a star formation of lights was placed atop Mill Mountain, a white star was mounted on the roof of the courthouse, and lights arranged in a star were placed on the roof of the municipal building.

The Williamson Road Civic League, following a meeting with Roanoke's city manager, adopted a ten-point plan for improvements to their section when the area was annexed by Roanoke City on January 1. The top priority was street improvements followed by storm water drainage.

E. S. Sisson, the mail carrier for Raleigh Court, was given two crisp one-hundred-dollar bills by the 337 families on his route just a few days prior to Christmas Day. A surprise presentation of the gift was made to Sisson at the postal substation.

Erskine Hawkins, who cowrote and popularized the song "Tuxedo Junction," and his orchestra performed for a floor show and dance at the American Legion Auditorium on December 27. White spectators were admitted.

Clark Hamilton, twenty-two, was placed in the Roanoke County jail on Christmas Eve for violating the Virginia miscegenation statute that prohibited blacks from marrying whites. It was a felony under Virginia law. Hamilton had been arrested on a warrant sworn out by his wife's mother, Ada Hammond of Roanoke County. Hamilton was black, and his wife, Florence, was white, according to the warrant. They had married on May 22 in the county, and both had listed themselves as "white."

The Roanoke Valley had a white Christmas as three inches of snow fell on Christmas Eve and more on Christmas Day, for a total of several inches.

The Karston Show came to the Roanoke Theatre on December 29, billed as America's number-one stage show "with every thrill in the book." The show featured Roberta doing her "fig leaf dance"; Parisian bombshell Renee Yvonne Barron performing "an act for the tired business man"; unicycle king Mel Hall, who rode an eighteen-foot-high unicycle while standing on his head; Gene Gory and his band, the Hendersons; and more.

Martha Ann Woodrum christened the forty-passenger American Airlines Convair Flagship "Roanoke" at a ceremony at Woodrum Field on December 27. The Convair replaced the DC-3 airliners that were operating on the Roanoke-New York and Roanoke-Memphis flight plans. Following the ceremony, American Airlines conducted preview flights around neighboring counties for 120 guests and dignitaries.

Roanoke city manager Arthur Owens told the city council that books and supplies would be moved to the Williamson Road Branch Library so that the city could effectively operate the branch beginning January 1 when its location would be in the city via annexation. Owens also agreed to staff the library with a part-time librarian.

Virginia attorney general J. Lindsay Almond spoke to a gathering of five hundred persons at the Hotel Roanoke for a rally to raise funds for a new Boy Scout camp in

Pulaski County. The campaign goal was $150,000. According to the Roanoke Council, some 3,600 scouts would be served by the camp.

The Church of Jesus Christ of Latter Day Saints (Mormons) held a groundbreaking ceremony on December 30 on a corner lot at Grandin Road and Brandon Avenue, SW. Presiding officer was Robert Price. Claude Rowland was president of the Roanoke branch of the church. Construction on the $100,000 chapel was expected to take a year.

Dr. John Hope Franklin of Howard University delivered an address at First Baptist Church, Gainsboro, on Emancipation Day in observance of the eighty-fifth anniversary of the Emancipation Proclamation.

1949

At 12:01 a.m. on January 1, the City of Roanoke doubled in size geographically and received an additional sixteen thousand residents due to annexation taking effect. The annexed territory included six schools and two fire stations, and assessed values were estimated at $13.5 million. A letter from Mayor W. P. Hunter welcoming the new citizens into the city was published on the front page of the *Roanoke Times*. In an effort to pay for the municipal services of a larger city, the Roanoke City Council adopted some new taxes in a special session convened on New Year's Eve. The new sources of revenue included a 5 percent transient room tax, a 5 percent tax on floral designs, a 10 percent tax on tobacco products, and a beer and wine tax.

Dr. Harry Penn of Roanoke was elected national president of the Omega Psi Fraternity during the organization's convention in Columbus, Ohio.

The Williamson Road Volunteer Fire Department made its last run—a flue fire on Hershberger Road on New Year's Eve at 8:45 p.m. At midnight the station was annexed into Roanoke city and staffed by paid firefighters.

Montgomery Ward opened a Catalog Office on January 3 on West Campbell Avenue.

Tommy Price and his orchestra presented a cabaret dance at the American Legion Auditorium on January 1. Sonya Glass was the vocalist.

First Baptist Church, Roanoke, entered 1949 debt free. The remaining $15,000 owed on the sanctuary was paid off the last business day of 1948. The sanctuary, one of the largest in the state, was begun in 1928 and formally opened on August 11, 1929. Architects were Frye and Stone of Roanoke.

The Foursquare Church at 612 Bullitt Avenue, SE, held a note-burning service on January 2.

A baby girl born in Lewis-Gale Hospital at 1:34 a.m. to Mr. and Mrs. Harold Hill of Roanoke county was the first birth in Roanoke of 1949.

Capt. Ralph S. Bryan Jr. of Roanoke was appointed commanding officer, Headquarters Company, 116 Infantry, Virginia National Guard, on January 1.

The Dixie Appliance Company, headquartered in Bluefield, West Virginia, announced on January 1 the acquisition of the former Dudley Store Equipment Company property in the Williamson Road section and its intent to establish a distribution branch there.

Lee Restaurant at 1903 Williamson Road closed, and a liquidation auction of its assets was advertised for January 12.

Graves-Humphreys Hardware Company formally opened its wholesale store at 1948 Franklin Road, SW, on January 3.

A new Kroger Grocery store opened on January 6 at 1915 Williamson Road.

A fire heavily damaged the Coffee Pot in the Grandin Court section on January 2. H. E. Legrande, the owner, said he would reopen in two weeks.

H. T. Angell, whose father helped start the Groundhog Club in 1918, held a meeting on January 4 to reorganize the club. At its zenith, the club regularly drew five thousand men to the Roanoke Auditorium for humorous roasts of members. The club disbanded in 1934.

A twelve-year-old boy was taken into custody for killing his grandmother, Mrs. H. T. Neece, and wounding her husband when he fired five bullets into their bed while the couple slept in their home on Sixth Street, SE. The boy admitted to police he fired the bullets as he was upset over being disciplined by his grandmother earlier in the day.

Capt. William Hopkins was appointed commanding officer of the 16th Engineer Company, Roanoke's Marine Corps Reserve Unit.

The Rev. Frank Efird of Christ Lutheran Church proposed at the first meeting of the year for the Roanoke Ministers' Conference that the organization become interracial. Efird asserted that clergy and churches must model the commands of Christ and be courageous.

Mrs. Bernice Moore of Salem was found dead face down in the mill race near her home at Hurts Crossing on January 4. Moore was a member of the prominent Moore Milling Company family of Salem. Authorities did not immediately determine the cause of her death.

Akers Brothers Garage moved from 385 W. Salem Avenue to 715 Patterson Avenue, SW, on January 5.

Julian Wise reported that the Roanoke Life Saving and First Aid Crew saved thirty-four lives in 1948. Founded in 1928 with six pieces of equipment, Wise said the crew in 1949 had 285 pieces of rescue and first-aid equipment.

Nelson Hardware Company purchased the three-story warehouse at 518 First Street, SE, from Graves-Humphrey Hardware on January 5.

A program of mountain ballads and folk songs was presented by Grace Albert to the members of the Executives Club at the Hotel Roanoke on January 12. Albert was a well-known stage and radio singer.

Lord Earl Jellicoe, attaché of the British Embassy in Washington, DC, addressed the Roanoke Rotary Club at a dinner at Hotel Roanoke on January 13. His topic was "Britain and Western Europe."

Virginia attorney general Lindsay Almond opined that the Roanoke City Council's adopted tax on wine and beer was invalid as there was no provision in the city's charter granting such authority. Almond's action put the city's 1949 budget out of balance by $200,000.

Dr. E. W. Senter of Salem announced January 8 that he would be a candidate for lieutenant governor in the Virginia Democratic primary. Senter had been practicing medicine in Salem since 1937.

The *Roanoke Times* raised the newsstand price of the Sunday paper from twelve cents to fifteen cents effective January 16. Home delivery was thirty-five cents per week for all seven days.

Luvelle Taylor was awarded the Boy Scoutmaster's Key by the National Council of Boy Scouts of America. Taylor was the first black scoutmaster in the Roanoke Area

Council to receive the award. He was the scoutmaster of Troop 101 of First Baptist Church, Gainsboro.

Paul Smith and the Tinker Mountain Boys performed for a new radio program on WDBJ that began airing in mid-January every Saturday at 7:00 p.m. The group performed a variety of "mountain music."

The Margaret Webster Shakespeare Company performed *Macbeth* at the Little Theatre at Hollins College on January 15. Lead performers were Carol Goodner, Joseph Holland, and Alfred Ryder.

"Dr. Neff, Mystifier of Magicians," came to the stage of the Roanoke Theatre on January 12. Ads read, "Madhouse of mystery, big company of ghosts, and gorgeous girls."

Howard Hammersley Jr. of the *Roanoke Times* received the Associated Press trophy for best photograph in the 1948 competition of Virginia newspaper photographers.

Ida Krehm, American pianist, performed on January 18 in the Jefferson High School auditorium. Her appearance was sponsored by the Thursday Morning Music Club. Krehm had twice won the Ontario Music Festival award and the Welsh Eisteddfod Prize.

The Junior Police Boys Club was organized at a meeting at Lee Junior High School on January 8. The Roanoke police department received 164 boys into the program, and Jimmy Kulp was elected president.

Eddie Bennett stands in front of his father's new 1949 Mercury with suicide doors at the Bennett home on Thirtieth Street, NW, 1949. *Edward J. Bennett.*

The Family Jewelry Company moved one door down, from 507 to 509 S. Jefferson Street, in mid-January. At 507, the N&W Railway opened a ticket office.

Officials with the town of Salem announced plans to transfer its town garage and equipment base from a site opposite Carver School to the newly acquired former POW camp property the town had purchased from the War Assets Administration.

This is looking east on Campbell Avenue from Jefferson Street. The Joy Shop and Barr Brothers Jewelers are at left, 1949. *Historical Society of Western Virginia.*

The Grandin Court Civic League, the Center Hill-Lakewood-Oak Hill Civic League, and the Raleigh Court Civic League consolidated to form one civic organization, the Raleigh Court Civic League, on January 10. C. L. Crockett was president of the 416-member group.

Ralph Long, chemical engineer at the American Viscose Roanoke plant, was named by the Roanoke Junior Chamber of Commerce as Outstanding Young Man of the Year in a ceremony and dinner at the Patrick Henry Hotel on January 11. Long was a charter member of the junior chamber of commerce and had held numerous leadership positions within the organization.

The attorney for Clark Hamilton waived a preliminary hearing for the navy veteran accused of violating Virginia's law against intermarriage between blacks and whites. The preliminary hearing was slated for January 12 after having been previously postponed. Judge R. T. Hubbard sent Hamilton's case to the Roanoke County Circuit Court grand jury that was scheduled for February 15.

First Lt. Mary Ellen Shull of Roanoke was among 117 women nationwide that became the first group of women in history awarded regular US Air Force commissions. She was a graduate of William Byrd High School and began her military career in 1942.

The following financial institutions listed their total assets and liabilities as recorded on December 31, 1948: Roanoke Industrial Loan Corporation, $537,273; Colonial-American National Bank, $26,587,276; First National Exchange Bank, $65,570,905; Mountain Trust Bank, $20,175,754; Peoples Federal Savings and Loan, $2,352,403; and Bank of Virginia, $62,291,364.

Roanoke Paint and Body Company opened on January 17 at 419 Salem Avenue, SW.

Nearly four hundred Boy Scout campaign leaders gathered for a dinner at the Patrick Henry Hotel on January 14 to formally launch a $150,000 campaign to acquire a new camp in Pulaski County. The campaign chairman was N. W. Kelley. Scout leaders had determined that the former site, Camp Powhatan, was inadequate. The new camp would serve not only Roanoke Valley Scouts but those within a fourteen-county area.

Hollywood actor and Roanoke native John Payne made visits to Jefferson High School and Roanoke College on January 14. The actor was accompanied by two publicity agents who took photos to use for a national magazine spread to promote his upcoming film *El Paso*. Photos of Payne were taken at the Patrick Henry Hotel, St. John's Episcopal Church, a barber shop, a downtown theatre, and at his home, "Fort Lewis" in Salem.

Work on the new section of Route 311 from Hanging Rock to Catawba Mountain began in mid-January. A convict camp was erected at the foot of the mountain for housing the laborers. The new road followed the path at many points of the old N&W Railway tracks.

Robert Carter, forty-five, walked into Roanoke City police headquarters on January 16 carrying a pot of cooked string beans with pieces of glass and confessed to killing his wife, Dorothy Carter, thirty-two, that evening. After shooting his wife in the kitchen, Carter took their two young children to a neighbor's house before going to the police station.

The Hawaiian Paradise Revue came to the stage of the Roanoke Theatre on January 19 that featured "17 native artists" performing "Dance of the Islands."

Twenty-five Roanoke-area Boy Scouts left for Washington, DC, on January 19, accompanied by Orville Boswell and Herbert Townsend, to assist capitol police with the inauguration activities of President Harry Truman. The scouts were from Raleigh Court Presbyterian Church, Oakland Baptist Church, and the Salvation Army.

The Roanoke City Council ordered that the fifty-six-year-old Academy of Music be closed, effective immediately on January 21, due to fire risks. City Manager Arthur Owens told the council, "I have vacillated too much. It should have been closed last March." Council acted based on the opinions of the city's fire chief, engineer, and building inspector. City officials made other venues available to shows scheduled at the academy.

Margaret Truman, daughter of President Harry Truman, was spotted dancing with Maj. William Zimmerman of Roanoke at the Inaugural Ball. Zimmerman was a White House military aide.

The newly organized Roanoke Jewish Forum Association announced upcoming lecturers. Dr. Julius Schreiber, a social psychiatrist, was scheduled for February 2, and author Maurice Samuel was slated for March 2. Lectures were held at the Hotel Roanoke.

The Elks Club presented their annual minstrel show for three nights beginning January 25. *Ridin' High* was produced by Lee Winters and was held at the Jefferson High School auditorium.

Vaughan Monroe and his orchestra performed at the American Legion Auditorium on January 25. Monroe brought with him the entire twenty-eight-member ensemble used on his *Camel Caravan* radio show.

The Boston Grand Opera Company presented *La Traviata* at the American Legion Auditorium on January 26. The leading roles were performed by Adina Belfiore and Robert Haydon.

With the closing of the Academy of Music by city officials, reporter Bill Talbott of the *Roanoke Times* interviewed George Herbert of Raleigh Court, who was a fourteen-year-old stage hand on the academy's opening night for the production of *Sudan*. According to Herbert, prior to the academy, traveling shows performed in the auditorium of the market building. Herbert worked at the academy for twenty-three years, during which time there were four fires and numerous managers. "The saloon in the Academy Hotel across the street was just as famous as the theatre. Between acts all the actors, stagehands, and gentlemen spectators would run like bees for the exits to be the first in line at the rail… those guys running across Salem Avenue for a short one is the funniest thing I can remember." The only time Herbert recalled a disappointed audience was when Tom Thumb came, and the audience literally threw tomatoes. He also remembered that after the show,

Charles Smith, president of Roanoke College, was presented a "Citizen of the Year" award by Virginia Governor William Tuck in 1949. *Archives, Roanoke College.*

men would crowd the back door hoping to ask a showgirl for a date. "It was so crowded back there sometimes we couldn't even get the scenery out."

When the Roanoke City Council began addressing street name changes in the newly annexed sections, the council decided to name three streets after journalists who covered their meetings. Locust Avenue, NE, became Whittaker Avenue for Clarence Whitaker of the *Roanoke Times*; Dogwood Avenue, SE, became Carico Avenue for Melville Carico of the *Times*; and Clifton Street, SE, became Barton Street for Barton Morris of the evening World-News.

Some one thousand persons attended a ceremony where Virginia governor William Tuck presented Roanoke College President Charles Smith a "Citizen of the Year" award given to Smith by Southwest Virginia Inc., a regional chamber of commerce organization.

Roanoke's first Advertising Club was organized on January 25 at the Hotel Roanoke. Professional advertisers, marketers, and public relations officials gathered to create a local organization that would become affiliated with the National Advertising Federation and promote excellence in the practice and craft of advertising. Those who helped organize the group included Shields Johnson, Kirk Lunsford, Otto Whittaker, Paul Porterfield, Chester Palmer, Charles Clarke, Garst Bishop, Kay Lee, Norman McVeigh, and Stephen Schlossberg.

Robert Lunn and his *Grand Ole Opry Show* came to the Roanoke Theatre on January 27.

The White Manufacturing Company, a builder of accessories for railroad locomotives, announced the construction of a new plant on Colorado Street in Salem opposite the Rowe-Jordan Furniture Corporation plant. The reason for the new plant was the company's inability to expand at its present location at 723 Third Street, SW, in Roanoke.

Bill's Hobby Shop, an antique and furniture repair shop, opened at 1909 West Avenue, Roanoke, on January 30.

Charlie Barnet and his orchestra performed for a floor show and dance at the American Legion Auditorium on February 3. White spectators were admitted.

Burton's Beauty Salon opened at 127 W. Kirk Avenue on January 31. Mrs. Burta Burton was the proprietor.

The David Kohen Company at 24 W. Campbell Avenue announced that "the F. W. Woolworth Company has leased our store over our heads." They held a going-out-of-business sale beginning January 31.

Salem's new dial telephones were put into operation at midnight on January 31. The old switchboard containing 4,800 fuses and 2,400 lines was deadened. Salem officials assisted the Chesapeake and Potomac Telephone Company make the switchover, which culminated three years of work at a cost of $675,000. A switchover ceremony was held

at midnight, and the first two callers on the new system were Roanoke College President Charles Smith and Salem mayor James Moyer.

Roanoke Clearance House No. 2 opened on February 1 at 122 E. Campbell Avenue.

Calvary Book Store, which sold Bibles, church supplies, and Christian books, opened on February 2 at 119 Franklin Road. The owner was Everette Whisnant.

Mrs. Ruth Bryan Rohde lectured at the Hotel Roanoke on February 1 under the auspices of the Roanoke Business and Professional Women's Club. Rohde was the daughter of William Jennings Bryan, a former member of Congress, and a minister to Denmark. She was also the first woman to serve on the House Foreign Affairs Committee. Her topic was the work and future of the United Nations.

Herman Palmer opened De Luxe Shoe Repair at 1845 Williamson Road on February 1.

Beverly T. Fitzpatrick was named as assistant commonwealth's attorney in Roanoke, effective February 1. The appointment was made by Commonwealth's Attorney C. E. Cuddy.

Edward Ould was elected president of the Roanoke Chamber of Commerce for 1949.

The new Monroe Junior High School formally opened on February 1. Principal R. V. Akers received the keys from C. H. Pate, who represented English Construction Company. Some four hundred students entered the school on the first day. A brief ceremony was held with students and school officials in the auditorium.

Buddy's Restaurant opened on February 1 at 6 S. Jefferson Street. Advertisements read, "Something new and different has been added to Roanoke—bowl of pickles served with all food." The blue-plate special of a meat, two vegetables, potatoes, rolls, and butter was priced at forty-five cents.

One-way streets were inaugurated in downtown Roanoke on February 1 and all went reasonably well, according to city police. The new design was purposed to speed up traffic

Monroe Junior High School officially opened on February 1, 1949, with an enrollment of four hundred students. R. V. Akers was principal. *Virginia Room, Roanoke Public Libraries.*

through a once-congested downtown. City Manager Arthur Owens was using the one-way street design on a sixty-day trial basis.

Some three thousand men turned out for a revival of Roanoke's Groundhog Club on February 1. The men-only gathering strictly prohibited women at the meeting that poked fun at city officials, municipal problems, and splintered seats at ballparks. H. T. Angell, son of the founder of the original Groundhog Club, was elected president.

First Methodist Church, Salem, began a $125,000 building campaign to erect a new church on the present site of its parsonage at College Avenue and Clay Street. The original church structure on the site was built in 1903.

The new Dixie Appliance Company distribution center opened on February 3 at Shenandoah Valley Avenue and Forest Road, with more than three hundred appliance dealers from twenty-six counties attending the opening ceremony.

Boston Service Station opened February 4 at 1514 Grandin Road, SW. Owners were Johnny Boston and Lacy Price. The station sold Shell gasoline and Goodyear tire products.

The Leonard Trio began broadcasting live from the Rainbow Room, corner of Patterson Avenue and Thirteenth Street, nightly Monday through Friday on WROV on February 7.

The Roanoke Rebels played the Detroit Clowns in basketball at the American Legion Auditorium on February 6. The Clowns had been around for almost twenty years and was originally started by a clown from the Barnum & Bailey Circus. The Detroit team offered good play coupled with on-court humor.

Walker Stinnett, seventy-seven, died from injuries on February 5 after being struck by a car as he crossed the highway near his home in the Williamson Road section. It was Roanoke's third pedestrian traffic fatality in 1949.

First Lt. William Flora of Roanoke was reported killed on February 4 when a two-engine B-25 aircraft in which he was riding crashed and exploded two miles offshore of New Orleans, Louisiana. Flora's wedding engagement was slated to be announced the following day.

Dr. Robert Lapsley Jr., pastor of Roanoke's First Presbyterian Church, spoke on the nationally broadcast *Presbyterian Hour* on February 6.

Leading lady western film star Peggy Stewart and her All-Star Revue came to the stage of the Roanoke Theatre on February 9. Joining Stewart were Slim Bergman and the Broome Brothers.

Robert Guerrant, twenty-eight, was sworn in as assistant judge of Juvenile and Domestic Relations Court on February 7.

The Polack Brothers Circus came to the American Legion Auditorium for a four-day run on February 14, sponsored by the Kazim Shrine Temple. Featured performers included Melitta and Wicons, Hubert Castle, Sikorska Duo, Malikova, and the Lopez Trio.

Francis Cocke, president of the First National Exchange Bank, announced in mid-February that the bank would erect a branch on Williamson Road, and a portion of the building would be leased to the postal service for a postal station. The building would be located at the intersection of Williamson Road and Pioneer Road.

The Williamson Road Insurance Agency opened on February 14 at 1914 Williamson Road. Bill Bryan and Scotty Bryan were the brokers.

The N&W Railway opened the largest PBX telephone exchange in Virginia in mid-February in Roanoke. The exchange connected to 582 N&W lines in Roanoke, thirty-one

trunk lines, and three city long-distance lines. In addition, the exchange through a push button system allowed access to 230 other N&W telephones across four states. Miss Sue Jones, the head operator, had been with the N&W for forty-six years.

A new, larger Kroger Grocery store opened at 24 W. Main Street in Salem on February 17. Smaller Kroger stores in Salem closed the day prior to the opening. Benjamin Black was the manager.

The Arcade Radio Shop opened at 118 Church Avenue on February 14.

Howard Rice, president of Blair Apartment Corporation, received approval from the town of Salem to construct a thirty-five-unit apartment building in the 200 block of Chestnut Street.

June Carr presented a road show on the stage of the Roanoke Theatre on February 16 that featured Cirrilo Trio, Cliff Taylor, Chris Randall, and a "bevy of gorgeous girls."

N&W Railway officials informed Roanoke city administrators that the company had no plans to build an underpass or overpass on Jefferson Street at its tracks to remedy traffic conditions. Such a plan had been discussed by city leaders for years but with no results.

William Martin was appointed to the Roanoke School Board on a 3–2 vote by the Roanoke City Council. Martin was selected to fill the unexpired term of Arnold Schlossberg.

Agnew and Connelly, a Roanoke feed and seed store, opened a branch in Vinton on February 15 at 200 Maple Avenue. Fred Goggin was store manager.

Clark Hamilton was indicted by a Roanoke County grand jury on February 15 on a charge of violating Virginia's miscegenation statute. His trial date was set for March 10. A five-man jury rendered the indictment. Hamilton had been held at the Salem jail since December 23.

Kann's new sub-deb shop opened on February 18 at the store at 309 S. Jefferson Street.

Miller Petty was appointed by the Roanoke County Board of Supervisors to fill the unexpired term of W. E. Meador on the school board.

Chester's, a women's apparel store, opened on February 18 at 24 W. Campbell Avenue.

"Red" Marion signed his contract to manage the Roanoke Red Sox, succeeding Pinky Higgins. Marion reported to the training camp of the Boston Red Sox in Florida and stated he would arrive in Roanoke with the team following spring training.

The State Water Control Board rejected Roanoke City's plan for sewage disposal in the annexed territory at a meeting on February 19 in Richmond. The board did not suggest an alternate plan. City Manager Arthur Owens responded that the city would continue its efforts to construct a sewage disposal and treatment facility. The plan rejected by the board was for the city to treat sewage with high levels of chlorine before it reached the Roanoke River.

The Roanoke Civic Ballet presented *An American in Paris* at the Jefferson High School auditorium on February 24. The choreographer was Gilbert Goodsell.

S. J. Phillips, president of the Booker T. Washington Birthplace Memorial, spoke at a mass meeting of black citizens held at First Baptist Church, Gainsboro, on February 22 in an effort to organize a Booker T. Washington Community Service Club. Other speakers included Mrs. Portia Pittman, daughter of Booker T. Washington, Dr. E. D. Downing, and the Rev. A. L. James, pastor of First Baptist.

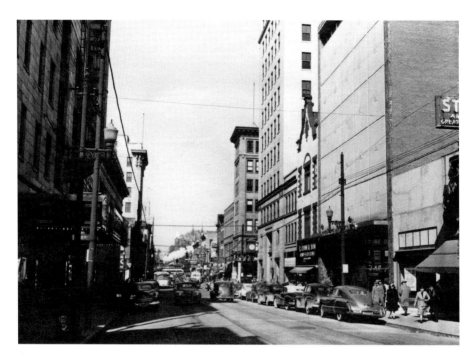

This February 1949 photo shows Jefferson Street looking north from Kirk Avenue. The American Theatre is at front left. *Digital Collection, Special Collections, VPI&SU Libraries.*

A public open house was held at the new Monroe Junior High School on February 24. The evening event was hosted by teachers and student guides with a performance by the school's band and basketball games between the city's four white junior high schools. Nearly seven thousand attended the event.

E. B. Wright began advertising house lots for his development Brymoor Park in late February. The new subdivision was located just outside the Roanoke city limits and adjacent to Lee Hy Park.

Bishop John Stamm, president of the Federal Council of Churches of Christ in America, spoke at a public meeting held at Greene Memorial Methodist Church on February 21. He also addressed the Roanoke Ministers' Conference that same day.

The New vocational building at Jefferson High School was completed in late February and became fully operational on March 1.

Red Hill Baptist Church held a note-burning service on February 20 to celebrate retiring the indebtedness on their sanctuary, which had been built in 1940.

The *Roanoke Times* began using the new composing room of the Times-World Corporation for its February 21 edition. The new mechanical building of the newspaper company contained over 120 pieces of heavy equipment necessary for its publications.

Roanoke superintendent of police Clay Ferguson announced his retirement in late February, to be effective April 1. Ferguson had been with the department for twenty-six years. Lt. S. A. Bruce, head of the Traffic Division, was named acting superintendent to begin April 2.

The "barn" adjacent to Jefferson High School was razed in 1949
for the vocational building. It was originally a stable for the L. H.
Vaughan farm. *Virginia Room, Roanoke Public Libraries.*

Hollywood on Stage came to the Roanoke Theatre on February 23. The acts included
Eddie Ryan, Glenn Vernon, Mabel Todd, Polly Nelson, Good & Goody, and the Jones
Sisters. The actress Tondalayo of the movie *White Cargo* performed her famed "Jungle
Dance" as seen in the film.

George Boyd, sixty-four, of Copper Hill was sentenced to three years in jail after be-
ing found guilty of attempting to kill Fred Grubb, forty-seven, of Back Creek. According
to testimony, Boyd hid in Grubb's home and tried to kill him with a shotgun blast.

Richard Pence of Roanoke was selected by the Virginia Junior Chamber of Commerce
to receive its Outstanding Young Man for 1948 award at the organization's annual meet-
ing in Richmond.

New vinyl-plastic 45 rpm records were demonstrated on February 21 for RCA Victor
and radio dealers in the Roanoke area at a meeting at the Patrick Henry Hotel. The dealers
were told that it would probably be several years before the new records would completely
replace the conventional ten- and twelve-inch variety.

The Roanoke Ministers' Conference launched the Roanoke Preaching Mission on
February 27, which continued through March 6. The effort involved some ninety-four
area churches representing fourteen denominations. The lineup of speakers included Dr.
William Hudson, Dr. Norman Vincent Peale, Dr. Clovis G. Chappell, Dr. Joseph Sizoo,
Dr. Theodore Adams, Dr. Norman Dunning, Bishop Edwin Penick, and many other
notable Protestant clergy. The mission event was headquartered at Greene Memorial
Methodist Church. Services were held nightly in the American Legion Auditorium.

The Hanover Shoe Store moved to a new location at 214 S. Jefferson Street in late February.

Rumors swirled around Roanoke in late February when it was learned that former British Prime Minister Winston Churchill might come to the city. The Virginia Chamber of Commerce had invited Churchill to speak at its Silver Anniversary convention in Roanoke in April, but chamber officials remained tight lipped about the invitation. Churchill eventually declined the invitation, writing, "I cannot add to my engagements."

The Patchwork Players announced a ten-play season for the summer. Leading the theatrical group were James Thompson, technical director; Francis Ballard, director; Malvina Ballard, assistant director; John Will Creasy, supervisor of construction and décor; and Elizabeth Ross, speech coach.

Robert Neece, twelve, was found guilty of voluntary manslaughter on February 24 in the slaying of his grandmother, Mrs. H. T. Neece, on January 3. A suspended five-year sentence was imposed by Judge Charles Burks in Hustings Court.

Dr. L. C. Downing presented to the officers of the Roanoke Community Fund a proposed campaign to expand Burrell Memorial Hospital with a new seventy-eight-bed addition. Downing reminded the fund's board that the current fifty-bed hospital was below Virginia Department of Health standards. The proposed addition was estimated to cost $1.1 million.

The Selah Jubilee Singers, stars of radio, stage, and screen, performed at the Club Morocco on February 25.

Some sixty citizens from the Roanoke region gathered in Salem and appointed an interim committee to draft a plan for a new country club in Roanoke. Joseph Stone was named president of the group, and Reginald Wood of Salem was treasurer. The group intended to construct a full-service club with golf, tennis, swimming, and club facilities. The group had exercised an option on a 117-acre tract near Burlington Elementary School.

Billy Lyons opened a tailor shop above the Park Theatre, 509 S. Jefferson Street, on February 28.

"Conquerors' Isle," a tale written by Nelson Bond of Roanoke, was broadcast nationwide by CBS on its *Escape* program on March 6. The story was about a fictional pilot who discovers a lost island in the South Pacific inhabited by a race of supermen who intend to conquer earth.

The 1949 All City-County basketball team was named in late February. The star players selected were Herbert Weaver (Jefferson), Richard Hiler (Byrd), Jimmy Slaydon (Fleming), Rudy Lacy (Jefferson), and Frank Mawyer (Jefferson). Only players for white schools were eligible. The selection committee consisted of the high school coaches.

Nelson Bond was announced as the director-producer of the Patchwork Players' *Summer Theatre of the Air*, which would be broadcast beginning in mid-June to coincide with the group's live stage performances.

Sammy Kaye and his orchestra performed at the American Legion Auditorium on March 1. Black spectators were admitted for half price.

The Pittsburgh Symphony Orchestra under the direction of a young Leonard Bernstein presented a concert in the auditorium of Jefferson High School on March 2. The event was sponsored by the Roanoke Community Concert Association. The soloist in the violin concerto was Hugo Kolberg. A local reviewer wrote the following about

Bernstein: "Conductor Bernstein is one of the most acrobatic we have ever watched...he seems to be physically playing every instrument in the orchestra, while perhaps humming the notes."

The Roanoke City Council at their meeting on February 28 directed the city manager to enter into a lease agreement with the federal government for the erection of a Marine Corps Armory and Training Center at Maher Field. At the same meeting, the council moved to acquire lands for the eventual erection of two fire stations in the Williamson Road and Garden City sections.

Elizabeth Journett, thirty-nine, was shot and died from her wounds at Burrell Memorial Hospital on February 28. Her neighbor, Grace Fitzgerald, was charged by police with the murder.

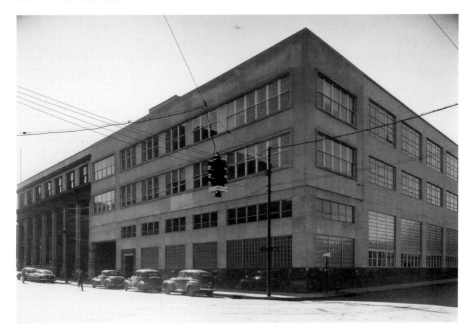

This February 1949 image shows the *Roanoke Times* building at Second Street and Salem Avenue. *Virginia Room, Roanoke Public Libraries.*

Roanoke property owners approved the issuance of $4.8 million in bonds for new schools and improvements, a new central library, and a health center in a March 1 referendum. A bond referendum held in Salem passed as property owners approved $415,000 for improvements to the water treatment plant and a new garbage disposal facility.

The State Corporation Commission issued a charter for the Cloverdale and Catawba Railroad Company in connection with plans to build a railroad from Cloverdale to Catawba for rail access to a new limestone and cement development for the area. The eleven-mile rail line would connect with the N&W Railway.

Kirk's Jewelers opened at its new location, the corner of Jefferson Street and Campbell Avenue, on March 3. A. O. Krisch was the store manager. As part of their grand opening,

the store displayed a private collection of diamonds and jewelry estimated to be valued at $1 million.

President Harry Truman accepted the resignation of James Forrestal as Secretary of Defense and nominated Roanoke native Louis Johnson for the post. Johnson, fifty-eight, had previously served as the assistant secretary of war under President Franklin Roosevelt. He was slated to assume his new post on March 31 pending Senate confirmation. Johnson was a graduate of Roanoke High School and the son of Dr. and Mrs. Marcellus Johnson Jr.

Officials with the Colonial-American National Bank announced a planned $200,000 renovation of the bank building in downtown Roanoke. Ben F. Parrott and Company was the contractor.

Appalachian Electric Power Company moved into their new headquarters building at 40 Franklin Road on March 7. The previous location had been 129 E. Campbell Avenue.

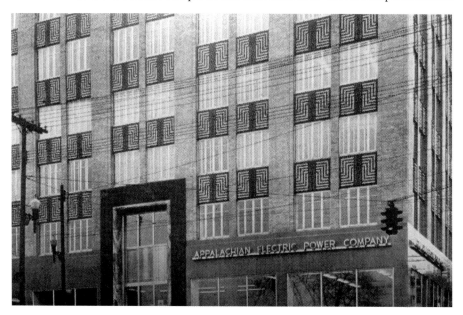

The new Appalachian Electric Power Company headquarters at 40 Franklin Road opened on March 4, 1949. *Virginia Room, Roanoke Public Libraries.*

Clark Hamilton was given a suspended term of three years after he pleaded guilty in Roanoke County Circuit Court on March 4 of violating Virginia's miscegenation statute. Hamilton admitted he was Negro, having been born in Russellville, Alabama. In obtaining a marriage license in Virginia, Hamilton declared himself as white and listed an erroneous birthplace. Hamilton boarded a train the following day to leave the state, and the marriage was deemed illegal and thereby annulled.

The body of Harold Shifflett, forty-four, was found dead on the track of the N&W Railway about one mile east of Vinton on March 4.

West End Baptist Church opened on March 6 at 1513 Rorer Avenue, SW. H. T. Snow was pastor.

Officials with the N&W Railway announced on March 5 plans to build thirteen more passenger and freight locomotives in the Roanoke Shops during 1949 for an estimated cost of $3.65 million. The Roanoke Shops were turning out a new engine on average every twenty-six days. Seven of the new engines were to be Class 6Ybs, three were to be Class As, and three Class Js.

Rutrough's, a men's clothier, held a formal opening of its new store located in the Ponce de Leon Hotel on March 7. Managers were Herbert Gilliam, Joe Lennon, and Dick Lynch.

The Lee-Hi Drive-In opened for the season on March 10.

Virginia governor William Tuck gave his approval for an expansion of the Catawba Sanatorium at a cost of $1.4 million. Construction plans were not detailed, but Catawba superintendent Dr. J. B. Nicholls stated that architects and engineers had been engaged to develop plans for the expansion.

Karston's Atomic Scandals, a vaudeville show, came to the Roanoke Theatre on March 9. The multiact program featured singers, dancers, acrobats, comics, daredevils, jugglers, and "atom bomb mystery girls."

Violinist Samuel Dushkin performed at Hollins College on March 7. Paul Berl accompanied him on piano. The Russian-American violinist had played with all major orchestras in the United States.

The Roanoke City Council approved the design of a new administration building for Woodrum Field at their March 7 meeting. Eubank and Caldwell of Roanoke was the architectural firm that designed and developed the plans for the $320,000 building.

Roanoke city manager Arthur Owens stated in mid-March that he hoped to reopen the Academy of Music as part of his plans for 1949.

The General Finance Corporation opened a Salem branch office at 118 E. Main Street on March 10. Parker Swanson was manager.

Virginia Scrap Iron and Metal advertised streetcar bodies for sale in mid-March from the Roanoke system. "There are many uses for these bodies such as: restaurants, fruit stands, cabins, etc." The sale price was $300 each.

Self-Service Stations, Inc., opened a new station at 402 Williamson Road on March 11. They sold Aeroflyte-brand fuel. They advertised as a "gasoteria" that served eight cars at once.

Roanoke County sheriff H. B. McManaway ordered a band of two hundred gypsies to leave the county on March 10. According to the sheriff, the group had encamped at a site west of Salem.

Carey Moomaw, ninety-four, died at his home in Roanoke on March 10. A native of Botetourt County, Moomaw had helped found the Second Presbyterian Church, served as manager of the Cloverdale Orchards, and was the former secretary-treasurer of Roanoke Iron Works.

Elm Super Market opened at the corner of Elm Avenue and Ferdinand Avenue on March 11.

Capt. W. S. Butts, commanding officer of the Naval Air Training Unit at the Norfolk Naval Air Station, announced on March 11 that a Naval Reserve Aviation Training Unit was to be established at Woodrum Field and began encouraging enlistments.

Officials with Burlington Mills announced that the Salem Full Fashion Hosiery Mills would be expanded by 60 percent. Employment at the plant was expected to increase from 240 to 360.

A three-hour minstrel show to benefit the American Legion Junior Drum and Bugle Corps was held for two nights, March 16 and 17, at the American Legion Auditorium.

Cotton Watts, a minstrel comedian, performed on the stage of the Roanoke Theatre on March 16.

Delta Electric Company moved to its new location at 816 W. Salem Avenue in mid-March. The business was owned by L. R. York and C. G. Tinnell.

Counterfeiters apparently passed through Roanoke the second weekend in March as banks discovered numerous bogus $20 bills being deposited by merchants on Monday. Law enforcement officials believed that over $1,000 in counterfeit money was spread around town.

The Salem Lions Club put on their annual minstrel show fundraiser in mid-March in the auditorium of Andrew Lewis High School. The cast of fifty included a sextet of end men and a forty-two-member chorus. The show ran for three nights. The show was directed by Davis Goodman, who was aided by James Moyer.

The Roanoke Advertising Club adopted a constitution and elected a board of directors at its first organizational meeting on March 16 at the Hotel Roanoke. The organization had about ninety charter members.

A group from Vinton Baptist Church posed in front of their church in March 1949. *Vinton Historical Society.*

The Roanoke Life Saving and First Aid Crew inaugurated its own emergency switchboard on March 17 with their number, 6315, being manned twenty-four hours per day. Prior to having their own emergency number, calls to the crew went through the Roanoke Fire Department.

Albert Oliver, twenty-eight, of Roanoke County shot and killed himself on March 19 after shooting Pearl Edwards, twenty, of Roanoke, in the jaw. Edwards was taken to Shenandoah Hospital.

Maryla Jonas, a Polish concert pianist, presented a concert in the auditorium of Jefferson High School on March 21 under the auspices of the Roanoke Community Concert Association.

The men of the American Legion heard from their wives, the legion's auxiliary, who attended a cabaret dance at the American Legion Auditorium on March19. According to the women, the entertainment was "repulsive, disgusting, and generally in very poor taste." The legion had sponsored the dance to end their annual spring conference, which had also included a "Harlem floor show." According to the women, the professional dancers stripped down to "threads," to which the legionnaires responded in writing to the auxiliary, "Those girls were really good. It was a true art form." Local legion officials described the dance and floor show as "perfectly all right." The ladies of the auxiliary also complained about the legionnaires' "whistling, cat-calling, and loud noise during the strip-tease."

A second band of gypsies was asked to move on from Roanoke County on March 21 by the sheriff. About forty gypsies with eight campers had camped on property belonging to R. H. Logan at Big Hill west of Salem. Logan called the authorities.

J. B. Fishburn, vice president of the Times-World Corporation, pushed the button that started the new Goss press at the newspaper company. The March 21 noon edition of the *World-News* was the first printed by the new machines.

The nine-acre Fort Lewis estate on Route 11 west of Salem was sold to M. L. Altizer of Greensboro, North Carolina, for $50,000. The new owner planned to make a tourist court out of the property.

A two-passenger, single-engine plane en route from Blacksburg to Richmond made a forced landing at the Horton farm near Forest Park School on March 22 due to bad weather and the pilot's inability to locate Woodrum Field. The plane landed safely.

Mountain Trust Bank held a formal opening on March 24 following extensive exterior and interior renovations and remodeling of the bank that cost an estimated $250,000. The first three floors of the bank's exterior facing Jefferson Street had been enclosed with gray and black granite, the latter imported from South Africa. The bank also added a "drive-in teller" on the Kirk Avenue side of the building.

Edward R. Dudley, a Roanoke native, was nominated as ambassador to Liberia by President Harry Truman and became the first black person to achieve the rank of ambassador in the history of the United States. Dudley's rank went from minister to ambassador when Liberia and the United States agreed to raise their consulates to embassies.

The abandoned streetcar barn of the Roanoke Railway and Electric Company on Walnut Avenue was purchased by Appalachian Electric Power Company for $110,000 on March 23.

Louis Johnson, a Roanoke native, was confirmed as secretary of defense by the US Senate on March 23. The vote was unanimous.

Joseph Kirkland resigned as physical director of the Roanoke Central YMCA on March 23 as he had accepted a professional football contract to play for the Buffalo Bills of the All-America Conference. He was to report to the team's training camp in July.

The Williamson Road branch of the Colonial-American National Bank opened on March 26 at Williamson Road and Grace Street in the space formerly occupied by the Williamson Road Pharmacy.

Evangelist Dr. Mordecia Ham spoke at two services held at the American Legion Auditorium on March 27. His sermon titles were "The Hidden Hand Undermining the U.S. Foundation" and "Who Elected Truman and Why?"

At the annual meeting of the Burrell Memorial Hospital Association held on March 24 at Loudon Avenue Christian Church, Dr. E. D. Downing was reelected president. Hospital officials reported that in 1948 Burrell Memorial treated 2,157 patients, 217 more than in 1947. Doctors performed 803 operations, delivered 423 babies, and handled 413 emergency cases. The board of directors also announced a campaign to raise $500,000 for a new seventy-five-bed hospital on land adjoining the site of the present hospital.

Traffic began flowing across the new J. Sinclair Brown Bridge that spanned the N&W Railway tracks in Salem on March 25. The bridge had been under construction since March 16, 1948.

Gilmer School held an open house on March 25 in honor of its diamond jubilee. Former students of "half-forgotten Negro schools" like Diamond Hill, Centre Avenue, and Gregory also attended.

Augusta Harrington, soprano, gave a concert at the Fifth Avenue Presbyterian Church on March 25.

Eddy Arnold performed four shows on the stage of the Roanoke Theatre on March 25. He was joined by the Duke of Paducah, Roy Wiggins, Gabe Tucker, and Annie Lou and Danny.

Mr. and Mrs. James Leonard became the first persons in Roanoke to pick up a television transmission. Leonard, an electronics engineer, received the transmission on March 25 from Richmond station, WRVA-TV, using a rigged television set he set up on top of Mill Mountain. He moved the set to three different locations over three nights before getting reception from the front porch of the caretaker's home on the mountain. When a picture was received, the Leonards and the caretakers, Mr. and Mrs. James Campbell, watched boxing from Madison Square Garden as well as other shows.

The Easter Bunny came to Heironimus Department Store on March 26. Midmorning the bunny hatched from his Easter egg on the sidewalk in front of the store on Campbell Avenue, then spent the remainder of the day participating in the Tots & Teens Show on the store's third floor, inhabiting his Bunny House at Bunnyland on the fifth floor, and shaking hands with children throughout the store.

The Lone Star Cement Company awarded a contract to Walsh Construction Company of Davenport, Iowa, for construction of the eleven-mile standard-gauge railroad through a portion of Botetourt County to serve the cement firm's proposed quarry.

The Hoosier Hot Shots (Paul Trietsch, Gabe Ward, Gil Taylor, and Ken Trietsch) performed at the Roanoke Theatre on March 30. The musical and comedy act was a part of the nationally syndicated *Barn Dance* radio program.

The Roanoke Badminton Club joined the Southern Badminton Association and the American Badminton Association in late March. This allowed members to compete in sanctioned tournaments. Prominent in the club were Charley Turner, Rudy Rohrdanz, M. H. Lambert, and Jesse Bain.

This is the caretaker's home at Mill Mountain Park in 1949 where
the first television reception in the Roanoke Valley occurred in
March 1949. *Virginia Room, Roanoke Public Libraries.*

Officials with Burrell Memorial Hospital formally launched the campaign to erect a new seventy-five-bed hospital. The hospital was using a building originally erected as a school in 1889. The new hospital would include a pediatric ward, isolation ward, blood bank, cancer clinic, X-ray department, pharmacy, and physical therapy department. According to Burrell leaders, the hospital's service area had a census of forty-seven thousand blacks. The new hospital was estimated to cost $1.1 million. Half of that was proposed to be raised through public subscription, with the remainder coming from federal and state sources.

The twenty-second annual spring course of the Gill Memorial Eye, Ear, and Throat Hospital was announced for April 4 through 9. Among the distinguished faculty were Dr. L. P. Garrod from the University of London and Dr. Louis Paufique of the University of Lyon, France. Gill officials estimated that four hundred attendees from throughout the United States would enroll to learn from a twenty-four-member faculty.

The Crystal Spring Laundry and Dry Cleaners opened its new, expanded plant at the corner of Franklin Road and Elm Avenue, SW, on March 30. The laundry held an open house and gave away prizes to those in attendance, with the grand prize being a fur cape. J. M. Turner was the general contractor. The laundry was founded in 1906 in the 500 block of Second Street, SW. It relocated to the 720 Franklin Road site in 1915. Lewis Wells was president of the firm.

David Lawton opened Handwrought by Lawton on March 28 at 427 W. Campbell Avenue. Lawton's business was a silver craft shop that sold jewelry and flatware.

Louis Johnson was sworn in as US Secretary of Defense on March 28 in Washington, DC, before an estimated crowd of ten thousand.

Roanoke native Louis Johnson (*left*) is being sworn in as secretary of defense by Chief Justice Fred Vinson (*right*) on March 28, 1949. *Harry S. Truman Presidential Library.*

Chapman Electric Company at 119 E. Main Street, Salem, began its going-out-of-business sale in late March.

Stanley Radke, former owner of the Roanoke Red Sox baseball team, was convicted in Hustings Court on March 30 of two charges of embezzling more than $28,000 from Rosenberg Brothers and Business Realty Corporation and sentenced to six months in jail. The jury reached its verdict within three hours.

The Cave Spring Lions Club presented their annual minstrel show fundraiser at the City Market Auditorium on March 31. Ernest Robertson directed the show.

The first escalators in Roanoke went into service on March 31 when the N&W Railway passenger station opened. The partial opening allowed access to the passenger station though the renovations had not been completed. The escalators were so popular that passengers took several trips on them before boarding a train or exiting the station. The first person to purchase a ticket at the reopened station was Mrs. George Hill of Priest Lake, Idaho.

Capt. H. Clay Ferguson officially retired from the Roanoke Police Department, where he was honored for his many years of service. On April 1, he assumed duties as the chief house officer at the Hotel Roanoke, succeeding Charles Trout in that post.

Johnson-McReynolds Chevrolet Corporation opened its new truck showroom and service center in the 500 block of Williamson Road on April 2.

The Ravens, Dinah Washington, and Cootie Williams and his orchestra performed at the American Legion Auditorium on April 4. White spectators were admitted.

The Negro Citizens Committee of the Roanoke Chamber of Commerce announced plans to confer with the management of the city bus terminal on improvements for black patrons. The committee also circulated a letter congratulating President Harry Truman on his appointment of Edward Dudley as ambassador to Liberia.

This April 1949 photo shows the remodeled interior of the N&W Railway passenger station in Roanoke. *Digital Collection, Special Collections, VPI&SU Libraries.*

This shows the newly remodeled waiting room in the N&W Railway passenger station in Roanoke, April 1949. *Digital Collection, Special Collections, VPI&SU Libraries.*

Vinton Supply Company opened its farm equipment store at 119 E. Pollard Street on April 2. The store carried the Massey-Harris brand of tractors and equipment.

Loebel Cleaners opened a new location at 1706 Williamson Road in early April.

The property and assets of the A. L. Nelson Company and the A. L. Nelson Truck Company at 31 W. Shenandoah Avenue were auctioned off on April 4 to settle the estate of A. L. Nelson.

Murrell Dearing, four, was struck and killed by an automobile on April 2 in front of his home on Chapman Avenue, SW.

The USS *Roanoke* was commissioned at the Philadelphia Naval Shipyard on April 4. Navy officials described the ship as the world's most powerful light cruiser. Mayor W. P. Hunter led a delegation from Roanoke to attend the ceremony. The keel of the Roanoke was laid on May 15, 1945, and christened two years later. The Roanoke was manned by fifty-one officers and 922 enlisted men. Interestingly, the Roanoke was dedicated to "peace through strength" by Secretary of Defense Louis Johnson, a Roanoke native. William Zimmerman of Roanoke was a member of the crew.

Blair Pitzer Coal and Fuel Oil Company opened in early April at 324 Albemarle Avenue, SE.

The N&W Railway opened a ticket office at 507 S. Jefferson Street on April 4. W. A. Thurman was chief agent.

Conrad Thilbault, nationally known baritone, presented a concert at the Jefferson High School auditorium on April 6 under the auspices of the Roanoke Community Concert Association.

The Pantry Restaurant reopened at Bent Mountain on April 4 under the ownership of Mr. and Mrs. Dusty Rhodes.

Minstrel comedians Emmett Miller and Turk McBee performed their Dixianna show at the Roanoke Theatre on April 6.

The Roanoke City Council changed the names of several streets in the annexed Williamson Road section at their meeting on April 4. Most name changes were to surnames of state and federal political leaders, such as Truman, Trinkle, Tuck, and Barkley Avenues.

The Roanoke School Board gave preliminary approval on April 4 to architectural plans for a new black high school in the city. The plans were developed by the firm of Stone and Thompson. The new school's site was at the corner of Lynchburg Avenue and Fifth Street. Dr. Harry Penn indicated that the board may want to consider a new name for the school once it was built, but he did not elaborate.

Robert Carter was sentenced to sixteen years in prison for the murder of his wife, Dorothy, by Judge Dirk Kuyk.

The congregation of Greene Memorial Methodist Church approved a $200,000 remodeling plan to create education space within the existing building. Work was expected to begin after Easter. Martin Brothers Construction Company was the general contractor.

Dr. Bessie Randolph announced her retirement as president of Hollins College in a letter presented to the board of trustees on April 7. Randolph's retirement would take effect in June 1950. Randolph had been Hollins' president since 1933, during which time she helped to double the school's endowment and eliminate all debts.

Dr. Sherman Oberly of the University of Pennsylvania was named as the successor to Dr. Charles Smith as president of Roanoke College by the school's board of trustees. Oberly would assume his duties July 1, 1950.

The Roanoke Theatre presented showings of *Mom and Dad*, a film about teenage sexuality. The showings were segregated, with show times for women at 2:00 and 7:00 p.m., and a showing for men at 9:00 p.m. Each showing was followed by an on-stage commentary by Elliot Forbes, a radio personality who discussed "vital hygiene information."

The Salem Community Players presented the comedy *Mr. Pim Passes By*, under the direction of Francis Ballard. The play was performed at Andrew Lewis High School by the community theatre group.

A building permit was issued by Roanoke County for a third drive-in theatre in the Roanoke area. The permit was issued on April 8 to Max Holland and R. C. Saunders, both of Charlotte, North Carolina, for a drive-in on Route 117 (Peters Creek Road) near Burlington School. Holland and Saunders stated they hoped to have the theatre open for business by the spring of 1950.

Two brush fires burned eleven acres on Yellow Mountain and Little Brushy Mountain in Roanoke County on April 9. Both fires were caused by carelessness in burning brush.

The Barter Theatre Players presented *Dear Ruth* at the Little Theatre at Hollins College on April 13. The play starred Gordon Sommers, Charles Durand, and Elizabeth Wilson.

Dr. Robert Lapsley Jr. of First Presbyterian Church delivered the Easter sermon at the sunrise service held at Natural Bridge. The service was broadcast over local radio, and attendance was estimated to be five thousand.

Admiration Beauty and Gift Shop opened at their new location at 1914 Williamson Road on April 11.

The Organized Reserve Corps Armory was formally dedicated in a brief ceremony on April 10. Col. George Scithers, executive officer of the Virginia Military District, delivered the dedicatory remarks. A military parade was held later that afternoon through downtown Roanoke from Elmwood Park to the municipal building. A group of F-80 jet planes flew in formation over the parade. A few days prior, Secretary of Defense Louis Johnson had proposed the observance of "Armed Forces Day," and it was suggested that the armory dedication and parade in Roanoke was the first official observance of that day in the nation.

The first of Europe's displaced persons, "DPs," to arrive in Salem on April 10 were two adult siblings from Latvia, Arturs and Elza Mitans. The Mitans were initially housed at the Lutheran Children's Home.

Rabbi Arthur Lelyveld, national director of the B'nai B'rith Hillel Foundations, was the keynote speaker at the annual installation banquet of the Roanoke Chapter of B'nai B'rith held at the Hotel Roanoke on April 12. Udell Brenner was installed as the president of the local chapter.

Over twenty paintings by Allen Palmer were exhibited at the new art building at Hollins College in April. Most of the paintings were done at the artist's home at Cave Spring.

Dr. Haridas Muzumdar, a Hindu scholar, addressed the Roanoke Executives Club on April 13 at the Hotel Roanoke. His speech was on the importance of India and the United Nations. Muzumdar was a follower of Gandhi, and one of the seventy-eight disciples that walked with Gandhi in the famed March to the Sea in the spring of 1930.

Wynonie Harris, a blues singer, along with Dud Bascomb and his orchestra performed at the American Legion Auditorium on April 18. White spectators were admitted.

The last known surviving person to be associated with opening night at the Academy of Music for the production of *Sudan* died on April 16. George Herbert died at his home at the age seventy. He had been associated with the academy for many years.

The world-famous Potvin Exhibit came to Roanoke in mid-April for a two-week stay under the sponsorship of the Optimist Club. The exhibition featured wood carvings of Moise Potvin, a French-Canadian wood sculptor and violin maker. The exhibit was at 20 E. Campbell Avenue.

Claude Thornhill and his orchestra along with The Snowflakes performed a floor show and dance at the American Legion Auditorium on April 21. Black spectators were admitted.

Roy Acuff and the Smoky Mountain Boys performed at the Roanoke Theatre on April 20.

C. A. Peverall was granted the lease to Rockledge Inn and began advertising Rockledge Club dances for every Friday and Saturday nights. The opening dance for club members was April 23.

On April 18 the Roanoke City Council authorized the purchase of three lots along Williamson Road at Pioneer Road for the future construction of a Williamson Road Branch Library. The cost for the lots was $2,250.

Curtis Turner of Roanoke won the forty-lap stock car feature at the Winston-Salem speedway on April 18 before a crowd estimated at seven thousand.

The Williamson Road Kiwanis Club presented their annual minstrel show fund-raiser at the Lee Theatre on April 22 and 23. The show was directed by Lee Winter of Philadelphia.

Lewis Majors, seventy-three, succumbed to injuries he received when he was struck by a motorcycle on March 31. Majors died at Burrell Memorial Hospital on April 20.

American Airlines held an open house at Woodrum Field on April 23, flying passengers for free for brief flyovers around the Roanoke Valley in two forty-passenger planes. The purpose was to acquaint those who had never flown with air travel.

Bob Hope, Doris Day, and an array of radio and Hollywood personalities were slated to perform at the American Legion Auditorium on April 24 at 8:00 p.m. However, a long-standing 3:00 p.m. church music and sacred choral concert sponsored by the Thursday Morning Music Club prevented the staff from being able to prepare the facility for Hope's show, so the comedian and his troupe cancelled.

The Eden Corporation of Roanoke announced plans to construct fifty-two homes in the Williamson Road section along Floraland Drive to Hershberger Road. W. A. Ingram was head of Eden.

A fire from the Roanoke city dump at Washington Park smoldered for the better part of the day on April 21, and the smoke could be seen from all sections of the city. The dump had been opened earlier in the year near the park.

WSLS advertised its new "Top of the Morning" lineup beginning April 25. From 5:30 to 7:00 a.m. was *Community Almanac* with host Glenwood Howell, which included farm and home news, weather, county agents, favorite records, and live music from the local Dixie Playboys. From 7:00 to 7:45 a.m. was *The Sunny Side of Seven*, a segment sponsored by Johnson-McReynolds Chevrolet and hosted by Tom Hughes. From 7:45 to 8:00 a.m. was local and state news followed by a live weather report from Woodrum Field by B. B. Green.

Fifty-four baby beeves brought an average price of $27.39 per hundred pounds at the seventh annual Junior Fat Cattle Show held at Valleydale Stockyards in Salem on April 22.

Parfield Golf Driving Range opened on April 23 on Route 460 between Roanoke and Lakeside across from the skating rink.

The Roanoke Red Sox lost 10–7 against the Lynchburg Cardinals in the opening home game of the 1949 season at Maher Field on April 22. Attendance was 2,407. City Manager Arthur Owens threw out the ceremonial first ball.

The Woodrum Field terminal building, seen here in 1949, would
be razed and a new, more expansive terminal would be built in
the 1950s. *Virginia Room, Roanoke Public Libraries.*

Bireley's Bottling Company, located at 830 Moorman Road, NW, began advertising
in late April home delivery of their orange and tomato beverages and direct retail sales
from their plant.

Hidden Valley Country Club was issued a charter by the SCC on April 23. Club
members had exercised an option on a 280-acre tract on the west side of the Cave Spring-
Salem Road. Joseph Stone, Thomas Marshall, Reginald Wood, and Randolph Francis
were officers of the club.

The New York Philharmonic Orchestra performed at the American Legion
Auditorium on April 22 under the auspices of the Thursday Morning Music Club. The
conductor of the orchestra was Bruno Walter. Attendance was three thousand.

The American Viscose Corporation in its annual report to stockholders stated that
despite present market conditions for textiles, "the long range outlook for rayon is dis-
tinctly favorable."

The Sherwin-Williams Paint Company opened a new store at 29 E. Church Avenue
on April 25. F. B. Willock was the store manager.

Production at the Roanoke plant of American Viscose was cut by 50 percent at the
end of April, resulting in the layoff of four hundred workers and a reduction in hours of
other employees.

Junious White was convicted in Hustings Court of murdering his brother, Allen
White, on March 5 and sentenced to fifty years in prison.

Mrs. Rachel DeHart, forty-two, was killed and her husband, Dr. Rufus DeHart of
Radford Community Hospital, was injured when a four-seat plane they were riding in had
to do an emergency landing at Bent Mountain on April 28 due to low fuel. The couple
was flying from Leesburg. The crash occurred near the Adney's Gap entrance to the Blue
Ridge Parkway.

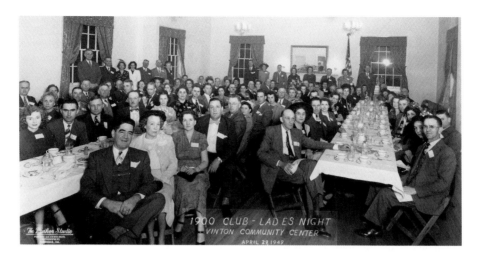

This was Ladies Night for the 1900 Club, held at the Vinton
Community Center in April 1949. *Vinton Historical Society.*

The Barter Theatre presented *Pursuit of Happiness* at Hollins College Little Theatre
on April 29. The comedy concluded Barter's season of plays for the Roanoke area.

Guy Lombardo and his Royal Canadians performed at the American Legion
Auditorium on May 2. Black spectators were admitted.

The 29th Division Association opened its spring festival for a five-day run on May 2
at the ball park show grounds on Shenandoah Avenue, NW. Prell's Broadway Shows was
the main attraction, along with a midway, rides, and theatres.

Perdue Cinema Service opened at its new location at 24 W. Church Avenue on May 2.

Slim Williams, a blackface comedian, along with Ches "Cupid" Davis, performed at
the Roanoke Theatre on May 4.

William Martin, who had recently been appointed by the Roanoke City Council to
the school board, resigned on May 2. Martin had been declared ineligible to serve due to
his residence outside one of the two districts for which he was appointed. Districts were
established for board appointments due to annexation.

Roanoke attorney Moss Plunkett filed papers on May 3 to challenge fellow Roanoker
Lindsay Almond Jr. for the Democratic nomination for Virginia attorney general.

The J. Sinclair Brown Bridge in Salem was formally dedicated on May 4. About one
thousand persons attended the event and heard Virginia governor William Tuck deliver
the dedicatory speech. Mayor James Moyer of Salem presided over the ceremony.

The Dixie Drive-In Theatre opened on May 4. The feature film was *Love Laughs at
Andy Hardy*, which starred Mickey Rooney. The drive-in was on Route 24 just east of
Vinton. The new drive-in could accommodate 310 cars.

The Roanoke City Council authorized the purchase of four lots on Eighth Street,
SW, between Campbell and Marshall Avenues for the construction of the municipal
health care center. The lots cost $3,500.

Moss Plunkett of Roanoke addressed a US House of Representatives subcommittee
in Washington, DC, on May 4 and declared the poll tax a "dollar disfranchisement." He
represented Americans for Democratic Action, which had allied itself with the NAACP
to abolish the poll tax.

More than one thousand students of Roanoke's black schools staged a physical education demonstration at Victory Stadium on May 6. The program included plays, folk dances, and track and field events.

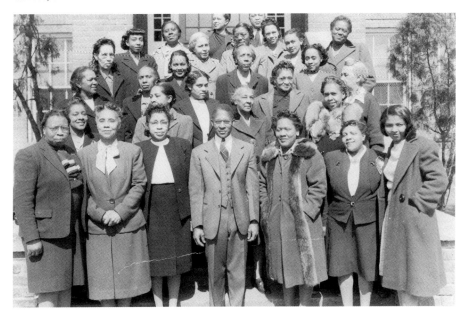

This is the faculty of the Harrison School for 1948–49.
Virginia Room, Roanoke Public Libraries.

J. B. Fishburn, chairman of the board of First National Exchange Bank, was honored by regional bankers at a banquet at the Hotel Roanoke on May 7 on the occasion of his sixtieth anniversary in banking. Fishburn was elected cashier of the First National Exchange Bank when it first opened in 1889.

Dr. T. Allen Kirk received the highest honor from the American Rose Society when the organization awarded him their Gold Medal. The award was presented to Kirk at a banquet held at the Patrick Henry Hotel on May 7.

On National Hospital Sunday, May 8, it was noted that Roanoke's first hospital, the Hart House, was still standing on Hart Avenue, NE. Further, the first baby born in Roanoke, after the name change, was Alma Hart, daughter of Dr. and Mrs. Henry Hart, who operated the hospital. Alma was still living in Roanoke in 1949. According to historians, the Hart home was originally built in 1837 by Zachariah Robinson and used as a tavern and inn. Among the notable guests were Henry Clay and James K. Polk. The Hart family moved into the home in 1876 and founded The Invalid's Home in what was then Big Lick.

Roanoke Grocers Inc. opened their new warehouse in early May at Albemarle Avenue and Third Street, SE. The company had eighty member stores that operated within a fifty-mile radius. The association was organized in 1939. R. E. Foutz was manager of the association.

The Manhattan Restaurant reopened on May 12 at 109 S. Jefferson Street following a remodel.

Dana Marie Weaver, sixteen, a student at Jefferson High School was found murdered in the kitchen of the Christ Episcopal Church Parish House on May 9, her death occurring there the evening prior. Her body was discovered by the church's custodian. According to police, Weaver had gone to the church Sunday evening for a youth group meeting, not knowing that the meeting had been cancelled in lieu of a picnic. She was last seen alive when she was dropped off at the church by friends. Police had no suspects.

The detective division of the Roanoke Police Department gives
an interview to local media, possibly in connection with the
murder of Dana Weaver. *Roanoke City Police Department.*

Kann's presented *The Cavalcade of Swimsuits* on the stage of the Grandin Theatre on May 10. The fashion show had models wearing swimwear from 1890 to 1949. Kann's ad for the event read, "The most exciting fashion show you ever saw!"

On May 10, Lee Scott, a senior at Jefferson High School, was arrested for the brutal murder of Dana Marie Weaver. Scott was an Eagle Scout and member at Christ Episcopal Church where Weaver was killed. The announcement of Scott's arrest was made by Capt. Frank Webb at police headquarters. The killing stunned the city such that the city council authorized a $500 reward for information leading to an arrest and conviction. According to police, Scott confessed to the slaying of Weaver, though his motive was unclear. One unusual report about Scott was that he collected money from his homeroom class for flowers for Weaver's funeral service just hours before his arrest. Weaver's funeral was conducted from Raleigh Court Methodist Church before an overflow crowd. She was interred at Evergreen Burial Park.

A flying saucer resembling a long cigar with a bright-red light and trailing smoke was seen over a large region in southwest Virginia on the evening of May 12. The first report came from J. S. Mays of Roanoke, who was riding in a car with a friend when both spotted the object. They were just north of Boones Mill at the time. Other reports quickly followed from points west and east of Roanoke with similar descriptions.

Miss Jemima Hurt, principal of Jamison School in Roanoke, retired after thirty-two years as principal there. She had served as an educator in Roanoke for forty-two years.

The Colonial Club of Roanoke held its home debut for the season at Maher Field on May 13. The baseball team was part of the Skyline League, which included teams from Altavista, Amherst, Appomattox, Buena Vista, Bedford, Clifton Forge, and Covington.

A packed audience at the American Legion Auditorium watched the Jaycees Talent Show. Some twenty-three acts competed, and the winner was Miss Martha Ann Snyder of Roanoke, who sang "One Kiss."

One hundred home sites in Lincoln Court were auctioned on May 14. The subdivision was located across from Lucy Addison High School.

The Virginia Amateur League opened their baseball season in mid-May. Teams were from Rocky Mount, Iron Gate, Salem, New Castle, Buchanan, Glenvar, and Fincastle-Troutville.

Giles Realty Company began advertising house lots in Southern Hills, a "new subdivision for colored."

Joie Chitwood's auto daredevil show came to Victory Stadium on May 19, featuring movie stuntmen, speedway auto racing, clowns, and motorcycle tricks. Paid admission exceeded 11,200, and over 1,000 spectators came on special passes.

Chimes were installed at Lawrence Memorial Methodist Church, Bent Mountain, in mid-May as a bequest from the estate of Byron Woodrum.

The Evans Diocesan House of the Episcopal Diocese of Southwestern Virginia was formally dedicated on May 17. The house served as the headquarters of the diocese. The new building was located at First Street and Highland Avenue, SW. The building was erected in honor of the donor, Mrs. Letitia Evans. Land for the building was donated by Mrs. Evelyn Shackelford and Mrs. Louise Fowlkes.

The Washingtonians and the Top-Hatters performed for a floor show and dance at the American Legion Auditorium on May 21.

This is the Starkey baseball team in 1949. Local baseball leagues were very popular in the 1940s, with most communities fielding a team. *Benton Hopper.*

Mrs. Annie Whales died in Burrell Memorial Hospital on May 20 from burns she received while trying to start a woodstove fire in her home.

The May issue of the *Nation's Business*, the magazine of the US Chamber of Commerce, profiled Roanoke's Mill Mountain with an article titled "The City That Owns a Mountaintop."

Lee Scott, sixteen, a student at Jefferson High School who was charged with the murder of his classmate Dana Marie Weaver, was given several psychiatric examinations while in the city jail. The examinations also included an interview conducted with Scott after he was administered sodium pentothal, a truth serum. Three psychiatrists examined Scott in an effort to discern his motive for killing Weaver and his ability to contribute to his defense.

Talbott Pingley, seven, died on May 21 from injuries he sustained when he was run over by a truck while on the campus of the Lutheran Children's Home of the South in Salem. Pingley had been a resident of the home for about six months.

The Carver High School Band performed at the dedication ceremony for the Booker T. Washington Memorial in Franklin County on May 23.

The Langhorne Place Swimming Pool was granted a charter by the SCC for the purpose of operating a swim club and pool for the residents of that development and their guests.

A new all-steel Lustron home, the first of its kind in the area, was completed at 16 S. College Avenue, Salem, in late May. The structure was brought in by truck in sections and assembled on site by J. A. Brightwell Company of Danville. It was used by Dr. Russell Smiley as his medical office.

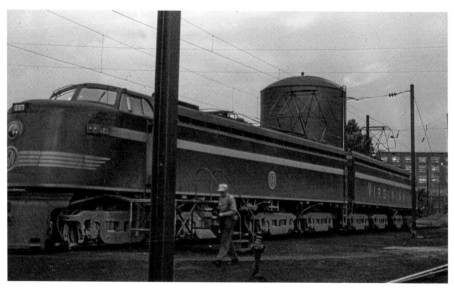

Virginian Railway No. 127 in Roanoke in 1949. Though smaller than the N&W Railway, the Virginian had a significant presence in Roanoke. *Virginia Room, Roanoke Public Libraries.*

Miss Emma Smith announced her retirement as principal of Wasena Elementary School, effective at the end of the school year. Smith had been principal of the school for twenty-one years and had not been absent a single day during that time.

A two-seat plane rented at Woodrum Field crash-landed in Carvins Cove and sank to the bottom on May 22. The pilot and passenger, William Wallace and Grady King, escaped relatively unharmed as they were quickly rescued by those at the cove. The two were sightseeing over the cove when the pilot, King, stated the fuel line cut off.

Grandpa Jones of the *Grand Ole Opry* performed at the Roanoke Theatre on May 25. He was joined by Ramona, "Hildergarde of the Hills."

Count Basie and his orchestra performed for a floor show and dance at the American Legion Auditorium on May 26. Joining Basie were Jimmy Rushing and Earl Warren. White spectators were admitted.

The chauffeur for Dr. E. G. Gill was arrested and charged with trying to extort $3,000 from the well-known ear, nose, and throat doctor. The May 25 arrest of William Lytle, twenty, was in response to Gill's assertion that Lytle threatened to kill his daughter, Betty Gill, if the money were not paid. Lytle had worked for Gill for three weeks.

Roanoke city manager Arthur Owens and councilman Dan Cronin testified before a congressional subcommittee in Washington, DC, on May 26 in favor of the Smith Mountain flood control and power dam on the Roanoke River.

One of two West Virginia brothers who drew prison terms for the murders of Roanoke and Franklin County law officers in the mid-1930s was paroled in late May. James Duling was given conditional release, and his brother, Graves Duling, received the same a few weeks later. The brothers drew thirty years each in Roanoke County Circuit Court in 1936 for the shotgun slaying of Deputy Sheriff Clarence Simmons as he drove home in the early-morning hours of July 17. In Franklin County, each of the pair was sentenced to ninety-nine years for the slaying of Deputy Sheriff Thomas Richards and a black prisoner. Simmons was killed on Route 220 in the Red Hill section. Law enforcement officials in both counties were surprised by the state parole board's decisions.

Sycamore's, a restaurant, opened on RFD 1, Salem, on May 28.

The Karston Vaudeville Show came to the Roanoke Theatre on June 1. The stage show starred Gene Gory and his band, "Nature Girl" Roberta who did her "Fig Leaf Dance," the Three Hendersons, and other acts.

The '49ers Covered Wagon arrived in Roanoke on May 30 for a downtown Roanoke parade to promote the $885,000 Opportunity Bond Drive. The wagon was displayed for two days at the corner of Campbell Avenue and Jefferson Street.

The Roanoke City Council changed its mind on the purchase of property for a new public health center. At its May 30 meeting, the council directed the city manager to not exercise an option on four lots previously considered and instead purchase a tract from the Fishburn family on the southwest corner of Campbell Avenue and Eighth Street, SW, for $20,000.

Goodwill Industries moved into their building at 11 W. Salem Avenue on June 1, culminating four years of planning. Their new quarters allowed them to serve one hundred physically handicapped persons.

Construction of a $20,000 roller skating rink began in early June at Kessler Mill Road and Route 11. A permit for the construction was secured by the Roanoke Skating Club Inc.

A groundbreaking ceremony was held on June 5 for what would become Hollins Road Baptist Church. Dr. Wade Bryant, pastor of First Baptist Church, Roanoke, directed the ceremony.

Work began on a new thirty-five-unit apartment building at 231 Chestnut Street in Salem in early June. The structure had architecture similar to Colonial Williamsburg.

The Roanoke Council of Church Women voted to end Bible classes for elementary school children at the end of the school year. The council's decision was in response to perceived opposition by the members of the Roanoke City Council and the school board. It was also noted that Baptist churches in the city had withdrawn their support. The voluntary classes had been taught for three years, with the RCCW raising the money necessary for the program. According to the organization, 3,050 children took the Bible classes, and 44 opted out.

Robert Lunn of the *Grand Ole Opry* performed on the stage of the Roanoke Theatre on June 8.

Two men who were convicted of murders that shocked the Roanoke region two decades prior were given paroles in early June by the state parole board. Buren Harmon of Floyd County was convicted of the December 1929 murder of high school student Freda Bolt. Harmon left Bolt to die on the side of Bent Mountain, came back the next day, and, finding her still alive, murdered her by strangulation. The murder of Bolt became the subject of a folk ballad popularized by the Carter family. Harmon had served twenty years. Albert Robertson of Roanoke was pardoned after serving twenty years for the murder of two Roanoke police officers on the night of July 1, 1925. Patrolman C. H. Morgan was shot through the head, and Patrolman W. M. Terry died two days later from being shot in the abdomen. A third patrolman, A. M. Smith, was also shot but partially recovered.

Howell Whiteside won the City-County golf tournament. The three-day event was held at Roanoke Country Club and Monterey Golf Club. Whiteside shot a total score of 281, beating George Fulton by four strokes. Over sixty area golfers competed. This was the first City-County tournament in ten years.

A grand jury indicted Lee Scott on June 6 for the murder of Dana Marie Weaver. His trial was slated to begin on June 27. Warren Messick was Scott's defense counsel.

Mildred Payne, sixteen, was struck by an auto driven by an unknown female on June 6. The driver picked up Payne after the accident but then abandoned the girl on a downtown street. Payne walked over two miles to her home in the Riverdale section and collapsed once inside. She was taken to the hospital, and police had no leads on the driver.

The Roanoke City Council authorized the city manager on June 6 to make an offer for approximately fifty-eight acres of land along the Roanoke River just east of Buzzard Rock Ford as the site for a new sewage-treatment plant.

The Roanoke Kiwanis Club dedicated their new swimming pool at Camp Kiwanianna near Shawsville on June 8. The club was responsible for building the pool for the summer camp.

Larry Vinson, twelve, won the City-County marbles tournament held in Elmwood Park on June 6. Runners-up were Kainey Agee and Billy Fralin. The annual tournament was sponsored by the Times-World Corporation.

The Roanoke Civic Orchestra presented its first concert on June 8 at the Jefferson High School auditorium. Franklin Glynn, organist and choirmaster at St. John's Episcopal Church, was the director of the forty-piece orchestra.

Seven students received diplomas in the first commencement on June 9 at the Booker T. Washington Memorial Trade School in Roanoke. The ceremony was conducted from High Street Baptist Church. The school had an enrollment in its first year of eighty-five students. S. J. Phillips, president of the Washington Birthplace Memorial, was the commencement speaker.

Roanoke's independent groceries, operating as a consortium with their own warehouse, adopted "Blue Jay Food Markets" as the emblem to be displayed in their stores. The member groceries numbered thirty-two and were part of Roanoke Grocers Inc.

Zeb Tuner of the *Grand Ole Opry* performed at the City Market Auditorium on June 11. He was joined by Wayne Fleming and His Rhythm Buddies.

The Roanoke Kiwanis Club and the Roanoke Valley Horseshow Association held a two-day first annual Roanoke Valley Horseshow at Lakeview Farm June 17 and 18. Lakeview was located on Route 11 one mile north of Roanoke. Two hundred entries in forty-one classes were exhibited.

The King Cole Trio, featuring Nat King Cole, performed a floor show and dance at the American Legion Auditorium on June 16. They were joined by Hal Singer and his orchestra. White spectators were admitted.

Jimmy Dorsey and his orchestra performed a floor show and dance at the American Legion Auditorium on June 14.

The Sweet Singing Johnsons performed at the Roanoke Theatre on June 15. The Johnson family was popular on radio and based in Charlotte, North Carolina.

The Patchwork Players opened their summer season with eighteen players from seven states. They had ten productions slated for their fifth season.

Don's Sandwich Shop opened in mid-June in Garden City at what was formerly Anderson's Confectionary. The new restaurant was operated by Donald Atkins.

Roanoke city manager Arthur Owens announced in mid-June that Assistant City Engineer J. R. Hildebrand would be promoted to planning engineer to work with the city's Planning Commission, effective August 1.

R. Q. Hite was appointed to a three-year term on the Roanoke School Board by the city council on June 12. Hite was a resident of the section recently annexed into the city. LeRoy Smith was reappointed to his seat on the board.

Dr. Frank Slaughter, a former resident surgeon at Jefferson Hospital, visited Roanoke in mid-June to sign copies of his books at the Book Nook. Slaughter left his medical practice after twenty years to pursue a career in writing. During the 1940s, Slaughter had several successful novels published, including *That None Should Die, In a Dark Garden, Golden Isle*, and *Divine Mistress*.

The new Leggett's department store being constructed on West Campbell Avenue installed "motor stairs" (escalator). The department store became the first downtown Roanoke retail establishment to have an escalator. The N&W Railway passenger station was the first establishment in the city to install an escalator.

The first push-button pedestrian-crossing traffic control was installed in mid-June at the intersection of Williamson Road and Liberty Road.

A meeting was held at William Fleming High School on June 14 for area residents interested in establishing an Episcopal church in the section. The meeting was convened by Bishop Henry Phillips.

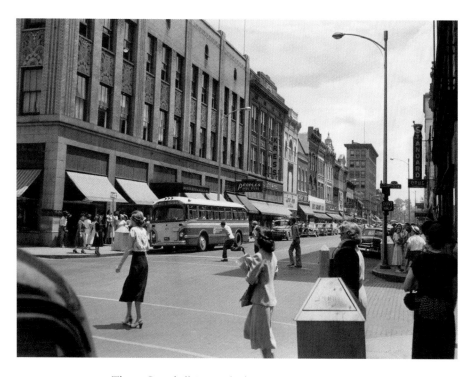

This is Campbell Avenue looking east at First Street in
1949. *Historical Society of Western Virginia.*

The Roanoke Red Sox established the Knot Hole Club in mid-June so boys could watch the baseball games from the right-field bleachers for free. A membership card cost a quarter.

Roanoke's oldest resident, James Willis, died on June 16 at the home of his daughter, Dora Spiers. Willis was 107.

The new chapel at the Veterans Administration Hospital was dedicated on June 17. The ecumenical dedication service featured Dr. Charles Smith, president of Roanoke College, as the principal speaker. The chapel could seat four hundred persons.

The new warehouse and office at the Noland Company, 1226 Center Avenue, NW, opened on June 17. The company held a public open house featuring refreshments and gifts.

F. W. Woolworth Company in downtown Roanoke was issued building permits in mid-June for expansion into two stores previously occupied by Kohen's Women's Wear and Walters Printing Company.

Billy Fralin of Bent Mountain won the Southern Marbles Tournament in Greensboro, North Carolina, in mid-June, which qualified him for the national tournament.

The Peters Funeral Home at 2408 Williamson Road was purchased in mid-June by the John M. Oakey Funeral Service for $75,000. I. L. Peters opened the business four years prior.

Appalachian Electric Power Company held a four-day electric range show and cooking demonstrations in the auditorium at their headquarters building June 21 through 24. The event featured a film, *The Constant Bride*, and daily prizes. Advertisements noted, "The demonstrations Friday are set aside for the Negro."

WDBJ radio celebrated its twenty-fifth anniversary on June 20. The station celebrated by having local bands, singers, and radio personalities broadcast throughout the day. The station began when a ham radio operator, F. E. Maddox, was encouraged by his employer, Richardson-Wayland Electrical Corporation, to build a commercial transmitter. That effort secured the license for WDBJ on May 5, 1924, for a twenty-watt station. The first broadcast occurred on June 20, 1924, when Maddox and Ray Jordan broadcast from the back of the electrical firm's building. The first thing heard was Jordan playing his fiddle accompanied by a man on the banjo doing "Turkey in the Straw." With that WDBJ was launched. It had no employees but was the first on the air in western Virginia. National radio personalities who recognized the anniversary on their broadcasts included Arthur Godfrey and quiz master Bill Cullen.

The first form of the modern-day credit card, known as the Charga-Plate, was initiated by three Roanoke retailers: S. H. Heironimus, N. W. Pugh, and Smartwear-Irving Saks.

Commissioning ceremonies for the Navy Associated Volunteer Unit 3 were held at Woodrum Field on June 19. The unit was the first established in Roanoke for the training of service personnel in western Virginia in the phases of naval aviation. More than twenty navy planes were brought from Norfolk for the unit. Several hundred attended the event or were positioned at various points overlooking the runways to watch the navy planes fly in.

Mrs. Adrian Wilhelm died from injuries she sustained when she was struck by an N&W Railway passenger train on June 19 near Starkey. She, her husband, and their four children were walking home alongside the tracks.

Burley Bush, ten, was found drowned on June 19 in the Lee-Hi Swimming Pool two hours after it had closed.

Western film star Charlie King performed at the Roanoke Theatre on June 22 along with the Sunrise Rangers.

The Roanoke City Council decided in a meeting with the city's library board on June 21 to approve the northwest corner of Elmwood Park as the site for the new main library. The library board had favored the site of the No. 1 Fire Station on Church Avenue as a more central location to downtown. The board believed the site may have been available due to a prior recommendation of the city manager that the No. 1 and No. 4 Fire Stations be consolidated.

Fire gutted the Magic City Launderers and Cleaners on June 22. The laundry was located at 902 13 Street, SW, at the foot of Memorial Bridge. E. C. Tudor was the laundry owner. Damage was estimated at $250,000, as the laundry was almost a complete loss.

The North 11 Drive-In Theatre opened on June 24. It was the third drive-in theatre in the Roanoke Valley. It was located at the intersection of Route 11 and Route 117 at the rear of Archie's Lobster House. Dewey Marshal was the manager. The first movie shown on opening night was *Homesteaders Paradise Valley*, which starred Allen Lane.

Larry Vinson, Roanoke marbles champion, and Billy Fralin, the Southern Tournament marbles champion, both competed in the National Marbles Tournament in Asbury Park,

New Jersey, on June 24. Neither prevailed, though Vinson missed the national title by only one game.

Excavation for the second phase of the Roanoke Times-World Corporation expansion began in late June. The expansion included construction of a garage and a small addition to the building that faced Campbell Avenue, SW. B. F. Parrott and Company was the general contractor.

The jury trial of Lee Scott got underway on June 27, with Judge Dirk Kuyk presiding. Kuyk closed the trial to the public. Over thirty witnesses had been procured for the trial, which was making headlines across the country. The jurors were sequestered for the duration of the trial in nearby hotels. On the second day, Scott's attorney, Warren Messick, stated that Scott was guilty of the slaying of Dana Marie Weaver and mounted a defense that the killing was over an argument about a mutual friend, Jimmy Webb. Messick argued that Scott was guilty of manslaughter, not murder. The prosecution was led by Assistant Commonwealth's Attorney Beverly Fitzpatrick, who argued for the death penalty. The coroner's report presented at the trial indicated that Weaver had died due to suffocation.

The Roanoke city manager initiated "Gripe Tuesday" on June 28. The weekly event was held in the city council chambers and allowed citizens to offer comments to the city manager and his staff.

The Roanoke Booster Club left for their annual trip. Some three hundred men boarded a special Powhatan Arrow passenger train for White Sulphur Springs, West Virginia, on June 29.

Property owners in Vinton approved four major bonds in a referendum on June 28. The bond issues supported the Vinton War Memorial, a sewage disposal plant site, a new jail and first-aid building, and a municipal parking lot.

Heavy rains in late June caused severe flooding in the Back Creek section of Roanoke County. According to older residents, it was the worst flooding in that section in nearly fifty years.

The Roanoke Electric Company held a formal grand opening for its store at 127 E. Campbell Avenue. The site was the former location of the Appalachian Electric Power Company.

Bullmoose Jackson and the Buffalo Bearcats performed a floor show and dance at the American Legion Auditorium on July 1. White spectators were admitted.

Common Glory, the Virginia historical drama, opened for its third season in early July in Williamsburg. Director of the set and costumes was Clara Black of Roanoke. She had been with the drama since its first summer season.

Hartman and Botts Service Center opened July 1 at the corner of Jefferson Street and Maple Avenue, SW. They sold Texaco gas and gave away fire chief hats to the children of customers on opening day.

On July 1, Lee Scott testified in his own defense at his murder trial, which had dominated the front page of local newspapers since it commenced. Scott stated in court the following: "Something just came over me and I struck her (Dana Marie Weaver) with the soda bottle I had in my hand. She swung at me, either with her fist or with her bottle." The two fell to the floor, where Scott held her down and then ultimately strangled her. According to Scott, he hit Weaver when she made a derogatory comment about his friend

and her former boyfriend, Jimmy Webb. The next day closing arguments were heard, and after two hours of deliberation, the jury rendered a verdict of guilty of first-degree murder for Scott. The jury fixed his punishment at life in prison. According to press reports, Scott showed no emotion when the verdict was read.

Irish Horan and the Lucky Hell Drivers performed a variety of automobile stunts at Victory Stadium on July 2. Stock car racers included Buddy Toomey, Whitey Reese, and Pancho Roberts.

Razing of the Bushnell Building on E. Main Street in Salem to make room for a parking lot began on July 1. The building was east of the courthouse and was considered to be one of the oldest in the town, having been put together with wooden nails and pegs.

Construction on the new US Marine Corps Reserve Armory at Maher Field began in mid-July. Wiley N. Jackson Company was the general contractor for the $153,000 armory, which was being erected between Victory Stadium and Maher Field. The armory was to house the 16th Engineer Company.

Cozy-Corner Drive-in Restaurant opened in early July at the corner of Tenth Street and Moorman Road, NW.

The Barter Theatre Players presented *Ladies in Retirement* at the Jefferson High School auditorium on July 8.

Pet Supply Shop opened on July 9 at 308 E. Main Street in Salem. The pet supply store was operated by T. T. Fairtrace.

The Cloth Store opened on July 12 at 26 W. Kirk Avenue.

The bandstand in Elmwood Park, photographed here in 1949, was a popular venue for summer concerts with local bands. *Virginia Room, Roanoke Public Libraries.*

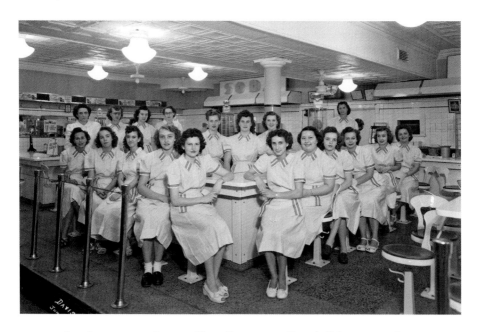

Lunch counter employees at Kress Company on Campbell Avenue pose for a photograph in the summer of 1949. *Virginia Room, Roanoke Public Libraries.*

Capt. William Odom, who had set a 4,957-mile nonstop world record for light-plane distance flying, addressed the Roanoke Junior Chamber of Commerce on July 13. Odom landed at Woodrum Field in his famed Beechcraft Bonanza, named *Waikiki Beach*, which he used to set the record. Clayton Lemon displayed the plane at his hangar.

The Book Nook hosted an author signing on July 12 for Nelson Bond for the release of his newest novel, *The Thirty-First of February.*

The Salem Town Council rejected a proposal to join with the City of Roanoke in a joint sewage treatment disposal plant. The town council opted to plan for its own plant.

The Roanoke City Council moved toward the creation of a Public Housing Authority at a July 11 meeting. City Manager Arthur Owens told the council that such an authority could be critical to launching a "slum clearance program" using federal funds.

Lee Scott was transferred from the Roanoke city jail to the state penitentiary in Richmond on July 12 to begin serving his ninety-nine-year sentence for the murder of Dana Marie Weaver. In a related matter, a female student at Jefferson High School was given $1,166 in reward money as her tip led to the arrest and conviction of Scott. The girl and her family donated the funds to Weaver's mother.

Paul Williams and his Hucklebuckers orchestra, Roy Brown and his orchestra, and Chubby Newsom performed a floor show and dance at the American Legion Auditorium on July 15. White spectators were admitted.

The new Essotane Gas bulk plant and retail gas appliance showroom opened at 711 Water Street in Salem on July 16. Kirk Mayberry was plant manager.

The Iota Chapter of the Phalanx Fraternity received its charter at a ceremony held at the Hunton Branch YMCA on July 14.

The N&W Railway General Offices became air-conditioned in mid-July. The office building was equipped with an air-conditioning plant that kept the interior cooled consistently between seventy-six and seventy-eight degrees.

The first polio case of the year was admitted to Roanoke Hospital in mid-July. The patient was a twelve-year-old girl from Huddleston.

A flash flood caused severe damage between Vinton and Stewartsville on July 15. Flood waters washed out a highway bridge across Falling Creek, and several parked cars were swept downstream.

W. H. Lyons opened a tailor shop above the Park Theatre at 509 S. Jefferson Street in mid-July.

Trumpeter Henry Busse and his orchestra performed at the Roanoke Theatre on July 20.

A westbound N&W Railway freight train plowed into an eastbound coal train just east of Elliston on July 16. The wreck sent a Class Y6A engine and two cars into the Roanoke River and derailed sixteen other cars. There were no casualties.

Mabry Mill, a landmark along the Blue Ridge Parkway, opened for weekends in mid-July.

Some sixteen thousand N&W Railway employees, including seven thousand in Roanoke, went to a five-day, forty-hour work week effective September 1, as announced by railway officials in mid-July. The new work hours were the result of negotiations with labor unions.

Officials with Roanoke Gas Company announced on July 19 that natural gas would be piped to Roanoke by the spring of 1950 from a main transmission line near Eagle Rock. The pipe would be thirty miles from Roanoke to Eagle Rock and cost about $600,000. The Roanoke gas line would connect to a trunk line operated by Virginia Gas Transmission Corporation.

The "Little House" at the intersection of Barham and Lofton Roads, SW, became Roanoke's Grandin Court Recreation Center on July 20. The center was formerly a schoolhouse.

Residents living near Washington Park complained to city officials about the dumping of garbage in an abandoned quarry in the park. The city health commissioner committed to spraying the dump once a week for flies.

Hustings Court authorized an additional dividend of 5 percent on all claims against the defunct State and City Bank. The July 20 ruling brought to 60 percent the amount of original obligations repaid since the bank closed in 1933.

Ralph Eversole, fourteen, won the Roanoke Soap Box Derby on July 20. A student at William Byrd, Eversole won a bike and a free trip to the national contest in Akron, Ohio. An estimated ten thousand people watched the event, which was held on Crystal Spring Avenue in South Roanoke. Eversole had a time of 29.95 seconds over the three-block track. The runner-up was Tommy Johnson. WDBJ and WSLS broadcast the final heats. Some fifty-six racers competed.

This was a Soap Box Derby car sponsored by First Federal in 1949. The derby was held on Crystal Spring Avenue in South Roanoke. *Historical Society of Western Virginia.*

At an organizational meeting of the Hidden Valley Country Club on July 20, it was announced that $100,000 of capital stock had been subscribed. The board of governors was given authorization to exercise a purchase option on the Musser Dairy Farm for their proposed golf course. Charter members numbered 360. Joe Stone was club president.

Twenty-three men gathered at the WSLS radio station on July 21 and formed a Roanoke chapter of the American Society for the Preservation and Encouragement of Barbershop Quartets. A. B. Swan headed the group.

Earl Dickerson, twenty-one, of Roanoke county drowned in a pond a half-mile east of Pinkard Court on July 23. He was with his brothers at the local swimming hole.

The Home Office Agency of Shenandoah Life Insurance Company moved to new headquarters during the week of July 24 at 128 W. Church Avenue, the site of the Magic City Mortgage Company building. Frank Clement was the manager.

The *Roanoke Times* introduced a new comic strip to its readers on July 25, *Mary Worth*. The *Times* described the comic strip as "a series of romantic novelettes about glossy girls in the more glamorous professions with the wise Aunt Mary as the linking character."

Sam Daniel of Columbia, South Carolina, won the annual Roanoke Exchange Club Invitational Tennis Tournament that was held in late July at the Roanoke Country Club. Daniel defeated Heath Alexander of Charlotte, North Carolina.

Fire of an undetermined origin destroyed the historic mansion of the Fort Lewis estate on July 25. Moten Altizer, owner, was the only person in the house at the time of the fire and was rescued from a second-story room. Four fire departments responded to the blaze and were hampered by a lack of water. By the time the fire was extinguished, only the twelve- to eighteen-inch thick wall remained standing.

The ruins of the Fort Lewis mansion near Salem were all that remained following a devastating fire on July 25, 1949. *Nelson Harris.*

The Hawaiian Paradise Revue came to the stage of the Roanoke Theatre on July 27 and featured seventeen "native artists" including the "lu-wow lovelies."

The Roanoke City Council authorized at its meeting on July 25 the liquidation of the city's farm and the cessation of operating the farm. The council instructed the city manager to close the farm by May 1, 1950, or sooner and to liquidate the city's dairy herd and farm equipment when feasible. The city had begun operating a farm when it opened the city almshouse many years ago. The city was operating farms on several large and small tracts throughout the Roanoke Valley.

Cook's opened at 1326 Grandin Road SW, on July 29. The store sold women's, children's, and infant clothing and was owned and operated by Mr. and Mrs. Ralph Cook.

The Roanoke City Council directed the mayor to appoint the commissioners to a Roanoke Redevelopment and Housing Authority. This was viewed as an initial step toward "slum clearance" and providing low-income housing using Federal funds.

Curtis Turner of Roanoke won a one-hundred-lap feature stock car race at Greensboro, North Carolina, on July 25.

E. R. Dearborn of Bedford bought the burned-out remains of the Fort Lewis estate mansion in late July. Dearborn indicated he intended to build a house where the old home once stood.

Roanoke's first air show in twelve years came to Woodrum Field on July 31. The All Star Air Show was sponsored by the Roanoke Exchange Club for the benefit of underprivileged children. One of the featured acts was "the world's smallest airport," which consisted of a plane that landed on a platform built atop a moving automobile. The

"White House" 121st Fighter Squadron of the DC Air National Guard also performed aerial formations. Two airport runways were roped off for parking. An estimated twenty thousand persons attended the show.

Robert Porterfield, founder of the Barter Theatre, told the Roanoke Rotary Club in a speech on July 28 that Roanokers must do everything possible to save the Academy of Music. "The Academy of Music is the finest auditorium for an actor in this country. It is the duty of the citizens of this city to save that building."

Henebry's of Roanoke purchased the jewelry establishment of J. A. Thomason at 215 Main Street in Salem in late July. The Salem store was made into a branch of Henebry's. The Thomason was the oldest jewelry house in the county, having been established in the 1880s.

Wayne Fleming of the *Grand Ole Opry* performed an open-air concert at the Lee-Hi Drive-In on July 30. He was joined by the Country Cavaliers.

A benefit concert featuring the Rising Sun Male Chorus, the Gospel Guides, Laverne Smiler, and pianists Johnson and Bennett was held at the American Legion Auditorium on July 30. The program was sponsored by Club Eli, a black charitable organization with branches in three states.

A new comic strip, *The Dripples*, debuted in the *Roanoke Times* on July 31.

Buddy Johnson and his eighteen-piece orchestra performed a show and dance at the American Legion Auditorium on August 3. White spectators were admitted.

Hippert Radio and Appliance Service opened at 1504 Grandin Road on August 3.

In the Democratic primaries held on August 2 in Roanoke City, the results were as follows: C. R. Kennett defeated Julian S. Wise for the nomination for city treasurer; John Hart defeated W. B. Carter for the nomination for commissioner of revenue; and Edgar Winstead won his ballot for city sergeant. In the Sixth District Congressional Democratic primary, J. Lindsay Almond defeated Moss Plunkett. In the Democratic primary, 12,355 Roanoke city voters participated. In the Republican primary on the same day, only 102 Roanokers cast a ballot.

E. F. Kindlan's Circle "K" Ranch Rodeo came to Victory Stadium for a four-day run on August 4. The rodeo featured bronco riding, bull riding, and film star Ken Maynard with his horse, Tarzan. The rodeo was a benefit for the Police Protective Association Pension Fund.

The Williamson Road Water Company moved into new quarters at 2405 Williamson Road in early August.

R. S. Byrd Grocery opened at a new location at 2449 Shenandoah Avenue, NW, on August 5.

Charles Cowman, four, was struck and killed by an automobile near his home on Oregon Avenue, SW, on August 5. Police suspected the boy ran out in front of the car while playing.

Mary Ann Saunders was held for a grand jury on the charge of murdering her boyfriend, Raymond Ross, nineteen, in late July. Ross died from gunshot injuries at Burrell Memorial Hospital.

William Stubbs, former manager of the Natural Bridge Hotel, was named as the new general manager of the Patrick Henry Hotel in early August. He succeeded Russell Seay, who resigned to become self-employed.

Fort Lewis Acres, a new subdivision three miles west of Salem, had thirty-four home sites up for auction on August 6.

Moir's Millinery opened at 16 W. Luck Avenue on August 7.

Construction on Salem's first incinerator plant began on August 8. The plant site was on a seven-acre tract at the southern terminus of Indiana Street. Lucas and Fralin of Roanoke was the general contractor.

A. L. Coleman, retired superintendent of service at Hotel Roanoke, died at his home on August 6. He was employed by the hotel for forty-five years and was well known to guests and locals. He was the first black man to serve on a jury in Roanoke in Hustings Court, which he did in 1948. He was involved in numerous civic organizations and was a trustee of Burrell Memorial Hospital.

The Barter Theatre presented a production of *Accent on Youth* at the Jefferson High School Auditorium on August 11. Joining the Barter cast was film star and Broadway actor Ian Keith.

George Fulton Jr. defeated Landon Buchanan to win the Roanoke Country Club annual golf tournament. Fulton had won four years in a row, a feat not achieved by any other golfer in the club's history.

George Akers Jr. was charged in the death of his brother, Lorenzo Akers, who died from gunshots wounds. Akers died at Burrell Memorial Hospital on August 8.

A delegation of black leaders asked the Roanoke City Council on August 8 to build a year-round recreation center for black youth. The council directed the city manager to consider a tract of land on Salem Avenue adjacent to the black veterans' housing project as a potential site for a center. The delegation, led by Dr. Harry Penn, also complained about garbage being dumped in a quarry behind Washington Park.

George Scott bought out the Roanoke Stamp and Coin Company at 6 E. Tazewell Avenue in early August.

By a margin of nearly three to one, Roanokers approved up to $4 million in bonds for a sewage treatment plant as a means of purifying the long-polluted Roanoke River. The August 9 referendum was backed by business and civic organizations as a necessary step for Roanoke's progress.

Women's professional baseball stopped over for two nights at Maher Field on August 9 and 10. The Springfield Sallies played the Chicago Colleens. Margaret Hill of Vinton was signed as pitcher with the Colleens and left with the team to play for the remainder of their season.

Radio star Cecil Campbell and his Tennessee Ramblers performed at the Roanoke Theatre on August 10.

Shenandoah Life Insurance Company formally opened and occupied their new headquarters building on Brambleton Avenue on August 9. B. F. Parrott and Company was the general contractor. Approximately fifty firms contributed to the construction and furnishing of the building.

A study conducted by the Virginia Association of Redevelopment and Housing Authorities and presented to the Roanoke city manager determined that the city needed four thousand low-rent housing units. The study found that 7,165 white families and 2,072 black families were living in substandard housing.

Virginia Plastics and Chemical Company, Quality Service Stores of America, and the Roanoke News Agency were all granted charters by the SCC in mid-August, and all had

This early 1950s photo shows the headquarters of the Shenandoah Life Insurance Company on Brambleton Avenue, which was completed in 1949. *Bob Stauffer.*

their principal offices in Roanoke. A Roanoke county company, the Neal Construction Company, of which Wiley Jackson was president, also received its charter.

Edna Latter Antiques opened on August 13 off the lobby of the Patrick Henry Hotel.

S. H. Heironimus held its college fashion show, *The Talk of the Campus*, in the ballroom of the Hotel Roanoke on August 12. Wilma Bell, promotion director of *Mademoiselle* magazine was guest commentator.

Salem residents had their first opportunity to see how the renovated carriage house at Longwood had been transformed into a small theatre when Salem youth presented the play *Me and My Shadow* on August 12.

More than 1,500 visitors toured the new Shenandoah Life Insurance Company building on Brambleton Avenue during a public open house on August 12.

Chief Robert White Eagle, a star of western films, performed roping, dancing, and archery tricks at the Jefferson Theatre on August 17. His appearance was sponsored by John Norman, Inc.

Gary May, eleven, a resident at the Baptist Orphanage in Salem was struck and instantly killed by an N&W Railway passenger train just east of the Moore Mill Lane crossing in Salem on August 13. May was returning from a fishing trip with several other boys from the orphanage.

The N&W Railway announced on August 14 that it had ordered a new type of coal-burning, steam turbine, electric drive locomotive. The 4,500 horsepower locomotives were being built by the Baldwin Locomotive Works in collaboration with Westinghouse Electric Corporation ad Babcock and Wilcox Company. The locomotives were designed for freight service.

Roanoke's soap box derby champ, Ralph Eversole, lost his first heat at the national championship race in Akron, Ohio, on August 14.

B. F. Bonner of Richmond obtained permits in mid-August for the construction of a ten-story apartment and office building to be erected in the 900 block of South

Jefferson Street. The structure was to be known as the Carlton Terrace Apartments. E. Tucker Carlton, formerly of Roanoke, was the architect.

Charley Turner won the City-County Tennis Tournament title for a thirteenth time in mid-August. Turner defeated Paul Rice in straight sets. Turner teamed with Landon Buchanan to win the double title. They defeated Rice and Lew Merritt. The tournament was held in South Roanoke Park.

Vinton Town Council accepted a bid by W. J. Blane, a contractor, for construction of a combination jail and first-aid station. The building site was adjacent to the firehouse and would face Jackson Street.

At its August 16 meeting, the Roanoke City Council authorized a contract to convert street lights to mercury lights with Appalachian Electric Power Company. According to power company officials, the number of street lights with mercury lights would make Roanoke the brightest city in the country next to Los Angeles.

A three-day workshop of the National Congress of Colored Parents and Teachers opened at High Street Baptist Church on August 18. Persons from nineteen states attended.

Ferguson Electric Company, an appliance and repair firm, opened at 1302 Grandin Road, SW, on August 19. The company was owned and operated by Hugh Ferguson and Harold Ferguson.

The Williamson Road Kiwanis and Lions Clubs squared off for a game of donkey baseball on August 22 at William Fleming Field as a fundraiser for both clubs.

The Jaycee All State Air Show was held at Woodrum Field on August 21. Featured pilots were Betty Skelton, Bevo Howard, Don Stremmel, and Woody Edmundson. The show also had delayed parachute jumping and four FR-80 jets. An estimated twenty thousand persons attended.

Three members of the Roanoke Red Sox were named to the Piedmont League All-Star Team for 1949. The players were Milton Bolling (shortstop), Pete Daley (catcher), and Charley Maxwell (outfielder).

The Roanoke City Council ended a simmering controversy at its August 22 meeting when it decided to finalize the location of the new main library—in the northwest corner of Elmwood Park with a 100-foot setback from Jefferson Street. The library board wanted the library only 18 feet back from the street, and the War Memorial Committee wanted a 150-foot setback. The War Memorial Committee was still pursuing plans to use Elmwood Park, along with the new library, as part of a grand memorial to World War II.

The installation of police telephones at strategic locations in downtown Roanoke began in late August. The call boxes had direct lines to the police station and could be used by policemen as well as citizens. Some twenty-five call boxes were installed, including a few in residential sections.

The first Roanoker to be stricken with polio in 1949 was a young married woman who was admitted to Roanoke Hospital on August 25.

Riggle's Bowling Alleys at 15 W. Church Avenue reopened for business on August 26 following a major remodeling.

Kitty Coxe and Juanita Stanley won the women's doubles title in the annual City-County Tennis Tournament in late August. They defeated Nell Boyd and Sugar Ellett. Stanley won the singles title, defeating Boyd.

The annual Roanoke Fair opened on August 29 at Maher Field for a six-day showing. The fair included livestock exhibits, a midway by the Marks Shows, nightly fireworks, and grandstand shows each evening in Victory Stadium.

Lindsey-Robinson and Company, a feed manufacturer, completed construction of a broiler experimental feeding house adjacent to its mill on Shenandoah Avenue, NW, in late August. The building had a capacity of about 3,750 broilers.

Mrs. Hazel Bowles opened the Roanoke Avenue Beauty Shop in late August.

The Patchwork Players ended their fifth and most successful summer season with a production of *Camille* at Hollins College and again at Jefferson High School. The manager estimated that twenty-five thousand attended the group's various performances around the valley, including outdoor plays in city parks.

A gorilla show was held at Starkey for two weeks in late August. Ads read, "World's only athletic ape, see local people compete with him in a bicycle race." The ape was named Joe Boxer.

The first meeting to be held in the Mormons' new chapel at 2115 Grandin Road was on August 28. About 550 persons attended a conference there of the Virginia West District of the Central Atlantic States Mission of the Church of Jesus Christ, LDS.

Leggett's department store opened at 112 W. Campbell Avenue on August 31. It was the forty-second store for the department store chain. The store had the first escalator in a retail establishment in downtown. The ground floor contained the hosiery, cosmetics, shoe, and men's clothing departments. The second floor was the women's department, and the third and fourth floors were for household furnishings, draperies, towels, bed linens, and other items for the home. The children's department was on the balcony section between the first and second floors. An estimated fifteen thousand persons visited the store on opening day.

Roanoke mayor W. P. Hunter named the five commissioners to the Roanoke Redevelopment and Housing Authority. They were John Windel, Thomas Wirsing Jr., Fred Mangus, Harold Hill, and Jacob Reid. Windel was named chairman.

Plans for a new thirty-five-acre park to be developed on the former Moomaw property near Cove Road, NW, were advanced when an application for a corporation charter was submitted in late August. The park, to be known as Crystal Lake, included facilities for boating, swimming, picnicking, and other recreation. Henry Giles was president of the group seeking the charter.

Former First Lady Edith Wilson spent a few days in Roanoke in early September. Mrs. Wilson was in town to attend the wedding of Jean Logan and Richard Watts III at St. Paul's Episcopal Church in Salem. She stayed at the Ponce de Leon Hotel.

Nonoperating employees of the N&W Railway, along with all such other employees of railroads nationwide, went to a five-day work week effective September 1.

Charles Brown, the Charles Brown Trio, and his orchestra performed a floor show and dance at the American Legion Auditorium on September 4. Cootie Williams and his orchestra also performed for the second half of the show. White spectators were admitted.

Boxing season began on September 2 at the American Legion Auditorium. Opening night featured boxers from several states, including locals Don Webber, Jesse Baker, Tommy Thomas, and Kid Jordan. Seating at the event was segregated.

St. Paul's Episcopal Church in Salem hosted a wedding in 1949 attended by former First Lady Edith Bolling Wilson, 1940s. *Virginia Room, Roanoke Public Libraries.*

Several Roanokers were getting television sets and reporting various levels of reception. C. B. Dixon of Rorer Avenue, SW, said in early September his set received a transmission from Charlotte, North Carolina.

Club Morocco held a breakfast dance on Labor Day from 4:00 a.m. to 8:00 a.m. Entertainers were Spodeeo Dee and his Harlem Capers, Lee "Shake Queen" Ta, Rita Grena, and Bertie Pilgrim, all from New York City. There was a reserved section for white spectators.

Little Jimmy Dickens of the *Grand Ole Opry* performed at the Roanoke Theatre on September 7.

The Booker T. Washington Memorial Trade School leased the property formerly owned by A. L. Nelson Truck Company on Shenandoah Avenue, adjacent to the N&W Railway General Offices. The trade school's academic session began on September 12.

Veterans of the 81st Division, known as the Wildcat Veterans Association, adopted a formal resolution at the close of their annual national convention held at the Hotel Roanoke complaining about the affront Roanoke had created when merchants did not display the US flag as requested by Roanoke's mayor as a means of welcoming them to the city.

George Fulton Jr. of Roanoke won the twenty-fifth annual Fairacre Golf Tournament held at Hot Springs on September 5.

A. R. Minton was elected by his city council colleagues as Roanoke's next mayor during the body's reorganizational meeting on September 6. Richard Edwards was chosen as vice mayor. Minton won on a 3–2 vote over Councilman Dan Cronin.

Norvel Lee, a black student at Howard University and native of Eagle Rock, won an appeal before the Virginia Supreme Court on September 7. Lee had refused to change his

seat on a Chesapeake and Ohio Railway passenger train on September 14, 1948. The local circuit court had levied a fine of twenty-five dollars on Lee. The state supreme court ruled in favor of Lee on the grounds that he was an interstate passenger, and thus federal antisegregation statutes prevailed; it therefore declared the fine invalid. If Lee, also an Olympic boxer, had been traveling only in Virginia, the fine would have stood.

Bunk's Diner at 610 Third Street, SE, became Blackie's Diner on September 8 when it came under new management. R. E. Arrington was the proprietor.

Benny Goodman and his twenty-piece orchestra performed for a show and dance at the American Legion Auditorium on September 10. Black spectators were admitted.

A ballot appeared on the front page of the *Roanoke Times* edition for September 9, encouraging citizens to vote on the location for the new Roanoke library. Elmwood Park had proven controversial, so the ballot had two main preferences: Elmwood Park or a city-owned property adjacent to the Municipal Building facing the Post Office.

The Roanoke County sheriff destroyed a 450-gallon still at Bent Mountain near the Floyd County line on September 8. The night raid resulted in the arrest of Moyer Radford and Virgil Jones of Franklin County.

The Roanoke Chamber of Commerce moved into new quarters on September 9 at 108 Kirk Avenue, SW.

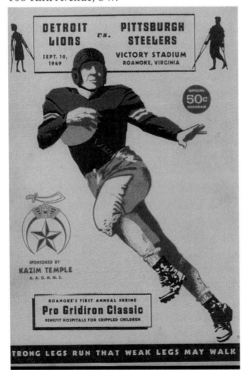

This is the program cover from the first major professional football exhibition game in Roanoke in September 1949 between the Lions and Steelers. *Nelson Harris.*

Riley's, a restaurant, opened at 13 Franklin Road on September 9. The establishment was owned and operated by Robert Riley and Rodney Riley, formerly managers of the Boiler Room.

William Fleming and Jefferson High School played against one another in football at Victory Stadium on September 9. While they had been opponents before, the game had historic value in that it was the first time in Roanoke's history that two city high schools had played one another, as Fleming had been annexed into the city. Though Addison High School was in Roanoke City, white and black schools did not compete against each other, as school sports were segregated. Jefferson won, 33–0.

The first major professional football game in Roanoke's history occurred on September 10 when the Detroit Lions played the Pittsburgh Steelers in a benefit game for the Kazim Temple's Crippled Children's Fund. Both teams arrived the previous day and stayed at the Patrick Henry Hotel. It was the

fifth exhibition game for both teams. The Lions won, 41–21, before a crowd of fourteen thousand.

Gilbert's Drive-In opened on September 10 at 1910 Memorial Avenue, SW.

A vaudeville revue show was at the Roanoke Theatre on September 14. It mostly featured female dancers—"maiden with a phantom lover," "girls in cellophane," "dance of ecstasy," and "models in scanties, gowns, and street dresses."

Dr. Wade Bryant of First Baptist Church, Roanoke, was the guest speaker for Grandin Court Baptist Church as the congregation held its first worship service on September 11 in its new educational building.

The Roanoke City Council stood firm in its plans for a new main library in Elmwood Park and at its September 11 meeting directed the city manager to proceed with approved plans. The council's strong reaction came as the *Roanoke Times* had printed straw poll ballots for readers on the front page of three editions.

Kay's Ice Cream opened a new store at 1323 Jamison Avenue, SE, in mid-September.

Joseph Sink of Salem died from injuries on September 12 that he sustained on the same day when a Virginian Railway motorcar derailed near Goodview. Sink was twenty-two.

Roanoke's skeet team won the state championship tournament in Richmond on September 12. The all-gauge skeet shoot team members were S. W. Strickler, W. E. Lucas, R. M. Saunders, H. S. Hewitt, and S. F. Candler.

Douglas S. Freeman, a well-known Virginia author and editor, delivered the convocation address at Roanoke College on September 16.

Art Jay Studio opened 118 E. Main Street in Salem on September 22. The photographic studio was located above Bibee's supermarket.

The Barter Theatre presented *The Imaginary Invalid* at the Jefferson High School Auditorium on September 16.

The Washingtonians performed at the Club Morocco on September 17. White spectators were admitted.

First Lt. Eugene Williams, twenty-four, of the US Air Force was killed in an aircraft accident in Germany on September 14. Williams was from Roanoke and trained at Tuskegee, Alabama. His brother, Leroy, died during World War II. The body was returned to Roanoke for burial.

The F. W. Woolworth Department Store building in downtown Roanoke was enlarged in mid-September. The new construction doubled the floor space and had entrances on both Campbell and Kirk Avenues.

The new Michael's Bakery building was under construction in mid-September on Williamson Road at Huntington Boulevard. The bakery's former quarters were on Church Avenue at First Street, SE.

The Roanoke City Council by a vote of 3–2 at its September 19 meeting increased the city's real estate tax rate to $2.66 per $100 of assessed valuation.

The Roanoke City Council approved a request from the Roanoke Merchants Association to erect a lighted star at the highest point on Mill Mountain. The request was made by Leo Henebry on behalf of the merchants' group. According to discussions at the council meeting, the star was to be lit on special occasions as a means of attracting attention to the city. Council members, however, suggested the star should be lit nightly. Henebry requested that the star be located on the site of the old observation tower, but

Mayor W. P. Hunter reminded Henebry and others that plans were in the works for a rebuilt tower to occupy the site. Roy C. Kinsey provided a sketch of the proposed star and noted that it would really be three stars in one, all with neon tubes.

The N&W Railway announced in late September that it was abandoning plans to build a railroad track from Cloverdale to the headwaters of Tinker Creek.

The newly constructed Wildwood Presbyterian Chapel was dedicated on September 25. The chapel had been built by the members and was a mission of Salem Presbyterian Church. The chapel was located on Little Brushy Mountain Road about two miles northwest of Salem. The site for the chapel had been donated by Mr. and Mrs. C. T. Verna, with the church being formally organized on November 19, 1944.

Over one thousand persons visited the Roanoke Council of Garden Clubs' annual flower show during the first three hours of its opening. The show opened on September 21 at the American Legion Auditorium and drew visitors from a three-state area.

The managers of the Roanoke area radio stations met with the Roanoke Retail Alliance Dealers Association on September 21 and all shared that television was at least two years or more away for Roanoke. The FCC had allocated four stations for the Roanoke area. A few in the Roanoke Valley with sets were picking up stations from Greensboro and other cities.

The board of directors of the Roanoke Hospital Association announced in mid-September that effective October 1, the name of Roanoke Hospital would change to Memorial and Crippled Children's Hospital. The board cited two reasons for the name change: to avoid confusion that the hospital was a municipal facility and to recognize the work of the hospital in being central to the treatment of polio victims through its Society for Crippled Children of Southwestern Virginia clinic. The hospital began in 1887 when the Circle of Mercy and Ready Helpers started the "Home for the Sick." The N&W Railway partnered with the hospital to salvage its finances in 1889 when depression came. In 1899, the railway turned the thirty-bed hospital over to a nonprofit corporation. The crippled children's ward was built in the late 1920s.

Mrs. Eugenia Reid died on September 21. She was a veteran educator at Addison High School and was noted for being the first home economics teacher in Roanoke and for starting the first summer camp for black girls that was located near Hollins.

The Roanoke city dump in Washington Park caught fire in mid-September, being one of several fires there in as many weeks.

Skate-A-Drome opened on September 23 across from Lakeside. The rink was owned and operated by the Roanoke Skating Club, Inc. Ads read, "Ladies please wear skirts."

The real estate and assets of the Central Manufacturing Corporation were auctioned off on September 27. The company was located between Loudon Avenue and Center Avenue, NW, at First Street. The winning bid of $157,000 was by S. A. Barbour, who purchased most of the real estate and assets.

A building permit was issued by the Town of Salem to the Graham-White Manufacturing Company for a plant building to be erected at 1209 Colorado Street.

The Roanoke Advertising Club received its charter on September 27. James Moore was club president. The club was an affiliate of the Advertising Federation of America.

The congregation of Christ Lutheran Church held their last service in their sanctuary on Grandin Road near the Grandin Theatre on September 25. The church was known as Virginia Heights Lutheran Church, but the congregation had erected a new sanctuary at

Christ Evangelical Lutheran Church on Grandin Road is still under construction in this July 1949 image. *Christ Evangelical Lutheran Church.*

the corner of Grandin and Brandon Avenue, SW, and worshiped there for the first time the following Sunday.

The SCC granted a charter to Hospital Development Fund, Inc., on September 26 to raise funds to enlarge and equip Burrell Memorial Hospital. Paul Buford, president of Shenandoah Life Insurance Company, was head of the corporation.

The Roanoke Library Board contracted with the architectural firm of Frantz and Addkison to develop plans for the new main library in Elmwood Park. Eubank and Caldwell had developed an early plan in 1940.

Audrey Totter, Hollywood actress, visited patients at the Veterans Administration Hospital on September 28.

The Roanoke Tourist Restaurant opened on September 28 east of the city on Lynchburg Highway. Owners were E. J. See, E. E. See, and A. K. Larch.

The congregation of Thrasher Memorial Methodist Church in Vinton held a corner-stone-laying ceremony for their new educational building on September 29.

Boxing matches at the American Legion Auditorium on September 30 included locals Don Krupin and Lucky Fitzgerald. Kid Jordan boxed Sammy Pinkard for the "Colored Lightweight Title of Roanoke."

The straw-poll ballots published by the Times-World Corporation in their morning and evening newspapers pertaining to the preferred site for Roanoke's new main library affirmed the choice made by the city council. Of nearly 8,500 ballots received by the city clerk's office, 4,059 favored Elmwood Park, while 3,293 favored Church Avenue across from the federal post office.

Roy C. Kinsey developed metal stars covered with silver tinsel and rimmed with red neon tubes to be part of a Christmas decorating plan for downtown Roanoke. Kinsey

presented his stars to the Roanoke Merchants Association for approval on September 30. The innovation came in connection with the large neon star to be erected on Mill Mountain.

Hal Singer and his orchestra along with Earl Bostic and his orchestra performed a floor show and dance at the American Legion Auditorium on October 5. Guest vocalist was Kitty Dechovis. White spectators were admitted.

Roanoke Goodwill Industries held an open house on October 6 to showcase its new building at 11 W. Salem Avenue. This was the first permanent location for Goodwill.

Porterfield Distributing Company opened at new quarters in early October at 1354 Eighth Street, SW.

William Paxton, seventy-seven, died on October 1 while visiting relatives in Richmond. The Roanoke resident was prominent in local business affairs. In 1905 he had opened the Roanoke Shoe Company, which he operated for thirty-seven years.

An informal unveiling of the remodeled N&W Railway passenger station in Roanoke occurred on October 4 when workers removed temporary partitions. That action effectively completed a project that took almost a year. Portions of the remodeled station had been in use since April 14.

Postal officials announced in early October that a highway post office service would be inaugurated between Roanoke and Greensboro, North Carolina, by way of Winston-Salem, North Carolina, around November 1. A bus fitted like a railway postal car was used over the route.

Sherman Wayne Lovelace, seventeen, was jailed in Roanoke in early October and charged with bigamy. Upon investigation, it was learned that Lovelace had three wives. He had married a woman in a local church in August, but he had also had a wife and child in Tuscon, Arizona. It was then determined he had married another local woman in August 1948 on a trip to Bristol, Tennessee. When he was confronted by the father of his third wife, he replied, "Well, you got me."

This shows the remodeled lobby of the N&W Railway passenger station in Roanoke, which was completed in October 1949.
Digital Collection, Special Collections, VPI&SU Libraries.

The remodeled front exterior of the N&W Railway passenger station was the design of Raymond Loewy, 1949. *Digital Collection, Special Collections, VPI&SU Libraries.*

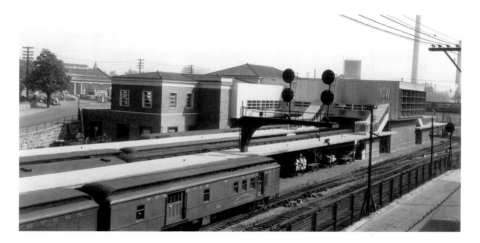

This 1949 image shows the back side of the N&W Railway passenger station. The American Legion Auditorium is in the background. *Digital Collection, Special Collections, VPI&SU Libraries.*

A permit for a $17,000 laundry and dry-cleaning plant was issued by the City of Roanoke to Vincent Wheeler on October 4. The laundry was to be located at 687 Brandon Avenue, SW.

Western film actor and singer Cal Shrum, along with others, performed at the Roanoke Theatre on October 5.

The Salem Creamery Company moved from 207 E. Main Street to 736 Fourth Street in early October. Furman Whitescarver was company president.

The Boiler Room opened at its new location at 128 E. Campbell Avenue on October 6. According to ads, the restaurant was the first establishment to be equipped with a

television for customers to view. The television, an Air-O-king brand, had been supplied by Leonard Electric Supply 131 Centre Avenue, NW.

The Rev. A. L. James was honored for thirty years of service as the pastor of First Baptist Church in Gainsboro on October 8. James had been instrumental in advocating for the Gainsboro Branch Library as well as other civic activities.

Air-Lee Soda Shoppe, operated by A. C. Myers, opened in early October at 3404 Williamson Road. A jumbo ice cream soda was ten cents.

Dr. T. Allen Kirk was named president emeritus by the American Rose Society in early October at the society's annual meeting at Salt Lake City, Utah. Kirk had served as the society's president in 1937 and 1938.

The new $600,000 expansion of the Johnson-Carper Furniture Company plant opened for visitors on October 7. Magazine editors and furniture retailers from around the country toured the new facility.

Hutson Cigar Store No. 2 opened on October 8 at 231 Franklin Road.

This 1949 images shows Hutson Cigar Company and Giles Realty office. *Virginia Room, Roanoke Public Libraries.*

The University of Virginia defeated Virginia Tech 26–0 in a football game played before fourteen thousand spectators in Victory Stadium on October 8. Roanoker and Jefferson High School graduate Ralph Shoaf scored two of Virginia's touchdowns.

Andre Marchal, the famous blind organist of the Church of St. Eustache, Paris, presented an organ concert at Hollins College chapel on October 13.

Possibilities Unlimited, a beauty shop, opened on October 10 on Grandin Road at Maiden Lane, SW.

Minstrel show comedians Emmett Miller and Tuck McBee, along with some vaude-ville acts, performed at the Roanoke Theatre on October 12.

Roanoke native and Hollywood actor John Payne formally kicked off the 1950 Roanoke Community Fund Campaign at a dinner at the Patrick Henry Hotel on October 18.

A shooting on Salem Avenue during the 5:00 p.m. rush hour created quite a stir and snarled traffic. Harry Ferguson, forty-five, fired five shots at Charles Wikerson, forty-seven. Wilkerson was struck three times and taken to Lewis-Gale Hospital. Ferguson was arrested by J. M. Nash, a traffic patrolman at the time of the incident. Wilkerson was shot on the sidewalk in front of the Royal Café at 19 E. Salem Avenue.

Roanoke Chamber of Commerce officials announced that Secretary of Defense Louis Johnson, a Roanoke native, would be the speaker at the annual membership dinner to be held at the Hotel Roanoke on January 25, 1950.

More than five thousand veterans of the Spanish American War gathered for their annual encampment in Tampa, Florida. At the event, the veterans heard for the first time the first marching song to be adopted by their organization, "The Volunteers," which was composed by E. B. Kromer of Roanoke.

Buddy Lewis's barnstorming Major League All-Stars played a group of local all-stars of the Virginia League in baseball at Maher Field on October 11. The major league play-ers included Lewis, Lou Brassie, Willie "Pudding Head" Jones, Whitey Lockman, Kirby Higbe, Billy Goodman, and Jimmy Brown among others. The major leaguers won, 9-2.

The City of Roanoke was honored when an F-47 Thunderbolt fighter was christened *The City of Roanoke* in a ceremony at Woodrum Field on October 11 in connection with the annual meeting of the Virginia League of Municipalities in the city.

Lt. Robert Kavanaugh of Roanoke was killed on October 11 when a fragmentation bomb on his jet fighter exploded during an air force live weapons show at Elgin Air Force Base in Florida. Kavanaugh was a 1944 graduate of Jefferson High School.

Stan Radke, former owner of the Roanoke Red Sox, was ordered to begin a twelve-month jail sentence on October 14 for embezzlement convictions.

Holdren Refrigerator Sales and Service opened a new store at 29 E. Main Street in Salem on October 15.

George Ryan, sixty-four, was found dead in his home at 1330 Campbell Avenue, SW, on October 15. Investigators determined the rooming house operator had died from carbon monoxide poisoning due to a faulty gas water heater that was burning in his basement.

The Roanoke Raiders, a black semipro football team, played the Washington Athletics in Springwood Park on October 16.

The Church of Jesus Christ of Latter-Day Saints (LDS) held an open house on October 22 for the public to view their new $100,000 church building at 2015 Grandin Road, SW. T. R. Pope of Salt Lake City, Utah, was the architect, and Frank Leak of Charlottesville was the contractor. Ezra Benson, a member of the Council of Twelve Apostles of the church, spoke at worship services on October 23.

The Dixie Minstrels, a charity show sponsored by the United Commercial Travelers of America local chapter, gave a three-night performance at Jefferson High School in mid-October. All the participants were locals.

Mrs. Sarah Robeson, eighty, died in Burrell Memorial Hospital from injuries she received when she was struck by a truck while she was crossing Commonwealth Avenue on October 14. She was the sixth pedestrian to be killed by an auto in the city during the year.

Louis Jordan and his band performed a floor show and dance at American Legion Auditorium on October 18. White spectators were admitted.

The Roanoke City Council decided at its October 17 meeting to appoint a fifteen-member Charter Study Commission to review and make recommendations to the city charter. Five members were councilmen, five members were appointed by the Roanoke Bar Association, and five members were citizens at large.

The board of directors of the Roanoke Chamber of Commerce gave a positive endorsement to the erection of a lighted star on Mill Mountain by the Roanoke Merchants Association.

Renee Martz, a nine-year-old child evangelist from Europe, spoke for thirteen nights in a crusade held at the American Legion Auditorium in late October. Joining her was song leader Roy Harthern. According to advertisements, Martz had just finished preaching to fifty thousand in England.

F. H. Ewald and Charles Clark opened Ewald-Clark, a camera and gift shop, at 7 W. Church Avenue on October 20. Ewald had been formerly associated with his father, J. F. Ewald, at Ewald's Pharmacy. Clark was the former advertising manager at Henebry's.

This is the grand opening of Ewald-Clark on W. Church Avenue on October 20, 1949. *Frank Ewald.*

Raymond Breton, a former pitcher for the Roanoke Red Sox, drowned in a pond near Alton, New Hampshire, on October 19. He was twenty. Benton pitched for the Rosox in 1948.

Allied Sales Company, food brokers, moved to a warehouse at 127 Norfolk Avenue previously occupied by the firm of Moir and Trout, which went out of business after twenty-five years. The owners of Moir and Trout, H. D. Shank and his two sons, opened

a furniture business in Salem. The Shank Furniture Company opened at 2 W. Main Street on October 21.

Liberty Clothing Company at 123 W. Campbell Avenue lost its lease and had a closing sale at the end of October. The clothing company had opened in Roanoke in 1908.

Dr. Frank Slaughter, a best-selling author and former Roanoke resident, came to Roanoke the third week of October, spoke to several organizations, and held a book-signing for his latest novel, *Divine Mistress*, at the Book Nook.

Roanoke Riding Stables opened October 22 on Peters Creek Road, directly behind Archie's, a restaurant. The business provided riding lessons, horse stables, buggy rides, and pony rides.

Mrs. Armandy Argabright, sixty-nine, was struck and killed by a truck on Route 221 on October 21 near E. M. Reed's store at Bent Mountain.

Buddy Haislip, twenty-one, of Starkey was killed in an auto accident on Franklin Road on October 25. It was the city's eleventh traffic fatality of the year.

The Roanoke Advertising Club voted to launch a national advertising campaign to promote the lighting of the star on Mill Mountain. The club appointed a committee to work with local radio stations and the Roanoke Merchants Association for the development of the campaign.

St. Paul's Lutheran Church at the junction of Route 460 and Route 117 was slated to be torn down to make room for the widening and straightening of 460. Groundbreaking services for the new church on Route 117 were held October 30.

Gold 'N-Krisp Dinette opened on October 29 at 1508 Williamson Road. That day free donuts and coffee were provided for two thousand people, as well as plastic animals for the children.

The Roanoke Ministers' Conference held a Protestant Reformation Service on October 30 at the American Legion Auditorium. The speaker was Dr. Ben Lacy, president of Union Theological Seminary in Richmond. Attendance was 1,100.

The remains of the old Fort Lewis estate were sold for $21,000 to Elbert and Hazel Dearborn of Bedford. The property was sold by Moten and Mary Altizer as Lot 6 in the Fort Lewis Estates.

Mr. and Mrs. H. A. Hoover opened Triangle Trailer Village on Route 117 across from Archie's Lobster House at the end of October.

Grand Ole Opry stars Grandpa Jones, Ramona, "Smitty" Smith, and Lennie Aleshire performed at the Roanoke Theatre on November 2.

The Barter Theatre presented *You Can't Take It with You* at the Jefferson High School Auditorium on November 4.

Grand Ole Opry stars Grandpa Jones, Ramona, "Smitty" Smith, and Lennie Aleshire performed at the Roanoke Theatre on November 2.

The Barter Theatre presented *You Can't Take It with You* at the Jefferson High School Auditorium on November 4.

Roanoke County's Mercy House received its first ambulance for the transport of its patients in late October when John M. Oakey Funeral Service donated one. The funeral home had been providing Mercy Hose free ambulance service for fifteen years.

An inaugural recital on the Alfred R. Berkeley memorial pipe organ was given on October 30 at St. John's Episcopal Church by Franklin Glynn, church organist.

This is a 1940s postcard of Archie's Lobster House on Route 117. *Bob Stauffer.*

Roanoke City's recreation department sponsored numerous Halloween festivities around the city that were well attended. An estimated 2,000 attended a party in Jackson Park that included chicken chasing, jitterbugging, and a costume parade. A crowd of 800 showed up at the Jaycee-Highland Park PTA–sponsored event in Highland Park that included a Laurel and Hardy movie, a bonfire, and music. The Junior Optimist Club entertained 500 at Norwich Park, and 1,500 gathered at William Fleming High School. The Yellow Mountain Boys performed for 750 at Garden City, and 500 were on the tennis courts at Raleigh Court for something resembling a three-ring circus.

The Angelic Gospel Singers and the Gospel Stars of Detroit performed at the American Legion Auditorium on November 3. A section was reserved for white spectators.

A branch post office was announced for the Melrose section at 1602 Orange Avenue, NW. Postal officials stated the branch would be open by November 10.

J. H. Weinstein and others purchased the former Appalachian Electric Power Company building at the southwest corner of Campbell Avenue and Second Street, SE, in late October.

The Engleby Auto Supply Company at 39 Luck Avenue, SW, was purchased by C. O. Light and T. M. Stephens from Carl Sturm.

The South Salem Social Service Club held a minstrel show fundraiser for Mercy House at South Salem School on November 3.

James Morris, twenty-six, of Rocky Mount was killed as the result on of auto-truck accident on Route 220, one mile south of Roanoke, on November 4. The car Morris was driving was struck by a truck being pursued by police and loaded down with liquor.

The Rev. Thomas Martin, pastor of St. Andrews Catholic Church since 1930, died in Georgetown Hospital in Washington, DC. Martin had been in ill health and had been transferred to Georgetown from Roanoke Hospital. He was sixty-six.

Karston's All-Star Vaudeville Revue came to the stage of the Roanoke Theatre on November 9. Performers included Mel Hall, comedians Hanlon and Clark, drummer Charlie Masters, and the acrobatic troupe Sorelle Saltons.

The Roanoke Merchants Association announced that the Roanoke Star on top of Mill Mountain would debut on November 23, the eve of Thanksgiving. The group estimated

the $25,000 star would be visible from one hundred miles away in good weather. The merchants' association and the chamber of commerce both reported that the purpose of the star was to advertise and promote Roanoke. It would be the largest man-made electric star in the world. A national advertising campaign was in the works, and the planning group adopted as their motto "Let's make Roanoke the Star City of the South."

The Roanoke Optimist Club laid the cornerstone for their new boys' clubhouse in Norwich on November 8.

Metropolitan Opera star James Melton gave a concert at the Jefferson High School Auditorium on November 8. His appearance was part of the Community Concert Association's season. He was often billed as "America's favorite tenor."

Roanoke author Nelson Bond had his second novel published in early November. *Exiles of Time* was a fantasy novel set in the fictional Merou, Bond's "never never land."

Construction on a $150,000 sales and service garage for Antrim Motors began in early November at 510 McClanahan Street, SW. Completion date was projected to be early May 1950. Antrim Motors was located at 503 Sixth Street, SW. Contractor for the work was B. F. Parrott and Company.

Electric Service Corporation held a formal opening at 26 W. Church Avenue on November 9.

"King Tornado," a five-gaited, four-year-old horse owned by W. A. Ingram of Roanoke, won the reserve junior championship in the National Horse Show at Madison Square Garden in New York City on November 7.

An organizational meeting for a Rotary Club in Salem was held at Longwood on November 11. Virgil Frantz was elected to head the new group, which reported thirty-one charter members.

In the general election for Roanoke County's seat in the Virginia House of Delegates held on November 8, incumbent Ernest Robertson, a Democrat, defeated the Republican candidate, Mrs. J. T. Engelby Jr., by a vote of 2,075 to 1,142. Voters in both Roanoke city and county overwhelmingly voted in favor of the Democratic nominee for governor, John Battle, who also won statewide. Roanoker Lindsay Almond was also elected statewide for attorney general.

The Williamson Road Lions Club voted to change their club's name to the North Roanoke Lions Club.

Herbie Jones of Washington, DC, and Proctor Heinold of Oklahoma were the title bout in boxing matches held at the American Legion Auditorium on November 9. Preliminary bouts featured locals Lucky Fitzgerald and Eddie Cabbler.

World-renowned violinist Fritz Kreisler performed at the American Legion Auditorium on November 14.

State highway officials reported in mid-November that the rebuilding and relocation of Route 311 on the southern side of Catawba Mountain was progressing and should be completed by midwinter.

The N&W Railway began using new luxurious sleeper cars on its Columbus-Roanoke run on November 9. Each of the eleven new cars had six bedrooms and ten roomettes that provided complete privacy, and each room had an individual thermostat that circulated fresh outside air through the cabin, with temperature regulation set by the occupant. It was believed to be the first such air-conditioning in railroad history.

Phelps and Armistead held a public open house at their new quarters at 20 Church Avenue, SE, on November 11. Music was provided by Wayne Fleming and his Country Cavaliers. The furniture store was formerly located at 113 W. Campbell Avenue. An estimated five thousand attended the event.

Radio star Richard Maxwell gave a concert at First Baptist Church, Roanoke, on November 16. He sang a variety of sacred and light classics music.

E. J. Thomas and Garland Vangegof managed the Tinker Creek Turkey Shoot during the second week in November. The shoot was limited to shotguns, though Thursday was rifle night.

The Virginia Tech freshmen squad defeated the freshmen of VMI in football at Victory Stadium on November 12. Slightly fewer than two thousand fans watched the game, which ended with a score of 41–12.

Roanoke College won the Virginia AAU cross-country championship held in Richmond on November 12.

Some six hundred workers at Virginia Bridge Company returned to their jobs on November 14 after a nationwide strike by steelworkers was settled.

Miller Petty resigned as a member of the Roanoke County School Board and was replaced by Mrs. Charles Peterson of Hollins.

The joint planning committee of the Roanoke Merchants Association and the chamber of commerce reported in mid-November that construction of the Roanoke Star was progressing, with work on the steel frame set to begin November 14. Notices about the star had been sent to over four hundred newspapers and radio stations across the country.

The Roanoke City Council voted 3–2 against another annexation suit at their November 14 meeting. Dan Cronin and Benton Dillard proposed a preliminary survey be done. A testy exchange ensued, and the matter was voted down.

Dr. Charles Cornell, chiropodist and foot specialist, opened his practice over Kirk's Jewelers at Campbell Avenue and Jefferson Street on November 15.

Cowboy film comics Mustard and Gravy performed at the Roanoke Theatre on November 16.

Fred Whitman opened his Peters Creek Esso Station on November 18. The service station was located at Peters Creek and Cove Road.

Lee Hardware House opened on November 18 at 1841 Williamson Road. The store was operated by Mr. and Mrs. George Brickman.

Santa Claus arrived at N. W. Pugh Department Store on the morning of November 19. Over two thousand packages were given to children by the store during his visit, and Santa was broadcast live from the store every evening at 6:30 over WDBJ.

The firm of Eubank and Caldwell of Roanoke presented architectural plans to the Roanoke School Board on November 21 for the new Huff Lane Elementary School to serve the Williamson Road section. The school would have twelve classrooms, a library, a clinic, and a cafeteria.

James Wolfe, pianist, performed at the Little Theatre at Hollins College on November 22.

The Ravens, Dinah Washington, and Joe Thomas and his orchestra performed a midnight-to-4:00 a.m. floor show and dance at the American Legion Auditorium on November 23, Thanksgiving Eve. White spectators were admitted.

Lt. S. A. Bruce was appointed superintendent of the Roanoke Police Department by the city manager on November 19. He had been the acting superintendent since March 31.

Clark's Self-Service Grocery opened on November 21 at 601 Virginia Avenue in Vinton.

Continental Vanities came to the stage of the Roanoke Theatre on November 23. The show advertised "fiery sirens, luscious lovelies, glorious godivas" and was "adult entertainment strictly for people with a high Eye-Q."

The Apperson property on Lee Highway was rezoned by the Roanoke County Board of Supervisors so that a swimming pool could be built. The 100 x 200–foot pool was expected to be open next spring. Amos and Bettie Mounts petitioned for the rezoning.

Local band leader Freddie Lee (real last name Corstaphney) teamed up with Kay Lee, an advertising manager, to write a song in tribute to the Roanoke Star. The recording was broadcast with Ginger Crowley as vocalist. The lyrics were as follows:

> Leaning on a slice of sky
> Glistening from a mountain high
> Listening to the wind go by
> Magic City Star.
> Going steady with the moon
> Whispering a Christmas tune
> Spinning in a tinsel swoon
> Magic City Star.
> Up and down the valley
> All around the town
> In every street and alley
> Oh sprinkle the night with twinkling light
> Send it down
> While catching clouds that go astray
> Latching on the Milky Way
> Shining like a holiday
> Magic City Star.

Approximately forty boys seeking concession work at Victory Stadium for the Thanksgiving Day football game were given physicals by the city health commissioner. The state labor board had agreed to suspend child labor restrictions for one day so the boys could work at the game.

Several local women's organizations banded together to push a joint legislative agenda for the upcoming session of the General Assembly. The Roanoke City Woman's Club, Roanoke City Junior Woman's Club, the YWCA, the Opti-Mrs. Club, and the Roanoke chapter of the AAUW advocated for a five-point program: increased construction of medical facilities, increased welfare funds for indigent persons, admission of women to juries, appointment of women to state boards and commissions, and increased funds for education and teachers.

F. W. Woolworth Company on W. Campbell Avenue opened its new fifty-eight-stool luncheonette on November 23. The larger, more modern lunch counter was the result of a remodeling project. A roast turkey dinner was fifty-five cents, apple pie fifteen cents, and banana royal twenty-five cents on opening day.

The Magazine Center opened on November 23 at 404 First Street, SW. It carried out-of-town newspapers and magazines and offered sandwiches, soft drinks, and tobaccos.

At 8:22 p.m. on November 23, Roanoke mayor A. R. Minton threw the ceremonial switch to light the Roanoke Star on Mill Mountain. Bob Kinsey, son of Roy Kinsey, threw the real switch to turn on the star. The opening line in the *Roanoke Times* front-page story read, "The City of Roanoke flashed its symbol of progress to the world last night." The lighting ceremony was broadcast live over the local radio stations, a ceremony that included "America" sung by the Greene Memorial Methodist Church choir, a speech by former congressman Clifton Woodrum, and patriotic singing by some 250 invited guests gathered beneath the star. Police reported traffic jams all throughout the city as drivers parked or stopped their automobiles to get a view. As soon as the star was lit, some seventy-five Boy Scouts switched on one hundred three-foot red stars hanging over the main streets in downtown. Lowell Thomas, well-known national radio personality, broadcast the lighting on his news show that was heard coast to coast.

More than twenty-five thousand were on hand to watch the annual Military Classic of the South between VMI and Virginia Tech at Victory Stadium on Thanksgiving Day. The game ended in a tie, 28–28. It was the forty-fifth game in the series, which opened in 1894.

Three local men were killed instantly in a head-on collision on Route 220 three miles south of Fincastle on November 24. Virgil Spence, thirty, Roy Joyce, thirty, and Hilton Wheeler, seventeen, were returning from a hunting trip.

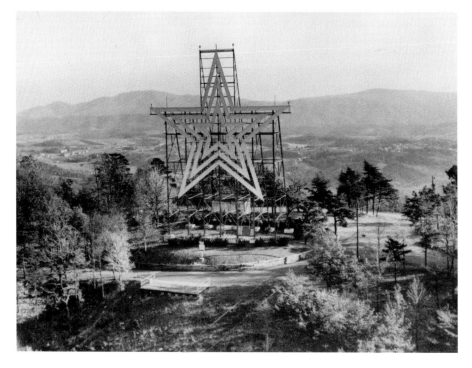

The Roanoke Star on Mill Mountain was first lit on Thanksgiving Eve in 1949. Bob Kinsey controlled the switch that lit the star. *Virginia Room, Roanoke Public Libraries.*

(L–r) Roy Kinsey Jr., Hollywood actor and Roanoke native John Payne, and Bob Kinsey are photographed on the day the Roanoke Star was lit. *Bob Kinsey.*

Movie comedian Al "Fuzzy" St. John and his Musical Rangers performed on the stage of the Salem Theatre on November 26.

Lee Garrett and Jim Shell, WROV announcers, resumed their popular *Open House* program, in which they broadcast live from various record stores in downtown Roanoke, playing a variety of popular music. Their show had been off the schedule due to football games. Shell was also emcee of the station's *Hillbilly Hit Revue.*

The December art exhibition at Hollins College was a collection of fifteen photographs by Ansel Adams. The show opened on December 1.

A 1950 Mercury went on display at the Roanoke Lincoln-Mercury Sales Corporation at 402 Luck Avenue, SW, the first of December. Of interest to Roanokers was the color—Roanoke Green. The new color was apparently the request of the local dealer for a new dark green. Mercury headquarters complied and named the new color Roanoke Green.

Sherman Lovelace was given a three-year sentence for bigamy, having pleaded guilty to the charge in Hustings Court on November 28. Lovelace had married a girl in Arizona when he was fifteen, then a second girl in Virginia, and then a third.

Russell Seay, manager of the Patrick Henry Hotel from 1947 to 1949, purchased the Plaza Restaurant on Williamson Road from Tom Scordas. Scordas retained the Plaza Tourist Court.

The press got to review the new Powhatan Arrow of the N&W Railway. The train left Roanoke at 11:00 a.m. on November 30 to Bluefield, West Virginia. The passenger train included upgrades and more modern amenities such as observation-lounge-tavern cars, larger seats, updated menus, better air-conditioning, and new dining cars. N. A. Turkheimer of the *Roanoke Times* was one of the fifty-two members of the press and radio to take the ride. He reported, "Chief of interest...was the observation-lounge-tavern car. With an open bar decorated in red leather and yellow piping, the lounge section seats

This is the Plaza Restaurant at 3011 Williamson Road in the 1940s. *Bob Stauffer.*

28 persons. The observation section has room for 16 passengers in individual seats." The observation area featured large, fog-proof windows for viewing the passing scenery.

The new Greensboro-to-Roanoke highway post service was inaugurated at 5:35 p.m. on November 30 when the new postal bus arrived in Roanoke. A brief ceremony was held that included local postal and civic officials. Music was provided by the American Legion Drum and Bugle Corps. Souvenir postal covers were the only mail items carried on the day, but regular mail service via the highway postal bus began December 1.

Roanoke native Ralph "Buddy" Shoaf, senior back at UVA, was named by the Norfolk Sports Club as the year's most valuable player in football within the boundaries of the Southern Conference. Shoaf was a graduate of Jefferson High School.

Sister Rosetta Tharpe along with The Rosettes gave a concert at the American Legion Auditorium on December 4.

The Class A Locomotive was completed in the N&W Railway Roanoke Shops in early December that had several "firsts" for a locomotive. It was the first engine of its type in the United States to have roller bearings on the main and side-rod connections and with lightweight reciprocating parts. This and other improvements were done to reduce maintenance. The first of the improved Class As was No. 1238 and was the fourth on an order of five the railway was building.

Garland's Drug Store opened at 1232 Jamison Avenue, SE, on December 2. At the time, it became Roanoke's largest drugstore.

Dr. Thad McCulloch opened his optometry practice on December 2 at 9 N. College Avenue in Salem.

Eastern Airlines inaugurated a new nonstop flight from Roanoke to Pittsburgh on December 2. Miss Pittsburgh, Jean Franz, brought gifts to the mayor and others on behalf of her city.

The Penguin Club of Salem honored two former Andrew Lewis High School football players, Dick Bunting and Skeet Hesmer, at a banquet. Both were playing for UNC. Crowell Little, Carolina's freshman coach, was the guest speaker.

The Booker T. Washington Memorial Trade School announced its new session for December 1. The school was open to black veterans and nonveterans and was located at 1401 Salem Avenue, SW.

The new Williamson Road Branch Post Office located at 2409 Williamson Road was dedicated on December 4. The building also housed the branch of the First National Exchange Bank.

Two teenagers were asphyxiated in a gas-filled kitchen on December 3 at 518 Patton Avenue, NE. Clifford Wright, sixteen, and Joyce Payne, fifteen, were found unresponsive and died shortly after being removed to the porch by a rescue squad. The city coroner initially ruled that the couple had died in a suicide pact.

The Hospital Development Fund of Roanoke launched a fundraising effort to raise $1.5 million for two Roanoke hospitals. The effort supported the construction of a new wing for the Memorial and Crippled Children's Hospital that would contain ten beds. The fund drive also supported the new seventy-five-bed Burrell Memorial Hospital. The Burrell plan had been developed by Stone and Thompson Architects. Clem Johnston was general chairman of the Fund.

Additional indoor toilets were being constructed in early December for Ogden, Starkey, and Vinton (Negro) Elementary Schools in Roanoke County.

The new Powhatan Arrow was exhibited in Roanoke to the general public on December 8. The $2 million streamliner was displayed at the N&W Railway passenger station. Over 4,200 toured the new train.

Carleton Drewry, Roanoke poet, had four poems included in *Poetry Awards, 1949*, an anthology of poems chosen from magazines all across the English-speaking world. His work was the largest of any poet represented.

The Southern Machinery and Supply Company moved to its new office and plant in the 2900 block of Shenandoah Avenue the second week in December. It had been in Roanoke for thirty-one years.

Dr. Carl Voss of New York City addressed the Roanoke Jewish Forum at the Patrick Henry Hotel on December 7. He asserted that "the United Nations is indeed the last best hope for peace on earth." Dr. Leo Platt was president of the forum.

The remodeling of the Roanoke County jail was completed, and prisoners returned to the jail on December 12 from being housed temporarily in the Roanoke City jail.

Unlike the Lee Hi and Dixie Drive-In Theatres, the North 11 Drive-In announced in mid-December that it would remain open all winter.

A small fire damaged the Palace Hotel at 204 First Street, NW, on December 8. James Salters, thirty, was admitted to Burrell Memorial Hospital with burns.

The SCC granted charters to four Roanoke concerns on December 8: Virginia Candies, Bireley's Fruit Drinks, Veterans Building Committee, and Four Leaf Universal.

Clarke Wray, president of the Roanoke Red Sox, announced that John "Red" Marion would return as the team's manager for the 1950 season.

A forest fire swept across fifteen acres on Read Mountain on December 9. Some forty men brought the blaze under control.

Harold Lloyd, former movie comedian, visited the Roanoke Kazim Temple on December 9 in his role as the national Imperial Potentate of the Shrine.

The Roanoke City Council sought to create a "Star Bowl" at Victory Stadium around the New Year holiday by bringing back Virginia Tech and VMI to play football. The bowl game would be in addition to the traditional Thanksgiving Day game. Both schools rejected the idea as impractical.

Horace Coleman, the former town manager of Vinton, died at his home in Norfolk on December 10 at the age of seventy-five. Coleman was the town's first manger and served in that capacity from 1936 until 1942.

The Roanoke Police Department was in possession of two different city flags. One was formally adopted as the city's flag in 1942 by the city council. The other flag was one presented to the mayor and council in 1931 by the Roanoke Parks Association, led by Genevieve Geisen. Both were blue but with slightly different emblems.

Ernest Six was shot and killed in the City Diner, 1066 Orange Avenue, NE, on December 11 by the restaurant manager, C. E. Begley, who witnesses stated was trying to break up a fight.

Joanna Dillon, fifteen, fainted and then shortly thereafter died while attending her classes at Andrew Lewis High School on December 12. The girl fainted in a restroom and could not be resuscitated by the Salem Rescue Squad. The county coroner said the cause of death was a cerebral hemorrhage.

An accidental acid dump into the Roanoke River by Yale and Towne Manufacturing Company in Salem was determined to be the cause of a massive fish kill in the river in mid-December.

Roanokers saw the Roanoke Star at its brightest for the first time on December 13 when Roy Kinsey stated that all the neon tubing was turned on for the first time. The star had a golden color as white and red neon tubing was used. The red tubing allowed the star to be seen from a farther distance than all-white.

Roanoke's Touchdown Club honored Roanoke native Ralph Shoaf at their banquet at the Hotel Roanoke on December 13. Shoaf was a halfback for UVA.

The renumbering of some six thousand houses in the annexed territories of Roanoke city began in mid-December along with the erection of 750 new street signs.

Two photographs of the Roanoke Star on Mill Mountain appeared in the December 19 edition of *Life* magazine.

Al Learned, freshman football coach for Virginia Tech, was the main speaker at a banquet for Roanoke city sandlot football players held at Monroe Junior High School on December 14. Some 250 boys attended the annual event.

William Clements, president of W. B. Clements, Inc., an auto parts store in Roanoke, died at the age of fifty-three at his home. He had been a candidate for the Roanoke City Council in 1942. He opened his business in 1937.

The fifth annual Roanoke City public school Christmas carol program was held at Jefferson High School on December 16, with some six hundred elementary, junior high, and senior high school students participating.

The new education building at Fort Lewis Baptist Church was formally dedicated on December 18. The nineteen-room structure was on the east side of the church. The church had several weeks prior celebrated its 125th anniversary.

Plans for a forty-eight-unit housing development for blacks in the eight hundred block of Grayson Avenue, NW, was announced by the developer, C. F. Kefauver, who sought a rezoning for the project. The local contractor was C. D. Bowles.

WROV held a third anniversary party at the American Legion Auditorium on December 16. Music was provided by Freddie Lee and his orchestra and Wayne Fleming with his Country Cavaliers. The station awarded some $6,000 in prizes, including a 1950 Packard Sedan, appliances, and jewelry. Net proceeds from the event benefited the

Christmas Basket Bureau. Some two thousand persons attended the party that was emceed by Hayden Huddleston.

Michael's Bakery opened a new bakery shop at 23 E. Church Avenue on December 16. It was near the bakery's main store in downtown. Pies were forty cents, and fruitcake was eighty-five cents per pound.

The Liberty Clothing Company at 123 W. Campbell Avenue announced in mid-December it was going out of business. The store did not get its lease renewed, and company officials could not find another suitable location. Ads declared a going-out-of-business sale through December 31.

Taylor Lodge No. 23, Ancient Free and Accepted Masons, in Salem celebrated its one-hundredth anniversary on December 17. Justice George Bushnell of Detroit addressed the Masons, who celebrated in the Laboratory Theatre at Roanoke College. Bushnell was a former member of the lodge before moving to Detroit to practice law. He was named to the Michigan Supreme Court in 1933. The lodge was chartered on December 11, 1849. According to Bushnell, the lodge was named for President Zachary Taylor, who was president at the time of the charter.

Roanoke's Curtis Turner was voted "Most Popular" by the drivers of NASCAR and was to be recognized as such at the annual NASCAR dinner in Daytona Beach, Florida, slated for February, 1950.

Karston's Follies of 1950 came to the stage of the Roanoke Theatre on December 21 and featured "girls in cellophane"; Renee Baron, "the Eyeful Tower"; and a variety of models.

The home of O. W. Boone was destroyed by fire on old Route 220 near Clearbrook School on December 18.

The Roanoke City Council adopted the city's operating budget for 1950, which included for the first time free textbooks for the city's schoolchildren. The cost for the textbook program was budgeted at $41,500.

The Salem Rotary Club received its charter at a dinner meeting at St. Paul's Episcopal Church Parish House on December 21. M. Carl Andrews was president of the club, and the charter was presented by George Leavall of Bristol, district Rotary governor.

Roanoke City and County law enforcement raided the White Hill Country Club on Lynchburg-Salem Turnpike and arrested twenty-four men on gambling charges. The club was in a house with poker tables on the first floor and dice games on the second.

Thomas Barksdale, seventy-nine, died at the home of his daughter in Farmville on December 21. Barksdale was believed to be the oldest living native of Roanoke. He was born on February 27, 1870, in the Neal House, a small hotel in the town of Big Lick. His father operated the hotel.

A fourteen-year-old crippled girl from Ronceverte, West Virginia, got her Christmas wish when she flew to Roanoke on December 22 and was taken atop Mill Mountain to view the Roanoke Star. She was greeted by Mayor A. R. Minton. Betty Jo Bostic had read of the star and wanted to see it. On her return flight, the pilots circled the star so she could see it one last time.

James Bear Sr., fifty-three, died at his home on Wycliffe Avenue on December 23 from smoke inhalation due to a fire in his bedroom. Bear was president of Double Envelope Corporation. He came to Roanoke in 1915 and founded Double Envelope.

This was a Christmas party and dance at the Roanoke Country Club
in December 1949. *Virginia Room, Roanoke Public Libraries.*

Saxophonist Illinois Jacquet and his orchestra, featuring the "Jumping Jacquets," performed for a floor show and dance at the American Legion Auditorium on December 26. White spectators were admitted.

On December 27 the Harlem Globetrotters came to the American Legion Auditorium, where they played the Kansas City All Stars. A preliminary game was held between the New York Celtics and the Philadelphia Stars. In between games were vaudeville acts. A section of seats was reserved for black patrons.

Dr. Alvah Stone, eighty, died at his home in Roanoke on December 24. Stone was one of the oldest practicing physicians in the city.

Some twenty-five members of Central Church of the Brethren welcomed the Litwinow family from Ukraine. They were the first displaced persons family to take up residence in the city. They arrived on the Tennessean from Washington, DC, and were greeted by the congregants at the N&W Passenger Station on December 24.

Det. Sgt. Joe Jennings, who spent his fifth Christmas at Lewis-Gale Hospital, was given $1,500 by his fellow policemen. Jennings was paralyzed by a bullet in the line of duty.

A concert by Cantor Jacob Barkin of Washington, DC, was held on December 26 at Beth Israel Synagogue in honor of the congregation's twenty-fifth anniversary.

Cotton Watts brought his *Talk of the Town Revue* to the Roanoke Theatre on December 28. He was joined by three other blackface comedians.

A joint committee of the Roanoke Chamber of Commerce and the Roanoke Merchants Association met on December 30 and agreed that the Roanoke Star would remain lit 365 nights a year and not just on special occasions. It was also reported at the meeting that $15,000 had been raised or pledged toward the total cost of $25,000 for the star.

There were several dances held at local night spots to ring in the New Year. Freddie Lee and his orchestra were at the Colonial Hills Club; the Leonard Trio played at the Silk Room in Salem; the Dixie Playboys were at Blue Ridge Hall; the Magic City Hillbillies entertained at the City Market Auditorium; and a floor show with Sam Umansky and his Kings of Swing was at the Riverjack Casino.

Appendix A:
Roanoke Valley World War II Casualties

Source: The Library of Virginia

Adams, Joseph N.
Aldred, Herbert R.
Allen, Edgar L.
Alley, James G.
Altice, Herbert W.
Altice, Swanson
Amos, Herman Levi
Arthur, Roy Allen
Atkinson, James R.
Atkinson, James S.
Aulthouse, Leroy
Ayers, Ray Charles
Bailey, Guinn L.
Baldwin, James D.
Baldwin, James Earl
Baldwin, Russell J.
Ball, Nathaniel H.
Ballou, William E.
Bane, David Donald
Basham, Derwood M.
Basham, Mac Lee
Bass, Horace A., Jr.
Bates, Charles B., Jr.
Baxter, Joseph E., Jr.
Benson, Edward, Jr.
Bent, Paul C., Jr.
Bethel, James F.
Blankenship, Ernest D.
Blankenship, Harry A., Jr.
Blankenship, James W.
Blankenship, Joseph M.
Blankenship, Lewis C.
Blankenship, Linwood E.

Bolden, Samuel
Boston, Jesse S., Jr.
Bow, Richard E.
Bowers, Robert E.
Bowling, Aaron J.
Bowman, Bruce
Boxley, Joseph W.
Boyd, Russell
Brammer, Paul F.
Brice, Robert M.
Briggs, Gillman A.
Brightwell, Henry L.
Brinkley, James L.
Brooks, Gordon C.
Brown, Alexander, Jr.
Brown, Benjamin L.
Brown, Jack A.
Brown, Lonnie J.
Bryan, Warren J.
Buchanan, Jack D.
Buchanan, Mack
Buck, Clovis C.
Burke, James W.
Burroughs, Sherman
Burton, Robert G.
Bush, James F.
Bush, James H.
Callahan, Keith S.
Callaway, Flanders, Jr.
Callis, Roy E., Jr.
Carper, George
Carroll, Oscar E.
Carwile, Wesley P.
Cassell, William O.

Chaffin, Albert
Chandler, Harold B., Jr.
Chapman, Carlton
Chapman, Harry P., Jr.
Chapman, William W., Jr.
Childress, Clyde W.
Christie, Billy
Clare, Roland W.
Clark, Douglas V.
Clark, Horace I.
Clark, Roland W.
Clarke, Robert M.
Clyburne, Joseph G.
Cole, Clarence L.
Coleman, Carlton V.
Coleman, Charles N.
Coleman, Roy W.
Coleman, William W.
Collins, Edward P.
Conner, Andrew L.
Conway, George P.
Cook, Russell Henry, Jr.
Cook, Stewart G.
Cowan, Francis M.
Cox, James A.
Crawford, Clayton L.
Crawford, Jesse
Crawford, John G.
Crawford, Richard D.
Crawley, Terry L., Jr.
Creasy, O. David, Jr.
Crowder, Max L.
Crowder, Paul C.
Cullen, Cary B.
Cumbie, Fred L.
Cumbie, James B., Jr.
Cunningham, Charles C.
Curry, George P.
Daniel, John C., Jr.
Davidson, Claude L.
Davidson, George L.
Davidson, R. L.
Davis, Lawton
Davis, Walter W.
Dillon, George O.

Dillon, John B.
Dillon, John H.
Dillon, Richard P.
Dillon, William F.
Dogan, Selma
Doran, Charles W.
Duffield, Alton
Dunlop, John
Dye, Sidney E.
Eades, Emmett K.
Eanes, John H.
Eaton, Hugh, Jr.
Elgin, Lewis C.
Emerson, Walter
Etter, Elwood A.
Evans, Elmer
Fallwell, Andre P.
Farewell, Amos E.
Faris, John R.
Ferguson, Claude S.
Fewox, Leonard J.
Fielder, Raymond S.
Filizinia, Henry
Findley, Joseph A.
Finley, Daniel L.
Finney, Alexander W.
Flint, Shirley D.
Flora, Aubrin
Ford, George A.
Fowlkes, Richard, Jr.
Fox, Paul
Francis, Henry L., Jr.
Francis, Randolph C.
Franklin, Guy E.
Frazier, B. E.
Fretwell, Billy C.
Fulcher, Leslie
Funk, Jack D.
Furrow, John E., Jr.
Furrow, Lawrence E.
Gallagher, William A., Jr.
Gallagher, William J., Jr.
Garst, Richard
George, William M.
Gibbs, James A.

Gilbert, Clarence H.
Gilmore, Jesse
Gilsdorf, Albert P., Jr.
Gish, Burger S.
Glenn, James B., Jr.
Goggin, Stephen M.
Gray, Cary L.
Gray, Herbert O.
Gray, Walker R.
Gray, Walter R., Jr.
Greer, George T., Jr.
Gregory, James A.
Gregory, Joseph, Jr.
Grigsby, Edward, Jr.
Grisso, Clifton
Grisso, George W.
Gross, Howard L.
Guerrant, Morris P.
Gunter, George W., Jr.
Guthrie, Leonard D.
Hale, Cloyse E.
Hale, Ralph W.
Hall, Cloyse E.
Hall, Linwood F.
Hall, Wesley B.
Hamilton, Ora D.
Hamm, William
Harmon, Darden C.
Harris, Charles L.
Harris, George B.
Harris, George B., Jr.
Harshbarger, Clyde
Haskins, Cecil
Hawkins, William M.
Heath, Enoch, Jr.
Hedrick, Hilary
Hedrick, James P.
Henry, Jackson
Henson, John, Jr.
Higgins, Roy
Hight, Reese C.
Hill, Edwin E.
Hill, Everett E.
Hinchee, Harry L.
Hippey, Frederick
Hobart, Robert L.

Hogan, Lawrence W.
Holcomb, Joseph R.
Holland, Frank L.
Holland, John L.
Holland, Max L.
Holt, Leonard H.
Hood, Elmore K.
Hubbard, Benjamin
Huddleston, Ralph D.
Hunnat, Armond
Hunter, George D., Jr.
Hurt, James H.
Hurt, James L.
Hurt, Welford J.
Hylton, Walter L., Jr.
Ingram, Russell W.
Irvin, Warren P.
Jamison, John R., Jr.
Janney, Alonzo
Jarrett, James T.
Jenks, Henry R.
Jennings, Claude W.
Jennings, Daniel M., Jr.
Jennings, Garland P.
Jewell, Fred J.
Jinks, Henry R.
Johnson, Andrew T., Jr.
Johnson, Darnell
Johnson, Ellis
Johnson, George D.
Johnson, Nathaniel
Johnson, Preston O.
Johnson, Robert D.
Jones, Marshall F.
Jones, Ralph V.
Jordan, Roy W.
Journell, Emmett
Kaplan, Alvin S.
Kavanaugh, Robert
Keen, Eugene M.
Keesling, Donald
Kelley, Andrew J.
Kelly, James E.
Kemper, Frank A.
Kesler, James O.
Kidd, Sammie H.

Killey, Philip Henry, II
King, Eugene J.
King, John W.
Kingery, Alvin C.
Kiser, Walter W.
Koontz, Philip E.
Krzyako, John
Kyle, Ralph L.
Kyle, Richard C.
LaBane, Fred
Lambert, William H.
Lane, Billy B.
Lane, William B.
Lange, Robert M.
Langhorn, Norwood
Lawson, John W. K.
Layman, Billy C.
Lee, Clifton G.
Leonard, Leon
Lewis, Tony, Jr.
Light, Bert L.
Light, Edward D.
Lilly, Lewis O., Jr.
Long, Alfred E., Jr.
Long, Frank M., Jr.
Looney, Arlan
Loyd, Ernest L., Jr.
Lucado, Leonard
Lucas, Warren P.
Lunsford, Frank J.
Magee, Kenny
Manning, Alton L.
Marshall, Lynwood V.
Martin, Brud E.
Martin, James S.
Martin, John Henry
Martin, Rush S., Jr.
Martin, Samuel M.
Mason, William
Mattox, Howard G.
Maxwell, Gordon S.
McAllister, Charles
McBride, David P.
McBride, Jack
McDaniel, Fred S.
McDonald, Furman L.

McGrady, Frank K.
McMinis, Willie
McPeak, Robert J.
McPherson, Duane
McVey, John C.
Menefee, Clinton
Michael, Alfred F.
Miliken, James P.
Miller, Earl T.
Miller, Harry C.
Miller, John N.
Miller, Richard E.
Milliron, Charles
Millner, Calvin C.
Mills, Ben F.
Mills, Robert B.
Milton, Joe
Minter, John H.
Montague, Daniel L., Sr.
Montague, Willjohn
Moock, Peter G.
Moody, Dallas D.
Moore, Claude S.
Moore, John D.
Morgan, Ralph W.
Myers, Herbert P.
Myers, Irving B.
Myers, William F., Sr.
Naviaux, Phillip
Neighbors, Clarence
Newman, Wilson G.
Newton, William H.
Nichols, Howard L.
Nichols, Sheldon T.
Nimmo, Ralph
Norton, Melvin
Nover, Frederick W., Jr.
Oakey, David R.
Obenchain, Fred A.
Obenshain, James H.
Obenshain, Raymond E.
O'Brien, James
Ofsa, Harry
O'Hearn, John J., Jr.
Oliver, Earl P.
Overstreet, Busey

Pace, Charles A.
Pace, Harold R.
Pace, Henry C.
Pandlis, Eugene
Parker, Charles
Parsons, Melvin
Patsel, Robert L.
Patterson, Robert R.
Paul, H. P.
Pauley, Ernest C.
Payne, Robert V., Jr.
Peale, Randolph
Pelueger, James
Peoples, John A., Jr.
Perdue, Fred C.
Perdue, William G.
Perry, Gilbert E.
Peters, Robert W.
Pflueger, James
Philpotts, James R.
Phlegar, Philip E.
Pierpont, George H.
Piner, Clarence W.
Pingley, William G., Jr.
Plunkett, Moss A., Jr.
Porterfield, Arthur R.
Powell, Harry, Jr.
Powers, Henry C.
Preston, Joseph A.
Price, Alvah S.
Price, James E., Jr.
Price, Raymond E.
Priest, John N.
Prilliaman, Edward R.
Pritchard, Robert L.
Puckett, David Sr.
Puckett, Eugene P., II
Quesenberry, William
Quinn, Edward T.
Rader, Walter J.
Ragland, Bertram
Raleigh, James M., Jr.
Raleigh, Joseph B.
Ramsey, Ralph N.
Ransone, Coleman B.
Rea, Virgil L.

Reed, Thomas E.
Reynolds, George
Rhodes, Cecil W.
Rice, Everett J.
Richardson, Cecil F.
Richardson, James W.
Ricks, Melvin C.
Robertson, Carl C.
Robertson, Cleo M.
Robertson, Norman A.
Robertson, Oscar B.
Rogers, James L.
Rogers, Junior E.
Roope, Robert L., Jr.
Ross, Leslie G.
Rountree, Alonza T., Jr.
Rucker, Earl C.
Russell, Philip
Sandefur, Hubert C., Jr.
Saul, William C.
Saunders, James H.
Saunders, Jesse J., Jr.
Schilling, Otey P., Jr.
Scott, Shelby W.
Scott, William E.
Scruggs, Charles H.
Selwyn, Stephen
Sexton, Charles W., Jr.
Sexton, James E.
Sexton, John G.
Shanks, Gray W.
Shaw, James
Shelton, Eugene D.
Shepheard, William H.
Shively, Nicholas, Jr.
Shuler, Ivan P.
Shure, Irving I.
Siler, Cecil
Simmons, Clarence
Simmons, James W.
Simms, Jack R.
Sink, Walter D., Jr.
Sisson, Victor E., Jr.
Sizer, Glenwood
Sledd, James
Slusher, Clovis, Jr.

Smith, Earl T.
Smith, Elmer J.
Smith, Guy R., Jr.
Smith, Harvey P.
Smith, John C.
Smith, Richard C.
Smith, Stewart B.
Snyder, Charles J.
Snyder, Ray L.
Sours, John W.
Sowder, John G.
Sowers, Curtis N.
Spangler, Robert
Spencer, Robert H., Jr.
Spencer, William W.
Spillan, Robert
Spradlin, Edward
Spradlin, Elmo W.
St. Clair, George C.
St. Clair, George J.
St. Clair, Joe R.
Staley, Leonard
Staney, Joseph, Jr.
Stanley, Joseph H.
Stanley, Norris P.
Stanley, Vernon O.
Stewart, Paul M.
Stone, A. H.
Stone, Luther K.
Stuart, David
Stuart, William E.
Stump, David E.
Stump, Robert M.
Sturdivant, Joseph P.
Sublette, Paul E.
Swartz, Lorenzo
Sweet, Charles L., Jr.
Tayloe, Herbert, Jr.
Templeton, Samuel M., III
Terry, Samuel C.
Thames, Sanford L.
Thomas, Billy S.
Thomas, Charles W.
Thomas, Ellis
Thompson, Ralph
Thompson, Robert J.

Thurston, James
Tompkins, Edmond P.
Topham, William F.
Trent, Enoch
Trimmer, George A.
Tucker, Paul C., Jr.
Turner, Everette G.
Turner, Frank E.
Turner, Louis M., Jr.
Vanhorn, Gaylord
Vaughan, Clyde E.
Vaughn, Dallie A.
Venable, Eugene
Wade, Demar B.
Walters, Lucian
Walters, Rodger W.
Walton, Edward D.
Watson, William H.
Watterson, Charles, Jr.
Weaver, Eldridge
Weaver, Murrell R.
Weaver, William
Webber, George B.
Webber, Harold C.
Webster, Alvin P.
Webster, Harold C.
Weeks, Julian J.
Weeks, Manuel
Weeks, Ulysses B.
Weston, Jack W.
Wheeler, Walter O.
Whitehead, Frederick C., Jr.
Whitlock, Ashby A., Jr.
Wickham, George C.
Wilkins, Walter W.
Williams, Leroi
Williams, Nathaniel E.
Wimmer, Erie
Winston, Paul D.
Witt, John A.
Witt, Richard L.
Witt, Royall K.
Wohlford, Dexter S., Jr.
Woodson, Lewis F.
Woodson, Rennie P.
Wrench, William

Wright, Charlie M.
Wright, Grover R.
Wright, James L.
Wright, Lawrence E.
Yeager, George H., Jr.

Youell, Thomas B., Jr.
Zimmerman, George A., Jr.
Zini, Andrew L.

Appendix B:
Roanoke Valley Civil Rights Timeline, 1940-1949

During the 1940s, the Roanoke Valley was segregated in every way. Schools were segregated; seating at theatres, auditoriums, stadiums, and on buses was segregated. There were separate water fountains and toilet facilities. When entertainers came to Roanoke for floor shows and dances, whites and blacks were not permitted to be on the dance floor at the same time. There was long-standing discrimination in employment, lodging, and healthcare. Amid this context, the Roanoke Valley's African American community began lobbying for equality and civil rights.

1940

- The cornerstone of Carver School in Salem was laid on March 17.

- Roanoke city councilman W. M. Powell expressed concern about the condition of housing in the predominantly black neighborhoods of the city and proposed that the council consider appointing a housing authority to address the matter.

- African Americans were provided a regulation baseball diamond and tennis courts for the first time in Roanoke. Both were located at Washington Park and funded through the Federal Works Project Administration.

- Carver School opened to the public in September, being the first consolidated school for blacks in Roanoke county.

- Black civic leaders advocated for the expansion of the branch library or a new branch library for blacks in the city of Roanoke through bond proceeds.

- The newly formed Roanoke Negro Teachers Association presented a petition to the Roanoke City School Board advocating for equal pay for black teachers as compared to white teachers.

- Carver School was formally dedicated on December 1.

- The Roanoke County Negro Teachers Association was formed to advocate for equal pay for black teachers as was given white teachers.

- The Roanoke City School Board adopted a recommendation from Superintendent D. E. McQuilkin that the salaries of black teachers achieve parity with white teachers. The plan would be achieved over a phased-in three-year period.

1941

- In February, Sarah Craig refused to move to the back of a city bus that was designated for black passengers. The matter was referred to Police Court. The charge against Craig was dismissed a few weeks later.

- In February, Mary Walters was fined ten dollars and given a suspended sentence for refusing to move to the back of a city bus.

- The Roanoke Chapter of the National Negro Congress was chartered in May.

- The Roanoke Civic League, a merger between two black civic organizations, was formed to advocate for equality and fair treatment toward the city's black neighborhoods.

- Gainsboro School for blacks was deemed to be in the poorest condition of all Roanoke schools, with no playground, a student-teacher ratio of 54–1, and half-day sessions for upper-grade students due to overcrowding.

1942

- Dr. Harry Penn, a dentist, entered the Democratic primary for the Roanoke City Council. He became the first African American in the city's history to run for city council. He lost in the primary.

- The new Gainsboro Branch Library for blacks opened and was dedicated on May 10.

1943

- Rev. A. L. James of First Baptist Church, Gainsboro, addressed the all-white Roanoke Ministers' Conference and urged the clergy to advocate for equality and fairness in regard to matters of race.

1944

- The Roanoke Civic League announced in January a plan to advocate for the hiring of black policemen in the City of Roanoke.

- A local chapter of the National Negro Congress was organized in March.

- The Roanoke City Council voted in March to install toilets for blacks at Maher Field as no such facilities had ever been provided at that site. The toilets had been requested by local baseball officials.

- Nine duly elected black delegates to the Virginia State Democratic Convention being held in Roanoke were refused voting status at the convention by the party's Credentials Committee. The committee asserted that only whites could be voting delegates. Among the nine delegates barred from voting were three from Roanoke.

- A petition with seven hundred signatures was presented to the Roanoke City Council advocating the hiring of black police officers.

- In November, Roanoke city manager W. P. Hunter reported to the city council that due to World War II and the lack of young black men, the time was not right to hire blacks as police officers.

- Eileen Evans of Roanoke filed suit in US District Court challenging Virginia's poll tax. She had been denied the vote at her precinct, Melrose, due to her refusal to pay the tax.

- Rev. Lanneau White of St. Paul's Methodist Church in Roanoke declared that segregation was "an abomination to the Lord" in a sermon broadcast over WDBJ radio. The station manager urged him to exercise caution in future broadcasts.

1945

- In April the Federal Bureau of Investigation and Roanoke police investigated a threatening letter received by Dr. Harry Penn from the Ku Klux Klan that offered to take him "for a ride" if he refused to stop speaking publicly about race matters.

- Dr. Harry Penn was elected to the Roanoke City Democratic Committee and became the first black person elected to a local committee of the party in the Sixth Congressional District since Reconstruction.

1946

- In June, Roanoke's police chief, J. F. Ingoldsby, announced the appointment of the city's first two black police officers, Woodrow Gaitor and Lonnie Caldwell.

- In November, Roanoke's new police superintendent, Clay Ferguson, appointed two additional black police officers, Harry Stovall and Leon Fields.

- Rev. William Simmons of Roanoke's Fifth Avenue Presbyterian Church sued Atlantic-Greyhound Bus Lines in US District Court for not allowing him to sit in any seat of his choosing when boarding a bus outward bound from Roanoke to North Carolina.

1947

- A jury awarded Simmons $25 in his suit against Atlantic-Greyhound Bus Lines. Simmons had sued for $20,000 in the test case of federal law barring segregated seating of interstate transportation by bus and rail lines.

- Dorothy Jones filed suit in US District Court against the election judges of Melrose Precinct for not being allowed to vote in 1946 due to an unpaid poll tax. The suit used an alternative legal strategy to challenge Virginia's poll tax.

- The Roanoke City School Board voted to realign schools by race due to over five hundred black students receiving only half-day sessions.

- In November, the Roanoke Tuberculosis Society, an organization of city and county public health workers, was denied meeting space at both the Hotel Roanoke and the Patrick Henry Hotel due to the hotels' policies barring blacks

from meeting on their premises. The society, which was one-third black, eventually moved their meeting to the Roanoke YWCA.

- One the eve of the Virginia NAACP state convention being held in Roanoke, the NAACP's leading national attorney, Thurgood Marshall, held a press conference in Roanoke and announced a plan to eliminate school segregation in Virginia county by county and the plan to file a lawsuit against the University of Virginia.

- Dr. Harry Penn is elected president of the Richmond-based Virginia Civil Rights Organization, which consisted of over one hundred organizations focused on ending segregation in Virginia.

1948

- Former Roanoker Oliver W. Hill addressed a civil rights rally at the Ninth Avenue Christian Church in Roanoke on January 4. A crowd of five hundred listened as Hill declared that segregation in all its forms must come to an end.

- Federal Judge John Paul ruled that bus companies had the right to segregate seating and deemed their rules in that regard "reasonable." Paul's ruling was in response to a favorable jury ruling in a suit brought by Rev. William Simmons against Atlantic-Greyhound.

- Judge Dirk Kuyk of Roanoke Hustings Court held that blacks could serve on local juries, a position he had advocated for years. Twenty-two blacks were listed among six hundred names eligible for jury duty.

- For the first time in Roanoke's history, blacks were appointed as election judges and clerks for the June 8 Roanoke City Council general election.

- Dr. Harry Penn was appointed to the Roanoke School Board by the Roanoke City Council on June 28, making him the first black person to ever serve in that capacity in Roanoke.

- A. J. Oliver, the first black attorney to practice in Roanoke, died at Burrell Memorial Hospital on October 8 at the age of eighty.

- Dr. W. E. B. Dubois, former director of special research for the NAACP, addressed a civil rights meeting at First Baptist Church, Gainsboro, on November 18.

- Clark Hamilton was arrested and placed in the Roanoke County jail on Christmas Eve for violating Virginia's miscegenation statute. Hamilton's arrest warrant had been sworn out by his mother-in-law after she determined he was black. Her daughter was white. Hamilton had declared himself as white for their marriage license.

1949

- Clark Hamilton was given a suspended sentence of three years after he plead guilty on March 4 to violating Virginia's miscegenation statute. His marriage was deemed illegal, and he boarded a train to leave the state the following day.

- A delegation of black citizens, led by Dr. Harry Penn, asked the Roanoke City Council on August 8 to build a year-round recreation center for black youth and to prohibit garbage from being dumped in an abandoned quarry adjacent to Washington Park. The garbage dump caught fire on a regular basis.

- Norvel Lee, a native of Botetourt County, won an appeal from the Virginia Supreme Court on September 7 for being fined twenty-five dollars in circuit court for refusing to change his seat from a "whites only" section on a Chesapeake and Ohio Railway passenger train the previous year. The Virginia Supreme Court held that as the train crossed state lines it was subject to federal antisegregation laws, and thus ruled in favor of Lee, who was black. If the train had traveled only through Virginia, a segregation state, the fine would have stood.

Index

Roanoke Merchants Association 230, 401, 418, 587, 590, 594, 595, 596, 598, 607

Roanoke Ministers' Conference 459, 489, 520, 529

Roanoke Ministers' Conference 6, 141, 165, 201, 239, 249, 279, 301, 316, 326, 332, 340, 382, 397, 452, 467, 529, 530, 533, 540, 548, 549, 595

Roanoke Motor Sales 115

Roanoke Municipal Airport 5, 25, 38, 39, 40, 41, 42, 44, 47, 57, 61, 65, 66, 71, 77, 88, 99, 101, 104, 106, 110, 112, 116, 117, 119, 124, 131, 133, 227, 233, 357

Roanoke Paint and Body Company 542

Roanoke Paint and Glass Company 348

Roanoke Paper Company 161, 210

Roanoke Photo Finishing 263, 464

Roanoke Pilot Club 119

Roanoke Police Department 12, 17, 20, 25, 27, 34, 37, 38, 42, 43, 49, 53, 57, 65, 68, 79, 80, 81, 83, 84, 87, 91, 99, 100, 101, 106, 111, 132, 133, 139, 140, 141, 150, 151, 153, 156, 176, 184, 193, 204, 207, 210, 216, 219, 233, 237, 240, 242, 243, 244, 245, 247, 248, 253, 261, 263, 272, 273, 276, 279, 281, 286, 288, 295, 296, 298, 299, 304, 306, 313, 314, 319, 322, 324, 332, 336, 338, 341, 342, 344, 345, 354, 357, 360, 366, 369, 370, 373, 377, 378, 379, 382, 391, 397, 398, 403, 404, 418, 423, 430, 436, 452, 465, 470, 480, 482, 484, 504, 532, 533, 540, 541, 543, 545, 551, 558, 566, 570, 583, 596, 598, 604, 606

Roanoke Raiders, football 393, 453, 459, 464, 530, 593

Roanoke Railway and Electric Company 37, 48, 64, 102, 157, 175, 250, 321, 332, 340, 388, 415, 439, 499, 555

Roanoke Recreation Association 141, 296, 299, 301, 323, 347, 359, 481

Roanoke Redevelopment and Housing Authority 579, 584

Roanoke Red Sox 207, 208, 210, 211, 226, 245, 247, 248, 249, 251, 296, 302, 303, 304, 355, 359, 361, 369, 389, 390, 392, 402, 420, 424, 448, 451, 455, 472, 473, 512, 525, 528, 547, 558, 562, 572, 583, 593, 594, 603

Roanoke Riding Stables 595

Roanoke River 11, 19, 42, 45, 65, 80, 96, 145, 148, 172, 175, 206, 220, 231, 275, 290, 300, 306, 359, 361, 374, 376, 385, 395, 468, 469, 504, 510, 547, 569, 570, 577, 581, 604

Roanoke Rotary Club 30, 55, 71, 90, 182, 540, 580

Roanoke Round Table of Christians and Jews 364

Roanoke Royals, baseball 417, 421, 490

Roanoker Restaurant 464

Roanoke Scrap Iron and Metal 165

Roanoke Semi-Pros, baseball 111, 162

Roanoke Shops, N&W 6, 12, 39, 55, 205, 292, 308, 450, 488, 553, 602

Roanoke Stamp and Coin Club 482

Roanoke Stamp and Coin Company 354, 581

Roanoke Star 587, 590, 594, 596, 598, 599, 600, 604, 605, 607

Roanoke-Starkey bus line 326

Roanoke Steel and Supply Company 434

Roanoke Street Railway Company 62, 250

Roanoke Sweeper Company 435

Roanoke Symphony Orchestra 25, 57, 79, 145, 200, 412, 525

Roanoke Theatre 17, 47, 135, 183, 190, 199, 207, 208, 212, 220, 225, 233, 236, 264, 292, 300, 302, 305, 306, 308, 310, 311, 313, 315, 320, 321, 322, 325, 327, 329, 334, 337, 341, 344, 357, 360, 361, 387, 391, 393, 394, 395, 399, 408, 412, 418, 427, 431, 442, 443, 446, 448, 451, 453, 454, 458, 463, 467, 470, 472, 476, 477, 478, 481, 490, 491, 493, 497, 500, 511, 517, 528, 534, 537, 541, 543, 544, 546, 547, 549, 553, 554, 556, 560, 562, 564, 569, 570, 571, 573, 577, 579, 581, 585, 587, 591, 593, 595, 596, 598, 599, 605, 606

Roanoke Times 7, 9, 12, 15, 17, 19, 28, 32, 33, 36, 48, 57, 81, 84, 87, 102, 106, 117, 121, 131, 132, 143, 147, 153, 161, 165, 171, 204, 273, 274, 276, 277, 284, 288, 300, 304, 315, 316, 319, 320, 321, 326, 329, 357, 368, 370, 382, 385, 391, 396, 399, 405, 406, 409, 445, 448, 460, 488, 508, 511, 525, 531, 539, 540, 541, 543, 544, 548, 574, 578, 580, 586, 587, 600, 601

Windsor Hills-Lee Hy Park Civic League 443

Wings Over Jordan 40, 85, 279, 479

Winstead, Edgar 214, 580

Wise, Julian 4, 50, 304, 477, 489, 491, 492, 497, 519, 540, 580

Witcher, Albert 414

Witten-Martin Furniture 73, 91

Witt, Royall 276

Wohlford, Dexter 278

Woman's Club 11, 56, 58, 72, 80, 87, 108, 110, 257

Woman's Club 14, 152, 181, 208, 260, 283, 288, 291, 307, 313, 488, 494, 599

Women's Christian Temperance Union 326, 394

Women's Land Army 254

Wonder Bar Night Club 356

Wood, Garrison 175

Woodlawn Methodist Church 420

Wood, Reginald 550, 563

Woodrow Wilson Junior High School 17, 76, 144

Woodrum, Byron 472, 480, 567

Woodrum, Clifton 42, 44, 47, 48, 55, 61, 97, 110, 117, 119, 122, 134, 155, 158, 174, 177, 178, 179, 180, 181, 190, 192, 199, 220, 230, 248, 250, 252, 275, 278, 291, 292, 293, 296, 300, 314, 316, 324, 326, 335, 336, 341, 343, 600

Woodrum Field 97, 117, 122, 124, 128, 133, 134, 135, 142, 151, 153, 155, 157, 174, 179, 180, 183, 191, 197, 198, 199, 202, 203, 204, 205, 212, 214, 215, 216, 217, 219, 220, 222, 224, 226, 233, 235, 236, 239, 241, 246, 247, 249, 251, 252, 256, 264, 265, 266, 268, 272, 275, 282, 290, 292, 293, 300, 309, 315, 326, 328, 330, 331, 334, 345, 349, 357, 370, 374, 379, 384, 386, 391, 394, 395, 400, 406, 408, 410, 414, 422, 424, 435, 442, 447, 464, 468, 470, 474, 481, 484, 489, 512, 513, 517, 531, 532, 535, 537, 553, 555, 562, 569, 573, 576, 579, 583, 593

Woodrum, Jordan 466, 478, 480

Woodrum, Martha Ann 119, 155, 181, 193, 219, 328, 433, 532, 537

Woods, James 223, 378, 499

Woodson Cafeteria 472, 477

Woodson, Frank 111

Woodson, Lewis 286

Woodson Pontiac 379

Wood, Walter 9, 14, 19, 20, 24, 26, 27, 34, 36, 42, 49, 51, 54, 61, 71, 79, 107, 122, 165, 180, 192, 198, 211, 216, 221, 230, 232, 315, 340

Woolworth's, department store 303, 409, 544, 572, 587, 599

Works Project Administration 6, 7, 30, 35, 36, 37, 38, 42, 48, 61, 62, 64, 71, 80, 81, 110, 112, 122, 126, 151, 152, 153, 155, 158, 172, 230, 400

World War 1 35, 59, 61, 78, 95, 108, 128, 134, 137, 149, 153, 183, 217, 384, 463

World War II, first local casualties 135

World War II, local casualty count 374

Wray, Clarke 354, 512, 528, 603

Wright, Charles 273

Wright Furniture Company 210, 216, 247, 367

Wright, James 260

Wright, John 67

Wright, Lawrence 220

Wright Siding Orchard 511

Wright, Virginia 108

WROV 355, 380, 382, 387, 393, 397, 399, 403, 479, 495, 535, 546, 601, 604

WSLS 40, 50, 54, 56, 60, 67, 74, 76, 79, 81, 87, 89, 92, 97, 103, 104, 114, 120, 131, 133, 153, 157, 184, 194, 196, 206, 224, 242, 244, 284, 308, 309, 368, 378, 380, 393, 399, 403, 414, 418, 421, 451, 454, 460, 474, 479, 515, 536, 562, 577, 578

Y

Yale and Towne Lock Plant 456

Yates, Harry 15, 26, 534

Yeager, George 233, 264, 457

Yeager Motor Company 457

Yellow Cab Company 324, 375, 390, 435

Yellow Mountain 341, 361, 524, 561

Yellow Mountain Garden Club 400

YMCA 9, 60, 70, 99, 107, 127, 130, 137, 147, 158, 189, 223, 244, 246, 255, 258, 259, 260, 275, 303, 307, 343, 377, 403, 412, 435, 444, 451, 461, 468, 470, 472, 474, 509, 555, 577

Youell, Thomas 324

Young Men;s Shop 295

About the Author

Local historian Nelson Harris is a native and former mayor of Roanoke, Virginia. He has been the pastor of Heights Community Church since 1999 and is an adjunct faculty member at Virginia Western Community College. He holds degrees from Radford University and Southeastern Baptist Theological Seminary and has done postgraduate work at Princeton Theological Seminary and Harvard University. A past president of the Historical Society of Western Virginia, he is a local history columnist for the *Roanoker* magazine and producer, writer and host for *Virginia History with Nelson Harris* on Blue Ridge PBS. He is the author of the following books:

The 17th Virginia Cavalry
Roanoke in Vintage Postcards
Images of Rail: Norfolk & Western Railway
Virginia Tech
Stations and Depots of the Norfolk & Western Railway
Downtown Roanoke
Salem and Roanoke County in Vintage Postcards
Roanoke Valley: Then and Now
Greater Raleigh Court: A History of Wasena, Virginia Heights,
 Norwich & Raleigh Court
Hidden History of Roanoke
Aviation in Roanoke
A History of Back Creek: Bent Mountain, Poages Mill, Cave Spring and Starkey
The Grand Old Lady on the Hill: An Informal History of the Hotel Roanoke
 (co-author)